R. L. Hobson

CHINESE
POTTERY AND
PORCELAIN

An Account of the Potter's Art in China
From Primitive Times
to the Present Day

IN TWO VOLUMES BOUND AS ONE

DOVER PUBLICATIONS, INC.
NEW YORK

This Dover edition, first published in 1976, is an unabridged republication of the work originally published by Funk and Wagnalls Company, New York, and Cassell and Company, Limited, London, in 1915. The work, which was formerly published in two separate volumes, is here bound in one volume.

International Standard Book Number: 0-486-23253-0
Library of Congress Catalog Card Number: 75-21139

Manufactured in the United States of America
Dover Publications, Inc.
180 Varick Street
New York, N.Y. 10014

CHINESE POTTERY AND PORCELAIN

Volume I

POTTERY
AND EARLY WARES

CONTENTS

LIST OF PLATES

THE COLOR PLATES FOLLOW PAGE 26.

STATUE OF LOHAN OR BUDDHIST APOSTLE, T'ANG DYNASTY
(618–906 A.D.). *British Museum . Frontispiece (Color Section)*

List of Plates

List of Plates

INTRODUCTION

WHEN we consider the great extent of the Chinese Empire and its teeming population—both of them larger than those of Europe—and the fact that a race with a natural gift for the potter's craft and a deep appreciation of its productions has lived and laboured there for twenty centuries (to look no farther back than the Han dynasty), it seems almost presumptuous to attempt a history of so vast and varied an industry within the compass of two volumes. Anything approaching finality in such a subject is out of the question, and, indeed, imagination staggers at the thought of a complete record of every pottery started in China in the past and present.

As far as pottery is concerned, we must be content with the identification of a few prominent types and with very broad classifications, whether they be chronological or topographical. Indeed, the potteries named in the Chinese records are only a few of those which must have existed ; and though we may occasionally rejoice to find in our collections a series like the red stonewares of Yi-hsing, which can be definitely located, a very large proportion of our pottery must be labelled uncertain or unknown. How many experts here or on the Continent could identify the pottery made in South Germany or Hungary a hundred years ago ? What chance, then, is there of recognising any but the most celebrated wares of China ?

In dealing with porcelain as distinct from pottery, we have a simpler proposition. The bulk of what we see in Europe is not older than the Ming dynasty and was made at one of two large centres, viz. Ching-tê Chên in Kiangsi, and Tê-hua in Fukien. Topographical arrangement, then, is an easy matter, and there

is a considerable amount of information available to guide us in chronological considerations.

The antiquity of Chinese porcelain, its variety and beauty, and the wonderful skill of the Chinese craftsmen, accumulated from the traditions of centuries, have made the study of the potter's art in China peculiarly absorbing and attractive. There is scope for every taste in its inexhaustible variety. Compared with it in age, European porcelain is but a thing of yesterday, a mere two centuries old, and based from the first on Chinese models. Even the so-called European style of decoration which developed at Meissen and Sèvres, though quite Western in general effect, will be found on analysis to be composed of Chinese elements. It would be useless to compare the artistic merits of the Eastern and Western wares.

It is so much a matter of personal taste. For my own part, I consider that the decorative genius of the Chinese and their natural colour sense, added to their long training, have placed them so far above their European followers that comparison is irrelevant. Even the commoner sorts of old Chinese porcelain, made for the export trade, have undeniable decorative qualities, while the specimens in pure Chinese taste, and particularly the Court wares, are unsurpassed in quality and finish.

The merits and beauty of porcelain have always been recognised by the Chinese, who ranked it from the earliest days among their precious materials. Chinese poets make frequent reference to its dainty qualities, its jade-like appearance, its musical ring, its lightness and refinement. The green cups of Yüeh Chou ware in the T'ang dynasty were likened to moulded lotus leaves ; and the white Ta-yi bowls surpassed hoar-frost and snow. Many stanzas were inspired by the porcelain bowls used at the tea and wine symposia, where cultivated guests capped each other's verses. In a pavilion at Yün-mên, in the vicinity of Ching-tê Chên, is a tablet inscribed, " The white porcelain is quietly passed all through the night, the fragrant vapour (of the tea) fills the peaceful pavilion," an echo of a symposium held there by some distinguished persons in the year 1101 A.D., and no doubt alluding to wares of local make.

Elsewhere [1] we read of a drinking bout in which the wine bowls of white Ting Chou porcelain inspired a verse-capping competition. " Ting Chou porcelain bowls in colour white throughout the Empire," wrote one. Another followed, " Compared with them, glass is a light and fickle mistress, amber a dull and stupid female slave." The third proceeded : " The vessel's body is firm and crisp ; the texture of its skin is yet more sleek and pleasing."

The author of the *P'ing hua p'u*, a late Ming work on flower vases, exhorts us : " Prize the porcelain and disdain gold and silver. Esteem pure elegance."

In their admiration of antiques the Chinese yield to none, and nowhere have private collections been more jealously guarded and more difficult of access. Even in the sixteenth century relatively large sums were paid for Sung porcelains, and £30 was not too much for a " chicken wine cup " barely a hundred years old. The ownership of a choice antique—say, of the Sung dynasty—made the possessor a man of mark ; perhaps even a marked man if the local ruler chanced to be of a grasping nature.

A story is told on p. 75 of this volume of a Ko ware incense burner (afterwards sold for 200 ounces of gold), which brought a man to imprisonment and torture in the early Ming period ; and, if the newspaper account was correct, there was an incident in the recent revolution which should touch the collector's heart. A prominent general, who, like so many Chinese grandees, was an ardent collector, was expecting a choice piece of porcelain from Shanghai. In due course the box arrived and was taken to the general's sanctum. He proceeded to open it, no doubt with all the eagerness and suppressed excitement which collectors feel in such tense moments, only to be blown to pieces by a bomb ! His enemies had known too well the weak point in his defence.

Collecting is a less dangerous sport in England ; but if it were not so, the ardent collector would be in no way deterred. Warnings are wasted on him, and he would follow his quarry, even though the path were strewn with fragments of his indiscreet fellows. Still less is he discouraged by difficulties of another kind, as illustrated

[1] In the *Kuei ch'ien chih* quoted in the *T'ao lu*, bk. ix., fol. 10.

by the story [1] of T'ang's white Sung tripod, which was so closely imitated that its owner, one of the most celebrated collectors of the sixteenth century, could not distinguish the copy from the original. An eighteenth century Chinese writer points the moral of the story : " When connoisseurs point with admiration to a vessel, calling it Ting ware, or, again, Kuan ware, how can we know that it is not a ' false tripod ' which deceives them ? " The force of this question will be appreciated by collectors of Sung wares, especially of the white Ting porcelains and the green celadons ; for there is nothing more difficult to classify correctly than these long-lived types. There are, however, authentic Sung examples within reach, and we can train our eyes with these, so that nothing but the very best imitations will deceive us ; and, after all, if we succeed in obtaining a really first-rate Ming copy of a Sung type we shall be fortunate, for if we ever discover the truth—which is an unlikely contingency—we may console ourselves with thoughts of the enthusiast who eventually bought T'ang's false tripod for £300 and " went home perfectly happy."

In spite of all that has been written in the past on Oriental ceramics, the study is still young, and it will be long before the last word is said on the subject. Still our knowledge is constantly increasing, and remarkable strides have been made in recent years. The first serious work on Chinese porcelain was Julien's translation of the *Ching-tê Chên t'ao lu*, published in 1856. The work of a scholar who was not an expert, it was inevitably marred by misunderstanding of the material, and subsequent writers who followed blindly were led into innumerable confusions. The Franks Catalogue, issued in 1876, was one of the first attempts to classify Oriental wares on some intelligible system ; but it was felt that not enough was known at that time to justify a chronological classification of the collection, and the somewhat unscientific method of grouping by colours and processes of decoration was adopted as a convenient expedient. At the end of last century Dr. S. W. Bushell revolutionised the study of Chinese porcelain by his *Oriental Ceramic Art*, a book, unfortunately, difficult to obtain, and by editing Cosmo Monk-

[1] See p. 95.

house's excellent *History and Description of Chinese Porcelain*. These were followed by the South Kensington Museum Handbook and by the translation and reproduction of the sixteenth century Album of Hsiang Yüan-p'ien, and later by the more important translation of the *T'ao shuo*.

It would be impossible to over-estimate the importance of Bushell's pioneer work; and I hasten to make the fullest acknowledgment of the free use I have made of his writings, the more so because I have not hesitated to criticise freely his translations where necessary. The Chinese language is notoriously obscure and ambiguous, and differences of opinion on difficult passages are inevitable. In fact, I would say that it is unwise to build up theories on any translation whatsoever without verifying the critical passages in the original. For this reason I found it necessary to work laboriously through the available Chinese ceramic literature, a task which would have been quite impossible with my brief acquaintance with the language had it not been for the invaluable aid of Dr. Lionel Giles, who helped me over the difficult ground. I have, moreover, taken the precaution of giving the Chinese text in all critical passages, so that the reader may satisfy himself as to their true meaning.

While Dr. Bushell's contributions have greatly simplified the study of the later Chinese porcelains, little or no account was taken in the older books of the pottery and early wares. The materials necessary for the study of these were wanting in Europe. Stray examples of the coarser types and export wares had found their way into our collections, but not in sufficient numbers or importance to arouse any general interest, and the condition of the Western market for the early types was not such as to tempt the native collector to part with his rare and valued specimens. In the last few years the position has completely changed. The opening up of China and the increased opportunities which Europeans enjoy, not only for studying the monuments of ancient Chinese art, but for acquiring examples of the early masterpieces in painting, sculpture, bronze, jade, and ceramic wares, have given the Western student a truer insight into the greatness of the earlier phases of Chinese art, and have awakened a new and widespread enthusiasm for them.

An immense quantity of objects, interesting both artistically and archæologically, has been discovered in the tombs which railway construction has incidentally opened ; and although this rich material has been gathered haphazard and under the least favourable conditions for accurate classification, a great deal has been learnt, and it is not too much to say that the study of early Chinese art has been completely revolutionised. Numerous collections have been formed, and the resulting competition has created a market into which even the treasured specimens of the Chinese collectors are being lured. Political circumstances have been another factor of the situation, and the Western collector has profited by the unhappy conditions which have prevailed in China since the revolution in 1912.

The result of all this, ceramically speaking, is that we are now familiar with the pottery of the Han dynasty ; the ceramic art of the T'ang period has been unfolded in wholly unexpected splendour ; the Sung problems no longer consist in reconciling ambiguous Chinese phrases, but in the classification of actual specimens ; the Ming porcelain is seen in clearer perspective, and our already considerable information on the wares of the last dynasty has been revised and supplemented by further studies. So much progress, in fact, has been made, that it was high time to take stock of the present position, and to set out the material which has been collected, not, of course, with any thoughts of finality, but to serve as a basis for a further forward move. That is the purpose of the present volumes, in which I have attempted merely to lay before the reader the existing material for studying Chinese ceramics as I have found it, adding my own conclusions and comments, which he may or may not accept.

The most striking additions to our knowledge in recent years have without doubt been those which concern the T'ang pottery. What was previously a blank is now filled with a rich series covering the whole gamut of ceramic wares, from a soft plaster-like material through faïence and stoneware up to true porcelain. The T'ang potters had little to learn in technical matters. They used the soft lead glazes, coloured green, blue, amber, and purplish brown

by the same metallic oxides as formed the basis of the cognate glazes on Ming pottery. They used high-fired feldspathic glazes, white, browish green, chocolate brown, purplish black, and tea-dust green, sometimes with frothy splashes of grey or bluish grey, as on the Sung wares. Sometimes these glazes were superposed as on the Japanese tea jars, which avowedly owed their technique to Chinese models. It is evident that streaked and mottled effects appealed specially to the taste of the time, and marbling both of the glaze and of the body was practised. Carving designs in low relief, or incising them with a pointed instrument and filling in the spaces with coloured glazes, stamping small patterns on the body, and applying reliefs which had been previously pressed out in moulds, were methods employed for surface decoration. Painted designs in unfired pigments appear on some of the tomb wares, and it is now practically certain that painting in black under a green glaze was used by the T'ang potters. Moreover, the existence of porcelain proper in the T'ang period is definitely established.

One of the most remarkable features of T'ang pottery is the strong Hellenistic flavour apparent in the shapes of the vessels and in certain details of the ornament, particularly in the former. Other foreign influences observable in T'ang art are Persian, Sassanian, Scytho-Siberian, and Indian, and one would say that Chinese art at this period was in a peculiarly receptive state. As compared with the conventional style of later ages which we have come to regard as characteristically Chinese, the T'ang art is quite distinctive, and almost foreign in many of its aspects.

The revelation of T'ang ceramics has provided many surprises, and doubtless there are more in store for us. There are certainly many gaps to fill and many apparent anomalies to explain. We are still in the dark with regard to the potter's art of the four hundred years which separate the Han and T'ang dynasties. The Buddhist sculptures of this time reveal a high level of artistic development, and we may assume that the minor arts, and pottery among them, were not neglected. When some light is shed from excavation or otherwise upon this obscure interval, no doubt we

shall see that we have fixed our boundaries too rigidly, and that
the Han types must be carried forward and the T'ang types carried
back to bridge the gap. Meanwhile, we can only make the best
of the facts which have been revealed at present, keeping our classi-
fication as elastic as possible. Probably the soft lead glazes belong
to the earlier part of the T'ang period and extend back to the Sui
and Wei, linking up with the green glaze of the Han pottery, while
the high-fired glazes tended to supersede these in the latter part
of the dynasty.

The high-fired feldspathic glazes seem to have held the field
entirely in the Sung dynasty, and the lead glazes, as far as our
observation goes, do not reappear until the Ming dynasty.

The Sung is the age of high-fired glazes, splendid in their lavish
richness and in the subtle and often unforeseen tints which emerge
from their opalescent depths. It is also an age of bold, free pot-
ting, robust and virile forms, an age of pottery in its purest mani-
festation. Painted ornament was used at certain factories in black
and coloured clays, and, it would seem, even in red and green enamels ;
but painted ornament was less esteemed than the true ceramic
decoration obtained by carving, incising, and moulding—processes
which the potters worked with the clay alone.

If we could rest content with a comprehensive classification of
the Sung wares, as we have had perforce to do in the case of the
T'ang, one of the chief difficulties in this part of our task would
be avoided. But the Chinese have given us a number of important
headings, under which it has become obligatory to try and group
our specimens. Some of these types have been clearly identified,
but there are others which still remain vague and ill-defined ; and
there are many specimens, especially among the coarser kinds of
ware, which cannot be referred to any of the main groups. But the
true collector will not find the difficulties connected with the Sung
wares in any way discouraging. He will revel in them, taking
pleasure in the fact that he has new ground to break, many
riddles to solve, and a subject to master which is worthy of
his steel.

Apparently a coarse form of painting in blue was employed

at one factory at least in the Sung period,[1] and we may now consider it practically certain that the first essays in painting both under and over the glaze go back several centuries earlier than was previously supposed. Blue and white and polychrome porcelain chiefly occupied the energies of the Imperial potters at Ching-tê Chên in the Ming dynasty, and the classic periods for these types fall in the fifteenth century. The vogue of the Sung glazes scarcely survived the brief intermediate dynasty of the Yüan, and we are told by a Chinese writer [2] that "on the advent of the Ming dynasty the *pi sê* [3] began to disappear." Pictorial ornament and painted brocade patterns were in favour on the Ming wares ; and it will be observed that as compared with those of the later porcelains the Ming designs are painted with more freedom and individuality. In the Ch'ing dynasty the appetite of the Ching-tê Chên potters was omnivorous and their skill was supreme. They are not only noted for certain specialities, such as the K'ang Hsi blue and white and *famille verte*, the *sang de bœuf* and peach-bloom reds, and for the development of the *famille rose* palette, but for the revival of all the celebrated types of the classic periods of the Sung and Ming ; and when they had exhausted the possibilities of these they turned to other materials and copied with magical exactitude the ornaments in metal, carved stone, lacquer, wood, shell, glass—in a word, every artistic substance, whether natural or artificial.

The mastery of such a large and complex subject as Oriental ceramics requires not a little study of history and technique, in books and in collections. The theory and practice should be taken simultaneously, for neither can be of much use without the other. The possession of a few specimens which can be freely handled and closely studied is an immense advantage. They need not be costly pieces. In fact, broken fragments will give as much of the all-important information on paste and glaze as complete specimens.

[1] See p. 99.

[2] In the *Ai jih t'ang ch'ao*, quoted in the *T'ao lu*, bk. ix., fol. 18 verso.

[3] The *pi sê*, or "secret colour," is used as a general term for glazes of the celadon type, among which the writer in question includes all the celebrated wares of antiquity from the T'ang "green (*ts'ui*) of a thousand hills," the Yüeh ware, the Ch'ai "blue (*ch'ing*) of the sky after rain," to the Sung Ju, Kuan, Ko, Tung-ch'ing, and Lung-ch'üan wares.

Those who have not the good fortune to possess the latter, will find ample opportunity for study in the public museums with which most of the large cities of the world are provided. The traveller will be directed to these by his "Baedeker," and I shall only mention a few of the most important museums with which I have personal acquaintance, and to which I gratefully express my thanks for invaluable assistance.

London.—The Victoria and Albert Museum possesses the famous Salting Collection, in which the Ch'ing dynasty porcelains are seen at their best: besides the collection formed by the Museum itself and many smaller bequests, gifts, and loans, in which all periods are represented. The Franks Collection in the British Museum is one of the best collections for the student because of its catholic and representative nature.

Birmingham and *Edinburgh* have important collections in their art galleries, and most of the large towns have some Chinese wares in their museums.

Paris.—The Grandidier Collection in the Louvre is one of the largest in the world. The Cernuschi Museum contains many interesting examples, especially of the early celadons, and the Musée Guimet and the Sèvres Museum have important collections.

Berlin.—The Kunstgewerbe Museum has a small collection containing some important specimens. The Hohenzollern Museum and the Palace of Charlottenburg have historic collections formed chiefly at the end of the seventeenth century.

Dresden.—The famous and historic collection, formed principally by Augustus the Strong, is exhibited in the Johanneum, and is especially important for the study of the K'ang Hsi porcelains. The Stübel Collection in the Kunstgewerbe Museum, too, is of interest.

Gotha.—The Herzögliches Museum contains an important series of the Sung and Yüan wares formed by Professor Hirth.

Cologne.—An important and peculiarly well-arranged museum of Far-Eastern art, formed by the late Dr. Adolf Fischer and his wife, is attached to the Kunstgewerbe Museum.

New York.—The Metropolitan Museum is particularly rich in

Ming and Ch'ing porcelains. It is fortunate in having the splendid Pierpont Morgan Collection and the Avery Collection, and when the Altmann Collection is duly installed in its galleries it will be unrivalled in the wares of the last dynasty. The Natural History Museum has a good series of Han pottery.

Chicago.—The Field Museum of Natural History has probably the largest collection of Han pottery and T'ang figurines in the world. It has also an interesting series of later Chinese pottery, including specimens from certain modern factories which are important for comparative study. These collections were formed by Dr. Laufer in China. There is also a small collection of the later porcelains in the Art Institute.

Boston.—The Museum of Fine Arts has a considerable collection of Chinese porcelain, in which the earlier periods are specially well represented. The American collections, both public and private, are especially strong in monochrome porcelains, and in this department they are much in advance of the European.

To acknowledge individually all the kind attentions I have received from those in charge of the various museums would make a long story. They will perhaps forgive me if I thank them collectively. The private collectors to whom I must express my gratitude are scarcely less numerous. They have given me every facility for the study of their collections, and in many cases, as will be seen in the list of plates, they have freely assisted with the illustrations. I am specially indebted to Mr. Eumorfopoulos, Mr. Alexander, Mr. R. H. Benson, Mr. S. T. Peters, and Mr. C. L. Freer, who have done so much for the study of the early wares in England and America. Without the unstinted help of these enthusiastic collectors it would have been impossible to produce the first volume of this book. What I owe to Mr. Eumorfopoulos can be partly guessed from the list of plates. His collection is an education in itself, and he has allowed me to draw freely on it and on his own wide experience. Of the many other collectors who have similarly assisted in various parts of the work, I have to thank Sir Hercules Read, Mr. S. E. Kennedy, Dr. A. E. Cumberbatch, Mr. C. L. Rothenstein, Dr. Breuer, Dr. C. Seligmann, M. R.

Koechlin, Mr. O. Raphael, Mr. A. E. Hippisley, Hon. Evan Char-
teris, Lady Wantage, Mr. Burdett-Coutts, the late Dr. A. Fischer,
Mr. L. C. Messel, Mr. W. Burton, Col. Goff, Mrs. Halsey, Mrs. Have-
meyer, Rev. G. A. Schneider, and Mrs. Coltart. A portion of the
proofs has been read by Mr. W. Burton. Mr. L. C. Hopkins
has given me frequent help with Chinese texts, and especially in the
reading of seal characters; and my colleague, Dr. Lionel Giles, in
addition to invaluable assistance with the translations, has con-
sented to look through the proofs of these volumes with a special
view to errors in the Chinese characters. Finally, I have to
thank my chief, Sir Hercules Read, not only for all possible
facilities in the British Museum, but for his sympathetic guidance
in the study of a subject of which he has long been a master.

R. L. HOBSON.

BIBLIOGRAPHY

ANDERSON, W., Catalogue of the Japanese and Chinese Paintings in the British Museum. 1886.

BINYON, L., " Painting in the Far East."

BRETSCHNEIDER, E., " Mediæval Researches from Eastern Asiatic Sources," Truebner's Oriental Series. 1878.

BRINKLEY, CAPT. F., " China, its History, Arts and Literature," vol. ix. London, 1904.

BURTON, W., " Porcelain : A Sketch of its Nature, Art and Manufacture." London, 1906.

BURTON, W., AND HOBSON, " Marks on Pottery and Porcelain." London, 1912.

BUSHELL, S. W., " Chinese Porcelain, Sixteenth-Century coloured illustrations with Chinese MS. text," by Hsiang Yüan-p'ien, translated by S. W. Bushell. Oxford, 1908. Sub-title " Porcelain of Different Dynasties."

BUSHELL, S. W., " Chinese Porcelain before the Present Dynasty," being a translation of the last, with notes. Peking, 1886.

BUSHELL, S. W., " Description of Chinese Pottery and Porcelain," being a translation of the T'ao shuo. Oxford, 1910.

BUSHELL, S. W., " Oriental Ceramic Art, Collection of W. T. Walters." New York, 1899.

BUSHELL, S. W., Catalogue of the Pierpont Morgan Collection. New York.

BUSHELL, S. W., " Chinese Art," 2 vols., " Victoria and Albert Museum Handbook." 1906.

CHAVANNES, EDOUARD, " La Sculpture sur pierre en Chine au temps des deux dynasties Han." Paris, 1893.

CHAVANNES, EDOUARD, " Mission Archéologique dans la Chine Septentrionale." Paris, 1909.

The Chiang hsi t'ung chih 江西通志. The topographical history of the province of Kiangsi, revised edition in 180 books, published in 1882.

The Ch'in ting ku chin t'u shu chi ch'êng 欽定古今圖書集成. The encyclopædia of the K'ang Hsi period, Section XXXII. Handicrafts (k'ao kung). Part 8 entitled T'ao kung pu hui k'ao, and Part 248 entitled Tz'ŭ ch'i pu hui k'ao.

Chin shih so 金石索, " Researches in Metal and Stone," by the Brothers Fêng. 1821.

The Ch'ing pi ts'ang 清秘藏, " A Storehouse of Artistic Rarities," by Chang Ying-wên, published by his son in 1595.

The Ching-tê Chên t'ao lu 景德鎮陶錄, " The Ceramic Records of Ching-tê Chên," in ten parts, by Lan P'u, published in 1815. Books VIII. and IX. are a corpus of references to pottery and porcelain from Chinese literature.

The Ching tê yao 景德窯, " Porcelain of Ching-tê Chên," a volume of MS. written about 1850.

The Cho kêng lu 輟耕錄, " Notes jotted down in the intervals of ploughing," a miscellany on works of art in thirty books, by T'ao Tsung-i, published in 1368. The section on pottery is practically a transcript of a note in the Yüan chai pi hêng, by Yeh Chih, a thirteenth-century writer.

D'ENTRECOLLES, PÈRE, " Two Letters written from Ching-tê Chên in 1712 and 1722," published in *Lettres édifiantes et curieuses*, and subsequently reprinted in Bushell's " Translation of the *T'ao shuo* " (q.v.), and translated in Burton's " Porcelain " (q.v.).

DE GROOT, J. J. M., " Les Fêtes Annuellement Célébrées à Émoi," " Annales du Musée Guimet," Vols. XI. and XII. Paris, 1886.

DE GROOT, J. J. M., " The Religious System of China." Leyden, 1894.

DILLON, E., " Porcelain " (The Connoisseur's Library).

DUKES, E. J., " Everyday Life in China, or Scenes in Fuhkien." London, 1885.

FOUCHER, A., " Étude sur l'iconographie bouddhique de l'Inde. Paris, 1900.

FRANKS, A. W., Catalogue of a Collection of Oriental Porcelain and Pottery. London, 1879.

GILES, H. A., A Glossary of Reference on Subjects connected with the Far East. Shanghai, 1900.

GRANDIDIER, E., " La Céramique Chinoise." Paris, 1894.

GRÜNWEDEL, A., " Mythologie des Buddhismus in Tibet und der Mongolei." Leipzig, 1900.

GULLAND, W. G., " Chinese Porcelain." London, 1902.

HIRTH, F., " China and the Roman Orient." Leipzig, 1885.

HIRTH, F., " Ancient Porcelain," a Study in Chinese Mediæval Industry and Trade. Leipzig, 1888.

HIRTH, F., AND W. W. ROCKHILL, " Chau Ju-kua, his Work on the Chinese and Arab Trade in the twelfth and thirteenth centuries, entitled *Chu-fan-chi.*" St. Petersburg, 1912.

HOBSON, R. L., " Porcelain, Oriental, Continental and British," second edition. London, 1912.

HOBSON, R. L., " The New Chaffers." London, 1913.

HOBSON, R. L., AND BURTON, " Marks on Pottery and Porcelain," second edition. London, 1912.

HSIANG YÜAN-P'IEN. See BUSHELL.

JACQUEMART, A., AND E. LE BLANT, " Histoire de la Porcelaine." Paris, 1862.

JULIEN, STANISLAS, " Histoire et Fabrication de la Porcelaine Chinoise." Paris, 1856. Being a translation of the greater part of the *Ching-tê Chên t'ao lu*, with various notes and additions.

The *Ko ku yao lun* 格古要論, " Essential Discussion of the Criteria of Antiquities," by Tsao Ch'ao, published in 1387 in thirteen books ; revised and enlarged edition in 1459.

LAUFER, BERTHOLD, " Chinese Pottery of the Han Dynasty," Leyden, 1909.

LAUFER, BERTHOLD, " Jade, a Study in Chinese Archæology and Religion," Field Museum of Natural History, Anthropological Series, Vol. X. Chicago, 1912.

The *Li t'a k'an k'ao ku ou pien* 禮塔鑫考古偶編, by Chang Chin-chien. 1877.

MAYERS, W. F., " The Chinese Reader's Manual." Shanghai, 1874.

MEYER, A. B., " Alterthümer aus dem Ostindischen Archipel."

MONKHOUSE, COSMO, " A History and Description of Chinese Porcelain, with notes by S. W. Bushell." London, 1901.

PLAYFAIR, G. M. H., " The Cities and Towns of China." Hong-Kong, 1910.

The *Po wu yao lan* 博物要覽, " A General Survey of Art Objects," by Ku Ying-t'ai, published in the T'ien Ch'i period (1621–27).

RICHARD, L., " Comprehensive Geography of the Chinese Empire." Shanghai, 1908.

SARRE, F., AND B. SHULZ, " Denkmäler Persischer Baukunst." Berlin, 1901–10.

STEIN, M. A., " Ruins of Desert Cathay." London, 1912.

STEIN, M. A., " Sand-buried Ruins of Khotan." London, 1903.

Shin sho sei, etc., " Japan, Antiquarian Gallery." 1891.

T'ao lu. See *Ching-tê Chên t'ao lu*.

T'ao shuo 陶說, " A Discussion of Pottery," by Chu Yen, in six parts, published in 1774. See BUSHELL.

Toyei Shuko, An Illustrated Catalogue of the Ancient Imperial Treasury called Shoso-in, compiled by the Imperial Household. Tokyo, 1909.

T'u Shu. See *Chin ting ku chin t'u shu chi ch'êng*.

WARNER, LANGDON, AND SHIBA-JUNROKURO, " Japanese Temples and their Treasures." Tokyo, 1910.

WILLIAMS, S. WELLS, The Chinese Commercial Guide. Hongkong, 1863.

YULE, SIR H., " The Book of Ser Marco Polo." London, 1903.

ZIMMERMANN, E., " Chinesisches Porzellan." Leipzig, 1913.

CATALOGUES AND ARTICLES IN PERIODICAL PUBLICATIONS

BAHR, A. W., " Old Chinese Porcelain and Works of Art in China." London, 1911.

BELL, HAMILTON, " ' Imperial ' Sung Pottery," *Art in America*, July, 1913.

BÖRSCHMANN, E., " On a Vase found at Chi-ning Chou," *Zeitschrift für Ethnologie*. Jahrg. 43, 1911.

BRETSCHNEIDER, E., *Botanicon Sinicum*, Journal of the North-China Branch of the Royal Asiatic Society. New Series, Vol. XVI., Part 1. 1881.

BRINKLEY, F., Catalogue of the Exhibitions at the Boston Museum of Arts, 1884.

Burlington Magazine, The, passim.

BUSHELL, S. W., " Chinese Porcelain before the Present Dynasty," Journal of the Peking Oriental Society, 1886.

Catalogue of a Collection of Early Chinese Pottery and Porcelain, Burlington Fine Arts Club, 1910.

CLENNELL, W. J., " Journey in the Interior of Kiangsi," Consular Report. H.M. Stationery Office.

COLE, FAY-COOPER, " Chinese Pottery in the Philippines, with postscript by Berthold Laufer," Field Museum of Natural History, Publication 162. Chicago, 1912.

EITEL, E. J., " China Review," Vol. X., p. 308, " Notes on Chinese Porcelain."

GROENEVELDT, W. P., Notes on the Malay Archipelago, Verhandelingen van het Bataviaasch Genootschap van Kunsten en Wetenschappen, Deel. xxxix.

HIPPISLEY, A. E., Catalogue of the Hippisley Collection of Chinese Porcelains, Smithsonian Institute. Second Edition. Washington, 1900.

HOBSON, R. L., Catalogue of a Collection of Early Chinese Pottery and Porcelain, Burlington Fine Arts Club. 1910.

HOBSON, R. L., Catalogue of Chinese, Corean and Japanese Potteries. New York Japan Society, 1914.

HOBSON, R. L., *Burlington Magazine*, Wares of the Sung and Yüan Dynasties, in six articles, April, May, June, August, and November, 1909, and January, 1910

HOBSON, R. L., " On Some Old Chinese Pottery," *Burlington Magazine*. August, 1911.

HOBSON, R. L., AND O. BRACKETT, Catalogue of the Porcelain and Works of Art in the Collection of the Lady Wantage.

KERSHAW, F. S., Note in Inscribed Han Pottery, *Burlington Magazine*, December, 1913.

LAFFAN, W., Catalogue of the Pierpont Morgan Collection in the Metropolitan Museum, New York.

MARTIN, DR., Note on a Sassanian Ewer, *Burlington Magazine*, September, 1912.

MEYER, A. B., " On the Celadon Question," *Oesterreichische Monatsschrift*, January, 1885, etc.

MORGAN, J. P., Catalogue of the Morgan Collection of Chinese Porcelains, by S. W. Bushell and W. M. Laffan. New York, 1907.

PARIS, Exposition universelle de 1878, Catalogue spécial de la Collection Chinoise.

PERZYNSKI, F., " Towards a Grouping of Chinese Porcelain," *Burlington Magazine*, October and December, 1910, etc.

PERZYNSKI, F., " Jagd auf Götter," in the *Neue Rundschau*, October, 1913.

PERZYNSKI, F., on T'ang Forgeries, *Ostasiatischer Zeitschrift*, January, 1914.

READ, C. H., in *Man*, 1901, No. 15, " On a T'ang Vase and Two Mirrors from a Tomb in Shensi."

REINAUD, M., " Relation des Voyages faits par les Arabes et les Persans dans l'Inde et à la Chine dans la IXᵉ siècle de l'ére chrétienne." Paris, 1845.

SOLON, L., " The Noble Buccaros," North Staffordshire Literary and Philosophic Society, October 23rd, 1896.

TORRANCE, REV. TH., " Burial Customs in Szechuan," Journal of the N. China Branch of the Royal Asiatic Society, Vol. XLI., 1910, p. 58.

VORETZSCH, E. A., Hamburgisches Museum für Kunst und Gewerbe, Führer durch eine Ausstellung Chinesischer Kunst, 1913.

WILLIAMS, MRS. R. S., Introductory Note to the Catalogue of a Loan Exhibition of Chinese, Corean, and Japanese Potteries held by the Japan Society of New York, 1914.

ZIMMERMANN, E., " Wann ist das Chinesische Porzellan erfunden und wer war sein Erfinder ? " *Orientalisches Archiv. Sonderabdruck.*

NOTE ON THE PAGINATION

In 37 places throughout this text the pagination has been adjusted to compensate for the fact that color plates and captions to color plates, formerly on numbered pages, have been moved to unfolioed special inserts. See, for instance, following page 28; a color plate and its caption formerly appeared on page 29, and 30 was a blank page.

CHINESE POTTERY AND PORCELAIN

CHAPTER I

THE PRIMITIVE PERIODS

POTTERY, as one of the first necessities of mankind, is among the earliest of human inventions. In a rude form it is found with the implements of the late Stone Age, before there is any evidence of the use of metals, and all attempts to reconstruct the first stages of its discovery are based on conjecture alone.

We have no knowledge of a Stone Age in China, but it may be safely assumed that pottery there, as elsewhere, goes back far into prehistoric times. Its invention is ascribed to the mythical Shên-nung, the Triptolemus of China, who is supposed to have initiated the people in the cultivation of the soil and other necessary arts of life. Huang Ti, the semi-legendary yellow emperor, in whose reign the cyclical system of chronology began (2697 B.C.), is said to have appointed " a superintendent of pottery, K'un-wu, who made pottery," and it was a commonplace in the oldest Chinese literature[1] that the great and good emperor Yü Ti Shun (2317–2208 B.C.) " highly esteemed pottery." Indeed, the Han historian Ssŭ-ma Ch'ien (163–85 B.C.) assures us that Shun himself, before ascending the throne, " fashioned pottery at Ho-pin," and, needless to say, the vessels made at Ho-pin were " without flaw."

According to the description given in the *T'ao shuo*, the evolution of the potter's art in China took the usual course. The first articles made were cooking vessels; then, " coming to the time of Yü (i.e. Yü Ti Shun), the different kinds of wine vessels are distinguished by name, and the sacrificial vessels are gradually becoming complete." [2]

[1] e.g. the *K'ao Kung chi*, a relic of the Chou dynasty (1122–256 B.C.).
[2] *T'ao shuo*, bk. ii., fol. 1. See S. W. Bushell, *Chinese Pottery and Porcelain*, being a translation of the *T'ao shuo*, Oxford, 1910, p. 34.

I should add that the author of the *T'ao shuo*, after accepting the earlier references to the art, inconsistently concludes: " I humbly suggest that the origin of pottery should strictly be placed in the reign of Yü Ti Shun, and its completion in the Chou dynasty " (1122–256 B.C.).

Unfortunately, none of the writers can throw any light on the first use of the potter's wheel in China. It is true that, like several other nations, the Chinese claim for themselves the invention of that essential implement, but there is no real evidence to illuminate the question, and even if the wheel was independently discovered in China, the priority of invention undoubtedly rests with the Near Eastern nations. Palpable evidence of its use can be seen on Minoan pottery found in Crete and dating about 3000 B.C., and on Egyptian pottery of the twelfth dynasty (about 2200 B.C.); while it is practically certain that it was used in the making of the Egyptian pottery of the fourth dynasty (about 3200 B.C.).

So far, the Chinese have nothing tangible to oppose to these facts earlier than the Chou writings, in which workers with the wheel (*t'ao jên*) are distinguished from workers with moulds (*fang jên*), the former making cauldrons, basins, colanders, boilers, and vessels (*yü*), and the latter moulding the sacrificial vessels named *kuei* and *tou*. We learn that at this time the Chinese potters also used the compasses and the polishing wheel or lathe. With this outfit they were able, according to the *T'ao shuo*, to effect the " completion " of pottery.

Whatever the truth of this pious statement may be, reflecting as it does the true Chinese veneration of antiquity, it is certain, at any rate, that the potter was not without honour at this time: for we read in the *Tso Chuan*[1] that " O-fu of Yü was the best potter at the beginning of the Chou dynasty. Wu Wang relied on his skill for the vessels which he used. He wedded him to a descendant of his imperial ancestors, and appointed him feudal prince of Ch'ên."

Examples of these early potteries have been unearthed from ancient burials from time to time, and the *T'ao shuo* describes numerous types from literary sources. But neither the originals, as far as we know them, nor the verbal descriptions of them, have anything but an antiquarian interest.

[1] A work of the fifth century B.C., quoted in the *Ching-tê Chên T'ao lu*, bk. ix., fol. 1.

The art of the Chou dynasty, as expressed in bronze and jade, is fairly well known from illustrated Chinese and Western works. It reflects a priestly culture in its hieratic forms and symbolical ornament. It is majestic and stern, severely disdainful of sentiment and sensuous appeal. Of the pottery we know little, but that little shows us a purely utilitarian ware of simple form, unglazed and almost devoid of ornament.

On Plate 1 are two types which may perhaps be regarded as favourable examples of Chou pottery. A tripod vessel, almost exactly similar to Fig. 1, was published by Berthold Laufer,[1] who shows by analogy with bronzes of the period good reasons for its Chou attribution, which he states is confirmed by Chinese antiquarians. His example was of hard " gray clay, which on the surface has assumed a black colour," and it had the surface ornamented with a hatched pattern similar to that of our illustration. It has been assumed that this hatched pattern is a sure sign of Chou origin, and I have no doubt that it was a common decoration at the time. But its use continued after the Chou period, and it is found on pottery from a Han tomb in Szechuan, which is now in the British Museum. It is, in fact, practically the same as the " mat marking " on the Japanese and Corean pottery taken from the dolmens which were built over a long period extending from the second century B.C. to the eighth century A.D.

The taste of the time is reflected in a sentence which occurs in the *Kuan-tzŭ*, a work of the fifth century B.C. : " Ornamentation detracts from the merit of pottery." [2] The words used for ornamentation are *wên ts'ai* 文彩 (lit. pattern, bright colours), and they seem to imply a knowledge of some means of colouring the ware. As there is no evidence of the use of glaze before the Han period, and enamelling in the ordinary ceramic sense is out of the question, we may perhaps assume that some of the pottery of the Chou period was painted with unfired pigments, a method certainly in use in the Han dynasty. There is a vase in the British Museum of unglazed ware with painted designs in black, red and white pigments, which has been regarded as of Han period, but may possibly be earlier (Plate 2, Fig. 3).

In addition to the Chou tripod, Laufer[3] illustrates five specimens

[1] *Chinese Pottery of the Han Dynasty*, Leyden, 1909, pp. 10–14.
[2] Quoted in the *Ching-tê Chên T'ao lu*, bk. ix., fol. 1.
[3] Loc. cit.

of pre-Han pottery, excavated by Mr. Frank H. Chalfant " on the soil of the ancient city of Lin-tzŭ in Ch'ing-chou Fu, Shantung," a district which was noted for its pottery as late as the Ming period.[1] This find included two pitchers, a deep, round bowl, a tazza or round dish on a high stem, and a brick stamped with the character *Ch'i*, all unglazed and of grey earthenware. From this last piece, and from the fact that Lin-tzŭ, until it was destroyed in 221 B.C., was the capital of the feudal kingdom of Ch'i, Laufer concluded that these wares belonged to a period before the Han dynasty (206 B.C. to 220 A.D.).

[1] See p. 200.

Fig. 1

Fig. 2

Plate 1.—Chou Pottery.

Fig. 1.—Tripod Food Vessel. Height 6⅛ inches. Fig. 2.—Jar with deeply cut lozenge pattern. Height 6¾ inches.
Eumorfopoulos Collection.

Fig. 3

Fig. 4

Fig. 1

Fig. 2

Plate 2.—Han Pottery.

Fig. 1.—Vase, green glazed. Height 14 inches. *Boston Museum.* Fig. 2.—Vase with black surface and incised designs. Height 16 inches. *Eumorfopoulos Collection.* Fig. 3.—Vase with designs in red, white and black pigments. Height 11½ inches. *British Museum.* Fig. 4.— "Granary urn," green glazed. Height 12 inches. *Peters Collection.*

CHAPTER II

THE HAN 漢 DYNASTY, 206 B.C. TO 220 A.D.

TWO centuries of internecine strife between the great feudal princes culminated in the destruction of the Chou dynasty and the consolidation of the Chinese states under the powerful Ch'in emperor Chêng. If this ambitious tyrant is famous in history for beating back the Hiung-nu Turks, the wild nomads of the north who had threatened to overrun the Chou states, and for building the Great Wall of China as a rampart against these dreaded invaders, he is far more infamous for the disastrous attempt to burn all existing books and records, by which, in his overweening pride, he hoped to wipe out past history and make good to posterity his arrogant title of Shih Huang Ti or First Emperor. His reign, however, was short, and his dynasty ended in 206 B.C. when his grandson gave himself up to Liu Pang, of the house of Han, and was assassinated within a few days of his surrender.

The Han dynasty, which began in 206 B.C. and continued till 220 A.D., united the states of China in a great and prosperous empire with widely extended boundaries. During this period the Chinese, who had already come into commercial contact with the kingdoms of Western Asia, sent expeditions, some peaceful and others warlike, to Turkestan, Fergana, Bactria, Sogdiana, and Parthia. They even contemplated an embassy to Rome, but the envoys who reached the Persian Gulf turned back in fear of the long sea journey round Arabia, the length and danger of which seem to have been vividly impressed upon them by persons interested, it is thought, in preventing their farther progress. [1] A considerable trade, chiefly in silks, had been opened up between China and the Roman provinces, and the Parthians who acted as middlemen had no desire to bring the two principals into direct communication.

Needless to say, China was not uninfluenced by this contact

[1] See Hirth, *China and the Roman Orient.*

with the West. The merchants brought back Syrian glass, the celebrated envoy Chang Ch'ien in the second century B.C. introduced the culture of the vine from Fergana and the pomegranate from Parthia, and some years later an armed expedition to Fergana returned with horses of the famous Nisæan breed. But from the artistic standpoint the most important event was the official introduction of Buddhism in 67 A.D. at the desire of the Emperor Ming Ti and the arrival of two Indian monks with the sacred books and images of Buddha at Lo-yang. The Buddhist art of India, which had met and mingled with the Greek on the north-west frontiers since Alexander's conquests, now obtained a foothold in China and began to exert an influence which spread like a wave over the empire and rolled on to Japan. But this influence had hardly time to develop before the end of the Han period, and in the meanwhile we must return to the conditions which existed in China at the beginning of the dynasty.

The hieratic culture of the Chou, and the traditions of Chou art with its rigid symbolism and formalised designs, had been broken in the long struggles which terminated the dynasty and banned by the iconoclastic aspirations of the tyrant Chêng, and though partially revived by Han enthusiasts, they were essentially modified by the new spirit of the age. Berthold Laufer,[1] in discussing the jade ornaments of the Chou and Han periods, speaks of the " impersonal and ethnical character of the art of that age " —viz. the Chou. " It was," he continues, " general and communistic ; it applied to everybody in the community in the same form ; it did not spring up from an individual thought, but presented an ethnical element, a national type. Sentiments move on manifold lines, and pendulate between numerous degrees of variations. When sentiment demanded its right and conquered its place in the art of the Han, the natural consequence was that at the same time when the individual keynote was sounded in the art motives, also variations of motives sprang into existence in proportion to the variations of sentiments. This implies the two new great factors which characterise the spirit of the Han time—individualism and variability— in poetry, in art, in culture, and life in general. The personal spirit in taste gradually awakens ; it was now possible for everyone to choose a girdle ornament according to his liking. For the

[1] Berthold Laufer, *Jade*, Field Museum of Natural History, Publication 154, Anthropological Series, vol. x., Chicago, 1912, pp. 232 and 233.

first time we hear of names of artists under the Han—six painters under the Western Han, and nine under the Eastern Han ; also of workers in bronze and other craftsmen.[1] The typical, traditional objects of antiquity now received a tinge of personality, or even gave way to new forms ; these dissolved into numerous variations, to express correspondingly numerous shades of sentiment and to answer the demands of customers of various minds."

Religion has always exerted a powerful influence on art, especially among primitive peoples, and the religions of China at the beginning of the Han dynasty were headed by two great schools of thought—Confucianism and Taoism. These had absorbed and, to a great extent, already superseded the elements of primitive nature worship, which never entirely disappear. Confucianism, however, being rather a philosophy than a religion, and discouraging belief in the mystic and supernatural, had comparatively little influence on art. Taoism, on the other hand, with its worship of Longevity and its constant questing for the secrets of Immortality, supplied a host of legends and myths, spirits and demons, sages and fairies which provided endless motives for poetry, painting and the decorative arts. The Han emperor Wu Ti was a Taoist adept, and the story of the visit which he received from Hsi Wang Mu, the Queen Mother of the West, and of the expeditions which he sent to find Mount P'êng Lai, one of the sea-girt hills of the Immortals, have furnished numerous themes for artists and craftsmen.

It is not yet easy for people in this country to study the monuments of Han art, but facilities are increasing, and a good impression of one phase at least may be obtained from reproductions of the stone carvings in Shantung, executed about the middle of the Han dynasty, which have been published from rubbings by Professor E. Chavannes.[2] On these monuments historical and mythological subjects are portrayed in a curious mixture of imagination and realism.

But these general considerations are leading us rather far afield, and it remains to see how much or how little of them is reflected in the pottery of the time.

As far as our present knowledge of the subject permits us to

[1] Occasionally of potters.

[2] *La Sculpture sur pierre en Chine au temps des deux dynasties Han*, Paris, 1893. A few of these are figured by Bushell in *Chinese Art*, vol. i. See also Chavannes, *Mission archéologique dans la Chine septentrionale*, Paris, 1909.

see, there is nothing in the pre-Han pottery to attract the collector. It will only interest him remotely and for antiquarian reasons, and he will prefer to look at it in museum cases rather than allow it to cumber his own cabinets. With the Han pottery it is otherwise. The antiquarian interest, which is by no means to be underestimated, is now supplemented by æsthetic attractions caught from the general artistic impetus which stirred the arts of this period of national greatness. Not that we must expect to find all the refinements of Han art mirrored in the pottery of the time. Chinese ceramic art was not yet capable of adequately expressing the refinements of the painter, jade carver, and bronze worker. But even with the somewhat coarse material at his disposal the Han potter was able to show his appreciation of majestic forms and appropriate ornament, and to translate, when called upon, even the commonplace objects of daily use into shapes pleasant to the eye. In a word, the ornamental possibilities of pottery were now realised, and the elements of an exquisite art may be said to have made their appearance. From a technical point of view, the most significant advance was made in the use of glaze. Though supported by negative evidence only, the theory that the Chinese first made use of glaze in the Han period is exceedingly plausible.[1] In the scanty references

[1] If geological arguments could be accepted at their face value, a vase found at Chi-ning Chou, in Shantung, would go far to prove the existence of a highly sophisticated glazed pottery at a date not less than 500 years B.C. The find is described and illustrated in the *Zeitschrift für Ethnologie*, Jahrg. 43, 1911, p. 153, by Herr Ernst Börschmann. The vase, which is 10 cm. high, is of globular form, with a short straight neck and two loop handles. It is of hard buff ware, with a chocolate brown glaze with purplish reflexions of a metallic appearance, and the glaze covers only the upper part of the exterior and ends in an uneven line with drops. One would say Sung or possibly T'ang, and of the type associated with the name Chien yao. This pot was found not in a tomb, but in the undisturbed earth at a depth of seven metres, by a German architect, while sinking a well ; and a reasoned case from the stratification of the soil is made out to prove that it must have at least an antiquity of twenty-four hundred years. It is, however, proverbial that geological arguments applied to relatively modern archæology lead to results more startling than correct ; and I refuse to accept this solitary specimen as evidence to upset the whole theory of the evolution of Chinese pottery. For it must do nothing less. This piece is of a style which is at present unknown before the T'ang dynasty. It has nothing in common with Han pottery as we know it, still less with Chou, and to accept its Chou date would be to believe that an advanced style of manufacture was in use 500 years B.C., that it was forgotten again for some twelve centuries, and then reappeared in precisely the same form. Fukien white porcelain seals have been found in an Irish bog in positions from which geologists might infer a colossal antiquity, but the history of porcelain has not been disturbed on that account ; and I cannot help thinking that this strange phenomenon at Chi-ning Chou must be regarded in much the same light.

The Han Dynasty, 206 B.C. to 220 A.D.

to earlier wares in ancient texts no mention of glaze appears, and, indeed, the severe simplicity of the older pottery is so emphatically urged that such an embellishment as glaze would seem to have been almost undesirable. The idea of glazing earthenware, if not evolved before, would now be naturally suggested to the Chinese by the pottery of the Western peoples with whom they first made contact about the beginning of the Han dynasty. Glazes had been used from high antiquity in Egypt; they are found in the Persian bricks at Susa and on the Parthian coffins, and they must have been commonplace on the pottery of Western Asia two hundred years before our era.

It is possible, of course, that evidence may yet be forthcoming to carry back the use of glaze in China beyond the limits at present prescribed, but all we can state with certainty to-day is that the oldest known objects on which it appears are those which for full and sufficient reasons can be assigned to the Han period. To explain all these reasons would necessitate a long excursion into archæology which would be out of place here. Many of them can be found in Berthold Laufer's[1] excellent work on the subject, and others will in due course be set out in the catalogue of the British Museum collections. But it would be unfair to ask the reader to take these conclusions entirely on trust, and some idea of the evidence is certainly his due.

There are a few specimens of Han pottery inscribed with dates, such as the vase (Plate 2, Fig. 1) from the Dana Collection, which is now in the Boston Museum; but in almost every case the inscriptions have proved to be posthumous and must be regarded at best as recording the pious opinion of a subsequent owner. It will be safer, then, to leave inscriptions out of consideration and to rely on the close analogies which exist between the pottery and the bronze vessels of the Han period and between the decorative designs on the pottery and the Han stone sculptures, and, where possible, on the circumstances in which the vessels have been found. Unfortunately, the bulk of the Han pottery which has reached Europe in recent years has passed through traders' hands, and no records have been kept of its discovery. But there are exceptional cases in which we have first-hand evidence of Han tombs explored by Europeans, and in two instances their contents have been brought direct to the British Museum. Both these hauls are from the rock-tombs in

[1] Berthold Laufer, *Pottery of the Han Dynasty*, Leyden, 1908.

Szechuan, the one made by the ill-fated Lieutenant Brooke, who was murdered by the Lolos, the other by the Rev. Thomas Torrance, to whom I shall refer again. The evidence of both finds is mutually corroborative ; it is supported by Han coins found in the tombs, by inscriptions carved on their doorways, and by the rare passages of decoration on the objects themselves, which correspond closely to designs on stone carvings published by Chavannes. In this way a whole chain of unassailable evidence has been welded together until, in spite of the remoteness of the period, we are able to speak with greater confidence about the Han pottery than about the productions of far more recent times.

The Han pottery is usually of red or slaty grey colour, varying in hardness from a soft earthenware to something approaching stoneware, and in texture from that of a brick to the fineness of delft. These variations are due to the nature of the clay in different localities and to the degree of heat in which the ware was fired. No chronological significance can be attached to the variations of colour, and to place the grey ware earlier than the red is both unscientific and patently incorrect. Most of the Szechuan ware is grey and comparatively soft, while of the specimens sent from Northern China the majority seem to be of the red clay. Some of the ware from both parts is unglazed, and in certain cases it has been washed over with a white clay and even painted with unfired pigment, chiefly red and black. The bulk of it, however, is glazed, the typical Han glaze being a translucent greenish yellow, which, over the red body, produces a colour varying from leaf green to olive brown, according to the thickness of the glaze and the extent to which the colour of the underlying body appears through it. Age and burial have wonderfully affected this green glaze, and in many cases the surface is encrusted in the process of decay with iridescent layers of beautiful gold and silver lustre. In other cases the decay has gone too far, and the glaze has scaled and flaked off. Another feature which it shares with many of the later glazes is a minute and almost imperceptible crackle. This feature is almost universal on the softer Chinese pottery glazes, and has nothing to do[1] with the deliberate and pronounced crackle of later Chinese porcelain, being purely accidental in its formation.

[1] Laufer seems to have mistaken it for the beginning of the regular Chinese crackle (see op. cit., p. 8). The Han green glaze contains a large proportion of lead oxide and is coloured with oxide of copper.

The colour of the glaze shows considerable variations, being sometimes brownish yellow, sometimes deep brown, and occasionally mottled like that of our mediæval pottery. A passage in the *T'ao shuo* [1] seems to imply the existence of a black glaze as well, but it is a solitary literary reference, and it is not perfectly clear whether a black earthenware or a black glaze is meant. It was thought at one time that the fine white ware with pale straw-coloured or greenish glaze, of which much of the T'ang mortuary pottery is made, was in use as early as the Han period, but I am now convinced that this is a later development, and cannot be included in the ware of the Han dynasty.

Among the technical peculiarities of Han pottery, the marks —usually three in number—of small, oblong rectangular kiln supports will often be noticed under the base or on the mouth of the wares. These so-called " spur-marks " were made by the supports or rests on which the ware was placed when in the kiln. In many cases, too, large drops of glaze have formed on the mouth of the piece, proving that the vessel was fired in an inverted position, which directed the down flow of the glaze as it melted towards the mouth. This is by no means universal. Indeed, the glaze drops on other pieces are found on the base even when the " spur-marks " appear on the mouth. The explanation of these apparently contradictory phenomena is that to economise space one piece was sometimes placed on top of another in the kiln.

The ornamentation of Han pottery was accomplished in several ways : by pressing the ware in moulds with incuse designs, which produced a low relief on the surface of the pottery ; by the use of stamps or dies [2] ; and more especially by applying strips of ornament which had been separately formed in moulds. All these ornaments were covered by the glaze when glaze was used. Laufer has made an exhaustive study of Han decoration in his book, and it will be sufficient here to give a few typical examples.

On Plate 2, Fig. 1 is a green-glazed vase of typical Han form with two handles representing rings attached to tiger masks which are borrowed, like the general form of the piece, from a contemporary bronze. This vase, formerly in the Dana Collection and now in the

[1] See Bushell, *Chinese Pottery and Porcelain*, p. 96. " In the tomb of the Empress Tao, consort of Wu Ti (140–85 B.C.) there was found one lac-black earthenware dish."

[2] One of these, in the form of a small roller, by which a continuous pattern could be impressed, is figured by Laufer, op. cit. Plate xxxvi.

Fine Arts Museum at Boston, has a posthumous date [1] incised on the neck corresponding to the year 133 B.C.

Fig. 2 is a rare specimen with reddish body and polished black surface in which are incised designs of birds, dragons and fish, and bands of vandykes, lozenges and pointed quatrefoil ornaments. It has the usual mask handles, and stands 16 inches high.

On Plate 3, Fig. 1, is a " hill jar " with brown glaze, standing on three feet which are moulded with bear forms. On the side is a frieze in strong relief with hunting scenes of animals, such as the tiger, boar, monkey, deer, hydra and demon figures, spaced out by conventional waves. This kind of frieze is frequently found ornamenting the shoulders of vases such as Fig. 1 of Plate 2, and the animals are usually represented in vigorous movement, often with fore and hind legs outstretched in a " flying gallop." The cover is moulded to suggest mountains rising from sea waves (the sea-girt isles of the Taoist Immortals), peopled with animals.

Fig. 2 is a green-glazed box or covered bowl of elegant form, the cover moulded in low relief with a quatrefoil design surrounded by a frieze of animals.

Fig. 3 is an incense burner of rare form derived from a bronze. It is a variation of the more usual " hill censer " (*po shan lu*) which has the same body with a cover in the form of hills as on Fig. 1. In this case the cover suggests a lotus flower in bud, and is surmounted by a duck. The whole is coated with an iridescent green glaze.

A few choice specimens of green-glazed Han pottery in the S. T. Peters Collection includes a well-modelled duck, a handsome vase with mask handles and hexagonal base, and a good example of the " granary urn." The last is a grain jar which derives its form from a granary tower. In some instances the tiled roof of the tower is represented by tile-mouldings on the shoulder ; but in this instance the form is entirely conventionalised into a cylindrical vase supported by three bear-shaped feet. The bear, an emblem of strength, is commonly employed in this capacity in Han art. Another ornamental form borrowed from a homely object is the model of a well-head, of cylindrical shape, with arched superstructure, in the centre of which a pulley-wheel is represented. The well bucket is usually added, resting on the edge of the well.

[1] See *Burlington Magazine*, December, 1913, where it is published with a note on the inscription by F. S. Kershaw.

Fig. 3

Fig. 1

Fig. 2

Plate 3.—Han Pottery.

Fig. 1.—"Hill Jar," with brown glaze. Height 9½ inches. *Eumorfopoulos Collection.* Fig. 2.—Box, green glazed. Height 5½ inches. *Eumorfopoulos Collection.* Fig. 3.—"Lotus Censer" green glazed. Height 10½ inches. *Rohenstein Collection.*

Plate 4.—Model of a " Fowling Tower."

Han pottery with iridescent green glaze.　Height 30 inches.
Freer Collection.

Plate 4 illustrates a remarkable structure which seems to represent a fowling tower. Models of houses and shrines have been found frequently in Han tombs, showing most of the elements which are combined in this complex ornament. The structure of wooden beams and galleries and the roofs with their tubular tile-ridges, the formal ox-heads supporting the angles of the lower gallery, the ornamentation of combed lines, are all features which occur in architectural tomb ornaments of the Han period. Here we have apparently a sporting tower, with persons engaged in shooting with crossbows at the pigeons which tamely perch on the roof. The dead birds have fallen into the saucer-like stand below. This rare and curious specimen is made of green-glazed pottery, and measures about 30 inches in height.

As already indicated, our knowledge of Han pottery is mainly derived from the articles disinterred from the tombs of the period, and this will explain the curious fact that Han pottery was almost unknown until quite recent times, and that information on the subject in Chinese ceramic literature is of the most meagre and least satisfying description. The ancestor-worshipping Chinese have always been averse to the systematic exploration of graves. Whatever their practice may have been when the opportunity occurred of rifling a grave unobserved, this at any rate has been the avowed principle. The result is that though China must be honeycombed with graves and tombs, they have not been overtly disturbed in any numbers until recent years, when extensive railway cuttings have opened up the ground. To the progress of railway engineering the sudden appearance of considerable quantities of mortuary pottery is chiefly due.

On the other hand, one of our most interesting finds was made away from the railway in Szechuan. Here, in the neighbourhood of Ch'êng-tu and along the banks of the Min, the soft sandstone hills which line the river had in ancient times been extensively tunnelled with elaborate chambers protected by small entrance doors. Whether these were ever used as dwellings is uncertain, but they certainly became eventually the tenements of the dead. The deposits of ages have covered over the entrances to these tombs, but from time to time torrential rain or some other cause exposed their approaches to the country folk, who invariably pillaged them for coins and smashed and scattered their less marketable contents. The Rev. Thomas Torrance, when stationed at Ch'êng-tu, had the

opportunity of exploring some of these caverns, and even succeeded in discovering some unrifled tombs, part of the contents of which he brought over and presented to the British Museum. The funeral furniture of these tombs varied according to the wealth and status of the owner. In the poor man's tomb were unprotected skeletons, small images in a niche, an iron cooking pot, and a few coins. In the rich man's were terra cotta coffins, encased in ornamented slabs, images apparently of the members of his household, a quantity of crockery, and a perfect menagerie of domestic animals and birds. To quote Mr. Torrance's own words : [1] " Standing with your reflector in the midst of a large cave, it seems verily an imitation Noah's Ark."

The practice of burying with the dead the objects which surrounded him in life has never entirely ceased in any country. Among primitive peoples it has taken the revolting form of immolating, or even burying alive, the household of a dead chieftain. Instances of this practice in China occur as late as the third century B.C., and voluntary acts of sacrifice at the tomb are recorded much later in China as in India. When humaner counsels prevailed figures of wood, straw and clay were substituted, straw images being suggested for the purpose by Confucius himself. In the Han dynasty the tomb of the well-to-do was furnished with models of his house, his shrine, his farmyard, threshing floor, rice-pounder, his cattle, sheep, dogs, and poultry, besides his retainers and certain half-human creatures which may have been his guardian spirits ; it was provided with vases for wine and grain, models of the stove and kitchen range with cooking pots and implements—the last merely indicated in low relief on the kitchen range—besides the more stately sacrificial vessels for wine and incense. [2] All these were modelled in pottery, and must have fostered a flourishing potter's trade, and given a tremendous impetus to the growth of modelling and design. The underlying idea of all this was, no doubt, to provide the spirit of the dead with the means of pursuing the habits of his lifetime, and the modern practice of supplying his needs by means of paper models which are transmitted to the

[1] *Burial Customs in Szechuan,* Journal of the North-China Branch of the Royal Asiatic Society, vol. xli., 1910, p. 58, etc.

[2] A very large series of Han sepulchral pottery, including most of the known types, is in the Field Museum, Chicago ; but most of our large museums possess specimens enough to give a good idea of the ware.

spirit world through the medium of fire serves the same purpose in a more economical fashion. But a fuller note on the grave furniture of the Han and T'ang periods will be given in the next chapter.

Little or nothing is at present known of the potteries in which the Han wares were made, but we may fairly assume that the manufacture was very general and that local potteries supplied local demands. An incidental reference in the *T'ao lu* gives us one solitary name, Nan Shan, where the potteries of the Emperor Wu Ti (140–85 B.C.) were situated;[1] and there is a mention of potteries in Kiangsi in the place which was afterwards the site of the celebrated porcelain centre, Ching-tê Chên.

The interval between the Han and T'ang periods, from 221 to 618 A.D., is marked by a rapid succession of short-lived dynasties, an age of conflict and division, in which China was again split up into warring states. The conditions were not favourable to the steady development of the ceramic industry, and little is known of the pottery of this period. From the few references in Chinese literature, however, we infer that new kinds of pottery appeared from time to time, and it is certain that the evolution which culminated in porcelain made sensible advances. This latter fact is proved by the scientific analysis of some vases obtained by Dr. Laufer near Hsi-an Fu in Shensi. There is a similar vase in the British Museum with ovoid body strongly marked with wheel-ridges, short neck and wide cup-shaped mouth, and loop handles on the shoulders. The ware is in appearance a reddish stoneware, and the glaze which covers the upper part is translucent greenish brown with signs of crackle. Dr. Laufer's vases are in the Field Museum at Chicago, where the body and glaze have been analysed by Mr. Nicholls, the results showing that the body is composed of a kaolin-like material (probably a kind of decomposed pegmatite) and is, in fact, an incipient porcelain, lacking a sufficient grinding of the material. The glaze is composed of the same material softened with powdered limestone and coloured with iron oxide. An iron cooking stove found with these vases has an inscription indicating by its style a date in the Han dynasty or shortly after it; and the nature of the pottery, in spite of its coarse grain and dark colour, which is probably due in part to the presence of iron in the clay, seems to show that the manufacture of porcelain was not far distant.

[1] Bk. ix., p. 3, quoting the *Chêng tzŭ t'ung*, which in turn quotes the *Han Shu*, or Han Histories. Presumably this is the Nan Shan near Lung Chou, in Shensi.

Meanwhile, there is little doubt that the Han traditions were kept alive, and the discovery of green glazed ware of Han type in the ruins of Bazaklik, in Turfan,[1] a site which from other indications appears to belong to the T'ang civilisation, shows that this type, at any rate, was long-lived. Two vases from a grave on the Black Rock Hill in Fu Chou, and now in the British Museum, which are proved to belong to a period anterior to the seventh century, seem to combine Han and T'ang characteristics. They are of dark grey stoneware with a mottled greenish brown glaze, ending considerably above the base in a wavy line, which is a common feature of T'ang wares.

It is highly probable that some of the tomb pottery discussed in the next chapter belongs to the later part of this intermediate period. Indeed among the pottery figures of this class there are specimens with slender, graceful bodies and elaborate details of costume (see Plate 7) which closely resemble the stone statues of the Northern Wei and the Sui dynasties; but with our present imperfect information on the tomb finds, it will be more convenient to treat these nearly related figures as one group.

Turning to Chinese literature, in default of other and more tangible evidence, we read in the *T'ao shuo*[2] of pottery dishes and wine vessels in the Wei dynasty (220–264 A.D.), and in the *T'ao lu* of pottery made at Kuan Chung, in the district of Hsi-an Fu, and at Lo-yang for Imperial use. The poet P'an Yo, of the Chin dynasty (265–419 A.D.), speaks of " cups of green ware." The actual words used are *p'iao tz'ŭ*,[3] of which the former is elsewhere used to describe " the bright tint of distant, well-wooded mountains," and as a synonym for *lü* (green), though, like the common colour word *ch'ing*, it is capable of meaning both blue and green. The ceramic glaze which most closely corresponds to the description *p'iao* is the bluish green celadon best known from Corean wares, but we have not yet sufficient grounds for assuming the existence of this particular type at such an early date.

Another poet[4] of the same period bids his countrymen, when

[1] Fragments of this ware which were brought back by the Grünwedel expedition in 1903 are in the Museum für Völkerkunde, in Berlin.

[2] See Bushell, op. cit., p. 97.

[3] 縹瓷. See also Bushell's translation of the *T'ao shuo*, pp. 97 and 98.

[4] Tu Yü, in his " Verses upon Tea." See *T'ao shuo*, Bushell's translation, p. 98. The words used are *Ch'i tsê t'ao chien* 器擇陶揀 for which Bushell has given the free and rather misleading version, " Select cups of fine porcelain."

selecting cups for tea-drinking, to choose the ware of Eastern Ou, a place in the Yüeh territory, and apparently in the neighbourhood of, if not identical with, the Yüeh Chou, which was celebrated for its wares in the T'ang dynasty. The period of the "Northern and Southern Dynasties" provides but two references, to a kind of wine vessel known as "crane cups" but otherwise unexplained, and to *chün-ch'ih* of fine and coarse ware,[1] which appear to have been Buddhist water vases for ceremonial washing, or *Kundikâ*, which the Chinese have transcribed in the form *Chün-ch'ih-ka*.

Buddhism was making great strides in China at this time. It was proclaimed the state religion of the Toba Tartars or Northern Wei, who ruled the north from 386 to 549 A.D., and Buddhist thought and the canons of Buddhist art were now firmly imposed upon the Chinese. The rock sculptures of this period visited and photographed by Chavannes show unmistakable traces of the Græco-Buddhist art of Gandhara; and in one remarkable instance among the figures which were sculptured round the entrance of a Buddhist grotto were deities with a thyrsus like that of Dionysus and a trident like Poseidon's.

In the annals of the brief Sui dynasty (581–617 A.D.), we find that a man named Ho Ch'ou succeeded in exactly imitating a glassy material called *liu li* by means of green ware. The exact meaning of this interesting passage is discussed elsewhere (p. 144), but it is difficult to imagine any but a porcellanous ware which could satisfy the conditions implied. Under the circumstance it is not surprising if theorists see in this green ware (*lü tz'ŭ*) something in the nature of the later celadon porcelain.

NOTE ON THE EARLY CHINESE TOMB WARES

With reference to the figures of men and animals and the other objects which were placed in the ancient tombs of China, much information will be found in Dr. J. J. M. de Groot's *Religious System of China*. The fundamental idea underlying these burial practices seems to have been that the soul of the dead was the actual tenant of the grave; but it is not clear in every case whether the sepulchral furniture was provided in expectation of a bodily resurrection, or in the belief that it would minister to the wants of the

[1] *tz'ŭ wa*, a phrase which Bushell has translated "porcelain and earthenware," though it is improbable that porcelain was meant at this early period (see Chap. XI.).

dead in his spiritual existence. Both ideas appear to have obtained in early times, though it is certain that the second alone explains the more modern custom of burning either the objects themselves or paper counterfeits of them at the tomb, and thus transmitting them through the medium of fire direct to the spirit world.

The older custom of burying with the dead all that was necessary for the continuation of the pursuits of his lifetime, dates back to the farthest limits of history, so that we read without surprise that in the Chou dynasty (1122–255 B.C.) there were placed in the tomb " three earthen pots with pickled meat, preserved meat, and sliced food ; two earthen jars with must and spirits," [1] besides " clothes, mirrors, weapons, jade and food pots." It became customary to hold a preliminary exhibition of the funeral articles at the dead man's house before removing them to the tomb, and this, as we may well imagine in a country of ancestor-worshippers, led to ostentation and extravagance which legislators of various periods vainly endeavoured to curtail.

The magnificent burials of the Chin and early Han emperors, the vast mausolea built by forced labour and stocked with costly furniture and treasure, chariots and live animals, and even human victims, must have been an intolerable burden to the community. There is no lack of instances of the immolation, voluntary or otherwise, of relatives and retainers at the tombs of great personages in ancient China, though the practice never seems to have been general, and was strongly reprobated by Confucius (551–479 B.C.). The sage even went so far as to condemn the substitution of wooden puppets, " for was there not a danger of their leading to the use of living victims ? " [2] Images of straw were all that he would permit.

When humaner influences prevailed, the ladies of the harem and the military guards, instead of following their Imperial master to the spirit world, were condemned to reside within the precincts of the mausoleum ; and doubtless the clay figures of women and warriors placed in the graves of more enlightened times were intended to relieve their human prototypes of this irksome duty. The earliest recorded allusion [3] to clay substitutes appears to be the words of Kuang Wu (in the first century A.D.), that " anciently,

[1] J. J. M. de Groot, *The Religious System of China.* Leyden, 1894, vol. ii., p. 383.
[2] Loc. cit., p. 807. [3] Loc. cit., p. 808.

at every burial of an emperor or king, human images of stoneware (*t'ao jên*), implements of earthenware (*wa ch'i*), wooden cars, and straw horses were used."

De Groot[1] quotes a long list of objects supplied for an Imperial burial of the Later Han (25–220 A.D.), including "eight hampers of various grains and pease ; three earthen pots of three pints, holding respectively pickled meat, preserved meat, and sliced food ; two earthen liquor jars of three pints, filled with must and spirits ; . . . one candlestick of earthenware ; . . . eight goblets, tureens, pots, square baskets, wine jars ; one wash-basin with a ewer ; bells, . . . musical instruments, . . . arms ; nine carriages, and thirty-six straw images of men and horses ; two cooking stoves, two kettles, one rice strainer, and twelve caldrons of five pints, all of earthenware ; . . . ten rice dishes of earthenware, two wine pots of earthenware holding five pints." The use of earthenware substitutes for the actual belongings of the dead was due in part to the spirit of economy preached by certain rulers at this time, and in part to the feeling that graves containing valueless objects would be safe from the desecration of the robber.

In addition to the general precepts of economy, we learn that definite regulations were issued prescribing the number and even the nature of the articles to be used by the various ranks of the nobility and by the proletariat. Thus in 682 A.D. Kao Tsung rebuked the competitive extravagance of the people in burial equipments, which even the ravages of famine had failed to diminish ; and in the K'ai Yüan period an Imperial decree[2] of the year 741 A.D. reduced the number of implements allowed to the various ranks in burial, officers of the first, second, and third classes of nobility being allowed seventy, forty, and twenty implements in place of ninety, seventy, and forty respectively ; while for the common people fifteen only were permitted. Moreover, all such implements were to be of plain earthenware (*ssŭ wa*), wood, gold, silver, copper, and tin being forbidden.

It is clear that at an early date wood was regarded as preferable to pottery as a material for sepulchral furniture, for the *Yin-yang tsa tsu*,[3] written in the eighth century, states that "houses and sheds, cars and horses, male and female slaves, horned cattle, and so forth, are made of wood." Indeed, the decree of 741 notwithstanding, wood seems to have become the standard material

[1] De Groot, loc. cit., p. 401. [2] Loc. cit., p. 696. [3] Loc. cit., p. 808.

for grave implements from this time onward. Thus, Chu Hsi of the Sung dynasty taught in his Ritual of Family Life " the custom of burying the dead with a good many *wooden* servants, followers, and female attendants, all holding in their hands articles for use and food "; and the contents of the Ming graves included " a furnace-kettle and a furnace, both of *wood*, saucer with stand, pot, or vase, an earthen wine-pot, a spittoon, a water basin, an incense burner, two candlesticks, an incense box, a tea-cup, a tea-saucer, two chopsticks, two spoons, etc., two *wooden* bowls, twelve *wooden* platters, various articles of furniture, including bed, screen, chest, and couch, all of *wood*; sixteen musicians, twenty-four armed lifeguards, six bearers, ten female attendants; the spirits known as the Azure Dragon, the White Tiger, the Red Bird, and the Black Warrior; the two Spirits of the Doorway and ten warriors—all *made of wood* and one foot high." These were among the implements permitted in the tombs of grandees; the regulations of 1372 allowed only one kind of implement in the tombs of the common folk.

From the foregoing passages it may be inferred that wood superseded pottery to a very great extent in the funeral furniture of the Sung and Ming periods, and consequently that the tombs in which a full pottery equipment has been found are most probably not later than the first half of the T'ang dynasty. Needless to say, the wooden paraphernalia rapidly perished under the ground, and while the pottery implements have preserved their original form and appearance, the wooden objects have mostly disintegrated.

An amusing fragment of folklore, translated by de Groot [1] from the *Kuang i chi*, " a work probably written in the tenth century," will form a fitting conclusion to this note, revealing as it does the thought of the Chinese of this period with regard to the burial customs which we have discussed :—

" During one of the last generations there lived a man, who used to travel the country as an itinerant trader in the environs of the place where his family was settled. Having been accompanied on one of his excursions for several days by a certain man, the latter unexpectedly said, ' I am a ghost. Every day and every night I am obliged to fight and quarrel with the objects buried in my tomb for the use of my manes, because they oppose my will.

[1] De Groot, loc. cit., p. 809.

I hope you will not refuse to speak a few words for me, to help me out of this calamitous state of disorder. What will you do in this case ? ' 'If a good result be attainable,' replied the trader, ' I dare undertake anything.' About twilight they came to a large tomb, located on the left side of the road. Pointing to it, the ghost said : ' This is my grave. Stand in front of it and exclaim, "By Imperial Order, behead thy gold and silver subjects, and all will be over."' Hereupon the ghost entered the grave. The pedlar shouted out the order, and during some moments he heard a noise like that produced by an executioner's sword. After a while the ghost came forth from the tomb, his hands filled with several decapitated men and horses of gold and silver. ' Accept these things,' he said ; ' they will sufficiently ensure your felicity for the whole of your life ; take them as a reward for what you have done for me.' When our pedlar reached the Western metropolis he was denounced to the prefect of the district by a detective from Ch'angngan city, who held that such antique objects could only have been obtained from a grave broken open. The man gave the prefect a veracious account of what had happened, and this magistrate reported the matter to the higher authorities, who sent it on to the Throne. Some persons were dispatched to the grave with the pedlar. They opened the grave, and found therein hundreds of gold and silver images of men and horses with their heads severed from their bodies."

In the present day [1] at important sacrifices to ancestors (and presumably at the funeral itself), it is customary to burn counterfeits of all kinds of furniture and objects which might be useful in the spirit-world. In general these counterfeits take the form of small square sheets of cheap paper adorned with pictures, stamped with a rudely carved wooden die, and representing houses, chairs, implements for cooking, writing and the toilette, carts and horses, sedan chairs, attendants and servants, slaves (male and female), cattle, etc. It is not clear when this custom first came into being, but it evidently replaced an earlier practice of burning real furniture, clothing, etc., at the tomb ; and de Groot implies, at any rate, that the two practices existed side by side in the eleventh century. " Bonfires of genuine articles," he says, [2] " and valuables continued for a long time to hold a place side by side with bonfires of counterfeits. We read e.g. that at the demise of the Emperor

[1] De Groot, loc. cit., p. 717. [2] Loc. cit., p. 718.

Shêng Tsung of the Liao dynasty (1030 A.D.) the departure of the cortège of death from the palace was marked by a sacrifice, at which they took clothes, bows and arrows, saddles, bridles, pictures of horses, of camels, lifeguards, and similar things, which were all committed to the flames." Marco Polo,[1] in describing the city of Kinsai, relates that the inhabitants burnt their dead, and " threw into the flames many pieces of cotton paper upon which were painted representations of male and female servants, horses, camels, silk wrought with gold, as well as gold and silver money."

[1] Who visited China about 1280.

CHAPTER III

THE Chinese Empire, reunited by the Sui emperors, reached the zenith of its power under the world-famed dynasty of the T‘ang (618–906 A.D.). A Chinese general penetrated into Central India and took the capital, Magadha, in 648. Chinese junks sailed into the Persian Gulf, and the northern boundaries of the empire extended into Turkestan, where traces of a flourishing civilisation have been discovered in the sand-buried cities in the regions of Turfan and Khotan, recently explored by Sir Aurel Stein and by a German expedition under Professor Grünwedel. In return, we read of Arab settlers in Yunnan and in Canton and the coast towns, and the last of the Sassanids appealed to China for help. A host of foreign influences must have penetrated the Middle Kingdom at this time, including those of the Indian, Persian, and Byzantine arts. Proof of this, if proof were needed, is seen in the wonderful treasures preserved in the Shoso-in at Nara in Japan, a temple museum stocked in the eighth century chiefly with the personal belongings of the Emperor Shomu, most of which had been sent over from China. Indeed, the Nara treasure is, in many respects, the most comprehensive exhibition of T‘ang craftsmanship which exists to-day.

The long period of prosperity enjoyed by China under the T‘ang is famed in history as the golden age of literature and art. The age which produced the poet Li Po, the painter Wu Tao-tzǔ, and the poet-painter Wang Wei, whose " poems were pictures and his pictures poems," was indeed an age of giants. It is certain that the potter's art shared in no small measure the progress of the period, though at this distance of time we can hardly expect that many monuments of this fragile art should have survived. Indeed, it has been the custom of writers in the past to dismiss the T‘ang pottery in a few words, or to disregard it entirely as an unknown

quantity Here, however, we have again been well served by the ancient burial customs of the Chinese, which still held good for part, at least, of the T'ang period.

The T'ang mortuary wares are similar in intention to those of the Han, but bespeak a much maturer art. The modelling of the tomb figures, which have been aptly compared with the Tanagra statuettes of ancient Greece, displays greater skill, spirit, and delicacy, and the materials used are more refined and varied. The body of the ware, which is usually fine as pipeclay, varies in hardness from soft earthenware, easily scratchable with a knife, to a hard porcellanous stoneware, and in colour from light grey and pale rosy buff to white, like plaster-of-Paris. The usual covering is a thin, finely crackled glaze of pale straw colour or light transparent green, and sometimes the surface has a wash of white clay between the body and the glaze. Some of the figures, however, are more richly coated in amber brown and leaf green glazes with occasional splashes of blue, while on others are found traces of unfired red and black pigments.

But as the mortuary pottery [1] comprises the largest and most important group of T'ang wares at present identified, we cannot do better than consider it first and as a separate class, setting forth at once the reasons for assigning it to this particular period. As will be seen in the note to the previous chapter (p. 17), earthenware appears to have been to a great extent superseded by wood as the fashionable material for sepulchral furniture towards the end of the T'ang period. This in itself is strong *primâ facie* evidence that the tombs furnished throughout with pottery are not later than the T'ang dynasty. Another argument of an ethnographical nature is supplied by the figures of ladies with feet of normal size. The fashion of cramping the feet, though it may have begun before the T'ang period, was certainly not universal until the end of this long dynasty. [2]

[1] No doubt this mortuary pottery was made locally to supply local needs, and there is no occasion to refer it to any of the better known pottery centres, though we do find mention of an imperial order for sepulchral ware sent to the potters at Hsin-p'ing (the old name for the district town of Ching-tê Chên) in the T'ang dynasty. See *T'ao lu*, bk. viii., fol. 2, quoting from the *Hsiang ling ming huan chih.*

[2] See *A Glossary of Reference on Subjects Connected with the Far East*, by H. A. Giles, Shanghai, 1900. " The practice among Chinese women of cramping the feet is said by some to have originated about 970 A.D. with Yao Niang, concubine of the pretender Li Yü. The lady wished to make her feet like the new moon. Others say that it was introduced by Pan Fei, the favourite of the last monarch of the Ch'i dynasty, 501 A.D."

But there are other cogent reasons which will appeal more directly to the student of ceramics. Among the few specimens of pottery in the Nara Collection,[1] there are several bowls and a dish, accorded in the official catalogue the meagre description " China ware," which have a peculiar glaze of creamy yellow with large, green mottling, and there is besides a drum-shaped vase, " green with yellowish patches." This type of glaze is found on many of the tomb wares, some of which have amber brown and violet blue splashes in addition. From these data it is possible to identify a series of T'ang glazes, including creamy white, straw yellow, faint green, leaf green, amber and violet blue, all soft and more or less transparent with minutely crackled texture and closely analogous to the coloured lead glazes used on our own " Whieldon " pottery of Staffordshire in the eighteenth century. Three years ago a Parisian dealer was offering for sale the contents of an important tomb. For once in a way, the chief articles of the find had been kept together; at least so it was positively asserted, and there was nothing improbable in the circumstance. They included two splendidly modelled figures and a saddled horse in the typical T'ang ware, with bold washes of green and brown glazes, and with them was a stone slab engraved with an inscription. I was able to examine a photograph and a rubbing of this stone, in which excellent judges could find no sign of spurious work. The inscription was long and difficult to translate, but the main facts were clear. It commemorated a princely personage of the name of Wên, whose style was Shou-ch'êng, a man of Lo-yang in Honan, who died at Ho-yang Hsien on the 16th day of the first month of the second year of Yung Shun, viz. 683 A.D.

Among the T'ang figurines the horse is conspicuous not only in its comparative frequency, but for the spirit and character with which it is portrayed. The men of T'ang were clearly great horse lovers. Their pictorial artists excelled in painting the noble beast, and the " Hundred Colts " by the celebrated painter Han Kan is a classic of horse painting. Among the precious fragments of T'ang pictures on silk which Sir Aurel Stein brought back from his first expedition in the Taklamakan Desert there were several with scenes in which horsemen figured. I have compared these with the tomb figures and found them to tally with wonderful exactitude,

[1] See the *Toyei Shuko* (Illustrated Catalogue of the ancient Imperial Treasure called Shoso-in, by Omura Seigai, Tokyo, 1910), Nos. 154, 155 and 156.

not only in pose and style and in the characteristic rendering of the head and neck, but also in the details of the harness, the saddle with high arched front and shelving back support, the square stirrups, bridle and bit and tassel-like pendant under the mouth.

A complete set of grave goods from a tomb opened by the Lao-tung railway near Lao Yang in the Honan Fu have been acquired by the British Museum through a railway engineer on the spot. They may be taken as a typical and, I believe, quite reliable, example of the grave furniture of a T'ang personage of importance. They include six covered jars of graceful oval form, made of hard white ware and coated with thin glaze of pale yellowish or faint green tint, which ends in the characteristic T'ang fashion in a wavy line several inches above the base. They measure about thirteen inches in height. These are presumed to have held the six kinds of grain. Next comes a graceful vase, probably for wine, with ovoid body, tall, slender neck, with two horizontal bands, a cup-shaped mouth, and two high, elegantly carved handles with serpent heads which bite on to the rim (Plate 14, Fig. 2). The only other vessels were a circular tray, on which stood a small, squat vase, with trilobe sides, small mouth, and three rudimentary feet, surrounded by seven shallow cups. Like the wine vase and covered jars, these have flat bases, in most cases carefully smoothed and lightly bevelled at the edge.[1] The retinue consisted of a charming figure of a lady on a horse, eight other ladies (probably of the harem) with high, peaked head-dress, low-necked dresses with high waists, and a shawl over the shoulders and falling down from the arms like two long sleeves ; natural feet are indicated in every case. With these were two figures of priestly appearance, with long cloaks and hoods, three other men in distinctive costumes, eleven retainers in civil costume with peaked head-gear, long coats with lappets open at the neck, waist belts, and high boots, their right hands held across the breast and their left at the side. One of these figures is remark-able for his foreign features, with exaggerated and pointed nose, sug-gesting a Western Asiatic origin. There are, besides, four men, apparently in armour, and two tall figures who seem to wear cap helmets with camail falling down the neck and breast armour, recalling in many ways our own mediæval men-at-arms. The supernatural element is represented by two strange, squatting

[1] Another common characteristic of the T'ang base is a central ring, or one or two concentric circles incised on the wheel.

COLOR PLATES

Frontispiece, Volume I. Statue of a Lohan or Buddhist Apostle, T'ang
Dynasty (618–906 A.D.)
British Museum. Height (with stand) 50 inches.

PLATE 8. THREE EXAMPLES OF T'ANG WARE WITH COLOURED GLAZES: IN THE EUMORFOPOULOS COLLECTION.

FIG. 1. Tripod incense vase with ribbed sides; white pottery with deep blue glaze outside encrusted with iridescence. Height 4⅝ inches.

FIG. 2. Amphora of light coloured pottery splashed with glaze. Mark incised *Ma Chên-shih tsao* ("made by Ma Chên-shih"). Height 8¼ inches.

FIG. 1.

FIG. 2.

FIG. 3.

Fig. 1.

Fig. 2.

PLATE 16. SUNG WARES.
FIG. 1. Bowl with six-lobed sides; thin porcellanous ware, burnt brown at the foot-rim, with bluish green celadon glaze irregularly crackled. *Alexander Collection.* Diameter 9½ inches.
FIG. 2. Tripod incense burner. White porcelain, burnt pale red under the feet. Lung-ch'üan celadon ware (?) This kind of celadon is known as *kinuta seiji* in Japan, where it is highly prized. *Eumorfopoulos Collection.* Height 4⅛ inches.

PLATE 17. TWO EXAMPLES OF SUNG WARES OF THE CHÜN OR KUAN FACTORIES.
FIG. 1. Bowl with lavender glaze, lightly crackled. *O. Raphael Collection.* Height 4½ inches.

PLATE 19. Vase of Close-Grained, Dark Reddish Brown Stoneware with
Thick, Smooth Glaze, Boldly Crackled. Ko Ware of the Sung Dynasty.
Eumorfopoulos Collection. Height 10⅝ inches.

PLATE 20. DEEP BOWL OF REDDISH BROWN STONEWARE WITH THICK, BOLDLY CRACKLED GLAZE. KO WARE OF THE SUNG DYNASTY. *Eumorfopoulos Collection*. Height (without stand) 4 inches.

PLATE 35. FLOWER POT OF CHÜN CHOU WARE OF THE SUNG DYNASTY.
Grey porcellanous body: olive brown glaze under the base and the numeral
shih (ten) incised. *Eumorfopoulos Collection.* Height (without wooden stand)
5⅞ inches.

Fig. 1.

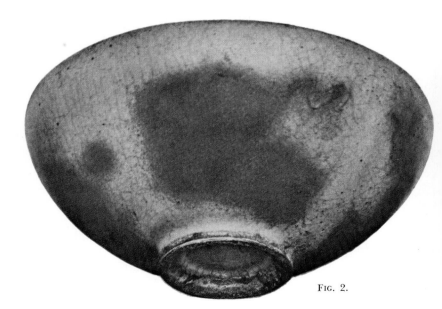

Fig. 2.

PLATE 36. CHÜN WARES.

FIG. 1. Flower pot of six-foil form. Chün Chou ware of the Sung dynasty. The base is glazed with olive brown and incised with the numeral *san* (three). *Alexander Collection*. Height 7¾ inches.

FIG. 2. Bowl of Chün type, with closed-grained porcellanous body of yellowish colour. Sung dynasty. *Eumorfopoulos Collection*. Diameter 5¾ inches.

FIG. 1.

FIG. 2.

PLATE 38. CHÜN WARES.
FIG. 1. Bowl of eight-foil shape, with lobed sides, of Chün type. Sung dynasty. Close-grained porcellanous ware of yellowish colour. *Alexander Collection.* Height 1⅞ inches.
FIG. 2. Pomegranate-shaped water pot of "Soft Chün" ware. Probably Sung dynasty. *Alexander Collection.* Height 3½ inches.

FIG. 1.

FIG. 2.

PLATE 39. TWO EXAMPLES OF "SOFT CHÜN" WARE.
FIG. 1. Vase of buff ware, burnt red at the foot rim, with thick, almost crys-
talline glaze. Found in a tomb near Nanking and given in 1896 to the Fitz-
William Museum, Cambridge. Probably Sung dynasty. Height 8⅛ inches.
FIG. 2. Vase of yellowish ware with thick opalescent glaze. Yüan dynasty.
Alexander Collection. Height 13⅜ inches.

PLATE 47. VASE OF BUFF STONEWARE.
With a scroll of rosette-like flowers in relief: thick flocculent glaze of mottled
blue with passages of dull green and a substratum of brown. Kuangtung ware,
seventeenth century. *Benson Collection.* Height 10¼ inches.

FIG. 1.

FIG. 2.

PLATE 51. TWO VASES WITH GLAZE IMITATING THAT OF THE CHÜN CHOU
WARES: IN THE EUMORFOPOULOS COLLECTION.
FIG. 1. Vase of Fat-shan (Kuangtung) Chün ware. Late Ming. Height 9¾
inches.
FIG. 2. Bottle-shaped vase, the base suggesting a lotus flower and the mouth
a lotus seed-pod, with a ring of movable seeds on the rim. Thick and almost
crystalline glaze of lavender blue colour with a patch of crimson. Yi-hsing
Chün ware of the seventeenth century. Height 9¾ inches.

PLATE 52. WINE JAR WITH COVER AND STAND.
Fine stoneware with ornament in relief glazed green and yellow in a deep
violet blue ground. Four-clawed dragons ascending and descending among
cloud scrolls in pursuit of flaming pearls; band of sea-waves below and formal
borders including a *ju-i* pattern on the shoulder. Cover with foliate edges
and jewel pattern, surmounted by a seated figure of Shou Lao, God of Lon-
gevity. About 1500 A.D. *Grandidier Collection, Louvre.* Height 22½ inches.

PLATE 53. VASE WITH CHRYSANTHEMUM HANDLES.
Buff stoneware with chrysanthemum design outlined in low relief and col-
oured with turquoise, green and pale yellow glazes in a dark purple ground.
About 1500 A.D. *Eumorfopoulos Collection*. Height 19½ inches.

PLATE 54. VASE WITH LOTUS HANDLES.
Buff stoneware with lotus design modelled in low relief and coloured with
aubergine, green and pale yellow glazes in a deep turquoise ground. About
1500 A.D. *Grandidier Collection, Louvre*. Height 18 inches.

PLATE 57. SEATED FIGURE OF KUAN YÜ, THE WAR-GOD OF CHINA, A DEIFIED WARRIOR.
Reddish buff pottery with blue, yellow and turquoise glazes, and a colourless glaze on the white parts. Sixteenth century. *Eumorfopoulos Collection*. Height 20⅜ inches.

Fig. 1 Fig. 2 Fig. 3

Plate 5.—T'ang Sepulchral Figures. *In the Benson Collection.*

Fig. 1.—A Lokapala or Guardian of one of the Quarters, unglazed. Fig. 2.—A Horse, with coloured glazes. Height 27 inches.
Fig. 3.—An Actor, unglazed.

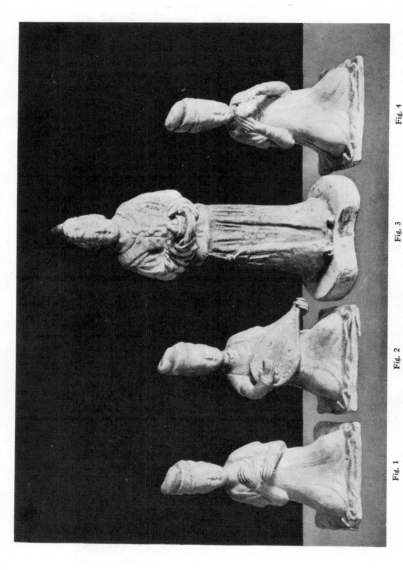

Fig. 1 Fig. 2 Fig. 3 Fig. 4

Plate 6.—T'ang Sepulchral Figures, unglazed.

Figs. 1, 2 and 4.—Female Musicians. Fig. 3.—Attendant with dish of food. Height 9½ inches.
Eumorfopoulos Collection.

Fig. 1

Fig. 2

Fig. 3

Plate 7.—T'ang Sepulchral Pottery.

Fig. 1.—Figure of a Lady in elaborate costume, unglazed. Height 14½ inches. *Eumorfopoulos Collection.* Fig. 2.—Vase, white pottery with traces of blue mottling : the glaze has perished. Height 8¾ inches. *Breuer Collection.* Fig. 3.—Sphinx-like Monster, green and yellow glazes. Height 25 inches. *Eumorfopoulos Collection.*

quadrupeds with legs like a bull, human heads with large ears and a single horn which are called by the Chinese *t'u kuai* or " earth-spirits." Finally, in addition to man and super-man, the animal world was represented by two saddled horses, two dromedaries, two pigs, two sheep, a beautifully modelled dog, and a goose. What more could a man desire in the underworld ? All these figures are of the usual white plaster-like body, with the pale, straw-coloured or greenish glazes which long burial has dissolved into iridescence where it has not actually caused it to flake away. Some of them stand on flat, plain bases ; others on their own feet and robes. The latter kind are all hollow beneath, and the quadrupeds have a large cavity under the belly, a feature common to the T'ang and Han animals, and one which I have noticed on bronzes of the same periods. Needless to add, these figures were made in moulds, the seams of which are still visible.[1]

A few examples of the tomb figures are illustrated in the adjoining plates. The tall, slender figure on Plate 7, Fig. 1, seems to represent a lady of distinction. The elaborate head-dress and costume, the necklace and pendant and the belt are all carefully modelled ; and the Elizabethan appearance of the collar is curious and interesting. The ware is soft and white like pipeclay, though still caked with the reddish loess clay from which it was exhumed. The style of this figure with its slender proportions is analogous to that of the graceful stone sculptures of the Northern Wei period. The genial monster in white clay and splashed green and yellow glazes illustrated on Plate 7 is one of the many sphinx-like creatures found in the tombs over which they were supposed to exercise a beneficial influence. Sometimes they have human heads on the bull body, and they are then described as *t'u kuai* or earth-spirits. In the present example we have a form which strongly resembles certain Persian or Sassanian monsters in bronze ; and it is highly probable that the idea of this creature came from a western Asiatic source.

Plate 5 shows a fine example of a horse in coloured glazes, a fierce figure in warrior's guise, who is, no doubt, one of the Lokapalas

[1] Laufer (*Jade*, p. 247) sounds a note of warning about the reconstruction of many of the T'ang figures. They were very frequently broken in the course of excavation, and when a head was missing its place was commonly supplied from another find. Another and more serious warning is given by F. Perzynski in the *Ostasiatischer Zeitschrift*, January to April, 1914, p. 464, in an article describing forgeries of coloured T'ang figures, and vases and ewers with mottled green and yellow glazes, in Honan Fu.

or Guardians of the Four Quarters in the Buddhist theogony, and a figure of an actor. The amusements, as well as the serious occupations of the dead, were provided for in the furniture of the tombs. A whole troop of mimes in quaint costumes and dramatic poses is shown in the Field Museum at Chicago, and Plate 6 illustrates three seated figures of musicians as well as a standing figure holding a dish of fruit.

A study of the salient features of these and other authenticated specimens leads naturally to the identification of fresh types, and so the series grows. For instance, the type of wine vase with serpent handles is found in glazes of various colours, all of the mottled T'ang kind, and with slight additions, such as the palmette-like ornaments in applied relief on a large example in the British Museum. These ornaments in their turn appear on bowls and incense vases often of globular form, like the well-known Buddhist begging bowl, but fitted with three legs. Splashed, streaked and mottled glazes further declare these to be T'ang, and the varying colour and hardness of their body material give us a deeper insight into the T'ang ware. All of these show the marks of the wheel, and many are neatly finished with simple wheel-made lines and ridges ; stamped ornaments in applied relief are their commonest form of decoration.

A fine specimen in the British Museum will serve to illustrate this type of bowl. It has a hard, white body, of typical globular form, with slightly constricted mouth, three legs with strongly modelled lion masks on the upper part, and between them pads of applied relief with lion mask ornaments. The glaze is not of the mottled kind, but is rather streaked ; it is deep, cucumber green and minutely crackled, and has run down into drops under the bowl. This fluidity is also the cause of the streakiness of the colour, which was evidently a characteristic feature of the T'ang pottery, for it appears unmistakably indicated in a T'ang painting figured by Sir Aurel Stein.[1] This painting, a silk banner of the T'ang period, was found in a walled-up library at Tun-huang, and depicts a standing Buddhist figure carrying a begging bowl with boldly streaked exterior.

In addition to the mottled glazes—which, by the way, are the

[1] *Ruins of Desert Cathay*, vol. ii., p. 195. Similarly bowls with spotted glaze are indicated in several of the silk pictures found by Sir Aurel Stein at Tun-huang, which are temporarily exhibited in the King Edward VII. galleries in the British Museum.

forerunners of the so-called " tiger-skin " porcelains of the seventeenth and eighteenth centuries—and the single colours already mentioned, instances have been identified on the principles already indicated of wares with a full yellow glaze and a streaky, brownish yellow. An interesting piece (Plate 8) in the Eumorfopoulos Collection is covered with a deep violet blue glaze on a fine white body. Others, again, have a dark chocolate brown glaze on a reddish buff body, and a rare ewer in the British Museum is distinguished by a deep olive brown glaze flecked with tea green, which seems to anticipate by a thousand years the " tea dust " glazes of the Ch'ien Lung period.[1]

Another variety of T'ang glaze, of which I have seen one example, was an olive brown with large splashes of a light colour, a greyish white, but with surface so frosted over by decay that its original intention remained in doubt. One might say that this was the father of the Japanese Takatori glazes with deep brown under-colour and large patches of frothy white. We may mention here three remarkable specimens found in a grave with a T'ang mirror and described in *Man* in 1901,[2] which are in the British Museum. One is an oblate ovoid vase, with small neck and mouth, of hard, light buff body, coated with a dull greenish black glaze with minute specks of lighter colour. The others are tea bowls of hard buff ware with dull brick-red glaze, not far removed in colour from the Samian ware of Roman times. No exact Chinese parallel has yet been found to these three pieces, though something approaching them is seen in certain bowls in the Eumorfopoulos collection which have a reddish brown glaze breaking into black, being apparently of the type associated with the name of Chien yao,[3] and which are known in Japan as *kaki temmoku*. This early kind of *temmoku*, which was probably made in Honan, has a hard whitish body, and the glaze is sometimes flecked with tea green as well as with golden brown. In some cases, too, a floral design or a leaf has been impressed or stencilled on the black glaze and appears in the brown or green colour (Plate 43, Fig. 1). It is said that a somewhat similar brown *temmoku* ware was made in Corea as well.

[1] Fragments of similarly glazed ware were discovered by Sir Aurel Stein on sites in Turfan, which were supposed to be of T'ang date (see p. 134).

[2] In a paper by Sir C. Hercules Read in the fifteenth number of *Man*, a publication of the Anthropological Institute.

[3] See p. 130.

The survival of the leaf green glaze of Han type has already been noted. It occurs in Plates 12 and 13.

A pale bluish green glaze, somewhat akin to a later variety of celadon, appears on a few small bowls and jars which have the characteristic T'ang finish : I have seen several figures of lions with a crackled light greenish brown glaze ; and a considerable class of bowls and melon-shaped vases have been found in Shansi with a hard buff stoneware body, coated with white slip under a transparent and almost colourless glaze, the combination producing a solid white or ivory colour (Plate 11, Fig. 3). These bowls have been considered by some Chinese authorities to be a production of the Ta Yi[1] kilns in Szechuan, but as there were factories in Shansi,[2] where wares of this type are reputed to have been made in T'ang times, it seems more probable that they are of local make. It should be added that the brown, tea dust, black, celadon and white glazes are high-fired and essentially different from the soft, crackled lead glazes previously described.

Apart from modelling in the round, an art in which we have seen that the T'ang potters excelled, the decorative ornament of the pottery hitherto discussed has been confined to applied reliefs. The processes of carving and engraving come early in the evolution of the potter's art in China, and we should expect to find in the T'ang wares some indications of the skill in these methods for which the Sung potters were so celebrated. Plate 12, Fig. 2, illustrates the use of engraved ornament under a green glaze, and the piece is remarkable not only for its elegant design, but for the beautiful lines of its simple form. A few years ago I saw for the first time one or two stands and boxes with patterns intricate as brocade work, floral scrolls, and geometrical designs, engraved with a point, and the spaces filled in with coloured glazes. They were reputed to be of T'ang date, and though no further evidence existed to prove that objects of such advanced technique and mature design really belonged to this remote period the proposition did not seem an impossible one. The textiles, inlaid woodwork, and painted lacquer in the Nara collections have just such designs which at first sight fill one with amazement at their modern feeling. A piece of brocade of undoubted T'ang origin, figured by Sir Aurel Stein,[3] with floral scrolls worked in silk,

[1] See A. W. Bahr, *Old Chinese Porcelain and Works of Art in China*, Plate IV.
[2] At P'ing-yang Fu, at Ho Chou, and elsewhere (see p. 97).
[3] *Ruins of Desert Cathay*, vol. ii., fig. 197.

Fig. 1

Fig. 3

Fig. 2

Plate 9.—T'ang Pottery.

Fig. 1.—Ewer of Sassanian form with splashed glazes; panels of relief ornament, in one a mounted archer. Height 13 inches. *Alexander Collection.* Fig. 2.—Vase with mottled glaze, green and orange. Height 3⅝ inches. *Eumorfopoulos Collection.* Fig. 3.—Ewer with dragon spout and handle; wave and cloud reliefs; brownish yellow glaze streaked with green. Height 11⅝ inches. *Eumorfopoulos Collection.*

Fig. 1

Fig. 2

Plate 10.—T'ang Pottery. *Eumorfopoulos Collection.*

Fig. 1.—Dish with mirror pattern incised and coloured blue, green, etc.; inner border of *ju-i* cloud scrolls on a mottled yellow ground, outer border of mottled green; pale green glaze underneath and three tusk-shaped feet. Diameter 15 inches. Fig. 2.—Ewer with serpent handle and trilobed mouth; applied rosette ornaments and mottled glaze, green, yellow and white. Height 10½ inches.

Fig. 3

Fig. 2

Fig. 1

Fig. 4

Plate 11.—T'ang Wares.

Fig. 1.—Cup with bands of impressed circles, brownish yellow glaze outside, green within. Height 2⅝ inches. *Seligmann Collection.*
Fig. 2.—Cup of hard white ware with greenish white glaze. Height 2⅜ inches. *Eumorfopoulos Collection.* Fig. 3.—Melon-shaped
Vase, greyish stoneware with white slip and smooth ivory glaze. Height 4 inches. *Breuer Collection.* Fig. 4.—Cup of porcellanous
stoneware, white slip and crackled creamy white glaze, spur marks inside. Height 3¼ inches. *Breuer Collection.*

looks like a piece of late Persian embroidery. And is not the art of the T'ang painters essentially modern in the directness of its appeal ?

The truth is, our knowledge of T'ang pottery has only just begun, and now that the ware is esteemed in Europe at its proper worth, the choicer specimens which have been treasured in China are finding their way westward. Every fresh arrival tells us something new and surprising, and it only wanted such a piece as Fig. 1, Plate 10, to establish the identity of the specimens whose T'ang origin we had before only ventured to conjecture. Here we have a form of dish which is found among the tomb wares of the T'ang period, made of the typical T'ang white body and finished in characteristic fashion and decorated with engraved designs of the most advanced type, filled in with coloured glazes, in addition to bands of mottling in green and white, and yellow and white. There are, besides, other specimens of similar make but with simpler, though scarcely less interesting, design of a mirror-shaped panel formed of radiating lotus leaves engraved in the centre with a stork in white and green, all in a deep violet blue ground. The coloured glazes used in the T'ang polychrome pottery are light and translucent lead glazes of the kind which reappears on the Ming and Ch'ing pottery and porcelain, and, as on the later wares, they are covered with minute accidental crackle. In their splashed and mottled varieties they have, as already noted, a resemblance to the glazes of the eighteenth-century Whieldon ware of Staffordshire, and it is interesting to note that the T'ang potters also used another form of decoration which was much fancied in Staffordshire about a thousand years later. This is the marbling of the ware, not merely by mottling the glaze as in Fig. 2 of Plate 9, or by marbling the surface, but by blending dark and light clays in the body as in the " solid agate " ware of Staffordshire. It only remains to prove that painting with a brush was practised by the T'ang potters, and though one is loath to accept such a revolutionary idea without positive proof, there is very good reason to think that such pieces [1] as Fig. 3, Plate 12, belong to the T'ang period. They have a white pottery body, painted in bold floral scroll

[1] Mr. C. L. Freer has in his collection in Detroit a vase of hard reddish ware with a freely drawn lotus design in brown under a pale green glaze, with parts of the flower in dry reddish brown slip or pigment over the glaze. It has the characteristic T'ang base and appears to belong to that period.

designs in black under a beautiful green glaze. We are getting used to surprises in connection with T'ang pottery, and probably in a year's time painted T'ang wares, which are now only accepted with reserve, will be an established fact which passes without comment.

Stamped patterns are not uncommon, and we often find small rings or concentric circles, singly, as in Fig. 1 of Plate 11, or stamped in clusters of five or seven, forming rosettes [1]; or, again, impressed key fret, as in Fig. 1 of Plate 12, which has a deep leaf green glaze.

The influence of the Western Asiatic civilisations has been already mentioned in casual hints, but it appears in concrete form in the peculiar shape of the ewer on Plate 9. The bird-headed vessel is found in Persian pottery of an early date, one example of which may be seen in the British Museum. Another remarkable instance of this form was illustrated and discussed by Dr. Martin in the *Burlington Magazine*, September, 1912.[2] It had, in addition, applied relief ornaments of a kind which we have already noticed, and Dr. Martin expressed his opinion that both the form and the ornaments are nearly related to Sassanian metal work. The fact that the last Sassanid king sought help from China [3] points to intercourse between the two realms, and in any case the northern trade route through Turkestan into Western Asia gave ample opportunity for the traffic in Persian and Sassanian wares. But more remarkable still is the classical spirit displayed in the piping boy and dancing girl [4] on a wonderful flask in the Eumorfopoulos Collection (Plate 13, Fig. 2). The Græco-Buddhist influence on early Chinese sculpture has already been remarked, and several classical designs are commonly pointed out on the T'ang metal mirrors; but here we have in pottery a figure which might have been taken from a Herculaneum fresco, surrounded by scroll-work worthy of the finest T'ang mirror. The body of the ware

[1] The small rosettes which commonly occur in the inlaid Corean designs recall these stamped T'ang patterns. Indeed the analogy between the Corean patterns in general and those found on T'ang pottery is most significant.

[2] It is now in the collection of Mrs. Potter Palmer.

[3] Yesdijird III., after his overthrow by the Arabs in 641, fled to Merv, and there appealed for aid to the Chinese Emperor. He does not appear to have fled for refuge to China, as has been sometimes asserted.

[4] The classical prototype is seen in a vase in the Fourth Vase Room (Case C) in the British Museum, on which we find two similar figures in relief surrounded by a grape vine scroll.

is whitish pottery, and the beautifully moulded surface is covered with a brownish green glaze, which, like that of Fig. 1, Plate 12, is clearly a survival of the Han glaze. Other instances might be quoted of Græco-Roman influences reflected in T'ang wares. There are obvious traces of the " egg and tongue " and " honeysuckle " patterns in border designs, and the shapes of vases and ewers often betray a feeling which is more Greek than Chinese.

Reverting to the engraved T'ang ornament, there is a little oblong box in the Kunstgewerbe Museum at Berlin with incised rosettes of prunus blossom form, glazed white and yellow in a green ground and finished almost with the neatness of Ch'ien Lung porcelain, but of undoubtedly T'ang origin. The same prunus design occurs on a typical T'ang bowl, in the Eumorfopoulos Collection, stencilled white in a green ground. I have postponed reference to these pieces because of the bearing of the latter on the decoration of the wonderful figure illustrated in the frontispiece, which will make a fitting climax to our series of T'ang specimens.

This figure, with its stand, measures 50 inches in height, and represents one of sixteen Lohan or Arhats, the Buddhist apostles. Its provenance has been kept discreetly concealed,[1] but we may

[1] Since writing the above note my attention has been drawn to a delightful article in the *Neue Rundschau* (Oct., 1913, p. 1427) by F. Perzynski, entitled *Jagd auf Götter*. Mr. Perzynski describes his hazardous journey to an almost inaccessible cave temple on a mountain top near Ichou in Chih-li, and there is little doubt that this is the place from which our wonderful figure came. He speaks of the hill as the Acthlohanberg, implying a tradition of eight of these figures of Lohan, which had apparently been concealed in this and other caverns for safety during a period of iconoclasm, such as occurred in the ninth and the thirteenth centuries, when thousands of Buddhist shrines were wrecked. He found the shrine bare of the Lohan, except for a few fragments. The rest had been pillaged, and several of the figures had evidently been broken in the attempt to remove them through the narrow aperture of the caves, or to conceal them afterwards. Parts of them, and a sadly damaged Lohan, were actually shown to him in the neighbourhood ; and he afterwards succeeded in obtaining a complete figure and a torso, which were exhibited by him in Berlin. On the altar of the shrine he found an incense burner of glazed ware, which he attributed to the Yüan dynasty, and there was a tablet recording the restoration of the altar in the reign of Chêng Tê (early sixteenth century). It is interesting to note that Mr. Perzynski assumed at once that these figures are of T'ang date. Incidentally, he mentions a visit to a hill which he calls the Kuanyinberg, where a cavern temple exists containing the remains of a colossal statue of Kuanyin. It is now broken, but Mr. Perzynski saw it standing in its enormous stature of three metres high, to which must be added a stand a metre high and two in width. This figure was originally in glazed pottery, possibly also of the T'ang period, but a great part of it had been restored in wood and plaster in the seventeenth century.

infer that it was taken from a temple or mausoleum, and we know that there were others with it, two of which were exhibited at the Musée Cernuschi, in Paris, in June, 1913. This one, however, has the advantage over the others of being complete with its pottery stand. The ware is white and comparatively hard; the colourless glaze on the fleshy parts has acquired a brown stain from the dripping of the cave moisture, and developed a minute crackle, both of which features are observable on some of the glazed vases from T'ang tombs; the pupils of the eyes are black. The draperies, of which the flowing folds are worthy of the finest classic sculpture, are glazed with mottled green, the upper robe with brownish yellow, both of T'ang type, and the latter is patched (in true Buddhist fashion) with green-edged bands with white designs resembling divided prunus blossoms in a yellow ground, in style recalling the decoration of the bowl previously mentioned. The technique, then, is that of the T'ang wares, but instead of being made in a mould like the grave statuettes, this monumental figure is modelled in the round by an artist worthy to rank with the masters of sculpture and painting who made the T'ang period famous.

When one looks at the powerful modelling of the head, the strong features composed in deep contemplation, and the restful pose of the seated form, one realises that here, at last, we have the great art which inspired the early Buddhist sculptors of Japan. It is no conventional deity which sits before us. The features are so human as to suggest an actual portrait, but for the supernatural enlargement of the ears in Buddhist fashion. The contracted brows bespeak deep concentration; the eyes, dreamy yet awake, look through and past us into the infinite; the nostrils are dilated in deep breathing; the lips compressed in firm yet compassionate lines. It is the embodiment of the Buddhist idea of abstraction and aloofness; yet it lives in every line, the personification of mental energy in repose. But so rare are examples of this style, that, unless we turn to painted pictures or frescoes such as have been brought back by the recent expeditions in Turfan, we must look in the temples of Japan, not, indeed, for similar Chinese work, but for the Japanese masterpieces in bronze, wood and lacquer, of the same period, which avowedly followed the Chinese art. The Yuima in the Hokkeji nunnery, ascribed to the middle of the eighth century; the portrait figure of the priest Ryoben († 773) in the Todaiji monastery, and the portrait figure of Chisho Daishi († 891) in the

Onjoji monastery,[1] are all conceived in the same grand style, and bespeak a kindred art.

But high as this figure ranks as sculpture, it is far more remarkable as pottery. To fire such a mass of material without subsidence or cracking would tax the capabilities of the best equipped modern pottery, while the skill displayed in the modelling is probably unequalled in any known example of ceramic sculpture. The contemporary grave figures hold a high place in ceramic modelling, but this statue is as far above the best of them as Dwight's stoneware bust of Prince Rupert towers above the Staffordshire figurines. Dwight's masterpiece has long been an object of wonder and admiration in the ceramic ante-room in the British Museum, and, with the help of the National Art Collections Fund and of several munificent individuals, the British Museum has been able to acquire this wonderful Chinese figure, which is now exhibited in the King Edward VII. galleries.

It is too early yet to attempt seriously the classification of the T'ang wares under their respective factories. Before this is possible the meagre allusions in Chinese literature must be supplemented by far fuller information. At present our knowledge of the T'ang factories is chiefly drawn from casual references in Chinese poetry and in the Chinese Classic on Tea, the *Ch'a Ching*, written by Lu Yü in the middle of the eighth century. From this we gather that the Yüeh Chou[2] kilns enjoyed a high reputation. An early allusion to this factory in reference to the " bowls of Eastern Ou " in the Chin dynasty has already been recorded.[3] The author of the Tea Classic tells us that among tea-drinkers the Yüeh bowls were considered the best, though there were some who ranked those of Hsing Chou[4] above them. Lu Yü, however, thought the judgment of the latter connoisseurs was wrong, because the Hsing Chou bowls resembled silver while the Yüeh bowls were like jade, because the Hsing bowls were like snow, the Yüeh like ice, and because the Hsing ware, being white, made the tea appear red, while the Yüeh ware, being green (*ch'ing*), imparted a green (*lü*) tint to the tea. The T'ang poet, Lu Kuei-mêng, further tells us that the Yüeh bowls " despoiled the thousand peaks of their blue green[5]

[1] See *Japanese Temples and their Treasures*, by Shiba-junrokuro, with translations by Mr. Langdon Warner, Tokyo, Shimbi Shoin, 1910, vol. ii., nos. 238, 268, and 300.
[2] 越州. [3] See p. 17. [4] 邢州, sometimes written 俹州.
[5] 翠色 *ts'ui sê*. Ts'ui is the colour of " a bird with blue-green feathers : a king-

colour." Yüeh Chou is the modern Shao-hsing Fu in the province of Chêkiang. It was celebrated in the tenth century for a special ware made exclusively for the princes of Wu and Yüeh, of the Ch'ien family, who reigned at Hung Chou from 907 to 976. This was the *pi sê* or " secret colour " ware which was made at Yüeh Chou until the Southern Sung period (1127–1279), when the manufacture was removed to Yü-yao.[1] The *pi sê*[2] ware has caused endless mystification among writers on Chinese porcelain. The name —which means literally " secret colour "—has been taken by some to imply that the colour was produced by a secret process (the most natural but not the generally accepted meaning), and by others that it was a forbidden colour, i.e. only permitted to be used by the princely patrons of the house of Ch'ien.[3] The author of the *Ching-tê Chen t'ao lu*[4] states that " it resembled the Yüeh ware in form, but surpassed it in purity and brilliance." This is, however, only the opinion of a nineteenth-century writer who does not claim to have seen a specimen of either. A tenth-century writer[5] makes use of the vague expression, " the secret colour preserves the note of the green (*ch'ing*) ware (*tz'ŭ*)," which apparently means that the secret-colour glaze did not rob the ware of the musical quality of usual *ch'ing* ware, implying a difference of some kind between the *pi sê* and the *ch'ing* glaze.

Literary references of this kind are open to so many inferences that their value is slight without some tangible specimen to help us to realise their import. This difficulty is greatly increased in dealing with Chinese descriptions because of the ambiguity of Chinese colour words, which is discussed elsewhere. But in the case of Yüeh Chou ware, or at any rate of one kind of it, we have

fisher " (Giles), and it seems to have been used indifferently to express a bluish green colour and greenish blue like turquoise. In Lu Kuei-mêng's poem it suggests the colour of distant hills. A passage in a seventeenth-century work, the *Ch'i sung t'ang shih hsiao lu* (quoted in the *T'ao lu*, bk. ix., fol. 8), seems to imply that there were lustrous reflections in the glaze of some of the Yüeh wares. It runs, " Yüeh yao cups with small feet are of the light green (*ch'ing*) of the chestnut husk ; when turned sideways they are the colour of emerald green jade (*fei ts'ui*)."

[1] See Julien, op. cit., p. 10. [2] 祕色.

[3] See *T'ao shuo*, bk. ii., fol. 5 recto, quoting the Sung work, *Kao chai man lu*, and *T'ao lu*, bk. ix., fol. 9, quoting a twelfth-century work, the *Ch'ing pi tsa chih*, " The *pi sê* vessels were originally the wares offered daily to the house of Ch'ien when it ruled over the country. No subject was allowed to have them. That is why they were called *pi sê*."

[4] Bk. v., fol. 4 recto. [5] See *T'ao shuo*, bk. ii., fol. 5 verso.

an important clue in another Chinese work. Hsü Ching, who accompanied the Chinese Ambassador to Corea in 1125, in a description of the Corean wares, makes the remark that " the rest of them have a general likeness to the old *pi sê* ware of Yüeh Chou and the new Ju Chou ware." [1] Fortunately, we can speak with considerable confidence of the Corean wares of this time, many examples of which have been taken from the tombs of the period. The British Museum has a fair number of examples, quite enough to show the typical Corean glaze, a soft grey green celadon of decidedly bluish tint, a thick smooth glaze often of great delicacy and beauty of tone.

In view of this the colour of the Yüeh bowls, the blue-green of the hills, is easily visualised. But China boasts so many makes of celadon [2] that he would be a bold man who would single out any one piece and say this is Yüeh ware. Among the numerous specimens of celadon which have reached Europe from various sources it is far from improbable that some were baked in the Yüeh kilns, but at present, alas, we are impotent to identify them.

The author of the *Ching-tê Chên t'ao lu* [3] places the Hsing Chou factory at the modern Hsing-t'ai Hsien, a dependency of Shun-tê Fu, in Chih-li. Little else is recorded about the white Hsing ware beyond a general statement in the annals of the T'ang dynasty [4] that the " white ware (*tz'ŭ*) cups of Nei Ch'iu were used by rich and poor throughout the empire." Nei Ch'iu, it should be explained, is identified as a township in the Hsing Chou. We may add that the ware of both Yüeh Chou and Hsing Chou was used for " musical cups " by Kuo Tao-yüan. [5] One of the criteria which the Chinese recognise in distinguishing ordinary pottery from the finer wares of a porcellanous nature is the note emitted by the ware when smartly tapped with the finger, and we may fairly infer that any bowls which were suitable for use as musical chimes would be of a sonorous, hard fired material if not actually porcelain.

[1] For further reference to this important passage, see p. 54.
[2] See ch. vi. [3] Bk. vii., fol. 13 recto.
[4] *T'ang kuo shih pu*, quoted in the *T'ao shuo ;* see Bushell's translation (*Chinese Pottery and Porcelain*), p. 36. It is worthy of note that Hsing Chou was in the same district as Tz'ŭ Chou, which has long been celebrated for its pottery. See p. 101.
[5] As stated in *Yo fu tsa lu*, a tenth-century work on music, quoted in the *T'ao shuo*, bk. ii., fol. 4 recto. Twelve cups were used, and they were sometimes marked with numerals.

The *Ch'a Ching* enumerates five other T'ang factories which supplied tea bowls, all of them inferior in reputation to the Yüeh Chou kilns. Ting Chou 鼎州 in the Hsi-an Fu,[1] in Shensi; Wu Chou 務州 in the Chin-hua Fu, in Chêkiang; Yo Chou 岳州 in Hunan; Shou Chou 壽州 in Kiangnan; and Hung Chou 洪州, the modern Nan-ch'ang Fu, in Kiangsi, the district in which is Ching-tê Chên, afterwards the ceramic metropolis of China. Of these wares we have only the meagre information that the Yo Chou ware was of green (*ch'ing*) colour; the Shou Chou ware, yellow; and that the Hung Chou ware was a brownish colour,[2] and made the tea appear black. The Hung Chou factory is also named in the *Ko ku yao lun*,[3] which tells us that " vessels made at Hung Chou in Kiangsi are yellowish black in colour." A sixth factory, apparently of some reputation though not mentioned in the *Ch'a Ching*, is named in a poem by Tu Fu, president of the Board of Works,[4] in the T'ang dynasty, who says : " The ware (*tz'ŭ*) baked at Ta-yi is light but strong. It gives out, when struck, a sound like the plaintive note of the Chin-ch'êng jade. The white bowls of your Excellency surpass the frost and snow. In pity hasten to send one to the pavilion of my studies." Ta-yi was in the department of Ch'iung Chou, in Szechuan.

The five brief dynasties which fill the interval between the T'ang and Sung periods are only known to ceramic history for two wares, the identity of which remains a matter of conjecture. The first is the *pi sê* ware of Yüeh Chou, which has already been discussed ; and the second is the celebrated but intangible Ch'ai ware. Chinese writers wax poetical over the Ch'ai ware. " Men of old," says a late Ming writer,[5] " described Ch'ai ware as blue like the sky, brilliant like a mirror, thin like paper, and resonant like a musical stone." An earlier and less hyperbolical description of it given in the *Ko ku yao lun*[6] states that it was made at Chêng Chou, in Honan, and named *ch'ai* by Shih Tsung (of the Posterior

[1] Not to be confused with the more celebrated Ting Chou 定州 in Chih-li.

[2] *ho* 褐, a coarse cloth or serge, used to suggest a brownish tint ; cf. *sê ho ju t'ung* = colour *ho* like copper.

[3] As quoted in the *T'ao lu* (see Julien, p. 5). The reference does not appear in the British Museum copy of the *Ko ku yao lun*.

[4] Quoted in the *T'ao shuo*, bk. ii., fol. 5 recto, and bk. v., fol. 3 recto.

[5] Ku Ying-t'ai in the *Po wu yao lan*, published in the T'ien Ch'i period (1621–1627).

[6] By Ts'ao-chao in 1387 ; republished in a revised and enlarged edition by Wang-tso in 1459.

Fig. 1

Fig. 2

Fig. 3

Plate 12.—T'ang Pottery with green glaze.

Fig. 1.—Bottle with impressed key-fret. Height 7½ inches. *Eumorfopoulos Collection.* Fig. 2.—Ewer with incised foliage scrolls. Height 4¼ inches. *Alexander Collection.* Fig. 3.—Vase with foliage scrolls, painted in black under the glaze, incised border on the shoulder. Height 4¼ inches. *Eumorfopoulos Collection.*

Fig. 2

Fig. 1

Plate 13.—T'ang Pottery.

Fig. 1.—Pilgrim Bottle with lily palmette and raised rosettes, green glaze. Height $7\frac{1}{2}$ inches. *Koechlin Collection.* Fig. 2.—Pilgrim Bottle (neck wanting), Hellenistic figures of piping boy and dancing girl in relief among floral scrolls, brownish green glaze. Height $8\frac{1}{2}$ inches. *Eumorfopoulos Collection.*

Fig. 2

Fig. 4

Fig. 3

Fig. 1

Plate 14.—T'ang Wares.

Fig. 1.—Incense Vase, lotus-shaped, with lion on the cover, hexagonal stand with moulded ornament; green, yellow and brown glazes. Height 19¾ inches. *Rothenstein Collection.* Fig. 2.—Sepulchral Amphora, hard white ware with greenish white glaze, serpent handles. Height 19¼ inches. *Schneider Collection.* Fig. 3.—Ewer with large foliage and lotus border in carved relief, green glaze. Height 6½ inches. *Koechlin Collection.* Fig. 4.—Sepulchral Vase, grey stoneware with opaque greenish grey glaze. Incised scrolls on the body, applied reliefs of dragons, figures, etc., on neck and shoulder. (?) T'ang. Height 20 inches. *Benson Collection.*

Chou dynasty, who reigned for five years from 954 to 959); that its colour was sky blue ; that it was " rich, refined, and unctuous," and had fine crackle-lines ; that in many cases there was coarse yellow clay on the foot of the wares ; and that it was rarely seen in the writer's time. Elsewhere [1] we read that, according to tradition, Shih Tsung, on being asked what kind of ware he would require for palace use, commanded that its colour for the future should be " the blue of the sky after rain as seen in the rifts of the clouds." [2] As early as the sixteenth century the Ch'ai ware had virtually ceased to exist, and a writer [3] of that time tells us " Ch'ai ware is no longer to be found. I once saw a fragment of a broken piece mounted in a girdle-buckle. Its colour was brilliant, and answered to the usual description of the ware, but the ware itself was thick." A century afterwards the ware was nothing more than a tradition, and later it developed a legendary character. Fragments of it were said to dazzle the eyes, and when worn on armour to turn aside missiles in battle.[4]

Chinese writers have been troubled by the apparent inconsistency of the descriptions, " thin as paper " and " having coarse yellow clay on the foot." The latter may, however, merely refer to patches of coarse clay or sand which had served to support the ware in the kiln, and which had partially adhered to the base, a thing not uncommon in the earlier manufactures. The expression has, however, led some later writers [5] to identify the Ch'ai ware with a fairly well-known type of comparatively soft buff pottery, coated with a luscious turquoise or pale lavender blue glaze, which

[1] In the *T'ao shuo*, bk. ii., fol. 5 verso.

[2] 雨過天青雲破處者 *yü kuo t'ien ch'ing yün p'o ch'u chê*. It will be observed that the colour word used is *ch'ing*, which has the meaning of blue or green, indifferently.

[3] Chang Ying-wên, in the *Ch'ing pi tsang*, written at the end of the sixteenth century.

[4] In the *Ju shih wo wên*, quoted in the *T'ao lu*, bk. ix., fol. 19, where we are told that " merchants bring fragments of Ch'ai ware to sell for 100 ounces of silver. They say that if inlaid in the helmet at the approach of battle, they are able to turn aside the fire implements (*huo ch'i*)."

[5] For example, in the *Li t'a k'an k'ao ku ou pien*, a modern work, we find : " As to what they call at present Yüan and Chün wares, these in material, colour, sound, and brilliancy are similar to Ch'ai yao, but they differ in thickness, and are perhaps the common folk's imitation wares, and not the Imperial Shih Tsung ware. But we are not yet able to say. If the ware has sky blue colour, clear and brilliant on a coarse yellow brick-earth body, and rings like bronze, it must be Ch'ai ware. As to Chün ware . . . the specimens have in every case red colour and variegated surface. . . ."

we shall have occasion to discuss later.[1] Needless to say, there
is no probability of this type being the real Ch'ai. Its compara-
tive commonness alone puts the supposition out of court, but the
suggestion serves to show that some Chinese thinkers, at any rate,
see the Ch'ai colour in just such glazes as the pale lavender blue
of Plate 38, Fig. 2, which undoubtedly satisfies in many respects
the description " blue of the sky after rain."

On the other hand, the celebrated Ju Chou ware of the Sung
dynasty, which aspired to equal the Ch'ai in colour, was evidently
of the grey green celadon type, with perhaps a tinge of blue like
the early Corean wares.[2] We have, then, two theories on the
nature of the Ch'ai glaze : (1) that it was an opalescent, turquoise
glaze, such as is seen on the Chün type of wares ; and (2) that
it belonged to the smooth grey green celadon class, with the bluish
tint strongly developed. There may be other theories[3] besides,
but it matters little, as no authentic specimen is known to exist.
In fact, the discussion under the circumstances would have but
little interest were it not for its bearing on some of the Sung wares,
which will be discussed in the next chapter.

[1] See p. 48.
[2] See pp. 39 and 54.
[3] I have seen, for instance, a remarkable ware of white porcellanous type, with a
transparent glaze of a faint bluish tinge, to which the name Ch'ai was boldly given.
It was certainly an early type, perhaps as early as the Sung dynasty, but it belonged
to a class of porcelain which is almost certainly Corean. The only specimen I have
seen with a mark of the Posterior Chou period is not a blue-glazed piece but a large
vase with wonderful purplish black glaze of the Chien-yao type in the Eumorfopoulos
collection. The mark, however, has been cut at some time subsequent to the manu-
facture, and can only be regarded as reflecting some unknown person's opinion as
to the date of the piece.

CHAPTER IV

THE SUNG 宋 DYNASTY, 960–1279 A.D.

WITH the Sung dynasty firmly established in 960 A.D., the Chinese Empire entered upon a long period of prosperity rendered glorious by the cultivation of the arts of peace. It is true that the boundaries of the Empire were contracted and the Tartar tribes on the north-west had made good their independence and remained a constant menace to the frontiers of China. In 1127 the dam was broken and the desert warriors, no longer to be kept in check by diplomacy or force, burst upon Northern China and drove the peace-loving Sung from their capital, the modern K'ai-fêng Fu in Honan. The Emperor Kao Tsung and his Court fled across the Yangtze to their new capital at Hang Chou, where the dynasty continued under the name of the Southern Sung until 1279. The description given by Marco Polo of Hang Chou, which he considered, even in 1280, to be "beyond dispute the finest and the noblest city in the world," presents a wonderful picture of the refinement and luxury of the Sung civilisation. The great city had its network of canals and its twelve thousand stone bridges, its flourishing guilds of craftsmen, its merchant princes who lived "nicely and delicately as kings," its three hundred public baths of hot water, its ten principal markets, its great lake lined with houseboats and barges, and its streets thronged with carriages. The citizens themselves were peaceful and orderly, neither wearing arms nor keeping them in their homes, and their cordiality to foreigners was hardly less than the good will and friendliness which marked their relations to one another.

The conditions which produced such a community as this were ideal for the development of literature and art, and the Sung dynasty has been described as a prolonged Augustan age for poets, painters, and art workers of every persuasion. It was, moreover, an age of

43

connoisseurs and collectors. Treatises were written on artistic subjects, encyclopædias were published, and illustrated catalogues issued by the order of the Emperor and his followers. Among the best known of these last publications are the *Hsüan Ho po ku t'u lu,* " Illustrated discussion of the antiquities in the palace of Hsüan Ho," and the *Ku yü t'u p'u,* " Illustrated description of ancient jade." It is true that modern criticism has seriously impugned the archæological value of both these classic works. It is said that ingenious conjectures and reconstructions, based on the reading of earlier literature, too often take the place of practical archæology and first-hand knowledge of the art of the Shang and Chou dynasties. Sung archæology, in fact, appears to have been in much the same theoretical condition as the Homeric criticism in Europe before the days of Schliemann. But for us these works must always have great interest, if only for the records they preserve of T'ang and Sung ideas. An excellent, if extreme, instance of the inherent weakness of Sung archæology is given by Laufer.[1] In describing certain objects of the Chou dynasty early writers had been in the habit of speaking of " grain pattern " and " rush pattern," assuming a knowledge in their readers which subsequent ages did not possess. In the Sung period the current ideas with regard to these patterns were expressed by the illustrator of the Sung edition of the *Li Chi* by ornamenting jade discs, in the one case with ears of wheat and in the other with a clump of rushes. Modern archæologists have identified the patterns in question on objects found in Chou burials, the grain pattern being symbolically rendered by a number of small raised discs, representing either grains of corn or heaps of grain, and the rush pattern by a kind of matting diaper, geometrically drawn. This instance serves to illustrate the salient differences between the Chou and Sung art, the two extremes ; the Chou art is symbolical and geometrical, the Sung impressionist and naturalistic. The Sung poets and painters [2] communed with Nature in the wilds and threw into their verse or on to their silks vivid impressions and ideal conceptions of the natural phenomena. The Chinese art of after years owes many of its noblest inspirations to Sung masters, but nowhere are these ideas developed with the same freshness and power as in the Sung originals.

The Sung dynasty was an age of achievement for the potter.

[1] *Jade,* op. cit., p. 17.
[2] See L. Binyon, *Painting in the Far East,* chap. ix.

The ceramic art now took rank beside that of the bronze worker and jade carver, and it received a great impetus from regular Imperial patronage. The Ting Chou and Ju Chou factories in the north worked under Imperial mandate. In the south the pottery centre in the Ch'ang-nan district received a new name from the *nien hao* of the Emperor Ching Tê (1004–1007), and developed into the world-famed Ching-tê Chên. In the succeeding century the Imperial factories at Hang Chou were celebrated for the Kuan yao or royal ware ; and numerous kilns were opened in the eighteen provinces, successfully following the lead of the Imperial potteries.

Subsequent ages have never ceased to venerate the Sung as the classic period of Chinese ceramic art, and in the eighteenth century the Emperor Yung Chêng sent down selected Sung specimens from the palace collection to be imitated by the Imperial potters at Ching-tê Chên. The same sentiment pervades Chinese ceramic literature. It harks back perpetually to the Sung wares as the ideal, collectors rave about them, and eulogy of the Ju, Kuan, Ko, Ting, and Lung-ch'üan wares has been almost an obsession with later Chinese writers.

Until recent years the European student has been almost entirely dependent for his knowledge of the subject on these literary appreciations or on relatively modern reproductions of the wares. Latterly, however, the interest aroused among Western collectors in the earlier wares and their consequently enhanced value have lured many authentic specimens from China, and our information on the Sung potteries has considerably expanded. But the difficulties of classification are still only in part surmounted. Many important problems remain unsolved, and for the understanding of several celebrated groups we are still at the mercy of Chinese textbooks and encyclopædias. Obscurity of phrase, ambiguity of colour words, quotations from early authorities passed on from writer to writer with diminishing accuracy, are among the many stumblingblocks which the student of these books must surmount at every turn. Many of the treatises occur in small encyclopædias and miscellanies on works of art, which are each merely a corpus of quotations from similar works of the past. Moreover, an accurate first-hand knowledge of the wares themselves does not seem to have been held essential for the Chinese compiler. It is true that the same might be said of many of our own art-manuals, and with less excuse, for the Chinese can at any rate plead the veneration

for the writers of the past in an ancestor-worshipping people, whereas our own shortcomings in this matter are due mainly to commercial reasons. But if the Chinese manuals are often misleading and obscure, they are at least brief—too brief, in many cases, and assuming a power to read between the lines which no European student can be expected to possess. The result is that where we have no actual specimens to help us, there is unlimited scope for conflicting theories on the meaning of the original text. However, as our collections grow and guiding specimens arrive, more of the Chinese descriptions are explained, and working back from the known to the unknown we are able to penetrate farther into the obscurities of the subject.

To take a single instance. The well-known celadon ware, with strongly built greyish white body, and beautiful smooth, translucent sea-green glaze, has been identified beyond all doubt with the Lung-ch'üan ware of Chinese books. When we read of the green porcelain (*ch'ing tz'ŭ*) bowls with fishes in relief inside or on the bottom, our thoughts at once turn with confidence to such specimens as Fig. 3, Plate 21, and we realise that for once we are certain of the meaning of the elusive colour word *ch'ing*. In the same way other phrases here and there can be run to earth ; and when we meet the same descriptive words in other contexts, the key to their meaning is already in our hands. In this way no little profit can even now be got from the study of Chinese works, and it tends to increase steadily, though, of course, one living example is more instructive than a host of descriptions.

The Sung wares are true children of the potter's craft, made as they are by the simplest processes, and in the main decorated only by genuine potter methods. The adventitious aid of the painter's brush was, it is true, invoked in a few cases, but even then the pigments used were almost entirely of an earthy nature, and it is very doubtful if painting in enamels had yet been thought of. Two years ago enamel-painting on Sung porcelain would have been denied in the most uncompromising terms. But the claims of certain specimens of the Tz'ŭ Chou type, with brick-red and leaf-green enamel on the glaze, to belong to the Sung period have been so persistently urged that they cannot be entirely ignored. At present I am unconvinced of their Sung origin ; but our knowledge of T'ang wares has developed with such surprising rapidity that we must be prepared for similar surprises in connection with the

Sung. Meanwhile it would be well to suspend judgment on this interesting point.

The bulk of the Sung wares, at any rate, and among these the best of them, were either wholly undecorated—that is, wholly dependent on form and glaze, or else ornamented by such methods as moulding, stamping, application of clay reliefs, carving, or etching with a fine point. All these processes were applied while the clay was still unfired, and the glaze was afterwards added and the ware finished once and for all in a single firing. It follows, then, that the glaze must be capable of standing the fierce heat required to bake the body, and as the Sung bodies are mostly of a high-fired porcellanous nature, the glazes used on them were limited to the refractory kinds composed largely of petuntse or porcelain stone. It follows also that any impurity, any particle of iron, for instance, in the clay would make its presence felt in the glaze and influence the colour of the latter, locally at any rate.

There is a striking contrast between the characteristic coloured glazes of the Sung and the T'ang periods. The latter are, as a rule, comparatively soft lead glazes, resembling in their colour, texture, and their minute crazing the latter glazes on Ming pottery. The former are thick and hard, and the crackle where it exists is positive and well defined.

Mr. W. Burton[1] makes some interesting comments on these high-fired glazes : " There are certain technical points of great interest to be drawn from a study of the Sung productions. In the first place, they prove that the Chinese, from a very early period, had learnt to fire their pottery at a much higher temperature than the contemporary potters of the West were using. . . . A third point of even greater interest, which seems to have escaped the notice of every previous writer, is that the method of firing used by the Chinese naturally produced glazes in which the oxide of iron and oxide of copper were present in the lowest state of oxidisation ; and this is the explanation of the seeming paradox that the green glazes, known to us as celadon, and the copper-red glazes, were amongst the earliest productions of the Chinese porcelain-makers, while in Europe they have been among the latest secrets to be acquired."

The most important feature of the Sung wares lies in their glaze, which holds *la qualité maîtresse de la céramique,* as an enthusiastic

[1] *Porcelain, A Sketch of its Nature, Art and Manufacture,* p. 56.

French writer has expressed it. Its richness, thickness, lustre, translucency, and its colour and crackle are the main criteria of the wares in the eyes of Chinese connoisseurs. *Tzŭ jun* (rich and unctuous), *hsi ni* (fine and glossy), *jung* (lustrous), *t'ung jung* (lustrous throughout or transparent) are among the phrases most constantly met in their appreciations. A word, too, is usually added on colour of the body material, which in many cases would appear to have been of a red or brown tint, iron-coloured or copper-coloured. Not that it is necessary to infer that in every instance the ware was red or brown throughout. It is a matter of observation that in many of the early wares the exposed places (usually confined to the edge of the foot rim or the unglazed base) have assumed a rusty red colour in the firing, while a flake broken from the glaze elsewhere reveals a white or greyish white porcelain body within. This will often explain the seeming inconsistency of the Chinese descriptions in which the word porcelain is applied to an apparently dark-coloured material. At the same time, it is well to remember that the Chinese words which we translate as porcelain were far more comprehensive than our own term.

Our speculations on the nature of the Ch'ai ware in a previous chapter brought us face to face with two main types of glaze, the thick opalescent glaze of pale lavender or turquoise tint, and the smooth translucent celadon glaze in which green is the dominant colour. These types are prominent on the Sung wares, and almost all the varieties of coloured Sung glazes—with such obvious exceptions as black and chocolate brown—have more or less affinity to these two. So that if we place the old turquoise [1] glaze at one end of the series and the green celadon at the other, the rest will find an intermediate place, with leanings, of course, towards one or other of the extremes. One of the puzzling features in the study of the Sung wares is the interrelation of the various makes, such as the Ju, Kuan, Ko, Lung-ch'üan, Tung ch'ing and Chün, which all appear to have had points of mutual resemblance, although the descriptions of individual specimens differ over a wide range. If, however, it can be assumed that the same fundamental principles of manufacture were observed in all these factories, and that the divergences in the wares arose from local conditions, such as variety of clays, different conditions of firing and slight

[1] This colour is quite distinct from the turquoise of the *demi-grand feu*, a more lightly fired colour familiar on the later porcelains.

Fig. 1

Fig. 2

Fig. 3

Plate 15.—Sung Wares.

Fig. 1.—Peach-shaped Water Vessel, dark-coloured biscuit, smooth greenish grey glaze. (?) Ju or Kuan ware. Length 5¼ inches. *Eumorfopoulos Collection.* Figs. 2 and 3.—Shallow Cup with flanged handle, and covered box, opalescent grey glaze. Kuan or Chün wares. Length of cup 7½ inches. Diameter of box 6 1/16 inches. *Rothenstein Collection.*

variations in the composition of the glaze, a formula is established which will cover most of our difficulties. I am assured by no less an authority on glazes than Mr. W. Burton [1] that this assumption is perfectly justifiable, and that one and the same glaze might emerge from the kiln as a celadon green, a grey green, dove grey, lavender grey, or lavender turquoise under slightly varying conditions of firing, and according to the presence or absence of an infinitesimal proportion of iron or copper oxide in the body or glaze. Even with their empirical methods the old Chinese potters must have soon discovered the conditions which favoured certain results, but in the meantime quite a number of apparently different wares would have emerged from the same factory, and yet, in spite of local peculiarities, a general relationship might be observed in productions of different districts. So that when one Chinese writer compares the Ju ware to the Ch'ai, another the Kuan to the Ju, another the Ko to the Kuan, and another the Lung-ch'üan to the Ko, it is not necessary to assume that these porcelains were all grass-green celadons because we happen to know that that colour was the prevailing tint of the Lung-ch'üan ware. The Ch'ai and the Lung-ch'üan may have been as far apart as lavender and celadon green, and the chain of relationship linked up by the Chinese writers still hold firm.

No one but an experienced potter can speak with confidence of the methods by which the varying colour effects in the Sung glazes were obtained, but it is quite certain that the Sung potters were not ignorant of the value of such colouring agents as the oxides of iron, copper, cobalt, and perhaps even of antimony. Green, blue, yellow, and brown glazes, which owed their tint to these minerals, had appeared some centuries before on the T'ang wares. But to what extent the men of Sung made deliberate use of these oxides is another question. It is certain, for instance, that the green celadon owed its colour to the presence of iron oxide, but whether that was a natural element in the clay of certain districts, or whether it was introduced in the glaze by the admixture of ferruginous clay, is not always clear. Again, those bursts of contrasting colour, usually red, which enrich the opalescent grey and lavender glazes, are most readily explained by the local presence

[1] Mr. Burton's practical experiments and the beautiful results obtained by following out his conceptions of Chinese methods are well known to all admirers of the Lancastrian pottery.

of copper or iron oxide in an appreciable quantity. No doubt these effects were at first accidental, but it is certain that observation and experiment eventually taught the potters to produce them systematically. Otherwise, how explain the appearance of these colours in symmetrical splashes ? The *flambé* glazes of the eighteenth century are known to have been produced by means of copper oxide, and it is not unreasonable to infer its presence in similar effects at an early date. But it is equally certain that many of the changing tints in the thick, uneven, bubbly glazes of the Sung and Yüan wares are due to opalescence alone. This has been proved to demonstration by Mr. Burton, who has produced from his kilns a porcelain glaze with passages of pale lavender, and even flushes of warm red, by using nothing but a thick, opalescent glaze entirely innocent of any colouring oxide.

Finally, a word of explanation is needed with regard to the frequent references to thinly potted specimens among the principal Sung wares. Almost all of the existing examples are of a thick and rather heavy type. Not that we would have them thinner, for much of their charm is due to the massive opulence of the thick opalescent glaze with its prismatic depths and changing hues. But the Chinese writers constantly refer to a thinner ware as well as the thick. Where are these thin and elegant pieces ? The suggestion that, being more fragile, they have by now all perished has been coldly received as an obvious and easy answer to a difficult question. But it is reasonable enough, after all, when one remembers that upwards of a thousand years have passed since their manufacture. The alternative that they existed only in the poetical imagination of later Chinese writers is far less probable, though doubtless account must be taken of the exaggerations indulged in by men who were describing the ideal wares of a classic period. " Thin as paper," for instance, must have been a poetic licence as applied to the Ch'ai ware. I shall not cite the illustrations in the Album of Hsiang Yüan-p'ien [1] as proof of the fineness and trim regularity of the best Sung specimens. Whatever the value of this manuscript may originally have been, no reliance can be placed on the illustrations as reproduced in *Porcelain of Different Dynasties*.[2] The original was unfortunately destroyed by

[1] A late sixteenth-century work, published with translations by Dr. S. W. Bushell, 1908, under the title of *Porcelain of Different Dynasties*.

[2] I have already had occasion to criticise the inconsistencies in the colouring, etc. of this work. See *Burlington Magazine*, April, 1909, p. 23.

fire in 1888, and what we have now is, at best, the reproduction of a copy, and probably that of a copy of a copy. It is quite possible that the thinner Sung wares are still represented in Chinese collections, rare though they must of necessity be. But I believe that even our own collections are capable of supplying proof that, making reasonable allowance for verbal exaggeration, the Sung potters did make wares which could fairly be described as thin. Many of the white Ting wares are thin enough to be translucent ; no one questions the correctness of the description as applied to them. It only wants one specimen to prove the case for the celadon glazes, and that may be seen in the beautiful bowl in Mr. Alexander's loan collection at the Victoria and Albert Museum (Plate 16). As for the Ju and Kuan ware, it is useless to consider their case until we are quite satisfied that we have established their identity ; and in the nature of things the opalescent glazes and those described as " thick as massed lard " by the Chinese can only have accompanied a relatively thin body. On the other hand, many of the Corean celadons are of unimpeachable thinness, and as they were contemporary with the Sung porcelains and were almost certainly copied from them, there seems no real ground to withhold belief entirely from the Chinese statements with regard to the thinness of certain coloured Sung wares.

CHAPTER V

JU, KUAN, AND KO WARES

Ju yao 汝窰

THOUGH no authenticated example of Ju ware is known in Europe, it is impossible to ignore a factory whose productions were unanimously acclaimed by Chinese writers as the cream of the Sung wares. Its place of origin, Ju Chou, in the province of Honan, lies in the very district which was celebrated in a previous reign for the Ch'ai pottery, and it is probable that the Ju factories continued the traditions of this mysterious ware. Nothing, however, is known of them until they received the Imperial command to supply a *ch'ing* (blue or green) porcelain to take the place of the white Ting Chou porcelain which had fallen into temporary disfavour on account of certain blemishes. This event, which took place towards the end of the Northern Sung period (960– 1127 A.D.), implies that whatever had been their past history, the Ju Chou factories were at this period pre-eminent for the beauty of their *ch'ing* porcelain. It would appear from the *Ch'ing po tsa chih*,[1] which was written in 1193, that the Ju Chou potters were set to work in the "forbidden precincts of the Palace," and that selected pieces only were offered for Imperial use, the rejected specimens being offered for sale. Even at the end of the twelfth century we are assured that it was very difficult to obtain examples of the ware.

From the various accounts on which we have to depend for our conception of the ware, it is clear that the body was of a dark colour.[2] The glaze was thick and of a colour variously described as "approaching the blue of the sky after rain" (i.e. like the Ch'ai

[1] Quoted in the *T'ao lu*, bk. ix., fol. 9 verso. We gather from this passage that Ju Chou potters were summoned to the Imperial precincts at K'ai-fêng Fu ; for Ju Chou itself is some distance from the capital.

[2] The *Liu ch'ing jih cha*—a Ming work quoted in the *T'ao shuo*—describes it as " in colour like Ko ware, but with a faint yellowish tinge " ; and the more modern *T'ao lu* (bk. vi., fol. 2) speaks of it as having " clay fine and lustrous like copper."

ware), pale blue or green,[1] and " egg white "[2] which seems to imply a white ware with a faint greenish tinge. The author of the *Ch'ing pi tsang*,[3] a work of considerable repute published in 1595, gives a first-hand description of the ware : " Ju yao I have seen. Its colour is ' egg white ' and its glaze is lustrous and thick like massed lard. In the glaze appear faint ' palm eye ' markings like crabs' claws.[4] Specimens with sesamum designs (lit. flowers), finely and minutely engraved on the bottom, are genuine. As compared with Kuan yao in material and make, it is more rich and unctuous (*tzŭ jun*)." Two mysterious peculiarities have been attributed to the Ju ware, viz. that powdered cornaline was mixed with the glaze, and that a row of nail heads was sometimes found under the base. The first has been taken as merely an imaginative explanation of the lustre of the glaze, but it is certain that some kind of pulverised quartz-like stone was used in the composition of later glazes, such as the " ruby red " (see vol. ii., p. 123). The second, which has been seriously interpreted to mean that actual metal nails were found protruding from the glaze (a physical impossibility, as the metal would inevitably have melted in the kiln), is probably due to a misunderstanding of a difficult Chinese phrase, *chêng ting*,[5] which may mean " engraved with a point " or " cut nails." The former seems to satisfy the requirements of the case, though it would be possible to render the sentence, " having sesamum flowers on the bottom and fine small nails," referring to the little projections often found on the bottom of dishes which have been supported in the kiln on pointed rests or " spurs."

In the list of porcelains made at the Imperial potteries about the year 1730[6] we read of imitations of Ju ware from specimens sent down from the Imperial collections. These imitations had in one case an uncracked glaze on a copper-coloured body, and in the other a glaze with crackle like fish roe ; and we may fairly

[1] 淡青 *tan ch'ing*, according to the *Ko ku yao lun*.
[2] 卵白 *luan pai*; according to the *Po wu yao lan*. Of three specimens figured in Hsiang's Album (op. cit., pp. 19, 22 and 34), two are described as *yü lan* (i.e. sky blue), and *fên ch'ing* (pale blue or green), and the third is undescribed.
[3] Pt. i., fols. 8 and 9.
[4] It is not clear what these markings were, whether spots in the glaze or a kind of crackle. The simile of " crabs' claws " is applied to crackle in other passages.
[5] 摰釘
[6] This interesting list, given in the *Chiang hsi t'ung chih*, bk. xciii., fol. ii., is summarised in vol. ii., ch. xii. It is also quoted in the *T'ao lu*, and translated by Bushell, *O. C. A.*, p. 369.

infer that the originals had the same peculiarities. A reputed specimen[1] of modern Ju glaze[2] has a pale greyish green tint, with just a suspicion of blue, and would answer fairly well to the description *tan ch'ing* or *fên ch'ing*.

But probably our safest clue to the appearance of Ju ware is to be found in the important passage already mentioned,[3] in which a Sung writer describes the Corean wares as in general appearance like the old *pi-sê* ware of Yüeh Chou and the *new* Ju Chou ware. The typical Corean wares of this time are not uncommon, and their glaze—a soft grey green or greenish grey, with a more or less obvious tinge of blue—would satisfy the Chinese phrases, *tan ch'ing* and *fên ch'ing*, and in the bluer specimens might, by a stretch of poetic phrase, even be likened to the sky after rain. The " egg white," however, must have been a somewhat paler tint if the expression can be taken in any literal sense.

From the foregoing considerations we may conclude that the Ju porcelain was a beautiful ware of celadon type, varying in tint from a very pale green to a bluish green.

Though it is nowhere definitely stated how long the Ju Chou factories retained their supremacy, it is tolerably clear from Hsü Ching's reference in 1125, or very soon after, to the " modern porcelain of Ju Chou," that they came into prominence towards the end of the Northern Sung period, perhaps in the last half of the eleventh century ; and as we have no further information about them, we may perhaps infer that they sank into obscurity when the Sung emperors were driven from the North of China by the invading Tartars in 1127. In any case, the Ju ware seems to have become as extinct as the Ch'ai by the end of the Ming dynasty. Hsiang Yüan-p'ien, late in the sixteenth century, states that " Ju yao vessels are disappearing. The very few which exist are almost all dishes, cups, and the like, and many of these are damaged and imperfect."[4] A few years later another writer[5] declares that the Ch'ai and Ju porcelains had ceased to exist.

[1] See Bushell, *O. C. A.*, plate 77.

[2] In a passage referring to modern imitations, the *T'ao lu* (bk. vii., fol. 10) states that " at Ching-tê Chên, the makers of the large vases known as *kuan ku* (imperial antiques) for the most part imitate the colour of Ju yao glaze. Beautiful specimens of these (imitations) are commonly called ' blue of the sky after rain.' "

[3] P. 39. Account of a mission to Corea in 1125 by Hsü Ching.

[4] Hsiang's Album, op. cit., Fig. 19.

[5] Son of the author of the *Ch'ing pi tsang*. His father (see p. 53) declared that he had seen Ju porcelain.

It is not to be supposed that Ju Chou had the monopoly of the particular kind of *ch'ing* ware in which its factories excelled. A number of other and not distant potteries were engaged in a similar manufacture, though with less conspicuous success. We read,[1] for instance, that " it was made in the districts of T'ang, Têng, and Yao on the north of the (Yellow) River, though the productions of Ju Chou were the best."

It has been already remarked that we possess no authenticated example of Ju porcelain. Doubtless there are many pieces which are tentatively assigned to Ju Chou by hopeful owners. But it must be confessed that the few which have hitherto been published as such are singularly unfortunate choices. Dr. B. Laufer, for instance, in his excellent work on jade,[2] incidentally figures two vases for divining rods of a well-known form, of which he hazards the remark " that both have presumably been made in the kilns of Ju-chou."

Dr. Laufer does not claim to have made a particular study of Chinese ceramics apart from the Han pottery, but if these pieces are Ju yao, then Ju yao, so far from having been extinct for some centuries, is a comparatively common ware. Another instance is the " funeral vase," now in the Victoria and Albert Museum, published[3] by its former owner, Dr. Bushell, as a specimen of Ju ware, mainly, I suppose, on the strength of the description, " Kuan Yin vase of Ju Yao," engraved on the stand by the Chinese collector [4] through whose hands it had previously passed. This form of certificate is always open to doubt, and had it really been a specimen of undoubted Ju yao, it is most improbable that the Chinese would have allowed it at that time to pass into foreign hands.

But a glance at the piece itself is sufficient to dispel all illusions on that point. So far from excelling other Sung wares, this piece is decidedly inferior in every detail to the most ordinary Sung specimens. It has a coarse, sandy, greyish buff body and impure greyish green tinge, such as appears on some of the early funeral wares which make no pretence to finished workmanship. The ornament consists of applied reliefs perfunctorily moulded, and

[1] In the *Cho kêng lu*, published in 1368, but of special interest because it repeats the statements of a Sung writer, Yeh-chih, author of the *Yüan chai pi hêng*.
[2] Op. cit., plate 20.
[3] Cosmo Monkhouse, *Chinese Porcelain*, plate 1, and Bushell, *Chinese Art*, vol. ii., fig. 7.
[4] Liu Yen-t'ing.

though its archæological interest is considerable, and, like almost all Chinese wares, it possesses a certain charm, any attempt to place it on a high artistic plane can only end in a *reductio ad absurdum*.

Many other examples of this ware have since arrived in Europe, and they all belong to the same type. Some, however, appear to be later than the others, having reliefs of white porcelain instead of the usual pottery. They are always described as " funeral vases " by the Chinese, and it is exceedingly probable that the description is correct. The subjects of the reliefs are always of a hieratic kind, including such figures as the dragon of the East, the tiger of the West, the tortoise of the North, and the red bird of the South, the sun disc, and a ring of indistinguishable figures, perhaps Buddhist deities. There is no reason why such a type of sepulchral vase may not have been in use for many centuries, and if the porcelain reliefs in one specimen suggest a date no earlier than the Ming dynasty, the glaze in another has strong analogies to some of the rougher T'ang wares. The majority of these vases are of coarse, rough make ; others are superior in finish and of comparatively attractive form. A good example, belonging to Mr. R. H. Benson, is shown on Plate 14. It is of dense grey stoneware, with opaque greenish grey glaze, with a balustrade supported by four figures on the shoulder, and a dragon and a figure on a tiger (perhaps representing the mythical Fêng Kan), besides some small figures with indistinct attributes on the neck. The height is 20 inches.

It is, of course, possible that some of these represent the coarser makes of the T'ang, Têng, and Yao districts (see p. 55), and that the attribution of the Bushell vase by Liu Yen-t'ing may refer to a lower quality of Ju yao which included these wares, or may be even the wares made at Ju Chou before or after its period of Imperial patronage.[1]

My own conception of the Ju yao is most nearly realised by the lovely but sadly damaged bowl in the Alexander Collection lately in the Loan Court at the Victoria and Albert Museum. Its peculiar form is difficult to reproduce by photographic means, but

[1] It would seem as if the manufacture had never entirely ceased at Ju Chou, for we read in Richard's Geography, p. 61, " The environs (of Ju Chou) were formerly very industrial, but have lost their activity. The manufacture of common pottery is still carried on and gives it some importance."

Fig. 1 of Plate 16 gives a fair idea of it. The colour is precisely that of the most beautiful bluish green Corean bowls, but the usual Corean finish and the sand marks on the base are absent, and the glaze is broken by a large, irregular crackle. Surely this cannot be far removed from the " secret colour" of the Yüeh ware and the *fên ch'ing* of the Ju ?

Another specimen of reputed Ju ware is an exquisite peach-shaped brush-washer or cup in the Eumorfopoulos Collection (Plate 15, Fig. 1). It has a dark-coloured body and a beautiful smooth glaze of pale greenish grey tint, and whatever its origin, it is certainly a refined and beautiful example of the potter's art.

Kuan yao 官窯

This ware is only second in importance to the Ju yao, and its exact nature is scarcely less speculative. The name, which means " official " or " Imperial " ware, seems to have been first applied to the porcelains made for Imperial use at the Northern Sung capital, the modern K'ai-fêng Fu, in Honan. The factory was established at the command of the Emperor Hui Tsung in the Chêng Ho period (1111–1117), according to the earliest [1] or in the preceding Ta Kuan period (1107–1110), according to a later [2] account. Its career, however, was interrupted by the flight of the Sung Court south of the Yangtze in 1127, though it is probable that a number of the potters followed the Court. At any rate, the traditions of the original factory were continued at the new capital, Hang Chou, by an official named Shao Ch'êng-shang, who set up kilns in the Imperial precincts, in the department called *Hsiu nei ssŭ*. Another writer locates this factory under the Phœnix Hill. Shortly after-wards a new pottery was started " below the suburban altar " at Hang Chou, which copied the forms of the older Kuan ware, but without equalling its quality. We have then no fewer than three different makes all included in the name of Kuan yao, all following one tradition but differing, as we shall see, in material and quality.

The first is the K'ai-fêng Fu variety. The earlier writers in

[1] The *Cho kêng lu*, published in 1368, but based on a thirteenth-century Sung work (see p. 55).

[2] The *T'ao lu* (bk. vi., fol. 2 verso). It is obvious that the term Kuan yao (Imperial ware) is liable to cause confusion, as it might be—and indeed was—equally applied to any ware made at any time at the Imperial factory. In recognition of this fact the Sung Kuan yao was sometimes named in later writers *Ta Kuan* 大觀 ware, after the Ta Kuan period.

the *Cho kêng lu* and *Ko ku yao lun* make no attempt to differentiate [1]
this porcelain from the later Kuan yao, but we find in a sixteenth-
century collection of miscellanies, the *Liu ch'ing jih cha,* the follow-
ing scrap of information : that " specimens (of the K'ai-fêng ware)
with streaky colour, white on the upper part and thin as paper,
were inferior to Ju ware " ; and the more modern *T'ao lu* informs
us that the K'ai-fêng Kuan ware was made of fine unctuous
material with thin body, the colour of the glaze being *ch'ing* (blue
or green) with a tinge of pale red (*fên hung*) and of varying depth
of tone. It is further stated that in the Ta Kuan period moon
white or *clair de lune* (*yüeh pai*), pale green or blue (*fên ch'ing*)
and deep green (*ta lü*) glazes were esteemed, whereas in the Chêng
Ho period only the *ch'ing* colour in varying depth of tone was
used. Moreover, the glaze had " crab's claw crackle," and the
vessels had a " red-brown mouth and iron foot." The latter phrase
(explained below) is not consistent with the account in the *Liu
ch'ing jih cha,* " white on the upper part," which certainly implies
a light-coloured clay, but I confess that I have little confidence
in the subtle distinctions of the *T'ao lu* in this passage. They are
mere assertions, without any reasons given, and it is not difficult
to find a source from which they may in part, at least, have been
derived, and which in itself guarantees no such differentiation.[2]
It is likely enough that the K'ai-fêng ware differed in body from
the red ware of Hang Chou, but it is not likely to have differed
very greatly in other respects, seeing that the southern variety
continued the traditions of the northern, and that the earliest
authorities do not trouble to distinguish the two wares at all.

Another critic,[3] discussing Kuan ware as a whole, makes its
characteristics practically the same as those of the Ko ware, to
which we shall come next, and states that " in regard to colour
in both cases the pale ch'ing (*fên ch'ing*) specimens are the best,

[1] A passage quoted in *T'ao lu,* bk. ix., fol. 13, from an eighteenth-century work,
the *Wên fang ssǔ k'ao,* forms a commentary on this attitude. " The old capital Kuan
factory," it says, " had only a brief existence, so that we must consider the *Hsiu nei
ssǔ* make to be first and the ' recent wares ' to be second."

[2] The list of wares made at the Imperial factories at Ching-tê Chên about 1730,
and published in the *Chiang hsi t'ung chih* (vol. xciii., fol. 11), refers to the imitation
of Kuan wares as follows : " Ta Kuan glazes on an iron-coloured body. These are
three kinds—yüeh pai, fên ch'ing, ta lü—all imitating the colour and lustre of Sung
ware sent to (or from) the palace (*nei fa sung ch'i*)." There is no reason to suppose
that *Ta Kuan* here is more than a mere synonym for *Kuan* (ware).

[3] Chang Ying-wên in the *Ch'ing pi tsang,* published in 1595.

the ' pale white ' (*tan pai* [1]) are second, while those with ash-coloured (*hui sê*) glaze are very inferior." From the same writer we gather that artificial staining of the crackle was employed on both Kuan and Ko wares, for he speaks of " ice-crackle with lines red as eel's blood " and " plum-blossom [2] crackle with ink-coloured lines," besides an inferior type of crackle with fine lines which did not suggest any particular pattern.

The Hang Chou Kuan ware, variously described as *Kuan yao*, *Hsiu nei ssŭ yao*, *Nei yao*, and *Shao yao* from the locality of the factory and the name of its manager, is described in both the *Cho kêng lu* and the *Ko ku yao lun*. In the former it was said to be a *ch'ing* ware, " finely levigated clay [3] is the rule, and it is of very exquisite make ; the coloured glaze is translucent [4]; it is the delight of the age." [5] The latter, [6] which makes no mention of an earlier Kuan ware, gives the following description of the *Nei yao:* " The material is fine and unctuous, the colour *ch'ing* with a flush of pale red (*tai fên hung*) and of varying intensity. Specimens with crab's-claw crackle, brown mouth, and iron foot, and of good colour rank with Ju yao. There are, besides, specimens with a black body which are called *wu ni yao*. All the imitations which are made at Lung-ch'üan are without crackle."

Further information is given in the *Po wu yao lan*, viz. that the clay used at the factory below the Phœnix Hill at Hang Chou for making Kuan yao was of reddish brown (*tzŭ*) colour, and that this explains the phenomenon of the " brown mouth and iron foot " [7]; for " the brown mouth is due to the fact that the vessel's mouth

[1] 淡白 a phrase which is not very lucid. In fact, I suspect a confusion with another *tan* 蛋, which means " egg," and would give the sense " egg white," like the *luan pai* of the Ju yao.

[2] On the subject of crackle, see vol. ii., p. 197. The idea of a crackle assuming the form of round four- or five-petalled flowers like plum blossoms was carried out by the Ch'ien Lung potters on some of the medallion bowls (see vol. ii., p. 244), with a ground of bluish green enamel on which a network of lines and plum blossoms was traced in black.

[3] 澄泥 *Ch'êng ni*, lit. " pure, limpid, or clear clay," an expression which is explained in the *T'ao shuo* (bk. i., fol. 4 verso) as " refined earth," the word *ch'êng* (or *têng*) being equivalent to 淘 *t'ao*, which means to wash.

[4] 瑩徹 *jung ch'ê*, lit. " brilliant penetrate, or brilliant right through."

[5] The age is here probably the Sung period, for we must bear in mind that the author of the *Cho kêng lu* is practically quoting verbatim from the Sung writer Yeh-chih.

[6] *Ko ku yao lun*, bk. vii., fol. 22.

[7] It may also explain the ruddy tinge of the green glaze, which, being transparent, would allow the reddish brown body colour to show through in the thinner parts.

points upwards and the glaze flows downwards and is thinner at the mouth than on the rest of the body, so that the brown colour (of the clay) is disclosed at the mouth." The iron foot is, of course, the raw edge of the clay which appears at the foot rim. As this peculiarity is not noted in the *Cho kêng lu*, we are at liberty to infer that it was not a constant feature of the Kuan wares, and that some of them, as already hinted in the quotation from the *Liu ch'ing jih cha*, had a whitish body.

Of the third Kuan yao made " below the suburban altar " at a slightly later date, we know nothing except that it followed the style of the older wares, but with inferior results.

Though we do not pretend to attach much weight to the illustrations in Hsiang's Album, the descriptions in the accompanying text cannot be ignored. They include ten specimens of Kuan yao,[1] five of which are explained as *fên ch'ing* (pale blue or green). Of the rest one is " pale *ch'ing* clear and lustrous like a sapphire blue jewel," [2] evidently with a decidedly blue tinge ; another is " kingfisher, blue as the clear blue sky," [3] recalling the Ch'ai "blue of the sky after rain " ; another is " sky blue " (*t'ien ch'ing*) ; another " onion green " (*ch'ing ts'ung*), the colour of onion sprouts ; and another is " egg green " (*luan ch'ing*), which recalls and perhaps explains the *luan pai* (egg white) of the Ju yao.

Among the various Sung and Yüan wares with more or less opalescent glazes which have reached Europe in recent years, it is possible to differentiate a considerable group whose characteristics seem to point to the Kuan yao. Their body is usually of fine grain, whitish colour and porcellanous texture, but assuming a rusty brownish tint in the exposed parts. It is, in fact, very much finer than the Yüan wares, usually so called, and all but the choicest wares of Chün type (see ch. ix.). The glaze, too, though generally opalescent, shows marked differences from that of the Chün and Yüan pieces. It is smooth and even instead of being lumpy and

[1] An early sixteenth-century work, the *Tu kung t'an tsuan* (quoted in the *T'ao lu*, bk. ix., fol. 8 verso) tells of a Chinese sybarite Li Fêng-ming, who held a " lotus flower banquet. There were crystal tables twelve in number, and on them a series of vessels, all of Kuan porcelain, a display of elegance rarely seen at any time."

[2] *Ya ku ch'ing pao shih. Ya ku* is explained by Bretschneider (*Mediæval Researches*, vol. i., p. 174) as equivalent to the Arabic *yakut*, and meaning a corundum, of which the Chinese recognise various tints, including deep blue, pale blue, muddy blue, besides yellow and white.

[3] *Ch'ing ts'ui jo yü lan t'ien.*

irregular, and it ends close up to the foot rim in a comparatively regular line instead of ending short of the base in a thick roll or in heavy drops. And the base instead of being quite bare or covered with a brown glaze, has a patch of the surface glaze underneath. The colours of this glaze show wide variations from a deep brownish green, which suggest the *ta lü*, to pale dove grey (*fên ch'ing*) and pale lavender blue tints, which approximate to the Chinese *t'ien ch'ing* or sky blue, though perhaps not so closely as does the so-called "old turquoise." Some of these glazes, especially the pale lavender and dove greys, are broken by passages of red or crimson, which in turn shade off into green and brown tints. Although the expression *tai fên hung* in the *Ko ku yao lun* [1] has already been rendered in its most natural sense, "with a tinge of red," we should perhaps mention a possible alternative which might make it refer to these very passages of red colour; and the fact that they sometimes assume fantastic shapes will explain why the Chinese saw in them "butterflies, birds, fish, unicorns, and leopards." [2] On the other hand, it is clear that these passages of red are not always accidental, for they sometimes take symmetrical forms, and it is quite possible that even the bird and fish forms may have been roughly designed in the colouring medium.

Plate 17 will serve to illustrate this group of possible Kuan wares. Another example is a dish in the British Museum which has a whitish porcellanous body and a slightly crackled pale lavender grey glaze of singular beauty. Other specimens in the same collection include a small tea bowl with misty grey glaze of the *fên ch'ing* type, smooth and uncracked, and a body which appears deep reddish brown at the foot; and a small bottle-shaped vase, with lobed body of melon shape, which, though of doubtful antiquity, answers closely to the Chinese descriptions. It has a dark-coloured but well levigated body, deep brown at the foot, and showing a brown tinge where the glaze has run thin at the lip, and the colour

[1] *Sê ch'ing tai fên hung.* A more literal rendering of this phrase is " the colour of the glaze is *ch'ing*, with a tinge of red," which would refer to the reddish tone of a pale lavender glaze. On the other hand, the word *tai* is apparently used to describe the contrasting colours in parti-coloured jade and agate, e.g. *huang sê tai t'u pan* in Laufer (*Jade*, p. 140) to describe " yellow jade with earthy spots," and again (op. cit., p. 142), *ch'ing yü tai hei sê*, " green jade with passages of black colour."

[2] *Po wu yao lan* (quoted in the *T'ao shuo*, vol. iii., fol. 13 verso). These accidental effects are mentioned on both the Kuan and Ko wares, and are said to be either of a yellowish or a brownish red tint.

is a pale bluish grey with rosy tinges where the body colour is able to penetrate the semi-translucent glaze. Another doubtful specimen, with very similar characteristics, was figured by me in the *Burlington Magazine* some years ago.[1]

Since the genuine Sung specimens were sent to the Imperial factories to be closely copied (about 1730), it might be supposed that the relatively modern imitations would supply some clue to the original types. There are one or two examples of eighteenth-century copies of Kuan ware in the British Museum on which the glaze is definitely lavender blue in tint, with a crackle which in one case is wide and emphasised by blackened lines, and in the other of a finer mesh.[2] The natural tendency, however, of modern imitative wares is to exaggerate some characteristic which this or that potter might imagine to be specially important, and as it is impossible to say in many cases exactly when the piece in question was made, we cannot be sure how far the potters in each case may have strayed from the original type.[3] No doubt in time these imitations would become a mere convention. It should be said in passing that the modern copies have a white porcelain body, and to obtain the appearance of " brown mouth and iron foot " the potters had recourse to the expedient of colouring the parts concerned with brown ferruginous clay.

The *Cho kêng lu*[4] refers to three minor wares which were regarded as inferior to Kuan ware, and later writers have assumed that they belonged to the same category. These are the Hsü wares, Yü-hang wares, and *wu-ni* wares. The first [5] is so little known that its identity has been lost in variant readings, such as Hsün 薰 in later writers, which is very near in appearance to *tung* 董, a common form used for the Tung ware (see p. 82); and we can safely leave it until some clearer information is forthcoming. The second, according

[1] " Wares of the Sung and Yüan Dynasties," *Burlington Magazine*, May, 1909 Plate i., fig. 4.

[2] See *Burlington Magazine*, May, 1909, Plate i., fig. 28 ; Plate ii., fig. 6.

[3] Speaking of the imitations of Kuan yao early in the nineteenth century, the *T'ao lu* (bk. ii., fol. 10) remarks : " Originally there were special departments for imitating Kuan yao. Now, only the imitators of the crackled wares make it. As for the imitations made at the (Imperial) factory, they are more beautiful," sc. than those made in the private factories.

[4] Bk. xxix., fol. 11.

[5] The word *Hsü* 續 has the meaning " continuation," and if it be not a place-name at present unidentified, it might conceivably be " the continuation or later Kuan ware."

Fig. 1

Fig. 2

Plate 18.—Sung dynasty.

Fig. 1.—Bowl with engraved peony design under a brownish green celadon glaze. Northern Chinese. Diameter 7¾ inches. *Eumorfopoulos Collection.*
Fig. 2.—Vase moulded in form of a lotus flower, dark grey stoneware, burnt reddish brown, milky grey glaze, closely crackled. Height 7 inches.
Freer Collection.

to the *T'ao lu*,[1] was a Sung ware made at Yü-hang Hsien, in the prefecture of Hang Chou. " Its colour was like Kuan porcelain without its crackle, its lustre (*jung*), and its unctuous richness (*jun*)." The *wu-ni* ware is dark-bodied earthenware, which is discussed on p. 133.

Ko yao 哥窯

Ko yao (the elder brother's ware), or *Ko ko yao*, as it is some-times called with the first character repeated, is unanimously ranked by Chinese writers with the Ju and Kuan wares. Accord-ing to the traditional accounts, it was first made by the elder of the two brothers Chang 章, who were potters of Lung-ch'üan Hsien in the Ch'u-chou Fu, province of Chekiang, each having a separate factory in the Liu-t'ien district. Most of the Chinese authorities are content to give the date of these brothers as some time in the Sung dynasty, but one account[2] narrows the period down to the Southern Sung (1127–1279 A.D.). Professor Hirth takes the rationalistic view that the story of the brothers is a myth embodying the fact that there were two distinct types of ware made in the Lung-ch'üan district. Be this as it may, the Ko yao is of considerable interest to us as forming a link between the obscure Ju and Kuan wares and the well-known Lung-ch'üan celadon, approaching the latter in its grass green and sea green varieties and the former in its most highly prized specimens of bluish green or grey tones.

Of its close resemblance to the Kuan ware there can be no doubt, for two highly reputable Chinese writers[3] describe the two wares simultaneously and under one heading, enumerating their various colours in order of merit as *fên ch'ing*, *tan pai*, and *hui sê* (see p. 60), besides mentioning the several kinds of crackle which appeared in the glaze. The only distinctions which the author of the *Ch'ing pi ts'ang* draws between the two wares are that (1) the Kuan yao crackle is of the " crab's claw "[4] type, while that of the Ko is like fish-roe,[5] and (2) the Ko glaze is somewhat less beautiful than

[1] Bk. vii., fol. 6 verso.
[2] The *Ch'i hsiu lei k'ao*, quoted by Hirth, *Ancient Chinese Porcelain*, p. 37.
[3] The authors of the *Po wu yao lan* and the *Ch'ing pi ts'ang*.
[4] 蟹爪紋 *hsieh chao wên*, a debatable phrase, which seems best explained as a large irregular crackle resembling the tangle of claws seen on the top of a basket of crabs.
[5] 魚子 *Yü tzŭ*. A crackle of finer mesh, which French writers describe as *truité*, or resembling the scales of a trout.

the Kuan. With regard to the crackle, other writers assert that short cracks are characteristic of the Ko yao, and one author uses the picturesque phrase, " crackle of a hundred dangers." [1] Accidental splashes of contrasting colour, which sometimes assumed fantastic forms, were common to the Ko and Kuan wares, as mentioned on p. 65, and the author of the *Po wu yao lan* explains these as " originating in the colour of the glaze and forming on its outer surface," and as " due to the fire's magic transmutation." Another account of the ware given in the *Ko ku yao lun* depicts it as of deep or pale *ch'ing* colour, with brown mouth and iron foot, and adds that when the colour was good it was classed with Tung [2] ware. The same passage further informs us that a great quantity of the ware " recently made at the end of the Yüan dynasty " was coarse and dry in body and inferior in colour, a statement to which we shall return presently.

Other descriptive references to Ko yao include a verse on a Ko ink palette belonging to Ku Liu, [3] which was " green (*lü*) as the waves in spring " ; the eighteenth-century list of Imperial wares [4] which mention " Ko glazes on an iron body," of two kinds, viz. millet-coloured and pale green [5] (or blue), both stated to have been

[1] 百及碎 *pai chi sui*, used by the author of the *P'ai shih lei p'ien*; see other references in the *T'ao shuo* and the *T'ao lu*.

[2] See p. 82.

[3] Quoted in the *T'ao shuo* (bk. v., fol. 9 verso).

[4] See vol. ii., p. 223.

[5] 米色 粉青 *mi sê fên ch'ing*. *Mi sê* is rendered in Giles's Dictionary, " Straw colour, the colour of yellow millet," and all Chinese authorities whom I have questioned agree that it is a yellow colour. Bushell in much of his published work rendered it "rice coloured," following Julien's *couleur du riz*, and others, including myself, have been misled by this rendering. Bushell, however, in a note in Monkhouse's *Chinese Porcelain*, p. 67, which is quoted at length in vol. ii., p. 220, pronounces in favour of the rendering yellow. The difficulty of finding a true yellow among the Sung wares to support the comparison with yellow millet has further complicated the question. The vase in the Victoria and Albert Museum, which is figured in Monkhouse (fig. 22) as a specimen of old *mi sê*, is probably a Yung Chêng reproduction of the Sung type. It has a stone-coloured crackle glaze, overlaid with a brownish yellow enamel, a technique which is foreign to the Sung wares. Possibly one type of Sung *mi sê* was illustrated by the " shallow bowl with spout, of grey stoneware with opaque glaze of pale sulphur yellow," which Mr. Alexander exhibited at the Burlington Fine Arts Club in 1910 (Cat. K. 18). Another kind is described by Bushell in the catalogue of the Morgan collection (p. 38) as follows : " Shallow bowl (*wan*). Greenish yellow crackled glaze of the Sung dynasty, leaving a bare ring at the bottom within. A specimen of ancient *mi sê* or millet-coloured crackle from the Kiang-hsi potteries. Formerly the possession of His Excellency Chang Yinhuan. D. 6 inches." Specimens of this type, with greenish and brownish yellow crackle glaze, have been found in Borneo, where they

copied from ancient specimens sent down from the palace; and a single specimen in Hsiang's Album, which is given as *fên ch'ing*. In these various descriptions it is possible to recognise a celadon green ware, green as the waves of spring, while the familiar stone grey and buff crackled wares, which range from greyish white to pale grey green and greenish yellow, seem to be indicated in the expressions *mi sê, fên ch'ing, tan pai*, and *hui sê*. The modern versions of the latter class, which are fairly common, are usually known even to-day as *Ko yao*, the expression in potter's language being practically synonymous with "crackled wares."[1] Other ancient factories where similar wares were made are Hsiang-hu and Chi Chou.[2]

As for the finer Ko wares, which appear to have been indistinguishable from the Kuan, we may look for them in the group described on p. 65, and in such beautiful pieces as that illustrated on Plate 19, a vase of fine oval form with delicate grey glaze of faint bluish tone boldly crackled. The solid quality of the glaze of this last specimen and the texture of the surface, which is smooth but lustrous, suggest some natural substance such as the shell of an egg or a smooth polished stone rather than an artificial material. The colour perhaps more truly answers the description "egg white" (*luan pai*) than any other Sung glaze which I have seen. Plate 20 illustrates another choice example but with a yellower tone of glaze ; and a large square vase in the Freer Collection[3] with thick, misty

have been reputed to be of enormous age ; there are several examples in the British Museum. The Hirth collection in the Gotha Museum includes four high-footed bowls of brownish yellow colour which seem to belong to this class.

[1] As explained in the *T'ao lu* (bk. ii., fol. 10 verso): "At Ching-tê Chên there is no special factory devoted to the imitation of Ko yao, but the manufacturers of crackled wares make it in addition to their own special line, and that is why they have the general name of Ko yao houses (*Ko yao hu*). Formerly, the manufacturers were acquainted with the origin of the word, but nowadays those who imitate Ko yao only copy a fixed model without knowing why it is called Ko yao."

[2] The Hsiang-hu wares were imitated at Ching-tê Chên in the Imperial factory about 1730. T'ang Ying himself gives the following note on them in the *T'ao Ch'êng shih yü kao*, written about this time : "Twenty *li* south-west of Ching-tê Chên is a waste place called Hsiang-hu 湘湖, where there were formerly the foundations of Sung kilns. It used to be easy to find porcelain (*tz'ŭ*) fragments of old vessels and waste pieces. The material was very thin, and the ware was evidently millet-coloured (*mi sê*) and pale green (*fên ch'ing*)." The memoir of Chiang (1322) states that " the ware was beautiful and lustrous, but not greatly prized at that time." See *T'ao lu*, bk. viii., fol. 12, and bk. v., fol. 2. For Chi Chou ware, see p. 98.

[3] See *Chinese, Corean, and Japanese Potteries*, New York, Japan Society, 1914 No. 307.

grey glaze showing a faint tinge of red, which recall the *sê ch'ing tai fên hung* of the Kuan ware, was shown in the New York exhibition of 1914. All these three specimens have a dark reddish brown body of fine close grain, and their glaze is very thick and unctuous with a tendency to contract into thick wax-like drops under the base.

From certain passages in the Chinese works it appears that a revival of the Ko yao took place in the Yüan dynasty, if indeed the manufacture had not been continuous. The *Ko ku yao lun*, for instance, under the heading of Ko yao, states that the " ware recently made at the end of the Yüan dynasty was coarse and dry in body and inferior in colour." In the *Po wu yao lan* [1] we read that " certain Ko wares made in private factories took their clay from the Phœnix Hill " (at Hang Chou, where the Kuan potteries were located), and the *T'ao lu* [2] definitely states that clay was brought from Hang Chou for this later Ko ware. Add to these the remark in the *Ko ku yao lun* on the subject of Kuan ware [3]—" all the imitations which are made at Lung-ch'üan are without crackle "—and it is clear that the Lung-ch'üan potters in the fourteenth century were busy copying both the Kuan and Ko wares, and that to obtain a closer resemblance to the former they actually sent to Hang Chou for the red clay which would produce the " brown mouth and iron foot." The alleged absence of crackle would indicate a departure from the original Ko methods, but we are at liberty to doubt the universal application of such sweeping statements, and I ventured to suggest [4] that a remarkable bowl in the British Museum was a Yüan example of Ko ware, because, in spite of its Ko crackle, it corresponds so closely to the other points in the descriptions of this make. In any case, there is little doubt that it belongs to an early period of manufacture.

The following extract from a work entitled *Pi chuang so yü*, [5] which would be still more interesting if we knew its date, serves to illustrate some of the difficulties the Chinese collector had to face in the past : " Ancient examples of Ko yao of the Sung period have survived, though for a long time past genuine and counter-

[1] Bk. ii., fol. 4.

[2] Bk. vi., fol. 5 verso.

[3] See above, p. 61.

[4] See *Burlington Magazine*, May, 1909, "Wares of the Sung and Yüan Dynasties," Plate iii., fig. 11.

[5] Quoted in the *T'ao lu*, bk. ix., fol. 9.

feit have been confused together. Among men there are very many who seek for the genuine Sung, but refined and beautiful specimens are exceedingly few. . . . Ts'ao Chiung, a man of high birth, secured an incense burner, in height about two inches and in width proportionate. The cover was beautiful jade carved with a pattern of sea waves of *Tung ch'ing* [1] colour, with a handle in form of a crane, a genuine piece, and exceedingly beautiful. It came to the ears of the eunuch Mai, governor of the district, and he put Chiung in prison and subjected him to the inquisition. His son had no choice but to offer the vessel as a gift. Later the powerful hand of the superintendent of the Board of Rites seized it. In the Chêng Tê period (1522–66) it was stolen, and, coming to the district below Wu, it became the property of Chang Hsin-fu of Tien-shan, Shanghai, who sold it for 200 ounces of gold. After that it came again into the hands of a connoisseur, and the Imperial authorities in the end did not succeed in recovering it. This was a genuine antique Ko vessel."

[1] Celadon green ; see p. 82.

CHAPTER VI

LUNG-CH'ÜAN YAO 龍泉窰

IN discussing the celebrated Lung-ch'üan celadons, we are able to build our structure on a more solid basis. For one group of them, at any rate, is so familiar that we should be tempted to abandon the difficult Chinese descriptions and construct an essay on the ware from actually existing specimens, were it not that in so doing we should miss our chief opportunity of applying a living test to the Chinese phrases.

The district of Lung-ch'üan in the prefecture of Ch'u-chou, province of Chekiang, was noted for its potteries as early[1] as the beginning of the Sung dynasty, but its greatest celebrity was attained by the market town of Liu-t'ien, where the Chang brothers are reputed to have worked.[2] The story that the elder Chang moved to Liu-t'ien while the younger brother remained at Lung-ch'üan is, I believe, based on a misreading of a Chinese passage,[3] the true meaning of which seems to be that while the elder brother made new departures which earned for his ware the distinctive name of Ko yao, the younger continued the Lung-ch'üan traditions, and consequently his ware was known as Lung-ch'üan yao. It appears that one vital difference between the two wares was crackle, which was used by the elder and not by the younger brother.

The productions of the Lung-ch'üan district are variously named in the *Ko ku yao lun*, " *Ch'u* ware " (from Ch'u-chou Fu, the name of the prefecture), " *ch'ing* ware," and " old *ch'ing* ware,"

[1] See *T'ao lu*, bk. vi., fol. 4. A factory of inferior reputation is supposed to have existed at the neighbouring village of Chin-ts'un (see Hirth, *Ancient Chinese Porcelain*, p. 38). And the *T'ao lu* (bk. vii., fol. 6) describes a factory at Li-shui Hsien in the Ch'u-chou district, whose productions were also known as Ch'u ware.

[2] In the *T'u shu*, bk. ccxlviii., section *Tz'ŭ ch'i pu hui k'ao*, fol. 13, we are told that the brothers Chang worked beneath the Han liu hill at Lung-ch'üan in the Sung and Yüan dynasties.

[3] *T'ao shuo*, bk. ii., fol. 12 recto.

and the various Chinese accounts agree in distinguishing two broad classes, the one having a thin body of fine material, and the other a thick body of coarser and heavier make.

The first of these two classes includes the Chang yao, or ware of the younger Chang, of which the *Ch'ing pi ts'ang* gives the following description : " There is one kind in the manufacture of which white clay is used, and the surface of the ware is covered with *ts'ui*[1] glaze through which the white shows in faint patches. This is what was made by the Chang family in the Sung dynasty, and is called Chang yao. Compared with the Lung-ch'üan ware in style and make, it gives the impression of greater delicacy and refinement." Another writer [2] describes it as " single-coloured and pure, like beautiful jade, and ranking with the Kuan yao ; whereas the Ko yao was pale in colour."

The eleven examples figured and described in Hsiang's Album are all apparently of this class, and their colour is variously described as " green, of jade-green tint (*ts'ui pi*), like a wet, mossy bank or slender willow twigs," " green like the green of onion (sprouts) " (*ts'ui jo ch'ing ts'ung*), " green like parrot's feathers," " green like the dull green (*lü*) of a melon," and " soft jade-green like onion sprouts in autumn." Hsiang's similes leave no doubt as to the prevailing tint of the ware, which clearly aimed at rivalling the tint of the prized green jade. As might be expected, few if any of Chang's celadons are to be found in our collections. Relatively few in numbers, assuming them to have been the work of one lifetime, and slender in structure, it is improbable that many of them can have survived the chances of eight or nine hundred years, and even supposing that any of them have reached Europe, their identity now could only be a matter of conjecture.

The second class is best known to us in those thick, massive porcelains with greyish white body and smooth grey green glaze which have been named in Persian countries *martabani* and in Europe *celadon*. The former name is no doubt derived from the port of Martaban, on the coast of Pegu, a meeting place of Eastern and Western traders, from which the Chinese goods were shipped or transhipped for Europe and the nearer East. The latter name

[1] *Ts'ui* has already been explained as meaning " kingfisher : a bird with bluish green plumage." That it also connotes the idea of a green colour is shown by the expression *ts'ui yü*, which is rendered in Giles's Dictionary, " emerald green jade."

[2] Author of the *Ch'un fêng t'ang sui pi*, quoted in the *T'ao shuo*, bk. ii., fol. 12.

has a more capricious origin, deriving from the shepherd Céladon, a stage personality whose familiar grey green clothing suggested a name for the grey green porcelain. He appeared in one of the plays founded on the early seventeenth-century romance, *L'Astrée*, written by Honoré d'Urfé.

Large dishes and plates, bowls, vases, bulb bowls and jars of this green ware have found their way to all parts of Europe in considerable numbers, and they evidently formed a staple of far Eastern trade in the Middle Ages. The subject of their distribution will be treated presently. First, we must complete their description.

The ware, as a general rule, has a greyish white mass varying from porcelain to stoneware, and with the peculiar quality of assuming a reddish brown tint wherever the glaze is absent and the " biscuit " was exposed to the fire of the kiln. It has, in fact, the " iron foot " though not the " brown mouth," for the body is of a whitish colour under the glaze, and consequently the mouth of the vessel varies from green to greenish white, according to the thickness of the glaze. The decoration is either carved, etched with fine point, or raised in relief by pressing in an intaglio mould or by the application of small ornaments separately formed in moulds. All these processes are applied to the body before the glaze is added, and the glaze, though covering them over, is transparent enough to allow the details to appear fairly distinctly. In the case of the applied reliefs, however, the glaze is often locally omitted, and the ornaments stand out in biscuit, which has assumed the usual reddish brown tint. This is well illustrated on Plate 21, in which two brown fishes are represented swimming round a sea green dish. A dish in the British Museum shows three fishes swimming beneath the green surface of the glaze. This fish design was frequent enough to have earned special notice in Chinese books, which are excessively niggard in their enumeration of designs. The *Ko ku yao lun*,[1] for instance, says " there is one kind of dish on the bottom of which is a pair of fishes, and on the outside are copper rings attached to lift it."

Elaborate designs of flowers, flying phœnixes in peony scrolls, dragons in clouds or waves, formed in relief by pressure in moulds, were certainly used on Sung celadons just as they were in the white Ting wares, but they seem to have been still more common on the Ming wares. But the best and most characteristic Sung

[1] Bk. vii., fol. 24 verso.

decoration was a beautiful freehand carving executed with admirable spirit and taste, in those bold, half naturalistic, half idealised sketches which distinguish the art of the time. Complex ornament, such as landscape and figure subjects, is occasionally found on old celadons ; and there is one kind of bowl of rounded form with rather high narrow foot which is decorated inside with groups of figures carved or impressed in intaglio, the subjects being the eight Taoist Immortals, or historical personages such as Confucius, the chess-playing General, etc., usually labelled with their names in Chinese characters. The glaze on these bowls varies widely in colour and texture, being sometimes smooth celadon green, sometimes yellowish or brownish green or again a pale apple green with crackled surface ; and it is possible that they come from some district other than Lung-ch'üan.[1]

The Lung-ch'üan celadon glaze is singularly beautiful with its soft, smooth translucent texture and restful tints, which vary from olive green through grass green and sea green to pale greenish grey, occasionally showing a decidedly bluish tone. The ware has enjoyed immense popularity in almost every part of the world for untold years, and nowhere more than in Japan, where choice specimens have always been highly valued, and it is not a little surprising to find that in this country alone its merits are underestimated. The Chinese themselves have been always loud in their praises of the finer varieties, though they have not always spoken in complimentary terms of the thick and massive types which were so suitable for the export trade. Of these the *Ch'ing pi ts'ang* observes that they readily withstand usage and handling, and do not easily break ; but the workmanship is somewhat clumsy, and the designs are lacking in antique elegance. With the finer examples within reach, these strictures were perhaps only natural; but there has never been any doubt of the Chinese appreciation of the celadon glaze, for while they have never ceased to reproduce it in other factories, it is always the old Lung-ch'üan ware which serves as their standard and model.

The modern celadon glaze is made by mixing ferruginous clay with the ordinary feldspathic glaze and adding a pinch of cobalt (the mineral from which the blue colour is obtained) to give it the requisite tone[2] ; and it is certain that the colour of the old

[1] Two examples in the Gotha Museum were figured in the *Burlington Magazine*, June, 1909, Plate iv.

[2] See *T'ao lu*, bk. iii., fol. 12 verso.

celadons is due to the presence of oxide of iron, whether assisted
or not by oxide of cobalt. Possibly the earliest celadons were the
accidental result of the iron in a strongly ferruginous clay escaping
in the heat of the kiln and imparting a green tinge to an other-
wise colourless glaze. The conditions in the Lung-ch'üan dis-
trict would have specially favoured such an accident, for the local
clays were of the ferruginous kind, as is shown by their peculiarity,
which we have already noted, of turning red or reddish brown when
exposed without protection to the heat of the kiln. The presence
of iron in greater or less quantity is a common feature of potter's
clays all the world over, and it is usual in modern potteries to pass
the clay over strong magnets in order to remove this disturbing
element when a pure white ware is in view. This fact alone will
explain the prevalence of green tints of the celadon type among
the earlier Chinese wares, and observation of these results would
naturally lead to the discovery that a certain quantity of par-
ticular clay mixed with the ordinary glaze would produce a beau-
tiful green colour, resembling jade. The reddish brown spots occa-
sionally observed in old celadon glazes are no doubt due to flaws
in the glaze-covering, which allowed a partial exposure of the body,
or to a local excess of iron oxide in the material. Like a great
many other accidental effects, these were turned to account by
the Chinese, and in some examples we find patches of brown which
evince a deliberate intention (Plate 21). These effects are highly
prized by the Japanese, who call the ware *Tobi seiji* or " spotted
celadon."

The manufacture of celadon must have been very extensive
in the Lung-ch'üan district. Besides the principal factories at
Liu-t'ien Shih, there were minor works at Chin-ts'un already men-
tioned, and according to the *T'ao lu*[1] at Li-shui Hsien[2] in the Ch'u-
chou Fu, the latter already operative in the Sung dynasty. Its
wares were included in the comprehensive term *Ch'u yao*, and
" the material was coarse and thick, the colour similar to that
of Lung-ch'üan ware, both dark and light, but the workmanship was
coarser."

At the beginning of the Ming dynasty, we are told[3] that the
Lung-ch'üan factories were removed to Ch'u-chou, and that the
ware made on the new site was green (*ch'ing*), with a white body
which, like the older ware, assumed a red colour in the exposed

[1] Bk. vii., fol. 7 recto. [2] 麗水縣 [3] *T'ao lu*, bk. vi., fol. 6.

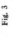

Fig. 1

Fig. 2

Fig. 3

Plate 21.—Three examples of Lung-ch'üan Celadon Porcelain.

Fig. 1.—Plate of spotted celadon. (?) Sung dynasty. Diameter 6½ inches. *Eumorfopoulos Collection.* Fig. 2.—Octagonal Vase with crackled glaze and biscuit panels moulded with figures of the Eight Immortals in clouds. (?) Fourteenth century. Height 9¼ inches. *Eumorfopoulos Collection.* Fig. 3.—Dish with engraved lotus scrolls and two fishes in biscuit. Sung dynasty. Diameter 11 inches. *Gotha Museum.*

parts, but that the ware was not so good as the old. Local tradition asserts that the celadon industry in the district came to an end with the Ming dynasty.[1]

Connoisseurs are much exercised over the differences between Sung and Ming celadons. The *T'ao lu* tells us nothing beyond the bare statement that the Ming ware was not so good, and the two general rules which have been laid down [2] for our guidance—viz. (1) that the colour of the Sung wares is deeper and more grass green, that of the Ming more grey green, and (2) that the bottoms of the Ming vessels are distinguished by an unglazed ring of reddish brown colour—can only be accepted with reserve. Of the two the colour test is probably the more reliable, but I have found too many exceptions in which the grey green occurs on pieces of obviously Sung origin to feel any great confidence in its guidance. The ring test breaks down in practice, and is illogical in its conception, implying, as it does, that the use of a circular support in the kiln was limited to one particular place and period. On the contrary, we know that this method of support was usual in the Siamese factories at Sawankalok,[3] and apparently before the Ming period, and as the Siamese potteries were started by Chinese, probably sent from Western China, it is only fair to suppose that this method of manufacture was in general use at an early date. The safest criterion of Sung workmanship is the style of the ware, and especially the boldness and freedom of the carved designs. In the Ming period the Sung patterns already exhibit an inevitable staleness and conventionality with a tendency to overcrowding of detail. In some cases, too, the designs are of a later order, and closely analogous to those of the blue and white Ming porcelains.

In addition to the Lung-ch'üan and Ch'u-chou celadons, which are readily recognised by their peculiar glaze and their reddish brown foot rims, there are many other kinds which are not easy to classify. Some of these have a dry, buff stoneware body and brownish green glaze, while others have a glaze of decided grey

[1] See Hirth, *Ancient Chinese Porcelain*, p. 31.

[2] See Bushell, *Oriental Ceramic Art*, p. 150.

[3] A large number of fragments and wasters, besides a few complete specimens, found on the site of these potteries, about 200 miles north of Bangkok, are now in the British Museum. The prevailing type of ware has grey porcellanous body and a thin transparent glaze of watery green celadon colour, often distinctly tinged with blue.

or blue grey tone. In conjecturing the origin of these we must
take into consideration the private factories which existed under
the Northern Sung at Ch'ên-liu [1] and other localities in the neigh-
bourhood of the eastern capital (*tung ching*), now named K'ai-
fêng Fu, in Honan. The *Ko ku yao lun* [2] describes the ware of
these parts under the heading *Tung yao* [3] : " It is pale green (*ch'ing*)
in colour, with fine crackle, and in many cases has a brown mouth
and iron foot. Compared with Kuan ware it lacks the red tinge,
and its material is coarse, wanting in fineness and lustre, and far
from equalling that of the Kuan ware. At the present day (i.e.
1387) it is rarely seen." Other writers repeat this passage with
little alteration, though the author of the *T'ao lu* adds that the
clay was of black colour and the glaze of varying depth. Hsiang's
Album includes one specimen of the *tung ch'ing tz'ŭ*, describing
the colour as *t'ieh ts'ui*, which probably means the blue green shade
of distant hills. [4] *Tung ch'ing* glaze is included in the list of those
imitated in the Imperial factories about 1730, two kinds, pale and
deep, being specified; and the *T'ao lu* [5] informs us that the *Tung
ch'ing* was copied to a considerable extent at Ching-tê Chên in
the early nineteenth century, and that the modern glaze was
exactly like the old. That this modern glaze was only a variety
of celadon is shown by the recipe given in the same work, [6] viz.
" to add to the ordinary glaze some of the mixture containing
ferruginous earth," which differs from that given for the modern
Lung-ch'üan glaze only in the absence of the pinch of cobalt (see
vol ii., p. 189).

A verse from a poem by Chang-lei (1046–1106) indicates the
green colour of the ware : " Green jade (*pi yü*) when carved

[1] 陳畱. See *T'ao lu*, vol. vi., fol. 3.

[2] Bk. vii., fol. 22.

[3] 董窰. A phrase which the author of the *T'ao lu* considers to be a mistake for
the homophone 東窰 (*tung yao* or Eastern ware). He also quotes another misnomer
for the ware, viz. 冬青器 *tung ch'ing ch'i* (winter green ware). This Tung ware
is constantly alluded to in other works as *tung ch'ing* 東青.

[4] 疊翠 lit. duplicated kingfisher green. Bushell, in his translation, renders it
literally " kingfisher feathers in layers," a metaphor from the well-known jewellery
with inlay of kingfisher feathers, which would suggest a turquoise tint. On the other
hand, we find in Giles's Dictionary the phrase 遠山疊翠 *Yüan shan t'ieh ts'ui*, " the
distant hills rise in many green ranges " (the two forms of *t'ieh* being alternatives),
a phrase recalling the " green of a thousand hills," which is used in reference to early
green wares. See p. 16.

[5] Bk. ii., fol. 9.

[6] Bk. iii., fol. 12.

makes a vessel; know it to be the porcelain (*tz'ŭ*) of the Tung kilns 東窰."[1]

In the classification of old celadons due account must be taken of the imitations made from the earliest times at Ching-tê Chên. Many of these would be distinguishable by their white porcelain body, the ordinary porcelain clay of the district not having the peculiar qualities of the Lung-ch'üan and Ch'u-chou Fu material. In fact, we know that it has been a common practice in recent times among the Ching-tê Chên potters to dress the exposed parts of their ware with brown ferruginous earth when they wished to reproduce the " brown mouth or iron foot " of the archaic wares. Another method which was found effective by imitators of the antique was to use a coarse yellowish clay for the body of the ware. This, however, should be generally recognisable. But the skill of the Chinese copyist is proverbial, and a good instance of his cunning is given in the now celebrated letters of Père d'Entrecolles, a Jesuit missionary stationed at Ching-tê Chên in the K'ang Hsi period. The passage[2] is interesting enough to be quoted in full:

" The mandarin of *Kim tê Chim,* who honours me with his friendship, makes for his patrons at the Court presents of old porcelain which he has himself a genius for fabricating. I mean that he has discovered the art of imitating antique porcelain, or at least that of comparative antiquity; and he employs a number of workmen for this purpose. The material of these false *Kou tom,* viz. counterfeit antiques, is a yellowish clay, obtained in a place quite near *Kim tê Chim,* called *Ma ngan chan.* They are constructed very thick. The mandarin has given me a plate of this make, which weighs as much as ten ordinary plates. There is nothing peculiar in the manufacture of these kinds of porcelain beyond that they are covered with a glaze made of yellow stone, mingled with the ordinary glaze, the latter predominating in the mixture, which gives the porcelain a sea green colour. When it is fired it is placed in a very rich broth made of chicken and other meats; in this it is baked a second time, and after that it is put in the foulest drain that can be found and left for a month or more. On issuing from this drain it passes for three or four hundred years old, or at any

[1] Quoted from the *Yün tsao* (a selection of verses) in the *T'ao lu,* bk. ix., fol. 3.

[2] See *Recueil des lettres édifiantes et curieuses.* The above passage occurs in a long letter dated from Jao Chou, September 1st, 1712. See Bushell, *Chinese Pottery and Porcelain,* Appendix, p. 206.

rate for a representative of the preceding Ming dynasty, when porcelain of this colour and thickness was appreciated at Court. These counterfeit antiques resemble the genuine pieces also in their want of timbre when struck, and if one holds them to the ear they produce no reverberation."

The worthy father's acquaintance with the antiques was probably limited, or he would not have instanced the last quality as evidence of good imitation. On the contrary, the lack of timbre would be regarded by Chinese connoisseurs as indication of a spurious ware, the note of the old porcelains being one of the criteria of their excellence. But the passage is otherwise most instructive.

It should be remembered, too, that at the time of which d'Entrecolles speaks, an extensive use was being made at Ching-tê Chên of a beautiful celadon glaze on a fine white porcelain body. These celadons of the period will be discussed in their proper place, as they make no pretence of antiquity and are easily distinguished by their pure white body and pale soft green glaze. Indeed, they often have the ordinary white glaze under the base and a period mark in blue.

Another factory which made free use of the celadon glaze was that of Yang Chiang, province of Kuangtung. As a rule, the ware is recognisable by its reddish brown stoneware body, but in cases where the biscuit is lighter in colour and more porcellanous in texture, confusion may easily arise.

Nor must we forget the extensive manufacture of celadons outside China itself. The Corean wares have already been mentioned. As a rule, their soft velvety glaze is recognised by its peculiar bluish grey tone, difficult to describe but easy to remember when once seen. The colour, however, varies to distinctly greener and browner shades, which are liable to be confused with Chinese celadons of the Lung-ch'üan and northern types. Fortunately, most, though not all, of the Corean decorations are very characteristic, particularly the delicate inlaid designs [1] in white and black clays ; and the finish of the ware underneath is usually distinctive, a very low foot rim, the base slightly convex, and the disfiguring presence of the sand, which in three little piles supported the ware in the kiln.

[1] The only example which I have seen of an inlaid celadon which might be taken for Chinese is a dish in the Stübel Collection in the Kunstgewerbe Museum, Dresden. It has a faint design, apparently inlaid, in a brownish colour.

There are, however, quite a number of ambiguous celadons with a brownish green glaze, usually bowls, of which some are decorated inside with beautiful carved and moulded designs of bold foliage (Plate 18, Fig. 1) and even with the design of boys among flowering branches and the slight combed patterns which are found on the Corean white wares. Were it not for the apparently Chinese provenance of so many of these bowls, and the absence of the Corean characteristics in their bases, one would be tempted to class them as Corean on the strength of their general appearance. Probably we have in this group both the Chinese prototypes and the close imitations made by the Corean potters who followed these models just as they followed the white ware of Ting Chou. One of the combed bowls formerly treasured as a tea bowl in Japan is now in the Kunstgewerbe Museum, Berlin, but unfortunately the Japanese name *shuko-yaki*, by which Dr. Kümmel informs me it was known in Japan, sheds no light on the question of its origin.

The Sawankalok wares of Siam, too, have already had a passing mention. These are easily distinguished by their coarse grey body, reddish at the base, and thin, watery green glaze, very transparent and showing a bluish efflorescence where it has run thick. Once seen, they are hardly likely to be confused with any Chinese celadon, except a few of the coarser Ming and later types, in which the glaze happens to be very pale and thin. The Siamese wares, moreover, usually have a small raw irregular ring under the base, made by the end of a tubular kiln support, and differing from the broad regular ring on the Lung-ch'üan dishes described above.

But the most puzzling of the external celadons are those made at various times and places in Japan. They are, as a rule, close and careful copies of Chinese types, with which they are readily confounded by persons not familiar with Japanese peculiarities. In many cases, too, they will puzzle the most expert. It is well-nigh impossible to put into words any distinctive criteria of these wares. The biscuit is usually white and porcellanous, and though it sometimes assumes a natural tinge of red at the base, the colour is not so deep and decided as on the Lung-ch'üan wares. The chief distinction is an inevitable Japanese flavour in the form and decoration of the ware, but this, again, is an intangible feature which can only be realised by the practised eye. Finally, it should be said that remarkably close copies of the celadon green glaze (and of the

typical ornament as well) were made in Egypt and Persia in the late Middle Ages. At a short distance they might often be taken for Chinese, but on inspection the body will be found to have that soft, sandy texture which is an unmistakable characteristic of the near-Eastern pottery.

It is impossible to leave the subject of celadon without a few words on the distribution of the ware in the Middle Ages, though I have no intention of embarking on the lengthy discussion which the interesting nature of the subject invites, nor of reopening the much-debated *Celadonfrage* which elicited many interesting contributions[1] from Professors Karabacek, A. B. Meyer, and Hirth, and Dr. Bushell. Probably no single article of commerce can tell so much of the mediæval trade between China and the West as the old celadon porcelains whose fragments are constantly unearthed on the sites of the old-world trading stations. The caravan routes through Turkestan and the seaborne trade through the Eastern Archipelago and the Indian Ocean to the Persian Gulf, Red Sea, and east coast of Africa can be followed by porcelains deposited at the various trading centres and ports of call. Much, too, has been learnt from the writings of Chinese, Arab, and European travellers and geographers. Professor Hirth, as early as 1888, worked out the principal routes of Chinese seaborne trade from the " Records of Chinese Foreign Trade and Shipping,"[2] compiled by Chao Ju-kua about 1220 A.D., starting from the Tingui[3] of Marco Polo, which he identifies with Lung-ch'üan itself, and finishing in Egypt and Zanzibar. The porcelain was carried by land and river to the great port of Ch'üan-chou Fu, and thence in junks to Bruni in Borneo, Cochin China, and Cambodia, Java, Lambri, and Palembang, in Sumatra, where the traders of the East and West met and exchanged goods. Thence the trade proceeded to Quilom in Malabar, Guzerate, Cambray, and Malwa, and as far as Zanzibar. Numerous other localities might be men-

[1] In the *Oesterreichische Monatschrift*, January, 1885, and succeeding numbers, A. B. Meyer's *Alterthümer aus dem Ostindischen Archipel*, etc. etc.

[2] The *Chu fan chih*, the author of which was Imperial inspector of foreign shipping, etc., in the province of Fukien. See Hirth, *Ancient Chinese Porcelain : A Study in Chinese Mediæval Industry and Trade*, Leipsig, 1888 ; and the translation of the *Chu fan chih*, published by Hirth and Rockhill, 1912.

[3] Where Marco Polo (see Yule, bk. ii., p. 218) states that " they make vessels of porcelain of all sizes, the finest that can be imagined . . . and thence it is exported all over the world."

tioned, and much has been written[1] of the veneration in which old Chinese wares have always been held in the Philippines and Borneo, and of the magic powers attributed to the old dragon jars by the natives of these countries.

The green celadon was highly valued in India and Persia, where it was reputed to have the power of disclosing the presence of poison. An early reference to the Chinese porcelain occurs in the writings of the Persian geographer Yacut,[2] who mentions " four boxes full of Chinese porcelain and rock crystal " among the effects of a native of Dour-er-Raçibi in Khouzistan, who died in 913 A.D. The trade with Egypt is indicated in the much-quoted incident of the gift of forty pieces of Chinese porcelain sent from Egypt by Saladin to Nur-ed-din in Damascus in 1171, and by the later gift of porcelain vases sent in 1487 by the Sultan of Egypt to Lorenzo de' Medici. A large proportion of the celadons in our collections has been brought and still comes from India, Persia, and Egypt.[3] The Sultan's treasure at Constantinople[4] teems with celadons collected in mediæval times. Fragments of celadon are unearthed on almost every important mediæval site which is excavated in the East. The British Museum has small collections of such fragments from Bijapur in India, the island of Kais in the Persian Gulf, Rhages in Persia, Ephesus, Rhodes, Cairo, and Mombasa, to mention a few sites only. Fragments of celadon were found, in company with Chinese coins ranging in date from 990–1111 A.D., by Sir John Kirk and Lieut. C. Smith, near Kilwa in Zanzibar, and the former, while British representative in Zanzibar, was able to form a considerable collection of complete specimens which were treasured by the natives with almost religious care. A story told by Sir John Kirk illustrates the attitude of the native mind towards these treasured wares. A celadon dish with particularly fine carving was the subject of a family dispute, and to satisfy the rival claims

[1] See A. B. Meyer, op. cit. ; Ling Roth, *The Natives of Borneo;* Carl Bock, *Head Hunters of Borneo;* Fay-Cooper Cole, *Chinese Pottery in the Philippines,* Chicago 1912.

[2] A thirteenth-century writer, one of whose works is translated by Barbier and Maynard, *Dictionnaire Géographique de la Perse.* See p. 240 of this book. Fragments of celadon porcelain were found on the ninth-century site of Samarra on the Euphrates. (See p. 148.)

[3] Much of the celadon found in Egypt would seem to be as late as the early part of the sixteenth century, to judge from the general name given to it by Egyptian merchants, " *baba ghouri,*" after the sultan who reigned at that time.

[4] See E. Zimmermann in the *Cicerone,* III. *Jahrgang,* s. 496 ff.

a local Solomon decided that it should be divided between the disputants. One large fragment of it is now in Sir John Kirk's collection, which includes many interesting dishes, crackled and plain, and ranging in colour from dark olive green to the pale watery tint of the Sawankalok[1] wares. Other specimens of interest are the large, wide-mouthed, bowl-shaped vases with sides deeply ribbed or carved in high relief with bold floral designs. They have the peculiar feature of being constructed at first without a bottom, which was separately made in the form of a saucer and dropped in, the glaze holding it firmly in position. Similar vases[2] have been found in India and elsewhere. One of the first pieces of celadon to arrive in this country was the celebrated Warham bowl, which was bequeathed to New College, Oxford, in 1530 by Archbishop Warham. It is of dull grey green celadon, the outside faintly engraved with four lotus petals, each containing a trefoil, and in the bottom inside is the character *ch'ing* 清 (pure) surrounded by rays. It has a fine silver-gilt mount of English make.[3] It would be possible to multiply references to the traffic in celadon wares which was carried on briskly between China and the West in the Middle Ages, but enough has been said to give some idea of the extent and nature of the trade, which was mainly in the coarsest types of ware. Apart from the unlikelihood that very fine or precious porcelains would be embarked on such long and hazardous journeys, there was actually a law in force in China as early as the eighth century[4] which forbade, under penalty of imprisonment, the exportation of " precious and rare articles," anticipating by a thousand years the restrictive legislation of the Italian Government.

[1] See *Burlington Magazine*, June, 1909, p. 164. Other pieces, apparently of Siamese make, have been found in Egypt, and it is most probable that Siamese celadons were shipped by the traders at Martaban in Pegu and sold by them along with the Chinese goods.

[2] See *Catalogue of the Early Chinese Pottery and Porcelain*, Burlington Fine Arts Club, 1910, B. 27.

[3] See *Cat. B. F. A.*, 1910, E 20, and Plate.

[4] See *Chau Ju-kua* (translated by Hirth and Rockhill), p. 9.

Plate 22.—Vase of Lung-ch'üan Porcelain.

With grey green celadon glaze of faint bluish tone, peony scroll in low
relief. Probably Sung dynasty. Height 19½ inches. *Peters Collection.*

CHAPTER VII

TING YAO 定窯

TING ware is by general consent ranked among the finer Sung porcelains, and it is happily, like the Lung-ch'üan celadons, fairly well known to Western collectors. Its name derives from its place of origin, Ting Chou, the modern Chên-ting Fu, in the province of Chih-li, where the manufacture of a white ware, if not actually a white porcelain, appears to have existed from remote times. Indeed, the " white ware (*pai tz'ŭ*) of Ting Chou " is mentioned in the middle of the seventh century,[1] though nothing further is heard of it until it came to enjoy the patronage of the Sung emperors. As already hinted in connection with the Ju Chou porcelain, the Ting ware suffered a temporary eclipse at Court owing to some defects in the glaze ; but it was not long in recovering its reputation, for the *Ko ku yao lun* states that it was at its best in the Chêng Ho and Hsüan Ho periods, which extended from 1111 to 1125 A.D., and we learn that the Ting Chou potters accompanied the Court in its flight across the Yangtse in 1127. The manufacture seems to have been re-established after this event in the neighbourhood of Ching-tê Chên, and the *nan ting* or Southern Ting ware is said to have so closely resembled the original that to distinguish the two in after years was regarded as a supreme test of connoisseurship.[2]

Ting ware has a white body of fine grain and compact texture, varying from a slightly translucent porcelain to opaque porcellanous stoneware. Though not so completely vitrified as the more modern porcelains, and lacking their flint-like fracture, it was nevertheless capable of transmitting light in the thinner and finer specimens, and consequently it can be regarded as one of the earliest Chinese

[1] See Hirth, *Ancient Chinese Porcelain*, op. cit., p. 4. The passage discovered by Hirth occurs in the *T'ang pên ts'ao*, the pharmacopœia of the T'ang dynasty, compiled about 650 A.D.

[2] See *T'ao shuo*, bk. ii., fol. 7 verso.

wares which fulfils the European definition of porcelain. The glaze is of ivory tint, sometimes forming on the outsides of bowls or dishes in brownish gummy tears, which were regarded by Chinese collectors as a sign of genuineness.[1] The finer and whiter varieties are known as *pai ting* (white Ting) and *fên ting* (flour Ting), as distinct from the coarser kind, whose opaque, earthy body and glaze of yellowish tone, usually crackled and stained, earned it the name of *t'u ting* or earthen Ting.

In the best period the pure white undecorated Ting ware, with rich unctuous glaze, compared to " congealed fat " or " mutton fat," was most esteemed, though ornament was freely used, especially on the Southern Ting. Designs carved in low relief or etched with a point were considered best, the moulded and stamped ornament being rightly regarded as inferior. There is a remarkable, though sadly damaged, example of Northern Ting ware in the British Museum. It was found in a Manchurian tomb of the twelfth century, and bears out the current descriptions of the ware with its fine white body, rich ivory glaze, and " tear drops " on the reverse. The ornament, a lotus design in bold freehand carving, displays all the freshness and power of Sung craftsmanship. This dish has, moreover, a characteristic common to the Sung Ting bowls and dishes, viz. the mouth rim is bare of glaze. Many of the early wares were fired upside down, whence the bare mouth rim, which was usually hidden by a metal band.[2]

Favourite carved designs with the Ting potters seem to have been the mu-tan peony, the lily, and flying phœnixes. They are, at any rate, usually singled out for mention by Chinese writers.[3] Garlic and rushes are also incidentally mentioned as motives, and a few examples of a beautiful design of ducks on water are known in Western collections. The moulded ornament is generally more elaborate, dense peony scrolls with phœnixes flying through them, radiating panels of flowers, dragons in clouds, fishes among water plants and wave patterns, etc. To judge from Hsiang's Album,

[1] See *Ko ku yao lun*, bk. vii., fol. 23. " Specimens with tear stains (*lei hên*) outside are genuine."

[2] The *T'ao lu*, bk. ix., fol. 13, quotes from *T'ang shih ssŭ k'ao* the following passage which bears on this point: " The Ting and Ju ware used by the Court generally have a copper band on the mouth. This was regarded as destroying their value. But modern collectors of Ting and Ju wares have come to regard the copper band on the mouth as a sign of genuineness. Dealers in curios declare it to be a sign of age."

[3] e.g. *Po wu yao lan*, *T'ao lu*, etc.

carved designs borrowed from ancient bronzes must have been highly prized.

Of the three kinds of ornament usually associated by Chinese writers with the Ting ware, the *hua hua* (carved decoration) and the *yin hua* (stamped or moulded decoration) have already been mentioned. The meaning of the third, *hsiu hua*,[1] is not so clear, as the phrase can bear two interpretations, viz. painted ornament or embroidered ornament. In the latter sense it would suggest a rich decoration like that of brocade without indicating the method by which it was applied. But in the former it was the usual Chinese expression for painted ornament, and it is difficult to imagine that it was intended to indicate anything else in the present context. On the other hand, no examples of painted Ting ware are known to exist either in actual fact or in Chinese descriptions. This anomaly, however, may perhaps be explained in one of two ways. A creamy white ware of *t'u ting* type, boldly painted with brown or black designs, is known to have been made at the not far distant factories of Tz'ŭ Chou [2] in the Sung dynasty, and it is possible that either the painted Ting ware has been grouped with the Tz'ŭ Chou ware in modern collections, or that Chinese writers mistook the Tz'ŭ Chou ware for painted Ting ware and added this third category to the Ting wares by mistake. In any case they regarded the painted ware as an inferior article.

The high estimation in which fine specimens of white Ting ware have always been held by Chinese connoisseurs is well illustrated by a passage in the *Yün shih chai pi t'an*.[3] It tells how Mr. Sun of the Wu-i river estate treasured in his mountain retreat Ting yao incense-burners, and among them one exquisite specimen of the Sung period. It was a round vessel with ear handles and three feet, and the inscription *li hsi yai* (李西涯) was engraved in seal characters on the stand. During the Japanese raids in the Chia Ching period this vessel passed into the hands of one Chin Shangpao, who sold it to T'ang, the President of Sacrifices (*t'ai ch'ang*), of P'i-ling. T'ang, whose residence bore the romantic but chilly name of Ning-an (Frozen Hut), is the celebrated collector mentioned in connection with another Ting vessel on p. 95. " Although

[1] 綉 or 繡花. The word *hua* (lit. flowers) is used in the general sense of " ornament." The attempts of certain translators to confine it to the literal sense " flowers " has led to ridiculous results.

[2] See p. 101.

[3] An early eighteenth-century work, quoted in the *T'ao lu*, bk. ix., fol. 11.

T'ang had many wonderful porcelains," the story runs, " when this vessel arrived, they all, without exception, made way for it. And so throughout the land when men discuss porcelains, they give the first place to T'ang's white incense vase. T'ang, they say, did not readily allow it to be seen." And in this respect, if all accounts are true, T'ang was not unlike a good many Chinese collectors of the present day.

On the other hand, the Ting ware was often marred by certain blemishes which are not always easy to understand. The " awns " (*mang*), for instance, which degraded it at Court in favour of the Ju Chou ware in the early Sung period were probably flaws in the glaze. The " bamboo thread brush marks " mentioned in the *Liu ch'ing jih cha*[1] may perhaps be lines left in the glaze which was applied by means of a bamboo brush. Three other defects which rendered the ware comparatively worthless are named in the *Ko ku yao lun*,[2] viz. *mao* (thatch), *mieh* (bamboo splints), and *ku ch'u* (bare bones). The author fortunately explains that (1) to thatch (*mao*) means to cover over defects, (2) bamboo splints (*mieh*) is used of lines and recalls the brush marks mentioned above, and (3) bare bones (*ku ch'u*) are patches where the glaze is defective and the body shows through. *Ku*, in the sense of " body or biscuit," we are further informed, is a " curio-market expression." Modern collectors will probably not be so fastidious as the Chinese of the fourteenth century, and will welcome a Sung specimen of Ting porcelain, even though it suffer from *mang* and *ku ch'u*.

The *pai ting* and the *t'u ting*, the fine and coarse white varieties, alone have been identified in Western collections ; but there are coloured Ting porcelains which are known to us by literary references. An apocryphal red Ting ware [3] (*hung ting*) is mentioned in two passages of ambiguous meaning which need not necessarily have implied a true red glaze. In any case it finds no place in the older works, such as the *Ko ku yao lun* and *Ch'ing p'i tsang*, which only speak of purple or brown (*tzŭ*) Ting, and black Ting.

[1] See *T'ao shuo*, bk., ii., fol. 7.

[2] Bk. vii., fol. 23.

[3] The *Memoir of Chiang* (see p. 159), written in the Yüan dynasty, says that the " pure white ware of Ching-tê Chên in the Sung dynasty, when compared with the red porcelain (*hung tz'ŭ*) of Chên-ting and the Lung-ch'üan green ware, emulated these in beauty." Chên-ting is the Chên-ting Fu, the prefectural town of Ting Chou, and the ware indicated is no doubt Ting ware ; but here the comparison clearly seems to be between white wares, and unless the word *hung* (red) applies to some variety of the Ting biscuit as distinct from the glaze, it is difficult to understand.

" There is purple [1] Ting," says the *Ko ku yao lun*, " the colour of which is purple ; there is ink Ting, the colour of which is black, like lacquer. The body in every case is white, and the value of these is higher than that of white Ting."

Hsiang, who figured five specimens in his Album, compared them to the colour of ripe grapes and the skin of the aubergine fruit or brinjal, one specimen being *tzŭ ts'ui* (purple blue) ; and he further states that out of a hundred and more specimens of Ting ware he had only seen ten of purple and one of black colour.

The solitary specimen of black Ting, which appears in a very unconvincing illustration in Hsiang's Album,[2] is divided into two zones, one black, the other white, and Hsiang regards it as inestimably rare and precious. In this appreciation he follows the *Ko ku yao lun*, but other writers, such as the author of the *Ch'ing pi ts'ang*, take an entirely different view, holding neither the purple nor the black Ting ware of much account. With us at present the question is of academic interest only, as no examples of either kind worthy of notice have been identified in Western collections. The nearest approach to the description of the purple variety which I have seen is a small box from a tomb in Shansi, made of white porcellanous ware with a purplish black glaze on the cover. It is, however, a crude object, and of no particular merit. As for the black Ting, the nearest analogue to that which I can quote is the vases with black or brown black glaze belonging to the Tz'ŭ Chou class. Some of these (see Plate 30) have zones of black and white recalling Hsiang's description. It is, perhaps, worth noting in this connection that the black glaze on these wares was liable to shade off into lustrous brown, indicating the presence of iron oxide, and to resemble in this respect the so-called " hare's fur " or " partridge " glazes of the celebrated Chien yao tea bowls.[3] This fact may account for a passage in an early writer,[4] who says

[1] 紫 *tzŭ*, " purple or dark red brown," is, like most Chinese colour-words, a somewhat elastic term. The dictionary gives instances in which it is applied to " red sandal wood," " brown sugar," the ruby, the violet, and the peony.

[2] Op. cit., fig. 35.

[3] See p. 131. I have seen a single specimen of a bowl with carved design and creamy white glaze inside and all the appearances of a Ting ware, but coated on the exterior with a lustrous coffee brown monochrome. But without any other example to guide one's judgment, I should hesitate to say that this piece was older than the Ming dynasty.

[4] Hsü Tz'ŭ-shu, author of the *Ch'a Su*, a book on tea, quoted in the *T'ao shuo*, bk. v., fol. 15 verso.

"the ancients favoured as tea bowls Ting ware with hare's fur marking, and these were used in the powdered-tea competitions," but the work deals with tea rather than ceramics, and it is probable that a confusion had arisen in the author's mind between the Chien yao tea bowls and Ting ware. On the other hand, it would appear that bowls with glaze which has some analogies with the "hare's fur" were made at an early date in Northern China. (See Fig. 1 of Plate 43 and p. 132.)

Though little is heard of the coloured Ting wares after the Sung period,[1] the manufacture of white Ting and the commoner *t'u ting* continued at Ching-tê Chên and elsewhere. In fact, it cannot be said to have suffered intermission up to the present day. A few of these imitative wares of later date were of such excellence as to merit historical notice. In the Yüan dynasty, for instance, P'êng Chün-pao, a goldsmith of Ho Chou, in Shansi,[2] was celebrated for his imitations of old Ting wares, and the *Ko ku yao lun,* an almost contemporary work, describes his productions as exactly like Ting ware when of fine body,[3] but as being " short " and " brittle," and consequently not really worth much. " But dealers in curiosities give them the name of *hsin ting* or New Ting, and amateurs collect it at great cost, which is most ridiculous." Again, the *Po wu yao lan* describes another wonderful imitation of Ting ware made in the sixteenth century[4] by Chou Tan-ch'üan, a native of Wu-mên, who settled at Ching-tê Chên, and was reputed the best potter of his time. Though, generally speaking, his material was not as fine as the original, still his copies of *Wên wang* censers[5] and sacrificial vessels with " monster heads and halberd ears " so closely resembled the originals that it was only necessary to " rub away the kiln-gloss all over the surface " to make the illusion complete. Among the literary references to pottery and

[1] The potteries in the Chên-ting Fu district were active up to the end of the Ming dynasty, at any rate (see p. 199); and no doubt many of the coarse *t'u ting* specimens belong to the Ming period, but as their forms are archaic it is almost impossible now-adays to differentiate them.

[2] Julien, op. cit., p. 21, places this town in Kiang-nan, but this is clearly an error.

[3] In contrast with these there were specimens with " green mouth," *ch'ing k'ou* which were " wanting in richness and lustre."

[4] The date of Chou Tan-ch'üan is not given, but he is mentioned in the *Ni ku lu,* a mid-sixteenth-century work.

[5] A well-known type of bronze incense burner of the Shang dynasty. See the *Shin sho sei,* bk. i., fol. 2 ; and Hsiang's Album, fig. 1, where a Ting ware copy is illustrated.

porcelain collected in books viii. and ix. of the *T'ao lu* is a story narrated in the *Yün shih chai pi t'an*, illustrating the cleverness of Chou Tan-ch'üan. Julien[1] has translated it as follows : " One day he (Chou) embarked on a merchant boat from Kin-tchong and landed on the right bank of the Kiang. Passing P'i-ling, he called on T'ang, the President of the Sacrifices (*T'ai ch'ang*), and asked permission to examine at leisure an ancient tripod of Ting porcelain[2] which was one of the gems of his collection. With his hand he took the exact measurements of the vessel ; then he made an impression of the patterns on the tripod with some paper which he had hidden in his sleeve, and returned at once to Ching-tê Chên. Six months after he returned and paid a second visit to Mr. T'ang. Taking from his sleeve a tripod, he said to him, ' Your Excellency owns a tripod censer of white Ting porcelain. Here is its fellow, which belongs to me.' T'ang was astounded. He compared it with the old tripod, which he kept most carefully preserved, and could find no difference. He tried its feet against those of his own vessel and exchanged the covers, and found that it matched with perfect precision. T'ang thereupon asked whence came this wonderful specimen. ' Some time ago,' answered Chou, ' I asked your leave to examine your tripod at leisure. I then took all its measurements with my hand. I assure you that this is a copy of yours, and that I would not deceive you in the matter.' The *T'ai ch'ang*, realising the truth of this statement, bought for forty ounces of silver the tripod, which filled him with admiration, and placed it in his collection beside the original as though it were its double. In the Wan Li period (1573–1619), Tu-chiu, of Huai-an, came to Fou-liang. Smitten with a deep longing for T'ang's old censer, he could think of nothing else, and even saw it in his dreams. One day he went with Kien-yu, the *T'ai ch'ang's* nephew, and after much importunity he succeeded in getting from him for a thousand ounces of silver the imitation made by Chou, and returned home completely happy."

Other examples of Ting imitations in the late Ming period, described in the *Po wu yao lan*, include " magnolia blossom cups ; covered censers and barrel-shaped censers with chain-armour pattern, ball and gate embroidery and tortoise pattern mingled together in an ornamental ground." But we gather that though these have

[1] Julien, op. cit., pp. xxxiii.-xxxv. ; the reference in the *T'ao lu* is bk. viii., fol. 5.
[2] Perhaps the celebrated " white Ting censer " described on p. 92.

been confounded with Chou's work they were inferior both in material and workmanship to his early masterpieces.

At any rate, it is certain that besides these conspicuous crafts-men whose names have become historical, there were many name-less potters at Ching-tê Chên who devoted their skill to the imita-tion of *pai ting* porcelain in the Ming and Ch'ing dynasties. Very beautiful wares of this class are occasionally seen which have a " slickness " of decoration and a mechanical refinement of finish characteristic of an art which is already crystallised and has lost its freshness and spontaneity. These are, no doubt, the work of later copyists. Indeed, we are expressly told in the *T'ao lu* [1] that at the end of the eighteenth century there were still potters at Ching-tê Chên who made a specialty of *pai ting ch'i* or white Ting wares. These, moreover, were makers of curiosities and orna-mental wares (*wan*), and they sometimes painted their wares with underglaze blue.

Among the provincial wares of the Ting type the *Ko ku yao lun* mentions Hsiang yao, which " has crab's claw crackle. When rich and lustrous it is highly esteemed, but when yellow and of coarser material, it is of little merit or value." Another work [2] gives this ware a flattering mention in stating that the Ting ware resembled Hsiang yao in colour. The locality of its manufacture is left in doubt, but it was probably Hsiang-shan, in the Ning-po prefecture of Chekiang. The *T'ao lu* names a good number of pro-ducers of white ware, some definitely described as of Ting type, among the lesser factories. Su Chou, [3] for instance, in Anhui, in the modern prefecture of Fêng-yang, had a pottery dating from the Sung period. Its productions resembled Ting ware in colour, and had a considerable reputation. In fact, when the Ting porcelain became scarce the Su Chou ware was largely bought in Northern China as a substitute, though in reality it was far from equal to the genuine Ting.

Ssŭ Chou, [4] too, another place in Anhui, had a pottery dating from Sung times, which made wares of Ting type, and " persons who liked a bargain often bought them in place of Ting porcelain."

[1] Bk. ii., fol. 9 verso.

[2] The *Liu ch'ing jih cha*, written by T'ien Yi-hêng in the Ming dynasty.

[3] 宿州 *T'ao lu*, vol. vii., fol. 9 verso. See also bk. ix., fol. 9, where the *Ch'ing po tsa chih* (1193 A.D.) is quoted as follows : " The wares used at the present day, which are made at So Chou and Ssŭ Chou, are not genuine Ting ware."

[4] 泗州 *T'ao lu*, vol. vii., fol. 9 verso.

Fig. 1

Fig. 2

Plate 23.—Ivory white Ting Ware, with carved ornament.
Sung dynasty.

Fig. 1.—Bowl with lotus design. Diameter 8½ inches. *Eumorfopoulos Collection.* Fig. 2.—Dish with ducks and water plants. Diameter 8¾ inches. *Alexander Collection.*

Fig. 1

Fig. 2

Plate 24.—Sung and Yüan Porcelain.

Fig. 1.—Ewer, translucent porcelain, with smooth ivory white glaze. Sung or Yüan dynasty. Height 6 inches. *Alexander Collection.*
Fig. 2.—Vase of ivory white Ting ware with carved lotus design. Sung dynasty. Height 11⅜ inches. *Eumorfopoulos Collection.*

Fig. 1

Fig. 2

Plate 25.—Ting Ware with moulded designs, Sung dynasty.

Fig. 1.—Plate with boys in peony scrolls, ivory white glaze. Diameter 7¾ inches. *Peters Collection.* Fig. 2.—Bowl with flying phœnixes in lily scrolls, crackled creamy glaze; *t'u ting* ware. Diameter 6 inches. *Koechlin Collection.*

Fig. 1

Fig. 2

Plate 26.—T'u ting Ware, Sung dynasty, with creamy crackled glaze.

Fig. 1.—Brush washer in form of a boy in a boat. Length 7⅛ inches. *Rothenstein Collection.* Fig. 2.—Figure of an elephant. Length 10½ inches. *Eumorfopoulos Collection.*

Plate 27.—Vase of bronze form with row of studs and
moulded belt of *k'uei* dragon and key-fret patterns.

"Ostrich egg" glaze. (?) Kiangnan ware, of Ting type; Sung
dynasty. Height 17⅝ inches. *Peters Collection.*

Plate 28.—Vase of bronze form with two bands of raised
key pattern.

Thick creamy glaze, closely crackled and shading off into brown with
faint tinges of purple. (P) Kiangnan Ting ware. Fourteenth century.
Height 15½ inches. *Koechlin Collection.*

In the same district, during the Yüan and Ming periods, a thin white ware with " earthen " body was made at Hsüan Chou,[1] which was evidently of *t'u ting* type. Brinkley[2] speaks of a pottery of this kind which is greatly esteemed by the Japanese under the name of Nyo-fu ware[3]; and a little wine cup with a slight engraved floral decoration in the British Museum is possibly an example of this class. It has an earthy looking body, and creamy white glaze, and is thin and very light to handle. Under the base are engraved the words 含馨 *han hsing* (" to contain fragrance ").

In Kiang-su, the western portion of Kiang-nan, is the " white earth village " Pai-t'u Chên,[4] where potteries existed from Sung times, making a ware of the local clay, very thin, white and lustrous, beautiful in form and workmanship. Thirty kilns were worked, chiefly by families of the name Tsou, under the direction of a headman, the potters numbering several hundreds.

Under the heading of Hsi yao,[5] the *T'ao shuo* alludes to four factories in the province of Shansi, which are interesting to-day in view of the various wares excavated in the railway cuttings now under construction in that province. A fuller description of these potteries is given in the *T'ao lu*, which mentions P'ing-yang Fu in the southern half of Shansi as a pottery centre in the T'ang and Sung dynasties, where the ware was white but disqualified by a glaze lacking in purity. At Ho Chou, in the same district, a superior ware was made as early as the T'ang dynasty, which was even considered worthy of mention in the *Ko ku yao lun*, probably because of the connection of P'êng Chün-pao (see p. 94) with this place in the Yüan dynasty. The *T'ao lu* tells that the Ho ware was made of fine rich material, the body unctuous and thin, and the colour usually white, and that it was more beautiful than P'ing-yang ware—a qualified compliment! A coarse pottery made at Yü-tzŭ Hsien, in the T'ai-yüan prefecture in the north, and at P'ing-ting Chou in the west, complete the quartet. The former dated from T'ang times, and the latter, dating from the

[1] 宣州 *T'ao lu*, vol. vii., fol. 10 verso.

[2] F. Brinkley, *Japan and China*, vol. ix., p. 259.

[3] Nyo-fu is the Japanese name for Kiang-nan, the province of which Anhui forms a part.

[4] In the district of Hsiao Hsien, department of Hsü Chou. The ware is described in the *T'ao lu* (bk. vii., fol. 7) under the name Hsiao 蕭 yao.

[5] 西窰.

Sung, was made of a dark-coloured clay which gave a dusky tinge to the white glaze. A small melon-shaped vase, reputed to have come from a tomb in Shansi, is shown in Plate 11. It has a hard, buff grey body, with a dressing of white slip and white glaze, the effect of the combination being a pleasing surface of solid-looking ivory white. A factory which made white wares in the neighbouring province of Shansi is named in the twelfth century *Ch'ing po tsa chih*.[1] It was situated at Huang-p'u Chên, in Yao Chou, where, as we are told in the *T'ao shuo*, they had at an early date made flat-bottom bowls which were called " little seagulls." The place is near Hsi-an Fu.

Wares of the *t'u ting*, the " earthy " Ting, type, with creamy glaze, were made at Nan-fêng Hsien,[2] in the province of Kiangsi, during the Yüan dynasty; and at Chi Chou[3] in the same province there were factories in the Sung dynasty which deserve some attention. The latter were situated at Yung-ho Chên, in the Chi Chou district, in the prefecture of Chia-an Fu, and one of the productions appears to have resembled the purple (*tzŭ*) Ting ware, though it was coarser and thicker, and of no great merit. The *Ko ku yao lun*[4] speaks of five factories in this place producing white and purple (*tzŭ*) wares, flower vases of large size and considerable value, and small vases which were ornamented, and crackled wares of great beauty. The best of these potteries belonged to a man named Shu 書. We are further informed by the *Chü chai tsa chi*[5] that Shu, the old man (*Shu wêng*), was skilled in making ornamental objects, and that his daughter, *Shu chiao* (the fair Shu), excelled him. Her incense burners and jars of various kinds commanded a price almost equal to that of Ko yao. The author proceeds to describe a dish and a bowl in his own collection as of " grey ware with invisible blue[6] glaze, which was capable of keeping water sweet for a month." It has been assumed that the decoration of the " small vases " was painted,[7] but the expression in the text (*yu hua*)[8] gives no clue to the kind

[1] Quoted in the *T'ao lu*, bk. ix., fol. 9.

[2] 南豐縣.

[3] 吉州.

[4] Bk. vi., fol. 23 verso. This account does not appear in the original edition, and was added in the later edition of 1459.

[5] Quoted in the *T'ao shuo*.

[6] 黝 *yu*, which means " black," or "invisible blue or green."

[7] See Bushell, *T'ao shuo*, p. 48.

[8] " Have ornament."

of decoration, and we are left quite in the dark as to its real
nature.

The industry seems to have ended abruptly at the beginning
of the Yüan dynasty, the story being that when the Sung minister
Wên was passing by all the ware in the kilns turned to jade, and
the potters, fearing that the event might reach the Emperor's ears,
closed down the kilns and fled to Ching-tê Chên. The meaning
of this myth has never been satisfactorily explained, but it was
pointed out that a large number of Yung-ho names appear in the
early lists of Ching-tê Chên potters, and the *Ko ku yao lun*
asserts that excavations on the site of the kilns were made in
the Yung Lo period (1403–1424), and that several kinds of jade
cups and bowls were found—cautiously adding, however, that
this might or might not have been the case. The ruins of the
Yung-ho potteries seem to have been still visible in the fifteenth
century.[1]

From a passage in the *T'ao lu* we learn that crackle was a
speciality of some of the Yung-ho potters. Under the heading of
Sui ch'i yao[2] (crackle wares), we are told that " these are the wares
made in the Southern Sung period. Originally they were a special
class of the ware made at Yung-ho Chên. . . . The clay was coarse
but strong, the body thick, the material heavy. Moreover, there
were 'millet coloured' (*mi sê*) and pale green (*fên ch'ing*) kinds.[3]
The potters used *hua shih* (steatite) in the glaze, and the crackle
was in running lines, like a broken thing. They smeared and
blackened the ware with coarse ink or ochreous earth ; then they
finished it. Afterwards they rubbed it clean, and it was found
to have hidden lines and stains of red or black, like cracked ice,
beautiful to look at. There were besides pieces with plain crackled
ground, to which they added blue decoration." This appears to
be the first mention of painted blue decoration, and if it is true
that it was made in the Sung period, it carries this important
method back farther than has been usually supposed. Possibly
the ware was of the same type as the coarse crackled porcelain,
with roughly painted blue designs, found in Borneo and Malaysia,
where it is credited with great antiquity. There is a very interest-

[1] See *Ko ku yao lun*, loc. cit.

[2] 碎器窯. *T'ao lu*, bk. vi., fol. 7 recto and verso.

[3] These must have resembled Ko yao. Hence, perhaps, the comparison in value
between the fair Shu's ware and the Ko yao, p. 98.

ing specimen in the Kunstgewerbe Museum, Berlin, which bears on this question. It came from Japan, where it had been treasured as a Chinese tea bowl of the Sung period, and it has a brownish green crackled glaze painted in dark blue with the characters *O mi t'o fo* (Amitabha Buddha), which was sometimes written in this way as a charm against evil.

CHAPTER VIII

TZ'Ŭ CHOU 磁州 WARE

A LARGE and important class of wares, closely related to the Ting group, was made at Tz'ŭ Chou, formerly in the Chang-tê Fu in Honan, and now included in the Kuang-p'ing Fu in Chihli. The name of the place, previously Fu-yang, was changed to Tz'ŭ Chou in the Sui dynasty (589–617 A.D.), and as it was derived, as Chinese writers are careful to explain, from the *tz'ŭ* stone from which the ware was made, we may infer that this material, and no doubt the local potteries, assumed importance at this early date. There were, in fact, a few fragments of pottery of the Tz'ŭ Chou type, decorated with brown spots, among the Chinese wares found on the ninth-century site of Samarra, in Persia, by Professor Sarre (see p. 148) ; and a finely painted fragment of a Tz'ŭ Chou vase in the Anthropological Museum at Petrograd was brought from a site in Turfan, which was in all probability as early as the tenth century. Moreover, it is constantly asserted by traders in China that this or that piece of painted Tz'ŭ Chou ware was found in a T'ang tomb, and in many cases, such as that of the brown-painted vase with lotus design mentioned on p. 33, the form of the specimen and the style of the decoration are quite consistent with a T'ang attribution. There is, however, no information on the subject earlier than the Sung dynasty, when the Tz'ŭ Chou factories enjoyed a high reputation.[1] The *Ko ku yao lun* gives the following brief notice of them under the heading " Old Tz'ŭ wares " :—

" Old Tz'ŭ wares (*tz'ŭ ch'i*) were made at Tz'ŭ Chou, in the Chang-tê Fu in Honan. Good specimens closely resemble Ting ware, but have not the tear-stains. There are, besides, specimens with engraved and painted[2] ornament. The plain white pieces command a higher price than Ting ware. The recent (i.e. late

[1] See *T'ao lu*, bk. vii., fol. 13 verso.
[2] *Hsiu hua*, lit. " embroidered ornament," but see p. 91.

fourteenth century) productions of the factory are not worthy of consideration."

If, as this account seems to imply, the Tz'ŭ Chou factories were in low water at the end of the Yüan dynasty, like many other potteries at this time, they managed to retrieve their fortunes, for they still carry on an unbroken tradition to this day.[1] The ware is in general use among the common folk of Peking and Northern China,[2] and is still decorated (though coarsely) in the antique style with free and sketchy painted designs in dark brown and maroon slip, the body being greyish white, with creamy crackled glaze. This is, of course, only one kind out of many, but the traditions have been so closely preserved that from this type alone it is easy to identify many Tz'ŭ Chou specimens among the early wares which have lately come from excavations in China.

The quantity of pottery produced at Tz'ŭ Chou in the last nine or ten hundred years must have been enormous, but as the post-Sung wares do not seem to have appealed to Chinese connoisseurs, little has been heard of it until recent times, and the stray specimens which did find their way to Europe were either unclassified or grouped with Corean specimens in deference to a mistaken Japanese opinion.[3] Now, however, considerable interest has been taken in the ware by Western collectors, and a plentiful supply is forthcoming, so that it is possible to make a comparative study of the different types, and to appreciate the varied and clever decorative methods of the Tz'ŭ Chou potters. But the conservative nature of the wares will always make it extremely difficult for us to fix the exact period during the many centuries when any individual piece was made, and the early dates assigned indiscriminately, though perhaps excusable on account of the archaic character of the painted decoration, should be accepted with caution.

The plain white Tz'ŭ Chou wares of the Sung period, which favourably compared with the Ting porcelain, have been identified in a few instances only by peculiarities of shape. Indeed, it is unlikely that we shall have any other means of discriminating them from the latter ware. But by far the largest group of

[1] For incidental reference to Tz'ŭ Chou vases and wine jars in the fifteenth and sixteenth centuries, see p. 128.

[2] See Bushell, *O. C. A.*, p. 164.

[3] See Brinkley, *Catalogue of the Exhibition at the Boston Museum of Arts*, 1884; also *Burlington Magazine*, August, 1911, p. 264.

the Tz'ŭ Chou family consists of the painted wares. Like the rest of the Tz'ŭ Chou pottery which has so far been identified, these have a greyish buff body of porcellanous stoneware usually coated with a white clay slip and covered with a transparent glaze almost colourless, but with a creamy tinge. On this glaze, and sometimes under it, the painters executed rapid, bold, and rather impressionist designs in shades of brown, varying from black to a soft sepia colour. The earliest specimens seem to have been of this kind, and it is certain that this method of decoration was practised in the Sung period, if not earlier.[1] In a few cases the glaze seems to have been omitted, the brown painting appearing on a lustreless white slip ; and where the brown or black colour was laid on in broad washes, details were often etched out with a pointed instrument. The black, moreover, when in considerable areas, sometimes developed passages of lustrous coffee brown[2] (due to the presence of iron), such as is seen in the " partridge cups " of Chien yao. It is probable that the Sung Tz'ŭ Chou ware, with its solid ivory white surface, often crackled, and its sketchy floral designs, may have served as a model to the Japanese for the Kenzan style of decoration and the ivory white Satsuma faience.

Another style of ornament, which may date from Sung times, and is certainly common on later wares, consists of a broad band of floral scrolls, with large lily or aster flowers, enclosed by smaller zones of floral pattern or formal designs. Next come the large panels of figure subjects, usually of Taoist sages, or birds and animals in foliage, enclosed by bands of formal ornament or floral scrolls. In some cases a beautiful pale blue glaze of turquoise tint covers this class of ornament (Plate 32, Fig. 1), strangely recalling the Persian and Syrian pottery with still black paintings under a turquoise glaze. Indeed, it was a common error a few years back

[1] The pottery found in Sung tombs near Wei Hsien, in Shantung, in 1903, includes a few examples of this type of ware with sketchy brown designs. Laufer (*Chinese Pottery of the Han Dynasty*, Appendix ii.) has illustrated this important find, though he is inclined to think that it may have been made at the neighbouring potteries of Po Shan Hsièn. If this is so, we must reckon with the fact, in itself not at all surprising, that other factories besides Tz'ŭ Chou were working on the same lines. See p. 107.

[2] It would appear that the Tz'ŭ Chou potters were capable of producing these lustrous brown passages in the black glaze intentionally, for the floral design on Fig. 1 of Plate 34 is expressed in this manner.

to class the stray specimens of this type as Persian; but a comparison with the brown-painted Tz'ŭ Chou specimens shows their true origin, and the discovery of a small dish of this kind in a Sung tomb[1] proves the antiquity of this method of decoration in China. The brown and black was supplemented, in the Ming period if not earlier, first by a maroon slip and later by iron red and green enamel.[2] A specimen with panelled decoration in these colours was described by Brinkley[3] as having been preserved in Japan since 1598, showing that this class of decoration was at any rate contemporary with the " red and green family " of porcelain. A specimen in the Benson Collection shows, further, that aubergine and green were sometimes used in combination with turquoise glaze, as in the Ming " three-colour porcelain." Underglaze blue is also found on Tz'ŭ Chou wares, but we have no clue to the date when it was introduced.

The ordinary ware, made in quite modern times at Tz'ŭ Chou, is illustrated by a small flask and a figure obtained by Dr. Bushell, and now in the British Museum. Though decorated in the characteristic style with slight sketchy design in brown and maroon, they show a decided falling off when compared with the older specimens. The body is a hard, greyish white stoneware; there is no slip covering, and the glaze is yellowish, soft-looking, and freely crackled, without the solid qualities of the older ivory glaze on a white slip coating. I am inclined to think that this degenerate type of ware dates back no farther than the nineteenth century, and that the Tz'ŭ Chou pottery preserved its character up to and perhaps throughout the eighteenth century. There are several examples of pottery pillows, with body and glaze of good quality and finely painted in black and brown, with panelled designs sometimes containing floral motives, sometimes figure subjects. One of these, exhibited at the Burlington Fine Arts Club in 1910,[4] was tentatively ascribed to the late Ming period. Since then the British Museum has acquired another, and I have heard of two more in private hands. The three last bear the mark of a potter named

[1] At Wei Hsien. See note on p. 103.

[2] There are specimens—mostly small bowls—of a very archaic appearance, with the red and green painting which are persistently claimed as of Sung period. But see p. 46 and Plate 30.

[3] *Catalogue of the Boston Exhibition*, op. cit., 1884.

[4] *Cat. B. F. A.*, 1910, E 63. This example has the mark of Wang Ch'ih-ming. See p. 221.

Plate 29.—Vase of Porcellanous Stoneware.

With creamy white glaze and designs painted in black. Tz´ŭ Chou ware,
Sung dynasty (960–1279 A.D.). Height 17 inches. *In the Louvre.*

Fig. 1

Fig. 2

Fig. 3

Fig. 4

Plate 30.—Four Jars of painted Tz'ŭ Chou Ware.

Fig. 1.—Dated 11th year of Chêng T'ing (1446 A.D.). Height 9½ inches. *Eumorfopoulos Collection.*
Fig. 2.—Painted in red and green enamels. (?) Sung dynasty. Height 4½ inches. *Alexander Collection.* Fig. 3.—Lower half black, the upper painted on white ground. Sung dynasty. Height 15½ inches. *Benson Collection.* Fig. 4.—With phœnix design, etched details. Sung dynasty. Height 9¾ inches. *Rothenstein Collection.*

Fig. 1

Fig. 2

Plate 31.—Tz'ŭ Chou Ware. *Eumorfopoulos Collection.*

Fig. 1.—Tripod Incense Vase in Persian style with lotus design in pale
aubergine, in a turquoise ground. Sixteenth century. Height 6½ inches.
Fig. 2.—Pillow with creamy white glaze and design of a tethered bear in
black. Sung dynasty. Length 12½ inches.

Fig. 1

Fig. 2

Plate 32.—Tz'ŭ Chou Ware. *Eumorfopoulos Collection.*

Fig. 1.—Figure of a Lohan with a Deer, creamy white glaze coloured with black slip and painted with green and red enamels. Said to be Sung dynasty. Height 12½ inches. Fig. 2.—Vase with *graffiato* peony scrolls under a green glaze. Sung dynasty. Height 16 inches.

Fig. 3

Fig. 1

Fig. 2

Plate 33.—Tz'ŭ Chou Ware.

Fig. 1.—Vase with panel of figures representing music, painted in black under a blue glaze. Yüan dynasty. Height 11½ inches. *Eumorfopoulos Collection.* Fig. 2.—Vase with incised designs in a dark brown glaze, a sage looking at a skeleton. Yüan dynasty. Height 12½ inches. *Peters Collection.* Fig. 3.—Vase with painting in black and band of marbled slips. Sung dynasty. Height 16 inches. *Eumorfopoulos Collection.*

Fig. 1

Fig. 2

Fig. 3

Plate 34.—Tz'ŭ Chou Ware. *Eumorfopoulos Collection.*

Fig. 1.—Bottle of white porcellanous ware with black glaze and floral design in lustrous brown. Sung dynasty or earlier. (?) Tz'ŭ Chou ware. Height 13½ inches. Fig. 2.—Bottle with bands of key pattern and lily scrolls cut away from a black glaze. Sung dynasty. Height 9½ inches. Fig. 3.—Bottle with graffiato design in white glaze

Chang,[1] and on some of them we find additional inscriptions containing the words *ku hsiang* (of old Hsiang) and *hsiang ti* (of the region of Hsiang). Hsiang, I find, is the old name of Chang-tê Fu, the prefecture in which Tz‘ŭ Chou is situated, and this fact definitely connects the ware with the factories under discussion. At the same time the relatively large number of these pieces in our collections and the style of Chang's mark seem to indicate that they are of fairly recent date, probably not older than the seventeenth century.

On the other hand, a greater age has been credited to these pillows in the belief that they are " corpse pillows " recovered from ancient tombs, a theory for which a quotation from a Ming writer in the *T‘ao shuo* is responsible.[2] It is stated that " the pillows of ancient porcelain that are two feet and a half long and six inches broad may be used. Those only one foot long are known as ' corpse pillows,' and are among the things found in ancient tombs ; and even when these are of white Ting Chou porcelain of the Sung dynasty, they ought not to be used." Now the pillows made by Chang and others are rarely more than a foot long, and according to this passage should be regarded as corpse pillows. But I cannot help thinking that either the measurements given are incorrect, or that the figures are inaccurately quoted ; for apart from the difficulty of making porcelain pillows thirty inches long, such a size would be wholly unnecessary, and is, in fact, more than twice the length of the ordinary Chinese pillow, as we know from existing examples in various materials. At the present day there is no such distinction in size between the two sorts of pillow, and de Groot[3] assures us that the head of the corpse is rested on a small pillow "not differing from those in use among the living."

From the same passage in the *T‘ao shuo* we learn that a curious belief existed in China that porcelain pillows were " efficacious in keeping the eyes clear and preserving the sight, so that even in old age fine writing can be read," and that this belief obtained as early as the Sung dynasty, much use of such pillows having been made in the court of Ning Tsung.

Among the many types of Tz‘ŭ Chou ware, old and new, figures and statuettes, usually of deities, played an important part. There are examples of coarse modern figures in the British Museum,

[1] See p. 221. [2] See Bushell, op. cit., p. 122. [3] Op. cit., vol. i., p. 91.

but there are others,[1] strong and forcefully modelled, which rank with the best ceramic statuary. These, no doubt, belong to the older and better periods. A good example is shown in Plate 32.

The other large group of Tz'ŭ Chou wares, that with engraved designs (*hua*, *hua*), is perhaps the most interesting of the three. One class, the white ware with carved ornament, if it existed, has been merged, like the plain white, in the Ting wares. The vase (Plate 33, Fig. 2) with brown glaze and panelled design exactly corresponding to those of the typical painted wares, but engraved with a pointed instrument through the brown glaze, forms a link between the two main groups.[2] But the more characteristic Tz'ŭ Chou engraved ornament is executed by what is usually known as the *graffiato* process, the lines of the design being cut through a layer of slip which contrasts in colour with the underlying material. This is illustrated by those vases on which the ornament is etched through a covering of white slip disclosing the greyish body beneath, or, better still, by specimens like Plate 34, Fig. 3, in which the ground of the pattern is freely cut away, exposing considerable areas of the body.[3] The greyish body colour combines with the transparent but creamy glaze to produce a delicate mouse-coloured surface, from which the pattern stands out in ivory white. In other cases a thick lustrous brown black glaze has been boldly carved, leaving the design to contrast with an unglazed grey biscuit (Plate 34, Fig. 3). By varying and combining these different methods, and by changing and counter-changing the slips, a great diversity of effects was readily obtained. It has been frequently remarked that some of the engraved specimens with bands of large foliage scrolls have an astonishing resemblance to Italian *graffiato* ware of the sixteenth century; and this resemblance is particularly striking when, as sometimes happens, a green glaze is used instead of the ordinary creamy covering. No doubt these carved wares, like their fellows with painted orna-

[1] See *Burlington Magazine*, August, 1911, and *Cat. B. F. A.*, D 19 and 41.

[2] The link is strengthened by the presence of the black painted bands which border the main designs. See also *Burlington Magazine*, loc. cit., August, 1911, " On Some Old Chinese Pottery."

[3] On a few specimens, the date of which is by no means certain, a design of leaves is executed by a peculiar process, in which an actual leaf seems to have been used as a stencil, being stuck on to the ware while the slip was applied, and afterwards removed, leaving a leaf-shaped pattern in reserve. A somewhat similar use of leaf stencilling is described on p. 133.

Tz ŭ Chou Ware 107

ment, were made for many centuries, but there is good reason to
think that they date back to early times, for fragments both of
the *graffiato* with white slip and mouse-coloured ground, and of
the dark brown glaze cut away, were found in Sir Aurel Stein's
excavations in Turfan on sites which can hardly have been open
after the twelfth century.[1] An important example recently
acquired by the British Museum actually bears a Sung date. It
is a pillow with carved panels on the sides containing each a large
flower and formal foliage ; and on the top is a panel with the
four characters *Chia kuo yung an* ("everlasting peace in the family
and state") etched in a ground powdered with small circles. This
panel is flanked by two incised inscriptions stating that the pillow
was made by the Chao family in the fourth year of Hsi Ning
i.e. 1071 A.D.). I have seen one other dated specimen of *graffiato*
Tz'ŭ Chou ware with beautifully carved floral designs and an
inscription of the year 1063. Another Tz'ŭ Chou type is seen in
a pillow in the Eumorfopoulos Collection which has passages of
marbling in black and brown, and small black rosette ornaments
inlaid in Corean fashion. The variety of decorations used on
this group of wares seems to be inexhaustible.

It has already been hinted that other factories were at work
on the same lines as Tz'ŭ Chou, and as we have no means of iden-
tifying their peculiarities, it would perhaps be safer to use some
such formula as "Tz'ŭ Chou type" in the ascription of doubtful
pieces. Po-Shan Hsien, in Shantung, was mentioned in a note
on p. 103, and the *T'ao lu*[2] gives a short account of another factory
at Hsü Chou,[3] in Honan, where the *tz'ŭ* stone (see p. 101) was also
used in wares which were both plain white and decorated. This
factory was active in the Ming dynasty, and it is stated that its
wares were superior to the "recent productions"[4] of Tz'ŭ Chou.

A reference to porcelain figures in Honan in the Sung dynasty
may be quoted in this connection. It occurs in the *Liang ch'i
man chih*, an early thirteenth-century work by Fei Kuan, and
runs as follows : "In Kung Hsien (in the Honan Fu) there are
porcelain (*tz'ŭ*) images called by the name of Lu Hung-chien. If

[1] See p. 134.
[2] Bk. vii., fol. 14. Some authorities seem to have considered that the Hsü Chou
factories go back to Sung times.
[3] 許州.
[4] The *T'ao lu* was written at the end of the eighteenth century.

you buy ten tea vessels you can take one image. Hung-chien was a trader who dealt in tea—unprofitably, for he could not refrain from brewing his stock. Hung-chien formerly was very fond of tea, and it brought him to ruin." Possibly the images of Hung-chien, which were given away with ten tea vessels, were made at Tz'ŭ Chou or Hsü Chou. Figures are still part of the stock-in-trade of the former factory.

CHAPTER IX

CHÜN WARES AND SOME OTHERS

Chün Chou 均州 *ware* [1]

THE Chün ware is said to have been first made in the early part of the Sung dynasty at Chün Chou or Chün-t'ai, the modern Yü Chou in the K'ai-fêng Fu in Honan. Like the Lung-ch'üan celadon, thanks to its strength and solidity, it has survived in sufficient numbers to give us some idea of the qualities which Chinese writers have described in picturesque terms. That it finds no mention in the *Cho kêng lu* and the *Ko ku yao lun* seems to imply that it was not appreciated by the virtuosi of the fourteenth century, owing, no doubt, to the fact that, as hinted in later works, it was chiefly destined for everyday uses and aimed at serviceable qualities rather than " antique elegance." By the end of the Ming dynasty, however, its beautiful glazes had won it a place among the celebrated Sung wares, although even at this time certain varieties only were considered estimable. The *Ch'ing pi ts'ang*, for instance, which appears to rank the Chün ware above that of Lung-ch'üan, gives the following criticism : " The Chün Chou ware, which is red like rouge, is highly prized ; that which is *ch'ing* like onion blue (*ts'ung ts'ui*), and that which is purplish brown (*tzŭ*) like ink, are esteemed second ; single-coloured pieces, which have the numerals one, two, etc., as marks on the bottom, are choice ; the specimens of this ware with mixed colours (*tsa sê*) are not worth collecting." It was not long, however, before even the despised " mixed colours " were not only appreciated by collectors, but studiously imitated by the Ching-tê Chên potters.

The body of the wares, which are now classed as " Chün type," varies considerably in quality and texture. The choicest examples in Western collections, usually deep flower pots or shallow bulb bowls with lovely glazes of dove grey, lavender, crushed straw-

[1] 均 is an alternative form of 鈞.

berry, dappled purple and crimson, and other tints, are made of
a clay which, though dark-coloured on the exterior, shows con-
siderable refinement and closeness of texture within. It is, in
fact, a porcellanous ware of whitish grey tone. It is noticed that
these pieces are almost always marked with incised Chinese numerals,
and there are critics who would confine the Chün wares to this
group alone. But it is clear from a passage in the *Po wu yao lan*[1]
that there were other types in which the body was of "yellow
sandy earthenware," coarse and thick, and without refinement,
with all the characteristics, in fact, of the ware which these same
critics habitually relegate to the category of *Yüan tz'ŭ*, or ware
of the Yüan dynasty. But we shall return to this question later.
Modern Chinese collectors, we are told,[2] in recognition of these
distinctions, classify Chün wares in two groups, *tz'ŭ t'ai* (porcelain
body) and *sha t'ai* (sandy, or coarse-grained, body).

The Chün glazes are of the thick, opalescent kind which flows
sluggishly and often stops short of the base in a thick, wavy roll
or in large drops. On the upper edges of the ware they are thin
and more or less transparent and colourless, but in the lower parts
and the hollows in which the glaze collects in thick masses the
depth and play of the colour are wonderful. These irregularities
are specially noticeable on the coarse bodies, but even on the more
refined specimens where the glaze has a smoother flow and more
even distribution, the colour is never quite continuous or unbroken.
In the opalescent depths of the glaze, bubbles, streaks, hair-lines,
and often decided dappling are observed, and a scarcely perceptible
crackle is usually present.[3] Some of these markings which varie-

[1] Bk. ii., fol. 7 verso. In discussing the glazes with mixed colour, the author says :
"Of these wares, the sword-grass bowls and their saucers alone are refined. The other
kinds, like the garden seats, boxes, square vases, and flower jars, are all of yellow sandy
earthenware. Consequently, they are coarse and thick, and not refined." The first
sentence is difficult, and has given rise to much discussion. The word *ti*, which Bushell
has (rightly, I think) rendered saucers, literally means "bottom" or "base." Hirth
reads it, "Those which have bottoms like the flower pots in which sword-grass is grown
are considered the most excellent " ; and Julien appears to have quite misunderstood
the application of the passage. The original is 此窰惟種菖蒲盆底佳甚. The shallow
saucers in which the deep flower pots stood are often included among the bulb
bowls. See Plates 37 and 40.

[2] See the excellent account of the Chün wares by Mrs. Williams in the introduction
to the *Catalogue of a Loan Exhibition of Chinese, Corean, and Japanese Potteries held
by the Japan Society of New York*, 1914.

[3] Shrivelled glaze is sometimes seen on the Chün types of pottery. Probably this
was at first, at any rate, an accidental effect ; but it is the prototype of the "dragon

gate the surface of the Chün wares have been noticed by Chinese writers as " hare's fur marking " and " flames of blue." [1] Others, which appear to be irregular partings in the colour of the glaze, have been named *ch'iu ying wên* or " earthworm marks." These last rarely appear except on the finer type of Chün wares, and, like the "tear stains " on the Ting porcelains, they are regarded as signs of authenticity.

Though the beautiful Chün wares of the *tz'ŭ t'ai* group will always be rare and costly, Western collectors have been fortunate in securing a fair number of specimens, and a wonderful series of them was brought together in March, 1914, in the exhibition held by the Japan Society of New York. The forms of the flower pots vary considerably. Some have globular body with high spreading neck and wide mouth ; others are bell-shaped like a deep cup ; others are deep bowls with sides shaped in six or eight lobes like the petals of a flower ; others are of quatrefoil form ; and others of oblong rectangular shape with straight sides expanding towards the mouth. The saucers in which they stood are shallow bowls corresponding in form to the pots, but supported by three or four feet which are usually shaped like the conventional cloud scroll or *ju-i* head. They are otherwise without ornament, except in the case of the plain rounded saucers, which have two bands of raised studs or bosses, borrowed, no doubt, from a bronze vessel. These flower pots and saucers are almost invariably incised with a numeral under the base, and the fact that when the pots and saucers fit properly the numerals on each are found to tally seems to indicate they are, as suggested below, size numbers. But there is no doubt that

skin " glazes which the Japanese made at a later date. There is a good example in the Eumorfopoulos Collection of a bowl with thick grey Chün glaze, with a patch of reddish colour, and which is shrivelled in the most approved fashion, the glaze contracting into isolated drops and exposing the body between them.

[1] See *T'ao shuo*, bk. ii., fol. 15 verso, quoting the *Liu ch'ing jih cha.* In the case of the former (*t'u ssŭ wên*) some confusion has been caused by a variant reading 莵 of the word 兎 (*t'u* = hare), which refers the simile to the " dodder " ; but the commoner phrase, " hare's fur marking," is far more descriptive of a dappled surface. Brinkley's explanation of the second phrase, *huo yen ch'ing*, as referring to the blue centre of a tongue of flame, applying the simile to the passages of blue which sometimes occur in the variegated Chün glazes, seems to meet the case. The flame-like effects are mentioned in an interesting passage in the *T'ang chien kung t'ao yeh t'u shuo* (quoted in the *T'ao lu*, bk. viii., fol. 13) : " Men prize the Chün cups, tripods, and incense burners with smoke and flame glaze (*yen huan sê*). Although only pottery, still they combine the unexpected colours produced by the blowing tube (*t'o yo*)." The *t'o yo* 橐籥 seems to have been " a pipe for blowing up the furnace."

the saucers or stands were often used separately as bulb bowls, like the vessels of similar shape which are found in celadon and other wares. Vases of the fine Chün ware are occasionally seen. There is a choice example in the Pierpont Morgan Collection, a small ovoid vase with flat base; and in the same collection is a low beaker-shaped vase with flaring neck and globular body strengthened with four square ribs in imitation of a bronze.[1] No numbers have appeared so far on any of these vases, nor, as far as I am aware, on any Sung Chün wares except the flower pots and saucers. I have, however, seen dishes on which a number has been subsequently cut, and numbers occur on later copies of the Chün types described below.

The numerals engraved under the base of the flower pots, saucers, and bulb bowls in the finer Chün wares range from 1–10. Their significance has given rise to some debate, but the most reasonable theory seems to be that they indicate the sizes of the different forms, No. 1 being the largest, though an extra large bulb bowl[2] in the Eumorfopoulos Collection has the additional mark 大 *ta* (great). This is the view which, I believe, is usually accepted in China, and Mr. Eumorfopoulos, who has an exceptional series of these wares, has applied the test to all he has seen, and has found the size theory to hold good in all but a few cases, for which an explanation may yet be found.[3] Another suggestion, supported by some American collectors of note, such as Mr. Freer and Mr. Peters, is that the numbers refer to the Imperial kilns, and that the pieces so marked are Imperial wares. Whether the former theory will continue to stand the test of application to every fresh specimen remains to be seen. With regard to the latter, I shall give reasons presently for doubting that any special Imperial patronage was extended to this kind of ware; and whatever truth there may be in this explanation of the numbers, it is highly improbable that any serious evidence can ever be produced to sustain it.

It would be possible to construct a formidable list of the colours which appear in the Chün glazes, though many of the

[1] See Hamilton Bell, "'Imperial' Sung Pottery," *Art in America*, July, 1913, p. 182. The Chinese numerals are given on p. 211.

[2] *Cat. B. F. A.*, 1910, B 42.

[3] There is an obvious analogy in the "*size* 3" and "*S* 2," etc., incised under the Derby porcelain figures.

accidental effects would be very difficult to describe. On the edges and salient parts where the glaze is thin the colour is usually a transparent olive green which passes with the thickening of the glaze into a frothy grey shot with fine purple streaks. The grey sometimes remains thick and opaque, covering large areas, and it is liable to become frosted over with a dull film of crab-shell green. It is in this frosting and in the opaque curded grey that the V-shaped and serpentine partings known as "earthworm marks" most frequently occur; and sometimes a steel blue colour emerges in these partings and in small spots in the grey. For under the grey there seems to be always blue and red struggling upwards towards the surface. Hence the blue and lavender tinge which is so constant, the t'ien lan of the Chinese. But it is the red which almost always triumphs, emerging in fine streaks of purple, crimson or coral, like the colour lines in shot silk, or in strong flecks and dappling, completely overpowering the grey, which only remains on sufferance in a few fleecy clouds. The fine lines of colour are usually associated with a smooth silken surface to which a faint iridescence gives additional lustre; whereas the strongly dappled and mottled glaze is full of bubbles and pinholes (sometimes called "ant tracks" by the Chinese) which give the surface the seeded appearance of a strawberry. The red dappling is usually opaque and tending towards crimson or rouge red. It will be seen that the red varies in quantity from a mere tinge or flush to the intensity almost of a monochrome, and in tone from a pale or deep lavender to aubergine, plum purple, rose crimson, and rouge red. Making allowance for the capricious nature of Chinese colour words, these tints will be found to correspond with several of those indicated in the Yung Chêng list quoted on p. 119. On rare examples the grey and red colours are in abeyance, and the dominant tint is the transparent olive green, which is usually confined to the edges. This and the crab-shell green mentioned above supply the green shades which the Chinese writers include among the Chün colours.

But none of these glazes can with strict accuracy be described as monochromes "of uniformly pure colour" which the *Po wu yao lan* seems to have regarded as indispensable in the first-class Chün ware. In fact, it is difficult to conceive the possibility of a Chün glaze of perfectly uniform tint, without any trace of the perpetual war waged in the kiln between the red, grey, and blue elements. The nearest approach to a single colour is seen in some

of the grey glazes, but here, too, the colour is only relatively pure ; and I am convinced that the expression used by the *Po wu yao lan* is exaggerated, and the meaning is that the nearer the Chün colours approach to uniformity the more they were prized. It is true that several examples depicted in Hsiang's Album are monochrome purple, but I have no more confidence in the colouring of these illustrations than in the carved decoration which is indicated under their glaze, a phenomenon unrecorded in any other Chinese work, unexampled in any known specimen of the ware, and unlikely in view of the nature and the thickness of the Chün glaze itself.

It is clear, however, that an exaggerated mottling of the glaze and a confusion of many colours was viewed with disfavour by the old Chinese connoisseurs. These effects were explained in the *Po wu yao lan* as due to insufficient firing. Regarded in this light they were viewed with contempt by the earlier Chinese writers and labelled with mocking names, such as *lo kan ma fei* (mule's liver and horse's lung), pig's liver, and the like. In reality, they were the forerunners of the many delightful *flambé* glazes which the eighteenth-century potters were able to produce at will when they had learnt that, like all the Chün colours except the brown glaze on the base, they could be obtained from oxide of copper under definite firing conditions. How far the old Chün effects were due to opalescence[1] it is impossible to say, but we know that all of them can be obtained, whether turquoise, green, crimson, or lavender grey, by that " Protean medium," oxide of copper, according as it is exposed in the firing to an oxidising or reducing atmosphere, conditions which could be regulated by the introduction of air on the one hand, or wood smoke on the other, at the right moment into the kiln.

It should be added that the finer Chün wares as seen in the flower pots and stands have an olive or yellowish brown glaze over the base, which in rare instances is overrun by frothy grey or lavender. Another constant feature of these pieces is a ring of small scars or " spur marks " on the base.

The list of porcelains made at the Imperial factories about 1730 [2] includes a series of imitations of Chün glazes from specimens sent

[1] See p. 50.
[2] See *Chiang hsi t'ung chih*, vol. xciii, fol. 11 and seq. Quoted also in the *T'ao lu*, and translated by Bushell, *O. C. A.*, p. 369 ; and vol. ii., p. 223, of this work.

Fig. 1

Fig. 2

Plate 37.—Chün Chou Ware with porcellanous body (*tz'ŭ t'ai*).
Sung dynasty.

Fig. 1.—Flower Pot, with lavender grey glaze. Numeral mark, *ssŭ* (four).
Diameter 8¾ inches. *Eumorfopoulos Collection.* Fig. 2.—Bulb Bowl, of
quatrefoil form, pale olive glaze clouded with opaque grey. Numeral mark,
i (one). Length 10 inches. *Freer Collection.*

from the palace collections, which serve at once to show the variety of Chün colours and the extent to which they were copied. The actual colours described are :

 (1) Rose purple (*mei kuei tzŭ* 玫瑰紫).

 (2) Cherry apple red (*hai t'ang hung* 海棠紅).

 (3) Purple of the aubergine flower (*ch'ieh hua tzŭ* 茄花紫).

 (4) Plum bloom (*mei tzŭ ch'ing* 梅子青).

 (5) Donkey's liver and horse's lung (*lü kan ma fei* 驢肝馬肺), with the addition of four kinds obtained from other sources.[1]

 (6) Deep purple (*shên tzŭ* 深紫).

 (7) " Millet colour " (*mi sê* 米色).

 (8) Sky blue (*t'ien lan* 天藍).

 (9) Furnace transmutation or *flambé* (*yao pien* 窰變).

The potters of the Yung Chêng period (1723–35) succeeded wonderfully in their work of imitation, and existing examples bear witness to the beautiful colour effects which they obtained. The body of the ware, however, was, as a rule, a fine white porcelain,[2] which had to be carefully concealed by the brown glaze on the base. Many of the Yung Chêng specimens are marked with the seal mark of the period, and occasional instances occur in which this mark has been ground off in order to pass the piece as old. I have such a specimen, which was actually bought in the trade for Sung. It is a small dish, with beautiful turquoise green glaze in the centre and a *flambé* red on the sides. The place where the mark has been ground away when washed clean showed a fine white porcelain body. It is stated in the *T'ao lu* that the potters at Ching-tê Chên began to imitate the Chün wares towards the end of the Sung dynasty. No evidence is given to support the assertion, which may be merely a local tradition ; but one certainly sees occasional specimens with a porcelain body masked by a dark brown clay dressing under the base, the glazes of which obviously imitate the Chün. There are, for instance, saucers and bowls of this kind with purple glaze finely shot with grey on the exterior and a lavender grey inside which appear to be older than

[1] *Wai hsin tê* 外新得, lit. " recently obtained from outside." *Wai* evidently contrasts here with *nei* (the palace), which precedes the first five. Julien, however, gives it the sense " *emaux nouvellement inventés.*"

[2] See *T'ao lu*, bk. vi., fol. 7. " As to the ware made at Ching-tê Chên at the present day in imitation of the Chün wares, the body material is all of beautiful quality." This carries the imitation up to the end of the eighteenth century. There are, however, imitations made on a soft pottery body which bear the Yung Chêng mark.

the Yung Chêng period, though their shape precludes a greater age than the Ming dynasty.

There are, however, many other imitations of Chün ware in which the body is not of tell-tale white porcelain. The *Po wu yao lan*, for instance, written at the end of the Ming dynasty, states that " in the present day among the recent wares all this type of ware (viz. the Chün type) has the sandy clay of Yi-hsing [1] for its body ; the glaze is very similar to the old, and there are beautiful specimens, but they do not wear well." Yi-hsing is the place where the red stoneware tea pots, often called Chinese " buccaro," were made, and we know that a Yi-hsing potter, named Ou, was famous at the end of the Ming dynasty for his imitations of Ko, Kuan, and Chün glazes.[2] A bowl in the British Museum seems to answer the description of Ou's ware. It has a hard red stoneware body, and a thick undulating glaze of pale lavender blue colour, the comparative softness of which is attested by the well-worn surface of the interior.

The " Yung Chêng list " includes yet another type based upon Chün ware. It is called " Chün glaze of the muffle kiln," clearly a low-fired enamel rather than a glaze, whose colour is between the Kuangtung ware and the added[3] glaze of Yi-hsing, though in surface-markings, undulations and transmutation tints it surpasses them. This appears to be the " robin's egg " type of glaze,[4] to use the American collector's phrase, a thick, opaque enamel of pale greenish blue tint flecked with ruby red (see Plate 128).

The manufacture of glazes of the Chün type has continued at Yi-hsing since the days of Ou, and what is called Yi-hsing Chün is still manufactured in considerable quantity, the streaky lavender glazes being of no little merit. When applied to incense burners and vessels of archaic form, they are capable of being passed off as old, though the initiated will recognise them by their want of depth and transparency and by the peculiar satiny lustre of their surface.

[1] See p. 174.

[2] See p. 181. The list quoted on p. 223 of vol. ii. of the wares made at the Imperial potteries in 1730 includes " glazes of Ou : imitated from old wares of a man named Ou. There are two kinds, one with red markings, the other with blue."

[3] *kua yu* 掛釉 " applied or added glaze." The significance of the epithet *kua* lies in the fact that the bulk of the Yi-hsing ware was unglazed.

[4] See Bushell, *O. C. A.*, p. 374.

Another ware which has a superficial resemblance to Chün yao has been made for a long period at the Kuangtung factories,[1] if it does not actually go back to Sung times. A typical specimen, shown in Plate 51, is a vase of baluster form with wide shoulders strengthened by a collar with foliate edge, and small neck and mouth, ornamented with a handsome lotus scroll in relief. The body is a buff stoneware, and the glaze is thick, opaque, and closely crackled, and of pale lavender grey warming into purple.

Glazes of this kind have been made at several potteries in Japan e.g. Hagi, Akahada, and Seto.[2] Besides such specimens as this, there are many of the streaky, mottled Canton stonewares which are remotely analogous to the variegated Chün wares. The glazes of this type are more fluescent than those described in the preceding paragraph and have greater transparency, and the intention of their makers to imitate Chün types is shown by incised numerals which are occasionally added under the base. They are known in China as Fat-shan Chün, from the locality in which they are made, and though some examples may go back to Ming times, the best may, as a rule, be ascribed to the eighteenth century and the indifferent specimens to the present day.

From this digression on Chün imitations to which the mention of Yi-hsing led us, we must return to the original wares. It has been said that Chinese connoisseurs recognise two groups of Chün ware, the *tz'ŭ t'ai* and the *sha t'ai*, and there is no doubt that the contrast between the body material of the two is very marked. In explanation of this the Chinese to-day allege [3] that the flower pots and stands were made of a tribute clay sent annually from the Ching-tê Chên district to the " Imperial kilns " at Chün Chou, and that the coarser articles were made of native clays. The story has the air of an *ex post facto* explanation, and it is open to many grave objections. In the first place it is nowhere mentioned in Chinese literature, and in the second place the Chün Chou kilns, so far from having been described as " Imperial " in the Sung dynasty, are entirely ignored by the earlier writers, and even in the late Ming works, where they are first mentioned, the Chün wares are reckoned as of secondary importance. Thirdly, there does not seem to have been any need to import kaolin, for Chün Chou was in

[1] See p. 168.
[2] See *Burlington Magazine*, November, 1909, Plate iv., opp. p. 83.
[3] See Mrs. Williams, loc. cit., p. 33.

one of the kaolin producing districts of China.[1] There are, more-
over, many specimens of the Chün type which hold an intermediate
position between the finer flower pots and the coarse " Yüan tz'ŭ "
wares, and these have a decidedly porcellanous body, though in-
clined to be yellowish at the base rim. Some of these have glazes
almost as smooth and even as the flower pots, and of a beautiful
lavender grey colour with patches or large areas of aubergine or
amethystine purple, which in rare cases covers the entire exterior
of a bowl. In their finer types they are scarcely distinguishable
from the specimens which we have tentatively classed as Kuan on
p. 65, and in their coarser kinds they seem to belong to the so-
called " Yüan tz'ŭ " which are discussed at the end of this chapter.

Meanwhile, we must consider a very distinctive group to which
the term *sha t'ai*, in its sense of " sandy body," applies with par-
ticular exactitude. In the catalogue of the New York exhibition
of March, 1914, I ventured to differentiate this type by the name
of " soft Chün," which its general appearance seems to justify.
It is well illustrated in Plates 38 and 39. The body is buff and
varies in texture from stoneware to a comparatively soft earthen-
ware not far removed in colour from that of delft or maiolica,
though, like so many Chinese bodies, it has a tendency to assume
a darker red brown tint where exposed at the foot rim. The glaze
is unctuous and thick, but not opaque, often, indeed, showing con-
siderable flow and transparency : it is opalescent, and at times
almost crystalline, and endued with much play of colour. It varies
from a light turquoise blue of great beauty to lavender and occa-
sionally to a strong blue tint, and, as a rule, it is broken by one
or more passages of crimson red or dull aubergine purple, some-
times in a single well-defined patch, sometimes in a few flecks or
streaks, and sometimes in large irregular areas. This glaze usually
covers the entire exterior and appears again under the base, leaving
practically no body exposed except at the actual foot rim. It has
been attributed to various factories. The pure turquoise specimens
have even been called Ch'ai, and a little piece of this kind was
figured by Cosmo Monkhouse[2] as Kuan ware. On the other hand,
I am told[3] that it is widely known in China as *Ma chün*,[4] and is

[1] The modern Yü Chou. See vol. ii., p. 107.
[2] Op. cit., Plate 1.
[3] By Mr. A. W. Bahr.
[4] The name *Ma* is supposed to be that of a potter, but the statement is based on
oral tradition only. The character used is *ma* (horse).

usually thought to be of the Ming dynasty, but no reason is assigned for either the name or the date, and both seem to be based on traders' gossip to which no special importance need be attached. A fine vase of this kind in the British Museum has been much admired by Chinese connoisseurs, and they have, as a rule, pronounced it to be Sung. The important specimen (Plate 39) in the FitzWilliam Museum, Cambridge, was obtained from a tomb near Nanking,[1] a circumstance which is in favour of an early origin. In other respects this class of ware seems to answer to the aubergine and " sky blue " Chün types described by Chinese writers, and I regard it as one of the Sung varieties of Chün Chou ware, with " yellow, sandy earthenware " body of which the *Po wu yao lan* makes mention.[2]

That it continued to be made after the Sung period is practically certain, and there are specimens which one would unhesitatingly regard as Ming or Yüan from their form. But, on the other hand, the prevailing shapes are of the Sung kind, and we have very little to guide us in dealing with the various Chün types except the form and the quality of the ware. The " soft Chün " was very closely imitated at Yi-hsing on a yellowish body which resembles the original in colour, but is generally harder, with a thick unctuous glaze of somewhat crystalline texture and a turquoise lavender colour, with rather thin and feeble patches of dull crimson, which lack the spontaneous appearance of the originals. These Yi-hsing copies are often marked with an incised numeral like the Canton Chün.

With regard to the duration of the Chün Chou factories, the standard Chinese works on ceramics are curiously silent. They take no account of the ware after the Sung period, and leave us to infer that it either ceased to be made or ceased to be worthy of mention after that time. In two places only have I found any hint of its survival in later times. One is an incidental mention of Sung, Yüan, and Ming Chün wares in a modern work,[3] and the other is in the pottery (not the porcelain) section in the great K'ang Hsi Encyclopædia.[4] The latter passage is taken from the administrative records of the Ming dynasty, and contains two references

[1] It was deposited in the FitzWilliam Museum by Mr. W. H. Caulfield in 1896.

[2] See p. 110.

[3] The *Li t'a k'an k'ao ku ou pien*, of which the British Museum possesses a copy dated 1877.

[4] The *Ch'in ting ku chin t'u shu chi ch'êng*, fol. 10 of the subsection dealing with t'ao kung (the pottery industry), entitled *T'ao kung pu hui k'ao*.

to large supplies of vases (*p'ing* and *t'an*) and wine jars obtained from Chün Chou and Tz'ŭ Chou in the Hsüan Tê period (1426–1436) and in the year 1553 of the Chia Ching period. We further learn that in 1563 an Imperial edict abolished both the tax which had previously been levied on the Chün Chou wares and the subsidy which had to a great extent counterbalanced the tax. These documents prove beyond doubt that potteries of considerable size existed at Chün Chou in the Ming dynasty, though their mention in this particular context seems to imply that the ware was no longer ranked among the porcelains, and had apparently ceased to be regarded as an artistic production.

From this time onwards to the present day the ceramic history of this district is a blank, and we are unable to say whether the modern Yü Chou pottery is a continuation or only a revival of the ancient art of the place. A specimen of this modern ware in the Field Museum, Chicago, has close affinities with the " soft Chün." Its base shows a buff stoneware body washed over with dark brown clay, and the glaze is somewhat opalescent though thinner than the old glaze, and its colour is a light blue of a tint more grey than turquoise. Quantities of this modern Yü Chou ware are to be found in Peking, and occasionally it is passed off as old Chün, but no one with experience of the originals would be deceived by it.

Finally, there is the important group of wares obviously belonging to the Chün family but commonly described as Yüan tz'ŭ or ware of the Yüan dynasty (1280–1367), although no sanction for this name is found in the older Chinese books. The ware, however, is fairly common in the form of bowls, shallow dishes, and, more rarely, vases and incense burners. The bowls which are the most familiar examples are usually of conical form, with slightly contracted mouth and small foot, coated with thick fluescent glazes, which form in deep pools at the bottom within, and end outside in thick drops or a billowy line some distance above the base, leaving a liberal amount of the body material exposed to view. The body is of the *sha t'ai* class and usually of coarse grain, varying from a dark iron grey to buff stoneware and soft brick red earthenware, though, as already noted, there are finer specimens which link it with the *tz'ŭ t'ai* group. It is this roughness of substance which has caused the ware to be relatively little esteemed in China, for the glaze is often of singular beauty. The varieties in colour are

Fig. 1

Fig. 2

Plate 40.—Chün Chou Ware.

Fig. 1.—Bulb Bowl, porcellanous ware with lavender grey glaze passing into mottled red outside. Numeral mark, *i* (one). Sung dynasty. Diameter 9¼ inches. *Eumorfopoulos Collection.* Fig. 2.—Vase of dense reddish ware, opalescent glaze of pale misty lavender with passages of olive and three symmetrical splashes of purple with green centres. Sung or Yüan dynasty. Height 10⅜ inches. *Peters Collection.*

Fig. 2

Fig. 1

Plate 41.—Chün Chou Ware.

Fig. 1.—Dish with peach spray in relief. Variegated lavender grey glaze with purplish brown spots and amethyst patches, frosted in places with dull green. Sung dynasty. Diameter 8½ inches. *Freer Collection.* Fig. 2.—Vase and Stand, smooth lavender grey glaze. Sung or Yüan dynasty. Height 7¾ inches. *Alexander Collection.*

innumerable and clearly due to the opalescence of the thick, bubbly glaze, combined with the ever-changing effects of copper oxide on a highly fired ware. Lavender grey, dove grey, brown, and grey green are conspicuous, but as the thickness of the glaze varies with its downward flow, so the colour changes in tone and intensity from a thin, almost colourless skin on the upper edges to deep pools of mingled tints where the glaze has collected in thick masses. It is usually streaky and shot with fine lines of colour, but some- times there are large areas of misty grey or greenish brown tones too subtle for description. A section of these glazes will generally disclose the presence of red, and this red often bursts out on the surface in patches which contrast vividly with the surrounding tones. If the patches are large they will be found to shade off into green in the centre or at the edges. It should be added that crackle is almost always present, though it varies much in intensity and does not seem to have been intentional.

Decoration of any kind is unusual on these wares except on the large tripod incense burners, which often have slight applied reliefs in the form of animals, dragons, or peony sprays. Mr. Freer's dish (Plate 41, Fig. 1) with the raised floral spray is quite exceptional.

Whatever the verdict may be on the technical qualities of these rugged pieces as compared with more finely finished porcelain, there can be no doubt of the artistic merit of the subtle glaze colours, and I have seen people whose undoubted taste in other forms of art had not previously been directed to things ceramic, display a sudden and unexpected enthusiasm over the rough Yüan bowls. The peculiar shape of these bowls—which, without their foot take the form of a half coco-nut—has raised the question whether it can be in any way connected with the Polynesian khava bowls. The latter are actually made of coco-nut, and, curiously enough, their interior after much use acquires a vivid patina, whose colour recalls some of the Yüan tz'ŭ glazes. The resemblance, however, remarkable as it is, can only be accidental, for it is practically certain that the tints of these ceramic glazes were quite unfore- seen. Long use has usually given the surface of the Yüan tz'ŭ a smooth, worn feeling, but in its first freshness the glaze had a very high and brilliant lustre. This is shown by a few pieces which have lately been sent from China, where they were excavated evidently on the site of the old factory, and still remain in their

seggars or fireclay cases to which they became attached by some accident in the kiln. These and other spoilt pieces or wasters would be of immense interest if only the circumstance of their find-ing had been faithfully recorded. Unfortunately, however, they passed through many hands before reaching Europe, and we have only hearsay to support the statement that they were found in the neighbourhood of Honan Fu. The locality is a likely enough spot and not remote from Chün Chou, but we must consider that the real origin of the Yüan tz'ŭ has yet to be settled, and we must still remain in doubt whether the ware is a coarse variety of Sung Chün Chou ware, a continuation of that manufacture in the Yüan dynasty, or the production of a different factory. Judging from the character of the glazes, I am inclined to accept the first two alternatives, which are not mutually exclusive, for while many of the specimens have the appearance of Sung wares, there is every reason to suppose that the manufacture continued through the Yüan period. The formula, " Sung or Yüan ware of Chün type," adopted in the catalogue of the exhibition at the Burlington Fine Arts Club in 1910, is a discreet compromise which may well be retained till further evidence from China is forthcoming.

The evidence of Sir Aurel Stein's excavations in the regions of Turfan, imperfect as it is, points to the existence of this kind of ware at least as early as the Sung dynasty. Fragments with the typical glaze of the so-called Yüan-tz'ŭ were found, for instance, on a site which was thought to have been closed in the Sung dynasty, and again at Vash-shahri, which was " believed to have been occupied down to the eleventh or twelfth century." Making ample allowance for error in calculating the dates of these buried cities, we may still fairly consider that some of these finds come within the limits of the Sung dynasty.

Chien 建 yao

This ware, which has already been mentioned in several pas-sages, originated at Chien-an, but the factory was subsequently removed to the neighbouring Chien-yang. Both places are in the Chien-ning Fu, in the province of Fukien, and the term Chien yao derives from the character *chien,* which occurs in all these place names. The beginning of the manufacture is unknown, but it certainly dates back to the early Sung period, being mentioned

Fig. 1

Fig. 2

Plate 42.—Two *Temmoku* Bowls, dark-bodied Chien yao of the Sung dynasty.

Fig. 1.—Tea Bowl (*p'ieh*), purplish black glaze flecked with silvery drops. Diameter 7½ inches. *Freer Collection.* Fig. 2.—Tea Bowl with purplish black glaze shot with golden brown. Height 3¾ inches. *British Museum.*

Fig. 1

Fig. 2

Fig. 3

Plate 43.—Three Examples of "Honan *temmoku*," probably T'ang dynasty.

Fig. 1.—Bowl with purplish black glaze, stencilled leaf in golden brown. Diameter 6 inches. *Havemeyer Collection.* Fig. 2.—Ewer with black glaze. Height 4¾ inches. *Alexander Collection.* Fig. 3.—Covered Bowl, black mottled with lustrous brown. Height 7 inches. *Cologne Museum.*

in a tenth-century work,[1] and the potteries were still flourishing at the commencement of the Yüan dynasty.[2] A characteristic specimen figured in Plate 42 is a tea bowl with soft, dark brown earthenware body and thick, lustrous, purplish black glaze, mottled and streaked with golden brown. The brown forms a solid band at the mouth and tails off into streaks and drops on the sides, finally disappearing in a thick mass of black. The spots and streaks of brown suggested to Chinese writers the markings on a partridge's breast or on hare's fur, and the bowls are usually known as " hare's fur cups " [3] or " partridge cups." The dark colour of the glaze made them specially suitable for the tea-testing competitions which were in fashion in the Sung period, the object of the contest being to see whose tea would stand the largest number of waterings, and it was found that the least trace of the tea was visible against the black glaze of the Chien bowls. The testimony of an eleventh-century writer [4] on this point is of interest. " The tea," he says, " is light in colour and suits the black cups. Those made at Chien-an are purplish black (kan hei) with markings like hare's fur. Their material, being somewhat thick, takes long to heat, and when hot does not quickly cool, which makes them specially serviceable. No cups from any other place can equal them. Green (ch'ing) and white cups are not used in the tea-testing parties."

The Chinese tea contests were adopted by the Japanese, who elaborated them into the curious ceremony known as Cha no yu, which later assumed a semi-political aspect. The Japanese Cha jin (initiates of the tea ceremony) have always prized the Chien yao bowls, to which they gave the name temmoku, and Brinkley speaks of a great variety of Chien yao glazes which he saw in Japan. Of some he says that " on a ground of mirror black are seen shifting tints of purple and blue; reflections of deep green, like the glossy

[1] The Ch'ing yi lu, quoted in the T'ao shuo, bk. v., fol. 16 verso : " In Min (i.e. Fukien) are made tea bowls with ornamental markings like the mottling and spots on a partridge (chê ku pan). The tea-testing parties prize them." Oddly enough, the only specimen of this type of ware which I have seen with a date-mark was dated in the reign of Hsien Tê (954-960) of the Posterior Chou dynasty; but the inscription had been cut subsequently to the firing of the ware, and carries little weight. The piece in question is a remarkably large bottle-shaped vase with a splendid purplish black glaze with " hare's fur " marking, in the Eumorfopoulos Collection.

[2] See T'ao lu, bk. vii., fol. 8 verso.

[3] 兔毫盞 t'u hao chan.

[4] Ts'ai-hsiang, quoted in the T'ao shuo, bk. v., fol. 16 verso.

colour of the raven's wing; lines of soft silver, regular as hair."
The tea-testing contests seem to have lost popularity in China
at an early date, and late Ming writers took little interest in the
partridge cups, which one [1] at least of them voted "very inferior."
In Japan, on the other hand, the vogue of the tea ceremonies has
continued unabated to modern times, and no doubt the Chien
bowls were eagerly acquired by the Japanese æsthetes. Hence
their rarity in China to-day. Moreover, the Japanese potters of
Seto and elsewhere have copied them with astonishing cleverness,
so that the best Seto imitations are exceedingly difficult to dis-
tinguish from the originals. The ordinary run of the Japanese
copies, however, are recognised by a body of lighter tint and finer,
more porcellanous texture, besides their general imitative char-
acter and the Japanese touch which is learnt by observation but
is not easy to define in words.

Though we hear nothing further of this Chien yao after the
Yüan dynasty it is practically certain that the manufacture of
pottery of some sort continued in the district. A small pot of
buff stoneware with a translucent brown glaze (much thinner
than that of the hare's fur bowls and without the purple tint or
the golden brown markings) was found in a tomb near Chien-
ning Fu with an engraved slab dated 1560. The find was made
by the Rev. H. S. Phillips, who presented the pot, with a rubbing
of the inscription, to the British Museum.

In addition to the characteristic *temmoku* we have now quite
a large family of bowls, dishes, jars, and vases with thick purplish
black glazes more or less diversified by golden brown and tea-dust
green, which are at present grouped with the Chien yao pending
some more precise information as to their origin. They are, how-
ever, distinguished by a coarse porcellanous body of greyish white
or buff colour, and I understand that many of the bowls have come
from excavations in Honan; and there are features in the orna-
ment and in the ware itself which suggest that they date back as
far as the T'ang period. Fig. 3 of Plate 43, for instance, with its
large brown mottling on a black glaze, is analogous in form and
material to the white-glazed T'ang wares and in the mottling of
the glaze to the typical T'ang polychrome. The bowls, which are
usually small and shallow with straight sides, wide mouth, and
very narrow foot, or with rounded sides slightly contracting at the

[1] The *Liu ch'ing jih cha.*

mouth, have neither the weight of material nor smooth solidity of
glaze which characterise the true Chien yao. On the other hand,
they are more varied in the play of black and brown, and in some
cases they have designs and patterns which are clearly intentional.
The two extremes of colour are a monochrome black, usually of
purplish tint but sometimes brownish, and a lustrous brown often
decidedly reddish in tone. Between these come the black glazes
which are more or less variegated with brown in the form of mottling,
streaks, tears, irregular patches, and definite patterns. The glaze
in these bowls usually extends to the foot rim, and sometimes re-
appears in a patch under the base. The ornament in some cases
takes the form of rosettes or plum blossom designs in T'ang style
incised through the glaze covering ; in others, as in Fig. 1 of
Plate 43, we find a leaf design (evidently stencilled from a real
leaf) expressed in brown or dull tea green ; and occasionally there
are more ambitious designs, such as a hare or bird or foliage,
incised. On a red brown bowl in the Museum für Ostasiatische
Kunst at Cologne there are traces of a floral pattern in a lustrous
medium which resembles faded gilding.

We have already noted how the purplish black glaze of the
Tz'ŭ Chou ware breaks into lustrous brown ; the black Ting ware
and the debateable red Ting have been discussed ; and if we add
this family which may perhaps be provisionally described as Honan
temmoku, it would appear that glazes analogous to those of the
Chien yao " hare's fur " bowls were widely used in Northern China
at an early date.

A word of explanation may appropriately be added here of
the expression *wu-ni yao*,[1] which occurs in several passages in
Chinese books on pottery. It means " black clay ware," and as
a general term would naturally include the " hare's fur bowls."
Indeed, one passage[2] actually speaks of the *wu-ni yao* of Chien-an,
and the *T'ao lu*, which gives the ware a paragraph to itself, states
that it was made at Chien-an, in Chien-ning Fu, beginning in
the Sung dynasty, and that its clay was black. It further adds
that the glaze is " dry and parched " and that it was sometimes
green (*ch'ing*). It is clear from the above quotations that *wu-ni
yao* was a general expression for the dark-bodied Chien ware ; and
there the matter would have ended had not early works, such
as the *Cho kêng lu* and *Ko ku yao lun*, mentioned it in the cate-

[1] 烏泥窰 [2] In the *Liu ch'ing jih cha*.

gory of Kuan and Ko wares, the former naming it with the Hsün and Yu-hang wares, which were inferior to the Kuan, and the latter adding to the passage dealing with Kuan wares the following note : " There are black wares which are called *wu-ni yao*, all of which were imitated at Lung-ch'üan. They have no crackle." The *Po wu yao lan*, however, explains that these wares " were admitted *by confusion* into the category of Kuan and Ko wares," and that the " error has been handed down to this day." Probably it was the green variety which caused the confusion, as there seems no reason why the black glazes should have been associated with the Kuan class, though the dark red clay of the Phœnix Hill from which the Hang Chou Kuan ware was made may have had some resemblance to the dark red brown body of the Chien yao. As for the Lung-ch'üan imitations, we can only imagine that the statement refers to the later Ko wares, which are said to have been made with material brought from Hang Chou,[1] and that their glaze, too, was of the green variety, as would be expected in the Lung-ch'üan district, the home of the green celadons. At the same time it will be remembered that *wu-ni yao* means simply " black clay ware," and might have been fairly applied to any dark-bodied ware wheresoever made.

As already mentioned, many fragments of pottery were included in the important finds made by Sir Aurel Stein in his excavations in Turfan. Unfortunately, many of the sites have little evidential value, because they have clearly been revisited at comparatively late periods ; but there are a few localities which ceased to be inhabited as early as the Sung dynasty, and which furnished fragments of glazed pottery and porcellanous wares. I only mention those sites which, as far as these finds are concerned, were not vitiated by the occurrence of obviously recent wares. On one site named Ushaktal, supposed to have been abandoned in the Sung dynasty, if not before, were fragments of greenish brown celadon with combed ornament on the body, such as was certainly made in Corea and probably in China as well. The same site produced opalescent glazes of the Chün and Yüan type. The site of Vash-shahri, which was " occupied probably down to the eleventh or twelfth century," produced a number of interesting fragments (1) with buff and grey stoneware bodies and glazes of the opalescent Chün and Yüan kinds, (2) the same body with emerald green crackled

[1] See p. 72.

glaze, (3) celadon glazes over carved ornament, (4) speckled olive brown glaze resembling the later "tea dust," (5) opaque dark brown glaze, (6) speckled dark purplish brown glazes, (7) thick greenish glaze evenly dappled with pale bluish grey spots.

Early wares found on the mixed sites, such as Kan Chou and Hsi Yung ch'êng, which were occupied down to Sung times but evidently visited later, include carved white porcelain and creamy white ware of the *t'u Ting* class, and several kinds of Tz'ŭ Chou wares, the *graffiato*, as well as the black painted. But evidence from excavations of this kind is always open to the objection that the ruins may have been visited later, and the broken pottery dropped by subsequent explorers. This objection, however, cannot reasonably be offered to more than a small proportion of the objects found, and these finds, though not in themselves conclusive, may be regarded, at any rate, as valuable corroboration of existing theories.

MANY strange things are recorded by the early Chinese writers in connection with pottery and porcelain, and the tales are solemnly repeated from book to book, though occasionally a less credulous author adds some such comment as "This may be true, or, on the other hand, it may not." It is difficult, however, entirely to discredit the serious and circumstantial account given by a provincial governor of a curious custom which prevailed in his district. Fan Ching-ta, who was appointed administrator in Kuang-si in 1172, tells[1] us that "the men of Nan (-ning Fu) practise nose-drinking. They have pottery vessels such as cups and bowls from the side of which stands up a small tube like the neck of a bottle. They apply the nose to this tube and draw up wine or hot fluids, and in the summer months they drink water. The vessels are called nose-drinking cups. They say that water taken through the nose and swallowed is indescribably delicious. The people of Yung Chou have already recorded the facts as I have done. They grow a special kind of gourd for the purpose." Another extract from the same writer's works alludes to "drums with contracted waist" made of pottery in the villages of Lin-kuei and Chih-t'ien. The village people made a speciality of the manufacture of this pottery (yao), and baked it to the correct musical tone. On the glaze, we are told, they painted red flower patterns by way of ornament. The allusion to painting in red on the glaze at this early period is interesting, but it is quite likely that the designs were only in some unfired pigment.

Some of the stories may be regarded merely as figurative descriptions of the superhuman skill of the artist in rendering " life-movement." Thus we are told[2] of " four old porcelain (tz'ŭ) bowls painted with coloured butterflies. When water was poured in,

[1] In the *Kuei hai yü hêng chih,* quoted in the *T'ao lu,* bk. ix., fol. 2 verso.

[2] In the *Ning chai ts'ung hua,* quoted in the *T'ao lu,* bk. ix., fol. 4.

the butterflies floated on the surface of the water, fluttering about as if alive." It was an unnatural proceeding for butterflies in any case, and we can quite understand why " those who saw this, all maintained secrecy and did not divulge it."

A somewhat similar poetic licence is taken by the same author in another passage with reference to certain cups and bowls, apparently of the Sung dynasty, which were found in the K'ang Hsi period on the site of an old temple. " The bowls had a minute wave pattern which moved and undulated as in a picture by Wu Tao-tzǔ. As for the cups, when a little water was poured into them four fishes arose out of the sides and swam and dived."

But most curious of all were the Chinese views on the subject of " furnace transmutations " (*yao pien*) and the fables which sprang from them. At the present day the strange behaviour of metallic oxides, notably copper, under certain firing conditions, is well known and turned to good account. But in early times, when the unexpected happened, and a glaze which contained an infinitesimal quantity of copper oxide was accidentally subjected to an oxidising or reducing atmosphere in the kiln (by the admission of air or smoke at the critical moment), instead of coming out a uniform colour, was streaked and mottled all over with red, green and blue, or locally splashed with crimson or mixed colour, the potters saw in the phenomenon something supernatural. It was a terrifying portent, and on one occasion, we are told, they broke the wares immediately, and on another they even destroyed the kilns and fled to another place.

However, the irregular formation of the Chinese kilns greatly favoured these accidental effects, and in time they became comparatively common, so that these true " furnace transmutations " were taken for granted; and though they were not clearly understood before the end of the K'ang Hsi period, fairly rational explanations of them were offered by some of the late Ming writers. Thus the curious splashes of contrasting colour which appeared on the Kuan, Ko and Chün wares were attributed to the " fire's magical transmutation."

In these cases only a partial transmutation had taken place, affecting the glaze alone. But the idea of transmutation in the fire was carried farther in the Chinese imagination, and stories grew of cases in which " the vessel throughout was changed and became wonderful." Su Tung-p'o has, for instance, left a poem on

a vase organ, in the preface of which it is related[1] that in the year 1100 A.D., " while they were drinking at a farewell banquet to Liu Chi-chung, they heard the sounds of an organ and flute," and that on investigation "it was discovered that the sounds came out of a pair of vases, and that they stopped when the meal was over." Another story of the Sung dynasty tells of a wonderful basin in which the moisture remaining after it had been emptied displayed, when frozen, a fresh pattern every day. At first it was a spray of peach blossom, then a branch of peony with two flowers, then a winter landscape, " with water and villages of bamboo houses, wild geese flying, and herons standing upon one leg."

The story of the " self-warming cups " told by an early Sung writer[2] evidently belongs to the realm of pure fiction : " In the treasury of T'ien Pao (742 A.D.) there were green (ch'ing) ware (tz'ŭ) wine cups with markings like tangled silk. They were thin as paper. When wine was poured into them it gradually grew warm. Then it had the appearance of steaming, and next of boiling. Hence the name ' self-warming cups.' "

Scarcely less marvellous is the incident recorded in the Yü chang ta shih chi, written about 1454.[3] " At the time when the temple of the god (of pottery) was in existence, an Imperial order was given to Ching-tê Chên to make a wind-screen ; but it was not successful, and was changed in the kiln into a bed six feet long and one foot high. At the second attempt it was again changed and became a boat three feet long. Inside the boat were the various fittings all complete. The officials of the prefecture and district all saw it. But it was pounded to pieces with a pestle, for they did not dare to let it go to court." Another story[4] tells how Chia and I (John Doe and Richard Roe) when hunting were led in pursuit of a wounded hare into an ancient tomb in the mountains, where they found a large jar containing two white porcelain vases and an ink slab. Chia broke one of the vases, but I stopped any further vandalism and carried the other specimens home. He used the vase for flowers, but for several days he noticed " an emanation from within issuing from the Yin yün (generative power

[1] See T'ao shuo, Bushell, op. cit., p. 47.
[2] In the Yün hsien tsa chi, quoted in the T'ao lu, bk. ix., fol. 1 verso.
[3] Quoted in the T'ao lu, bk. viii., fols. 12 and 13.
[4] From the Erh shih lu, quoted in the T'ao lu, bk. ix., fol. 15.

of nature) like a vapour of cloud." Being puzzled, he tried pluck-
ing the stalks of the flowers, and "found that they contained no
moisture, and yet the plants did not wither. Moreover, the buds
kept strong, as if they had rooted in the clay of the vase. So he
began to be astonished at the vase, regarding it as a kind of *yao
pien*. One day, during a great storm of wind and rain, suddenly
there was a flash and a peal of thunder, and the vase was shaken
to pieces. I was very much alarmed and distressed."

The *Yang hsien ming hu hsi* speaks of instances in which the
Yi-hsing teapots were affected in a peculiar way, the ware chang-
ing from drab to rosy red when filled with tea ; and we have already
seen that Hsiang Yüan-p'ien illustrates in his Album examples of
this, which he solemnly assures us he would not have believed
had he not seen it happen before his eyes. In all these cases
the ware was supposed to have been completely changed in the
kiln and to have acquired supernatural properties. " The magic
of the god had entered into the ware in the firing and had not
left it."

CHAPTER XI

THE reader will have noticed that the word porcelain, which was avoided in the discussion of the earlier periods, has insensibly crept into the chapters which deal with the Sung wares. It was no longer right or proper that it should be excluded, and it is high time that our attitude on the interesting question of its origin was defined. Unfortunately, that attitude is still—and must necessarily remain—one of doubt and uncertainty, but we can at least clear away some of the existing misapprehensions on the subject.

The myth which carried back the manufacture of porcelain some eighteen centuries before our era has been definitely discredited, and the snuff bottles supposed to have been found in ancient Egyptian tombs which gave rise to the idea are now known to be of quite modern make. The more modest computation which placed the invention in the Han dynasty (206 B.C. to 220 A.D.) might have been almost as lightly dismissed had not Dr. Bushell, after disposing of the theory in his *Oriental Ceramic Art*[1] in 1899, seen fit to reverse his decision in later publications.[2]

The reasons given for this later attitude are on the surface so convincing that it is necessary to consider them in detail and to examine the authorities on which they are based. Bushell's statement runs as follows : " It is generally agreed that porcelain was first made in China, but authorities differ widely in fixing a date for its invention. The Chinese attribute its invention to the Han dynasty, when a new character *tz'ŭ* was coined to designate, presumably, a new substance. The official memoir on ' Porcelain Administration' in the topography of Fou-liang, the first edition of which was published in 1270, says that according to local tradition

[1] Op. cit., pp. 17-20.
[2] *Chinese Art*, vol. ii., p. 17, and the *Catalogue of the Morgan Collection* (1907), p. xlviii.

the ceramic works at Hsin-p'ing (an old name of Fou-liang) were founded in the time of the Han dynasty, and had been in constant operation ever since. This is confirmed by T'ang Ying, the celebrated superintendent of the Imperial potteries, appointed in 1728, who states in his autobiography that the result of his researches shows that porcelain was first made during the Han dynasty at Ch'ang-nan (Ching-tê Chên), in the district of Fou-liang."

From this and the passages immediately following it is clear that Bushell at that time leant strongly to the Han theory, which he had previously discarded, for three reasons, which we shall now examine. The first rests on the character *tz'ŭ*. Whether the character *tz'ŭ* was coined to designate a new substance in the Han dynasty is by no means certain. It undoubtedly appears in the Han dictionary, the *Shuo Wên*, but with the meagre definition " pottery ware," [1] and without any further indication of its nature. The second is based on a passage in the Annals of Fou-liang, which on examination proves to contain only the general word *t'ao* (ware) and not the character *tz'ŭ* at all. The actual passage runs : " The manufacture of pottery (*t'ao*) at Hsin-p'ing began in the Han dynasty. Speaking generally, this pottery was strong, heavy, and coarse, being fashioned of rich clay with moisture added, after methods handed down from the ancients." The third invokes the authority of T'ang Ying, but on reference to the autobiography of this distinguished ceramist in the *Chiang hsi t'ung chih*, we again find reference only to *t'ao* and not to *tz'ŭ*, viz. " It (*t'ao*) is not the growth of one day. Research shows that it began in the Han dynasty and was transmitted through succeeding generations. Its place (of manufacture) changed (from time to time), but it flourished at Ch'ang-nan." One obvious place for T'ang's research would be the Annals of Fou-liang, and I shrewdly suspect that his conclusions were based on the very passage quoted above, of which his words give a clear echo. But in any case, neither passage has any bearing on the origin of porcelain unless we assume that *t'ao* is the same as *tz'ŭ*, and that both words definitely mean *porcelain*,

[1] 瓦器也 *wa ch'i yeh*. The *Shuo Wên* was compiled by Hsü Shên and published first in 120 A.D. The word *tz'ŭ* 瓷 is compounded of the radical *wa* 瓦 (a tile, earthenware), and the phonetic *tz'ŭ* 次 (second, inferior), and carries no inherent suggestion of porcelain. If connoting a new material, it may be a name applied specially to glazed pottery which seems to date from the Han period, or even to stoneware as opposed to soft earthenware or brick.

an assumption which is not only quite unwarranted but in any case begs the whole question.

The Chinese words used at the present day for porcelain are *tz'ŭ*, *t'ao*, and *yao*, all of considerable antiquity, though their forms have undergone various changes and their meaning has been modified from time to time to keep pace with the evolution of the ware. The word *tz'ŭ* 瓷, as we have seen, was defined in the Han dictionary as merely " pottery ware." Its modern definition is a hard, fine-grained variety of *t'ao*, and if we add to this the quality of resonance—i.e. of emitting a musical note when struck—we have all the requirements of porcelain according to the Chinese definition. The synonym 磁, containing the radical 石 *shih* (a stone), which is also pronounced *tz'ŭ*, has come in the last two centuries to be used interchangeably with the older word 瓷, in spite of the protests of eighteenth-century purists.[1]

The word *t'ao* 陶 is a term even more comprehensive than our word " china." In the Han dictionary it appeared in the form 鈞 *t'ao* or *yao* (previously pronounced *fou*), composed of 缶 *fou* (earthenware) and the radical 勹 *pao* (to wrap), and its meaning was *kiln*, and by extension *the products of the kiln*. At that time the word in its modern form was only used as a proper name.

The third character *yao* (the Japanese *yaki*) is precisely synonymous with *t'ao*, meaning first a *kiln* and then *wares* of any kind. In its form 窯 it occurs in the Han dictionary ; another form is 窰, which, according to a Sung writer,[2] dates from the T'ang period, and a third form 窖 is current in modern dictionaries.

In short, the Chinese terms are all of a general and comprehensive kind, capable of embracing pottery, stoneware, and porcelain impartially, and there is no single Chinese word which corresponds to our precise term " porcelain." Under these circumstances

[1] Thus the author of the *T'ang shih ssŭ k'ao* (quoted in the *T'ao lu*, bk. viii., fol. 9 verso) : " The characters 磁 and 瓷 are not interchangeable. The latter is a hard and fine kind of *t'ao*. The material from which it is made is clay. The former 磁, on the other hand, is the name of a real stone which comes from the ancient Han-tan, which is the modern Tz'ŭ Chou. This department has potteries in which they use the *tz'ŭ* stone for the body of the ware. Hence the name *Tz'ŭ ch'i* (Tz'ŭ wares), not that the ware from the potteries of this place is all porcelain. I hear that at Ching-tê Chên the common usage is to employ the character 磁 for porcelain in writing and speaking. I have consulted friends whom I meet, and many use the two terms interchangeably. Truly this is altogether ridiculous. Tz'ŭ Chou is still making pottery at the present day." For the Tz'ŭ Chou pottery, see ch. viii.

[2] *Yeh chih*, quoted in the *T'ao lu*, bk. ix., fol. 13 recto.

it is clear that no theory on the origin of porcelain can be based merely on the occurrence of any of these words in early Chinese texts. Still less can any such theory be constructed from the very promiscuous use of the word " porcelain " in European translations, and it is a thousand pities that both Julien and Bushell were not more discriminating in this matter, or that they did not always (as Julien sometimes and Professor Hirth usually did) give the Chinese character in parentheses when any reasonable doubt could exist. Had this been done we should have been spared misleading references to " two porcelain cups of the Han dynasty," [1] and such loose writing [2] as " In the Wei dynasty (221–264 A.D.) which succeeded the Han we read of a glazed celadon ware made at Lo Yang for the use of the palace, and in the Chin dynasty (265–419) we have the first mention of blue porcelain produced at Wên-chou, in the province of Chehkiang, the progenitor of the sky-blue glazes tinted with cobalt, which afterwards became so famous." The " glazed celadon," needless to say, is purely conjectural, pottery (*t'ao*) vessels being all that is specified in the passage on which the statement is obviously based ; and the " blue porcelain " is evidently no other than the *p'iao tz'ŭ* (mentioned by the poet P'an Yo and discussed on p. 16), which is better rendered " green ware." [3]

The same kind of criticism applies to all the other references in early writers until we reach the Sui dynasty (581–617 A.D.). In the annals of this period there is a much discussed passage in which it is stated that the art of making a substance known as *liu-li* [4] had been lost in China, and that the workmen did not dare to experiment, but that one Ho Ch'ou 何稠, a connoisseur in pictures and antiquities, succeeded in making it with green ware (*lü tz'ŭ*), and that his imitations were not distinguishable from the original substance.

To understand the full import of this passage it is necessary to explain the nature of *liu-li*, and this is fortunately made quite clear by the author of the *T'ao shuo* in a commentary so interesting that I give it in full :

" I find that *liu-li* comes from the countries of Huang-chih,

[1] *T'ao shuo*, translated by Bushell, op. cit., p. 95.
[2] Bushell, *Chinese Art*, vol. ii., p. 18.
[3] See *T'ao shuo* (Bushell, op. cit., pp. 97 and 99). See also bk. ix., fol. 1 verso, where the passage from the Annals of the Sui Dynasty is quoted.
[4] 琉璃. See *T'ao shuo*, bk. iv., fol. 17 recto and verso.

Ssŭ-t'iao and Jih-nan.[1] That produced in Ta-ch'in (the eastern provinces of the Roman Empire) is in ten colours—pink, white, black, yellow, blue, green, deep purple, deep blue (or green), red, and brown. *Liu-li* was originally a natural substance.[2] Yen Shih-ku,[3] commenting in the Annals of the Han Dynasty, says, 'At the present time they commonly use molten stones, adding a number of chemicals and then pouring the substance (into moulds) and forming it ; but it is unsubstantial, brittle, and not a successful casting.' In the Northern Wei dynasty, in the reign of T'ai Wu (424–451 A.D.), a man of the Ta Yüeh-chih[4] who came to trade at the capital, said he could make *liu-li* by melting stones. Eventually he collected the ore and made it (*liu-li*), and the finished article surpassed the original in its brilliance and colour. The method has been handed down to the present day, and it was probably only an accidental intermission which occurred in the Sui dynasty. But the Chinese castings are brittle in substance, and when hot wine is poured into them they fly to pieces in the hand. What a pity the Yüeh-chih method has been handed down instead of Ch'ou's ! "

The allusions to melting stones, casting, etc., in this passage leave no doubt that the *liu-li*, as made in China, was a kind of glass, imitating a natural stone.[5] It is, in fact, usually translated in the dictionaries as " opaque glass," and in connection with pottery it has the sense of glaze—e.g. *liu li wa* " glazed pottery."

We can now return to Ho Ch'ou, who " took green ware and made *liu-li*." [6] It has been thought that what he made must have been a kind of porcelain, but there is no indication of any

[1] The first two are apparently unidentified, but Jih-nan is Cochin China, whither, no doubt, the substance came as an article of trade.

[2] Early writers refer to it as *pi liu li*, which is a transcription of the Sanskrit *Vaidurya*, a stone supposed to be of the beryl type, but the identification is a matter of dispute. See Laufer, *Jade*, p. 111, footnote.

[3] A seventh-century writer.

[4] The *Ta Yüeh-chih* have been identified with the Massagetæ, who in the fifth century were in possession of Afghanistan. See Bushell, *T'ao shuo*, op. cit., p. 100.

[5] The substance is discussed at length in connection with *pi-liu-li* by Laufer (*Jade*, pp. 109-112), but this author seems very loath to admit the meaning glass for *liu-li*, though he allows that it is a common term for ceramic glaze. But the passage quoted above from the *T'ao shuo* can hardly be explained in any other way than in reference to a kind of glass.

[6] The exact words of the text are 稠以綠瓷爲之與眞無異 (*Ch'ou i lü tz'ŭ wei chih yü chên wu i*). " Ch'ou took green ware and made it (*liu-li*) not different from the real."

such achievement, for though it is possible to make an artificial porcelain with glass as a constituent, the converse is not true: you cannot make glass out of either pottery or porcelain. The most probable explanation of the passage seems to be that Ho Ch'ou (who was apparently not a potter) experimented at some pottery with the materials used in glazing the green ware, and found that he could make a very good glass (*liu-li*) with the potter's green glaze, and perhaps other ingredients, a result which is in no way surprising, seeing that the softer ceramic glazes have a very close affinity to glass. But no further inferences can be drawn from this passage, and it is not even clear that Ho Ch'ou made a ceramic ware at all. All we are told is that he made *liu-li*. I have rather laboured this negative point, because Professor Zimmermann has published a declaration of belief that Ho Ch'ou was the discoverer of porcelain.[1] Apart from the obvious criticism which the writer himself anticipates, that such an epoch-making discovery would hardly have escaped the notice of Ho Ch'ou's biographer, Professor Zimmermann opens his case with a fundamental error, for which he has to thank Dr. Bushell. It is true that he only names Julien as the source of his information, but his version of the story of Ho Ch'ou is taken verbatim from Bushell's *Oriental Ceramic Art*,[2] where the crucial passage is unfortunately rendered " but he (Ho Ch'ou) succeeded in making vessels of green porcelain which could not be distinguished from true glass." This mistranslation puts an entirely different complexion on the passage, and goes a long way to justify Professor Zimmermann's inferences that Ch'ou made a glassy ware of the nature of porcelain. It is an instructive instance of the pitfalls which beset the student of Chinese subjects, especially when he has to rely on other people's translations.

Strange to say, a similar mistranslation occurs in Dr. Hirth's short but excellent treatise on *Ancient Chinese Porcelain*,[3] in a passage which is nevertheless of great importance to our quest. It has been the custom with Chinese compilers of reference works to incorporate the material of previous editions, adding their own commentaries and any further information which happened to

[1] *Orientalisches Archiv*, Bd. ii., 1911, and *Chinesisches Porzellan*, p. 24.
[2] Op. cit., p. 20. Dr. Bushell, in his translation of the *T'ao shuo*, has given the more correct rendering, " Ch'ou made *some* (i.e. *liu-li*) of green porcelain."
[3] Op. cit., pp. 3 and 4.

have reached them, and to this we are indebted for the preservation of many passages from ancient writers which would otherwise be extremely difficult of access. Thus Hirth found embalmed in the Sung Pharmacopœia two early references to the material *pai o* 白堊 which he shows to be without doubt the kaolinic earth used in the manufacture of porcelain, and which, like many other strange materials, entered into Chinese medicinal prescriptions. The first mention of this substance is taken from the writings of T‘ao Yin-chü, who died in 536 A.D., to the effect that the *pai o*, besides being used in medicines, was employed at that time for painting pictures ; and Hirth argues that so celebrated a writer on scientific subjects as T‘ao Yin-chü could not have failed to note it if the *pai o* had been in general use for ceramic purposes as well. This is followed by a quotation from the T‘ang Pharmacopœia (compiled about 650 A.D.) : " It (*pai o*) is now used for painter's work, and rarely enters into medicinal prescriptions ; during recent generations it has been prepared from white ware [1] (*tz‘ŭ*)." By rendering the last sentence " during recent generations it has been used to make white porcelain," Hirth invested the passage with a greater interest than it actually possesses. But even when stripped of this fictitious importance, it constitutes the first literary evidence we have of the use of kaolin by Chinese potters. This is followed by another quotation from the T‘ang Pharmacopœia recommending for medicinal purposes a powder prepared from the white ware of Ting Chou.[2]

Whether we are to understand that the Chinese pharmacist ground up broken pieces of Ting ware or merely made use of the refined and purified clay obtained at the potteries, matters little. Neither proceeding would be without parallel in Europe in far later times than the T‘ang period. But the specific reference to white Ting ware at this early date is most interesting in view of the fact that Ting Chou was celebrated in the Sung dynasty for a white ware which is undoubtedly a kind of porcelain.

The presence of a kaolin-like material in a dark-coloured ware, probably of the third century, which was disclosed by the analysis made by Mr. Nicholls in Chicago, has already been recorded (p. 15). We have no means of ascertaining what length of time

[1] 近代以白瓷爲之 *Chin tai i pai tz‘ŭ wei chih* = " in recent generations with white ware they make it."

[2] 定州白瓷 *Ting chou pai tz‘ŭ*. For the Ting Chou ware, see ch. vii.

elapsed before a white material of this nature was evolved, but it was clearly in existence in the beginning of the sixth century. Possibly it was not porcelain according to the strict European definition, but there is every reason to suppose that it was a hard white ware, such as the Chinese would not hesitate to include in their porcelain category. Such a ware appears on some of the funeral vases which may safely be referred to the early T'ang period (see p. 26), and in default of other evidence I think we can say that porcelain in the Chinese sense already existed at the end of the Sui dynasty.[1]

Though this period happens to coincide with the lifetime of Ho Ch'ou, neither his name nor any other has been associated with the event by the Chinese, and it is highly probable that porcelain only came into being by a process of evolution from pottery and stoneware, the critical moment arriving with the discovery of deposits of kaolinic earth. As a mere speculation, I would suggest that the deposits were those at Han tan, the modern Tz'ŭ Chou, which supplied material for the Ting Chou potters.[2] It is, at any rate, significant that the new name, which we are led to suppose was derived from the tz'ŭ stone,[3] was given to that place in the Sui dynasty.

Numerous literary references from this time onwards have already been quoted which are highly suggestive of porcelain. The " false jade vessels " of T'ao Yü in the early years of the seventh century; the eighth-century tea bowls of Yu Chou and Hsing Chou which were compared respectively to jade and ice, to silver and snow, the former being green and the latter white. The twelve cups used for musical chimes by Kuo Tao-yüan; the white bowls immortalised by the poet Tu " of ware (tz'ŭ) baked at Ta-yi, light but strong, which gives out a note like jade when struck."

[1] Père d'Entrecolles (in his letter dated from Ching-tê Chên in 1712) makes the statement that the district of Ching-tê Chên sent regular supplies of its ware, which he terms porcelain, to the Emperor from the second year of the reign of Tam ou te (sic). Though he gives the date as 422, it is clear that he really refers to the first Emperor, Wu Tê, of the T'ang dynasty (618–627 A.D.). It is not clear how he arrived at the conclusion that the ware in question was porcelain, and as he refers to the Annals of Fou-liang as his authority, we may assume that the Chinese phrase contained the inconclusive term tz'ŭ or t'ao. He adds that " nothing is said as to the inventor, nor to what experiments or accident the invention was due."

[2] See p. 101.

[3] See p. 142.

The quality of translucency which in Europe[1] is regarded as distinctive of porcelain is never emphasised in Chinese descriptions. I can find no mention of it in any of the earlier writings,[2] and the first unmistakable literary evidence of its existence[3] comes from a foreign source. The Arab traveller, Soleyman, who describes his experiences in China in the ninth century, states that " they had a fine clay (*ghādar*) from which bowls were made, and in the transparency of the vessels the light of the water was visible ; and they were (made of) fine clay." [4] This statement practically proves the existence of translucent porcelain in the Tʻang dynasty, and we confidently await the arrival of specimens from Chinese excavations. Some of the export porcelains of the time have been actually unearthed at Samarra on the Euphrates by Professor Sarre,[5] of the Kaiser Friederik Museum, Berlin, and they include (1) bowls of gummy white porcelain with unglazed gritty base ; (2) greenish white ware ; (3) yellowish white with small crackle ; and (4) a pure white porcelain with relief designs, such as birds

[1] The European definition of porcelain may be stated thus : " Porcelain comprises all varieties of pottery which are made translucent by adding to the clay substances some natural or artificial fluxing material." In China the usual constituents are *kaolin*, which forms the clay substance, and *petuntse* (china stone), which is the natural fluxing material. I should add that it is doubtful whether we are strictly justified in using the word *kaolin* as a general name for porcelain earth (*o tʻu*); but the term has been consecrated by usage, and has practically passed into our language in this sense. A slight translucency is observable near the rim on a white Tʻang cup in the Eumorfopoulos Collection. The body of this piece is a soft white material, and the translucency is caused by a mingling of the glaze with the body where it is very thin, and it may be compared with the translucency of the Persian " gombroon " ware. But neither of these wares can be ranked as porcelain proper.

[2] It is, however, mentioned in connection with some of the Sung wares (the Kuan, for example), but only in relation to the glaze.

[3] It is true that Bushell, in his translation of the *Tʻao shuo* (op. cit., p. 102) implies this quality in a " brown ware (*tzʻŭ*) bowl " sent as tribute by the Pʻo-hai in 841 A.D. which is described as " translucent both inside and outside, of a pure brown colour, half an inch thick but as light as swan's down." The words of the text 內外通瑩 *nei wai tʻung jung* (" inside and out throughout lustrous ") are in themselves capable of suggesting translucence, but the remaining features—the brown glaze and the great thickness—are sufficient to preclude the idea of a translucent ware ; and I imagine that the quality of lustre or translucency here applies only to the glaze. The Pʻo-hai appear to have been a subject state of Corea.

[4] I am indebted for this literal translation of the much-quoted passage to Mr. Edwards, of the Oriental MSS. Department of the British Museum. It has been more freely rendered by M. Reinaud, *Relation des voyages faits par les Arabes*, etc., Paris, 1845, p. 34.

[5] See F. Sarre, " Kleinfunde von Samarra und ihre Ergebnisse," in *Islam*, July, 1914.

and fishes, under the glaze. Other pottery found on that site included mottled ware of typical T'ang type, and a creamy white of the Tz'ŭ Chou type with brown spots.[1]

From considerations of form and the general character of the ware, I am inclined to regard three specimens in Plates 44 and 45 as belonging to the T'ang period. Fig. 1 of Plate 44 has a thin ivory white glaze running in gummy drops and clouded with pinkish buff staining outside and with a reddish discoloration within. Fig. 2 of the same Plate is remarkable in many ways. It is so thin as to seem to consist of little else but glaze, and is consequently almost as translucent as glass. The colour of the glaze is pearly white powdered with tiny specks, and the crackle is clearly marked. The base is flat and discloses a dry white body of fine grain. But its most conspicuous feature is the arresting beauty of its outline, which recalls some choice specimen of Græco-Roman glass, and displays a classic feeling frequently observed in T'ang pottery and in the Corean wares which owe so much to T'ang models.

Fig. 2, Plate 45, shows the celebrated phœnix ewer belonging to Mr. Eumorfopoulos which has proved so difficult to classify.[2] It is a white porcellanous ware translucent in the thinner parts, and the glaze is of light greenish grey with a tendency to blue in places. The form and ornament show strong analogies with specimens of T'ang pottery. The neck, for instance, may be compared with Fig. 2 of Plate 14 ; the phœnix head and the foliate mouth with Fig. 1 of Plate 9, and the carved ornament on the body with Fig. 3 of Plate 14.

Among the Sung wares many of the white Ting specimens are found to be translucent in their thinner parts, and these may be fairly regarded as porcelain proper. A considerable number of other white porcelains have come over of late under the description of Sung wares, and many of them are certainly early enough in form and style to belong to that period. They are true hard porcelain, translucent, and of a creamy white colour. Being for the

[1] Fragments of white porcelain with carved designs were found in some of the sites excavated by Sir Aurel Stein in Turfan, and there are fragments similar to the Samarra finds obtained from ancient sites in the Persian Gulf and now in the British Museum. But the evidence of these pieces is not conclusive, for the sites were inhabited for many centuries. That of Samarra, on the other hand, is most important, for the city was only of a mushroom growth, which began and ended in the ninth century. See also p. 134.
[2] See *Cat. B. F. A.*, 1910, A 43.

most part without decoration, they can only be judged by their forms, and in view of the conservative habits of the Chinese, it would be rash to assert too emphatically their Sung origin. Yüan and even early Ming dates are suggested by the more cautious critics; but the possibility of a Sung origin having been established, I am inclined to give the evidence of form its full weight.

There are, besides these, other well-defined types of translucent porcelain which may confidently be attributed to a period as early as the Sung, but here the possibility—nay, probability— of a Corean origin has to be considered. It is certain that many of them have been found in Corean tombs; the provenance of the rest is doubtful. One type is a delicious smooth white porcelain with glaze of faintly bluish tinge, highly translucent, and worked very thin at the edges. The base of the vessels (usually small shallow bowls or saucers) is unglazed, and shows a soft-looking sugary body of close texture, rather earthy than glassy, and slightly browned by the fire. They have, in fact, almost the appearance of a " soft-paste " porcelain like that of Chelsea. These are so different from any known Chinese type that I strongly incline to a Corean origin for them. Another type is of hard but translucent ware with glaze of distinctly bluish tinge. A bowl in the British Museum is a good example of this. Of the usual conical form, it has a plain outside, and the inside is decorated with an incised design of not very clear meaning, but apparently a close foliage ground with highly formalised figures of boys. If this interpretation is correct, it is a conventional rendering of the well-known pattern of boys in foliage, Chinese in origin, but frequently used by the Corean potters. The design ends in Corean fashion, about an inch below the rim, leaving a plain band above it. The glaze is a faint bluish colour all over, and is powdered with specks, a fault in the firing; the base is almost entirely unglazed, and the biscuit, where exposed, has turned reddish brown. The style of this piece is strongly Corean. The same peculiarities in the base are shared by another type of small bowl, usually decorated inside with a sketchy design in combed lines. Some of these are creamy white; others are bluish white with a decided blue tinge in the well of the bowl where the glaze has formed thickly.[1] Another group, which is also said to be represented among the Corean tomb

[1] See *Cat. B. F. A.*, 1910, F 9 and 14.

Fig. 2

Fig. 1

Plate 44.—Early Translucent Porcelain, probably T'ang dynasty.

Fig. 1.—Cinquefoil Cup with ivory glaze clouded with pinkish buff stains. Diameter 3¾ inches. *Breuer Collection.*
Fig. 2.—Vase of white, soft-looking ware, very thin and translucent with pearly white, crackled glaze powdered with brown specks. Height 3⅛ inches. *Peters Collection.*

Fig. 1

Fig. 2

Plate 45.—T'ang and Sung Wares.

Fig. 1.—Square Vase with engraved lotus scrolls and formal borders. *T'u-ting* ware, Sung dynasty. Height 20 inches. *Peters Collection.* Fig. 2.—Ewer with phœnix head, slightly translucent porcelain with light greenish grey glaze with tinges of blue in the thicker parts ; carved designs. Probably T'ang dynasty. Height 15¼ inches. *Eumorfopoulos Collection.*

wares, is practically indistinguishable from the creamy white Ting Chou porcelain.

The whole question of these interesting porcelains is complicated by the fact that the Coreans were admittedly indebted to the Ting Chou potters for many of their designs ; [1] and by the fact that while close intercourse between China and Corea existed the Coreans may well have imported Chinese wares and deposited some of them in the tombs. An authentic find of these porcelains in a Chinese tomb would give important evidence on this point, but so far there is no evidence of their being found in China beyond the statement of traders, and it is quite certain that they have been found in Corean tombs. It may be added that the Japanese class them as *hakugorai* or white Corean ware, and stoutly support their Corean origin.

[1] See passage from Hsü Ch'ing's notes, p. 39.

CHAPTER XII

CHING-TÊ CHÊN

CHING-TÊ CHÊN, the metropolis of the ceramic world, whose
venerable and glorious traditions outshine Meissen and
Sèvres and all the little lights of Europe, and leave them
eclipsed and obscure, is an unwalled town or mart (*chên*) on the
left bank of the Ch'ang River, which flows into the Po-yang Lake,
on the northern border of the province of Kiangsi. In ancient
times it was known as Ch'ang-nan Chên, the mart on the south
of the Ch'ang, but when the Sung Emperor Chên Tsung com-
manded that officially manufactured porcelain (*kuan chih tz'ŭ*)
should be sent to the capital, and that the workmen should in-
scribe the pieces with the *nien hao* or name of the period, which
in this case was Ching Tê (1004–1007), the name of the place
was changed to Ching-tê Chên.

The district town is Fou-liang, seven miles higher up the river,
a place of relatively small importance, but the residence of the
district magistrate ; and both Fou-liang and Ching-tê Chên are
within the prefectural jurisdiction of Jao Chou Fu, which is situated
near the mouth of the Ch'ang.

The wares of Ching-tê Chên are distributed by various routes,
some overland to Chi-mên or to Wu-yuan and thence to Hang
Chou, Su Chou, Shanghai, etc. ; the rest by boat down the Ch'ang,
and thence either to Kiu-kiang on the Yangtze for further dispatch
to Chin-kiang and northwards via the Grand Canal, or to the south-
west corner of the lake and up the estuary of the Kan River to
Nan-Ch'ang Fu. From this latter town they could be carried by
water (with an interruption of thirty miles of road) all the way
to Canton. They are known under various names in Chinese
books—Chên yao, Ching-tê yao, Fou-liang yao, Jao Chou yao,
Jao yao, Ch'ang-nan yao, and Nan-ch'ang yao—all of which are
easily explicable from the foregoing paragraph.

The old name of Fou-liang was Hsin-p'ing, and according to

the Annals of Fou-liang the manufacture of pottery[1] was traditionally held to have begun in the district of Hsin-p'ing in the Han dynasty. In the same passage the development of the local industry is traced by means of a few significant incidents. In the first year of Chih Tê in the Ch'ên dynasty (583 A.D.) the potters of the district were called upon to provide plinths for the Imperial buildings at Chien-k'ang (afterwards Nanking), but the plinths, when finished, though cleverly made, were not strong enough to carry the weight of the columns. In the fourth (or, according to another reading, the second) year of Wu Tê of the T'ang dynasty (621 A.D.), "porcelain jade"[2] was offered as tribute to the Emperor under the name of false jade vessels (chia yü ch'i), and from this time forward the duty (of supplying the Emperor) became an institution,[3] and a potter named Ho Chung-ch'u gained a great reputation. In the Ching Tê period of the Sung dynasty, as already stated, officially manufactured porcelain was sent to the capital, where it supplied the needs of the palaces and great establishments. In the T'ai Ting period of the Yüan dynasty (1324–1327) the porcelain factory came under the inspection of the Intendant of the Circuit, who supplied the required wares when orders had been received, and closed the factory if there were no orders (from the Court).

Continuing into the Ming dynasty, the same authority gives details of the various administrative changes which may perhaps be "taken as read," one or two important facts only calling for mention. Thus in the thirty-fifth year[4] of Hung Wu, we are told that the factories were opened, and that supplies of porcelain were sent to the Court. There seems to have been some difference of opinion about the building of the Imperial Ware Factory (Yü ch'i ch'ang).

[1] See p. 141.

[2] 陶玉 t'ao yü. There are variant readings to this passage as given in the Chiang hsi t'ung chih (bk. xciii., fol. 5 verso), which make t'ao yü the name of a man, the passage being read "T'ao-yü forwarded as tribute false jade vessels." As pointed out elsewhere, this expression "false jade" seems to imply a porcellanous ware. The comparison of porcelain and even fine pottery to jade is a commonplace in China, and it is not necessary to infer that any particular colour, green or otherwise, is indicated.

[3] The text is simply 置務 chih wu = "established duty."

[4] In order to bring this date into Hung Wu's lifetime, it is necessary to reckon from the year 1364, when he was proclaimed Prince of Wu. But other records (see T'ao lu, bk. v., fol. 4 recto) give the date as second year of Hung Wu—i.e. 1369, instead of 1398 as above. Hung Wu was proclaimed Emperor in 1368, and died in 1398.

Some authorities place this event in the Hung Wu period, but the *Chiang hsi t'ung chih*,[1] though quoting the other opinions in a note, mentions only the building of the Imperial Factory in the reign of Chêng Tê (1506–1521) in the main text, viz.: " In the beginning of the Chêng Tê period the Imperial Ware Factory was established for dealing specially with the Imperial wares." The Imperial establishment was burnt down in the Wan Li period, and again destroyed in the revolt of Wu San-kuei in 1675, but the most serious blow dealt to the prosperity of Ching-tê Chên fell in the T'ai p'ing rebellion in 1853, when the town was sacked and almost depopulated. The Imperial Factory was rebuilt in 1864, and the industry has in a great measure revived, though it is still but the shadow of its former greatness.

Though this great porcelain town has traded with the whole world for several centuries, " bringing great profit to the Empire and to itself great fame " (to quote from the *T'ao lu*), it seems to have been rarely visited by Europeans, and first-hand descriptions of it are few. We are fortunate, however, in possessing in the letters [2] of Père d'Entrecolles an intimate account of the place and its manufactures, written by a Jesuit missionary who was stationed in the town in the early years of the eighteenth century. These interesting letters are so well known that I shall not quote them extensively here. The picture they give of the enormous pottery town, with its population of a million souls and the three thousand furnaces which, directly or indirectly, provided a living for this host, and of the arresting spectacle of the town by night like a burning city spouting flames at a thousand points, a description which inspired the oft-quoted lines in Longfellow's " Keramos," shows us the place in the heyday of its prosperity.

A more modern but scarcely less interesting account of Ching-tê Chên and the surrounding country appears in a Consular report,

[1] Bk. cxiii., fols. 7 and 8. The *T'ao shuo* makes practically the same statement in connection with both periods, and Bushell (*O. C. A.*, p. 287) gives us to understand that the first structure was burnt down and that erected in the Chêng Tê period was a rebuilding. The *T'ao lu* states that a special Imperial factory was erected on the Jewel Hill in the Hung Wu period, and that there were other kilns scattered over the town working for the palace, and that the name *Yü ch'i ch'ang* was given to all of them in the Chêng Tê period.

[2] Dated 1712 and 1722 from Ching-tê Chên, and preserved among the *Lettres édifiantes et curieuses*. They have been frequently published in part or in full, e.g. translated in W. Burton's *Porcelain*, and printed in French as an appendix to Bushell's *Translation of the T'ao shuo*.

made in 1905, of a *Journey in the Interior of Kiangsi*,[1] from which I have taken the following paragraphs :

" During the last forty-five years Ching-tê Chên has had time to recover, in a very large measure, from this last calamity, but it is said to be not so busy or so populous as before the T'ai p'ing rebellion.

"Everything in Ching-tê Chên either belongs to, or is altogether subordinate to, the porcelain and earthenware industry. The very houses are for the most part built of fragments of fireclay (called ' *lo-p'ing-t'u* ') that were once part either of old kilns or of the fireclay covers in which porcelain is stacked during firing. The river bank is covered for miles [2] with a deep stratum of broken chinaware and chips of fireclay, and, as far as one could judge, the greater part of the town and several square miles of the surrounding country are built over, or composed of, a similar deposit. A great industry, employing hundreds of thousands of hands, does not remain localised in a single spot for 900 years without giving to that spot a character of its own.

"This is perhaps what struck me most forcibly in Ching-tê Chên —that it is unlike anything else in China. The forms, the colour, the materials used in the buildings, the atmosphere, are somewhat reminiscent of the poorer parts of Manchester, but resemble no other large town that I have ever visited.

"At present there are 104 pottery kilns in the town, of which some thirty or so were actually in work at the time of my visit. The greater part of the kilns only work for a comparatively short season every summer. During this busy season, when every kiln is perhaps employing an average of 100 to 200 men, the population of Ching-tê Chên rises to about 400,000, but of this nearly, if not quite, half are labourers drawn from a wide area of country, chiefly from the Tuch'ang district, who only come for the season, live in rows of barrack-like sheds, and do not bring their families with them."

It is interesting to compare this modern account with the Memoirs of Chiang,[3] written in the Yüan dynasty, from which we

[1] By Walter J. Clennell, H.M. Consul at Kiu-kiang, printed for H.M. Stationery Office.

[2] The long river front, "crowded for three miles by junks," was a feature of the place, which was sometimes known as the "thirteen *li* mart." A *li* is about 630 English yards.

[3] See p. 159.

see that the work was carried on in the same intermittent fashion, the potters receiving land to cultivate instead of payment, living round the master of the pottery, and being liable to be summoned to the kilns when required. The opening of the kilns in those days was in some measure dependent on the success of the harvest, and in any case the work depended on the season, as the paste would freeze in winter, and could not be worked.

The hills which surround Ching-tê Chên are rich in the materials required by the potters, china clay and china stone of various qualities, fireclay for the seggars (cases to protect the porcelain in the kiln), or for mixing in the coarser wares, and numerous other minerals. There was water-power which could be used in the mills for crushing and refining the minerals, and abundant wood for firing. Although coal is worked nowadays not many miles away, the potters still adhere to the wood, which has served their kilns from time immemorial. It should be added that at the present day—and no doubt for some time past—the local clays have been supplemented from various districts, supplies coming overland from Chi-mên and by water from greater distances.

A good Chinese map of Ching-tê Chên is given in the *T'ao lu* (bk. i., fol. 1), and a large map of the district is attached to Mr. W. Clennell's report, which is easily obtainable.

This description of Ching-tê Chên has led us far from the period with which we are at present concerned. In the Sung dynasty the place had already arrived at considerable importance, and the record of its 300 kilns implies a very large population. The excellence of its porcelain had already won for it the onerous privilege of supplying Imperial needs, and, as we have seen, it was consecrated under the new and Imperial name of Ching-tê Chên in the opening years of the eleventh century. The earliest existing record of its productions, the Memoirs of Chiang, written at the beginning of the fourteenth century, tells us that the Sung porcelains made at Ching-tê Chên were pure white [1] and without a flaw, and were carried for sale to all parts under the proud name of " Jao Chou jade." It rivalled the " red porcelain " of Chên-ting Fu and the green of Lung-ch'üan in beauty.

[1] An incidental reference to white porcelain bowls at Hsin-p'ing (the old name for the district town of Ching-tê Chên) in 1101 A.D. occurs in the *Ch'ang nan chih* (quoted in the *T'ao lu*, bk. viii., fol. 15). It is a verse on the subject of tea drinking : " The white porcelain is quickly passed from hand to hand all night ; the fragrant vapour fills the peaceful pavilion."

The *Ko ku yao lun* describes the Imperial ware of this time as " thin in body and lustrous," and mentions " plain white pieces with contracted waist," adding that the specimens " with unglazed rim," [1] though thin in body, white in colour, lustrous, and surpassingly beautiful, are lower in price than the Ting wares.

It is not too much to assume that some of this " Jao Chou jade " has survived to the present day, and we may look for it among the early translucent white porcelains, of which a considerable number have reached Europe during the last few years. Many of these have Sung forms and the Sung style, though, of course, plain white wares are always difficult to date. In the specimens to which I refer the glaze is usually of a warm ivory tone, tending to cream colour ; it is hard and usually discontinued in the region of the base, both underneath and on the side, and the exposed body is rather rough to the touch. (See Plate 24, Fig. 1.)

It is not clear whether we are to infer from the comparison with Lung-ch'üan ware quoted above that the Ching-tê Chên potters produced a celadon in the Sung dynasty, but it is probable enough that they did so, and that the green or greenish white (*ch'ing pai*) [2] made in the Yüan period was a continuation of this. If we can believe the statement in the *T'ao lu*, they began early to copy the wares of other factories, imitating the Chün Chou ware at the end of the Sung period and the crackled Chi Chou ware in the Yüan.

It seems to me possible that the reference to the imitation of Chün ware may be explained by an interesting passage from a late twelfth-century [3] writer quoted in the *T'ao lu*, who says that in the Ta Kuan period (1107–1110) there were among the Ching-tê Chên wares " furnace transmutations " (*yao pien*) in colour red like cinnabar. [4] He is inclined to attribute this phenomenon to the fact that " when the planet Mars in the Zodiac approaches its greatest brightness, then things happen magically and contrary to the usual order." The potters were evidently disturbed by the appearance of the wares, and broke them. He tells us, further, that he stayed at Jao Chou and obtained a number of specimens

[1] 毛口者 *mao k'ou chê*, lit. " hair mouth things." Bushell renders " with unglazed mouth." See *Ko ku yao lun*, bk. vii., fol. 24 verso, under the heading of " Old Jao wares."

[2] See p. 160.

[3] Chou Hui, author of the *Ching po tsa chih*, a miscellany published in 1193, quoted in *T'ao lu*, bk. viii., fol. 6 r. and v.

[4] Cf. descriptions of Chün Chou ware, chap. ix.

(of the local ware), and after examining them he could say that, " compared with the red porcelain (*hung tz'ŭ*) of Ting Chou,[1] they were more fresh and brilliant in appearance." It will be remembered that an echo of this last sentence occurred in the Memoirs of Chiang.

A passage in the *Po wu yao lan*[2] might be taken to mean that blue-painted porcelain, " blue and white," was made at Ching-tê Chên prior to the Yüan period, but as the remainder of the sentence seems to be based on the *Ko ku yao lun*, and no evidence is given for the words in question, too much importance need not be attached to a phrase which may be a confusion arising from the *ch'ing pai* of earlier writers.

[1] See p. 92.
[2] Bk. ii., fol. 8 verso. " The body was thin and glossy (*jun*), the colour white, the ornament blue (or green) (花青 *hua ch'ing*), and compared with Ting ware it was little inferior."

CHAPTER XIII

THE YÜAN 元 DYNASTY, 1280–1367 A.D.

THE Yüan dynasty, which lasted from 1280 to 1367, was established by Kublai Khan, grandson of the great Mongol conqueror, Genghis Khan. The Mongols completely subjugated China, and though their rule was comparatively brief, it had a disastrous effect on the artistic development of the country. The Mongol governors whose services to the reigning house had been rewarded by all the lucrative posts, made full use of their opportunities to enrich themselves by extortion and oppression. Trade and industry were convenient subjects for their exactions, and these consequently languished. The ceramic industry was among the sufferers, and many of the old potteries were closed down in this troubled period. The potteries at Ching-tê Chên, which had gradually risen to a position of great importance in the Sung dynasty, suffered for this eminence by being brought under the immediate care of a Mongol commissioner, and much of their trade passed into the hands of manufacturers in Kiangsi and Fukien.[1] The earliest account [2] which we have of the industry in this important centre, written at the beginning of the fourteenth century, ends with a bitter cry against the depredations of the governors and the subordinate officials, who were banded together to rob the people, and against whom no redress could be obtained. Dr. Bushell published a translation of the chief part of it in *Oriental Ceramic Art*,[3] and apart from the sorrowful picture which it draws it gives a good idea of the productions of the district in the Yüan dynasty. A short notice in the *T'ao lu* gives a slightly different impression, and leads us to suppose that the heavy hand of the Mongol officials

[1] See p. 164.

[2] The Memoirs of Chiang Ch'i, entitled *T'ao chi lüo*, which were incorporated in the Annals of Fou-liang in 1322, and again in the geographical annals of the province of Kiangsi (*Chiang hsi t'ung chih*, bk. xciii., fol. 5 verso).

[3] Op. cit., pp. 178–183.

was felt chiefly at the Imperial potteries, while the private factories were comparatively flourishing and even supplied some of the wares required by the Court.

We learn from the Memoirs of Chiang that a variety of porcelains were made to meet the tastes of the different regions of Southern China. The market in Northern China does not seem as yet to have been studied. Thus, while the kilns at Hu-t'ien,[1] on the river bank opposite to Ching-tê Chên, supplied a brownish yellow [2] ware which was popular in the province of Chêkiang, the greenish white[3] porcelain of Ching-tê Chên found a profitable market in Hunan and Hupeh, Szechuan, and Kuangtung. The inhabitants of Kiangsu and Anhui seem to have been less critical, for the inferior wares known as " yellow stuff " (huang liao), which did not sell in Kiangsi, Kiangnan, Kuangtung, Fukien, and Chêkiang, was foisted on them.

The finest porcelain was made of the stone (shih) from Chin-kêng, while stone and earth from other neighbouring sites were used for mixing in the inferior wares and for making seggars[4] and moulds. The glaze was made of " glaze earth " from Ling-pei mixed with the ashes of brushwood from the Yu-shan hills which had been burnt with lime and persimmon wood. I mention these technical details because their similarity with the description of the manufacture in the eighteenth century show that the method of porcelain making at both periods was essentially the same. The decoration was effected by stamping or pressing in moulds, by painting or by carving [5]; and the ware was fired either upright or inverted.

Some idea of the forms and ornament of these wares may be gathered from another passage which would be far more illuminating if the fanciful names used were less difficult to understand. Bushell has boldly translated them according to his ideas, and I quote his renderings in inverted commas and in the pious hope that they may be correct, giving at the same time the original characters.

There were bowls (wan), with high feet and with fish and water

[1] See p. 163.

[2] huang hei, lit. yellow black or, perhaps, yellow and black.

[3] Ch'ing pai, a term also applied to greenish white jade ; probably a pale celadon tint.

[4] i.e. cases in which the porcelain was fired.

[5] 印花 yin hua, 畫花 hua hua, and 雕花 tiao hua.

ornament ; platters (*t'ieh*) with " glazes shaded in different tones," [1]
sea eyes, and snow flowers [2] ; dishes (*p'an*) of the horse hoof and
betel-nut kinds, the latter suggesting a brownish red colour ; large
bowls (*yü*) with lotus ornament (or shaped like a lotus flower),
or of " square form with indented corners " [3] ; bowls and platters
(*wan t'ieh*) with painted decoration,[4] with silver designs,[5] with
" fluted sides," [6] and with " encircling strings." [7] Such wares as
these had a profitable market in Chêkiang, Kiangnan, Kiangsi
and Fukien.

There were besides incense burners of many forms, most of
which were modelled after bronzes, e.g. those shaped like the fabu-
lous beast *i*, " which eats tigers and can go five hundred *li* at a
bound " [8] ; those like the bronze incense burners on three or four
feet (*ting*), like the cups used in the ancestral temple (*i*), like the
large iron cauldrons (*li*). Others had elephant legs, and others were
shaped like incense caskets or barrels. The vase forms include the
goblet (*ku*),[9] the gall-bladder (*tan*), the wine pot (*hu*) with spout
and handle, the Buddhist washing vessel (*ching*), the gardenia
(*chih tzŭ*), the lotus leaf (*ho yeh*), the gourd (*hu lu*), musical pipes
(*lü kuan*), vessels with ring-and-mask handles *shou huan*,[10] and
glass (*liu li*) forms.

The *Ko ku yao lun*, which was written about sixty years later
than the publication of the Memoirs of Chiang, supplements this
information in a short paragraph on " Old Jao Chou wares." " Of
the Yüan wares," it says,[11] " those with small foot and moulded
ornament (*yin hua*), and the specimens inscribed inside with the
characters *shu fu* [12] are highly valued. The recently made wares
with large foot and plain white (*su*) glaze are wanting in brilliancy
(*jun*). There are also green (*ch'ing*) wares and those with enamelled

[1] The text is 發暈 *fa yün*, lit. " emit mist," perhaps in the sense of " clouded."
[2] These are literal renderings of *hai mu* and *hsüeh hua*, but I have no clue to their
meaning.
[3] The text is 耍角 *Shua chio*, lit. " sport corners."
[4] 繡花 *hsiu hua*, lit. " embroidered ornament." See p. 91.
[5] *yin hsiu*, lit. " silver embroidery or painting."
[6] 蒲脣 *p'u ch'un*, which literally means " rush (or matting) lips."
[7] 弄弦 *lung hsien*, lit. " play lute."
[8] See Giles's Dictionary.
[9] 瓴. Bushell renders it " trumpet-shaped beakers."
[10] Lit. " animal rings."
[11] Bk. vii., fols. 24 and 25.
[12] 樞府 lit. " pivot palace " ; i.e. Imperial palace.

(*wu sê*[1]) ornament, and they are very common. Of the modern (i.e. beginning of the Ming dynasty) wares good specimens with white colour and lustrous material are very highly valued. There are besides dark green [2] wares with gilt ornament. They are chiefly wine pots and wine cups, which are very lovely."

The *T'ao lu* has a paragraph on the *shu fu* wares which reflects (not always very clearly) these earlier accounts, adding that " this is the ware made in the private (*min*) factories and supplied to the palace ; the material had to be fine, white and unctuous clay, and thin specimens were preferred. . . . Inside them were written the characters *shu fu* as a mark. At the time the private factories also issued imitations of these wares ; but of the porcelains destined for the Emperor ten out of a thousand, one out of a hundred, only were selected. The private factories were unable to achieve uniform success." The author has inserted the gilt and enamelled,[3] and a large number of the other wares mentioned in the Memoirs of Chiang and the *Ko ku yao lun* in that irresponsible fashion which makes much of the Chinese ceramic literature exceedingly difficult to handle. Indeed, one is tempted to ask what was his authority for the statement that the " private factories " made the *shu fu* ware, in spite of the very circumstantial tone of the passage.

It is clear that the best of the Yüan wares made at Ching-tê Chên was plain white or white with engraved and moulded designs; and in this connection it is interesting to find an example of *shu fu* porcelain described and illustrated in Hsiang's Album.[4] It is a small, bottle-shaped vase with bulbous mouth, engraved with a dragon and cloud design, and stated to be marked with the characters *shu fu* under the base. We are told that in colour, form, and design it was copied from a specimen of the Northern Ting ware, and that the *shu fu* ware, itself copied from Ting Chou originals, served as a model for the fine white engraved porcelains of the Yung Lo and Hsüan Tê periods of the Ming dynasty. It stood, in short, midway between the soft, opaque-looking, creamy white Sung ware and the thin, hard, and highly

[1] Lit. " five-coloured."

[2] *ch'ing hei.* Bushell renders the two words " greenish black."

[3] 亦有戧金五色花者 *i yu ch'uang chin wu sê hua chê.* The expression *ch'uang chin,* which also occurs in the *Ko ku yao lun,* apparently carries the idea of gilding, though its literal meaning ("originate gold") is very vague. Bushell renders the phrase " pencilled with designs in gold," and Julien " rehaussée d'or."

[4] Op. cit., Fig. 21.

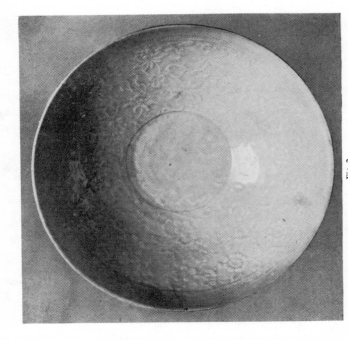

Fig. 1.

Fig. 2

Plate 46.—Ting Ware and Yüan Porcelain.

Fig. 1.—Bottle with carved reliefs of archaic dragons and *ling chih* funguses. *Fên ting* ware, said to be Sung dynasty. Height 8¾ inches. Fig. 2.—Bowl with moulded floral designs in low relief, unglazed rim. Translucent porcelain, probably Yüan dynasty. Diameter 8 inches. *Eumorfopoulos Collection*.

translucent Ming porcelain, such as the white Yung Lo bowl in the Franks Collection (see Plate 59). Just such an intermediate position as this is held by a bowl[1] in the British Museum with white, translucent body, soft-looking glaze of faint creamy tinge and engraved design of phœnixes and peony plants in Sung style. It has, moreover, a raw mouth rim which shows that it was fired inverted, and as there is no *shu fu* mark it may well have been one of the copies of the Palace types which the *T'ao lu* informs us were made at the private factories.

It is always difficult to determine the age of plain white wares, but among the archaic specimens of translucent porcelain with creamy white glaze and rough finish at the base which have come from China in recent years under the varying descriptions of Sung, Yüan and early Ming, there are, no doubt, several examples of the Yüan wares of Ching-tê Chên (see Plate 46, Fig. 2).

The mention, in the Memoirs of Chiang and the *Ko ku yao lun*, of painted decoration, enamelled ornament, silvering, and gilding, though apparently but crudely used and little appreciated, is nevertheless of great interest from the historical standpoint.

The potteries at Hu-t'ien which are mentioned in the Memoirs of Chiang (see p. 160) were only separated from Ching-tê Chên by the width of the river. They are described in the *T'ao lu*[2] as active at the beginning of the Yüan dynasty and producing a ware which, though of coarse grain, had " a considerable amount of antique elegance," and appealed to the taste of the inhabitants of the Chêkiang. The clay was hard and tough, and the colour of the ware brownish yellow[3] as a rule, but even when of a " watery white " tone it was tinged with the same brown colour. At the end of the eighteenth century all trace of the factories had disappeared, though the village still existed[4] and the old wares were still to be found.

Brinkley, who seems to have met with examples of the ware in Japan, describes it as follows[5] : " The *pâte* is thick and dense, without any of the delicacy of porcelain, and the glaze is muddy

[1] See *Burlington Magazine*, August, 1909, p. 298.

[2] Bk. v., fol. 3 verso.

[3] *huang hei*, lit. " yellow black."

[4] The village 湖田市 Hu-t'ien Shih and the pagoda are marked in the map of Ching-tê Chên (*T'ao lu*, bk. i., fol. 1) on the south of the river and opposite to the Imperial factories.

[5] *China and Japan*, vol. ix., p. 303.

yellow. . . The surface of the pieces is generally relieved by deeply incised designs of somewhat archaic character, figure subjects being most common. Some examples are preserved in Japanese collections, where they are known as *Ningyo-de* (figure subject variety) in allusion to the nature of the incised designs." In spite of its apparent roughness it was thought worthy of imitation at Ching-tê Chên in the Ming dynasty.[1]

Among the causes to which was attributed the lack of prosperity at Ching-tê Chên in the Yüan period, the Memoirs of Chiang includes (1) the uncertainty of the season on which the opening of the factory partly depended, (2) the intolerable taxation and the exactions of officials, and (3) the competition of the potteries at Lin-ch'uan, Nan-fêng Hsien, and Chien-yang, all of which, as Bushell indicates, lay on the trade route between Ching-tê Chên and south-eastern coast towns.

Of these we learn in the *T'ao lu* that Lin-ch'uan[2] in the Fu-chou Fu in Kiangsi (not far south of Ching-tê Chên) made a ware of fine clay and thin substance, the colour of which was mostly white with a slight yellowish tinge, and that some of the pieces were coarsely ornamented, though we are not informed how the ornament was applied. The same authority informs us that Nang-fêng Hsien[3] in the Chien-yang Fu (also in Kiangsi) made a ware of refined clay but somewhat thick substance, which was, as a rule, decorated with blue designs (*ch'ing hua*), though some had the colour of the *t'u ting* ware, i.e. the coarser and yellower variety of Ting Chou porcelain.

From this passage it appears that " blue and white " may be added to the types of ware made in the Yüan period.

The third factory, at Chien-yang in Fukien, has already been discussed at some length. It was chiefly celebrated for the dark-coloured wares (*wu-ni yao*) and the " hare's fur " and " partridge " tea bowls.[4]

These names by no means exhaust the list of factories which were active in the Yüan period. Others have been incidentally mentioned elsewhere under the headings of Yüan-tz'ŭ, P'êng ware, Hsin Ting ware, etc.[5]

[1] See *T'ao lu*, bk. ii., fol. 4 verso ; and Julien op. cit., p. 42.
[2] 臨川. See *T'ao lu*, bk. vii., fol. 10 verso.
[3] 南豐縣.
[4] See p. 131.
[5] See pp. 94, 128, etc.

The *Ko ku yao lun* enumerates certain pottery forms which, it asserts, were not in use before the Yüan period. As usual, the Chinese descriptions are exceedingly difficult to visualise, and in many cases are open to several interpretations, and are not easy to reconcile with established facts. However, I quote the passage as it stands : " Men of old when they drank tea used *p'ieh*[1] (? bowls with curved sides), which were easy to drain and did not retain the sediment. For drinking wine they used cups (*chan*) ; they had not yet tried cups with handles (*pa chan*[2]), and in old times they had no *ch'üan p'an*.[3] The Ting ware *ch'üan p'an* which one sees nowadays are the brush washers (*hsi*) of olden times. The men of old used ' decoction vases ' for pouring wine, and did not use ewers (*hu p'ing*) or bowls with contracted lip or tea cups (*ch'a chung*) or dishes with rims.[4] These were all forms used by the Mongols. The men of China only began to use them in the Yüan dynasty. They never appear in old Ting or Kuan wares." [5]

[1] 擎. Bushell (*O. C. A.*, p. 186) renders " wide shallow bowls."

[2] 把盞. The handles may be either long stems or handles in the modern sense, but both these types are found on far more ancient wares, e.g. the tazza or high footed goblet in Chou pottery, and the small cups with round handles of the T'ang dynasty.

[3] 勸盤, lit. " exhort dishes." Bushell renders " rounded dishes." They were probably flat-bottomed shallow bowls, used as saucers.

[4] 臺 *t'ai p'an*, lit. " terraced dishes."

[5] *Ko ku yao lun*, bk. vii., fol. 25 verso.

CHAPTER XIV

KUANGTUNG 廣東 WARES

THOUGH the province of Kuangtung has long been celebrated for its pottery, only very meagre information is procurable on the history of its factories. A single reference in the *T'u shu*[1] carries us back to the T'ang dynasty (618–906), when we learn that earthenware cooking vessels were made in the potteries (*t'ao chia*) of Kuang Chou (i.e. Canton), which when glazed were better than iron vessels and more suitable for the decoction of drugs. " A vessel of the capacity of a bushel sold for ten cash : and they were things which were worth preserving."

The next mention occurs in the *T'ao lu*, which gives a short account of the wares under the heading *Kuang yao*, but beyond the statement that the industry originated at Yang-Chiang, it gives no information as to the date or circumstances of its commencement.[2] For the rest this account is very confused and un-

[1] The *T'u shu*, Section xxxii., Part viii., section entitled *T'ao kung pu tsa lu*, fol. 1 verso ; quoting from the *Ling piao lu i* 嶺表錄異, by Liu Hsün, of the T'ang dynasty.

[2] Bk. vii., fol. 16. " This is the ware which was first made at Yang-chiang Hsien 陽江縣 in the Chao-ch'ing Fu in Kuangtung. It is, in fact, an imitation of the *Yang-tz'ŭ* ware. Consequently, the Records of the Province state that the productions of Yang-chiang in Kuangtung include ' porcelain wares ' (*tz'ŭ ch'i*). I have seen incense burners (*lu*), vases (*p'ing*), cups (*chien*), plates (*t'ieh*), bowls (*wan*), dishes (*p'an*), pots (*hu*), and boxes (*ho*) of this manufacture. They are very ornamental and bright, but in taste, fineness, elegance, and lustre they are not equal to porcelain wares. Nor have they been able to avoid the occurrence of flaws exposing the body, which are unsightly. Still they are imitated at T'ang's manufactory, the imitations being admirable in their elegance and lustre, and excelling the Kuang yao. These, like the Tz'ŭ-Chou and Hsü-Chou types of ware, are none of them made of porcelain clay." The *T'ao chêng chi shih* states : " He (i.e. T'ang Ying) imitates singularly well the Kuang yao glaze, being particularly successful with the spotted blue (*ch'ing tien* 青點) kind of glaze. Following this author, imitations were also made of the copies produced at T'ang's factory." The greater part of this passage seems to contain a confusion of ideas. *Yang-tz'ŭ* 洋磁 or " foreign porcelain " was the name given to the painted Canton enamels which are described on the next page of the *T'ao lu* under that heading. The passage beginning " I have seen " and ending " equal to porcelain wares " is taken almost verbatim from the sections which deal with Canton enamels

satisfactory, and seems in part to refer to the porcelain decorated at Canton (see vol. ii., p. 211), or more probably to the Canton enamels. It is only in the last passage that we come into touch with a ware which is readily recognised as the familiar Canton stoneware. This is a hard-fired ware, usually dark brown at the base, but varying at times to pale yellowish grey and buff, with a thick smooth glaze distinguished from other ceramic glazes by its characteristic mottling and dappling. The colour is often blue, flecked and streaked with grey green or white over a substratum of olive brown, or again green with grey and blue mottling. At times the brown tints predominate, but the most prized varieties are those in which the general tone is blue. These were specially selected for imitation at the Imperial factories under T'ang Ying, and they are highly valued in Japan, where the ware in general goes by the name of *namako*.[1] In other specimens the glaze has a curdled appearance, and sometimes it seems to have boiled up like lava. The mottled glazes at times have a superficial resemblance to the dappled Chün wares, and there is no doubt that in recent times these imitative effects have been studied.

The dating of the mottled Kuangtung wares, or Canton stonewares as they are commonly named, is always a difficult matter. They are still made and exported in large quantities, but it is certain that they go back at least to late Ming times. Sir Arthur Church exhibited a tray of this ware at the Burlington Fine Arts Club in 1910[2] which bore a date corresponding to 1625, and the name of the maker, Chin-shih. The glaze of this interesting piece is remarkably deep, rich and lustrous, and it may be regarded as typical of the finest period of the ware. The tray illustrated by Fig. 1 of Plate 48 closely resembles it in colour and quality. Stamped marks occasionally occur in these wares, the most frequent

and cloisonné enamels. The remark on " imitation of the Yang-tz'ŭ ware " could by no stretch of imagination be applied to the mottled Kuang yao ; but it does apply to the large group of porcelain obtained in the white from Ching-tê Chên and painted at Canton precisely in the style of the Canton enamels (see vol. ii., p. 243). This is no doubt what the author had in his mind. The sentence about the unsightly flaws can apply to either the enamels or the Kuang yao, but more particularly to the latter. For the rest, " T'ang's factory " is the Imperial factory at Ching-tê Chên, which was under the management of the celebrated T'ang Ying between 1728 and 1749.

[1] From its supposed resemblance to the colour of the sea-snail (*namako*).

[2] *Cat. B. F. A.*, 1910, K 43. Like so many Chinese dates, this was cut in the ware after the firing, but there is every reason to suppose that it indicates the true date of the manufacture. Sir Arthur has since presented this tray to the British Museum.

being the seals used by two potters, apparently brothers, named Ko Ming-hsiang and Ko Yüan-hsiang (see p. 221). It was formerly said that they lived at the end of the Ming period, but Dr. Bushell in his *Chinese Art*[1] reduced their antiquity to the reign of Ch'ien Lung (1736–1795). No reason is given for either of these dates, but their work is familiar, and as some of the examples have a decidedly modern aspect, I am strongly in favour of the later attribution. Plate 47 is a fine example of a Kuangtung glaze, in which the blue is conspicuous.[2] It is probably of seventeenth-century date.

Another Kuangtung group consists chiefly of figures and objects modelled in the round and coated with rich crimson red *flambé* or pea green celadon glazes, with a liberal display of dark brown or red biscuit. Figures of the god of War and other deities are often represented, the draperies heavily glazed and the flesh parts in unglazed biscuit, which sometimes has the appearance of being browned by a dressing of ferruginous clay. (See Plate 48.)

Brinkley[3] describes several additional types of Kuang yao, including a buff stoneware with " creamy crackled glaze of t'u Ting type."[4] " The characteristic type is a large vase or ewer[5] decorated with a scroll of lotus or peony in high relief and having paint-like, creamy glaze of varying lustre and uneven thickness, its buff colour often showing tinges of blue." Vases of similar make seem also to aim at copying the red-splashed lavender glazes of the Chün and Yüan wares, and sometimes the colour is very beautiful, but the glaze has distinctive characteristics (see Plate 48, Fig. 2). It is opaque, and lacks the translucent and flowing character of the originals, and the surface has a peculiar sticky lustre, and something of that silken sheen which distinguishes the Canton

[1] Op. cit., vol. ii., p. 15.

[2] Modern English potters produce flocculent glazes of the Canton type by means of zinc, and Mr. Mott, of Doulton's, showed me a specimen illustrating the effect of zinc which was remarkably like the glaze of Plate 47 both in the blue dappling and the greenish frosting. Possibly the use of zinc was known to the Kuangtung potters and gave them their characteristic types of glaze. Other effects resembling the Canton glazes were produced by Mr. Mott by both zinc and tin in the presence of cobalt and iron.

[3] *Japan and China*, vol. ix., p. 261.

[4] See p. 90.

[5] Such a piece from the British Museum collection is figured in the *Burlington Magazine*, January, 1910, p. 218.

and Yi-hsing glazes of this class. The crackle, too, is more open and obvious. Some of these pieces have the appearance of considerable antiquity, and are reputed to date back to Sung times.[1] Midway between these and the familiar mottled Canton stoneware come what are known in China as the Fat-shan Chün.[2] Their obvious intention to imitate the old Chün wares is declared by the appearance of numerals incised in Chün Chou fashion under the base. A typical example (see Plate 51) is a high-shouldered flower vase with short neck and small mouth (not a Sung but a Ming form, be it noted), with thick, rolling, crackled glaze of pinkish cream colour, shading into lavender and flushing deep red on the shoulders. In rare instances the crimson spreads over the greater part of the surface. The biscuit at the base is brownish grey if its light tint is not concealed by a wash of dark clay. The glaze, unlike that of the type described by Brinkley, is fairly fluescent, thin at the mouth, and running thick in the lower levels. Other examples of this class have heavily mottled grey or blue glazes nearer in style to the Canton stoneware. Indeed, they are clearly made at the same factory as the latter, for we have a connecting link between the two groups in a vase in the Eumorfopoulos Collection, a tall cylinder with streaky lavender blue glaze and the usual silken lustre, the base of buff colour washed with brown slip and marked with the square seal of Ko Ming-hsiang. Many of these " Fat-shan Chün " wares are exceedingly attractive, but by far the most beautiful are the rare dishes in which the glaze has been allowed to form in deep pools of glass in the centre.[3] In these pieces all the changing tints of the surrounding glaze are concentrated in the cavity in a crystalline mass of vivid colour. Such wares are, I think, not older than the Ch'ing dynasty, though they have been erroneously described by some writers as Sung.[4]

[1] See *Burlington Magazine*, January, 1910, p. 220.

[2] I am indebted to Mr. A. W. Bahr for much information on these and the Yi-hsing Chün imitations.

[3] Three beautiful examples were exhibited at the Burlington Fine Arts Club in 1910, (*Cat.*, K 20, 23 and 41), on the last of which the lavender tints on the sides passed into a glassy pool of brilliant peacock blue.

[4] There is an interesting example of this crystalline glaze in Mrs. Potter Palmer's collection. It is a bowl of coarse grey porcelain, with blue glaze on the exterior. Inside is a crimson red glaze of Canton type, in the centre of which is a pool of amber glass. The explanation seems to be that we have here a bowl of coarse export porcelain treated at a Canton factory with their crystalline glaze.

With regard to the dates of the Fat-shan Chün types, the remarks made on the Canton stoneware apply equally to them. Many are frankly modern ; the finer pieces may be assigned to the eighteenth century, and a few perhaps go back to the Ming dynasty. From the current name we infer that they are made at Fat-shan, but this is the only evidence existing on the question. Fat-shan is situated a few miles south-west of Canton with which it is connected by railway. It is a large town, " renowned for its vast silk manu-factures, cloth-making, embroidery, cutlery, matting, paper, and porcelain." [1] No doubt the word porcelain in this context is a comprehensive term, and includes stoneware and pottery, if, indeed, it means anything else. But the precise provenance of the various kinds of Kuang yao is far from clear. All that we learn from the T'ao lu is that the Kuang yao originated at Yang-chiang. Probably the type of mottled glaze which characterises the Canton stone-ware was first made there, and was afterwards adopted in the factories which sprang up in the neighbourhood of Canton. Other localities in the province of Kuangtung in which the ceramic in-dustry is represented include Chao-Ch'ing Fu,[2] which may be only a trading centre for the wares ; Shih-wan, in Po-lo Hsien, a few miles east of Canton, which is said [3] to supply the Canton markets with " pots, dishes, and jars of every needed shape and size, some of the latter as large as hogsheads, glazed and unglazed, together with a large variety of imitation grotto work and figures for gardens, gallipots, little images, etc." ; and the prefecture of Lien-chou, in the extreme south of the province, which exports its wares from Pak-hoi. A few specimens bought in the neighbourhood of the Shih-wan potteries, and no doubt of local make, are in the British Museum. They consist of lion joss-stick holders, crab-shaped pots for growing lily bulbs, and small figures of a hard, rough stoneware of buff or drab colour. The bulb pots have an opaque green glaze with passages of transparent *flambé* colours, not unlike the Yi-hsing or Canton Chün glazes, and the other

[1] Richards, *Comprehensive Geography of the Chinese Empire*, 1908, p. 210.

[2] Richards, op. cit., p. 209. " Considerable trade is carried on in tea, porcelain, etc."

[3] S. Wells Williams, *Commercial Guide to China*, 1863, p. 13. Speaking of pottery the author says : " The charges for freight forbid it to be carried far, and manufactures of it are numerous ; that for Canton is at Shih-hwan." No doubt this is Shih-wan 石灣. Another name for Canton pottery is Shakwan ware, which is probably a variant of Shih-wan.

Fig. 3

Fig. 2

Fig. 1

Plate 48.—Kuangtung Ware.

Fig. 1.—Dish in form of a lotus leaf, mottled blue and brown glaze. About 1600. Diameter 8¼ inches. *British Museum.*
Fig. 2.—Vase with lotus scroll in relief, opaque, closely crackled glaze of pale lavender grey warming into purple.
(?) Fourteenth century. Height 7⅞ inches. *Peters Collection.* Fig. 3.—Figure of Pu-tai Ho-shang, red biscuit, the draperies
glazed celadon green. Eighteenth century. Height 8¼ inches. *British Museum.*

Plate 49.—Covered Jar of Buff Stoneware.

With cloudy green glaze and touches of dark blue, yellow, brown and white;
archaic dragons, bats and storks in low relief; border of sea waves.
Probably Kuangtung ware, seventeenth century. Height 33 inches.
Eumorfopoulos Collection.

pieces have washes of the thin, translucent green, turquoise, yellow, and purplish brown glazes which are usually applied on the biscuit of pottery or porcelain. The exhibits at the Paris Exhibition[1] in 1878 included " tea jars, tobacco pots, medicine jars, cassolettes, various pots, plates, sauce vessels, rice bowls, wine and rice cups, spoons, bird-cage pots, mortars, candlesticks, crucibles and lamps " from the Pak-hoi district.

[1] *Catalogue spécial de la Collection Chinoise à l'Exposition Universelle*, Paris, 1878, pp. 10-12.

CHAPTER XV

YI-HSING 宜興 WARE

THE potteries at Yi-hsing Hsien, in the prefecture of Ch'ang-chou, in Kiangsu, at no great distance from Shanghai, have long been celebrated for elegantly shaped teapots of unglazed stoneware in red and other colours. They have, in fact, been honoured with a special book, the *Yang-hsien ming hu hsi*,[1] or "Story of the teapots of Yang-hsien" (an old name for Yi-hsing), written in the seventeenth century[2]; but though extracts from this work occur in the *T'ao lu* and elsewhere, I have been unable to get access to any copy of the original. This deficiency, however, has been made good by an important translation given by Brinkley[3] of a short Japanese work which, he says, "owes nothing to Japanese research, being merely transcribed from Chinese annals." The legendary story of the discovery of the all-important clay deposits in Mount Tao-jung Shu-shan is followed by a description of the chief varieties of this material which include light yellow clay for mixing; another, yellow clay called *shih huang* (stone yellow) which turned to cinnabar red in the firing; a blue clay which turned to dark brown; a clay which produced a "pear skin" colour; a light scarlet clay which produced a pottery of the colour of pine spikelets; a light yellow clay making a green ware; and another producing a light red pottery. The "pear skin" clay mixed with white sand formed a material of a light ink brown colour.

With these materials, and with their conspicuous skill in blending clays, it may well be imagined that the Yi-hsing potters were able to make innumerable varieties in their ware. The commonest shades, however, are deep and light red, chocolate brown, buff, drab and black brown; occasionally the clays are speckled—e.g. buff ware with blue specks—or powdered with minute particles

[1] 陽羨名壺系.
[2] By Chou Kao-ch'i. See Bushell, *O. C. A.*, p. 635.
[3] F. Brinkley, *Japan and China*, vol. ix., pp. 355-63.

174

of quartz, and frequently two or more clays are used in contrasting tints on the same piece. The body of the ware is sometimes soft enough to powder under the knife, but as a rule it is a very hard stoneware, capable of receiving a fine polish on the lapidary's wheel. The choicest teapots are unglazed, though often a sort of natural gloss has formed on the surface in the kiln.

But to continue the history of the factories as outlined in Brinkley's translation, we are told that the first maker of " choice utensils of pottery for tea-drinking purposes " was a priest of the Chin-sha temple about thirteen miles south-east of Yi-hsing, and that the first really great Yi-hsing potter was Kung Ch'un 龔春 who flourished in the Chêng Tê period (1506–1521). Though it would appear that Kung Ch'un, while attending his master Wu I-shan at the Chin-sha temple, surreptitiously learnt the secrets of the priest, his fame completely eclipsed that of his teacher, and he is usually venerated as the founder of the Yi-hsing potteries. His pots are described as being " hand made, and in most of them thumb-marks are faintly visible. Generally their colour is that of a chestnut, and they have a subdued lustre like oxidised gold. Their simplicity and accuracy of shape are inimitable ; worthy to be ascribed to divine revelations."

Supernatural qualities form the only point in common between this description and that of the two teapots figured in Hsiang's Album,[1] and confidently assigned to Kung Ch'un. One of these is a drab ware and of hexagonal shape, which appears to have been formed in a mould ; the other is in the form of a wine ewer and of vermilion red ; and both are stated to have the wonderful quality of changing colour when filled with tea. In fact, in the second illustration the artist has depicted this phenomenon, the pot being vermilion red above and green below the tea-line. The price of these two pots in the sixteenth century was no less than 500 taels or ounces of silver.[2] Brinkley's translation gives a considerable list of Yi-hsing potters who made a reputation in the Ming dynasty, but as the characters are not added it does not always help us to identify the names,[3] among the potter's marks, and in

[1] Op. cit., figs. 45 and 46.

[2] A tael is about one Mexican dollar and a third, i.e. approximately thirty pence.

[3] Four of the most celebrated names, however, are incidentally mentioned in the T'ao lu (bk. vii., fol. 11 verso), viz. (1) Shih Ta-pin 時大賓 ; (2) Li Chung-fang 李仲芳 ; (3) Hsü Yu-ch'üan 徐友泉 ; (4) Ch'ên Chung-mei 陳仲美 ; and (5) Ch'ên Chün-ch'ing 陳俊卿.

most cases the characteristics assigned to them are entirely vague. We learn, for instance, that one man's "forte was beauty of decoration," and that three others were "renowned for the excellence of their pottery." On the other hand, it is important to read that Tung Han in the Wan Li period (1573–1619) was "the first potter who ornamented the surface of the Yi-hsing ware with elaborate designs in relief," and that many of the pieces designed by Ch'ên Chung-mei,[1] who had formerly been a porcelain maker, "such as perfume boxes, flower vases, paper weights, and so forth, show singularly fine moulding and chiselling. His vases were shaped in the form of flowers, leaves, and fruits, and were decorated with insects. His dragons sporting among storm-clouds, with outstretched claws and straining eyes; his statuettes of the goddess Kuan-yin, her features at once majestic and benevolent—these are indeed wonderful productions, instinct with life." This passage shows, at any rate, that in the Ming period the Yi-hsing potters did not confine their attention to tea wares. Perhaps the most celebrated Yi-hsing potter was Shih Ta-pin, who followed in the footsteps of the great Kung Ch'un, and eventually surpassed him.

Brinkley's translation gives us very precise views of what the true form of the teapot should be. It should be small, so that the bouquet of the tea be not dispersed, and every guest should have a pot to himself. It should be shallow, with a cover which is convex inside; and it is very important that the spout should be straight. Crooked spouts were very liable to become obstructed by the tea leaves. "One drinks tea for pleasure, and one may justly feel irritated if the beverage declines to come out of the pot." The true form of teapot, we are told, began with Kung Ch'un, from which one infers that the tea bowls of the T'ang and Sung usage were in vogue up to his time. But the correct shape once established, the Yi-hsing potters soon began to take liberties with it, and to twist it into all manner of fanciful forms, such as fruits (persimmon, pomegranate, finger citron), the leaf or the seed-pod of the lotus, creature forms such as fish leaping from waves,

[1] The *Yang-hsien ming hu hsi* (quoted in the *T'ao lu*, bk. viii., fol. 8 verso) states that Ch'ên Chung-mei began by making porcelain at Ching-tê Chên. "It was exceedingly clever, and of an ornamental kind, made with supernatural ingenuity. But the results of his trade were far from sufficient to establish a name, so he gave it up and came to Yang-hsien (i.e. Yi-hsing). He took a delight in blending the teapot clays, putting his heart and soul into the work, and his ware was considered superhuman."

Fig. 1 Fig. 2

Fig. 3 Fig. 4

Fig. 5 Fig. 6

Plate 50.—Yi-hsing Stoneware, sometimes called *Buccaro.*

Figs. 1–4.—Teapots in the Dresden Collection, late seventeenth century. (1) Buff with dark patches. Height 5 inches. (2) Red ware with pierced outer casing. Diameter 5½ inches. (3) Black with gilt vine sprays. Height 4½ inches. (4) Red ware moulded with lion design. Height 4¾ inches. Fig. 5.—Peach-shaped water vessel, red ware. Diameter 4⅛ inches. *Dresden Collection.* Fig 6.—Red teapot, moulded design of trees, etc. Inscription containing the name of Ch'ien Lung. Diameter 4½ inches. *Hippisley Collection.*

a phœnix, and innumerable other quaint shapes, always skilfully modelled and often of high artistic merit.

The ware, as already stated, is chiefly red, dark and light, chocolate brown, buff, and drab, and it is usually without glaze. The decoration consists of: (1) Engraved designs, cut in the ware while it was still soft. These are usually inscriptions of a poetic nature, great importance being attached to the calligraphy. Indeed, we are told that "some of the potters of Yi-hsing owed their reputation chiefly to their skill in carving inscriptions. Such a man was Chan-chien, whose style of writing has been much imitated by modern artists. Another was Ta-hsin, who was employed by Shih Ta-pin to write inscriptions, and who was such a master of penmanship that his inscriptions have been carefully transcribed and are used by connoisseurs as a standard of excellence." (2) Low reliefs, either formed in the teapot mould or separately stamped out and stuck on. Occasionally gilding is found on these, but it is probably a European addition. (3) Stamped diapers of key fret, and other familiar patterns, usually forming the background for relief ornament or borders. (4) Openwork designs applied in panels over an inner lining which was usually washed with a light-tinted clay. The pierced work is commonly of floral design, often the prunus, bamboo and pine pattern, and on dishes and saucers it has no backing but is left à jour. All these methods of ornament are found on the examples which reached Europe at the end of the seventeenth century, and they supplied designs for the European potters of that period. (5) A later type of ornament consists of opaque coloured enamels in painted designs or as ground-colours completely hiding the surface of the ware. The colours are always of the *famille rose* variety, including opaque pink,[1] and I do not know of any example which suggests an earlier date than Ch'ien Lung (1736-1795). Most, indeed, appear to be nineteenth century.

In addition to these, certain less familiar styles of ornament are found on the smaller objects, such as the heads of opium pipes, which are beautifully made and tastefully decorated. The red ware is sometimes coated with a transparent glaze of yellowish tint, giving a surface of warm reddish brown, exactly similar to

[1] I have seen specimens of Yi-hsing red ware coated with a dappled bird's egg glaze of blue green ground flecked with crimson, a type which was thought to represent the "Chün glaze of the muffle kiln." See vol. ii., p. 217.

the eighteenth century Astbury ware of Staffordshire; or, again, it is polished on the lapidary's wheel like the Böttger ware of Dresden. Inlaid designs in fine white clay and marbling are further varieties; and occasionally coloured glazes of great beauty occur. But these will be discussed presently.

There is no limit to the variety of articles made by the Yi-hsing potters, but they chiefly excelled in small and dainty articles for the writing-table, the toilet, and the tea-table, and personal ornaments. Their tea wares have always been highly prized in Japan, where they have been cleverly copied in Banko ware and by the Kioto potters. Similarly, when tea-drinking became an institution in Europe in the last half of the seventeenth century, and the East India companies set themselves to supply the necessary apparatus from China, the Yi-hsing red teapots became fashionable, and were immediately imitated by enterprising potters. The Dutch and English seem to have been the first to succeed in this new departure, and we read that Ary de Milde and W. van Eenhorn, of Delft, applied for a monopoly of the manufacture in Holland in 1679, while John Dwight, of Fulham, included the " Opacous, redd and Dark coloured Porcellane or China " in the patent taken out in London five years later. The brothers Elers, of Dutch extraction, started the industry in Staffordshire about 1693, and made red stoneware teapots scarcely distinguishable from the Chinese, and which sold for a guinea a piece.

The Yi-hsing wares in the celebrated Chinese ceramic collection formed by Augustus the Strong at Dresden supplied designs for the fine red stoneware made in the first years of the eighteenth century by Böttger, who also discovered the secret of true porcelain in Europe and founded the famous Meissen porcelain factory.

From the earliest days of their importation the Yi-hsing wares have been known in Europe, especially in Italy, Spain, and Portugal, by the Portuguese name of *buccaro*. The true *buccaro* is a scented pottery, first imported from Central and South America, where it was made by the Indian population and afterwards manufactured in Portugal and Spain; and Count Lorenzo Magalotti, who wrote in 1695, protested against the application of the name " to certain unglazed pieces of Oriental origin," asserting that " true Buccaro never came from China or Japan, and that they must not be looked for out of the pottery sent over from Central America

or the Portuguese imitations."[1] But the protests of purists were unavailing, and *buccaro* seems to have become a regular term for unglazed pottery, even the archaic black ware from the Etruscan tombs receiving the name of *buchero nero*.

Another important group of Yi-hsing wares presents an entirely different aspect, and indeed it is little understood in Europe, though it is probably bought by unwary collectors for the Sung types which it purports to imitate. This is the Yi-hsing Chün, to which allusion has already been made in discussing the imitation Chün wares. The traditions of this manufacture go back to the Ming dynasty, when a potter named Ou 歐 gained a great reputation for his glazes, which " copied the Ko ware in crackle and the Kuan and Chün wares in colour."[2] This is, no doubt, the manufacture mentioned in the *Po wu yao lan* in the passage dealing with Chün yao : " At the present time (i.e. 1621–1627), among the recent manufactures this kind of ware is all made with the sandy clay (*sha t'u*) of Yi-hsing as body ; the glaze is rather like the original, and in some cases beautiful, but it does not wear well."

Though the original glazed wares of Ou are probably rarer to-day than their Chün Chou prototypes, there is no reason to suppose that Ou's successors have not kept up the continuity of the manufacture. It is certainly very much alive to-day, and an early eighteenth century reference to " the applied glaze of Yi-hsing "[3] seems to imply its existence at that time. I have

[1] For this and other information on the subject, see M. L. Solon's paper on " The Noble Buccaros " in the North Staffordshire Literary and Philosophic Society's *Proceedings*, October 23rd, 1896.

[2] See *T'ao lu*, bk. vii., fol. 11 verso : " (Ou ware) was made in the Ming dynasty by a man of Yi-hsing . . . who took the name of Ou, and everybody called it Ou's ware. It included wares which imitated Ko ware in crackle, Kuan and Chün wares in colour. Ou's bright coloured glazes were very numerous. The wares consist of flower dishes, stands for boxes, etc. The glazes with red and blue markings are particularly choice. At Ch'ang-nan the factory of T'ang used to imitate them." The last sentence refers to the celebrated T'ang Ying, who supervised the Imperial factory at Ching-tê Chên from 1728-1749. The statement that T'ang's factory imitated them is no doubt based on the oft-quoted list given in the *Chiang hsi t'ung chih* of wares made at the Imperial factory about 1730, which include " glazes of Ou. Imitations of the old ware of the potter named Ou, including two kinds, that with red and that with blue markings."

[3] In the list quoted in the last note. The words are 宜興掛釉, *Yi hsing kua yu.* The word *kua*, which means " suspended, applied," is probably inserted because the Yi-hsing ware was usually unglazed.

before me as I write a tripod incense burner of archaic form, the body a light buff stoneware and the glaze a deep lavender, breaking into blue. It is a thick and rather opaque glaze, sufficiently flowing to have left the upper edges almost bare and formed thickly on the flatter and lower levels ; the colour is broken by streaks and clouding, which mark the downward flow of the glaze ; the surface has a barely perceptible crackle, which will no doubt become more marked with age, and a subdued lustre between the brilliancy of the old opalescent Chün types and the viscous, silken sheen of the Canton glazes [1] which also imitate them. The colour and glaze are distinctly attractive, and have much in common with the old Chün glazes, and though this is a frankly modern piece, it shows the potentialities of the ware. Similar specimens made, say, a hundred or two hundred years ago, and proportionately aged by time and usage, might well cause trouble to the collector.

There are, besides, quantities of common glazed pottery made at Yi-hsing in the present day, and probably for a considerable time back, which has no mission to imitate the antique. Many of the modern ginger pots are said to come from this locality, and their glazes—some with clear colours (yellow, green, or purple), others opaque and clouded, often covering moulded ornament in low relief—may help us to identify kindred types of glaze on pieces which are more ornamental and perhaps much older. But pottery, as distinct from porcelain and the finer stonewares, has never commanded much interest in China, and it has never been systematically collected and studied. The result is that it is extremely difficult to place the various types which appear from time to time except in large and ill-defined groups. A series of typical pieces of modern Yi-hsing pottery, for instance, would no doubt be of the greatest value in identifying the rather older wares made in the same place under similar traditions, but no one in Europe [2] has thought it worth their while to form one.

I have noticed that a certain type of glazed pottery is distinguished by a concave base which serves instead of the usual hollowed-

[1] A similar effect is produced by zinc and tin on modern English wares. See note on p. 168. It has been suggested that these minerals were used on the Kuang-tung stonewares, and appearances, at any rate, point to their presence in the Yi-hsing *flambé* glazes as well.

[2] Dr. Laufer collected a considerable series of wares made in certain modern factories which he visited in China, and they may be seen in the Field Museum, Chicago, and in the Natural History Museum in New York.

out foot and foot rim, and by a glaze which stops a little short of
the base in an even, regular line which is quite distinct from the
wavy glaze line of the Yüan and earlier wares. A jar of this type
in the British Museum has a typical Yi-hsing glaze, and though
this is not perhaps sufficient ground for generalising, I would
suggest that this peculiar finish is an indication of Yi-hsing
manufacture.

CHAPTER XVI

MISCELLANEOUS POTTERIES

IN addition to the factories which have received individual notice, there are numerous others which are only names to us ; and, on the other hand, there is a host of nameless wares which have reached Europe at various times and through divers channels, and are now awaiting classification with very little chance of being definitely located. A consideration, however, suggested by the *Chinese Commercial Guide*[1] may help towards the grouping of these miscellaneous wares. We are told that the charges for freight forbid the wares to be carried far in the ordinary way of internal trade, and that manufactures of pottery are numerous, supplying the local needs. Now the number of ports open to foreign trade in China is limited, and in the past the sea trade was of far smaller volume, and was concentrated in a few of the southern coast towns. Consequently, in dealing with pottery which we may assume to have been brought by the export trade to Europe, it will be necessary for general purposes to take account only of the factories in the neighbourhood of the seaports in question. These will be found to be almost entirely in the southern half of China.

Thus, starting from the south and following the coast line, we come first to the potteries which supplied Pakhoi and Canton, and we may assume that Hongkong and Kowloon would be supplied from the neighbourhood of Canton. These have already been discussed, and we can pass on to Swatow, which would draw supplies from the Ch'ao-chou Fu potteries. This neighbourhood furnished an exhibit to the Paris Exhibition of 1878, consisting of " tea jars, tobacco jars, braziers and pots, lamps, tiles, flower pots, fruit jars, spoons, vases of various sorts, figures, dishes, cups and saucers, and spittoons."

At the same exhibition, Amoy, to which we come next, was

[1] S. Wells Williams, *Chinese Commercial Guide*, 1863, p. 132.

represented by " dishes, rice bowls, wine cups, saucers and spoons, preserve jars, wine bottles, etc., in common porcelain," besides tiles of various kinds, which implies the manufacture of pottery as well. These wares, we are informed in the catalogue, are largely exported to Saigon, Siam, Manilla, etc. ; a statement confirmed by the *Chinese Commercial Guide*,[1] which adds India, the Archipelago, and the southern provinces. This is interesting in view of the quantities of coarse china, blue and white [2] and coloured, which is brought from these parts by collectors who take its crude appearance as evidence of age. The factories are located at Pa-kwoh, a village near Shih-ma, which lies between Amoy and Chang-chou Fu. Tung-an Hsien in the same neighbourhood is also named as a pottery centre.

There are several important factories within easy reach of Shanghai. Those at Yi-hsing have been discussed at some length, but there is another large centre of the industry on the east side of the Lake T'ai-hu opposite to Yi-hsing. This is Su Chou 蘇州, which, according to the catalogue of the Paris Exhibition, was still celebrated for its pottery in 1878. But the reputation of Su Chou does not rest on its modern achievements. Its name occurs frequently in the pottery section of the great encyclopædia (compiled by order of the Emperor K'ang Hsi) as one of the prominent pottery centres in the Ming dynasty. Tiles for the palaces and temples of Nanking were made there, and vases and wine vessels for the Imperial Court. The nature of these last can be guessed from a hint given in one passage of the encyclopædia[3] : " At Su Chou iron rust (*hsiu*) and other materials are used for the yellow wares. For the vessels with dragon and phœnix destined for Imperial use, a resinous substance [4] and cobalt blue [5] are used."

In the Hsüan Tê period (1426–1435), Su Chou was noted for

[1] Op. cit., p. 114.

[2] A coarse blue and white porcelain, often decorated with dragons which overlap the rim and are continued on the reverse of the bowls and dishes, seems to belong to one of these provincial factories. The glaze is thick and bubbly, and the blue of the decoration rather dull and dark ; but these pieces have a certain age, and belong to the first half of the eighteenth century, for they were copied at Worcester and Lowestoft. They often have marks " of commendation," such as *hsi yü* (" western jade "), etc.

[3] The *Ch'in ting ku chin t'u shu chi ch'êng*, section viii., subsection named *T'ao kung pu hui k'ao*, fol. 15.

[4] 松香 *sung hsiang*, rendered " turpentine " by Bushell, *O. C. A.*, p. 264.

[5] 無名異 *wu ming i*, " nameless rarity," the designation under which cobalt was imported in the Sung dynasty. (See Bushell, *O. C. A.*, p. 439.)

the manufacture of artistic pots for holding fighting crickets. In reference to these we are informed in the *T'ao shuo* (see Bushell, op. cit., p. 140) that " those fabricated at Su Chou by the two makers named Lu 陸 and Tsou 鄒 were beautifully moulded, and artistically carved and engraved, and the pots made by the Elder and the Younger Hsiu 秀, two daughters of Tsou, were the finest of all. At this time fighting crickets was a favourite pastime, and hundreds and thousands of cash were staked upon the event, so that they did not grudge spending large sums upon the pots, which were decorated in this elaborate way, and consequently far surpassed the ordinary porcelain of the period."

The large and important potteries at Po-shan Hsien 博山縣 in the Ch'ing-chou Fu, in Shantung, were represented only by a small exhibit at the Paris Exhibition of 1878, consisting of " a bottle of glazed pottery, three tea jars in red ware, ten specimens of glazed pottery, a brazier in terra cotta, and seven crucibles." Laufer tells us that these potteries date back to Sung times, and have preserved the old traditions of manufacture. The district is also noted for its glass, enamels and glazing materials, but it is situated inland, and not conveniently near any of the treaty ports.

In the early days of the European trading companies, pottery, as distinct from porcelain, does not seem to have received much attention from the merchants, and we may fairly assume that most of the earthenwares which reached Europe before the last century hailed from the neighbourhood of Canton or from Yi-hsing and the Shanghai district. But long before the first European vessels reached the coasts of China, Arab and Chinese merchantmen had carried cargoes of pottery and coarse porcelain to the Philippines, the East Indian Archipelago, the Malay Peninsula, Siam, Ceylon, and India. The Arabs had a trading station in Canton in the eighth century, and Chinese junks sailed from Canton and the Fukien ports in the Sung, Yüan, and Ming dynasties. A Chinese account of the sea trade in the twelfth and thirteenth centuries may be read in the work of Chao Ju-kua,[1] and it will be found from this book and from Marco Polo's accounts that Ch'üan-chou Fu on the Fukien coast was a busy centre of foreign trade in the Sung and Yüan periods. Hirth[2] has traced the probable route by which

[1] *Chau Ju-kua*, translated by F. Hirth and W. W. Rockhill. St. Petersburg, 1912.
[2] *Ancient Chinese Porcelain*, op. cit. See also p. 86.

the Lung-ch'üan celadons reached this port for shipment, and doubtless the other wares, including coarse white porcelain, stonewares and pottery, which are found in the Philippines and Borneo (to name only two of many localities) were largely supplied from the Fukien potteries. Many of these wares are of undoubted antiquity, and some of the types are unknown in China to-day. They may have been made solely for export, but in any case their disappearance in China is quite intelligible. For even in the eighth century the merchants were forbidden[1] to export " precious and rare articles," and most of these trade goods are of coarse make and unlikely to be preserved by the Chinese at home.

On the other hand, the natives of the Philippines and the Dyaks of Borneo have preserved these old potteries with scrupulous care. The various types of jars have been christened with special names [2] alluding to their form or decoration ; they have been credited with supernatural powers ; and numerous legends have grown endowing them with life and movement, power of speech, and influences malevolent or benign.

A good collection of these pots would be of considerable interest, but the value attached to them by their native owners is out of all proportion to their intrinsic worth, and makes them difficult to procure. An important series, however, of the Philippine jars has been formed by the Field Museum at Chicago, and they are described with full illustration in one of the excellent publications of that institution.[3] Among other things we are told that " every wild tribe encountered by the writer in the interior of Luzon, Palawan, and Mindanao possesses these jars, which enter intimately into the life of the people. Among many the price paid by the bridegroom for his bride is wholly or in part in jars. When a Tinguian youth is to take his bride, he goes to her house at night, carrying with him a Chinese jar which he presents to his father-in-law. The liquor served at ceremonies and festivals is sometimes contained in these jars, while small porcelain dishes contain the food offered to the spirits." [4]

A general similarity in form is noticeable in the Philippine

[1] See *Chau Ju-kua*, Introduction, p. 9.

[2] e.g. gusi, rusa, naga, tempajan, blanga.

[3] *Chinese Pottery in the Philippines*, by Fay-Cooper Cole, with a postscript by Berthold Laufer, Field Museum of Natural History, Publication No. 162, Chicago U.S.A., 1912.

[4] *Ibidem*, p. 14.

jars, an ovoid body more or less elongated being common to all, while the neck varies a little in its height and width. A series of loop handles or pierced masks on the shoulder, to hold a cord for suspension, is a constant feature. The older types, which are said to date back to a period ranging from the thirteenth to the fifteenth century, are frequently decorated with one or two large dragons coiling round the sides, and either modelled in low relief or incised in the body. Others are quite plain, and the glazes include black, brown, dark green, and a brownish yellow of varying depth. A later group, not older than the end of the Ming dynasty, is without ornament, but coated with single-colour or variegated glazes of the Canton and Yi-hsing types—e.g. speckled blue with green flecks, green with blue streaks and lines, blue and green mottled and crackled, light bluish green—the glaze often ending short of the base in an even line, which is, perhaps, characteristic of Yi-hsing.

The British Museum has a small series from Borneo, which includes, among the older types of pottery, a jar with black-brown glaze and bands of cloud design and stiff leaves deeply incised, and an ovoid jar with many loop handles on the shoulders, two dragons in relief, and a ground of incised wave pattern all covered with a yellowish brown glaze which ends in a regularly waved line some way short of the base. Of later make is a jar with translucent purplish brown glaze, and four circular panels with figure ornament in low relief glazed green, a type described by the Japanese as " Old Kochi." [1] There are, besides, a jar with roughly painted blue dragon designs under a crackled white glaze, the ware being a coarse porcelanous stoneware ; another with enamel colours in addition to the underglaze blue including the rose pink which is not older than the eighteenth century ; and another type with rough stoneware or earthen body covered with a crackled, greyish white enamel of putty-like surface on which enamel colours are coarsely painted. The typical jar which the island natives so highly prize is of the ovoid form with a number of loop handles on the

[1] Kochi, the Japanese name for Kochin China, seems to have been used in a vague and comprehensive sense for Southern China, and we understand by *Kochi yaki* the old pottery shipped from the coast towns of Fukien and Kuangtung. This category in Japan seems to include not only a variety of earthenware with coloured glazes—green, yellow, aubergine, turquoise, and violet—but the coarser yellowish white wares of the *fu ting* (see p. 90) type. See Brinkley, op. cit., vol. ix. p. 29.

shoulder and dragons in relief.[1] An unusually ornate example is shown on Plate 49. It has a cloudy green crackled glaze with dragons of both the ordinary and the archaic kind, besides storks and a bat in low relief, and there are touches of dark blue and yellow, white and brown in the glaze. It is probably of Canton make and not older than the seventeenth century. In modern times jars are made in Borneo itself by the Chinese in the coast towns.

A certain amount of Chinese pottery found its way, like the celadon porcelains in early times, by the caravan routes into Turkestan, India, Persia, and Western Asia. Such wares would be more naturally drawn from the potteries in Honan, Chihli, and the north-western provinces, and it is not surprising that the fragment found by Sir Aurel Stein in the buried cities of Turkestan should have included the brown painted wares of Tz'ŭ Chou.

But the greatest difficulties in classification are presented by the miscellaneous pottery which collectors have picked up from time to time in China, or antique dealers have sent over to supply the demand created by the increasing interest taken in Chinese pottery by Western amateurs. These come, as a rule, without any hint as to their place of origin, and in most cases it is quite impossible to locate them. There are, however, certain well-defined groups which come together naturally.

One of these is represented by the Tradescant jar in the Ashmolean Museum, Oxford. It was exhibited at the Burlington Fine Arts Club in 1910, and described in the catalogue[2] as " Jar with globular body, short neck, and wide mouth ; five loop handles ; stoneware covered with a bright green glaze ; the ornament consists of floral scrolls in yellow with touches of brown and is in low relief ; round the base a formal design. Height, 12 inches." A similar jar is shown on Plate 56, and in the Goff collection in the Brighton Museum is another of the same make, but with the design incised with a point instead of applied in relief. The Tradescant Collection was given to Elias Ashmole in 1659 by John Tradescant. It was formed by the father of the donor, who died in 1627, so that

[1] On the subject of pottery among the Dyaks in Borneo, see H. Ling Roth, *The Natives of Sarawak and British North Borneo*, vol. ii., p. 284 ; A. W. Neuwenhais, *Quer durch Borneo*, vol. ii., plate 40 ; Hose and McDougall, *The Pagan Tribes of Borneo*, 1912, vol. i., pp. 64 and 84, and plates 46-48. See also A. B. Meyer, *Alterthümer aus dem Ostindischen Archipel*.

[2] *Cat. B. F. A.*, 1910 I 11.

at the lowest computation the antiquity of these wares is fixed in the late Ming period. Another group is represented by Plate 58, Fig. 2. Its characteristics are a comparatively thin buff earthenware body, soft enough to powder under the knife, and a sparing use of brownish yellow, bright turquoise, green[1] and aubergine glazes of the usual crackled type applied direct to the body. The specimens are generally vases or incense burners of curious and archaic forms, with ornament moulded in low relief, the whole bearing the unmistakable signs of a ware which has been pressed in a mould. The inside and bottom of the incense burners are usually unglazed. The colours, as a rule, are pleasing and soft, and it is the common practice to label them indiscriminately Ming. As nothing definite is known of their place of origin, this chronology can only be based on their archaistic appearance, or on the fact that they have the usual " on biscuit " glazes, which seems to be the accepted signal for a Ming attribution. Needless to say, the use of this method of colouring survived the demise of the last Ming emperor, and it is improbable that wares which must be comparatively common in China (judging from the handsome way in which the quite recently created demand for them has been answered) should have a minimum antiquity of two hundred and seventy years.

The fact is that dating of these glazed potteries is as difficult as that of the cognate glazed tiles, and it is as unreasonable to exclude a Ch'ing origin as it would be to exclude a Ming. The balance of probabilities, at any rate, is in favour of the bulk of them being no older than the eighteenth century.

A third group is also consistently labelled Ming, but with better reason, though even here a little more elasticity in the dating is advisable. It has an exact parallel in porcelains of undoubted Ming origin, viz. those represented by Plate 61, etc., which usually take the form of jars and vases with designs outlined in fillets of clay, or channelled or even pierced à jour. The spaces between the outlines are filled with coloured glazes which are fired, in the case of porcelain, in the cooler parts of the biscuit kiln. These are the glazes de demi-grand feu, according to the French definition, and they

[1] A little flask in the Victoria and Albert Museum (Case 24, No. 809, 1883) of this type of ware with a green glaze was obtained in 1883 in the neighbourhood of Canton. Possibly a portion of this group comes from one of the Canton factories, but it is the kind of ware which might have been made in any pottery district, and there are quite modern examples of the same type of glaze and biscuit in the Field Museum of Chicago which were manufactured at Ma-chuang, near T'ai-yüan Fu, in Shensi.

consist of turquoise and aubergine purple or violet and green (the three colours or *san ts'ai*, all minutely crackled), supplemented by a white formed by slip and a thin brownish yellow. Occasionally the purple is so deep as to appear almost black; and the details of the designs are often etched in the paste with a fine point. Precisely similar wares are found with an earthenware body; and they are, no doubt, contemporary with the analogous porcelains, though how long the traditions of this type of ware continued has never been precisely determined. The porcelain on which washes of turquoise and aubergine glaze are combined is a development of this type, and this has certainly survived to comparatively modern times. Reticulated ornament was used on the three-colour pottery vases no less than on the porcelain (Plate 55); and besides the covered wine jars and vases there are figures and grotto pieces of similar style both in pottery and porcelain, many of which must date from Ming times.

Plate 53 illustrates a beautiful vase in the Eumorfopoulos Collection which belongs to a cognate group. It has a buff stoneware body, the ornament is outlined in relief, and the glazes which fill the outlines are very similar to those of our main group, though some of the colours are more transparent and glassy and wanting in the solidity of the latter. The chrysanthemum handles are a frequent feature of the vases of this class, of which a notable instance is in the Salting Collection. Plate 54 illustrates another vase of similar kind, but with lotus handles, lotus designs, and a fine turquoise ground. Of the same type, but less rare, are certain wide-mouthed jars, bowls, and flower pots with bold floral designs, lotuses, etc., outlined in fillets of clay and filled with the same kinds of glaze, the background now turquoise and now aubergine (Plate 58, Fig. 1). The base is usually washed over with a thin purplish brown. These several types were copied in the Japanese Kishiu pottery in the nineteenth century, and though the copies are rarely difficult to distinguish by the eye alone the Japanese glazes (particularly the aubergine) will be found on handling to have a peculiar moist and rather sticky surface. Though no doubt of Ming origin, it is extremely probable that the manufacture of the Chinese bowls and flower pots of this class continued into the last dynasty.

Fig. 2 of Plate 56 exemplifies another kind of pottery with fine white body like pipeclay, and usually with sharply moulded designs

in antique bronze style and in the bronze forms of beakers and four-legged incense burners. The glaze is usually leaf green, but it often breaks out into a frothy grey scum, such as is seen on some of the Canton and Yi-hsing glazed pottery. It is a common practice to label these wares as T'ang, but I am inclined to place them in a much more recent period (seventeenth or eighteenth century), and to locate them among the miscellaneous Kuangtung wares, pending further information on the subject.

There are other specimens with a somewhat similar white and relatively soft body material, not glazed but stained with a brown-ish black dressing of clay, and somewhat recalling bronze. These are usually vases of elegant, well-moulded form, such as Plate 56, Fig. 3, and they are often marked *Nan hsiang t'ang*.[1] They are, no doubt, of relatively modern make.

Though it would be easy to suggest many possible places of origin for these wares, such speculation can be of no real value without far more definite evidence than we possess at present. Still, it may serve some useful purpose in the future, if not at once, if we add one or two more records, however meagre, to the existing lists of Chinese potteries. The section of the *T'u shu*, which is devoted to *T'ao kung* (the pottery industry), mentions the following factories as of some importance in the Ming dynasty. In the province of Honan, in addition to the well-known potteries of Chün Chou and Ju Chou, we read that there was a factory in the Ju-ning Fu at the village of Ts'ai 蔡, which was intermittently active in the first half of the fifteenth century.[2]

From another passage we learn that in the valleys of Ching[3] 荆 and the hills of Shu (or Szech'uan) there are black and yellow clays suitable for pottery ; that the potters had their kilns in holes in the mountains ; and that they used the yellow clay for the body of the ware and overlaid it with the black, making jars, drug pots, cauldrons, pots, dishes, bowls, sacrificial vessels, and the like. They also made one kind of ware which resembled that of Chün Chou.

Specimens of modern pottery in the Field Museum, Chicago, include ornamental wares such as pomegranate-shaped water pots, etc., covered with an oily green glaze recalling some of the Sung

[1] See p. 219.

[2] *T'u Shu*, op. cit., section *T'ao kung pu hui k'ao*, fol. 9.

[3] Ching is the name of the old state of Ch'u, which included Hunan and Hupeh, so that the expression here used covers an enormous tract of Central China. See *T'u shu*, section *T'ao kung pu tsa lu*, fol. 2.

types. The body is apparently dark coloured, and shows brown at the edges where the glaze is thin. This ware is made at Ch'êng-tu in Szech'uan.

The geographical annals of the province of Shensi are quoted[1] with reference to potteries in the T'ung-chou Fu as follows : " The inhabitants of Lei-hsiang and Pai-shui[2] are good potters, and the porcelains (*tz'ŭ ch'i*) which they make are of surpassingly clever workmanship. These are what are commonly called *lei kung ch'i* (vessels of the Lord of Thunder). Some say that the potteries of Hsiang only began to be active when the original wares had ceased to be made. The village of Lei-hsiang is east of Shên Hsien, and it is the place of the temple of the Hsiang family. The inhabitants of the place sometimes dig up castaway Hsiang wares. Their shape and style are archaic ; the colour of the ware is green (*lü*), deep and dark, but brilliant. One kind has slight ornament in raised clay, but if the hand is passed over it, the surface feels smooth and without perceptible relief or indentation.[3] When compared with the Hsüan,[4] Ko and other wares, it may be said to surpass them." The description in the last part seems to apply to the older wares which preceded those made in the district at the time of writing.

The modern potteries at Yo Chou, in Shensi, are represented in the Field Museum, Chicago, by a black-painted ware in Tz'ŭ Chou style, by a greyish white ware with sketchy blue designs, and by a black slag-like earthenware which is extremely light to handle. It is also suggested that a well known type of pottery, painted with free floral designs in black and white on a creamy glaze which is stained a pinkish brown colour, is an earlier product of the same potteries.

The potteries at Ch'ü-yang Hsien 曲陽縣 in the Chên-ting Fu, in Chihli, are mentioned[5] in the administrative records of the Ming dynasty in the Hsüan Tê period, and again under the dates 1553 and 1563, as supplying wine jars and vases for the Court. This place is only a few miles east of Ting Chou, which was celebrated for its white wares in the Sung period, and these references carry the record of the industry in that district to the last

[1] *T'u Shu*, section *T'ao kung pu chi shih*, fol. 2 recto.
[2] 雷祥 and 白水.
[3] This appears to mean that the glaze covering up the reliefs filled all the surrounding hollows and made an even surface.
[4] i.e. ware of the Hsüan Tê period (1426-1435 A.D.).
[5] *T'u Shu*, section *T'ao kung pu hui k'ao*, fol. 10.

part of the Ming dynasty. Unfortunately, nothing is said of the nature of the wares made at this time for the Court.

Reference is made elsewhere (p. 202) to the potteries at Wu-ch'ing Hsien, in the Peking district. Possibly these are the potteries described by Bushell[1] as still active in modern times. "The ordinary glaze," he remarks, "is a reddish brown of marked iridescence, shining with an infinity of metallic specks, an effective background to the moulded decoration which covers the surface. The designs are generally of hieratic character."

The "sun-stone" glazes made at the Rookwood Potteries (Cincinnati, Ohio, U.S.A.) and on the Lancastrian wares[2] are of this kind, the infinity of metallic specks being due to "super-saturation" of the glaze with iron oxide. A specimen of this modern Peking ware may be seen in the British Museum.

The tile works at Liu-li-chü, near Peking, date back to the Yüan dynasty, and their modern productions as represented in the Field Museum include a pottery with incised designs filled in with yellow, green, and dark aubergine glazes, not unlike in style to the Japanese Sanuki ware. Another type has forms taken from bronzes and is distinguished by a shining green glaze.

In the province of Shan-tung, besides the tile works at Lin-ch'ing,[3] the important potteries at Yen-shên Chên 顏神鎭 in the Ch'ing-chou Fu are noticed[4] as follows : "The inhabitants have inherited from their ancestors the art of making good pottery. The usual wares are cisterns (kang), jars (ying), cauldrons (fu), and such-like pottery (fou), made without flaw. The profit to the people is not less than that made at Ching-tê Chên on the right bank of the Yangtze." Yen-shên Chên is quite close to Po-shan Hsien, and no doubt the industry at the two places is intimately connected. The latter, which is noted to this day for its manufactures of pottery and glass, has already been mentioned[5] more than once.

At Yi-chên 儀眞 in the Yang-chou Fu, in Kiangsu, there were factories which supplied wine jars, etc., to the palace at Nanking in the early years of the Ming dynasty ; and in the seventh year of Chia Ching (1528) supplies of similar vessels were sent from

[1] O. C. A., p. 637.
[2] Made at Pilkington's Tile Works, Clifton Junction, by Manchester.
[3] See p. 202.
[4] T'u Shu, section entitled T'ao kung pu tsa lu, fol. 2 verso.
[5] On pp. 103 and 188.

Fig. 1

Fig. 2

Plate 55.—Ming Pottery with dull *san ts'ai* glazes.

Fig. 1.—Wine Jar with pierced outer casing, horsemen and attendants, rocky background. Fifteenth century. Total height 19½ inches. *Eumorfopoulos Collection.* Fig. 2.—Tripod Incense Vase, dragons and peony designs and a panel of horsemen. Dated 1529 A.D. Height 22 inches. *Messel Collection.*

Fig. 1

Fig. 2

Fig. 3

Plate 56.—Miscellaneous Pottery.

Fig. 1.—Jar with dull green glaze and formal lotus scroll in relief touched with yellow and brown glazes. About 1600. Height 12 inches. *Goff Collection.* Fig. 2.—Beaker of bronze form, soft whitish body and dull green glaze. (?), Seventeenth century. Height 16½ inches. *Eumorfopoulos Collection.* Fig. 3.—Vase of light buff ware with dull black dressing, vine reliefs. Mark *Nan hsiang fang* (see p. 219).

Ning-kuo Fu 寧國府 in the south-west of Anhui.[1] The latter place is mentioned elsewhere[2] under its earlier name of Hsüan Chou 宜州 as producing a thin white ware made of " plastic clay " in the Yüan and Ming periods. A verse of Wang Shih-chêng (1526–1593) speaks of the " snow white porcelain of Hsüan Chou." [3] The *T'ao lu* enumerates factories which began in the Ming dynasty and continued to the nineteenth century, and apparently produced an inferior type of porcelain, and probably pottery as well. They were located at Huai-ch'ing Fu 懷慶府, I-yang Hsien 宜陽縣, Têng-fêng Hsien 登封縣, and Shan Chou 陝州 in Honan ; at Yi Hsien 嶧縣 and Tsou Hsien 鄒縣 in Yen-chou Fu in Shantung ; in the Lung Shang 隴上 district in Shensi, and at Hêng-fêng 橫峰 in Kiangsi. The last-mentioned factory was established by a man named Ch'ü Chih-kao from Ch'u-chou Fu in the early Ming period. In the Chia Ching period (1522–1506) it was transferred to the I-yang 弋陽 district to a place called Ma-k'êng, not many miles south of Ching-tê Chên. Both the Lung-shang and Ma-k'êng wares are described as very coarse.

The value of pottery for architectural purposes was recognised in China from the earliest times. Unglazed bricks and tiles of Han and pre-Han periods are preserved by Chinese collectors, particularly when they happen, as is often the case, to have inscriptions in old seal characters, or other ornament. The familiar Chinese roof tile is a long convex object like a horizontal section of a tube, and those intended for the border are ornamented at one end with a disc, usually stamped with a dragon or other design in sunk relief. Here and there, on the apex of the roof or at the corners, are ornamental tiles carrying figures of deities, heroes, mythical creatures or birds, modelled in the round and usually with great force and skill. Besides these, architectural mouldings and antefixal ornaments in pottery are commonly used on temples and pavilions of an ornamental kind.

The use of tiles—and, no doubt, of other architectural embellishments in pottery—was encouraged by government enactments at various times. In the T'ang dynasty (618–906 A.D.),[4] in the districts south and west of the Yangtze, under the inspectorship of

[1] *T'u Shu*, section xxxii, *T'ao kung pu hui k'ao, fol.* 9.

[2] *T'ao lu*, bk. vii., fol. 10 verso.

[3] Quoted in the *T'ao lu*, bk. ix., fol. 2.

[4] Recorded in the *T'ang Shu*, the passage in question being quoted in the encyclopædia, *T'u Shu*, section xxxii, *T'ao kung pu chi shih*, fol. 1 verso.

a man named Tan 丹, the inhabitants were ordered to use tiles
on their houses in place of wood in order to lessen the risk of fire ;
kilns were erected to provide the tiles, and those who were too
poor to carry out the alterations by themselves received State
help. A somewhat similar but more important edict was issued
in the twenty-seventh year of Hung Wu[1] (1394), that bricks and
tiles should be used in all the buildings in the capital, which was
then Nanking, and that kilns should be set up every year on the
Chü-pao shan for their manufacture. It was not long after this
that the famous " porcelain pagoda " was erected at Nanking,[2]
the lower part of which was faced with white porcelain bricks,
the remaining storeys with pottery with coloured glazes.

Tile factories existed in all parts of China to supply local needs,
and the few singled out for mention in the *T'u Shu*[3] were perhaps
of more than usual importance in the Ming dynasty. They are
Lin-ch'ing 臨清 in the extreme west of Shantung ; Su Chou 蘇州
in Kiangsu, on the east side of the lake T'ai-hu, and facing the
potteries of Yi-hsing, which supplied tiles for the palaces and temples
of Nanking ; the neighbouring Ch'ang-chou Chên, and Yi-chên
and Kua Chou in the Yang-chou Fu of the same province ; Wu-
Ch'ing Hsien 武清縣, in the district of Peking, where the potters
asked for permission to make tiles for public use in 1574.

The tile works at Liu-li-chü (mentioned on p. 200) date from
the Yüan dynasty. They are also situated in the neighbourhood
of Peking, but whether in the Wu-ch'ing Hsien or not, I have failed
to discover.

When Peking became the capital of the Ch'ing emperors, no
doubt the tile factories at Wu-ch'ing Hsien assumed still greater
importance ; and according to the catalogue of the exhibition
in Paris in 1878,[4] the neighbourhood of Amoy was then celebrated
for its bricks and tiles. This branch of the potter's industry is
represented by a small collection of bricks, tiles, mouldings, and
antefixal ornaments in the British Museum. It includes unglazed
bricks from the Great Wall of China, which may date from 220 B.C.,
a few Han bricks and tile-ends with moulded ornament ; white

[1] See the *T'u Shu*, section *T'ao kung pu hui k'ao*, fol. 7 verso.
[2] It was completed in 1430, and destroyed by the T'aip'ing rebels in 1853.
[3] In the section *T'ao kung pu hui k'ao*, fol. 9.
[4] *Catalogue spécial de la Collection Chinoise*, op. cit., pp. 10 12. The exhibits from
Amoy included " carreaux de pavage, tuiles pour toitures."

porcelain bricks and coloured pottery tiles and mouldings from the Nanking pagoda; and tiles from the Ming tombs near Nanking, which were built in 1400 A.D., and like the pagoda destroyed in the T'aip'ing rebellion in 1853. The Nanking tiles and mouldings are of hard buff pottery with translucent glazes of green and yellow colour, minutely crackled, additional colours being formed with red and creamy white slips. The tile-ends are ornamented with dragon medallions.

Other architectural pottery in the same collection came from the Imperial pleasure grounds at Peking, which were wrecked in 1860. These include tiles and antefixal ornaments from the pavilions and temples in the Yüan Ming Yüan and from the Summer Palace, and a few blue-glazed tiles from the Temple of Heaven. Numerous tiles with relief figures and pottery figures from niches were picked up in the ruins of the temples and pavilions in the Imperial grounds after their capture in 1860; and many of the mouldings were found to display strong European influences, due, no doubt, to the designs of the Jesuits Attiret and Castiglione, who assisted the Emperor Ch'ien Lung in erecting some of the buildings. Some of these are in the British Museum besides antefixes in the form of yellow dragon heads from the Winter Palace at Peking and from the cele- brated Temple of Kin-shan, or Golden Island, in the Yangtze; and a tile from the Huang-ssŭ, the Great Lama temple, built by K'ang Hsi in 1647. The tile in question is evidently part of a restoration, for it bears the date corresponding to 1770.

The ordinary tiles and mouldings are not likely to be extensively collected by private individuals, but many of the ridge tiles, with figures of deities, horsemen, lions, ch'i-lin, and phœnixes, have found their way into collections to which their spirited modelling has served as a passport. The glazes on these are often richly coloured, and include yellow, green, violet purple, aubergine and purplish black, and occasionally high-fired glazes with flambé or variegated colours. By accident or design, the figures are not infrequently detached from their tiles and mounted on wooden stands. The pottery figures from niches in the walls of temples and public buildings are often finely modelled and richly glazed, and, needless to say, they find a welcome in Western collections (Plate 58).

It is a common but illogical practice to assign all these figures in architectural pottery to the Ming dynasty; illogical, because so

many of them have been brought from the Imperial buildings at Peking which are known to have been mostly erected in the K'ang Hsi and Ch'ien Lung period. On the other hand, nothing is more difficult to date than this type of glazed pottery, in which the ware, the colours, and the decorative traditions seem to have continued almost unchanged from the early Ming times to the present day. The tiles from the Nanking pagoda and from the eighteenth-century buildings at Peking are practically interchangeable.

Nor must we forget that the potters who made the architectural pottery often turned their hands and materials to the manufacture of vases and figures and other ceramic ornaments for domestic use, and even imposing altar sets for the temples. An important example of this work is seen in Fig. 2 of Plate 55, a large incense vase [1] of traditional form (from an altar set) with bowl-shaped body, wide mouth, two upstanding handles, and three feet with lion masks. It is ornamented with a peony scroll and two dragons in high relief, and is made of pottery with a dull turquoise green glaze. An inscription on the handles proclaims the fact that it was " dedicated by the chieftain Kuo Hsin-shê; made in the eighth year of Chia Ching," i.e. 1529. In more recent times the tile works near Peking have turned their attention to the manufacture of vases and bowls with rich soft monochrome glazes, yellow, green, turquoise and aubergine in the manner of the similarly coloured porcelains which are highly prized, and, as Bushell tells us, "the soft excipient (i.e. the pottery body) seems to impart an added softness " to the glazes. " The fact that yellow clay," he continues, " used often to be mixed with the porcelain earth in the old fabrics to enhance the brilliancy of the glaze colours, gives a certain vraisemblance to the fraudulent reproductions which I have seen sold for as many dollars as they would cost in cents to produce." It is unlikely that the issue of these by-products of the tile factories is confined to the neighbourhood of Peking. Among the miscellaneous potteries I should add that Ka-shan,[2] in Chekiang, is reputed to have been noted in the seventeenth and eighteenth centuries for a fine porcellanous stoneware with opaque, camellia-leaf green glaze minutely crackled.

[1] See *Catalogue B. F. A.*, 1910, L. 1.
[2] See Dr. Voretzsch, *Catalogue of Chinese Pottery.*

Fig. 1

Fig. 2

Fig. 3

Fig. 4

Plate 58.—Miscellaneous Pottery.

Fig. 1.—Jar with lotus design in green, yellow and turquoise glazes in an aubergine ground. About 1600. Height 6½ inches. *Hippisley Collection.* Fig. 2.—Vase of double fish form, buff ware with turquoise, yellow and aubergine glazes. (?) Seventeenth century. Height 5¾ inches. *British Museum.* Fig. 3.—Roof-tile with figure of Bodhidharma, deep green and creamy white glazes. Sixteenth century. Height 10⅞ inches. *Benson Collection.* Fig. 4.—Bottle with archaic dragon (*ch'ih lung*) on neck, variegated glaze of lavender, blue and green clouded with purple and brown. (?) Eighteenth century Yi-hsing ware. Height 10 inches. *Peters Collection.*

CHAPTER XVII

MARKS ON CHINESE POTTERY AND PORCELAIN

THE custom of placing on works of art the name of the maker, the date of manufacture, or some sign or symbol indicating the intention with which they were made, dates back in China at least as far as the Han dynasty. Such marks occur on pottery and porcelain rarely at first, but with a frequency which increases in proportion as we draw nearer to modern times. They are incised or stamped in the soft body of the ware, or painted under the glaze (usually in blue) or over it in enamel colours or gold; and they are generally placed on the base of the ware, though there are fairly numerous instances in which the mark is written along the mouth rim or in some other more or less conspicuous position.

The earliest marks, as far as I am aware, are incised, and those on the Han, T'ang, and Sung potteries, not to mention the intermediate dynasties, should be scrutinised with the greatest care to make sure whether the incisions were made before the pottery was baked or afterwards. There should be no difficulty in determining this point, for the lines cut with a sharp instrument in the fired ware are necessarily harder and less free than those incised in the soft clay, and the edges of the incisions will present obvious differences in the two cases. Unfortunately the early date-marks which I have seen up to the present have almost all been cut after the firing. It does not necessarily follow that such inscriptions are modern additions. Indeed in many cases they are in a style which is clearly old. But their value as evidence is very small, for it is impossible to prove the exact time of their carving; and at best we can only regard them as representing the opinion of some former owner as to the date of the vessel in question. At their worst, they are deliberate frauds added by modern vendors with intent to deceive.

Incised or stamped marks have always been common on pottery, but porcelain is usually marked by painting with a brush, and for this purpose underglaze blue is the commonest medium, red and

other on-glaze colours being used chiefly on the relatively modern wares decorated in *famille rose* enamels. Similarly the ordinary script is usual in marks, and seal characters are quite exceptional on porcelain earlier than the eighteenth century.

It is not safe to take the older date-marks on porcelain at their face value. The Chinese with their proverbial veneration for antiquity habitually placed the date-marks of the classical reigns on their porcelain whether decorated in the style of the period mentioned or not. Already in the sixteenth century the Hsüan Tê and Ch'êng Hua marks were used in this way, and in the K'ang Hsi period the names of these two classic reigns were used more frequently than that of the K'ang Hsi period itself. In fact the Hsüan Tê and Ch'êng Hua are on the whole the most familiar marks of all, though the actual wares of these two periods are among the rarest. The date-marks of the other Ming Emperors are less frequently plagiarised, except upon the deliberate imitations of the wares of the time, such as those made at the Imperial factory in the Yung Chêng period, which we may be sure were carefully marked with the appropriate *nien hao*. Moreover, the Japanese, who have expended much ingenuity on reproducing Ming wares, have made free with Ming date-marks, especially those of Chia Ching and Wan Li.

In the year 1677 the potters at Ching-tê Chên were forbidden by an order of the district prefect [1] to inscribe the period-name of the Emperor or any sacred writing on their porcelain, lest the names should be profaned in the breaking of the ware. It is certain that this prohibition was not effective for long ; but probably the current date-mark was suppressed for a time at least, and it is quite likely that we should trace to this interval the custom of putting symbols or conventional marks inside the double ring which was usually occupied by the *nien hao*, a common practice in the K'ang Hsi period. In many cases, too, the rings were left empty ; but it is a mistake to regard this as an infallible sign of K'ang Hsi manufacture, for it is a thing which might happen at any time through negligence, the rings being made by one person and the marks written by

[1] See *T'ao lu*, bk. viii., fol. 14 verso (quoting the *I chih*) : " In the sixteenth year of K'ang Hsi the district magistrate, Chang Ch'i-chung, a man of Yang-ch'êng, forbade the workmen of Ching-tê Chên to inscribe on the porcelain vessels the *nien hao* of the Emperor or the handwriting (*tzŭ chi* 字跡) of the holy men, to prevent their being broken and injured."

another. There are, besides, well authenticated instances of the empty double ring on Wan Li porcelain,[1] and on post K'ang Hsi wares. It was, however, such a frequent occurrence on the K'ang Hsi wares that the modern imitators make a common practice of leaving the rings blank on their copies of the K'ang Hsi blue and white. It is not clear whether the prefect's prohibition applied to the names of Ming emperors, but probably it did not, as it is unlikely that the adherents of the reigning dynasty would be sensitive about the titles of the house which they had exterminated. In any case, Ming marks, especially those of the fifteenth century, are very common on the K'ang Hsi porcelain, and the K'ang Hsi mark itself is comparatively rare except on the specimens which must belong to the later years of the reign.

En revanche, the K'ang Hsi mark is freely used on quite modern wares, that period being now regarded as classical ; so that we are confronted with the paradox that if a specimen of fine quality [2] is marked Ch'êng Hua, it may generally be assumed that it was made in the K'ang Hsi period, while the bulk of the pieces which bear the K'ang Hsi mark are of modern date.

The Yung Chêng and Ch'ien Lung porcelains are highly esteemed to-day, and consequently the marks of these periods are considered worthy of a place on modern imitations ; but on the whole the bulk of the specimens bearing these marks will be found to belong to the period indicated, and the imitations are generally so coarse as to be unmistakable. The temptation to borrow the reign marks of the subsequent periods is so slight that we may safely accept the later marks as correct indications of date.

Marks written in enamel colours and even in gold become increasingly common on the *famille rose* porcelains from the Yung Chêng period onwards, the red mark being more familiar on the modern wares than the blue ; and seal characters frequently replace the ordinary script in the reign marks of the Yung Chêng and subsequent periods. Date marks in seal form before the eighteenth century are very unusual, and should be regarded with suspicion.

It will be seen from the foregoing notes that Chinese date marks must be treated with great caution. In fact it is safer to regard them merely as secondary evidence, first basing one's judgment

[1] See *Catalogue B. F. A.*, 1910, E 4.

[2] This qualification is very necessary, because there are plenty of inferior pieces with the Ch'êng Hua mark which are quite modern.

on the paste and glaze, the style of decoration and the quality of the colours. The one exception to this declaration of unfaith is the marks on the Imperial porcelain. These would naturally be correct and reliable, except where deliberate imitations of the older wares were undertaken ; and then, no doubt, the mark of the period imitated would be used to make the illusion complete. The Imperial marks were the work of calligraphers who were selected for the purpose, and the writing is careful and in good style. In fact a well-written mark is almost as certain a sign of Imperial ware as the five-clawed dragon itself.[1]

At the private factories the marks were often carelessly, even illegibly, written, and probably little trouble was taken with this part of the decoration except on the choicer specimens. On a large proportion of the private wares the mark was omitted altogether.

The marks on Chinese pottery and porcelain may be conveniently grouped under the following headings :—

(1) Date marks.
(2) Hall marks.
(3) Potters' names and factory marks.
(4) Marks of dedication, felicitation, commendation, etc.

(1) *Date marks.*

The date marks conform to the two Chinese systems of chronology, (*a*) the cyclical, and (*b*) the reign names of the Emperors.

(*a*) The system by which the years are divided into cycles of sixty, each year of the cycle having a name, carries back Chinese chronology to the year 2637 B.C., from which the first cycle is dated. We are at present in the 76th cycle.

The year names are composed of two characters, the first being one of the Ten Stems, and the second one of the Twelve Branches ; and as the stems and the branches are taken in strict rotation, it is clear that the combinations will not be exhausted until sixty have been formed, that number being the least common multiple of ten and twelve.

The Ten Stems 十干 *Shih kan* are as follows :—

1 甲 *chia*
2 乙 *i* } corresponding to the element 木 *mu* = wood.

3 丙 *ping*
4 丁 *ting* } corresponding to the element 火 *huo* = fire.

[1] The Ch'ien Lung enamelled Imperial ware is frequently marked in red within a square panel reserved in the opaque bluish green enamel which so often covers the base.

5 戊 *wu* or *mou*⎫
6 己 *chi* ⎬ corresponding to the element 土 *t'u* = earth.
7 庚 *kêng* ⎫
8 辛 *hsin* ⎬ corresponding to the element 金 *chin* = metal.
9 壬 *jên* ⎫
10 癸 *kuei* ⎬ corresponding to the element 水 *shui* = water.

The Twelve Branches 十二支 *shih êrh chih*, which correspond to the twelve animals of the zodiac, and through them to the twelve divisions of the day are as follows :—

			Appertaining to the sign of the		Corresponding to	
1	子	*tzŭ*	.. rat	.. Aries	11–1 a.m.	N.
2	丑	*ch'ou*	.. ox	.. Taurus	1–3 a.m.	N.N.E.¾E.
3	寅	*yin*	.. tiger	.. Gemini	3–5 a.m.	E.N.E.¾N.
4	卯	*mao*	.. hare	.. Cancer	5–7 a.m.	E.
5	辰	*ch'ên*	.. dragon	.. Leo	7–9 a.m.	E.S.E.¾S.
6	巳	*ssŭ*	.. serpent	.. Virgo	9–11 a.m.	S.S.E.¾E.
7	午	*wu*	.. horse	.. Libra	11 a.m.–1 p.m.	S.
8	未	*wei*	.. sheep	.. Scorpio	1–3 a.m.	S.S.W.¾W.
9	申	*shên*	.. monkey	.. Sagittarius	3–5 a.m.	W.S.W.¾W.
10	酉	*yu*	.. cock	.. Capricornus	5–7 a.m.	W.
11	戌	*hsü*	.. dog	.. Aquarius	7–9 a.m.	W.N.W.¾N.
12	亥	*hai*	.. boar	.. Pisces	9–11 a.m.	N.N.W.¾W.

The table of cycles subsequent to the Christian era,[1] i.e. cycles 45–76, dating from 4–1923 A.D., will be useful in calculating the year of the cyclical dates with the help of the accompanying table of numerals :—

	(a)				(b)		(c)		
1	一	..	*i*	..	〡	..	壹	or	弌
2	二	..	*êrh*	..	〢	..	貳	,,	弍
3	三	..	*san*	..	〣	..	叄	,,	弎
4	四	..	*ssŭ*	..	✕	..	肆		
5	五	..	*wu*	..	൦	..	伍		
6	六	..	*liu*	..	⊥	..	陸		
7	七	..	*ch'i*	..	亠	..	柒		
8	八	..	*pa*	..	亖	..	捌		
9	九	..	*chiu*	..	夊	..	玖		
10	十	..	*shih*	..	〇	..	什	or	拾

(*a*) is the normal form ; (*b*) is commonly used for accounts ; (*c*) is used on drafts, pawntickets, etc.

[1] For the complete tables of cycles see Mayers, op. cit., p. 362.

TABLE OF CYCLICAL DATES FROM A.D. 4

Cyclical Signs.	CYCLE BEGINNING 4 / 304 / 604 / 904 / 1204 / 1504 / 1804	64 / 364 / 664 / 964 / 1264 / 1564 / 1864	124 / 424 / 724 / 1024 / 1324 / 1624	184 / 484 / 784 / 1084 / 1384 / 1684	244 / 544 / 844 / 1144 / 1444 / 1744	Cyclical Signs.	CYCLE BEGINNING 4 / 304 / 604 / 904 / 1204 / 1504 / 1804	64 / 364 / 664 / 964 / 1264 / 1564 / 1864	124 / 424 / 724 / 1024 / 1324 / 1624	184 / 484 / 784 / 1084 / 1384 / 1684	244 / 544 / 844 / 1144 / 1444 / 1744
甲 子	04	64	24	84	44	甲 午	34	94	54	14	74
乙 丑	05	65	25	85	45	乙 未	35	95	55	15	75
丙 寅	06	66	26	86	46	丙 申	36	96	56	16	76
丁 卯	07	67	27	87	47	丁 酉	37	97	57	17	77
戊 辰	08	68	28	88	48	戊 戌	38	98	58	18	78
己 巳	09	69	29	89	49	己 亥	39	99	59	19	79
庚 午	10	70	30	90	50	庚 子	40	100	60	20	80
辛 未	11	71	31	91	51	辛 丑	41	101	61	21	81
壬 申	12	72	32	92	52	壬 寅	42	102	62	22	82
癸 酉	13	73	33	93	53	癸 卯	43	103	63	23	83
甲 戌	14	74	34	94	54	甲 辰	44	104	64	24	84
乙 亥	15	75	35	95	55	乙 巳	45	105	65	25	85
丙 子	16	76	36	96	56	丙 午	46	106	66	26	86
丁 丑	17	77	37	97	57	丁 未	47	107	67	27	87
戊 寅	18	78	38	98	58	戊 申	48	108	68	28	88
己 卯	19	79	39	99	59	己 酉	49	109	69	29	89
庚 辰	20	80	40	100	60	庚 戌	50	110	70	30	90
辛 巳	21	81	41	101	61	辛 亥	51	111	71	31	91
壬 午	22	82	42	102	62	壬 子	52	112	72	32	92
癸 未	23	83	43	103	63	癸 丑	53	113	73	33	93
甲 申	24	84	44	104	64	甲 寅	54	114	74	34	94
乙 酉	25	85	45	105	65	乙 卯	55	115	75	35	95
丙 戌	26	86	46	106	66	丙 辰	56	116	76	36	96
丁 亥	27	87	47	107	67	丁 巳	57	117	77	37	97
戊 子	28	88	48	108	68	戊 午	58	118	78	38	98
己 丑	29	89	49	109	69	己 未	59	119	79	39	99
庚 寅	30	90	50	110	70	庚 申	60	120	80	40	100
辛 卯	31	91	51	111	71	辛 酉	61	121	81	41	101
壬 辰	32	92	52	112	72	壬 戌	62	122	82	42	102
癸 巳	33	93	53	113	73	癸 亥	63	123	83	43	103

It will be seen that cyclical dates without any indication of the particular cycle intended are merely tantalising. On the other hand when the reign is specified as well, the combination gives the most precise form of date. But unfortunately there are many cases in which the reign name is absent, and we can only judge the cycle by the style of the ware, a calculation which is always open to dispute. It is not often that the cycle is so clearly indicated by an indirect method as in the oft-quoted mark *yu hsin ch'ou nien chih*

又
年 辛 = made in the *hsin ch'ou* year recurring (*yu*). This can
製 丑

only be 1721, when the *hsin ch'ou* year actually recurred in the (sixty-first year of) reign of K'ang Hsi.[1]

(*b*) The more usual form of date mark is that which gives the reign name of an Emperor. On ascending the throne the Emperor discarded his family name and assumed a title by which his reign was thenceforth known. This is the name which appears in the date marks, and it is known as the *nien* (period) *hao* (name). After his death the Emperor received another title, the *miao hao*, or name under which he was canonised ; but though reference might be made to him in history under his *miao hao*, it is obvious that the posthumous name cannot occur on contemporary date marks.

In reckoning the date of an Emperor's reign it was not usual to include officially the year in which his predecessor had died, but to date the reign from the first day of the year following. Thus, though K'ang Hsi became Emperor in 1661, his reign is dated officially from 1662.

The Imperial date mark is usually written in six characters beginning with the name of the dynasty and ending with the words *nien chih* (made in the period) : the *nien hao* coming in the middle :—

	1	2	3	4	5	6
e.g.	*Ta*	*ming*	*ch'êng*	*hua*	*nien*	*chih* = made (*chih*)

4 化 大 1
5 年 明 2
6 製 成 3

in the Ch'êng Hua period (*nien*) of the great Ming (dynasty).

Occasionally the word *nien* is replaced by *yü* 御 (Imperial),

[1] Though the reign of K'ang Hsi officially dates from 1662, in reality it began with the death of the previous Emperor in 1661 ; see p. 216.

yü chih meaning made by Imperial command ; and in place of *chih* we sometimes find the word *tsao* 造 or more rarely *tso* 作 both of which have the same meaning " made."

The six characters may be written in two lines of three, or in three lines of two, or again in one long line read from right to left ; and for reasons of space, and sometimes for no apparent reason, the first two characters are omitted, e.g. 年成 製化. The omission of the *nien hao* is rare except on a few Japanese copies of Chinese porcelain, e.g. 年大 製明 *ta ming nien chih* = made in the great Ming dynasty.

As already mentioned, the seal forms of the mark were frequently employed from the eighteenth century onwards (see p. 209). An archaic form of seal character occurs in the Yung Lo mark which is given below.

The use of the *nien hao* on the Imperial wares made at Ching-tê Chên was made obligatory by a command issued in the Ching-tê period (1004–1007), when the name of the town was altered to Ching-tê Chên.

Ming Dynasty

HUNG WU, 1368—1398.

Same in seal characters.

YUNG LO, 1403—1424

Ming Dynasty

Same in archaic characters.

HSÜAN TÊ, 1426—1435.

Same in seal characters.

Ming Dynasty

化 大
年 明
製 成

CH'ÊNG HUA,
1465—1487.

成 Same in seal charac-
玖 ters (the first two
omitted).

治 大
年 明
製 弘

HUNG CHIH,
1488—1505.

德 大
年 明
製 正

CHÊNG TÊ,
1506—1521.

靖 大
年 明
製 嘉

CHIA CHING,
1522—1566.

慶 大
年 明
製 隆

LUNG CH'ING,
1567—1572.

Ming Dynasty

曆 大
年 明
製 萬

WAN LI,
1573—1619.

啟 大
年 明
製 天

T'IEN CH'I,
1621—1627.

年 崇
製 楨

CH'UNG CHÊNG,
1628—1643.

Ch'ing Dynasty.

治 大
年 清
製 順

SHUN CHIH,
1644—1661.

Same in seal
characters.

熙年製　大清康

K'ANG HSI,
1662—1722.

Same in seal
characters.

正年製　大清雍

YUNG CHÊNG,
1723—1735.

Same in seal
characters.

隆年製　大清乾

CH'IEN LUNG,
1736—1795.

Same in seal
characters.

年製　嘉慶

CHIA CH'ING,
1796—1820.

Same in seal
characters.

光年製　大清道

TAO KUANG,
1821—1850.

Same in seal
characters.

豐年製　大清咸

HSIEN FÊNG,
1851—1861.

Same in seal
characters.

Ch'ing Dynasty　　　　　　　　　　　*Ch'ing Dynasty*

治 大
年 清　　T'UNG CHIH,
製 同　　1862—1874.

緒 大
年 清　　KUANG HSÜ,
製 光　　1875—1909.

Same in seal
characters.

Same in seal
characters.

(2) Hall marks.

The " hall mark," which is of frequent occurrence on both porcelain and pottery, is so called because it includes the word *t'ang* 堂 (hall) or some equivalent such as *chai* 齋 (a study), *t'ing* 亭 (a pavilion), *hsien* or *hsüan* 軒 (a porch, balcony or pavilion), *kuan* 館 (a residence or hostelry), *fang* 房 (a room or house), *chü* 居 (a dwelling). The word *t'ang* as explained in Giles's Dictionary is " a hall : especially a hall of justice or court ; the ancestral hall ; an official title." *T'ang ming* is " the family hall name—a fancy name usually consisting of two characters followed by *t'ang* (e.g. *wu tê t'ang chin* = Chin of the military valour hall), and referring to some event in family history. It is generally inscribed in one of the principal rooms of the house, and is used in deeds, on graves, boundary stones, etc."

The hall mark, then, may contain the studio name of the maker or of the recipient of the ware, or it may have reference literally to the building for which the ware was intended. The last interpretation can be generally applied to the marks referring to halls or pavilions in the precincts of the Imperial palace. Again, the hall may be the shop of a dealer who ordered the goods. But in the absence of prepositions, it is not always—not often, I should perhaps say—possible to determine which of these alternatives is implied in any particular hall mark ; e.g. 堂林 製玉 *Lin yü t'ang chih* may mean " made in the Abundant-Jade Hall," or " for " the same, or by a man whose studio name was *Lin-yü t'ang*.

As to the antiquity of hall marks, it was not considered ana-chronistic to cut one on a Han granary urn which is now in the British Museum ; but unfortunately as the cutting was done after the ware was baked it is now impossible to say at what period it was executed. A Sung example is quoted in the *Ni ku lu* (written in the middle of the sixteenth century) as inscribed on a Ting Chou vase in the handwriting of the Mi family, viz., *jên ho kuan* 仁和館 (Hotel of Benevolence and Harmony). A similar mark similarly placed is 仁存堂 *jên ts'un t'ang* (Hall of Benevolence), on a Tz'ŭ Chou jar in the Eumorfopoulos Collection.

Hall marks on Ming porcelain are rare. There is, however, one which occurs fairly often on late Ming porcelains of various kinds, including pieces decorated in blue and blue and white, underglaze red, blue and enamel colours, pierced designs and slip. This is 佳玉器堂 *yü t'ang chia ch'i*, " beautiful vessel for the Jade Hall."

It is improbable that the *yü t'ang* was a factory name, as the specimens so marked have little homogeneity. Giles's Dictionary tells us that *yü t'ang* is a name for the Han Lin College at Peking, which was so called in memory of Chou Chih-lin of the Sung dynasty, upon whom the Emperor bestowed these two characters in admiration of his qualities. From this we might infer that the wares so marked were made for the Han Lin ; but why, one asks, in that case should the examples in our collections be so many and so evidently of the same period ? On the whole I prefer to regard the mark as of general (and complimentary) significance, i.e. " beautiful vessel for the home of pure worth," like another mark much affected on late Ming porcelain *fu kuei chia ch'i* ("fine vessel for the rich and honourable ! ").

Hall marks are very frequent on the porcelains of the Ch'ing dynasty, and enough are given below to illustrate their various forms. Many of them are no doubt hall names of makers and decorators, and as such belong to the category of artists' signatures.

Special interest attaches to those hall marks which have been identified as referring to pavilions in the precincts of the Imperial palace. We are told by Bushell [1] that the " fashion of inscribing upon porcelain made for the Imperial palace the name of the particular pavilion for which it was intended seems to have begun in the reign of Yung Chêng," and observation shows that these hall marks only

[1] *O. C. A.*, p. 79.

HALL MARKS

佳　玉
罍　堂

Yü t'ang chia ch'i =fine vessel for the jade hall (late Ming).

Chih lan chai chih = made for the epidendrum hall (seventeenth century).

Yü hai t'ang chih =made for the Yü-hai (jade sea) hall (about 1700).

Ku yüeh hsüan chih = made by Ku-yüeh-hsüan. (See Vol. ii., p. 215.)

堂　彩
製　華

Ts'ai hua t'ang chih = made for the hall of bright painting (nineteenth century).

Yu ch'ai = quiet pavilion—a studio name of a painter.

堂　彩
製　潤

Ts'ai jun t'ang chih = made for the hall of bright colours (nineteenth century).

Wan shih chü = myriad rocks retreat; studio name of a painter.

Nan hsiang t'ang = south aspect hall (on eighteenth century pottery).

Chu shih chü = red rocks retreat; studio name of a painter.

become frequent on the later porcelains. In fact most of the examples with which I am acquainted are nearer in style to the Tao Kuang than to the Yung Chêng wares, and the majority of the hall marks written in red on the glaze will be found to be of early nineteenth century date.

PALACE HALL MARKS

堂 成
置 德

Ch'êng tê t'ang chih = ordered for the Ch'êng-tê (complete virtue) hall.

齋 思
製 補

Ssŭ pu chai chih = made for the Ssŭ-pu pavilion (i.e. pavilion for meditation for the correction of faults).

Ching wei t'ang chih = made for the Ching-wei (reverent awe) hall.

Hsü hua t'ang chih tsêng = made¹ for the Hsü-hua hall, for presentation.

Tan ning chai chih = made for the Tan-ning (peace and tranquillity) pavilion.

堂 慎
製 德

Shên tê t'ang chih = made for the Shên-tê (cultivation of virtue) hall. (See Vol. ii., p. 264.)

博 慎
古 德
製 堂

Shên tê t'ang po ku chih = antique made for the Shên-tê hall.

(3) *Potters' names, etc.*

Marks which include potters' names (apart from the uncertain hall marks) are rare on Chinese porcelain though frequent enough on pottery. But it will be remembered that at Ching-tê Chên at any rate the porcelain passed through so many hands that the individuality of the work was lost, and consequently a personal mark would be, as a rule, misleading. The question of signatures in the field of the decoration has been discussed [1] with the conclusion that they belong rather to the artists who painted the original copied by the pot-painters than to the pot-painter himself.

Perhaps we should include here a fairly common type of mark, usually in the form of a small seal of a conventional and quite illegible character, which goes by the name of " shop marks." But it is not clear whether they refer to the maker or the firm who ordered the porcelain.

[1] Vol. ii., p. 167.

POTTERS' MARKS

Ma chên shih tsao = made by Ma ch'ên-shih (on a T'ang vase).

Chang chia tsao = made by the Chang family (on Tz'ǔ Chou ware). (See Vol. i., p. 105.)

Wang shih ch'ih ming = Mr. Wang Ch'ih-ming (on Tz'ǔ-Chou ware).

I shêng = harmonious prosperity. Perhaps a potter's name (on Kuangtung ware).

MARKS ON KUANGTUNG WARE

Ko ming hsiang chih = made by Ko Ming-hsiang (eighteenth century).

Ko yüan hsiang chih = made by Ko Yüan-hsiang (eighteenth century).

Huang yün chi = mark of Huang-yün (nineteenth century).

Li Ta-lai = potter's name.

Hou-ch'ang = potter's name.

POTTERS' MARKS—*continued*

Yi hsing tzŭ sha = brown earth (lit. sand) of Yi-hsing.

(?) *Chao-chin* = a potter's name.

Ming-yüan = a late Ming potter at Yi-hsing.

(?) *Chung t'un shih* = Chung-t'un family.

Hui mêng - chên = name of a late Ming potter at Yi-hsing, copied on modern wares.

(?) *Li-chih* = a potter's name.

Ch'ên Ming Yüan chih = made by Ch'ên Ming - Yüan, Yi-hsing.

Shan jên ch'ên wei = the hermit Ch'ên-wei.

Yü lan pi chih = secretly made by Yü-lan; Yi-hsing (nineteenth century).

Lai-kuan = potter's name.

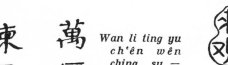

Wan li ting yu ch'ên wên ching su = Ch'ên Wên-ching modelled it in the *ting-yu* year of Wan Li (i.e. 1597).

Chao tsung ho yin = seal of Ho Chao-tsung.

POTTERS' NAMES, ETC.

Chiang ming kao tsao = made by Chiang Ming-kao (about 1700).

Wang tso t'ing tso = made by Wang Tso-t'ing (early nineteenth century).

Wang ping jung tso = made by Wan Ping-jung (early nineteenth century).

Ch'ên kuo chih tsao = made by Ch'ên Kuo-chih (about 1700).

Ling nan hui chê = Ling-nan (Canton) painting. Seal of Pai-shih (white rock). (See Vol. ii., p. 211.)

Tao kuang ting wei wên lang shan chih = made by Wên Lang-shan in the ting-wei year of Tao Kuang (i.e. 1847).

Fu fan chih tsao = made on the borders of Fukien. (See Vol. ii., p.108.)

Yü fêng yang lin = Yang Lin of Yü-fêng. (See Vol. ii., p. 212.)

(?) Trader's mark on export porcelain. (See Vol. ii., p. 136.)

Three examples of "shop marks."

(4) *Marks of dedication, felicitation,* etc.

In many cases the place of a date mark, hall mark, or potter's name is taken by a word or phrase commending or describing the ware or invoking a benediction on the possessor. Such marks may be conveniently subdivided into marks of (*a*) dedication, (*b*) felicitation, (*c*) commendation ; to which may be added (*d*) symbols used as marks.

(*a*) *Marks of dedication* indicating the destination or intention of the ware contain the name of a place or person or some word suggesting the use to which the vessel was dedicated. This group naturally overlaps that of the hall marks, there being no essential difference between a palace hall mark and such a mark as *Shu fu* 樞府 (Imperial palace) which was inscribed on the Imperial porcelain of the Yüan dynasty.

A few marks of dedication are mentioned in the *Po wu yao lan* [1] e.g. 壇 *t'an* (altar) on the altar cups of the Hsüan Tê period ; 茶 *ch'a* (tea), 酒 *chiu* (wine), 棗湯 *tsao t'ang* (decoction of jujubes), and 薑湯 *chiang t'ang* (decoction of ginger), which were inscribed inside the altar cups of the Chia Ching period, besides 金籙 *chin lu* (golden seal), 大醮 *ta chiao* (great sacrifice), and 壇用 *t'an yung* (altar use), which were written beneath them ; all indicating the offerings and the altars for which the cups were destined.

Dedications to temples, institutions, and even to individuals, often of considerable length, also occur not infrequently.

(*b*) *Marks of felicitation* include good wishes such as *ch'ang ming fu kuei* (long life, riches and honour), *wan fu yu t'ung* (may infinite happiness embrace all your affairs), both of which have been noted on Ming porcelain ; words of good omen such as *fu, lu, shou,* separately or together, 吉 *chi* (good luck), 慶 *ch'ing* (prosperity), etc.

(*c*) *Marks of commendation* are also frequent, especially in the K'ang Hsi period and on blue and white porcelain. They allude to the beauty of the ware, comparing it with jade or gold or gems, or to the subject of the decoration ; and they vary in length from a single character such as 玉 *yü* (jade) to a sentence like *ch'i shih pao ting chih chên* (a gem among precious vessels of rare stone).

(*d*) A sacred symbol or emblematic ornament often replaces the mark on K'ang Hsi porcelain ; but as these will be found among the symbols, etc., described in vol. ii., ch. xvii., there is no need to discuss them any further. The most frequently used are the *pa pao* (Eight Precious Things), and the *pa chi hsiang* (the Eight Buddhist Emblems of Happy Augury).

[1] Vol. ii., p. 34.

 Shun = harmony.

 Lu = prosperity.

 Shou = longevity (seal form).

 The same, with the Swastika interwoven.

The "spider" mark, a fanciful form of *shou*.

hsi (joy) repeated = double joy, a wedding symbol.

 Mark resembling a "cash" or coin inscribed *ch'ang ming fu kuei* = long life, riches, and honours!

fu kuei ch'ang ch'un = riches, honours, and enduring spring!

Wan fu yu t'ung = a myriad happinesses embrace all (your affairs)!

 Kung ming fu kuei Hung fu ch'i t'ien = a famous name, riches and honours, vast happiness equalling heaven!

 t'ien t'i yi chia ch'un = spring time for the whole family of heaven and earth.

ta ya chai = pavilion of grand culture. The Empress dowager's mark.

tê hua ch'ang ch'un = virtue culture and enduring spring; enclosed by *Wan li nien tsao* = made in the Wan Li period (1573—1619).

MARKS OF COMMENDATION

天 *t'ien* = heaven.

珍 *Chên* = a gem.

雅玩 *Ya wan* = elegant trinket.

全 *Ch'üan* = complete.

玉 *Yü* = jade.

珍玩 *Chên wan* = precious trinket.

富貴佳器 *fu kuei chia ch'i* = fine vessel for the rich and honourable.

錦玉 南川 *Nan ch'uan chin yü* = embroidered jade of Nan-ch'uan (i.e. Ching-tê Chên).

鼎之珍 奇石寶 *Ch'i shih pao ting chih chên* = a gem among precious vessels of rare stone.

珍賞 愛蓮 *Ai lien chên shang* = precious reward of the lover of the lotus.

 han hsing = to contain fragrance.

For other marks on porcelain and pottery see *Marks on Pottery and Porcelain,* by W. Burton and R. L. Hobson, and *The New Chaffers*.

MISCELLANEOUS MARKS AND SYMBOLS

 Conch-shell.

 The moon hare.

 Incense-burner (*ting*).

 The moon hare.

 ju-i head.

 The moon hare.

 Knot (*chang*).

 Artemisia leaf.

 Swastika (*wan*).

 Fungus (*ling-chih*).

 Swastika in a lozenge symbol.

 Fungus (*ling-chih*).

 Stork (on a late Ming blue and white dish).

 Fu (one of the twelve ornaments on ancient embroidery).

END OF VOL. I.

CHINESE POTTERY AND PORCELAIN

Volume II

MING AND CH'ING PORCELAIN

CONTENTS

LIST OF PLATES

THE COLOR PLATES FOLLOW PAGE 14.

vii

List of Plates

List of Plates

List of Plates

List of Plates

List of Plates

CHINESE POTTERY AND PORCELAIN

CHAPTER I

THE MING 明 DYNASTY, 1368–1644 A.D.

A S we have already discussed, so far as our imperfect know-
ledge permits, the various potteries which are scattered
over the length and breadth of China, we can now concen-
trate our attention on the rising importance of Ching-tê Chên.
From the beginning of the Ming dynasty, Ching-tê Chên may be
said to have become the ceramic metropolis of the empire, all
the other potteries sinking to provincial status. So far as Western
collections, at any rate, are concerned, it is not too much to say
that 90 per cent. of the post-Yüan porcelains were made in this
great pottery town.

What happened there in the stormy years which saw the over-
throw of the Mongol dynasty and the rise of the native Ming is
unknown to us, and, indeed, it is scarcely likely to have been of
much interest. The Imperial factories were closed, and did not
open till 1369, or, according to some accounts, 1398.[1] If we follow
the *Ching-tê Chên T'ao lu,* which, as its name implies, should be
well informed on the history of the place, a factory was built in
1369 at the foot of the Jewel Hill to supply Imperial porcelain
(*kuan tz'ŭ*), and in the reign of Hung Wu (1368–1398) there were
at least twenty kilns in various parts of the town working in the
Imperial service. They included kilns for the large dragon bowls,
kilns for blue (or green) ware (*ch'ing yao*), "wind and fire"[2] kilns,
seggar kilns for making the cases for the fine porcelain, and *lan
kuang* kilns, which Julien renders *fours à flammes étendues.* The
last expression implies that the heat was raised in these kilns
by means of a kind of bellows (*kuang*) which admitted air to

[1] See vol. i, p. 153.　　　　[2] *fêng huo.* Bushell renders "blast furnaces."

the furnace, and Bushell's rendering, "blue and yellow enamel furnaces," ignores an essential part of both the characters[1] used in the original.

From this time onward there is no lack of information on the nature of the Imperial wares made during the various reigns, but it must be remembered that the Chinese descriptions are in almost every case confined to the Imperial porcelains, and we are left to assume that the productions of the numerous private kilns followed the same lines, though in the earlier periods, at any rate, we are told that they were inferior in quality and finish.

The Hung Wu 洪武 palace porcelain, as described in the *T'ao lu*, was of fine, unctuous clay and potted thin. The ware was left for a whole year to dry, then put upon the lathe and turned thin, and then glazed and fired. If there was any fault in the glaze, the piece was ground down on the lathe, reglazed and refired. "Consequently the glaze was lustrous (*jung*) like massed lard." These phrases are now so trite that one is tempted to regard them as mere Chinese conventionalities, but there is no doubt that the material used in the Ming period (which, as we shall see presently, gave out in the later reigns) was of peculiar excellence. The raw edge of the base rim of early specimens does, in fact, reveal a beautiful white body of exceedingly fine grain and smooth texture, so fat and unctuous that one might almost expect to squeeze moisture out of it.

The best ware, we are told, was white, but other kinds are mentioned. A short contemporary notice in the *Ko ku yao lun*,[2] written in 1387, says, " Of modern wares (made at Ching-tê Chên) the good examples with white colour and lustrous are very highly valued. There are, besides, *ch'ing*[3] (blue or green) and black (*hei*) wares with gilding, including wine pots and wine cups of great charm." Such pieces may exist in Western collections, but they remain unidentified, and though there are several specimens with the Hung Wu mark to be seen in museums, few have the appearance of Ming porcelain at all. There is, however, a dish in the British Museum which certainly belongs to the Ming dynasty, even if it

[1] 爁橫 *lan kuang*, lit. " burn tube." Omitting the radical 火 (*huo*, fire) in both cases, Bushell takes the characters as *lan* (blue) and *huang* (yellow). Possibly Bushell's edition had variant readings.

[2] Bk. vii., fol. 25 recto.

[3] Or, perhaps, " greenish black," taking the two words together.

is a century later than the mark implies. The body is refined and white, though the finish is rather rough, with pits and raised spots here and there in the glaze and grit adhering to the foot rim; but it is painted with a free touch in a bright blue, recalling the Mohammedan blue in colour, the central subject a landscape, and the sides and rim divided into panels of floral and formal ornament. It must be allowed that the style of the painting is advanced for this early period, including as it does white designs reserved in blue ground as well as the ordinary blue painting on a white ground.

Yung Lo 永樂 (1403–1424)

The usual formulæ are employed by the *T'ao lu* in describing the Imperial ware of this reign. It was made of plastic clay and refined material, and though, as a rule, the porcelain was thick, there were some exceedingly thin varieties known as *t'o t'ai*[1] or " bodiless " porcelains. Besides the plain white specimens, there were others engraved with a point[2] or coated with vivid red (*hsien hung*). The *Po wu yao lan*,[3] reputed a high authority on Ming porcelains and written in the third decade of the seventeenth century, adds " blue and white " to the list and gives further details of the wares. The passage is worth quoting in full, and runs as follows : " In the reign of Yung Lo were made the cups which fit in the palm of the hand,[4] with broad mouth, contracted waist, sandy (*sha*) foot, and polished base. Inside were drawn two lions rolling balls. Inside, too, in seal characters, was written *Ta Ming Yung Lo nien chih*[5] in six characters, or sometimes in four[6] only, as fine as grains of rice. These are the highest class. Those with mandarin ducks, or floral decoration inside, are all second quality. The cups are decorated outside with blue ornaments of a very deep colour, and their shape and make are very refined and beautiful and in a traditional style. Their price, too, is very high.

[1] 脫胎 lit. " omit body." A slightly thicker porcelain is known as *pan t'o t'ai*, or " half bodiless."

[2] 彩錐 *ts'ai chui*. These words seem to have been taken to mean " decorated with an awl " ; but they are better translated separately to mean " bright coloured " and " (engraved with) an awl," the suggestion being that *ts'ai* refers to enamelled porcelain.

[3] Bk. ii., fol. 8 verso.

[4] 壓手杯 *Ya shou pei*, lit. " press hand cups."

[5] " Made in the Yung Lo period of the great Ming dynasty."

[6] The reading in the British Museum copy is 白 *pai* (white), which seems to be an error for 四 *ssŭ* (four) : taken as it stands, it would mean written in white slip.

As for the modern imitations, they are coarse in style and make, with foot and base burnt (brown), and though their form has some resemblance (to the old), they are not worthy of admiration."

As may be imagined, Yung Lo porcelain is not common to-day, and the few specimens which exist in our collections are not enough to make us realise the full import of these descriptions. There are, however, several types which bear closely on the subject, some being actually of the period and others in the Yung Lo style. A fair sample of the ordinary body and glaze of the time is seen in the white porcelain bricks of which the lower story of the famous Nanking pagoda was built. Several of these are in the British Museum, and they show a white compact body of close but granular fracture ; the glazed face is a pure, solid-looking white, and the unglazed sides show a smooth, fine-grained ware which has assumed a pinkish red tinge in the firing. The coarser porcelains of the period would, no doubt, have similar characteristics in body and glaze. The finer wares are exemplified by the white bowls, of wonderful thinness and transparency, with decoration engraved in the body or traced in delicate white slip under the glaze and scarcely visible except as a transparency. Considering the fragility of these delicate wares and the distant date of the Yung Lo period, it is surprising how many are to be seen in Western collections. Indeed, it is hard to believe that more than a very few of these can be genuine Yung Lo productions, and as we know that the fine white " egg shell " porcelain was made throughout the Ming period and copied with great skill in the earlier reigns of the last dynasty, it is not necessary to assume that every bowl of the Yung Lo type dates back to the first decades of the fifteenth century.

It is wellnigh impossible to reproduce adequately these white porcelains, but Plate 59 illustrates the well-known example in the Franks Collection, which has long been accepted as a genuine Yung Lo specimen. It represents the *ya shou pei* in form, with wide mouth and small foot—the contracted waist of the *Po wu yao lan* ; the foot rim is bare at the edge, but not otherwise sandy, and the base is glazed over, which may be the sense in which the word " polished " [1] is used in the *Po wu yao lan*. The ware is so thin and transparent that it seems to consist of glaze alone, as

[1] 滑 *hua*, lit. " slippery." The meanings include " polished, smooth, ground," etc., from which it will be seen that the word could equally refer to a glazed surface or an unglazed surface which had been polished on the wheel.

Fig. 1

Fig. 2

Plate 59.—White Eggshell Porcelain Bowl with Imperial dragons
faintly traced in white slip under the glaze.

Mark of the Yung Lo period (1403–1424) incised in the centre in archaic
characters. 1. Exterior. 2. Interior view. Diameter 8¾ inches. *British Museum.*

though the body had been pared away to vanishing point before the glaze was applied—in short, it is *t'o t'ai* or " bodiless." When held to the light it has a greenish transparency and the colour of melting snow, and there is revealed on the sides a delicate but exquisitely drawn design of five-clawed Imperial dragons in white slip (not etched, as has too often been stated), showing up like the water-mark in paper. On the bottom inside is the date-mark of the period etched with a point in four archaic characters (see vol. i, p. 213). A more refined and delicate ceramic work could hardly be imagined.

Close to this bowl in the Franks Collection there are two smaller bowls or, rather, cups which in many ways answer more nearly the description of the *ya shou pei*,[1] though they are thick in substance and of coarser make. They have straight spreading sides, wide at the mouth, with foliate rim, and contracted at the foot. The foot rim is bare of glaze, but the base is covered. They are of an impure white ware with surface rather pitted, and inside is a lotus design traced in white slip under the glaze and repeated in radiating compartments. These are perhaps a product of the private factories. The same form is observed among the blue and white porcelain in two small cups, which are painted in blue with a landscape on the exterior and with bands of curled scrolls inside and the Yung Lo mark in four characters. The base is unglazed, and though they are undoubtedly intended to represent a Yung Lo type, these not uncommon bowls can hardly be older than the last dynasty. Another blue and white bowl in the Franks Collection has the Yung Lo mark and the scroll decoration inside, and on the exterior a long poem by Su Shih, covering most of the surface. It is painted in a grey blue, and the ware, though coarse, has the appearance of Ming manufacture, perhaps one of the late Ming copies which are mentioned without honour in the *Po wu yao lan*. It is, however, of the ordinary rounded form.[2]

Hsiang Yüan-p'ien illustrates in his Album one Yung Lo specimen, a low cylindrical bowl of the " bodiless " kind, " thin as paper," with a very delicate dragon and phœnix design, which

[1] This conical form of bowl was by no means new in the Ming period. In fact, we are told in the *T'ao shuo* that it is the *p'ieh* of the Sung dynasty, the old form of tea bowl. See vol. i, p. 175.

[2] There are several others of this type in Continental museums ; cf. Zimmermann, op. cit. Plate 23.

is seen when the bowl is held to the light and carefully inspected. This style of ornament is described as *an hua* (secret decoration), but it is not stated whether, in this case, it was engraved in the paste or traced in white slip.

The mention of " fresh red " (*hsien hung*), which seems to have been used on the Yung Lo porcelain as well as in the succeeding Hsüan Tê period, brings to mind a familiar type of small bowl with slight designs in blue inside, often a figure of a boy at play, the exterior being coated with a fine coral red, over which are lotus scrolls in gold. There are several in the British Museum, and one, with a sixteenth-century silver mount, was exhibited at the Burlington Fine Arts Club in 1910.[1] The term *hsien hung* is certainly used for an underglaze copper red on the Hsüan Tê porcelain, and it is doubtful whether it can have been loosely applied to an overglaze iron red on the earlier ware. For the bowls to which I refer have an iron red decoration, though it is sometimes wonderfully translucent and, being heavily fluxed, looks like a red glaze instead of merely an overglaze enamel (see Plate 74). Several of these red bowls have the Yung Lo mark, others have merely marks of commendation or good wish. Their form is characteristic of the Ming period, and the base is sometimes convex at the bottom, sometimes concave. They vary considerably in quality, the red in some cases being a translucent and rather pale coral tint, and in others a thick, opaque brick red. Probably they vary in date as well, the former type being the earlier and better. It is exemplified by an interesting specimen in the Franks Collection marked *tan kuei* (red cassia), which indicates its destination as a present to a literary aspirant, the red cassia being a symbol of literary success. This piece has, moreover, a stamped leather box of European—probably Venetian—make, which is not later than the sixteenth century. This, if any of these bowls, belongs to the Yung Lo period, but it will be seen presently that the iron red was used as an inferior but more workable substitute for the underglaze red in the later Ming reigns, and, it must be added, these bowls are strangely numerous for a fifteenth-century porcelain. That they are a Yung Lo type, however, there is little doubt, for this red and gold decoration (*kinrande* of the Japanese) is the adopted style which won for the clever Kioto potter, Zengoro Hozen, the art name *Ei raku*, i.e. Yung Lo in Japanese.

[1] *Cat.*, F 6.

CHAPTER II

HSÜAN TÊ 宣德 (1426–1435)

IN this short reign, which Chinese writers regard as the most brilliant period of their porcelain industry, the number of kilns occupied with the Imperial orders had increased to fifty-eight, the majority of them being outside the Imperial factory and distributed among the private factories. According to the *T'ao lu*,[1] the clay used at this time was red and the ware like cinnabar, a statement which is difficult to reconcile with the glowing description of the jade-like white altar cups and other exquisite objects for which the reign was celebrated. It is, of course, possible that a dark coloured body was employed in some of the wares, as was done at other periods, or it may be that the words are hyperbolically used to describe a porcelain of which the exposed parts of the body assumed a red colour in the firing. This latter peculiarity is noticeable on specimens of later Ming porcelain, particularly the blue and white of the Chia Ching period. But in any case a red biscuit cannot have been invariable or even characteristic of the period, for no mention is made of such a feature in the *Po wu yao lan*, which gives by far the fullest account of the Hsüan Tê porcelain.

The description in the *Po wu yao lan*,[2] which seems to have been generally accepted, and certainly was largely borrowed by subsequent Chinese works, may be freely rendered as follows :

" Among the wares of the Hsüan Tê period there are stem-cups[3] decorated with red fish. For these they used a powder made of red precious stones from the West to paint the fish forms, and from the body there rose up in relief in the firing the precious brilliance of the fresh red ravishing the eye. The brown and blackish

[1] Bk. v., fol. 5.

[2] Bk. ii., fol. 8.

[3] *pa pei*, lit. handle cups. This type, as illustrated in Hsiang's Album (op. cit., No. 54) is a shallow cup or tazza on a tall stem which was grasped by the hand.

colours which resulted from imperfect firing of the red are inferior. There were also blue decorated wares, such as stem-cups with dragon pine and plum designs, wine stem-cups with figure subjects [1] and lotus designs, small cinnabar pots and large bowls in colour red like the sun, but with white mouth rim, pickle pots and small pots with basket covers and handles in the form of bamboo joints, all of which things were unknown in ancient times. Again, there were beautiful objects of a useful kind, all small and cleverly made with finely and accurately drawn designs. The incense vases, trays and dishes [2] were made in large numbers, and belong to a common class. The flat-sided jars with basket covers, and the ornamented round pots with flanged[3] mouth for preserving honey, are very beautiful and mostly decorated in colours (*wu ts'ai*). The white cups, which have the character *t'an* (altar) engraved inside the bowl, are what are known as ' altar cups.' The material of these things is refined and the ware thick, and the form beautiful enough to be used as elegant vases in the true scholar's room. There are besides white cups for tea with rounded body,[4] convex[5] base, thread-like foot, bright and lustrous like jade, and with very finely engraved[6] dragon and phœnix designs which are scarcely inferior to the altar cups. At the bottom the characters *ta ming hsüan tê nien chih*[7] are secretly engraved in the paste, and the texture of the glaze is uneven, like orange peel.[8] How can even Ting porcelain compare with these ? Truly they are the most excellent porcelains of this reign, and unfortunately there have not been many to be seen since then. Again, there are the beautiful barrel-shaped seats, some with openwork ground, the designs filled in with colours (*wu ts'ai*), gorgeous as cloud brocades, others with solid ground filled in with colours in engraved floral designs, so beautiful and brilliant as to dazzle the eye ; both sorts have a deep green (*ch'ing*) background. Others have blue

[1] An example of the figure subjects on Hsüan Tê blue and white is given in the *T'ao shuo,* " teacups decorated with figures armed with light silk fans striking at flying fire-flies " ; see Bushell's translation, op. cit., p. 136.

[2] " Citron dishes " are specially mentioned in the *Wên chên hêng ch'ang wu chi* (*T'ao lu,* bk. viii., fol. 4).

[3] *Ch'ang k'ou,* lit. "shed mouth."

[4] Lit. "pot-bellied."

[5] Lit. "cauldron (*fu*) base."

[6] *an hua,* secret decoration (see p. 6).

[7] "Made in the Hsüan Tê period of the great Ming dynasty."

[8] Lit. " orange-peel markings (*chü p'i wên*) rise in the glaze."

Fig. 1

Fig. 2

Plate 60.—Reputed Hsüan Tê Porcelain.

Fig. 1.—Flask with blue decoration, reputed to be Hsüan Tê period. Height 3¼ inches. *British Museum.* Fig. 2.—Brush Rest. (?) Chang Ch'ien on a log raft; partly biscuit. Inscribed with a stanza of verse and the Hsüan Tê mark. Length 6 inches. *Grandidier Collection.*

Fig. 2

Fig. 1

Plate 61.—Porcelain with *san ts'ai* glazes on the biscuit.

Fig. 1.—Wine Jar with pierced casing, the Taoist Immortals paying court to the God of Longevity, turquoise blue ground. Fifteenth century. Height 11½ inches. *Eumorfopoulos Collection.* Fig. 2.—Screen with design in relief, horsemen on a mountain path, dark blue ground. About 1500. Height 14 inches. *Benson Collection.*

(*lan*) ground, filled in with designs in colours (*wu ts'ai*), like ornament carved in cobalt blue (*shih ch'ing,* lit. stone blue). There is also blue decoration on a white ground and crackled grounds like ice. The form and ornament of these various types do not seem to have been known before this period."

It will be seen from the above that the Hsüan Tê porcelains included a fine white, blue and white and polychrome painted wares, underglaze red painted wares, and crackle. The last mentioned is further specified in the *Ch'ing pi tsang* as having " eel's blood lines," [1] and almost rivalling the Kuan and Ju wares. The ware was thick and strong, and the glaze had the peculiar undulating appearance (variously compared to chicken skin, orange peel, millet grains, or a wind ruffled surface) which was deliberately produced on the eighteenth century porcelains.

Another surface peculiarity shared by the Hsüan Tê and Yung Lo wares was " palm eye " (*tsung yen*) markings, which Bushell explains as holes in the glaze due to air bubbles. It is hard to see how these can have been other than a defect. Probably both these and the orange peel effects were purely fortuitous at this time.

Of the various types which we have enumerated, the white wares need little comment. The glaze was no doubt thick and lustrous like mutton fat jade, and though Hsiang in his Album usually describes the white of his examples as " white like driven snow," it is worthy of note that in good imitations of the ware particular care seems to have been given to impart a distinct greenish tint to the glaze.

The honours of the period appear to have been shared by the " blue and white " and red painted wares. Out of twenty examples illustrated in Hsiang's Album, no fewer than twelve are decorated chiefly in red, either covering the whole or a large part of the surface or painted in designs, among which three fishes occur with monotonous frequency. The red in every case is called *chi hung,* and it is usually qualified by the illuminating comparison with " ape's blood," and in one case it is even redder than that !

The expression *chi hung* has evidently been handed down by oral traditions, for there is no sort of agreement among Chinese writers on the form of the first character. The *T'ao lu* uses the

[1] i.e. red lines coloured by rubbing ochre into the cracks. See vol. i, p. 99.

character 祭, which means "sacrificial," and Bushell[1] explains this " as the colour of the sacrificial cups which were employed by the Emperor in the worship of the Sun." Hsiang uses the character 積 which means " massed, accumulated." And others use the character 霽 which means " sky clearing," and is also applied to blue in the sense of the " blue of the sky after rain." In the oft quoted list of the Yung Chêng porcelains we find the item, " Imitations of Hsüan chi hung wares, including two kinds, hsien hung (fresh red) and pao shih hung (ruby red)." There can be little doubt that both these were shades of underglaze red derived from copper oxide, a colour with which we are quite familiar from the eighteenth century and later examples.

For in another context we find the hsien hung contrasted with fan hung, which is the usual term for overglaze iron red, and the description already given of the application of pao shih hung leaves no doubt whatever that it was an underglaze colour. The two terms are probably fanciful names for two variations of the same colour, or perhaps for two different applications of it, for we know that it was used as a pigment for brushwork as well as in the form of a ground colour incorporated in the glaze. The secret of the colour seems to have been well kept, and the general impression prevailing outside the factories was that its tint and brilliancy were due to powdered rubies, the red precious stone from the West which gave the name to the pao shih hung.[2] It is known that in some cases such stones as cornelian (ma nao) have been incorporated in the porcelain glazes in China to increase the limpidity of the glaze. This is reputed to have happened in the case of the Ju yao, but neither cornelian nor ruby could serve in any way as a colouring agent, as their colour would be dissipated in the heat of the furnace. The real colouring agent of the chi hung is protoxide of copper. If there were nothing else to prove this, it would be clear from the fact hinted in the Po wu yao lan that the failures came out a brownish or blackish tint. This colour has always proved a difficult one to manage, and in the early part

[1] O. C. A., p. 371.

[2] Unfortunately the term pao shih hung has been loosely applied in modern times to the iron red. See Julien, op. cit., p. 91 note : " Among the colours for porcelain painting which M. Itier brought from China and offered to the Sèvres factory, there is one called pao shih hung, which, from M. Salvétat's analysis, is nothing else but oxide of iron with a flux." In other words, it is a material which should have been labelled fan hung. This careless terminology has led to much confusion.

of the last dynasty, when it was freely used after the manner of the Hsüan Tê potters, the results were most unequal, varying from a fine blood red to maroon and brown, and even to a blackish tint.

The peculiar merits of the Hsüan Tê red were probably due in some measure to the clay of which the ware was composed, and which contained some natural ingredient favourable to the development of the red. At any rate, we are told[1] that in the Chia Ching period (1522-1566) " the earth used for the *hsien hung* ran short."

Among the favourite designs[2] expressed in the Hsüan Tê red were three fishes, three fruits,[3] three funguses, and the character *fu* (happiness) repeated five times.[4] All these are mentioned among the Yung Chêng imitations. A good idea of the fish design is given by a cylindrical vase in the Franks Collection, which is plain except for two fishes in underglaze red of good colour, and rising in slight relief in the glaze. The glaze itself is of that faint celadon green which was apparently regarded as a necessary feature of the Hsüan Tê copies, and which incidentally seems to be favourable to the development of the copper red. The *sang de bœuf* red of the last dynasty is avowedly a revival of the Hsüan Tê red in its use as a glaze colour. Indeed, certain varieties of the *sang de bœuf* class are still distinguished as *chi hung*. The large bowls, " red as the sun and white at the mouth rim," as mentioned in the *Po wu yao lan*, have a counterpart in the large bowl of the last dynasty with *sang de bœuf* glaze, which, flowing downwards, usually left a colourless white band at the mouth.

The Hsüan Tê period extended only to ten years, and specimens of Hsüan red are excessively rare to-day, even in China. It is doubtful if a genuine specimen exists outside the Middle Kingdom, but with the help of the old Chinese descriptions and the clever imitations of a later date,[5] there is no difficulty in imagining the vivid splendours of the " precious stone red " of this brilliant period.

Among the " blue and white " wares of all periods, the Hsüan

[1] *T'ao lu*, bk. v., fol. 7 recto.

[2] The *Ch'ing pi tsang* mentions " designs of flowers, birds, fish and insects, and such like forms " as typical ornaments on the red painted Hsüan porcelain.

[3] The three fruits (*san kuo*) are the peach, pomegranate, and finger citron, which typify the Three Abundances of years, sons and happiness.

[4] *Wu fu*. This may, however, be emblematically rendered by five bats, the bat (*fu*) being a common rebus for *fu* (happiness).

[5] See p. 122.

Tê porcelain is unanimously voted the first place by Chinese writers, and its excellence is ascribed principally to the superior quality of an imported mineral variously described as *su-ni-p'o*, *su-p'o-ni* and *su-ma-ni*. These outlandish names are, no doubt, attempts to render in Chinese the foreign name of the material, which was itself probably the name of the place or people whence it was exported. There is little doubt that this mysterious substance was the same species as the Mohammedan blue (*hui hui ch'ing*) of the following century. Indeed, this latter name is applied to it in Hsiang's Album. The Mohammedan blue was obtained from Arab traders, and its use for painting on pottery had been familiar in the Near East, in Persia and Syria for instance, at least as early as the twelfth century.[1] The *su-ni-p'o* blue was no doubt imported in the form of mineral cobalt, and though there was no lack of this mineral in the neighbourhood of Ching-tê Chên, the foreign material was of superior quality. It was, however, not only expensive but unsuited for use in a pure state. If applied by itself, it had a tendency to run in the firing, and it was necessary to blend it with proportions of the native mineral varying from one in ten for the finest quality to four in six for the medium quality. The native mineral used by itself tended to be heavy and dull in tone, owing to its inability to stand the intense heat of the kiln, and was only employed alone on the coarser wares. The supply of Mohammedan blue was uncertain and spasmodic. It ceased to arrive at the end of the Hsüan Tê period, and it was not renewed till the next century (see p. 29). Its nature, too, seems to have varied, for we are expressly told that the Hsüan Tê blue was pale in tone while the Mohammedan blue of the sixteenth century was dark.

[1] According to Bushell, *O. C. A.*, p. 130, " cobalt blue, as we learn from the official annals of the Sung dynasty (*Sung shih*, bk. 490, fol. 12), was brought to China by the Arabs under the name of *wu ming yi*." This takes it back to the tenth century. *Wu ming yi* (nameless rarity) was afterwards used as a general name for cobalt blue, and was applied to the native mineral. The name was sometimes varied to *wu ming tzŭ*. Though we are not expressly told the source of the *su-ni-p'o* blue, it is easily guessed. For the Ming Annals (bk. 325) state that among the objects brought as tribute by envoys from Sumatra were " precious stones, agate, crystal, carbonate of copper, rhinoceros horn, and 回回青 *hui hui ch'ing* (Mohammedan blue)." See W. P. Groeneveldt, *Verhandelingen van het Bataviaasch Genootschap van Kunsten en Wetenschappen*, vol. xxxix., p. 92. These envoys arrived in 1426, 1430, 1433, 1434, and for the last time in 1486. Sumatra was a meeting-place of the traders from East and West, and no doubt the Mohammedan blue was brought thither by Arab merchants. Possibly some of the mineral was brought back by the celebrated eunuch Chêng Ho, who led an expedition to Sumatra in the Yung Lo period. See also p. 30.

Possibly, however, this was not so much due to the nature of the
material as to the method of its application, for Chinese writers
are by no means unanimous about the paleness of the Hsüan Tê
blue. The *Ch'ing pi ts'ang*, for instance, states that "they used
su-p'o-ni blue and painted designs of dragons, phœnixes, flowers,
birds, insects, fish and similar forms, deep and thickly heaped
and piled and very lovely."

Authentic specimens of Hsüan Tê blue and white are virtually
unknown, but the mark of the period is one of the commonest on
Chinese porcelain of relatively modern date. In most cases this
spurious dating means nothing more than that the period named
was one of high repute ; but there is a type of blue and white,
usually bearing the period mark of Hsüan Tê, which is so mannered
and characteristic that one feels the certainty that this really
represents one kind at least of the Hsüan porcelain. It is usually
decorated in close floral scrolls, and the blue is light dappled with
darker shades, which are often literally " heaped and piled " (*tui
t'o*) over the paler substratum.

I have seen examples of this style belonging to various periods,
mostly eighteenth century, but some certainly late Ming[1] (see
Plate 67, Fig. 4). Seven examples of Hsüan blue and white porce-
lain are figured in Hsiang's Album,[2] comprising an ink pallet, a vase
shaped like a section of bamboo, a goose-shaped wine jar, a vase
with an elephant on the cover, a tea cup, a sacrificial vessel, and
a lamp with four nozzles. In five of these the blue is confined to
slight pencilled borders, merely serving to set off the white ground,
which is compared to driven snow. The glaze is rich and thick,
and of uneven surface, rising in slight tubercles likened to " grains
of millet." This is the " orange skin " glaze. The blue in each
case is *hui hu*[3] *ta ch'ing* (deep Mohammedan blue). Of the two
remaining instances, one is painted with a dragon in clouds, and
the other with " dragon pines," and in the latter case the glaze
is described as " lustrous like mutton fat jade," and the blue as
" of intensity and brilliance to dazzle the eye."

The impression conveyed by all these examples is that they

[1] See *Cat. B. F. A.*, 1910, L 23 ; a pilgrim bottle belonging to Mrs. Halsey, in-
scribed after export to India with the word Alamgir, a name of the famous Aurungzib.
Cf. also the fine cylindrical vase in the Victoria and Albert Museum (Case 2), with
floral scrolls in this type of blue combined with underglaze red, and the Hsüan Tê mark.

[2] Op. cit., Nos. 9, 31, 37, 39, 48, 69 and 83.

[3] *Hui hu* is a variant for *hui hui* (Mohammedan).

represent a type quite different from that described as "heaped and piled," a type in which delicate pencilling was the desideratum, the designs being slight and giving full play to the white porcelain ground. It is, in fact, far closer in style to the delicately painted Japanese Hirado porcelain than to the familiar Chinese blue and white of the K'ang Hsi period.

Plate 60 illustrates a little flask-shaped vase in the Franks Collection, which purports to be a specimen of Hsüan Tê blue and white porcelain. It has a thick, "mutton fat" glaze of faint greenish tinge, and is decorated with a freely drawn peach bough in underglaze blue which has not developed uniformly in the firing. The colour in places is deep, soft and brilliant, but elsewhere it has assumed too dark a hue.[1] Its certificate is engraved in Chinese fashion on the box into which it has been carefully fitted—*hsüan tz'ŭ pao yüeh p'ing*, "precious moon vase of Hsüan porcelain"— attested by the signature Tzŭ-ching, the studio name of none other than Hsiang Yüan-p'ien, whose Album has been so often quoted. Without attaching too much weight to this inscription, which is a matter easily arranged by the Chinese, there is nothing in the appearance of this quite unpretentious little vase which is inconsistent with an early Ming origin.

On the same plate is a brush rest in form of a log raft, on which is a seated figure, probably the celebrated Chang-Ch'ien, floating down the Yellow River. The design recalls a rare silver cup of the Yüan dynasty, which was illustrated in the *Burlington Magazine* (December, 1912). Here the material is porcelain biscuit with details glazed and touched with blue, and the *nien hao* of Hsüan Tê is visible on the upper part of the log beside two lines of poetry. Whether this brush rest really belongs to the period indicated or not, it is a rare and interesting specimen. Two other possible examples of Hsüan Tê blue and white are described on p. 32.

As to the other types of Hsüan ware named in the *Po wu yao lan,* with one exception I can find no exact counterpart of them in existing specimens, though parts of the descriptions are illustrated by examples of apparently later date. Thus the form of the white tea cups, "with rounded body, convex base, and thread-like foot," is seen in such bowls as Fig. 1 of Plate 74, which is proved by its mount to be not later than the sixteenth century. Other

[1] Probably due to over-firing.

COLOR PLATES

FRONTISPIECE, VOLUME II. COVERED JAR OR POTICHE.
Painted with coloured enamels on the biscuit. Eight petal-shaped panels with flowering plants, birds and insects on the sides; with a band of smaller petals below enclosing lotus flowers, and borders of red wave pattern and floral sprays. Base unglazed. Early part of the K'ang Hsi period (1662–1722). *British Museum*. Height 25 inches.

PLATE 62. BARREL-SHAPED GARDEN SEAT.
Porcelain with coloured glazes on the biscuit, the designs outlined in slender
fillets of clay. A lotus scroll between an upper band of clouds and a lower
band of horses in flying gallop and sea waves. Lion mask handles. About
1500 A.D. *British Museum.* Height 14¼ inches.

PLATE 72. VASE WITH IMPERIAL FIVE-CLAWED DRAGONS IN CLOUD SCROLLS OVER SEA WAVES.
Band of lotus scrolls on the shoulder. Painted in dark Mohammedan blue.
Mark on the neck, of the Chia Ching period (1522–1566) in six characters.
Victoria and Albert Museum. Height 21 inches.

FIG. 2.

FIG. 1.

PLATE 73. Two Bowls with the Chia Ching Mark (1522–1566), with Designs Outlined in Brown and Washed in with Colours in Monochrome Grounds.

FIG. 1. With peach sprays in a yellow ground. Diameter 8 inches. *Alexander Collection.*

FIG. 2. With phoenixes (*féng-huang*) flying among scrolls of *mu-tan* peony. *Cumberbatch Collection. Diameter 7 inches.*

FIG. 1.

FIG. 2.

PLATE 74. TWO BOWLS IN THE BRITISH MUSEUM WITH GILT DESIGNS ON A MONOCHROME
GROUND. PROBABLY CHIA CHING PERIOD (1522–1566).
FIG. 1. With lotus scroll with etched details on a ground of iron red (*fan hung*) outside. Inside
is figure of a man holding a branch of cassia, a symbol of literary success, painted in underglaze
blue. Mark in blue, *tan kuei* (red cassia). Diameter 4½ inches.
FIG. 2. With similar design on ground of emerald green enamel. Mark in blue in the form
of a coin or *cash* with the characters *ch'ang ming fu kuei* (long life, riches and honours). Diam-
eter 4¾ inches.

FIG. 2.

FIG. 1.

PLATE 77. TWO EXAMPLES OF MING BLUE AND WHITE PORCELAIN IN THE BRIT-
ISH MUSEUM.

FIG. 1. Ewer of thin, crisp porcelain with foliate mouth and rustic spout with
leaf attachments. Panels of figure subjects and landscapes on the body: "rat
and vine" pattern on the neck and a band of hexagon diaper enclosing a
cash symbol. Latter half of the sixteenth century. Height 7 inches.

FIG. 2. Octagonal stand perhaps for artist's colours. On the sides are scenes
from the life of a sage; borders of *ju-i* pattern and gadroons. On the top are
lions sporting with brocade balls. Painted in deep Mohammedan blue. Mark

PLATE 80. COVERED JAR OR POTICHE.
Painted in iron red and green enamels, with a family scene in a garden, and brocade borders of *ju-i* pattern, peony scrolls, etc. Sixteenth century. *Salting Collection (Victoria and Albert Museum)*. Height 17½ inches.

PLATE 81. BEAKER-SHAPED VASE OF BRONZE FORM.
With dragon and phoenix designs painted in underglaze blue, and red, green
and yellow enamels: background of fairy flowers *(pao hsiang hua)* and
borders of "rock and wave" pattern. Mark of the Wan Li period (1573–
1619) in six characters on the neck. An Imperial piece. Carved wood stand
with cloud pattern. *British Museum.* Height 18½ inches.

PLATE 84. VASE OF BALUSTER FORM WITH SMALL MOUTH (*mei p'ing*).
Porcelain with coloured glazes on the biscuit, the designs outlined in slender
fillets of clay. A meeting of sages in a landscape beneath an ancient pine
tree, the design above their heads representing the mountain mist. On the
shoulders are large *ju-i* shaped lappets enclosing lotus sprays, with pendent
jewels between: fungus (*ling chih*) designs on the neck. Yellow glaze under
the base. A late example of this style of ware, probably seventeenth century.
Salting Collection (Victoria and Albert Museum). Height 11 inches.

PLATE 85. VASE.
With crackled greenish grey glaze coated on the exterior with transparent
apple green enamel: the base unglazed. Probably sixteenth century. *British
Museum*. Height 14 inches.

Fig. 1.

Fig. 2.

PLATE 88. TWO EXAMPLES OF THE UNDERGLAZE RED *(chi hung)* OF THE K'ANG
HSI PERIOD (1662–1722), SOMETIMES CALLED *lang yao.*
FIG. 1. Bottle-shaped vase of dagoba form with minutely crackled *sang-de-
boeuf* glaze with passages of cherry red. The glaze ends in an even roll short
of the base rim, and that under the base is stone-coloured and crackled.
British Museum. Height 8½ inches.
FIG. 2. Bottle-shaped vase with crackled underglaze red of deep crushed straw-
berry tint. The glaze under the base is pale green, crackled. *Alexander Col-
lection.* Height 10¾ inches.

FIG. 1.　　　　　　FIG. 2.　　　　　　FIG. 3.

PLATE 89. THREE EXAMPLES OF K'ANG HSI BLUE AND WHITE PORCELAIN IN THE BRITISH MUSEUM.
FIG. 1. Ewer with leaf-shaped panels of floral arabesques, white in blue, enclosed by a mosaic pattern in blue and white: stiff plantain leaves on the neck and cover. Silver mount with thumb-piece. Height 7⅛ inches.
FIG. 2. Deep bowl with cover, painted with "tiger-lily" scrolls. Mark, a leaf. Height 7½ inches.
FIG. 3. Sprinkler with panels of lotus arabesques, white in blue, and ju-i shaped border patterns. A diaper of small blossoms on the neck. Mark, a leaf. Height 7⅛ inches.

PLATE 90. COVERED JAR FOR NEW YEAR GIFTS.
With design of blossoming prunus (*mei hua*) sprays in a ground of deep
sapphire blue, which is reticulated with lines suggesting ice cracks: dentate
border on the shoulders. *Victoria and Albert Museum.* Height 10 inches.

FIG. 1. FIG. 2.

PLATE 95. TWO EXAMPLES OF PORCELAIN PAINTED WITH COLOURED ENAMELS
ON THE BISCUIT, THE DETAILS OF THE DESIGNS BEING FIRST TRACED IN BROWN.
K'ANG HSI PERIOD (1662–1722).
FIG. 1. One of a pair of Buddhistic Lions, sometimes called Dogs of Fo. This
is apparently the lioness, with her cub: the lion has a ball of brocade under
his paw. On the head is the character *wang* (prince) which is more usual
on the tiger of Chinese art. *S. E. Kennedy Collection.* Height 18 inches.
FIG. 2. Bottle-shaped vase and stand moulded in bamboo pattern and deco-
rated with floral brocade designs and diapers. *Cope Bequest (Victoria and
Albert Museum).* Height 8¾ inches.

PLATE 96. VASE OF BALUSTER FORM PAINTED IN COLOURED ENAMELS ON THE
BISCUIT.
The design, which is outlined in brown, consists of a beautifully drawn
prunus (*mei hua*) tree in blossom and hovering birds, beside a rockery and
smaller plants of bamboo, etc., set in a ground of mottled green. Ch'êng Hua
mark but K'ang Hsi period (1662–1722). *British Museum*. Height 16¾ inches.

PLATE 97. SQUARE VASE.
With pendulous body and high neck slightly expanding towards the top:
two handles in the form of archaic lizard-like dragons (*chih lung*), and a
pyramidal base. Porcelain painted with coloured enamels on the biscuit, with
scenes representing Immortals on a log raft approaching Mount P'êng-lai in
the Taoist Paradise. K'ang Hsi period (1662–1722). *British Museum.* Height
20½ inches.

PLATE 103. CLUB-SHAPED (*rouleau*) VASE.
Finely painted in *famille verte* enamels with panel designs in a ground of
chrysanthemum scrolls in iron red; brocade borders. Last part of the K'ang
Hsi period (1662–1722). *Salting Collection (Victoria and Albert Museum)*.
Height 17 inches.

PLATE 108. DISH PAINTED IN UNDERGLAZE BLUE AND *famille verte* ENAMELS.
In the centre, a five-clawed dragon rising from waves in pursuit of a pearl.
Deep border in "Imari" style with cloud-shaped compartments with chrysan-
themum and prunus designs in a blue ground, separated by close lotus
scrolls reserved in an iron red ground in which are three book symbols.
K'ang Hsi period (1662–1722) . *Alexander Collection*. Diameter 19½ inches.

Fig. 1.

Fig. 2.

PLATE 110. Two Examples of "Powder Blue" (ch'ui ch'ing) Porcelain of the K'ang Hsi Period (1662–1722), in the Victoria and Albert Museum.
Fig. 1. Bottle of gourd shape with slender neck: powder blue ground with gilt designs from the Hundred Antiques (po ku) and borders of ju-i pattern, formal flowers and plantain leaves. Height 7½ inches.
Fig. 2. Bottle-shaped vase with famille verte panels of rockwork and flowers reserved in a powder blue ground. Salting Collection. Height 7 inches.

FIG. 2.

PLATE 111. TWO EXAMPLES OF SINGLE-COLOUR PORCELAIN IN THE SALTING COLLECTION (VICTORIA AND ALBERT MUSEUM).

FIG. 1. Bottle-shaped vase of porcelain with landscape design lightly engraved in relief under a turquoise blue glaze. Early eighteenth century. Height 8½ inches.

FIG. 2. Water vessel for the writing table of the form known as *T'ai-po tsun* after the poet Li T'ai-po. Porcelain with faintly engraved dragon medallions under a peach bloom glaze; the neck cut down and fitted with a metal collar. Mark in blue of the K'ang Hsi period (1662–1722) in six characters. Height 2¾ inches.

FIG. 1.

PLATE 115. VASE OF BALUSTER FORM.
With ornament in white slip and underglaze red and blue in a celadon green
ground: rockery and birds on a flowering prunus tree. Yung Chêng period
(1723–1735) . *Alexander Collection.* Height 15½ inches.

PLATE 120. COVERED JAR OR *potiche* PAINTED IN *famille rose* OR "FOREIGN COL-OURS" (*yang ts'ai*) WITH BASKETS OF FLOWERS.

Deep borders of ruby red enamel broken by small panels and floral designs. On the cover is a lion coloured with enamels on the biscuit. From a set of five vases and beakers in the collection of Lady Wantage. Late Yung Chêng period (1723–1735). Height 34 inches.

FIG. 2.

FIG. 3.

PLATE 123. EIGHTEENTH CENTURY GLAZES.

FIG. 1. Square vase with tubular handles, and apricot-shaped medallions on front and back. *Flambé* red glaze. Ch'ien Lung period (1736–1795). *British Museum.* Height 6¾ inches. FIG. 2. Bottle-shaped vase with deep blue (*ta ch'ing*) glaze: unglazed base. Early eighteenth century. *British Museum.* Height 15¾ inches. FIG. 3. Vase with fine iron red enamel (*mo hung*) on the exterior. Ch'ien Lung period (1736–1795). *Salting Collection (Victoria and Albert Museum).* Height 5 inches.

PLATE 130. VASE WITH PEAR-SHAPED BODY AND WIDE MOUTH; TUBULAR HANDLES.
Porcelain with delicate *clair de lune* glaze recalling the pale blue tint of some
of the finer Sung celadons. About 1800. *British Museum.* Height 7¾ inches.

examples of these bowls will be discussed later. They are characterised by a convexity in the centre which cannot be shown in reproductions.

The secret decoration (*an hua*) consists of designs faintly traced usually with a sharp-pointed instrument in the body and under the glaze. There is an excellent example of this in a high-footed cup in the Franks Collection which has the Hsüan Tê mark, the usual faintly greenish glaze, beneath which is a delicately etched lotus scroll so fine that it might easily be overlooked and is quite impossible to reproduce by photographic methods. It is, no doubt, an early eighteenth-century copy of Hsüan ware.

The one exception mentioned above is the type represented by the "barrel-shaped seats." The description of these leaves no room for doubt that they belonged to a fairly familiar class of Ming ware, whose strength and solidity has preserved it in considerable quantity where the more delicate porcelains have disappeared. Plate 62 gives a good idea of the Ming barrel-shaped garden seat, "with solid ground filled in with colours in engraved floral designs." The other kind, "with openwork ground, the designs filled in with colours (*wu ts'ai*), gorgeous as cloud brocades," must have been in the style of Plate 61. These styles of decoration are more familiar to us on potiche-shaped wine jars and high-shouldered vases than on garden seats, but the type is one and the same. Quite a series of these vessels was exhibited at the Burlington Fine Arts Club in 1910, and they are fully described in the catalogue. Some had an outer casing in openwork ; others had the designs outlined in raised threads of clay, which contained the colours like the ribbons of cloisonné enamel[1] ; in others, again, the patterns were incised with a point. The common feature of all of them was that the details of the pattern were defined by some emphatic method of outlining which served at the same time to limit the flow of the colours. The colours themselves consist of glazes containing a considerable proportion of lead, and tinted in the usual fashion with metallic oxides. They include a deep violet blue (sometimes varying to black or brown), leaf green, tur-

[1] On the parallelism between this type of porcelain decoration and cloisonné enamel, see *Burlington Magazine*, September, 1912, p. 320. It is worthy of note that missing parts of these vases, such as neck rim or handles, are often replaced by cloisonné enamel on metal, which is so like the surrounding porcelain that the repairs are often overlooked.

quoise, yellow,[1] and a colourless glaze or a white slip which served as white colour, though at times the white was represented merely by leaving the unglazed body or biscuit to appear. These coloured glazes differ from the on-glaze painted enamels in that they are applied direct to the body of the ware, and are fired at a relatively high temperature in the cooler parts of the great kiln, a circumstance expressed by the French in the concise phrase, *couleurs de demi-grand feu*.[2]

The central ornament consisted chiefly of figures of sages or deities in rocky landscape, or seated under pine trees amid clouds, dragons in clouds, or beautiful lotus designs; and these were contained by various borders, such as floral scrolls, gadroons, *ju-i* head patterns, fungus scrolls, and symbols hanging in jewelled pendants. As a rule, the larger areas of these vases are invested with a ground colour and the design filled in with contrasting tints. Sometimes the scheme of decoration includes several bands of ornament, and in this case—as on Plate 62—more than one ground colour is used. The *Po wu yao lan* speaks of green (*ch'ing*) and dark blue (*lan*) grounds, and existing specimens indicate that the dark violet blue was the commonest ground colour. Next to this, turquoise blue is the most frequently seen ; but besides these there is a dark variety of the violet which is almost black, and another which is dark brown, both of which colours are based on cobaltiferous oxide of manganese. It has already been observed that this type of decoration was frequently used on a pottery body as well as on porcelain.

The question of the antiquity of the above method of polychrome decoration is complicated by the contradictory accounts which Dr. Bushell has given of a very celebrated example, the statuette of the goddess Kuan-yin in the temple named Pao kuo ssŭ at Peking. The following reference to this image occurs in the *T'ung ya*, published in the reign of Ch'ung Chêng (1625–1643): " The Chün Chou transmutation wares (*yao pien*) are not uncommon to-day. The Kuan-yin in the Pao kuo ssŭ is a *yao pien*." Dr.

[1] The yellow of this group is usually of a dull, impure tint, but there is a small jar in the Peters Collection in New York on which the yellow is exceptionally pure and brilliant, and almost of lemon colour.

[2] In these cases the porcelain would be first fired without glaze and the colours added when it was in what is called the " biscuit " state. In the blue and white ware, on the other hand, and the bulk of Chinese glazed porcelain, body and glaze were baked together in one firing.

Bushell, who visited the temple several times, gives a minute description of the image, which contains the following passage [1]: "The figure is loosely wrapped in flowing drapery of purest and bluest turquoise tint, with the wide sleeves of the robe bordered with black and turned back in front to show the yellow lining; the upper part of the cloak is extended up behind over the head in the form of a plaited hood, which is also lined with canary yellow." To the ordinary reader, such a description would be conclusive. A fine example of Ming porcelain, he would say, decorated with the typical coloured glazes on the biscuit. Bushell's comment, however, is that the "colours are of the same type as those of the finest flower pots and saucers of the Chün Chou porcelain of the Sung dynasty." It should be said that the temple bonzes insist that they can trace the origin of the image back to the thirteenth century. If these are indeed the typical Chün Chou glazes, then all our previous information on that factory, including Bushell's own contributions, is worthless. In another work,[2] however, the same writer states that it (the image in question) is "really enamelled in 'five colours'—turquoise, yellow, crimson, red brown and black." This is precisely what we should have expected, and it can only be imagined that Bushell in the other passage was influenced by the statement in the *T'ung ya* that it was a furnace transmutation piece, a statement probably based on the superstition that it was a miraculous likeness of the goddess, who herself descended into the kiln and moulded its features. As to the other temple tradition, that it was made in the thirteenth century, it is not necessary to take that any more seriously than the myth concerning its miraculous origin, which derives from the same source.

It is hardly necessary to state that all the existing specimens of this class (and they are fairly numerous) do not belong to the Hsüan Tê period. Indeed, it is unlikely that more than a very small percentage of them were made in this short reign. Whether the style survived the Ming dynasty is an open question; but it is safe to assume that it was largely used in the sixteenth century.

The discussion of this group of polychrome porcelain leads naturally to the vexed question of the introduction of enamel painting over the glaze. By the latter I mean the painting of

[1] Bushell, *O. C. A.*, p. 152. [2] Translation of the *T'ao shuo*, op. cit., p. 51.

designs on the finished white glaze in vitrifiable enamels, which were subsequently fixed in the gentle heat of the muffle kiln (*lu*)— *couleurs de petit feu*, as the French have named them. No help can be got from the phraseology of the Chinese, for they use *wu ts'ai* or *wu sê* (lit. five colours) indifferently for all kinds of polychrome decoration, regardless of the number of colours involved or the mode of application. There is, however, no room for doubt that the delicate enamel painting, for which the reign of Ch'êng Hua (1465–1487) was celebrated, was executed with the brush over the fired glaze. It is inconceivable that the small, eggshell wine cups with peony flowers and a hen and chicken " instinct with life and movement " could have been limned by any other method. If this is the case, then what could the Chinese writers mean when they contrasted the *wu ts'ai* ornament of the Hsüan Tê and Ch'êng Hua periods, but that the same process of painting was in use in both reigns ? The Ch'êng Hua colours were more artistic because they were thin and delicately graded, while the Hsüan Tê *wu ts'ai* were too thickly applied.[1] For this reason, if for no other, we may rightly infer that painting in on-glaze enamels was practised in the Hsüan Tê period, if, indeed, it had not been long in use.[2]

There is another and an intermediate method of polychrome decoration in which the low-fired enamels (*de petit feu*) are applied direct to the biscuit, as in the case of the *demi-grand feu* colours, but with the difference that they are fixed in the muffle kiln. This method was much employed on the late Ming and early Ch'ing porcelains, and it will be discussed later ; but it is mentioned here because there are several apparent examples of it in Hsiang's Album, one [3] of which is dated Hsüan Tê. The example in question is a model of the celebrated Nanking pagoda, and it is described as *wu ts'ai*, the structure being white, the roofs green, the rails red, and the doors yellow, while the date is painted in blue. I have hesitated to assume that this is intended to represent an on-glaze painted piece, though there is much in the description to indicate such a conclusion ; but it is certainly either this or a

[1] This is the verdict of the *Po wu yao lan*, and it is repeated in the *T'ao lu*, see Bushell, op. cit., p. 60.

[2] Painted decoration is mentioned in Chiang's Memoir of the Yüan dynasty (see vol. i, p. 160), but without any particulars ; and the *Ko ku yao lun* speaks of *wu sê* decoration of a coarse kind at the end of the Yüan period (see vol. i, p. 161). The latter may, of course, refer to the use of coloured glazes.

[3] Op. cit., fig. 77.

member of the class under discussion, viz. decorated in enamels of the muffle kiln applied to the biscuit.[1] In either case it proves the knowledge of vitrifiable enamels at this period to all who accept the evidence of Hsiang's Album.

Examples of Hsüan Tê polychrome porcelain enumerated in the *T'ao shuo* included wine pots in the form of peaches, pomegranates, double gourds, a pair of mandarin ducks and geese ; washing dishes (for brushes) of " gong-shaped outline," with moulded fish and water-weeds, with sunflowers and with lizards ; and lamp brackets, " rain-lamps," vessels for holding bird's food, and cricket[2] pots (see vol. i, p. 188).

Specimens of on-glaze painted porcelain with the Hsüan Tê mark are common enough, but I have not yet seen one which could be accepted without reserve. Perhaps the nearest to the period is a specimen in the Franks Collection, a box made of the lower part of a square vase which had been broken and cut down. It was fitted with a finely designed bronze cover in Japan, and it is strongly painted in underglaze blue and the usual green, yellow, red and purple on-glaze enamels. The mark is in a fine dark blue, and the porcelain has all the character of a Ming specimen.

There is, in the same collection, a dish of a different type, but with the Hsüan Tê mark in Mohammedan blue and other evidences of Ming origin. The glaze is of a faintly greenish white and of considerable thickness and lustre, and the design consists of lotus scrolls in gold. Painting in gold in the Hsüan Tê period is mentioned in the *T'ao shuo*[3] in connection with the pots for holding the fighting crickets alluded to above.

[1] The application of these enamels in large washes puts them practically in the category of glazes, but for the sake of clearness it is best to keep the terminology distinct. After all, the difference between a high-fired glaze which is applied to the biscuit and a low-fired enamel applied in the same way is only one of degree, but if we use the term enamel or enamel-glaze for the colours fired in the muffle kiln as distinct from those fired in the porcelain kiln, it will save further explanations.

[2] A late Ming writer quoted in the *T'ao lu* (bk. viii., fol. 18) says, " At the present day Hsüan ware cricket pots are still very greatly treasured. Their price is not less than that of Hsüan Ho pots of the Sung dynasty."

[3] Bushell, op. cit., p. 140.

CHAPTER III

CH'ÊNG HUA 成花 (1465–1487) AND OTHER REIGNS

THE Ch'êng Hua porcelain shares with that of the Hsüan Tê period the honours of the Ming dynasty, and Chinese writers are divided on the relative merits of the two. Unfortunately, no material remains on which we might base a verdict of our own, but we may safely accept the summing up which the *Po wu yao lan*, the premier authority on early Ming wares, gives as follows [1] : " In my opinion, the blue and white porcelain of the Ch'êng Hua period does not equal that of the Hsüan Tê, while the polychrome of the Hsüan period does not equal that of the ' model [2] emperor's ' reign. The reason is that the blue of the Hsüan ware was *su-ni-p'o* [3] blue, whereas afterward it was all exhausted, and in the Ch'êng Hua period only the ordinary blue was used. On the other hand, the polychrome (*wu ts'ai*) decoration on the Hsüan ware was deep and thick, heaped and piled, and consequently not very beautiful ; while on the polychrome wares of the Ch'êng Hua period the colours used were thin and subdued, [4] and gave the impression of a picture." [5] Elsewhere we read that the Hsüan Tê porcelain was thick, the Ch'êng Hua thin, and that the blue of the Hsüan blue and white was pale, that of the Ch'êng Hua dark ; but on this latter point there are many differences of opinion, and among the wares made at the Imperial factory in the Yung Chêng period we are told that there were " copies of Ch'êng Hua porcelain with designs pencilled in pale blue (*tan ch'ing*)." [6]

The only types of Ch'êng Hua porcelain considered worthy of mention by Chinese writers are the polychrome, the blue and white,

[1] *Po wu yao lan*, bk. ii., fol. 9 verso.
[2] 憲 *hsien*. The emperor Ch'êng Hua was canonised as Hsien Tsung.
[3] See p. 12.
[4] 淺淡 *ch'ien tan*. The *T'ao shuo*, quoting this passage, uses a variant reading, *ch'ien shên* 深, which Bushell renders " whether light or dark."
[5] *yu hua i*, lit. " have the picture idea."
[6] See Bushell, *O. C. A.*, p. 385.

and the red monochrome, though doubtless the other methods of previous reigns were still used. Stress is laid on the excellence of the designs which were supplied by artists in the palace,[1] and on the fine quality of the colours used, and an interesting list of patterns is given in the *T'ao shuo*,[2] which includes the following :

1. Stem-cups (*pa pei*), with high foot, flattened bowl, and spreading mouth ; decorated in colours with a grape-vine pattern.

" Among the highest class of Ch'êng Hua porcelain these are unsurpassed, and in workmanship they far excel the Hsüan Tê cups." Such is the verdict of the *Po wu yao lan*, but they are only known to us by later imitations.

A poor illustration of one of these is given in Hsiang's Album,[3] and we are told in the accompanying text that the glaze is *fên pai*, " white like rice powder," while the decoration, a band of oblique vine clusters and tendrils, is merely described as *wu ts'ai* (polychrome), but it is obviously too slight to be executed by any other method than painting with enamels on the glaze. The price paid for this cup is stated as one hundred taels (or ounces) of silver.

2. Chicken cups (*chi kang*), shaped like the flat-bottomed, steep-sided, and wide-mouthed fish bowls (*kang*), and painted in colours with a hen and chickens beneath a flowering plant.

A valuable commentary on Ch'êng Hua porcelains is given by a late seventeenth-century writer in notes appended to various odes (e.g. on a " chicken cup " and on a Chün Chou vase). The writer is Kao Tan-jên, who also called himself Kao Chiang-ts'un, the name appended to a long dissertation on a Yüan dynasty silver wine cup, which now belongs to Sir Robert Biddulph and was figured in the *Burlington Magazine*.[4] " Ch'êng Hua wine cups," he tells us, " include a great variety of sorts. All are of clever workmanship and decoration, and are delicately coloured in dark and light shades. The porcelain is lustrous and clear, but strong. The chicken cups are painted with a *mu tan* peony, and below it a hen and chicken, which seem to live and move." Another writer [5] of the same period states that he frequented the fair at the *Tz'ŭ-*

[1] See Hsiang's Album, op. cit., fig. 38.
[2] Bk. vi., fols. 7-9, and Bushell's translation, op. cit., pp. 141-3.
[3] Op. cit., fig. 55.
[4] *Burlington Magazine*, December, 1912, pp. 153-8.
[5] The author of the *P'u shu t'ing chi* (*Memoirs of the Pavilion for Sunning Books*), quoted in the *T'ao shuo*, loc. cit.

ḯên temple in the capital, where porcelain bowls were exhibited, and rich men came to buy. For Wan Li porcelain the usual price was a few taels of silver; for Hsüan Tê and Ch'êng Hua marked specimens two to five times that amount; but "chicken cups" could not be bought for less than a hundred taels, and yet those who had the means did not hesitate to buy, and porcelain realised higher prices than jade.

An illustration in Hsiang's Album [1] gives a poor idea of one of these porcelain gems, which is described as having the sides thin as a cicada's wing, and so translucent that the fingernail could be seen through them. The design, a hen and chicken beside a cock's-comb plant growing near a rock, is said to have been in the style of a celebrated Sung artist. The painting is in " applied colours (*fu sê*), thick and thin," and apparently yellow, green, aubergine and brown. Like that of the grape-vine cup, it is evidently in enamels on the glaze.

3. Ruby red bowls (*pao shao wan*)[2] and cinnabar red dishes (*chu sha p'an*). These were, no doubt, the same as the " precious stone red (*pao shih hung*) and cinnabar bowls red as the sun," described in the chapter on Hsüan Tê porcelain. Kao Chiang-ts'un remarks on these that " among the Ch'êng wares are chicken cups, ruby red bowls, and cinnabar dishes, very cleverly made, and fine, and more costly than Sung porcelain."

4. Wine cups with figure subjects and lotuses.

5. " Blue and white " (*ch'ing hua*) wine cups, thin as paper.

6. Small cups with plants and insects (*ts'ao ch'ung*).[3]

7. Shallow cups with the five sacrificial altar vessels (*wu kung yang*).

8. Small plates for chopsticks, painted in colours.

9. Incense boxes.

10. All manner of small jars.

All these varieties are mentioned in the *Po wu yao lan*, which gives the place of honour to the grape-vine stem-cups. The only kind specifically described as blue and white is No. 5, and the inference is that the other types were usually polychrome.

[1] Op. cit., fig. 64.

[2] Bushell (*T'ao shuo*, p. 142) gives the misleading version, " bowls enamelled with jewels " and " jewel-enamelled bowls," omitting in his translation the note in the text which explains their true meaning as *pao shih hung* or ruby red.

[3] 草虫 *ts'ao ch'ung* can equally well mean " plants and insects " or " grass insects," i.e. grasshoppers. In fact, Julien translated the phrase in the latter sense.

Plate 63.—Baluster Vase

With designs in raised outline, filled in with coloured glazes on the
biscuit ; dark violet blue background. About 1500. Height 14¾ inches.
Grandidier Collection (Louvre).

Fig. 1

Fig. 2

Fig. 3

Plate 64.—Fifteenth-century Polychrome Porcelain.

Fig. 1.—Vase with grey crackle and peony scrolls in blue and enamels. Ch'ēng Hua mark. Height 16¼ inches. *British Museum.* Fig. 2.—Vase with turquoise ground and bands of floral pattern and winged dragons incised in outline and coloured green, yellow and aubergine. Height 22 inches. *S. E. Kennedy Collection.* Fig. 3.—Box with bands of *ju-i* clouds and pierced floral scrolls ; turquoise and yellow glazes in dark blue ground. Diameter 10 inches. *Grandidier Collection.*

Fig. 1

Fig. 2

Fig. 3

Plate 65.—Ming *san ts'ai* Porcelain.

Fig. 1.—Vase with winged dragons, *san ts'ai* glazes on the biscuit, dark blue ground. Dedicatory inscription on the neck, including the words "Ming dynasty," Cloisonné handles. Height 22¼ inches. *S. E. Kennedy Collection.* Fig. 2.—Figure of Kuan-yin, turquoise, green and aubergine glazes, dark blue rockwork. Fifteenth century. Height 28 inches. *Grandidier Collection.* Fig. 3.—Vase with lotus scrolls, transparent glazes in three colours. Late Ming. Height 20 inches. *Grandidier Collection.*

The following designs are enumerated and explained by **Kao Chiang-ts'un** in the valuable commentary which has already been mentioned :—

11. Wine cups with the design known as " the high-flaming candle lighting up red beauty," explained as a beautiful damsel holding a candle to light up *hai-t'ang* (cherry apple) blossoms.

12. Brocade heap pattern[1] ; explained as " sprays of flowers and fruit massed (*tui*) on all sides." [2]

13. Cups with swings, with dragon boats, with famous scholars and with children.

The swings, we are told, represent men and women[3] playing with swings (*ch'iu ch'ien*) : the dragon boats represent the dragon boat races[4] ; the famous scholar (*kao shih*) cups have on one side Chou Mao-shu, lover of the lotus, and on the other T'ao Yüanming sitting before a chrysanthemum plant ; the children (*wa wa*) consist of five small children playing together.[5]

14. Cups with grape-vines on a trellis, fragrant plants, fish and weeds, gourds, aubergine fruit, the Eight Buddhist Emblems (*pa chi hsiang*), *yu po lo* flowers, and Indian lotus (*hsi fan lien*) designs.

None of these need explanation except the Buddhist Emblems, which are described on p. 298, and the *yu po lo*, which is generally explained as a transcription of the Sanskrit *utpala*, " the dark blue lotus."

Though the reader will probably not have the opportunity of identifying these designs on Ch'êng Hua porcelain, they will help him in the description of later wares on which these same motives not infrequently occur. The nine illustrations[6] of Ch'êng Hua porcelain in Hsiang's Album, for the most part feebly drawn and badly coloured, form an absurd commentary on the glowing descrip-

[1] *Chin hui tui*, lit. brocade ash-heaps.

[2] Not as Bushell (*T'ao shuo*, op. cit., p. 143), " medallions of flower sprays and fruits painted on the four sides"; *ssŭ mien* (lit. four sides) being a common phrase for " on all sides " does not necessarily imply a quadrangular object.

[3] *Shih nü*, strangely rendered by Bushell " a party of young girls."

[4] The dragon boats raced on the rivers and were carried in procession through the streets on the festival of the fifth day of the fifth month. See J. J. M. de Groot, *Annales du Musée Guimet*, vol. xi., p. 346. A design of children playing at dragon boat processions is occasionally seen in later porcelain decoration.

[5] Cf. the favourite design of children under a pine-tree on Japanese Hirado porcelain.

[6] Op. cit., figs. 38, 49, 55, 56, 63, 64, 65, 66 and 76.

tions in the text. Their chief interest lies in their bearing on the question of polychrome painting. In some cases the designs have all the appearance of on-glaze enamels ; in others they suggest transparent glazes or enamels on the biscuit. The colours used are green, yellow and aubergine brown, the *san ts'ai* or " three colours," notwithstanding which the decoration is classed under the general term *wu ts'ai* (lit. five colours), or polychrome. The phrases used to describe the colouring include *wu ts'ai, fu sê, t'ien yu,* of which *fu sê*[1] means "applied colours," which might equally suggest on-glaze enamels or on-biscuit colours, and *t'ien yu*[2] decidedly suggests on-biscuit colouring. On the other hand, in one case[3] we are expressly told that the " colour of the glaze is lustrous white and the painting *upon it*[4] consists of geese, etc.," an unequivocal description of on-glaze painting.

Though the Ch'êng Hua mark is one of the commonest on Chinese porcelain, genuine examples of Ch'êng Hua porcelain are virtually unknown in Western collections. The Imperial wares of the period were rare and highly valued in China in the sixteenth century, and we can hardly hope to obtain them in Europe to-day ; but there must be many survivors from the wares produced by the private kilns at the time, and possibly some few examples are awaiting identification in our collections. Unfortunately, the promiscuous use of the mark on later wares, the confused accounts of the blue in the " blue and white," and the conflicting theories on the polychrome decoration, have all helped to render identifications difficult to make and easy to dispute. The covered cake box in the Bushell collection, figured by Cosmo Monkhouse[5] as a Ch'êng Hua specimen, is closely paralleled in make and style of decoration by a beaker-shaped brush pot in the Franks Collection.[6] Both are delicately pencilled in pale blue ; both have a peculiar brown staining in parts of the glaze and a slight warp in the foot rim. In the British Museum piece, however, the foot rim is grooved at the sides

[1] 數色. Bushell has translated it " diffused colours," but *fu* is also used for " applying externally " in the medicinal sense, which seems specially appropriate here.

[2] 填汕, lit. " fill up (with) glaze," the colour of the glaze being specified in each case. Cf. *lan ti t'ien hua wu ts'ai* (blue ground filled up with polychrome painting), a phrase used to describe the decoration of the barrel-shaped garden seats of the Hsüan Tê period. See p. 17.

[3] Fig. 63, a cup in form like the chicken cups (*chi kang*).

[4] 其上 *ch'i shang*.

[5] Op. cit., Plate ii.

[6] See E. Dillon, *Porcelain*, Plate xviii.

to fit a wooden stand, a feature which was not usual before the K'ang Hsi period, and something in the style of the drawing is rather suggestive of Japanese work. There is, however, another specimen in the Franks Collection[1] which is certainly Chinese of the Ming dynasty, and possibly of the Ch'êng Hua period, of which it bears the mark. It is a vase of baluster form, thick and strongly built, with great weight of clay at the foot, and unfortunately, like so many of the early polychrome vases which have come from China in recent years, it is cut down at the neck. It has a greyish crackled glaze, painted with a floral scroll design, outlined in brown black pigment and washed in with leaf green, yellow, manganese purple and bluish green enamels, which are supplemented by a little underglaze blue, and the mark is in four characters in blue in a sunk panel under the base.

Though too clumsy to belong to any of the groups of Imperial wares described in the *Po wu yao lan*, this vase is certainly an old piece, and possibly the production of one of the private factories of the Ch'êng Hua period. In the Eumorfopoulos and Benson Collections [2] there are a few examples of these massive-footed vases, most of them unfortunately incomplete above, decorated in polychrome glazes with engraved or relief-edged designs, but not, as a rule, in on-glaze enamels. These are clearly among our earliest examples of polychrome porcelain, and we should expect to find here, if anywhere, specimens of the coloured porcelain of the fifteenth century. See Plate 64.

Though the fifteenth century was distinguished by two brilliant periods, there are considerable gaps in the ceramic annals of the time. The reign of the Emperor Chêng T'ung,[3] who succeeded to the throne in 1436, was troubled by wars, and in his first year the directorate of the Imperial factory was abolished ; and, as soldiers had to be levied, relief was given by stopping the manufacture of porcelain for the palace. In 1449 this emperor was actually taken captive by the Mongols, and his brother, who took his place from 1450 to 1456 under the title of Ching T'ai,[4] reduced the customary supplies of palace wares in 1454 by one third. The reign of Ching T'ai is celebrated for cloisonné enamel on metal.

[1] See E. Dillon, *Porcelain*, Plate vii.
[2] See *Cat., B. F. A.*, 1910, H 21, I 7.
[3] 正統. [4] 景泰.

In 1457, when Chêng T'ung was released and returned to the throne under the title of T'ien Shun[1] (1457–1464), the Imperial factory was re-established, and the care of it again entrusted to a palace eunuch. There are no records, however, of the wares made in these periods, though we may assume that the private factories continued in operation even when work at the Imperial pottery was suspended. The directorship was again abolished in 1486, and porcelain is not mentioned in the official records until the end of the reign of Hung Chih[2] (1488–1505).

In Hsiang's Album[3] we are told that the pale yellow of the Hung Chih period was highly prized, and that the polychrome wares vied with those of the reign of Ch'êng Hua. Four examples are given : an incense burner, a cup moulded in sunflower design, and a spirit jar (all yellow), besides a gourd-shaped wine pot with yellow ground and accessories in green and brown, apparently coloured glazes or enamels applied to the biscuit. The yellow glazes are described as pale yellow (*chiao*[4] *huang*), and likened to the colour of steamed chestnuts (*chêng li*[5]) or the sunflower (*k'uei hua*[6]).

The yellow colour is of old standing in Chinese ceramics. We have found it on T'ang pottery, in the *mi sê* of the Sung period, in the blackish yellow of the Yüan ware made at Hu-t'ien, and in the early Ming porcelains. Peroxide of iron or antimony are the usual metallic bases of the colour, and it was used either in high-fired glazes or in enamels of the muffle stove. The yellow for which the Hung Chih period was noted was a yellow glaze, applied direct to the biscuit, or added as an overglaze to the ordinary white porcelain. When applied to the biscuit it assumes a fuller and browner tint than when backed by a white glaze. These yellow glazes often have a slightly mottled or stippled look, the colour appearing as minute particles of yellow held in suspension in the glaze.

Marked examples, purporting to be Hung Chih yellow, are occasionally seen, but the most convincing specimen is a saucer dish in the Victoria and Albert Museum, of good quality porcelain, with a soft rich yellow glaze and the Hung Chih mark under the base in blue. Part of its existence was spent in Persia, where it was

[1] 天順.
[2] 弘治.
[3] Op. cit., No. 42.

[4] 嬌, delicate, beautiful.
[5] 蒸栗.
[6] 葵花.

inscribed in Arabic with the date 1021 A.H., which corresponds to 1611 A.D.

A beautiful seated figure of the goddess Kuan-yin in the Pierpont Morgan Collection, not unlike Plate 65, Fig. 2, but smaller, is decorated with yellow, green and aubergine glazes on the biscuit, and bears a date in the Hung Chih period which corresponds to 1502.

A dish of fine white porcelain with the Hung Chih mark is in the British Museum, and examples of the blue and white of the period may be seen in the celebrated Trenchard bowls. These last are the earliest known arrivals in the way of Chinese porcelain in this country, and they were given by Philip of Austria, King of Castile, to Sir Thomas Trenchard in 1506. One of them is illustrated in Gulland's *Chinese Porcelain*,[1] with a description written by Mr. Winthrop after a personal inspection. The decoration consists of floral scrolls outside and a fish medallion surrounded by four fishes inside. The account of the colour, however, is not very flattering : " One of the bowls bore this decoration very distinctly traced in blackish cobalt, while the other bowl had a very washed-out and faded appearance." The ware itself is described as " rather greyish." Probably these bowls were made for the export trade, and need not necessarily be regarded as typical of the Hung Chih blue and white.

Chêng Tê 正德 (1506–1521)

The reign of Chêng Tê, though not mentioned in the *Po wu yao lan* and but briefly noticed in the *T'ao shuo*, must have been an important period in the history of Chinese porcelain. The *yü ch'i ch'ang* (Imperial ware factory) was rebuilt [2] and the direct supervision of a palace eunuch renewed. The porcelain, we are told in the *T'ao lu*, was chiefly blue painted and polychrome, the finest being in the underglaze red known as *chi hung*. An important factor in the blue decoration was the arrival of fresh supplies of the Mohammedan blue.[3] The story is that the governor of Yunnan obtained a supply of this *hui ch'ing* from a foreign country, and that it was used at first melted down with stone for making imitation jewels. It was worth twice its weight in gold. When, however. it was found that it would endure the heat of the kiln, orders were

[1] Vol. ii., p. 277. [2] See vol. i, p. 154. [3] See p. 12.

given for its use in porcelain decoration, and its colour was found to be " antique and splendid." Hence the great esteem in which the blue and white of the period was held.[1] The merit of this new Mohammedan blue was its deep colour, and the choicest kind was known as "Buddha's head blue" (*Fo t'ou ch'ing*). Its use at this period was not confined to the Imperial factory, for we read that the workmen stole it and sold it to the private manufacturers. In the following reign a method of weighing the material was instituted, which put an end to this pilfering.

Some account has already been given[2] of this material and its use in combination with the commoner native mineral blue. It was, no doubt, the blue used on Persian, Syrian and Egyptian pottery of the period exported by the Arab traders. One of the oldest routes[3] followed by Western traders with China was by river (probably the Irrawady) from the coast of Pegu, reaching Yung-ch'ang, in Yunnan, and so into China proper. This will explain the opportunities enjoyed by the viceroy of Yunnan. There were, of course, other lines of communication between China and Western Asia by sea and land, and a considerable interchange of ideas had passed between China and Persia for several centuries, so that reflex influences are traceable in the pottery of both countries. Painting in still black under a turquoise blue glaze is one of the oldest Persian methods of ceramic decoration, and we have seen that it was closely paralleled on the Tz'ŭ Chou wares (vol. i, p. 103).

It is related that a thousand Chinese artificers were transplanted to Persia by Hulagu Khan (1253–1264), and it is probable that they included potters. At any rate, the Chinese dragon and phœnix appear on the Persian lustred tiles of the fourteenth century. At a later date Shah Abbas (1585–1627) settled some Chinese potters in Ispahan. Meanwhile, quantities of Chinese porcelain had been traded in the Near East, where it was closely copied by the Persian, Syrian and Egyptian potters in the sixteenth century. The Persian pottery and soft porcelain of this time so closely imitates the Chinese blue and white that in some cases a very minute inspection is required to detect the difference, and nothing is commoner than to find Persian ware

[1] This account is quoted from the *Shih wu kan chu*, published in 1591.
[2] See p. 12.
[3] See Hirth, *China and the Roman Orient*, p. 179.

of this type straying into collections of Chinese porcelain.[1] Conversely, the Persian taste is strongly reflected in some of the Chinese decorations, not only where it is directly studied on the wares destined for export to Persia, but in the floral scrolls on the Imperial wares of the Ming period. The expressions *hui hui hua* (Mohammedan ornament or flowers) and *hui hui wên* (Mohammedan designs) occur in the descriptions of the porcelain forwarded to the palace, and there can be little doubt that they refer to floral arabesque designs in a broad sense, though it would, of course, be possible to narrow the meaning to the medallions of Arabic writing not infrequently seen on Chinese porcelain, which was apparently made for the use of some of the numerous Mohammedans in China.

An interesting series of this last-mentioned type is exhibited in the British Museum along with a number of bronzes similarly ornamented. Many of these are of early date, and five of the porcelains bear the Chêng Tê mark and unquestionably belong to that period. These comprise a pair of vases with spherical tops which are hollow and pierced with five holes, in form resembling the peculiar Chinese hat stands ; the lower part of a cut-down vase, square in form ; an ink slab with cover, and a brush rest in the form of a conventional range of hills. The body in each case is a beautiful white material, though thickly constructed, and the glaze, which is thick and of a faint greenish tinge, has in three of these five pieces been affected by some accident of the firing, which has left its surface dull and shrivelled in places like wrinkled skin.[2] The designs are similar throughout—medallions with Arabic writing surrounded by formal lotus scrolls or cloud-scroll designs, strongly outlined and filled in with thin uneven washes of a beautiful soft Mohammedan blue. The glaze being thick and bubbly gives the brush strokes a hazy outline, and the blue shows that tendency to run in the firing which we are told was a peculiarity of the Moham-

[1] The converse is equally true, and Chinese porcelain of this kind is frequently classed among Persian wares. Indeed, there are not a few who would argue that these true porcelains of the hard-paste type were actually made in Persia. No evidence has been produced to support this wholly unnecessary theory beyond the facts which I have mentioned in this passage, and the debated specimens which I have had the opportunity to examine were all of a kind which no one trained in Chinese ceramics could possibly mistake for anything but Chinese porcelain.

[2] This peculiarity occurs on a tripod incense vase in the Eumorfopoulos Collection, which in other respects resembles this little group, but it is a peculiarity not confined to the Chêng Tê porcelain, for I have occasionally found it on much later wares.

medan blue if not sufficiently diluted with the native mineral cobalt. The inscriptions are mainly pious Moslem texts, but on the cover of the ink slab is the appropriate legend, " Strive for excellence in penmanship, for it is one of the keys of livelihood," and on the brush rest is the Persian word *Khāma-dān* (pen rest). In the same case are three cylindrical vases, apparently brush pots, decorated in the same style but unmarked. One has dark Mohammedan blue and probably belongs to the next reign. The other two, I venture to think, are earlier. They are both of the same type of ware, a fine white material, which takes a brownish red tinge in the exposed parts, and the glaze, which is thick and of a soft greenish tint, has a tendency to scale off at the edges. The bases are unglazed and show the marks of a circular support. The larger piece is remarkably thick in the wall, and has a light but vivid blue of the Mohammedan sort ; the smaller piece is not quite so stoutly proportioned, but the blue is peculiarly soft, deep, and beautiful, though it has run badly into the glaze, and where it has run it has changed to a dark indigo.[1] One would say that this is the Mohammedan blue, almost pure ; and if, as I have suggested, these two specimens are earlier types, they can only belong to the Hsüan Tê period.

Another blue and white example with Chêng Tê mark in the British Museum is of thinner make and finer grain ; but, as it is a saucer-dish, this refinement was only to be expected. It is painted in a fine bold style, worthy of the best Ming traditions, with dragons in lotus scrolls, but the blue is duller and greyer in tone than on the pieces just described.

Two specimens of Chêng Tê ware are figured in Hsiang's Album,[2] one a tripod libation cup of bronze form and the other a lamp supported by a tortoise, and the glaze of both is " deep yellow, like steamed chestnuts."

The Chêng Tê mark is far from common, but it occurs persistently on certain types of polychrome porcelain. One is a saucer-dish with carved dragon designs under a white glaze, the depressions of the carving and a few surrounding details being washed over with light green enamel. The design consists of a circular medallion

[1] A somewhat similar effect is seen on the little flask ascribed to the Hsüan Tê period. See p. 14.

[2] Op. cit., Nos. 52 and 80. These are the latest specimens which are given by Hsiang Yüan-p'ien.

Fig. 1

Fig. 2

Plate 66.—Porcelain with Chêng Tê mark.

Fig. 1.—Slop Bowl with full-face dragons holding *shou* characters, in under-glaze blue in a yellow enamel ground. Height 3½ inches. *British Museum.*

Fig. 2.—Vase with engraved cloud designs in transparent coloured glazes on the biscuit, green ground. Height 8⅛ inches. *Charteris Collection.*

Fig. 1

Fig. 2

Fig. 3

Fig. 4

Plate 67.—Blue and White Porcelain. Sixteenth Century.

Fig. 1.—Bowl with Hsüan Tê mark. Diameter 4 inches. *Dresden Collection.* Fig. 2.—Covered Bowl with fish design. *Dresden Collection.* Fig. 3.—Bottle, peasant on an ox. Height 8½ inches. *Eumorfopoulos Collection.* Fig. 4.—Bottle with lotus scrolls in mottled blue. Height 9 inches. *Alexander Collection.*

in the centre enclosing a dragon among clouds, and two dragons
on the outside, the space between them faintly etched with sea
waves. The ware is usually thin and refined. These dishes are
not uncommon, and it is difficult to imagine that they can all belong
to such an early period. On the other hand, one also meets with
copies of the same design with the Ch'ien Lung mark (1736–1795),
which display unmistakable difference in quality. Another type
has the same green dragon design with engraved outlines set in a
yellow ground, and in most cases its antiquity is open to the same
doubts. It is certain, however, that these pieces represent a style
which was in vogue in the Chêng Tê period. A small vase of this
kind was the only piece with the Chêng Tê mark in the exhibition
at the Burlington Fine Arts Club in 1910,[1] and it had the appear-
ance of a Ming specimen. A good example of this Chêng Tê poly-
chrome belonging to the Hon. Evan Charteris is illustrated in
Fig. 2 of Plate 66. It has the designs etched in outline, filled
in with transparent green, yellow and aubergine glazes, the three
colours or *san ts'ai* of the Chinese ; and the Chêng Tê mark is
seen on the neck.[2] And a square bowl in the British Museum,
similar in body and glaze to the blue and white specimens with
Arabic inscriptions, is painted in fine blue on the exterior with
dragons holding *Shou* (longevity) characters in their claws, the
background filled in with a rich transparent yellow enamel. This
piece (Plate 66, Fig. 1) has the mark of Chêng Tê in four characters
painted in Mohammedan blue, and is clearly a genuine specimen.

[1] *Cat.*, H 8. [2] A similar vase is in the Victoria and Albert Museum.

CHAPTER IV

CHIA CHING 嘉靖 (1522–1566) AND LUNG CH'ING 隆慶 (1567–1572)

THE Imperial potteries at Ching-tê Chên were busy in the long reign of Chia Ching, grandson of Ch'êng Hua, under the supervision of one of the prefects of the circuit who took charge in place of the palace eunuch of previous reigns. Chinese accounts of the porcelain of this important period, summarised in the *T'ao shuo*, include passages from the late Ming and therefore almost contemporary works, the *Shih wu kan chu* and the *Po wu yao lan*. In the former we are told that the Mohammedan blue was largely used, but that the material for the " fresh red " (*hsien hung*)[1] was exhausted, and that the method of producing the red colour was no longer the same as of old, the potters being capable only of making the overglaze iron red called *fan hung*. The *Po wu yao lan* gives a more intimate description of the ware, and the passage [2]—the last in that work on the subject of porcelain—may be rendered as follows :—

" Chia Ching porcelain includes blue-decorated and polychrome wares of every description ; but unfortunately the clay brought to the place from the neighbouring sources in Jao Chou gradually deteriorated, and when we compare these two classes of porcelain with the similar productions of the earlier periods of the dynasty the (Chia Ching) wares do not equal the latter. There are small white bowls (*ou*) inscribed inside with the character *ch'a* 茶 (tea), the character *chiu* 酒 (wine), or the characters *tsao t'ang* 棗湯 (decoction of dates), or *chiang t'ang* [3] 薑湯 (decoction of ginger);

[1] 鮮紅土 *hsien hung t'u*, lit. " the earth for the fresh red," an expression which would naturally refer to the *clay* used in making ware of this particular colour, though Bushell has preferred to take it in reference to the *mineral* used to produce the colour itself. See p. 123.

[2] Bk. ii., fol. 10.

[3] A Ming writer quoted in the *T'ao lu*, bk. viii., fol. 4, adds that these cups were marked under the base 金籙 *chin lu* (golden seal), 大醮 *ta chiao* (great sacrifice), 壇用 *t'an yung* (altar use).

these are the sacrificial altar vessels regularly used by the Emperor Shih Tsung (i.e. Chia Ching), and they are called white altar cups, though in form and material they are far from equalling the Hsüan Tê vessels. The Chia Ching shallow wine cups with rimmed mouth,[1] convex centre,[2] and foot with base rim,[3] decorated outside in three colours with fish design, and the small vermilion boxes, no bigger than a " cash," are the gems of the period. As for the small boxes beautifully painted with blue ornament, I fear that the Imperial factories of after times will not be able to produce the like. Those who have them prize them as gems."

A few supplementary comments in the *T'ao shuo* further inform us that the Mohammedan blue of the Chia Ching period was preferred very dark (in contrast with the pale blue of the Hsüan Tê porcelain), that it was very lovely, and that supplies of this blue arrived providentially at the time when the " fresh red " failed [4] ; and also that the supplies of earth from Ma-ts'ang were daily diminishing till they were nearly exhausted, and consequently the material of the ware was far from equalling that of the Hsüan Tê period. The *T'ao lu* adds practically nothing to the above statements.

Fortunately, there are still to be found a fair number of authentic specimens of Chia Ching porcelain, but before considering these in the light of the Chinese descriptions, it will be helpful as well as extremely interesting to glance at the lists of actual porcelain vessels supplied to the palace at this time. From the eighth year of this reign, the annual accounts of the palace porcelains have been preserved in the Annals of Fou-liang, from which they were copied in the provincial topographies. Two of these lists (for the years 1546 and 1554) are quoted by Bushell,[5] and a general summary of them is given in the *T'ao shuo*.[6] To quote them in full here would take too much space, but the following notes may be useful to the reader,

[1] *Ch'ing k'ou*, lit. mouth like a gong or sounding stone.

[2] *Man hsin*, lit. loaf-shaped centre.

[3] *Yüan tsu*, lit. foot with outer border.

[4] An extract from the *I Chih* (quoted in the *T'ao lu*, bk. viii., fol. 14) states that " in the 26th year of Chia Ching, the emperor demanded that vessels should be made with ' fresh red ' (*hsien hung*) decoration ; they were difficult to make successfully, and Hsü Chên of the Imperial Censorate, memorialised the throne, requesting that red from sulphate of iron (*fan hung*) be used instead." A memorial of similar tenor was sent to the emperor by Hsü Ch'ih in the succeeding reign.

[5] *O. C. A.*, pp. 223-6.

[6] Bk. vi., fols. 9-15. See also Bushell's translation op. cit., pp. 145-51, and *O. C. A.*, loc. cit.

who, with his knowledge of the later porcelains, should have no difficulty in reconstructing for himself the general appearance of the court wares of the time.

The actual objects [1] supplied consisted chiefly of fish bowls (*kang*), covered and uncovered jars (*kuan*), of which some were octagonal, bowls (*wan*), dinner bowls (*shan wan*) of larger size, saucer dishes (*tieh*) and round dishes (*p'an*), tea cups (*ch'a chung*), tea cups (*ou*), wine cups (*chiu chan*), and libation cups (*chüeh*) with hill-shaped saucers (*shan p'an*) to support their three feet, various vases (*p'ing*), slender ovoid jars for wine (*t'an*), ewers or wine pots (*hu p'ing*), and wine seas (*chiu hai*) or large bowls. A large number of complete dinner-table sets (*cho ch'i*) occur in one of the lists, and we learn from the *T'ao shuo* that uniform sets with the same pattern and colours throughout were an innovation of the Ming dynasty. A set [2] comprised 27 pieces, including 5 fruit dishes (*kuo tieh*), 5 food dishes (*ts'ai tieh*), 5 bowls (*wan*), 5 vegetable dishes (*yün tieh*), 3 tea cups (*ch'a chung*), 1 wine cup (*chiu chan*), 1 wine saucer (*chiu tieh*), 1 slop receptacle (*cha tou*), and 1 vinegar cruse (*ts'u chiu*). The slop receptacle appears to have been a square bowl used for the remnants of food (see Plate 66, Fig. 1).

The sacrificial vessels of the period included tazza-shaped bowls and dishes (*pien tou p'an*), large wine jars (*t'ai tsun*), with swelling body and monster masks for handles, " rhinoceros " jars (*hsi tsun*) in the form of a rhinoceros carrying a vase on its back, besides various dishes, plates, cups, and bowls of undefined form.

The decorations are grouped in six headings :—

(1) Blue and white (*ch'ing hua pai ti*, blue ornament on a white ground), which is by far the largest.

(2) Blue ware, which included blue bowls (*ch'ing wan*), sky-blue bowls (*t'ien ch'ing wan*), and turquoise bowls (*ts'ui ch'ing wan*). In some cases the ware is described as plain blue monochrome, and in one item it is " best blue monochrome " (*t'ou ch'ing su*), while in others there are designs engraved under the glaze (*an hua*). In others, again, ornament such as dragons and sea waves is mentioned without specifying how it was executed. Such ornament

[1] Some idea of the quantity supplied may be gathered from the following items in the list for the year 1546 : 300 fish bowls, 1,000 covered jars, 22,000 bowls, 31,000 round dishes (*p'an*), 18,400 wine cups.

[2] See Bushell, *O. C. A.*, p. 226.

may have been etched with a point in the blue surface,[1] or pencilled in darker blue on a blue background or reserved in white in a blue ground. Another kind is more fully described as " round dishes of pure blue (*shun ch'ing*) with dragons and sea waves inside, and on the exterior a background of dense cloud scrolls [2] with a gilt [3] decoration of three lions and dragons." Bushell[4] speaks of the " beautiful mottled blue ground for which this reign is also remarkable," and which, he says, was produced by the usual blend of Mohammedan and native blue suspended in water.

(3) Wares which were white inside and blue outside.

(4) White ware, plain [5] or with engraved designs under the glaze (*an hua*, lit. secret ornament).

(5) Ware with brown glaze in two varieties, *tzŭ chin* (golden brown), and *chin huang* (golden yellow), with dragon designs engraved under the glaze. These are the well-known lustrous brown glazes, the former of dark coffee brown shade, and the latter a light golden brown.

(6) Ware with mixed colours (*tsa sê*), which included bowls and dishes decorated in iron red [6] (*fan hung*) instead of the "fresh red " (*hsien hung*); others with emerald green colour (*ts'ui lü sê*); bowls with phœnixes and flowers of Paradise in yellow in a blue ground; cups with blue cloud and dragon designs in a yellow ground; boxes with dragon and phœnix designs engraved under a yellow glaze; dishes with design of a pair of dragons and clouds in yellow within a golden brown (*tzŭ chin*) ground; and globular bowls with embossed [7] ornament in a single-coloured ground.

To these types Bushell adds from other similar lists crackled ware (*sui ch'i*), tea cups of " greenish white porcelain " (*ch'ing pai tz'ŭ*), which seems to be a pale celadon, and large fish bowls with pea green (*tou ch'ing*) glaze.

The source of the designs of the porcelain is clearly indicated

[1] There are examples of this work in the British Museum, in which the blue seems to have been sponged on or washed on, and the decoration picked out with a needle-point, and then the whole covered with a colourless glaze.

[2] *hsiang yün*, lit. felicitous clouds.

[3] 貼金, *t'ieh chin*, lit. stuck-on gold.

[4] *O. C. A.*, p. 221.

[5] 甜白 *t'ien pai*, a phrase frequently used in this sense, though it is not quite obvious how it derives this meaning from its literal sense of " sweet white."

[6] See p. 34. The *fan hung* is an overglaze colour of coral tint, derived from oxide of iron ; the *hsien hung* is an underglaze red derived from oxide of copper.

[7] *jang hua*, lit. " abundant or luxuriant ornament." *Embossed* is Bushell's rendering.

in the following passage in the *T'ao shuo*[1]: " Porcelain enamelled in colours was painted in imitation of the fashion of brocaded silks, and we have consequently the names of blue ground, yellow ground, and brown gold (*tzŭ chin*) ground. The designs used to decorate it were also similar, and included dragons in motion (*tsou lung*), clouds and phœnixes, *ch'i-lin*, lions, mandarin ducks, myriads of gold pieces, dragon medallions (*p'an lung*, lit. coiled dragons), pairs of phœnixes, peacocks, sacred storks, the fungus of longevity, the large lion in his lair, wild geese in clouds with their double nests, large crested waves, phœnixes in the clouds, the son-producing lily, the hundred flowers, phœnixes flying through flowers, the band of Eight Taoist Immortals, dragons pursuing pearls, lions playing with embroid- ered balls, water weeds, and sporting fishes. These are the names of ancient brocades, all of which the potters have reproduced more or less accurately in the designs and colouring of their porcelain."

The following analysis of the designs named in the Chia Ching lists will show that the blue and white painters of the period took their inspiration from the same source :—

Floral Motives.

Celestial flowers (*t'ien hua*), supporting the characters *shou shan fu hai* 壽山福海, "longevity of the hills and happiness (in- exhaustible as) the sea."

Flowers of the four seasons (the tree peony for spring, lotus for summer, chrysanthemum for autumn, and prunus for winter).

Flowering and other plants (*hua ts'ao*).

The myriad-flowering wistaria (*wan hua t'êng*).

The water chestnut (*ling*).

The pine, bamboo, and plum.

Floral medallions (*t'uan hua*).

Indian lotus (*hsi fan lien*).

Knots of lotus (*chieh tzŭ lien*[2]).

Interlacing sprays of lotus supporting the Eight Precious Sym- bols or the Eight Buddhist Emblems.[3]

Branches of *ling chih*[4] fungus supporting the Eight Precious Symbols.

[1] See Bushell's translation, op. cit., p. 151.

[2] 結子蓮.

[3] See p. 298.

[4] 靈芝 *ling chih*, a species of agaric, at first regarded as an emblem of good luck, and afterwards as a Taoist emblem of immortality.

Ling chih fungus and season flowers.

Lotus flowers, fishes, and water weeds.

Floral arabesques (*hui hui hua*).

Flowers of Paradise (*pao hsiang hua*) 寶相花.

The celestial flowers and the flowers of Paradise are no doubt similar designs of idealised flowers in scrolls or groups.[1] The *pao hsiang hua*, which is given in Giles's Dictionary as " the rose," is rendered by Bushell " flowers of Paradise " or " fairy flowers." Judging by the designs with this name in Chinese works, and also from the fact that the rose is a very rare motive on Chinese wares before the Ch'ing dynasty, whereas the *pao hsiang hua* is one of the commonest in the Ming lists, Bushell's rendering is probably correct in the present context.

Animal Motives, mythical or otherwise.

Dragons, represented as pursuing jewels (*kan chu*) ; grasping jewels (*k'ung chu*) ; in clouds ; emerging from water ; in bamboo foliage and fungus plants ; among water chestnut flowers ; among scrolls of Indian lotus ; emerging from sea waves and holding up the Eight Trigrams (*pa kua*) ; holding up the characters *fu* 福 (happiness) or *shou* 壽 (longevity), as on Fig. 1 of Plate 66.

Dragons of antique form. These are the lizard-like creatures (*ch'ih*) with bifid tail which occur so often in old bronzes and jades.

Dragon medallions (*t'uan lung*).

Nine dragons and flowers.

Dragons and phœnixes moving through flowers.

Dragon, and phœnixes with other birds.

Phœnixes flying through flowers.

A pair of phœnixes.

Lions [2] rolling balls of brocade.

Flying lions.

Hoary [3] lions and dragons.

Storks in clouds.

Peacocks (*k'ung ch'iao*) and *mu-tan* peonies.

[1] See Bushell, *O. C. A.*, p. 563.

[2] 獅子 *shih tzŭ*. The mythical lion is a fantastic animal with the playful qualities of the Pekingese spaniel, which it resembles in features. In fact the latter is called the lion dog (*shih tzŭ k'ou*), and the former is often loosely named the " dog of Fo (Buddha)," because he is the usual guardian of Buddhist temples and images.

[3] 蒼 *ts'ang*, azure or hoary.

Birds flying in clouds.
Fish and water weeds.
Four fishes.[1]

Human Motives.

Children (*wa wa*) playing.

Three divine beings (*hsien*) compounding the elixir of Immortality.

Two or four Immortals.

The Eight Immortals (*pa hsien*) crossing the sea ; or paying court to the god of Longevity (*p'êng shou*), or congratulating him (*ch'ing shou*).

A group of divine beings (*hsien*) paying court to the god of Longevity.

Two designs of doubtful meaning may be added here :

(1) " Jars decorated with *chiang hsia pa chün*," [2] a phrase which means " the eight elegant (scholars) of Chiang-hsia (i.e. below the river)," but has been translated by Bushell, using a variant reading,[3] as " the eight horses of Mu Wang." The latter rendering ignores the presence of *chiang hsia*, and the former, though a correct reading of the original, is not explained in any work of reference to which I have had access.

(2) " Bowls with *man ti ch'iao*," lit. " graceful (designs) filling the ground." The meaning of *ch'iao* is the difficulty, and Bushell in one translation [4] has rendered it " graceful sprays of flowers," which sorts well with rest of the phrase, but in another [5] he has assumed that it means " graceful beauties " in reference to the well-known design of tall, slender girls, which the Dutch collectors named *lange lijsen* (see Plate 92, Fig. 2). The latter rendering, however, goes badly with *man ti*, " filling the ground," which is certainly more applicable to some close design, such as floral scroll work. This is, however, a good example of the difficulty of translating the Chinese texts, where so much is left to the imagination, and consequently there is so much room for differences of opinion.

[1] Named by Bushell mackerel, carp , marbled perch, and another.
[2] 江下八俊.
[3] 駿 *chün*, a fleet horse.
[4] Translation of the *T'ao shuo* (p. 145).
[5] *O. C. A.*, p. 227.

Fig. 2

Fig. 1 Fig. 3

Plate 68.—Blue and White Porcelain. Sixteenth Century.

Fig. 1.—Perfume Vase, lions and balls of brocade. Height 8¾ inches. *V. & A. Museum.* Fig. 2.—Double Gourd Vase, square in the lower part. Eight Immortals paying court to the God of Longevity, panels of children (*wa wa*). Height 21 inches. *Eumorfopoulos Collection.* Fig. 3.—Bottle with medallions of *ch'i-lin* and incised fret pattern between. Late Ming. Height 9 inches. *Halsey Collection.*

Fig. 1

Fig. 2

Plate 69.—Sixteenth Century Porcelain.

Fig. 1.—Bowl of blue and white porcelain with silver gilt mount of
Elizabethan period. Height 3¾ inches. *British Museum.* Fig. 2.—
Covered Jar, painted in dark underglaze blue with red, green and
yellow enamels ; fishes and water plants. Chia Ching mark. Height
17 inches. *S. E. Kennedy Collection.*

Fig. 1

Fig. 2

Plate 70.—Porcelain with Chia Ching mark.

Fig. 1. - Box with incised Imperial dragons and lotus scrolls ; turquoise and dark violet glazes on the biscuit. Diameter 9½ inches. *V. & A. Museum.*
Fig. 2.—Vase with Imperial dragons in clouds, painted in yellow in an iron red ground. Height 8½ inches. *Cologne Museum.*

Fig. 1 Fig. 2

Fig. 3

Plate 71.—Sixteenth Century Porcelain.

Figs. 1 and 2.—Two Ewers in the Dresden Collection, with transparent green, aubergine and turquoise glazes on the biscuit, traces of gilding. In form of a phœnix (height 11 inches), and of a crayfish (height 8¼ inches). Fig. 3.—Bowl with flight of storks in a lotus scroll, enamels on the biscuit, green, aubergine and white in a yellow ground. Chia Ching mark. Diameter 7 inches. *Alexander Collection.*

Emblematic Motives.

Heaven and Earth, and the six cardinal points (*ch'ien k'un liu ho*[1]), or "emblems of the six cardinal points of the Universe."

Ch'ien and *k'un* are the male and female principles which are represented by Heaven and Earth, and together make up the Universe. The identification of these emblems is obscure. They might simply be the Eight Trigrams (*pa kua*), which are explained next, for two of these are known as *ch'ien* and *k'un*, and together with the remaining six they are arranged so as to make up eight points of the compass. But in that case, why not simply say *pa kua* as elsewhere ?

On the other hand, we know that certain emblems were used in the Chou dynasty[2] in the worship of the six points of the Universe, viz. a round tablet with pierced centre (*pi*) of bluish jade for Heaven ; a yellow jade tube with square exterior (*ts'ung*) for Earth ; a green tablet (*kuei*), oblong with pointed top, for the East ; a red tablet (*chang*), oblong and knife-shaped, for the South ; a white tablet, in the shape of a tiger (*hu*), for the West ; and a black jade piece of flat semicircular form (*huang*) for the North. All these objects are illustrated in Laufer's *Jade*, but as they have not, to my knowledge, appeared together in porcelain decoration, the question must for the present be left open.

The *pa-kua* 八卦, or Eight Trigrams, supported by dragons or by waves and flames.

These are eight combinations of triple lines. In the first the lines are unbroken, and in the last they are all divided at the centre, the intermediate figures consisting of different permutations of broken and unbroken lines (see p. 290). These eight diagrams, by which certain Chinese philosophers explained all the phenomena of Nature, are supposed to have been constructed by the legendary Emperor Fu Hsi (B.C. 2852) from a plan revealed to him on the back of the "dragon horse" (*lung ma*) which rose from the Yellow River.[3] Among other things, they are used to designate the points of the compass, one arrangement making the first figure represent the South (also designated *ch'ien* 乾 or Heaven), and the last figure the North (also designated *k'un* 坤 or Earth), the remaining figures

[1] 乾坤六合. [2] See Laufer, *Jade*, p. 120.

[3] See Mayers, part ii., p. 335.

representing South-West, West, North-West, North-East, East, and South-East.

The *pa pao* 八寶, or Eight Precious Symbols, supported by fungus sprays.

These are usually represented by (1) a sphere or jewel, which seems to have originally been the sun disc ; (2) a circle enclosing a square, which suggests the copper coin called a " cash " ; (3) an open lozenge, symbol of victory or success ; (4) a musical stone (*ch'ing*) ; (5) a pair of books ; (6) a pair of rhinoceros horns (cups) ; (7) a lozenge-shaped picture (*hua*) ; (8) a leaf of the artemisia, a plant of good omen, which dispels sickness. (See p. 299.)

The *pa chi hsiang* 八吉祥, or Eight Buddhist Symbols, supported on lotus scrolls.

These symbols, which appeared among the auspicious signs on the foot of Buddha, comprise (1) the wheel (*chakra*), which is sometimes replaced by the hanging bell ; (2) the shell trumpet of Victory ; (3) the umbrella of state ; (4) the canopy ; (5) the lotus flower ; (6) the vase ; (7) the pair of fish, emblems of fertility ; (8) the angular knot (representing the entrails), symbol of longevity. (See p. 298.)

The hundred forms of the character *shou* (longevity)—*pai shou tz'ŭ*.

Ju-i sceptres and phœnix medallions.

The *ju-i* 如意 ("as you wish ") sceptre brings fulfilment of wishes, and is a symbol of longevity (see vol. i., p. 227). The head of the *ju-i*, which has a strong resemblance to the conventional form of the *ling chih* fungus, is often used in borders and formal patterns variously described as " *ju-i* head patterns," " cloud-scroll patterns," or " *ju-i* cloud patterns."

Close ground patterns of propitious clouds (*yung hsiang yün ti*).

Cloud designs are propitious because they symbolise the fertilising rain, and they are commonly represented by conventional scrolls as well as by the more obvious cloud patterns.

Crested sea waves (*chiang ya hai shui*).

Chiang ya 薑芽 (lit. ginger shoots) is rendered by Bushell " crested waves," the metaphor being apparently suggested by the curling tops of the young plant.

Cups decorated [1] with the characters *fu shou k‘ang ning* 福壽康寧 (happiness, long life, peace, and tranquillity).

A blue and white vase with these characters in medallions framed by cloud scrolls on the shoulders is shown on Plate 68.

Miscellaneous Motives.

The waterfalls of Pa Shan 巴山 in the province of Szechuan.

Gold weighing-scales (*ch‘êng chin* 秤金).

A design named *san yang k‘ai t‘ai* 三陽開泰, a phrase alluding to the " revivifying power of spring," and said by Bushell to be symbolised by three rams. Cf. Fig. 2 of Plate 122.

The mark of the Chia Ching period, though not so freely used as those of Hsüan Tê and Ch‘êng Hua, has been a favourite with Japanese copyists, whose imitations have often proved danger-ously clever. Still, there are enough genuine specimens in public and private collections in England to provide a fair representation of the ware. In studying these the blue and white will be found to vary widely, both in body material and in the colour of the blue, according to the quality of the objects.

Plate 77 illustrates a remarkably good example of the dark but vivid Mohammedan blue on a pure white ware of fine close grain with clear glaze. The design, which consists of scenes from the life of a sage, perhaps Confucius himself, is painted in typical Ming style, and bordered by *ju-i* cloud scrolls and formal brocade patterns. The Chia Ching blue is often darker [2] and heavier than here, resembling thick patches of violet ink, to use Mr. Perzynski's phrase. This powerful blue is well shown in the large vase given by Mr. A. Bur-man to the Victoria and Albert Museum (Plate 72), and by a fine ewer in Case 22 in the same gallery. The latter has an accident-ally crackled glaze on the body with brownish tint, due, no doubt, to staining.

On the other hand, a large double-gourd vase in the British Museum, heavily made (probably for export), is painted with the eighteen Arhats, or Buddhist apostles, in a dull greyish blue, which

[1] *hua* 花. Bushell (*T‘ao shuo*, p. 146) has rendered this with " *flowers* and inscrip-tions, etc." In many cases in these lists it is almost impossible to say whether the word *hua* has the sense of *flowers* or merely *decoration*. The present passage *fu shou k‘ang ning hua chung* seems to demand the second interpretation.

[2] This dark blue Chia Ching ware was carefully copied at the Imperial factory in the Yung Chêng period. See p. 203.

would certainly have been assigned to the Wan Li period were it not for the Chia Ching mark. This is, no doubt, the native cobalt without any admixture of Mohammedan blue.

The body material in these specimens varies scarcely less than the blue. In the colour stand on Plate 77 the ware is a pure clean white, both in body and glaze. On other specimens—particularly the large, heavily built jars and vases made for export to India and Persia —the ware is of coarser grain, and the glaze of grey or greenish tone. The tendency of the Ming biscuit to assume a reddish tinge where exposed to the fire is exaggerated on some of these large jars, so that the exposed parts at the base and foot rim are sometimes a dark reddish brown. Doubtless the clay from different mines varied considerably, and the less pure materials would be used on these relatively coarse productions. On the other hand, the better class of dish and bowl made for service at the table is usually of clean white ware, potted thin and neatly finished, and differing but little in refinement from the choice porcelains of the eighteenth century. Such are the dragon dish described on p. 32 and the polychrome saucers which will be mentioned presently.

The export trade with Western Asia and Egypt, both by sea and land, must have been of considerable dimensions in the middle of the sixteenth century. Broken pieces of Chinese blue and white are found on all the excavated sites in the Near East, and the influence of the Chinese porcelain is clearly seen in the blue, or blue and brown, painted faience made in Persia, Syria, and Egypt in the sixteenth century. The reflex influence of Persia on the Chinese wares has already been noted, and it is clear that Persian taste was studied by the makers of the dishes, bottles, pipes, and other objects with birds and animals in foliage and floral scrolls of decidedly Persian flavour, which are still frequently found in the Near East. It was this type of Chinese porcelain which inspired Italian maiolica potters in their decoration *alla porcellana*, as well as the decorators of the Medici or Florentine porcelain, the first European porcelain of any note. Françesco Maria, the patron of the Medici porcelain, died in 1587, and as little, if any, of the ware was made after his death, the rare surviving examples may be safely taken as reflecting, where any Chinese influence is apparent, the influence of the mid-sixteenth century porcelains.

An interesting series of Ming blue and white export wares collected in India was lent to the Burlington Fine Arts Club in

1910 by Mrs. Halsey. It included a few Chia Ching specimens, and among them a melon-shaped jar with lotus scrolls in the dark blue of the period. This melon form has been popular with the Chinese potters from T'ang times, and it occurs fairly often in the Ming export porcelains. A companion piece, for instance, at the same exhibition was decorated with handsome pine, bamboo, and plum designs. Others, again, are appropriately ornamented with a melon vine pattern, a gourd vine, or a grape vine with a squirrel-like animal on the branches. The drawing of these pieces is usually rough but vigorous, the form is good, and the blue as a rule soft and pleasing; and though entirely wanting in the superfine finish of the choice K'ang Hsi blue and white, they have a decorative value which has been sadly underrated.

The polychrome porcelains of the Chia Ching period are rarer than the blue and white, but still a fair number of types are represented in English collections. Of the colours applied direct to the biscuit the early glazes of the *demi-grand feu*—turquoise, aubergine violet, green and yellow—were doubtless applied as in the previous century to the large wine jars, vases and figures in the round. An unusual specimen of this class is the marked Chia Ching cake box in the Victoria and Albert Museum, illustrated on Plate 70. The design—Imperial dragons among floral scrolls—is traced with a point in the paste and covered with a delicate turquoise glaze, the background being filled with violet aubergine. Similarly engraved designs coloured by washes of transparent glazes in the three colours—green, yellow and aubergine brown—are found with the Chia Ching mark as with that of Chêng Tê, and Plate 73 illustrates two singularly beautiful bowls with designs outlined in brown and washed in with transparent glazes. The one has flowering branches of prunus, peach and pomegranate in white, green and aubergine in a yellow ground, and the other phœnixes and floral scrolls in yellow, green and white in a ground of pale aubergine. Both have the Chia Ching mark. Fig. 2 of Plate 71 is another member of the same group, with a beautiful design of cranes and lotus scrolls in a yellow ground. There are, besides, examples of these yellow and aubergine glazes in monochrome. A good specimen of the latter with Chia Ching mark in the British Museum has fine transparent aubergine glaze with iridescent surface, the colour pleasantly graded, which contrasts with the uniform smooth glaze and trim finish of a Ch'ien Lung example near to it.

Two interesting ewers in the Dresden collection (Figs. 1 and 2 of Plate 71) probably belong to this period, or at any rate to the sixteenth century. They are fantastically shaped to represent a phœnix and a lobster, and are decorated with green, yellow, aubergine and a little turquoise applied direct to the biscuit. Parts of the surface have been lightly coated with gilding, which has almost entirely disappeared. These pieces are mentioned in an inventory of 1640, and a lobster ewer precisely similar was included in the collection made by Philipp Hainhofer in the early years of the seventeenth century.[1]

Among the examples of on-glaze enamels of this period are those in which the coral red derived from iron oxide (*fan hung*) is the most conspicuous colour. This red is often highly iridescent, displaying soft ruby reflections like Persian lustre ; at other times it is richly fluxed, and has a peculiarly vitreous and almost sticky appearance. The former effect is well seen in a small saucer in the British Museum, which has a wide border of deep lustrous red surrounding a medallion with lions and a brocade ball in green. The latter is seen on a square, covered vase in the same case, decorated on each side with full-faced dragons in red and the usual cloud accessories in inconspicuous touches of green and yellow. The yellow enamel of the period is often of an impure, brownish tint and rather thickly applied, but these peculiarities of both yellow and red continued in the Wan Li period.

The combination of enamel colours with underglaze blue, which was so largely used in the Wan Li period as to be generally known by the name *Wan li wu ts'ai* (Wan Li polychrome), is not unknown on Chia Ching wares. The wide-mouthed jar, for instance, from the collection of Mr. S. E. Kennedy [2] (Plate 69, Fig. 2) is decorated with a design of fish among water plants in deep Chia Ching blue combined with green, yellow and iron red enamels; and a small bottle-shaped vase in the British Museum has the same blue combined with on-glaze red, green, yellow and aubergine, the design being fish, waves, and water plants. The greens of this and the Wan Li period include various shades—bright leaf green, pale

[1] See J. Böttger, *Philipp Hainhofer und der Kunstschrank Gustav Adolfs in Upsala*, Stockholm, 1909, Plate 71. The same interesting collection includes a marked Wan Li dish with cloud and stork pattern in underglaze blue, two cups, and a set of Indian lacquer dishes with centres made of the characteristic Chinese export porcelain described on p. 70.

[2] *Cat. B. F. A.*, D 17.

emerald, and a bluish green [1] which seems to be peculiar to the late Ming period.

A box in the collection of Dr. C. Seligmann has a dragon design reserved in a blue ground and washed over with yellow enamel, on which in turn are details traced in iron red ; and another peculiar type of Chia Ching polychrome in the Pierpont Morgan Collection (Cat. No. 882) is a tea cup with blue Imperial dragons inside, "on the outside deep yellow glaze with decoration in brownish red of intensely luminous tone, derived from iron, lightly brushed on the yellow ground : the decoration consists of a procession of boys carrying vases of flowers round the sides of the cup with addition of a scroll of foliage encircling the rim." Both these specimens have the Chia Ching mark.

Allusion has already been made (p. 6) to a type of bowl which belongs to the Ming period, though opinions differ as to the exact part of that dynasty to which it should be assigned. The bowls vary slightly in form, but the most usual kind is that shown on Plate 74 with well rounded sides. A common feature, which does not appear in the photograph, is a convex centre. Others, again, are shallow with concave base, but no foot rim. The decoration of those in the British Museum includes (1) a coral red exterior with gilt designs as described on p. 6, combined with slight under-glaze blue interior ornament, (2) a beautiful pale emerald green exterior similarly gilt, with or without blue ornament inside, and (3) a single specimen with white slip traceries in faint relief under the glaze inside, the outside enamelled with turquoise blue medallions and set with cabochon jewels in Persia or India. There are similar bowls in the Dresden collection, with pale sky blue glaze on the exterior. As already noted, one or two of the red bowls have the Yung Lo mark, but, as a rule, they are marked with phrases of commendation or good wish,[2] such as *tan kuei* (red cassia, emblem of literary success), *wan fu yu t'ung* (may infinite happiness embrace all your affairs !) Two of them are known to have sixteenth-century European mounts, viz. the red bowl mentioned on p. 6, and a green specimen in the British Museum.[3] Without denying the possibility of some of the red examples dating back to the Yung

[1] A good example of this colouring is a large bowl with Chia Ching mark in the Kunstgewerbe Museum, Berlin.

[2] See vol. i, p. 225.

[3] Figured in F. Dillon, *Porcelain*, Plate v.

Lo period, the conclusion is almost irresistible that we have here in one case the *fan hung* decoration which replaced the *hsien hung* in the Chia Ching period, and in another the *ts'ui lü* (emerald green), named among the colours of the Imperial Chia Ching porcelains.

The Chia Ching monochromes already mentioned include white, blue, sky blue, lustrous brown, turquoise, green, yellow, and aubergine, with or without designs engraved in the paste (*an hua*). None of these call for any further comment, unless it be the distinction between blue and sky blue of the Imperial wares. The former, no doubt, resulted from the Mohammedan blue (blended with native cobalt) mixed with the glaze, and must have been a fine blue of slightly violet tone : the latter was apparently the lavender-tinted blue which goes by the name of sky blue on the more modern porcelains.

We read in more than one passage in the Chinese works that the imitation of the classical porcelains of Hsüan Tê and Ch'êng Hua was practised in the Chia Ching period, and the name of a private potter who excelled in this kind of work has been preserved. A note on this artist, given in the *T'ao lu*[1] under the heading *Ts'ui kung*[2] *yao*, or Wares of Mr. Ts'ui, may be rendered as follows :—

" In the Chia Ching and Lung Ch'ing periods there lived a man who was clever at making porcelain (*t'ao*). He was famed for imitations of the wares in the traditional style and make of the Hsüan Tê and Ch'êng Hua periods, and in his time he enjoyed the highest reputation. The name given to his wares was Mr. Ts'ui's porcelain (*ts'ui kung yao tz'ŭ*), and they were eagerly sought in all parts of the empire. As for the shape of his cups (*ch'ien*), when compared with the Hsüan and Ch'êng specimens[3] they differed in size but displayed the same skill and perfection of design. In the blue and polychrome wares his colours were all like the originals. His were, in fact, the cream of the porcelains made in the private factories (*min t'ao*)."

[1] Bk. v., fol. 9 recto.

[2] 催公. *Ts'ui* is a fairly common name. It occurs as a mark on a small figure of an infant in creamy white ware of Ting type in the Eumorfopoulos Collection ; but it is highly improbable that this piece has anything to do with the Mr. Ts'ui here in question.

[3] The *Ming ch'ên shih pi chou chai yü t'an*, quoted in the *T'ao lu*, bk. viii., fol. 4, says, " When we come to Chia Ching ware then there are also imitations of both Hsüan Tê and Ch'êng Hua types (they even are said to excel them). But Mr. Ts'ui's ware is honoured in addition, though its price is negligible, being only one-tenth of that of Hsüan and Ch'êng wares."

It is interesting to note that the imitation of the early Ming porcelains began as soon as this, and we may infer from the usual Chinese procedure that the marks of the Hsüan Tê and Ch'êng Hua periods were duly affixed to these clever copies.

Lung Ch'ing 隆慶 (1567-1572)

We read in the *T'ao shuo*[1] that the Imperial factory was re-established in the sixth year of this reign (1572), and placed under the care of the assistant prefects of the district. This would seem to imply that for the greater part of this brief period the Imperial works had been in abeyance. Be this as it may, there was no falling off in the quantity of porcelain commanded for the Court, and the extravagant and burdensome demands evoked a protest from Hsü Ch'ih, the president of the Censorate,[2] in 1571. It was urged among other things that the secret of the copper red colour (*hsien hung*) had been lost, and that the potters should be allowed to use the iron red (*fan hung*) in its place : that the size and form of the large fish bowls which were ordered made their manufacture almost impossible : that the designs for the polychrome (*wu ts'ai*) painting were too elaborate, and that square boxes made in three tiers were a novelty difficult to construct. Fire and flood had devastated Ching-tê Chên, and many of the workmen had fled, and he (the president) begged that a large reduction should be made in the palace orders.

We are not told whether this memorial to the emperor had the desired effect. In the case of the next emperor a similar protest resulted in a large reduction of the demands. But the document discloses several interesting facts, and among other things we learn that the designs for some of the ware and for the coloured decoration were still sent from the palace as in the days of Ch'êng Hua.

The official lists of porcelain actually supplied to the Court of Lung Ch'ing have been briefly summarised in the *T'ao shuo*[3] ; but they do not include any new forms, and the motives of decoration were in the main similar to those recorded in the Chia Ching lists. The following, however, may be added to the summary in the previous chapter :—

[1] Bk. iii., fol. 7. [2] See Bushell, *O. C. A.*, p. 235.
[3] Bk. vi., fol. 16, and Bushell's translation, p. 152.

The *yü tsan hua*, rendered in Giles's Dictionary as the "tuberose," by Bushell as the "iris."

Clumps of chrysanthemum flowers.

Interlacing scrolls of *mu-tan* peony.

Ch'ang ch'un (long spring) flowers, identified by Bushell with the "jasmine."

A "joyous meeting," symbolised according to Bushell by a pair of magpies.

The Tartar pheasant (*chai chih*).

The season flowers supporting the characters 乾坤清泰 *ch'ien k'un ch'ing t'ai*, "Heaven and earth fair and fruitful!"

Monsters (*shou*) in sea waves.

Flying fish.

Historical scenes (*ku shih*), as well as genre subjects (*jên wu*).

Children playing with branches of flowers.

This last design occurs both in the form of belts of foliage scrolls, among which are semi-nude boys, and of medallions with a boy holding a branch, on blue and white and polychrome wares of the late Ming period. But it is a design of considerable antiquity, and it is found engraved on the early Corean bowls which, no doubt, borrowed from Sung originals.

Though all these designs are given under the general heading of blue and white, we may infer that the polychrome which is occasionally mentioned was used in combination with the blue. Thus the mention of "phœnixes in red clouds flying through flowers," of "nine red dragons in blue waves," and of "a pair of dragons in red clouds," recalls actual specimens which I have seen of Lung Ch'ing and Wan Li boxes with designs of blue dragons moving through clouds touched in with iron red. Again, where the blue designs are supplemented with "curling waves and plum blossoms in polychrome (*wu ts'ai*)," one thinks of the well-known pattern of conventional waves on which blossom and symbols are floating, as on Plate 79. Other types of decoration mentioned are yellow grounds and white glaze, both with dragon designs engraved under the glaze (*an hua*), peacocks and *mu-tan* peonies in gilding, and moulded ornament. A specific example of the last are the lions which served as knobs on the covers of the ovoid wine jars (*t'an*).

The author of the *T'ao shuo* pays a handsome tribute to the skill of the late Ming potters. "We find," he says, "that the porcelain of the Ming dynasty daily increased in excellence till

we come to the reigns of Lung Ch'ing and Wan Li, when there was nothing that could not be made." At the same time he finds fault with a particular kind of decoration which was encouraged by the degraded and licentious tastes of the Emperor Lung Ch'ing, and seems to have only too frequently marred the porcelain of the period.[1]

The rare examples of marked Lung Ch'ing porcelain in our collections do not call for special comment, and the unmarked specimens will hardly be distinguished from the productions of the succeeding Wan Li period. There are, however, two boxes in the British Museum which may be regarded as characteristic specimens of the Imperial blue and white porcelains. Both are strongly made with thick but fine-grained body material and a glaze of slightly greenish tone ; and the designs are boldly sketched in strong outline and washed in with a dark indigo blue. One is a square box with four compartments decorated with five-clawed dragons in cloud scrolls, extended or coiled in medallions according as space demanded ; and the other is oblong and rectangular, and painted on the sides (the cover is missing) with scenes of family life (*jên wu*). In both cases the base is unglazed except for a sunk medallion in which the six characters of the Lung Ch'ing mark are finely painted in blue.

[1] See *Ming ch'ên shih pi chou chai yü t'an* (quoted in *T'ao lu*, bk. viii., cf. 4 verso) : " For Mu Tsung (i.e. Lung Ch'ing) loved sensuality, and therefore orders were given to make this kind of thing ; but as a matter of fact ' Spring painting ' began in the picture house of Prince Kuang Chüan of the Han dynasty. . ."

CHAPTER V

THE long reign of Wan Li, the last important period of the Ming dynasty, is certainly the best represented in European collections, a circumstance due to the ceramic activity of the time not less than to its nearness to our own age. In the first year of the reign orders were given that one of the sub-prefects of Jaochou Fu should be permanently stationed at Ching-tê Chên to supervise the Imperial factory. It appears that he proved a stern taskmaster, and at the same time that the potters were severely burdened by excessive demands from the palace. The picture drawn by the censor in the previous reign of the afflicted condition of the potters, and the story told elsewhere [1] how they had made intercession daily in the temple of the god that the Imperial orders might be merciful, are fitting preface to the tale of the dragon bowls told as follows by T‘ang Ying,[2] the director of the factory in the first half of the eighteenth century.

" By the west wall of the Ancestral-tablet Hall of the spirit who protects the potters is a dragon fish bowl (*lung kang*). It is three feet in diameter and two feet high, with a fierce frieze of dragons in blue and a wave pattern below. The sides and the mouth are perfect, but the bottom is wanting. It was made in the Wan Li period of the Ming. Previously these fish bowls had presented great difficulty in the making, and had not succeeded, and the superintendent had increased his severity. Thereupon the divine T‘ung took pity on his fellow potters, and served them by alone laying down his life. He plunged into the fire, and the bowls came out perfect. This fish bowl was damaged after it had been finished and selected (for palace use), and for a long time it remained abandoned in a corner of the office. But when I saw it I sent a double-yoked cart and men to lift it, and it was brought to the side of

[1] See *T‘ao lu*, bk. viii., fols. 10 and 11, quoting from the *Ts‘ao t‘ien yu chi*.

[2] *T‘ang ying lung kang chi*, quoted in the *T‘ao lu*, bk. viii., fols. 11 and 12.

the Ancestral-tablet Hall of the god, where it adorns a high plat-form, and sacrifice is offered. The vessel's perfect glaze is the god's fat and blood ; the body material is the god's body and flesh ; and the blue of the decoration, with the brilliant lustre of gems, is the essence of the god's pure spirit."

The deification of T'ung was a simple matter to the Chinese, who habitually worship before the tablets of their ancestors ; but he seems to have become the genius of the place, and in this capacity to have superseded another canonised potter named Chao,[1] who had been worshipped at Ching-tê Chên since 1425.

To add to the difficulties experienced by the potters in satis-factorily fulfilling the Imperial demands, it had been reported in 1583 that the supplies of earth from Ma-ts'ang were practically worked out, and though good material was found at Wu-mên-t'o, which is also in the district of Fu-liang, the distance for trans-port was greater, and as the price was not correspondingly raised the supply from this source was difficult to maintain. Consequently we are not surprised to learn that in this same year another memorial was forwarded to the emperor by one of the supervising censors, Wang Ching-min, asking for alleviation of the palace orders, and protesting specifically against the demands for candlesticks, screens, brush handles, and chess apparatus as unnecessarily extravagant. It was urged at the same time that blue decoration should be sub-stituted for polychrome, and that pierced work (ling lung) should not be required, the objection to both these processes being that they were difficult to execute and meretricious in effect.

It is stated in the T'ao lu [2] that the supply of Mohammedan blue had ceased completely in the reign of Wan Li, and that on the other hand the chi hung or underglaze copper red was made, though it was not equal in quality to the hsien hung or pao shih hung [3] of the earlier periods. Both these assertions are based on the some-what uncertain authority of the T'ang shih ssŭ k'ao, and though the truth of the second is shown by existing specimens, the first is only partially true, for there are marked examples of Moham-medan blue in the British Museum and probably elsewhere. Either there were supplies of the Mohammedan material in hand at the

[1] Chao was supposed to have displayed superhuman skill in the manufacture of pottery in the Chin dynasty (265-419 A.D.).

[2] Bk. v., fol. 8.

[3] For explanation of these terms, see p. 10.

beginning of the reign, or they continued to arrive for part at least of the period.

The lists of porcelain supplied to the Court of Wan Li may be consulted with advantage, and the extracts from those of the previous reigns may be supplemented by the following, which, though not necessarily new forms and designs, do not appear in the Chia Ching and Lung Ch'ing records :—

Forms.

Trays for wine cups (*pei p'an*).[1]

Beaker-shaped [2] vases (*hu p'ing* 壺餅).

Flat-backed wall vases in the form of a double gourd split vertically.

Chess boards (*ch'i p'an*).

Hanging oil lamps [2] (*ch'ing t'ai* 檠臺).

Pricket candlesticks (*chu t'ai*). See *Cat. B. F. A.*, 1910, E 6 : a pricket candlestick with cloud and dragon designs in blue and the Wan Li mark.

Jars for candle snuff (*chien chu kuan*).

Screens (*p'ing*).

Brush handles (*pi kuan*).

Brush rests (*pi chia*).

Brush pots (*pi ch'ung*). Apparently the cylindrical jars usually known as *pi t'ung*.

Fan cases (*shan hsia*).

Water droppers for the ink pallet (*yen shui ti*).

Betel-nut boxes (*pin lang lu*).

Handkerchief boxes (*chin lu*).

Hat boxes (*kuan lu*).

Cool seats (*liang tun*), for garden use in summer.

Motives for Painted Decoration.

Floral, etc. :

Lily flowers (*hsüan hua*).

Hibiscus (*kuei*) flowers on a brocade ground.

Round medallions of season flowers.

Flower designs broken by medallions of landscape.

Marsh plants.

[1] Bushell's rendering, " cups and saucers," is misleading if not verbally incorrect.
[2] These are Bushell's renderings.

Sections of water melons (*hsi kua pan*).

Foreign pomegranates; sometimes tied with fillets.

The sacred peach.

Medallions of peach boughs with the seal character *shou* (longevity).

Apricot (*hsing*) foliage.

Pine pattern brocade.

Ginseng (*hsien*).

Hemp-leaved (*ma yeh*) Indian lotus.

Borders of bamboo foliage and branching prunus.

Grape-vine borders.

Animals, etc. :

Monsters : variously described as *hai shou* (sea monsters) and *i shou* (strange monsters).

Nine blue monsters in red waves.

Strange monsters attending the celestial dragon.

Sea horses.

Full-faced dragons (*chêng mien lung*). See Plate 66.

Medallions of archaic dragons (*ch'ih*) and tigers.

Ascending and descending dragons.

Couchant, or squatting (*tun*) dragons.

Flying dragons.

The hundred dragons.

The hundred storks.

The hundred deer.

(As in the " Hundred Shou Characters " and other similar phrases, the " hundred " is merely an indefinite numerative signifying a large number.)

Elephants with vases of jewels (of Buddhistic significance).

Water birds in lotus plants.

Six cranes, " symbolising the cardinal points of the universe " (*liu ho ch'ien k'un*).

Phœnixes among the season flowers.

Bees hovering round plum blossom.

Human :

Men and women (*shih nü*).

Medallions with boys pulling down (branches of) cassia (*p'an kuei*).

The picture of the Hundred Boys.

Fu, Lu, Shou (Happiness, Rank, and Longevity). It is not stated whether the characters only are intended, or, as is more probable, the three Taoist deities who distribute these blessings.

Emblematic Motives and Inscriptions.

The eight Buddhist emblems, bound with fillets (*kuan t'ao*).

Ju-i sceptres bound with fillets.

Ju-i cloud borders (*ju i yün pien*).

Midsummer holiday symbols (*tuan yang chieh*). Explained by Bushell as sprigs of acorns and artemisia hung up on the fifth day of the fifth moon.

Emblems of Longevity (*shou tai*), e.g. gourd, peach, fungus, pine, bamboo, crane, deer.

The " monad symbol " (*hun yüan*), which is apparently another name for the *yin yang*, and the Eight Trigrams. See p. 290.

Lozenge symbols of victory (*fang shêng*).

" The four lights worshipping the star of Longevity " (*ssŭ yang p'êng shou*).

Spiral (*hui* 廻) patterns.

Sanskrit invocations (*chên yen tz'ŭ*). See Plate 93.

Ancient writings found at Lo-yang (*lo shu*). Lo-yang (the modern Ho-nan Fu) was the capital of the Eastern Han (25–220 A.D.).

Inscriptions in antique seal characters (*chuan*).

Dragons holding up the characters 永保萬壽 *yung pao wan shou* (ever insuring endless longevity); and 永保洪福齊天 *yung pao hung fu ch'i t'ien* (ever insuring great happiness equalling Heaven).

Borders inscribed 福如東海 *fu ju tung hai* (happiness like the eastern sea); and 風調雨順天下太平 *fêng t'iao yü shun t'ien hsia t'ai p'ing* (favouring winds and seasonable rain : great peace throughout the empire).

" A symbolical head with hair dressed in four puffs " [1] bearing the characters 永保長春 *yung pao ch'ang ch'un* (ever insuring long spring).

Taoist deities holding the characters 萬古長春四海來朝 *wan ku ch'ang ch'un ssŭ hai lai ch'ao* (through myriads of ages long spring;

[1] 四鬆頭 *ssŭ hsŭ t'ou*, a phrase which would more usually refer to the beard than the hair of the head. The above rendering is Bushell's.

tribute coming from the four seas); or the same sentiment with *yung pao* (ever insuring) in place of *wan ku.*

Dragons in clouds holding the characters 聖壽 *shêng shou,* the emperor's birthday.

Miscellaneous.

Representations of ancient coins (*ku lao ch'ien*).

Landscapes (*shan shui*).

Necklaces (*ying lo* 瓔珞).

Jewel mountains in the sea waves (*pao shan hai shui*). This is, no doubt, the familiar border pattern of conventional waves with conical rocks standing up at regular intervals.

Round medallions (*ho tzŭ,* lit. boxes) in brocade grounds.

Most of these designs are given under the heading of " blue and white," though, as in the Lung Ch'ing list, the blue is in many cases supplemented by colour or by other forms of decoration such as patterns engraved in the body (*an hua*), and " designs on a blue ground," the nature of them not explained, but no doubt similar to those described on p. 61. The method of reserving the decoration in white in a blue ground (*ch'ing ti pai hua*) is specifically mentioned under the heading of "mixed decorations." The supplementary decoration consists of on-glaze enamels mixed with the underglaze blue ; bowls with coloured exterior and blue and white inside or vice versa ; yellow grounds with designs engraved under the glaze ; gilded fishes among polychrome water weeds, and other gilded patterns ; curling waves in polychrome and plum blossoms ; red dragons in blue waves, the red either under or over the glaze ; relief designs (*ting chuang*[1]) and pierced work (*ling lung*[2]).

The " mixed colours " included garden seats with lotus designs, etc., in polychrome (*wu ts'ai*) and with aubergine brown (*tzŭ*) lotus decoration in a monochrome yellow ground; tea cups with dragons in fairy flowers engraved under a yellow glaze ; yellow ground with polychrome (*wu ts'ai*) decoration ; banquet dishes, white inside, the outside decorated with dragons and clouds in red, green, yellow, and aubergine.

The custom of minutely subdividing the work in the porcelain factories so that even the decoration of a single piece was parcelled out among several painters existed in the Ming dynasty, though

[1] 頂樁. [2] 玲瓏.

perhaps not carried so far as in the after periods. It is clear that under such a system the individuality of the artists was completely lost, and we never hear the name of any potter or painter who worked at the Imperial factory. In the private factories probably the division of labour was less rigorous, and it is certain that many of the specimens were decorated by a single brush. But even so, signatures of potters or painters are almost unknown ; and only one or two private potters of conspicuous merit at the end of the Ming period are mentioned by name in the Chinese books. Mr. Ts'ui, for instance, has already been mentioned in the chapter on the Chia Ching period, and three others occur in the annals of the Wan Li period.

Of these, the most interesting personality was Hao Shih-chiu,[1] scholar, painter, poet, and potter, who signed his wares with the fanciful name *Hu yin tao jên*[2] (Taoist hidden in a tea pot), to show that he " put his soul " into the making of his pots. He lived, we are told,[3] in exaggerated simplicity, in a hut, with a mat for a door and a broken jar for a window ; but he was so celebrated as a man of talent and culture that his hut was frequented by the *literati*, who capped his verses and admired his wares. The latter were of great refinement and exquisitely beautiful, and his white " egg shell "[4] wine cups were so delicate as to weigh less than a gramme.[5] No less famous were his red wine cups, bright as vermilion, the colour floating in the glaze like red clouds. They were named *liu hsia chan*[6] (*lit.* floating red cloud cups), which has been poetically rendered by Bushell as " dawn-red wine cups " and " liquid dawn cups," and were evidently one of the reds of the *chi hung* class produced by copper oxide in the glaze, like the beautiful wine cups with clouded maroon red glaze of the early eighteenth century. All these wares were eagerly sought by connoisseurs throughout

[1] 吳十九.

[2] 壺隱道人. There is an allusion in this name to the story of Hu Kung, a magician of the third and fourth centuries, who was credited with marvellous healing powers. Every night he disappeared, and it was found at length that he was in the habit of retiring into a hollow gourd which hung from the door post. See A. E. Hippisley, *Catalogue of a Collection of Chinese Porcelains*, Smithsonian Institute, Washington, 1900. Hao's porcelain is also known as *Hu kung yao* (the ware of Mr. Pots).

[3] See *T'ao lu*, bk. v., fol. 10, and bk. viii., fol. 7, and *T'ao shuo*, bk. vi., fol. 26.

[4] 卵幕 *luan mu*, " the curtain inside the egg," which conveys the idea of extreme tenuity better than the most usual expression, " egg shell " porcelain.

[5] Half a *chu*.

[6] 流霞盞

Fig. 1

Fig. 2

Fig. 3

Fig. 4

Plate 75.—Ming Porcelain.

Fig. 1.—Tripod Bowl with raised peony scrolls in enamel colours. Wan Li mark.
Height 5¾ inches. *Eumorfopoulos Collection.* Fig. 2.—Blue and white Bowl, Chia Ching
period. Mark, *Wan ku ch'ang ch'un* (" A myriad antiquities and enduring spring !"). Height
3 inches. *Kunstgewerbe Museum, Berlin.* Fig. 3.—Ewer with white slip *ch'i-lin* on a
blue ground. Wan Li period. Height 9 inches. *Eumorfopoulos Collection.* Fig. 4.—
Gourd-shaped Vase with winged dragons and fairy flowers, raised outlines and coloured
glazes on the biscuit. Sixteenth century. Height 8¼ inches. *Salting Collection.*

Fig. 1

Fig. 2

Fig. 3

Fig. 4

Plate 76.—Blue and White Porcelain. Sixteenth Century.

Fig. 1.—Vase with monster handles, archaic dragons. Height 10⅞ inches. *Halsey Collection.* Fig. 2.—Hexagonal Bottle, white in blue designs. Mark, a hare. Height 11½ inches. *Alexander Collection.* Fig. 3.—Bottle with "garlic mouth," stork and lotus scrolls, white in blue. Height 11 inches. *Salting Collection.* Fig. 4.—Vase (*mei p'ing*), Imperial dragon and scrolls. Wan Li mark on the shoulder. Height 15 inches. *Coltart Collection.*

the Chinese empire. " There were also elegantly formed pots (*hu*), in colour pale green, like Kuan and Ko wares, but without the ice crackle, and golden brown [1] tea pots with reddish tinge, imitating the contemporary wares of the Ch'ên family at Yi-hsing, engraved underneath with the four characters, *Hu yin tao jên*."

The " red cloud " cups are eulogised by the poet Li Jih-hua in a verse addressed to their maker as fit to be " started from the orchid pavilion to float down the nine-bend river." [2]

The two other potters of this period whose names have survived are Ou of Yi-hsing fame (vol. i., p. 181) and Chou Tan-ch'üan, whose wonderful imitations of Sung Ting ware have been described in vol. i., p. 94. Many clever imitations of this latter porcelain were made at Ching-tê Chên in the Wan Li period, and a special material, *ch'ing-t'ien* [3] stone, was employed for the purpose ; but the followers of Ch'ou Tan-ch'üan were not so successful as their master, and their wares are described as over-elaborate in decoration and quite inferior to Ch'ou's productions. There was one type, however, which is specially mentioned, the oblong rectangular boxes made to hold seal-vermilion. These are described in a sixteenth-century work [4] as either pure white or painted in blue, and usually six or seven inches long. They are accorded a paragraph in the *T'ao shuo* [5] under the heading of *fang ting* or " imitation Ting ware," and they were probably of that soft-looking, creamy white crackled ware to which Western collectors have given the misleading name of " soft paste." [6]

Another private manufacture specially mentioned in the *T'ao lu* [7] was located in a street called *Hsiao nan* 小南, where, we are told, " they made wares of small size only, like a squatting frog, and

[1] *Tzŭ chin.* Golden brown with reddish tinge (*tzŭ chin tai chu*), accurately describes one kind of stoneware tea pots made at Yi-hsing (p. 177) ; but it is not stated whether Hao's imitations were in stoneware or porcelain.

[2] An allusion to the celebrated orchid pavilion at Kuei-chi, in Chêkiang, the meeting place of a coterie of scholars in the fourth century. The scene in which they floated their wine cups on the river has been popularised in pictorial art. See Plate 104 Fig. 1.

[3] 青田.

[4] The *K'ao p'an yü shih.*

[5] Bk. vi., fol. 16 recto.

[6] See p. 140.

[7] Bk. v., fol. 10 verso, under the heading, *Hsiao nan yao* (Little South Street wares).

called for that reason frog wares (*ha ma*[1] *yao*). Though coarse, they were of correct form; the material was yellowish, but the body of the ware was thin; and though small, the vessels were strong. One kind of bowl was white in colour with a tinge of blue (*tai ch'ing*), and decorated in blue with a single orchid spray or bamboo leaves; and even those which had no painted design had one or two rings of blue at the mouth. These were called " white rice vessels " (*pai fan ch'i*). There were, besides, bowls with wide mouths and flattened rims (*p'ieh t'an*)[2] but shallow, and pure white, imitating the Sung bowls. All these wares had a great vogue, both at the time and at the beginning of the present (i.e. the Ch'ing) dynasty."

Out of the comparatively large number of Wan Li porcelains in European collections the majority are blue and white. This is only to be expected, having regard to the preponderance of this style of decoration in the Imperial lists, and also to the fact that it was found easiest of all processes to execute. In fact, the censor pleading on behalf of the potters in 1583 asks that this style may be substituted for the more exacting polychrome and pierced work. It has already been mentioned that the supplies of Mohammedan blue apparently came to an end early in the reign, but there are enough examples of this colour associated with the Wan Li mark to show that it was used for part at least of the period. One of these is a well-potted bowl of fine white porcelain, entirely covered with Sanskrit characters (*chên yen tz'ŭ*), in the British Museum; and another piece* is a dish moulded in the form of an open lotus flower with petals in relief, and in the centre a single Sanskrit character. Both are painted in a clear and vivid Mohammedan blue, and have the Wan Li mark under the base. A dark violet blue, closely akin to the typical Chia Ching colour but with a touch of indigo, occurs on two dishes,* decorated with a pair of fishes among aquatic plants and bearing the four characters of the Wan Li mark surrounding a cartouche, which contains the felicitous legend, " Virtue, culture, and enduring

[1] 蝦蟆, apparently referring to the size of the vessels and not necessarily implying that they were shaped like a frog. On the other hand, small water vessels in the form of a frog have been made in China from the Sung period onwards.

[2] 撇坦.

* To avoid repetition the pieces mentioned here from the British Museum collection are marked with an asterisk.

spring " (see vol. i., p. 225). An intense but more vivid violet blue, which betrays something of the Mohammedan blend, is seen on a ewer * of Persian form, decorated with a *ch'i-lin* reclining before a strangely Italian-looking fountain. The ware of this piece, though thick, is of fine grain, and the glaze has a faint greenish tinge, and its mark, a hare,[1] (see vol. i., p. 227) occurs on several other examples of varying quality, but all of late Ming character.

Another group of marked Wan Li ware, comprising bowls and dishes with trim neat finish and obviously destined for table use, has a soft-looking glaze, often much worn, but, even in the less used parts, with a peculiar smoothness of surface which is, no doubt, largely due to age. There are three examples of this group in the British Museum, all painted in the same soft, dark indigo-tinged blue. One is a bowl with baskets of season flowers round the exterior, insects, and a border of dragon and phœnix pattern ; while inside is a blue medallion with a full-face dragon reserved in white. The other two are dishes with figure subjects and gourd vine borders, which are interesting because the painting shows signs of a transition state, part being in flat Ming washes, and part showing the marbled effect which was afterwards characteristic of the K'ang Hsi blue and white.

In striking contrast with this smooth, soft-surfaced ware is a vase* of square, beaker shape, and details which indicate a form derived from bronze. Though evidently an Imperial piece, it is of strong, heavy build, with a hard thick glaze of greenish tinge, so full of minute bubbles as to spread in places a veritable fog over the blue decoration beneath. The design, consisting of a dragon and phœnix among sprays of (?) lily, with rock and wave borders, is repeated in all the spaces, and below the lip in front is the Wan Li mark extended in a single line. A similar vase,* but with poly-chrome decoration, illustrated on Plate 81, will serve to show the form and design. Both are fine, decorative objects, in a strong, rugged style, which takes no account of small fire-flaws and slight imperfections in the glaze. The same strong, hard body and glaze is seen again on three flat, narrow-rimmed dishes,* which are con-spicuous for unusual borders, two having a large checker and the

* In the British Museum.

[1] A similar ewer in Dr. Seligmann's collection is marked with one of the trigrams of the *pa kua*.

third a chevron pattern, in addition to a thin blue line on either side of the edge. Sand adhering to the foot rim and faint radiating lines scored in the base are indications of rough finish, and they are clearly all the work of a private factory perhaps catering for the export trade.

A variety of boxes figured in the Imperial lists, destined for holding incense, vermilion, chess pieces, handkerchiefs, caps, sweetmeats, cakes, etc. A fair number of these have survived and found their way into Western collections. Round, square, oblong with rounded ends, and sometimes furnished with interior compartments, they are usually decorated with dragon designs in dark blue, occasionally tricked out with touches of iron red; but miscellaneous subjects also occur in their decoration, as in a fine example exhibited at the Burlington Fine Arts Club in 1910,[1] which has figure subjects on the cover and a landscape with waterfall, probably from a picture of the celebrated mountain scenery in Szechuan. Sometimes the covers of these boxes are perforated as though to allow some perfume to escape. Other interesting late Ming porcelains in the same exhibition were a pricket candlestick with cloud and dragon ornament and the Wan Li mark; a curious perfume vase (Plate 68, Fig. 1), which illustrates the design of lions sporting with balls of brocade, an unmarked piece which might even be as early as Chia Ching; and a wide-mouthed vase lent by the Ashmolean Museum, Oxford, with the familiar design of fantastic lions moving among peonies and formal scrolls on the body and panels of flowers separated by trellis diaper on the shoulder. The last is a type which is not uncommon, but this particular example is interesting because it belonged to one of the oldest collections in England, presented to the Oxford Museum by John Tradescant, and mostly collected before 1627.

The export trade with Western Asia was in full swing in the reign of Wan Li, and the Portuguese traders had already made their way to the Far East and brought back Chinese porcelain for European use. That it was, however, still a rare material in England seems to be indicated by the sumptuous silver-gilt mounts in which stray specimens were enshrined. Several of these mounted specimens still exist, and seven of them were seen at the Burlington Fine Arts Exhibition, 1910,[2] the date of the mounts being about 1580–1590. Taken, as they may fairly be, as typical specimens, they show on the

[1] *Cat.*, L 24. [2] *Cat.*, E 19-25.

whole a porcelain of indifferent quality, with all the defects and virtues of export ware—the summary finish of skilful potters who worked with good material but for an uncritical public, and rapid, bold draughtsmanship in an ordinary quality of blue usually of greyish or indigo tint. The most finished specimen was a bowl from the Pierpont Morgan Collection, with a design of phœnixes and lotus scrolls finely drawn in blue of good quality. Unlike the others, it had a reign mark (that of Wan Li), and probably it was made at the Imperial factory. A bottle mounted as a ewer from the same collection had a scale pattern on the neck, flowering plants and birds on the body, and a saucer dish was painted in the centre with a typical late Ming landscape, with mountains, pine trees, pagoda, a pleasure boat, and sundry figures. The blue of this last piece was of fair quality but rather dull, and it had a double ring under the base void of mark. Another bowl had on the exterior panel designs with deer in white reserved in a blue ground, in a style somewhat similar to that of the bottle illustrated on Plate 76, Fig. 3. There is a bowl in the British Museum, mounted with silver-gilt foot and winged caryatid handles of about 1580 (Plate 69, Fig. 1). The porcelain is of fine white material with thick lustrous glaze of slightly bluish tint and " pin-holed " here and there; and the design painted in blue with a faint tinge of indigo consists of a vase with a lotus flower and a lotus leaf and three egrets, in a medallion inside and four times repeated on the exterior. This is clearly an early Wan Li specimen, if, indeed, it is not actually as old as Chia Ching.

The most remarkable collection of Chinese export porcelain is illustrated by Professor Sarre [1] from a photograph which he was able to make of the *Chini-hane* or porcelain house attached to the mosque of Ardebil, in Persia. Ranged on the floor are some five hundred specimens—jars, vases, ewers, and stacks of plates, bowls and dishes, many of which had formerly occupied niches in the walls of the building erected by Shah Abbas the Great [2] (1587–1628). Unfortunately, the conditions were not favourable to photography, and the picture, valuable as it is, only permits a clear view of the nearer objects, the rest being out of focus and represented by mere shadows of themselves. They are, we are told, mainly blue and

[1] *Denkmäler Persischer Baukunst*, Plate lii., Text p. 41 and Fig. 44.

[2] The same emperor showed his appreciation for Chinese ceramics by importing a number of Chinese potters into Persia. See p. 30.

white, but with a sprinkling of coloured pieces, and it is clear from the picture that they belong to various periods of the Ming dynasty, mostly to the later part. They include, no doubt, presents from the Chinese Court,[1] besides the porcelains which came in the ordinary way of trade, and we recognise a large vase almost identical with the fine Chia Ching specimen on Plate 72 : a small-mouthed, baluster-shaped vase, similar in form and decoration to a marked Wan Li specimen in the Pierpont Morgan Collection [2] ; a bowl with lotus scrolls in blotchy blue, recalling the style of Plate 67, Fig. 4 ; a ewer with the curious fountain design described on p. 67 ; besides a number of the ordinary late Ming export types and some celadon jars and bulb bowls of a slightly earlier period. Some of the pots, we are told, are almost a metre in height. Among the tantalising forms in the indistinct background are some large covered jars with a series of loop-handles on the shoulders, such as are found in Borneo and the East Indies (see vol. i., p. 189).

One of the most attractive types of late Ming export porcelain, and at the same time the most easily recognised, consists of ewers, bowls, and dishes of thin, crisp porcelain with characteristic designs in pale, pure blue of silvery tone; see Plate 77, Fig. 1. The ware is of fine, white, unctuous material with a tendency (not very marked) to turn brown at the foot rim and in parts where the glaze is wanting. The glaze partakes of the faintly greenish tinge common to Ming wares, but it is clear and of high lustre. Here, again, a little sand or grit occasionally adhering to the foot rim and radiating lines lightly scored in the base indicate a summary finish which detracts from the artistic effect no more than the obviously rapid though skilful brush-work of the decoration. Sharply moulded forms and crinkled borders, admirably suited to this thin crisp material, give additional play to the lustrous glaze, and the general feeling of the ware is well expressed by Mr. F. Perzynski [3] in his excellent study of the late Ming blue and white porcelains, in which he remarks that " the artists of this group have used thin, brittle material more like flexible metal than porcelain."

The designs as shown in the illustration are typical of the ware.

[1] It is recorded that the Emperor Wan Li sent presents of large porcelain jars to the Mogul Emperor, and it is likely that similar presents had arrived at the Persian Court.

[2] *Cat.*, Case X, No. 245, and Plate xv.

[3] *Burlington Magazine*, October, 1910, p. 40.

Wan Li (1573–1619)

A freely drawn figure of a man or woman usually in garden sur-
roundings, standing before a fantastic rock or seated by a table
and a picture-screen often form the leading motive, though this
is varied by landscape, floral compositions, spirited drawings of
birds (an eagle on a rock, geese in a marsh, a singing bird on a
bough), or a large cicada on a stone among plants and grasses. The
borders of dishes and the exteriors of bowls are divided into radiating
compartments (often with the divisions lightly moulded) filled with
figures, plant designs, symbols, and the like, and separated by
narrow bands with pendent jewels and tasselled cords, which form
perhaps the most constant characteristics of the group. Small
passages of brocade diapers with swastika fret, hexagon and matting
patterns, are used to fill up the spaces. The finer examples of this
group are of admirable delicacy both in colour and design ; but
the type lasted well into the seventeenth century and became coarse
and vulgarised. It appears in a debased form in the large dishes
which were made in quantity for the Persian and Indian markets,
overloaded with crudely drawn brocade diapers and painted in dull
indigo blue, which is often badly fired and verges on black. The
central designs on these dishes, deer in a forest, birds in marsh,
etc., usually betray strong Persian influence.

I am not aware of any specimens of this group, either of the
earlier or the more debased kinds which bear date-marks, but still
a clear indication of the period is given by various circumstances.
A bowl in the National Museum at Munich is credibly stated to have
belonged to William V., Duke of Bavaria (1579–1597),[1] and a beau-
tiful specimen, also a bowl, with silver-gilt mount of about 1585,
is illustrated by Mr. Perzynski.[2] The characteristic designs of this
ware are commonplace on the Persian pottery of the early seven-
teenth century, and a Persian blue and white ewer in the British
Museum, which is dated 1616, clearly reflects the same style. The
shallow dishes with moulded sides are frequently reproduced in the
still-life pictures by the Dutch masters of the seventeenth century,
from whose work many precious hints may be taken by the student
of ceramics. To give one instance only, there are two such pic-

[1] See *Franks Catalogue*, No. 763.

[2] *Burlington Magazine*, March, 1913, p. 310. See also *Hainhofer und der Kunst-
schrank Gustav Adolfs*, op. cit., Plate 69, where a set of dishes of India lacquer is
illustrated, each mounted in the centre with a roundel of this type of porcelain. These
dishes are mentioned in a letter dated 1628.

tures [1] in the Dresden Gallery from the brush of Frans Snyders (1579–1657).

We shall have occasion later on to discuss more fully another kind of blue and white porcelain for which the Chinese and American collectors show a marked partiality, and which has received the unfortunate title, " soft paste," from the latter. It has an opaque body, often of earthy appearance, and a glaze which looks soft and is usually crackled, and the ware is usually of small dimensions, such as the Chinese *literatus* delighted to see in his study, and beautifully painted with miniature-like touches, every stroke of the brush clear and distinct. Ming marks—Hsüan Tê, Ch'êng Hua, etc.—are not uncommon on this ware, and there is no doubt that it was in use from the early reigns of the dynasty, but the style has been so faithfully preserved by the potters of the eighteenth century that it is wellnigh impossible to distinguish the different periods. A dainty specimen with the Wan Li mark illustrated in Fig. 2 of Plate 93 will serve to show the delicacy and refinement of this exquisite porcelain. At the same time it should be mentioned that the imitation Ting wares described on p. 96, vol. i., when painted in blue, are included in this group.

Two interesting kinds of decoration mentioned in the Wan Li list [2] are frequently found in combination with blue and white ; these are relief (*ting chuang* or *tui hua*) and pierced work (*ling lung*). Though both have been seen in various forms on the earlier wares, they occur at this period in a fashion which challenges special attention. I allude particularly to the small bowls with or without covers, decorated on the sides with unglazed (or " biscuit ") figures in detached relief, or with delicately perforated fretwork, or with a combination of both. The catalogue [3] of the Pierpont Morgan Collection illustrates two covered bowls of the first type with the Eight Immortals in four pairs symmetrically arranged on the sides, and a " biscuit " lion on the cover doing duty for a handle. A similar bowl, formerly in the Nightingale Collection, had the same relief decoration and painted designs in the typical grey blue of the Wan Li period; and Fig. 3 of Plate 78 represents an excellent

[1] Numbered 1191 and 1192. A number of other painters who have introduced these Chinese porcelains into their work are named by Mr. Perzynski (*Burlington Magazine,* December, 1910, p. 169).

[2] See p. 63.

[3] C 5-7.

Fig. 1

Fig. 2

Fig. 3

Plate 78.—Porcelain with pierced (*ling lung*) designs and biscuit reliefs. Late Ming.

Fig. 1.—Bowl with Eight Immortals and pierced swastika fret. Diameter 3¾ inches. *S. E. Kennedy Collection.* Fig. 2.—Bowl with blue phœnix medallions, pierced trellis work and characters. Wan Li mark. Height 2¼ inches. *Hippisley Collection.* Fig 3.—Covered Bowl with blue and white landscapes and biscuit reliefs of Eight Immortals. Height 6½ inches. *Grandidier Collection.*

Fig. 1

Fig. 2

Fig. 3

Plate 79.—Wan Li Polychrome Porcelain.

Fig. 1.—Vase (*mei p'ing*) with engraved design, green in a yellow ground, Imperial dragons in clouds, rock and wave border. Wan Li mark. Height 15 inches. *British Museum.* Fig. 2.—Bottle with pierced casing, phœnix design, etc., painted in underglaze blue and enamels; cloisonné enamel neck. Height 23 inches. *Eumorfopoulos Collection.* Fig. 3.—Covered Jar, plum blossoms and symbols in a

example from the Grandidier collection. The Chinese were in the habit of daubing these biscuit reliefs (just as they did the unglazed details of statuettes) with a red pigment which served as a medium for oil gilding, but as neither of these coatings was fired they have worn away or been cleaned off in the majority of cases. In the Rijks Museum, Amsterdam, is a picture [1] by Van Streeck (1632-1678), which shows one of these covered bowls with the biscuit reliefs coloured red, and Mr. Perzynski [2] alludes to another in a still-life by Willem Kalf (1630-1693) in the Kaiser Frederick Museum, Berlin, with the figures both coloured [3] and gilt. An excellent example of the second kind of decoration is illustrated by Fig. 2 of Plate 78, one of a set of four bowls in the Hippisley Collection, with phœnix medallions and other decoration in a fine grey blue, the spaces filled with perforated designs of the utmost delicacy, veritable " devil's work," to borrow a Chinese term for workmanship which shows almost superhuman skill. The small pierced medallions contain the characters *fu, shou, k'ang, ning* [4] (happiness, longevity, peace, and tranquillity), and under the base are the six characters of the Wan Li mark. A line cut in the glaze (before firing) at the lip and on the base-rim seems to have been designed to give a firm hold to a metal mount, a use to which it has been actually put in one case ; and in another the glazing of the mark under the base has been omitted with the result that it has come from the kiln black instead of blue. The third kind which combines the reliefs and the pierced ornament is illustrated by Fig. 1 of Plate 78. The reliefs of these medallions are small and very delicately modelled, and the subjects are various, including human and animal figures, birds and floral compositions ; the borders are often traced in liquid clay, which is left in unglazed relief. An example in the British Museum has an interior lining washed with blue to serve as a backing for the pierced work, and it is painted inside with dragon designs in Wan Li grey blue. It bears a mark which occurs on other late Ming porcelains, *yü t'ang chia ch'i* (beautiful vessel for the Jade Hall). [5] Examples of this same

[1] *Cat.*, No. 112D.
[2] *Burlington Magazine*, December, 1910, p. 169.
[3] The figures sometimes stand out against a background coloured with washes of green, yellow and aubergine glaze. See Plate 82, Fig. 2.
[4] See p. 43.
[5] See vol. i., p. 218.

pierced and relief work in white, without the supplementary blue designs, though rare, are yet to be seen in several collections. If marked at all they usually bear the apocryphal date of Ch'êng Hua, but an example in the Marsden Perry collection, Providence, U.S.A., has the T'ien Ch'i (1621–1627) date under the base, which no doubt represents the true period of its manufacture. This intricate *ling lung* work, which the Wan Li censor deprecated as too difficult and elaborate, has been perpetuated, though it was probably never more beautifully executed than in the late Ming period. The later examples are mostly characterised by larger perforations, which were easier to manage. There are several references to the pierced and relief decorations in the lists of porcelain supplied to the Court of Wan Li, e.g. " brush rests with sea waves and three dragons in relief over pierced designs, and landscapes," " landscape medallions among pierced work," and " sacred fungus carved in openwork, and figures of ancient cash." In the finer examples of pierced work the most frequent design is the fret or key pattern often interwoven with the four-legged symbol known as the swastika, which commonly serves in Chinese for the character *wan* (ten thousand), carrying a suggested wish for " long life," as expressed in the phrase *wan sui* (Jap. *banzai*), ten thousand years. The pierced patterns are carved out of the porcelain body when the ware has been dried to a " leather-tough " consistency, and the manipulative skill exercised in the cutting and handling of the still plastic material is almost superhuman. Similar *tours de force* distinguish the Japanese Hirado porcelain, and Owen's work in our own Worcester ware exhibits extraordinary skill, but I doubt if anything finer in this style has ever been made than the *ling lung* bowls of the late Ming potters.

Another form of decoration which, if not actually included in the *ling lung* category, is at any rate closely allied to it, is the fretwork cut deeply into the body of the ware without actually perforating it, the hollows of the pattern being generally left without glaze. This ornament is used in borders or to fill the spaces between blue and white medallions after the manner of the pierced fretwork, and it was evidently contemporaneous with the latter, viz. dating from the late Ming period onwards (Plate 68, Fig. 3).

It will be convenient here to consider another type of decoration which was probably in use in the early periods of the Ming dynasty,

certainly in the reign of Wan Li, and which has continued to modern times. This is the decoration in white clay varying in thickness from substantial reliefs to translucent brush work in thin slip or liquid clay, which allows the colour of the background to appear through it. The designs are painted or modelled in white against dark or light-coloured grounds of various shades—lustrous coffee brown (*tzŭ chin*), deep blue, slaty blue, lavender, celadon, plain white, and crackled creamy white—and they are usually slight and artistically executed. The process, which is the same in principle as in the modern *pâte sur pâte*, consisted of first covering the ground with colouring matter, then tracing the design in white slip (i.e. liquid clay) or building it up with strips of clay modelled with a wet brush, and finally covering it with a colourless glaze. In this case the white design has a covering of glaze. When a celadon green ground is used the design is applied direct to the biscuit and the celadon glaze covers the whole, but being quite transparent it does not obscure the white slip beneath. Sometimes, however, as in Fig. 3 of Plate 75, the design is unglazed and stands out in a dry white " biscuit." Elaborate and beautiful examples of slip decoration were made in the K'ang Hsi and later periods, and Pére d'Entrecolles, writing in 1722, describes their manufacture, stating that steatite and gypsum were used to form the white slip.[1] The Ming specimens are usually of heavier make and less graceful form, and distinguished by simplicity and strength of design, the backgrounds being usually lustrous brown or different shades of blue. They consist commonly of bottles, jars, flower pots, bulb bowls, dishes, and narghili bowls, and many of them were clearly made for export to Persia and India, where they are still to be found. On rare examples the slip decoration is combined with passages of blue and white.

There is little to guide us to the dating of these wares, and marks are exceptional.[2] There is, however, a flower pot in the British Museum with white design of *ch'i-lin* on a brown ground which has the late Ming mark *yü t'ang chia ch'i*[3] ; and a specimen with an Elizabethan metal mount was exhibited at the Burlington Fine Arts Club in 1910.[4] These are, no doubt, of Ching-tê Chên make ; but there is a curious specimen in the British Museum which seems to be of provincial manufacture. It is a dish with slaty blue ground

[1] See p. 196. [2] I have seen occasional specimens with the Wan Li mark.
[3] See vol. i., p. 218. [4] *Cat.*, J 21.

and plant designs with curious feathery foliage traced with consider-
able delicacy. The border of running floral scroll has the flowers
outlined in dots, and the whole execution of the piece is as dis-
tinctive as the strange coarse base which shows a brown-red biscuit
and heavy accretions of sand and grit at the foot rim. The same
base and the same peculiarities of design appeared on a similar
dish with celadon glaze exhibited by Mrs. Halsey at the Burlington
Fine Arts Club in 1910,[1] and in the British Museum there are other
dishes clearly of the same make, but with (1) crackled grey white
glaze and coarsely painted blue decoration, and (2) with greenish
white glaze and enamelled designs in iron red and the Ming blue
green. It is clear that we have to deal here with the productions of
one factory, and though we have no direct clue to its identity, it
certainly catered for the export trade to India and the islands;
for the enamelled dishes of this type have been found in Sumatra.
Mrs. Halsey's dish came from India, and fragments of the blue and
enamelled types were found in the ruins of the palace at Bijapur,[2]
which was destroyed by Aurungzebe in 1686. Probably the factory
was situated in Fukien or Kuangtung, where it would be in
direct touch with the southern export trade, and the style of
the existing specimens points to the late Ming as the period of
its activity.

The process of marbling or " graining " has been tried by potters
all the world over, and the Chinese were no exceptions. The effect
is produced either by slips of two or more coloured clays worked
about on the surface, or by blending layers of clays in two or more
colours (usually brown and white) in the actual body. Early ex-
amples of this marbling occur among the T'ang wares, and Mr.
Eumorfopoulos has examples of the Ming and later periods. One
of these, a figure with finely crackled buff glaze and passages of
brown and white marbling in front and on the back, has an incised
inscription, stating that it was modelled by Ch'ên Wên-ching in
the year 1597.[3]

The use of underglaze red in the Wan Li period has already
been mentioned (p. 59), and though Chinese writers classed it as

[1] *Cat.*, A 33. In the Lymans Collection in Boston there are several examples of
this ware, including specimens with dark and light coffee brown grounds and a jar
in blue and white.

[2] A collection of these is in the British Museum, and they include many types of
late Ming export porcelains.

[3] *Cat. B. F. A.*, K 37.

chi hung they would not admit it to an equality with the brilliant reds of the fifteenth century.[1] Where red is named in the lists of Imperial porcelains we are left in doubt as to its nature, whether under or over the glaze ; but there are two little shallow bowls in the British Museum with a curious sponged blue associated with indifferent underglaze red painting, which bear the late Ming mark *yü t'ang chia ch'i*.[2] A bowl of lotus flower pattern, similar in form to that described on p. 66, but deeper, and painted with similar designs in pale underglaze red, though bearing the Ch'êng Hua mark, seems to belong to the late Ming period.

The Wan Li polychromes will naturally include continuations of the early Ming types, such as the large jars with decoration in raised outline, pierced or carved and filled in with glazes of the *demi-grand feu*—turquoise, violet purple, green and yellow—wares with flat washes of the same turquoise and purple, incised designs filled in with transparent glazes of the three colours (*san ts'ai*), green, yellow and aubergine, and, what is probably more truly characteristic of this period, combinations of the first and last styles. A good example of the transparent colours over incised designs is Fig. 1 of Plate 79, a vase of the form known as *mei p'ing* with green Imperial dragons in a yellow ground and the Wan Li mark. All three of the *san ts'ai* colours were also used separately as monochromes with or without engraved designs under the glaze, a striking example in the Pierpont Morgan Collection being a vase with dragon handles and engraved designs under a brilliant iridescent green glaze, " which appears like gold in the sunlight." [3] But though these types persisted, they would no doubt be gradually superseded by simpler and more effective methods of pictorial decoration in painted outline on the biscuit, filled in with washes of transparent enamels in the same three colours. These softer enamels, which contained a high proportion of lead and could be fired at the relatively low temperature of the muffle kiln, must have been used to a considerable extent in the late Ming period, though their full development belongs to the reign of K'ang Hsi, and there will always be a difficulty in separating the examples of these two

[1] A jar with vertical bands of ornament in a misty underglaze red of pale tint in the Eumorfopoulos collection probably belongs to this period. Though technically unsuccessful, the general effect of the bold red-painted design is most attractive.

[2] See vol. i., p. 218.

[3] *Cat.*, J 16.

periods, whether the colours be laid on in broad undefined washes, as on certain figures and on the " tiger skin " bowls and dishes, or brushed over a design carefully outlined in brown or black pigment. There is one species of the latter family with a ground of formal wave pattern usually washed with green and studded with floating plum blossoms, in which are galloping sea horses or symbols, or both, reserved and washed with the remaining two colours, or with a faintly greenish flux, almost colourless, which does duty for white. This species is almost always described as Ming ; and with some reason, for the sea wave and plum blossom pattern is mentioned in the Wan Li lists as in polychrome combined with blue decoration. But the danger of assuming a specimen to be Ming because it exhibits a design which occurred on Ming porcelain is shown by an ink pallet in the British Museum, which is dated in the thirty-first year of K'ang Hsi, i.e. 1692. This important piece (Plate 94, Fig. 2) is decorated in enamels on the biscuit over black outlines with the wave and plum blossom pattern, the same yellow trellis diaper which appears on the base of the vase in Plate 97, and other diaper patterns which occur on so many of the so-called Ming figures. This piece is, in fact, a standing rebuke to those careless classifiers who ascribe all on-biscuit enamel indiscriminately to the Ming period, and I am strongly of opinion that most of the dishes,[1] bowls, ewers, cups and saucers, and vases with the wave and plum blossom pattern and horses, etc., in which a strong green enamel gives the dominating tint, belong rather to the K'ang Hsi period. The same kind of decoration is sometimes found applied to glazed porcelain, as on Fig. 3 of Plate 79, a covered potiche-shaped vase in the British Museum with the design of " jewel mountains and sea waves," with floating blossoms, and *pa pao*[2] symbols in green, yellow and white in an aubergine ground, supplemented by a few plain rings in underglaze blue. The style of this vase and the quality of the paste suggest that it really does belong to the late Ming period.

The use of enamels over the glaze was greatly extended in the Wan Li period, though practically all the types in vogue at this time can be paralleled in the Chia Ching porcelain, and, indeed, have been discussed under that heading. There is the red family in which

[1] There is a whole case full of them in the celebrated Dresden collection, a fact which is strongly in favour of a K'ang Hsi origin for the group.

[2] Eight Precious Things. See p. 299.

the dominant colour is an iron red, either of curiously sticky appearance and dark coral tint or with the surface dissolved in a lustrous iridescence. Yellow, usually a dark impure colour, though sometimes washed on extremely thin and consequently light and transparent, and transparent greens, which vary from leaf tint to emerald and bluish greens, occur in insignificant quantity. This red family is well illustrated by a splendid covered jar in the Salting Collection (Plate 80), and by three marked specimens in the British Museum, an ink screen, a bowl, and a circular stand. It also occurs on another significant piece in the latter collection, a dish admirably copying the Ming style but marked *Shên tê t'ang po ku chih* [1] (antique made for the Shên-tê Hall), a palace mark of the Tao Kuang period (1821–1850). It should be added that this colour scheme [2] is frequently seen on the coarsely made and roughly decorated jars and dishes with designs of lions in peony scrolls, etc., no doubt made in large quantities for export to India and Persia. They are not uncommon to-day, and in spite of their obvious lack of finish they possess certain decorative qualities, due chiefly to the mellow red, which are not to be despised.

But the characteristic polychrome of the period, the *Wan Li wu ts'ai*, combines enamelled decoration with underglaze blue, and this again can be divided into two distinctive groups. One of these is exemplified by Plate 81, an Imperial vase shaped after a bronze model and of the same massive build as its fellow in blue and white, which was described on p. 67. Here the underglaze blue is supplemented by the green, the impure yellow and the sticky coral red of the period, and the subject as on the blue and white example consists of dragons and phœnixes among floral scrolls with borders of rock and wave pattern. The object of the decorator seems to have been to distract the eye from the underlying ware, as if he were conscious of its relative inferiority, and the effect of this close design, evenly divided between the blue and the enamels, is rather checkered when viewed from a distance. But both form and decoration are characteristic of the Wan Li Imperial vases, as is shown by kindred specimens, notably by a tall vase in the Pierpont Morgan Collection, of which the design is similar and the

[1] See vol. i., p. 219.

[2] The fact that the enamellers' shops at Ching-tê Chên to this day are known as *hung tien* (red shops) points to the predominance of this red family in the early history of enamelled decorations.

form even more metal-like, having on the lower part the project-
ing dentate ribs seen on square bronze and cloisonné beakers of
the Ming dynasty. Two other marked examples of this colour
scheme, from which the absence of aubergine is noteworthy, are
(1) a ewer in the British Museum with full-face dragons on the neck
supporting the characters *wan shou* (endless longevity) and with
floral sprays on a lobed body, and (2) a straight-sided box with
moulded six-foil elevation, painted on each face with a screen
before which is a fantastic animal on a stand, and a monkey,
dog and cat in garden surroundings.

The second—and perhaps the more familiar—group of *Wan Li
wu ts'ai* is illustrated by Fig. 1 of Plate 82, on which all the
colours, including aubergine, are represented in company with the
underglaze blue. There is no longer the same patchy effect, because
the blue is more evenly balanced by broader washes of the enamel
colours, particularly the greens. The design of this particular ex-
ample is a figure subject taken from Chinese history (*shih wu*),
supplemented by a brocade band of floral scroll work on the
shoulder and formal patterns on the neck and above the base.
The former and the latter positions are commonly occupied in
these vases by a band of stiff leaves and a border of false gad-
roons, both alternately blue and coloured. The stiff leaves in this
instance are replaced by floral sprays, and the coloured designs
are outlined in a red brown pigment. The mark under the base
is the " hare," which has already been noticed on examples of late
Ming blue and white.[1] Another late Ming mark, *yü t'ang chia
ch'i*,[2] occurs on a dish in the British Museum, with design of the
Eight Immortals paying court to the god of Longevity (*pa hsien
p'êng shou*), painted in the same style but with a predominance
of underglaze blue.

But it is not necessary to multiply instances, for the type is
well known, and must have survived for a long period. Indeed,
many competent authorities assign the bulk of this kind of porcelain
to the Yung Chêng period (1723–1735); and it is undoubtedly true
that imitations of Wan Li polychrome were made at this time,
for they are specifically mentioned in the Yung Chêng list of Imperial
wares.[3] But I am inclined to think that the number of these late
attributions has been exaggerated, and that they do not take suffi-
ciently into account the interval of forty-two years between the

[1] See p. 67. [2] See vol. i., p. 218. [3] See p. 224.

reigns of Wan Li and K'ang Hsi. It was a distracted time when
the potters must have depended largely upon their foreign trade in
default of Imperial orders, and it is probable that much of this
ware, characterised by strong, rather coarse make, greyish glaze and
boldly executed decoration in the Wan Li colour scheme, belongs to
this intermediate period. The vases usually have the flat unglazed
base which characterises the blue and white of this time.[1] Two
handsome beakers, with figure subjects and borders of the peach,
pomegranate and citron, and a beautiful jar with phœnix beside
a rock and flowering shrubs, in the British Museum, seem to belong
to this period, but there are numerous other examples, many of
which are coarse and crude, and obviously made wholesale for the
export trade.

Among the various examples of Wan Li polychrome exhibited
at the Burlington Fine Arts Club in 1910, there was one which
calls for special mention, a box[2] with panels of floral designs
surrounded by fruit and diaper patterns in the usual colours of
the *wu ts'ai*, with the addition of an overglaze blue enamel. It is
true that this blue enamel was clearly of an experimental nature
and far from successful, but its presence on this marked and in-
dubitable Wan Li specimen is noteworthy. For it has long been
an article of faith with collectors that this blue enamel does not
antedate the Ch'ing dynasty, being, in fact, a characteristic feature
of the K'ang Hsi *famille verte* porcelain. The rule still remains an
excellent one, and this solitary exception only serves to emphasise
its general truth, showing as it does that so far the attempts at a
blue enamel were a failure. But at the same time the discovery
is a warning against a too rigid application of those useful rules of
thumb, based on the generalisation from what must, after all, be a
limited number of instances.

Marked examples of Wan Li monochromes are rarely seen, but
we may assume that the glazes in use in the previous reigns con-
tinued to be made—blue, lavender, turquoise, violet and aubergine
brown, yellow in various shades, leaf green, emerald green, apple
green, celadon, coffee brown, and golden brown—besides the more
or less accidental effects in the mottled and *flambé* glazes. The plain
white bowls of the period had a high reputation,[3] and a good speci-
men in the British Museum, though far from equalling the Yung
Lo bowl (Plate 59), is nevertheless a thing of beauty. The white

[1] See p. 90. [2] H 17, exhibited by Mr. G. Eumorfopoulos. [3] See p. 4.

wares of the Ting type made at this time have been already dis-
cussed.[1] The monochrome surfaces were not infrequently relieved
by carved or etched designs under the glaze, but it must be con-
fessed that monochromes are exceedingly difficult to date. Particular
colours and particular processes continued in use for long periods,
and the distinctions between the productions of one reign and
the next, or even between those of the late Ming and the early
Ch'ing dynasties, are often almost unseizable. At best these
differences consist in minute peculiarities of form and potting, in
the texture of the body and glaze, and the finish of the base,
which are only learnt by close study of actual specimens and by
training the eye to the general character of the wares until the
perception of the Ming style becomes instinctive. But some-
thing further will be said on this subject in the chapter on
Ming technique.

THE LAST OF THE MINGS

T'ai Ch'ang 泰昌 (1620)

T'ien Ch'i 天啓 (1621–1627)

Ch'ung Chêng 崇禎 (1628–1643)

Chinese ceramic history, based on the official records, is silent on
the subject of the three last Ming reigns, and we are left to infer
that during the death struggles of the old dynasty and the establish-
ment of the Manchu Tartars on the throne work at the Imperial
factory was virtually suspended. The few existing specimens which
bear the marks of T'ien Ch'i and Ch'ung Chêng (the T'ai Ch'ang
mark is apparently unrepresented) are of little merit. A barrel-
shaped incense vase with floral scrolls and a large bowl with four-
clawed dragons of the former date in the British Museum are painted
the one in dull greyish blue, and the other in a bright but rather
garish tint of the same colour; both have a coarse body material
with blisters and pitting in the glaze, and the painting of the designs
is devoid of any distinction. Similarly, a polychrome saucer dish
with the same mark and in the same collection, decorated with an
engraved dragon design filled in with purple glaze in a green ground,
carries on the early tradition of that type of Ming polychrome,
but the ware is coarse, the design crudely drawn, and the colours

[1] See p. 94.

impure.[1] From the same unflattering characteristics another dish in the British Museum, with large patches of the three on-biscuit colours—green, yellow and aubergine—may be recognised as of the T'ien Ch'i make. This is a specimen of the so-called tiger skin ware, of which K'ang Hsi and later examples are known—a ware which, even in the best-finished specimens with underglaze engraved designs, is more curious than beautiful. On the other hand, one of the delicate bowls with biscuit figures in high relief, already described (p. 75), proves that the potters of the T'ien Ch'i period were still capable of skilful work when occasion demanded. A pair of wine cups in the British Museum, with freely drawn designs of geese and rice plants in pale greyish blue under a greyish glaze, are the solitary representatives of the Ch'ung Chêng mark.

In the absence of Imperial patronage, and with the inevitable trade depression which followed in the wake of the fierce dynastic struggle, it was fortunate for the Ching-tê Chên potters that a large trade with European countries was developing. The Portuguese and Spanish had already established trading connections with the Chinese, and the other Continental nations—notably the Dutch—were now serious competitors. The Dutch East India Company was an extensive importer of blue and white porcelain, and we have already discussed one type of blue and white which figures frequently in the Dutch pictures of the seventeenth century.

There is another group of blue and white which can be definitely assigned to this period of dynastic transition, between 1620–1662. A comparative study of the various blue and white types had already led to the placing of this ware in the middle of the seventeenth century, and Mr. Perzynski, in those excellent articles [2] to which we have already alluded, has set out the characteristics of this ware at some length, with a series of illustrations which culminate in a dated example. There will be no difficulty in finding a few specimens of this type in any large collection of blue and white. It is recognised by a bright blue of slightly violet tint under a glaze often hazy with minute bubbles, which suggested to Mr. Perzynski the picturesque simile of " violets in milk." Other more tangible

[1] Other saucers of this kind have a decoration of radiating floral sprays, and there are bowls of a familiar type with small sprays engraved and filled in with coloured glazes in a ground of green or aubergine purple. Some of these have a rough biscuit suggesting the late Ming period ; others of finer finish apparently belong to the K'ang Hsi period. They often have indistinct seal marks, known as " shop marks," in blue.

[2] *Burlington Magazine*, December, 1910, p. 169, and March, 1913, p. 311.

characteristics appear in the designs, which commonly consist of a figure subject—a warrior or sage and attendant—in a mountain scene bordered by a wall of rocks with pine trees and swirling mist, drawn in a very mannered style and probably from some stock pattern. Other common features are patches of herbage rendered by pot-hook-like strokes, formal floral designs of a peculiar kind, such as the tulip-like flower on the neck of Fig. 4 of Plate 82 ; the band of floral scroll work on the shoulder of the same piece is also characteristic. In many of the forms, such as cylindrical vases and beakers, the base is flat and unglazed, and reveals a good white body, and European influence is apparent in some of the shapes, such as the jugs and tankards.

As for the dating of this group, an early example of the style of painting in the Salting Collection [1] has a silver mount of the early seventeenth century, and a tankard of typical German form in the Hamburg Museum has a silver cover dated 1642. [2] There is, besides, a curious piece in the British Museum, the decoration of which has strong affinities to this group. It is a bottle with flattened circular body and tall, tapering neck, with landscape and figures on one side and on the other a European design copied from the reverse of a Spanish dollar, and surrounded by a strap-work border. The dollar, from a numismatic point of view, might have been made equally well for Philip II. (1556–1598), Philip IV. (1621–1665), or Charles II. (1665–1700), but there can be little doubt from the style of the ware that it belonged to one of the two earlier reigns.

A comparison of the ware and the blue of this group leads to the placing of the fairly familiar type illustrated by Figs. 3 and 5 of Plate 82 in the same intermediate period, and similarly certain specimens of polychrome, with underglaze blue and the usual enamels, display the characteristic body and blue painting, and even some of the decorative mannerisms. These specimens, particularly when of beaker form, are often finished off with a band of ornament engraved under the glaze.

[1] Figured in Monkhouse, op. cit., Fig. 2. The date of the mount is disputed, some authorities placing it at the end of the sixteenth century.

[2] Figured by Perzynski, *Burlington Magazine*, March, 1913. A vase of this style with tulip design in the palace at Charlottenburg has a cyclical date in the decoration, which represents 1639 or 1699 (probably the former) in our chronology.

Fig. 1

Fig. 2

Fig. 3 Fig. 4 Fig. 5

Plate 82.—Late Ming Porcelain.

Fig. 1.—Jar of Wan Li period, enamelled. Mark, a hare. Height 9 inches. *British Museum.*
Fig. 2.—Bowl with Eight Immortals in relief, coloured glazes on the biscuit. Height
3¼ inches. *Eumorfopoulos Collection.* Figs. 3, 4 and 5.—Blue and white porcelain,
early seventeenth century. Height of Fig. 5, 17 inches. *British Museum.*

Plate 83.—Vase

With blue and white decoration of rockery, phœnixes, and flowering shrubs.
Found in India. Late Ming period. Height 22 inches. *Halsey Collection.*

CHAPTER VI

THE TECHNIQUE OF THE MING PORCELAIN

ALTHOUGH the processes involved in the various kinds of decoration and in the different wares have been discussed in their several places, a short summary of those employed in the manufacture of the Ching-tê Chên porcelain during the Ming period will be found convenient. The bulk of the materials required were found in the surrounding districts, if not actually in the Fou-liang Hsien. The best kaolin (or porcelain earth) was mined in the Ma-ts'ang mountains until the end of the sixteenth century, when the supply was exhausted and recourse was had to another deposit at Wu-mên-t'o. The quality of the Wu-mên-t'o kaolin was first-rate, but as the cost of transport was greater and the manager of the Imperial factory refused to pay a proportionately higher price, very little was obtained. The material for the large dragon bowls, and presumably for the other vessels of abnormal size, was obtained from Yü-kan and Wu-yüan and mixed with powdered stone (*shih mo*) from the Hu-t'ien district. Other kaolins, brought from Po-yang Hsien and the surrounding parts, were used by the private potters, not being sufficiently fine for the Imperial wares.

The porcelain stone, which combined with the kaolin to form the two principal ingredients of true porcelain, came from the neighbourhoods of Yü-kan and Wu-yüan, where it was pounded and purified in mills worked by the water power of the mountains, arriving at Ching-tê Chên in the form of briquettes. Hence the name *petuntse*,[1] which, like kaolin, has passed into our own language, and the term *shih mo* (powdered stone) used above.

The glaze earth (*yu t'u*) in various qualities was supplied from different places. Thus the Ch'ang-ling material was used for the blue or green (*ch'ing*) and the yellow glazes, the Yi-k'êng for the pure white porcelain, and the T'ao-shu-mu for white porcelain and

[1] 白木子 *pai tun tzŭ*, white blocks.

for " blue and white." This glazing material was softened with varying quantities of ashes of lime burnt with ferns or other frondage. Neither time nor toil was spared in the preparation of the Imperial porcelains, and according to the *T'ung-ya* [1] the vessels were, at one time at any rate, dried for a whole year after they had been shaped and before finishing them off on the lathe. When finished off on the lathe they were glazed and dried, and if there were any inequalities in the covering they were glazed again. Furthermore, if any fault appeared after firing they were put on the lathe, ground smooth, and reglazed and refired.

It was not the usual custom with Chinese potters to harden the ware with a slight preliminary firing before proceeding to decorate and apply the glaze, and consequently such processes as underglaze painting in blue, embossing, etc., were undergone while the body was still relatively soft and required exceedingly careful handling. The glaze was applied in several ways—by dipping in a tub of glazing liquid (i.e. glaze material finely levigated and mixed with water), by painting the glaze on with a brush, or by blowing it on from a bamboo tube, the end of which was covered with a piece of tightly stretched gauze. One of the last operations was the finishing off of the foot, which was hollowed out and trimmed and the mark added (if it was to be in blue, as was usually the case) and covered with a spray of glaze. To the connoisseur the finish of the foot is full of meaning. It is here he gets a glimpse of the body which emerges at the raw edge of the rim, and by feeling it he can tell whether the material is finely levigated or coarse-grained. The foot rim of the Ming porcelains is plainly finished without the beading or grooves of the K'ang Hsi wares, which were evidently designed to fit a stand [2] ; and the raw edge discloses a ware which is almost always of fine white texture and close grain (often almost unctuous to the touch), though the actual surface generally assumes a brownish tinge in the heat of the kiln. The base is often unglazed in the case of large jars and vases, rarely in the cups, bowls, dishes, or wine pots, except among the coarser types of export porcelain. A little sand or grit adhering to the foot rim and radiating lines under the base caused by a jerky movement of the lathe are signs

[1] A sixteenth-century work. See p. 2.

[2] Many observers positively assert that the grooved foot rim does not occur on pre-K'ang Hsi porcelain. If this is true, it provides a very useful rule for dating ; but the rigid application of these rules of thumb is rarely possible, and we can only regard them as useful but not infallible guides.

of hasty finish, which occur not infrequently on the export wares. The importance of the foot in the eyes of the Chinese collector may be judged from the following extract from the *Shih ch'ing jih cha* [1]:—

"Distinguish porcelain by the vessel's foot. The Yung Lo 'press-hand' bowls have a glazed bottom but a sandy foot; Hsüan ware altar cups have 'cauldron' [2] bottom (i.e. convex beneath) and wire-like foot; Chia Ching ware flat cups decorated with fish have a 'loaf' centre [3] (i.e. convex inside) and rounded foot. All porcelain vessels issue from the kiln with bottoms and feet which can testify to the fashion of the firing."

It is not always easy unaided by illustration to interpret the Chinese metaphors, but it is a matter of observation that many of the Sung bowls, for instance, have a conical finish under the base, and that the same pointed finish appears on some of the early Ming types, such as the red bowls with Yung Lo mark. The "loaf centre" of the Chia Ching bowls seems to refer to the convexity described on p. 35. The blue and white conical bowls with Yung Lo mark (see p. 6) have, as a rule, a small glazed base and a relatively wide unglazed foot rim.

But this digression on the nether peculiarities of the different wares has led us away from the subject of glaze. The proverbial thickness and solidity of the early Ming glazes, which are likened to "massed lard," are due to the piling up of successive coatings of glaze to ensure a perfect covering for the body, and the same process was responsible for the undulating appearance of the surface, which rose up in small rounded elevations "like grains of millet" and displayed corresponding depressions. [4] This uneven effect, due to an excess of glaze, was much prized by the Chinese connoisseurs, who gave it descriptive names like "millet markings," "chicken skin," or "orange peel," and the potters of later periods imitated it freely and often to excess. Porcelain glazes are rarely dead white, and, speaking generally, it may be said that the qualifying

[1] Quoted in *T'ao lu*, bk. viii., fol. 6.

[2] *fu ti.*

[3] *Man hsin.*

[4] See *T'ao shuo*, bk. iii., fol. 7 verso. "Among other things the porcelain with glaze lustrous and thick like massed lard, and which has millet grains rising like chicken skin and displays palm eyes (*tsung yen*) like orange skin, is prized." The expression "palm eyes" occurring by itself in other contexts has given rise to conflicting opinions, but its use here, qualified by the comparison with orange peel and in contrast with the granular elevations, points clearly to some sort of depressions or pittings which, being characteristic of the classical porcelain, came to be regarded as beauty spots.

tint in the Ming period was greenish. Indeed, this is the prevailing tone of Chinese glazes, but it is perhaps accentuated by the thickness of the Ming glaze. This greenish tinge is most noticeable when the ware is ornamented with delicate traceries in pure white clay or slip under the glaze.

As for the shape of the various Ming wares, much has already been said in reference to the various lists of Imperial porcelains, more particularly with regard to the household wares such as dishes, bowls, wine pots, boxes, etc. No precise description, however, is given in these lists of the actual forms of the vases, and we have to look elsewhere for these. There are, however, extracts from books on vases [1] and on the implements of the scholar's table in the *T'ao shuo* and the *T'ao lu*, in which a large number of shapes are enumerated. Observation of actual specimens shows that bronze and metal work supplied the models for the more elaborate forms which would be made, partly or wholly, in moulds. These metallic forms, so much affected by the Chinese *literatus*, though displaying great cleverness in workmanship and elaboration of detail, are not so pleasing to the unprejudiced Western eye as the simple wheel-made forms of which the Chinese potter was a perfect master. Of the latter, the most common in Ming porcelains are the potiche-shaped covered jar (Plate 80) and the high-shouldered baluster vase with small neck and narrow mouth (Plate 84), which was known as *mei p'ing* or prunus jar from its suitability for holding a flowering branch of that decorative flower. Next to these, the most familiar Ming forms are the massive and often clumsy vases of double gourd shape, or with a square body and gourd-shaped neck, bottles with tapering neck and globular body, ovoid jars, melon-shaped pots with lobed sides, jars with rounded body and short narrow neck, all of which occur in the export wares. These are, as a rule, strongly built and of good white material, and if the shoulders are contracted

[1] e.g. The *P'ing shih*, the *P'ing hua p'u*, and the *Chang wu chih*, all late Ming works. An extract from the second (quoted in the *T'ao lu*, bk. ix., p. 4 verso) tells us that " Chang Tê-ch'ien says all who arrange flowers first must choose vases. For summer and autumn you should use porcelain vases. For the hall and large rooms large vases are fitting ; for the study, small ones. Avoid circular arrangement and avoid pairs. Prize the porcelain and disdain gold and silver. Esteem pure elegance. The mouth of the vase should be small and the foot thick. Choose these. They stand firm, and do not emit vapours." Tin linings, we are also told, should be used in winter to prevent the frost cracking the porcelain ; and *Chang wu chih* (quoted *ibidem*, fol. 6 verso) speaks of very large Lung-ch'üan and Chün ware vases, two or three feet high, as very suitable for putting old prunus boughs in.

(as is nearly always the case) they are made in two sections, or more in the case of the double forms, with no pains taken to conceal the seam. Indeed, elaborate finish had no part in the construction of these strong, rugged forms, which are matched by the bold design and free drawing of the decoration. I may add that sets of vases hardly come within the Ming period. They are an un-Chinese idea, and evolved in response to European demands. The mantelpiece sets of five (three covered jars and two beakers) are a development of the mid-seventeenth century when the Dutch traders commanded the market. The Chinese altar-set of five ritual utensils is the nearest approach to a uniform set, consisting as it did of an incense burner, two flower vases, and two pricket candlesticks, often with the same decoration throughout.

The Ming bowls vary considerably in form, from the wide-mouthed, small-footed bowl (*p'ieh*) of the early period to the rounded forms, such as Fig. 1 of Plate 74. In some cases the sides are moulded in compartments, and the rims sharply everted. Others again are very shallow, with hollow base and no foot rim ; others follow the shape of the Buddhist alms bowl with rounded sides and contracted mouth ; and there are large bowls for gold-fish (*yü kang*), usually with straight sides slightly expanding towards the upper part and broad flat rims, cisterns, hot-water bowls with double bottom and plug hole beneath, square bowls (Plate 66, Fig. 1) for scraps and slops, and large vessels, probably of punch-bowl form, known as " wine seas." The commonest type of Chinese dish is saucer-shaped, but they had also flat plates bounded by straight sides and a narrow rim, which has no relation to the broad, canted rim of the European plate constructed to carry salt and condiments.

The Chinese use porcelain plaques for inlaying in furniture and screens, or mounting as pictures, and there are, besides, many objects of purely native design, such as barrel-shaped garden seats for summer use, cool pillows, and hat stands with spherical top and tall, slender stems. But it was only natural that when they began to cater for the foreign market many foreign forms should have crept in, such as the Persian ewer with pear-shaped body, long elegant handle and spout, the latter usually joined to the neck by an ornamental stay : the hookah bowl : weights with wide base and ball-shaped tops for keeping down Indian mats, etc., when spread on the ground ; and at the end of the Ming period a few

European shapes, such as jugs and tankards. In the Ch'ing dynasty European forms were made wholesale.

In considering the colours used in the decoration, we naturally take first the limited number which were developed in the full heat of the porcelain furnace, the *couleurs de grand feu* of the French classification. These were either incorporated in the glazing material or painted on the porcelain body and protected by the glaze. Chief among them was blue, which we have already discussed in its various qualities. The Mohammedan blue—the *su-ni-p'o* of the Hsüan Tê period and the *hui hui ch'ing* of the reigns of Chêng Tê and Chia Ching—was an imported material of pre-eminent quality but of uncertain supply. It was supplemented—and, indeed, usually blended—with the native mineral[1] which was found in several places. Thus the *po-t'ang* blue (so called from a place name) was found in the district of Lo-p'ing Hsien in the Jao-chou Fu ; but the mines were closed after a riot in the Chia Ching period, and its place was taken by a blue known as *shih-tzŭ ch'ing* (stone, or mineral, blue) from the prefecture of Jui-chou in Kiangsi. According to Bushell[2] the *po-t'ang* blue was very dark in colour, and it was some-times known as *Fo t'ou ch'ing* (Buddha's head blue) from the tradi-tional colour of the hair of Buddha. Another material used for painting porcelain was the *hei chê shih* (black red mineral) from Hsin-chien in Lu-ling, which was also called *wu ming tzŭ*. It was evidently a cobaltiferous ore of manganese and a blue-producing mineral, doubtless the same as the *wu ming i* (nameless wonder), which we have already found in use as a name for cobalt.

Much confusion exists, in Chinese works, on the subject of these blues, and it is stated in one place that the " Buddha head blue " was a variety of the *wu ming i*, which would make the *po t'ang* blue and the *wu ming i* and the *wu ming tzŭ* one and the same thing. In effect they were the same species of mineral, and the local dis-tinctions are of no account at the present day except in so far as they explain the variety of tints in the Ming blue and white. It is, however, interesting to learn from a note on Mohammedan blue

[1] Cobalt, the source of the ceramic blues, is obtained from cobaltiferous ore of man-ganese, and its quality varies according to the purity of the ore and the care with which it is refined.

[2] *O. C. A.*, p. 263. This very dark blue recalls one of the Chia Ching types noted on page 36.

in the K'ang Hsi Encyclopædia that the native mineral, when carefully prepared, was very like the Mohammedan blue in tint.

All these blues were used either for painting under the glaze or for mixing with the glaze to form ground colours or monochromes, which varied widely in tint, according to the quantity and quality of the cobalt, from dark violet blue (*chi ch'ing*) through pale and dark shades of the ordinary blue colour to slaty blue and lavender. Some of them—notably the lavender and the dark violet blue—are often associated with crackle, being used as an overglaze covering a greyish white crackled porcelain. This treatment of the surface is well illustrated by a small covered jar in the British Museum with a dark violet blue apparently uncrackled but covering a crackled glaze. Two lavender blue bowls in the Hippisley Collection with the Chêng Tê mark are similarly crackled. Other Ming blue monochromes are a small pot found in Borneo and now in the British Museum with a dark blue of the ordinary tint used in painted wares, and a wine pot in the same collection with dragon spout and handle of a peculiar slaty lavender tint strewn with black specks, the colour evidently due to a strain of manganese in the cobalt.

Next in importance to the blue is the underglaze red derived from copper, which was discussed at length in connection with the Hsüan Tê porcelains.[1] Its various tints, described as *hsien hung* (fresh red), *pao shih hung* (ruby red), and cinnabar bowls " red as the sun," are, we may be sure, more or less accidental varieties of the capricious copper red. The same mineral produced the *sang de bœuf*, maroon and liver reds, and probably the peach bloom[2] of the K'ang Hsi and later porcelains.

Other colours incorporated in the high-fired glaze in the Ming period are the pea green (*tou ch'ing*) or celadon, and the lustrous brown (*tzŭ chin*) which varied from coffee colour to that of old gold. Both of these groups derived their tint from iron oxide, carried in the medium of ferruginous earth. The use of two or more of these coloured glazes on one piece is a type of polychrome which was doubtless used on the Ming as on the later porcelains.

The glazes fired at a lower temperature, in the cooler parts of the great kiln, and known for that reason as *couleurs de demi-grand feu*, include turquoise (*ts'ui sê*), made from a preparation of old copper (*ku t'ung*) and nitre ; bright yellow (*chin huang*), composed

[1] See p. 10. [2] But see p. 177.

of $1\frac{1}{5}$ oz. of antimony mixed with 16 oz. of pulverised lead ; bright green (*chin lü*), composed of $1\frac{2}{5}$ oz. of pulverised copper, 6 oz. of powdered quartz and 16 oz. of pulverised lead ; purple (*tzŭ sê*), composed of 1 oz. of cobaltiferous ore of manganese, 6 oz. of powdered quartz and 16 oz. of pulverised lead. These colours, melting as they did at a lower temperature than that required to vitrify the porcelain body, had to be applied to an already fired porcelain " biscuit." [1]

The irregular construction of the Chinese kilns resulted in a great variety of firing conditions, of which the Chinese potter made good use ; so that, by a judicious arrangement of the wares, glazes which required a comparatively low temperature were fired in the same kiln as those which needed the same heat as the porcelain body itself. The glazes just enumerated are familiar from the large covered jars, vases, garden seats, etc., with designs raised, carved, or pierced in outline, many of which date from the fifteenth century.[2] Their manufacture continued throughout the Ming period, both in porcelain and pottery, and in the latter, at any rate, continued into the Ch'ing dynasty.

Another group of glazes applied likewise to the biscuit and fired in the temperate parts of the kiln differs from the last mentioned in its greater translucency.[3] These are the *san ts'ai* or three colours, viz. green, yellow and aubergine, all of which contain a considerable proportion of lead, and differ little in appearance from the on-glaze enamels of the muffle kiln. They were used either as monochromes, plain or covering incised designs, or in combination to wash over the spaces between the outlines of a pattern which had been incised or painted on the biscuit.

Finally, the enamels of the *Wan li wu ts'ai*,[4] overglaze colours used in addition to underglaze blue, were composed of a vitreous flux coloured with a minute quantity of metallic oxide. The flux, being a glass containing a high percentage of lead, was fusible at such a low temperature that it was not possible to fire them in the large kiln. Consequently these enamels were painted on to the finished glaze, a process which greatly increased the freedom of

[1] *Biscuit* is the usual term for a fired porcelain which has not been glazed.

[2] See p. 17.

[3] It has been suggested by Mr. Joseph Burton that the opacity of the colours described in the preceding paragraphs may have been due to the addition of porcelain earth to the glazing material.

[4] See p. 82.

design, and fired in a small " muffle " or enameller's kiln, where the requisite heat to melt the flux and fix the colours could be easily obtained.

Though the *T'ao shuo*, in the section dealing with Ming technique, makes a general allusion to painting in colours on the glaze, the only specific reference to any colour of the muffle kiln, excepting gold, is to the red obtained from sulphate of iron (*fan hung sê*). This, we are told, was made with 1 oz. of calcined sulphate of iron (*ch'ing fan*) and 5 oz. of carbonate of lead, mixed with Canton ox-glue to make it adhere to the porcelain before it was fired. This is the iron red, the *rouge de fer* of the French, which varies in tint from orange or coral to deep brick red, and in texture from an impalpable film almost to the consistency of a glaze, according to the quantity of lead flux used with it. On the older wares it is often deeply iridescent and lustrous, owing to the decomposition of the lead flux. This *fan hung* is the colour which the Chia Ching potters were fain to substitute for the underglaze copper red (*chi hung*) when the usual material for that highly prized colour had come to an end, and difficulty was experienced in finding an effective substitute.

The remaining colours of the on-glaze palette are more obviously enamels ; that is to say, glassy compounds ; and as they were, in accordance with Chinese custom, very lightly charged with colouring matter, it was necessary to pile them on thickly where depth of colour was required.

Hence the thickly encrusted appearance of much of the Chinese enamelled porcelain. The Wan Li enamels consisted of transparent greens of several shades (all derived from copper), including a very blue green which seems to have been peculiar to the Ming palette, yellow (from antimony) pale and clear or brownish and rather opaque, and transparent aubergine, a colour derived from manganese and varying in tint from purple to brown. Two thin dry pigments—one an iron red and the other a brown black colour derived from manganese—were used for drawing outlines ; and the brown black was also used in masses with a coating of transparent green to form a green black colour, the same which is so highly prized on the *famille noire* porcelains of the K'ang Hsi period. As for the blue enamel of the K'ang Hsi period, it can hardly be said to have existed before the end of the Ming dynasty.[1]

[1] See, however, p. 85.

Gilding, which was apparently in use throughout[1] the Ming period, was applied to the finished porcelain and fired in the muffle kiln. The gold leaf, combined with one-tenth by weight of carbonate of lead, was mixed with gum and painted on with a brush. The effect, as seen on the red and green bowls (Plate 74), was light and filmy, and though the gold often has the unsubstantial appearance of size-gilding, in reality it adheres firmly[2] and is not easily scratched.

Of the other processes described in the *T'ao shuo*,[3] embossed (*tui* 堆) decoration was effected by applying strips or shavings of the body material and working them into form with a wet brush. Some of the more delicate traceries, in scarcely perceptible relief, are painted in white slip. Engraved (*chui* 錐) decoration was effected by carving with an iron graving-tool on the body while it was still soft. And so, too, with the openwork (*ling lung*), which has already been described.[4] All these processes were in use in one form or another from the earliest reigns of the Ming dynasty, and some of them, at any rate, have been encountered on the Sung wares. High reliefs, such as the figures on the bowls described on p. 74, would be separately modelled and " luted " on by means of liquid clay ; and, as already noted, these reliefs were often left in the biscuit state, though at times we find them covered with coloured glazes. It is hardly necessary to add that the same processes were applied to pottery, and that the reliefs took many other forms besides figures, e.g. dragon designs, foliage, scrollwork, symbols, etc.

The crackled glazes of the Sung period were still made, though the Ming tendency was to substitute painted decoration for monochrome ; and we have already noted the crackled blue and lavender in which a second glaze is added to a grey white crackle. This process is particularly noticeable in the " apple green " monochromes (Plate 85), both of the Ming and Ch'ing dynasties, in which a green overglaze itself uncrackled is washed on to a crackled stone grey porcelain. The green is often carried down over the slightly browned biscuit of the foot rim, forming a band of brown. But

[1] See p. 2.

[2] The *T'ao lu* (bk. ix., fol. 17 verso) quotes an infallible method for fixing the gold on bowls so that it would never come off ; it seems to have consisted of mixing garlic juice with the gold before painting and firing it in the ordinary way.

[3] Loc. cit., and Bushell, *O. C. A.*, p. 268.

[4] See p. 75.

this, so far from being a peculiarity of the Ming technique, is much more conspicuous on the porcelains of the early eighteenth century, when it was the constant practice to dress the foot rim of the crackled wares with a brown ferruginous earth in imitation of the " iron foot " of their Sung prototypes.

The work at the Imperial factory [1] was divided between twenty-three departments, nine of which were occupied with accessories, such as the making of ropes and barrels, general carpentry, and even boat building. Five separate departments were employed in making the large bowls, the wine cups, the plates, the large round dishes, and the tea cups ; another in preparing the " paste " or body material, and another in making the " seggars " or fireclay cases in which the ware was packed in the kiln. Five more were occupied in the details of decoration, viz. the mark and seal department, the department for engraving designs, the department for sketching designs, the department for writing, and the department for colouring.

It does not appear that the work of decoration was so minutely subdivided in the Ming period as in later times, when we are told that a piece of porcelain might pass through more than seventy hands ; but it is clear, at least, that the outlining and filling in of the designs were conducted in separate sheds. This is, indeed, self-apparent from the Ming blue and white porcelains, the designs of which are characterised by strong and clear outlines filled in with flat washes of colour.

With regard to the actual designs, we are told that in the Ch'êng Hua period they were drawn by the best artists at the Court, and from another passage [2] it is clear that the practice of sending the patterns from the palace continued in later reigns as well. Such designs would no doubt accumulate, and probably they were collected together from time to time and issued in the form of pattern books. [3] Another method in which the painters of Ming blue and white were served with patterns is related in the *T'ao shuo* [4] :—
" For painting in blue, the artists were collected each day at dawn and at noon, and the colour for painting was distributed among

[1] See *T'ao shuo*, bk. iii., fol. 10 verso.

[2] See p. 55.

[3] e.g. The *Chieh tzŭ yüan ma chuan* of the K'ang Hsi period, mentioned by Perzynski, *Burlington Magazine*, March, 1913, p. 310.

[4] Bushell's translation, op. cit., p. 71.

them. Two men of good character were first selected, the larger pieces of porcelain being given to one, the smaller pieces to the other; and when they had finished their painting, the amount of the material used was calculated before the things were taken to the furnace to be baked. If the results were satisfactory, then the pieces were given as models to the other painters, and in the rest of the pieces painted, the quantity of the colour used and the depth of the tint was required to be in exact accordance with these models." There was little scope for originality or individual effort under this system, where everything, even to the amount of material used, was strictly prescribed. To translate their model with feeling and accuracy was the best that could be expected from the rank and file. But with the manual skill and patient industry for which the Chinese are proverbial, and the good taste which prevailed in the direction of the work, it was a system admirably suited to the task, and it unquestionably led to excellent results.

As to the systems in use in the private factories we have no information, but we may fairly assume that their processes were much the same; and that, not having the benefit of the designs sent from Court, they were more dependent upon the pattern books and stock designs more or less remotely connected with the work of famous painters.

CHAPTER VII

MISCELLANEOUS PORCELAIN FACTORIES

ALTHOUGH from the Ming period onwards our interest is almost entirely centred in Ching-tê Chên, there were other factories which cannot be altogether ignored. A certain number have already been mentioned at the end of the first volume, our scanty information being drawn chiefly from the pottery section of the K'ang Hsi Encyclopædia. The same monumental work includes in another part[1] a discourse on porcelain (*tz'ŭ ch'i*), in which several additional factories are named. The passage in question is prefaced by a quotation from the *T'ien kung k'ai wu*, a late-seventeenth century manual, in which we are told that the white earth (*o t'u* [2]) necessary for the manufacture of fine and elegant ware was found in China in five or six places only[3] : viz. at Ting Chou, in the Chên-ting Fu in Chih-li, at Hua-ting Chou in the Ping-liang Fu in Shensi, at P'ing-ting Chou in the T'ai-yüan Fu in Shansi, and at Yü Chou in the K'ai-fêng Fu in Honan, in the north; and at Tê-hua Hsien in the Ch'üan-chou Fu in Fukien, at Wu-yüan Hsien and Ch'i-mên Hsien in the Hui-chou Fu, in Anhui, in the south. As to the wares made in these localities, we are told that the porcelains of the Chên-ting and K'ai-fêng districts were generally yellow and dull and without the jewel-like brilliancy, and that all put together were not equal to the Jao Chou ware. It would appear, then, that the Ting Chou factories so noted in Sung times were still extant, though they had lost their importance. For the rest, the Ch'i-mên district supplied Ching-tê Chên with the raw material, the Tê-hua wares will be discussed presently, and we have no information about the productions (if any) of the other localities.

[1] *Ku chin fu shu chi ch'êng*, section xxxii., bk. 248, section entitled *tz'ŭ ch'i pu hui k'ao*, fol. 13 verso.

[2] 堊土.

[3] The supplies of porcelain earth in the immediate district of Jao Chou Fu were exhausted by this time.

The province of Fukien apparently contained several factories besides the important centre at Tê-hua. The Annals of Ch'üan-chou Fu (celebrated as a trading port in the Middle Ages), for instance, are quoted with reference to a porcelain (*tz'ŭ ch'i*) manufacture at Tz'ŭ-tsao in the Chin-chiang Hsien, and three other places in the district of An-ch'i are named as producers of white porcelain which was inferior to that of Jao Chou. Similarly, the Annals of Shao-wu Fu, on the north-east border of the province, allude to white porcelain made at three places,[1] the factory at T'ai-ming in An-jen being the best, but all were far from equalling the Jao Chou ware.

The district of Wên-chou Fu (formerly in the south of Fukien but now transferred to northern Chekiang) was noted for pottery in the distant days of the Chin dynasty (265–419 A.D.), and for the " bowls of Eastern Ou." [2] Of its subsequent ceramic history we have no information, but there is an interesting specimen in the British Museum which seems to bear on the question. It is an incense burner in the form of a seated figure of the god of Longevity on a deer, skilfully modelled in strong white porcelain and painted in a good blue in the Ming style ; and on the box in which it came was a note to the effect that it is Wên-chou ware. If there is any truth in this legend (and it would be quite pointless if untrue), then a blue and white porcelain in the style of the better class of Ming export ware was made at Wên-chou.

Another interesting specimen in the same museum, which should also be mentioned here, is a bottle with wide straight neck, of fine white ware thickly potted, with soft, smooth-worn glaze painted in a greyish blue with a medley of flowers, fruit, insects, and symbols, completed by borders of *ju-i* heads and stiff leaves. It is marked under the base in a fine violet blue, *fu fan chih ts'ao*, which, rendered "made on the borders of Fukien," might refer to the factories at Shao-wu Fu or even Wên-chou Fu. This is another piece which has many affinities with the late Ming export blue and white.

But the Fukien porcelain *par excellence* is a white ware of distinctive character and great beauty which was and still is made

[1] The others were the Ch'ing-yün factory at Ssŭ-tu, and the Lan-ch'i factory in the Chien-ning district. The latter district was mentioned in vol. i., p. 130, in connection with the hare's fur bowls of the Sung period.

[2] See vol. i., p. 17.

at Tê-hua Hsien, in the central part of the province.[1] This is the *blanc de Chine* of the French writers and the modern Chien yao of the Chinese, but to be carefully distinguished from the ancient Chien yao with mottled black glaze which was made in the Sung dynasty at Chien-yang in the north of the province.[2] The *T'ao lu*[3] informs us that the porcelain industry at Tê-hua began in the Ming dynasty, that the cups and bowls usually had a spreading rim, that the ware was known as *pai tz'ŭ* (white porcelain), that it was rich and lustrous but, as a rule, thick, and that the images of Buddha were very beautiful. This condensed account is supplemented by a few remarks in the K'ang Hsi Encyclopædia,[4] from which we gather that the material for the ware was mined in the hills behind the Ch'êng monastery and that it was very carefully prepared, but if the porcelain was worked thin it was liable to lose shape in the kiln, and if it was too thick it was liable to crack. At first it was very expensive, but by the time of writing (about 1700) it was widely distributed and no longer dear.

Tê-hua porcelain is, in fact, a fine white, highly vitrified material, as a rule very translucent and covered with a soft-looking, mellow glaze which blends so intimately with the body that they seem to be part and parcel of one another. The glaze varies in tone from ivory or cream white to the colour of skim milk, and its texture may be aptly described by the homely comparison with blancmange. When the ivory colour is suffused by a faint rosy tinge, it is specially prized; but I can find no reason for supposing that the cream white and milk white tints represent different periods of the ware. On the contrary, there is good evidence to show that they were made concurrently.

As the ware is with few exceptions plain white or white decorated with incised, impressed, moulded, or applied ornaments of a rather formal and often archaic character, there will always be a difficulty in determining the date of the finer specimens, viz. whether they are Ming or early Ch'ing. The nature of the ware itself is a most uncertain guide, for one of the most beautiful examples of the material which I have seen is a figure of a European soldier which

[1] Tê-hua was formerly included in the Ch'üan-chou Fu, but is now in the Yungch'un Chou.
[2] See vol. i., p. 131.
[3] Bk. vii., fol. 13 verso.
[4] Loc. cit.

cannot be older than 1650. I need hardly say that owners of Fukien porcelain, particularly of the figures, habitually give themselves the benefit of this ever present doubt, and that these pieces are usually listed in sale catalogues as Ming or early Ming according to taste. This attitude is fundamentally illogical, for the ware is still made at the present day, and the Ming specimens in modern collections are likely to be the exception, and not, as optimistic owners would lead one to suppose, the rule. But in any case it will be more convenient to deal with the ware as a whole in the present chapter than to attempt the difficult task of treating its different periods separately, even though the bulk of our examples belong to the Ch'ing dynasty.

Tê-hua porcelain can be conveniently studied in the British Museum, where there is a fairly representative collection comprising more than a hundred specimens. It includes a number of the figures for which the factories were specially noted, of deities and sages such as Kuan-yin, goddess of Mercy; Kuan-yü, god of War; Bodhidharma, the Buddhist apostle; Manjusri, of the Buddhist Trinity; Hsi-wang-mu, the Taoist queen of the west; the Taoist Immortals; besides small groups representing romantic or mythological subjects such as Wang Chih watching the two spirits of the pole stars playing chess. But the favourite subject of the Tê-hua modeller was the beautiful and gracious figure of Kuan-yin, represented in various poses as standing on a cloud base with flowing robes, seated in contemplation on a rocky pedestal, or enthroned between her two attributes, the dove—which often carries a necklace of pearls—and the vase of nectar, while at her feet on either side stand two diminutive figures representing [1] her follower Lung Nü (the dragon maid), holding a pearl, and the devoted comrade of her earthly adventures Chên Tsai. The Kuan-yin of this group is reputed to have been the daughter of a legendary eastern King named Miao-chuang, but other accounts make the deity a Chinese version of the Buddhist Avalokitesvara, and it is certain that her representations as the Kuan-yin with eleven heads and again with a " thousand " hands reflect Indian traditions. In the latter manifestations the sex of the deity is left in doubt, but there can be no question on that head when she is represented with a babe in her arms as " Kuan-yin the Maternal," to whom childless women pray, a figure strangely

[1] According to de Groot, *Annales du Musée Guinet*, vol. xi., p. 195.

resembling our images of the Virgin and Child. Indeed, we are told [1] that the Japanese converts to Christianity in the sixteenth century adopted the Kuan-yin figure as a Madonna, and that there is in the Imperial Museum in the Ueno Park, Tokio, a remarkable collection of these images among the Christian relics. There is, however, another deity 'with whom this Kuan-yin may easily be confounded, viz. the Japanese Kichimojin, also " the Maternal," the Sanskrit Hâriti, who was once the devourer of infants but was converted by Sakyamuni and was afterwards worshipped as the protector of children. This deity figures in Japanese pictorial art as a " female holding a peach and nursing in her bosom an infant, whose hands are folded in prayer. In front stand two nude children, one of whom grasps a peach, the other a branch of bamboo." [2]

Among the Tê-hua porcelains in the British Museum are no fewer than nine specimens—groups, figures, or ornamental structures— with figures in European costumes which date from the middle to the end of the seventeenth century. One, a soldier apparently Dutch, about 1650, is well modelled in deliciously mellow and translucent cream white porcelain. Most of the others are more roughly designed, and vary in tint from cream to milk white.

It is said that the natives of the Fukien province are among the most superstitious of the Chinese, and Bushell [3] sees a reflection of this religious temperament in the nature of the Tê-hua wares. If this is so, they must have had exalted opinions of their European visitors, whom they often furnish with the attributes of Chinese divinities, representing them in positions and poses which seem to caricature native deities and sages. There is, for instance, an ornament in form of a mountain retreat with a shrine in which is seated a figure in a three-cornered European hat and a Buddha-like attitude. Another group consists of a European mounted on a *ch'i-lin*, posing as an Arhat, and another of a European standing on a dragon's head which would symbolise to the Chinese the attainment of the highest literary honours.

There are, besides, in the British Museum collection figures of animals and birds, the Buddhist lion, the cock, the hawk, or the

[1] Brinkley, *China and Japan*, vol. ix., p. 274.

[2] See W. Anderson, *Catalogue of the Japanese and Chinese Paintings in the British Museum*, p. 75.

[3] *O. C. A.*, p. 628.

parrot, mostly fitted with tubes to hold incense sticks; and there are a pair of well modelled figures of Chou dogs.

As for the vessels of Tê-hua porcelain, they consist chiefly of incense vases and incense burners, libation cups shaped after bronze or rhinoceros horn models, brush pots, wine cups, water vessels for the study table and the like (often beautifully modelled in the form of lotus leaves or flowers), boxes, tea and wine pots, cups and bowls, and more rarely vases.

An extensive trade was done with the European merchants, whose influence is apparent in many of the wares, such as coffee cups with handles, mugs of cylindrical form or globular with straight ribbed necks in German style, and "barber-surgeons' bowls" with flat pierced handles copied from silver models. Indeed, the superficially European appearance of some of these pieces has led serious students to mistake them for early Meissen porcelain and even for that nebulous porcelain supposed to have been made by John Dwight, of Fulham, at the end of the seventeenth century. Père d'Entrecolles [1] incidentally mentions the fact that some Ching-tê Chên potters had in the past removed to Fukien in the hope of making profits out of the European traders at Amoy, and that they had taken their plant and even their materials with them, but that the enterprise was a failure.

Conversely, the influence of the Tê-hua wares is obvious in many of the early European porcelains, such as those made at Meissen, St. Cloud, Bow, and Chelsea, which were often closely modelled on the Fukien white. There is, indeed, a striking similarity between the creamy soft-paste porcelain of St. Cloud and the creamy variety of the *blanc de chine*, both having the same mellow, melting appearance in the glaze.

It would be possible to guess from these European copies, if we had no other means, the character of the Tê-hua porcelain of the K'ang Hsi period with its quaintly moulded forms, its relief decoration of prunus sprigs, figures of Immortals, deer, etc., the only conspicuously absent type being the incised [2] ornament which was unsuited to the European ware. But there is no lack of actual

[1] In the letter dated from Jao Chou, September, 1712, loc. cit.

[2] Incised designs on Fukien wares consist of the ordinary decoration etched in the body of the ware and of inscriptions which have evidently been cut through the glaze before it was fired. The latter often occur on wine cups, and are usually poetical sentiments or aphorisms, e.g. "In business be pure as the wind"; "Amidst the green wine cups we rejoice."

Fig. 2

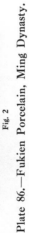

Fig. 3

Fig. 1

Plate 86.—Fukien Porcelain, Ming Dynasty.

Fig. 1.—Figure of Kuan-yin with boy attendant. Ivory white. Height 10¼ inches. *Eumorfopoulos Collection.* Fig. 2.— Bottle with prunus sprigs in relief, the glaze crackled all over and stained a brownish tint. Height 9⅛ inches. *Eumorfopoulos Collection.* Fig. 3.—Figure of Bodhidharma crossing the Yangtze on a reed. Ivory white. Height 7½ inches. *Salling Collection (V. & A. Museum).*

Fig. 1

Fig. 2

Fig. 3

Plate 87.—Ivory White Fukien Porcelain.

Fig. 1.—Libation Cup. About 1700. Length $3\frac{7}{8}$ inches. *British Museum.*
Fig. 2.—Cup with sixteenth-century mount. Height 2 inches. *Dresden
Collection.* Fig. 3.—Incense Vase and Stand. About 1700. Diameter
$6\frac{3}{4}$ inches. *British Museum.*

specimens of the period of active export which extended from about 1650–1750. Naturally they vary greatly in quality, which depends on the purity and translucence, of the ware whether it be cream or milk white, and on the soft aspect and rich lustre of the glaze. A large series, which may be taken as representative of the K'ang Hsi period, was collected by Augustus the Strong, and is still to be seen at the Johanneum at Dresden ; or, rather, part of it is still there, for much of that historic collection was given away or pilfered from time to time, and many specimens with the Dresden cata-logue numbers engraved are now to be found in our own museums. Many of the figures at Dresden have evidently been coated with a kind of black paint, which probably served as a medium for oil gilding, but this unfired colouring has worn away, and only traces now remain.

Occasionally one finds among the Tê-hua wares a specimen with dry appearance and crazed or discoloured glaze, defects due to faulty firing or to burial in damp soil. Such pieces are surprising in a ware with such apparent homogeneity of body and glaze, and the crazed examples might be easily mistaken for one of the *t'u ting* (or earthy Ting ware) types.

As to the history of the factories, it is expressly stated in the *T'ao lu* that they were started in the Ming dynasty. No account need be taken of the few legendary specimens to which tradition assigns an earlier origin than this, such as the so-called flute of Yoshitsune, a twelfth-century hero of Japan, and the incense burner in St. Mark's, Venice, which is reputed to have been brought from China by Marco Polo. The latter is of the same model as Fig. 3 of Plate 87, perhaps from the same mould, and I have seen at least half a dozen others in London. A third piece which was long re-garded as a document is the jewelled white plate in the Dresden collection, supposed to have been brought back from Syria by a Crusader in the twelfth century. The story is no doubt apocryphal, but in any case it has no real bearing on the question, for the plate is not Fukien ware but a specimen of white Ching-tê Chên porcelain with a " shop mark " in underglaze blue. It has been set with jewels in India or Persia, like a sixteenth-century bowl in the British Museum, but the " Crusader plate " is probably a century later.

Brinkley [1] asserts, without giving any authority, that the Tê-hua industry was virtually discontinued at the end of the eighteenth

[1] *Japan and China*, vol. ix., p. 273.

century, and revived in recent years. The latter part of the state-
ment is unquestionably true, for we have the eye-witness of a
missionary [1] who visited the place about 1880 and describes the
manufactory as the most extensive of its kind in Fukien—" pottery,
pottery everywhere, in the fields, in the streets, in the shops. In
the open air children are painting the cups. Each artist paints
with his own colour and his own few strokes, whether a leaf, a tree,
a man's dress or beard, and passes it over to his neighbour, who
in turn applies his brush to paint what is his share in the decoration."
Unfortunately there is no reason to suppose that the writer made
his observations with an expert eye which would make a distinction
between pottery and porcelain, but in any case it is certain that
he found a vast ceramic industry in full blast at Tê-hua.

With reference to the modern ware Brinkley says [2] : " A con-
siderable number of specimens are now produced and palmed off
upon unwary collectors. But the amateur can easily avoid such
deceptions if he remembers that in genuine pieces of ivory white
the ware is always translucid when held up to the light, a property
which, if not entirely absent, is only possessed in a comparatively
slight degree by the modern product. The general quality of the
glaze and the technique of a piece should be sufficient guides, but
if any doubt remains an examination of the base of the specimens
will probably dispel it. In the old ware the bottom of a vase or
bowl, though carefully finished, is left uncovered, whereas the
modern potter is fond of hiding his inferior pâte by roughly over-
spreading it with a coat of glaze."

Probably these observations are in the main correct, but experi-
ence shows that relative opacity and glazed bases are by no means
confined to modern wares. Still, if the collector aims at acquiring
pieces of good colour, whether cream or milk white, with translucent
body, pure glaze and sharp modelling, he is not likely to go far
astray.

The description quoted above of the painting of modern Fukien
ware is interesting in view of the common assertion that the Tê-hua
white porcelain was never painted. This assertion is probably based
on a passage in the first letter of Père d'Entrecolles : " Celle (i.e.
la porcelaine) de Fou-kien est d'un blanc de neige qui n'a nul éclat

[1] *Everyday Life in China, or Scenes in Fukien*, by E. J. Dukes, London, 1885,
p. 140. The reference is given by Bushell in his *Oriental Ceramic Art*.

[2] Loc. cit., p. 273.

et qui n'est point mélangé de couleurs." On the other hand, a distinct reference is made to the painting in colours in a modern Chinese work.[1] Unfortunately, the question has been complicated by the existence of many pieces of Fukien white which have been enamelled in Europe. In the first half of the eighteenth century in Holland, Germany, and elsewhere, there were decorators busy enamelling white porcelain of whatever kind they could get, and the *blanc de chine* offered a ready subject for this treatment. The decoration thus added was usually in Oriental taste, and might be confused with indifferent Chinese work. Many of these pieces are in the British Museum. On the other hand, there are in the same collection two cups with roughly painted floral designs in green and red which are obviously Chinese, though they might well have been painted in the mechanical method described by Mr. Dukes, which was probably traditional. Mr. Eumorfopoulos possesses several good examples of this painted Fukien ware, one of which may be described to show the style of painting affected. It is executed in leaf green, lustrous red, and the turquoise green which we associate with the Wan Li period, and the form— a double-bottomed bowl—is likewise reminiscent of the Ming dynasty.

The Japanese, whose traditions have often proved most misleading, have frequently classed the Fukien white as Corean porcelain (*haku-gorai* or white Corean), probably because specimens reached them from the Corean ports. In the British Museum, for instance, there is a beautiful white incense vase, formerly in the collection of Mr. Ninagawa of Tokio, and labelled by him as " Corean porcelain, 500 years old." It has all the characteristics of the finest cream white Fukien ware of late Ming or K'ang Hsi period, and if this piece is Corean, then I do not believe that even the subtle perception of the Japanese could find any difference between Corean and Fukien white. It is only right to add that other Japanese experts have pronounced it Chinese. Incidentally, I may mention that the base of this vase is glazed.

Marks were occasionally used by the Tê-hua potters, either

[1] The *Li t'a k'an k'ao ku ou pien*, a copy of which, published in 1877, is in the British Museum. This book does not inspire confidence, but I give the passage for what it is worth : " When the glaze (of the Chien yao) is white like jade, glossy and lustrous, rich and thick, with a reddish tinge, and the biscuit heavy, the ware is first quality . . Enamelled specimens (*wu ts'ai*) are second rate."

incised or stamped in seal form,[1] on the bottoms of cups and other vessels, and on the backs of figures. Reign marks are rare, but apocryphal dates of the Hsüan Tê period occasionally occur, as on a figure of Li T'ieh-kuai in the British Museum. Others consist of potters' marks too often illegible because the thick glaze has filled up the hollows of the stamps, fanciful seal marks, frets, whorls, and occasionally the swastika symbol. A few examples are given in vol. i., p. 222.

[1] In the Pierpont Morgan collection (vol. i., p. 78), a specimen with a blue mark is described as Fukien porcelain ; but I should accept the description with the greatest reserve, white Ching-tê Chên ware being very often wrongly described in this way.

CHAPTER VIII

THE CH'ING 清 DYNASTY, 1644–1910

THE reigns of the Manchu chieftains T'ien Ming, T'ien Tsung, and Ts'ung Tê (1616–1643) are included in the chronology of the Ch'ing or Pure Dynasty, but it is more usual to reckon that period from 1644, when the Emperor Shun Chih 順治 was firmly established on the throne after the suicide of the last of the Mings. Little is known of the ceramic history of the seventeen years during which Shun Chih occupied the throne. The official records which deal only with the Imperial factory are almost silent, and when they do speak it is merely to chronicle failures. It is clear, however, that the Imperial factory at Ching-tê Chên had again been opened; for orders were sent in 1654 for a supply of large "dragon bowls" for the palace gardens. They were to be 2½ feet high, 3½ feet in diameter, 3 inches thick at the sides, and 5 inches at the bottom. For four years the potters wrestled with this difficult order without success. This time there was no "divine T'ung" to purchase success by a holocaust of himself; and eventually the Emperor was persuaded to withdraw the command. No better fortune attended an order given in 1659 for oblong plaques (3 feet by 2½ feet, and 3 inches thick) which were intended for veranda partitions.

Beyond these two negative items there is no information of the reign of Shun Chih in the Chinese books, and the porcelain itself is scarcely more illuminating, for authentic marked examples of this period are virtually unknown. A figure already mentioned as bearing the date 1650 belongs rather to the pottery section, but it shows that the traditions of the Ming glazes of the *demi-grand feu* were still kept alive. The blue and white and the polychrome made in the private factories at this time have been discussed with the transition wares (pp. 89 and 90), and for the rest we can only assume that the Shun Chih porcelains are not to be distinguished from those of the last Ming reigns

on the one hand, and those of the early years of K'ang Hsi on the other.

Reflecting on the insignificance of the Shun Chih porcelains, one is tempted to ask how it is that the celebrated Lang T'ing-tso, whose name is usually associated with the beautiful Lang yao of the K'ang Hsi period, did not succeed in raising the wares of this period to a more conspicuous level. Lang T'ing-tso was governor of Kiangsi from 1654 and viceroy of Kiangsi and Kiangnan from 1656–1661 and again from 1665–1668. His name is mentioned (according to Bushell,[1] at any rate, for I have not been able to verify the statement) in connection with the efforts to make the dragon bowls for the palace in 1654 ; but we shall return to this point in discussing the Lang yao.

Meanwhile, we pass to the reign of K'ang Hsi 康熙 (1662–1722), the beginning of what is to most European collectors the greatest period of Chinese porcelain, a period which may be roughly dated from 1662–1800. Chinese literary opinion gives the preference to the Sung and Ming dynasties, but if monetary value is any indication the modern Chinese collector appreciates the finer Ch'ing porcelains as highly as the European connoisseur. These latter wares have, at any rate, the advantage of being easily accessible to the Western student, and they are not difficult to obtain provided one is ready to pay the high price which their excellence commands. It will be no exaggeration to say that three quarters of the best specimens of Chinese porcelain in our collections belong to this prolific period, and they may be seen in endless variety in the museums and private galleries of Europe and America, nowhere perhaps better than in London itself.

With regard to the porcelains made in the early years of K'ang Hsi there is very little information, and their special excellence has been assumed mainly on the supposition that the Viceroy Lang T'ing-tso exercised a beneficent influence on the wares of this period. He is reputed to have been sponsor of the Lang yao, which in the ordinary acceptation of the term[2] includes the beautiful

[1] *O. C. A.*, p. 294.

[2] In the second volume of the Pierpont Morgan catalogue—which, unfortunately, had not the benefit of Dr. Bushell's erudition—the late Mr. Laffan extended the term *lang yao* so as to embrace the magnificent three-colour vases with black ground and their kindred masterpieces with green and yellow grounds. It is impossible to justify this extension of the term unless we assume that the pieces in question were all made between the years 1654–1661 and 1665–1668, while Lang T'ing-tso was viceroy of Kiangsi.

sang de bœuf red, an apple green crackle, and perhaps a cognate crackled green glaze on which are painted designs in *famille verte* enamels. The explanation of the term *lang yao* is far from clear, and, as already hinted, the connection of the viceroy Lang T'ing-tso with this or any other of the K'ang Hsi porcelains is by no means established. Bushell[1] accepted the derivation of Lang yao from the first part of the viceroy's name as representing the best of several Chinese theories, and on the supposition that " the ceramic pro-duction of this time has retained the name of the viceroy, in the same way as the names of Ts'ang Ying-hsüan, Nien Hsi-yao, and T'ang Ying, who were in turn superintendents of the Imperial pot-teries, were afterwards given to the *Ts'ang yao*, *Nien yao*, and *T'ang yao*." There are many objections to this reasoning. In the first place, Lang T'ing-tso was viceroy of the two provinces of Kiangsi and Kiangnan for three or four years only (1665–1668) during the reign of K'ang Hsi, and it was only in his capacity as viceroy of Kiangsi that he would have been concerned with Ching-tê Chên, even supposing that the man who had charge of two large provinces could find time to devote himself to the details of ceramic manufactures. Secondly, it is nowhere recorded that Lang T'ing-tso was concerned in any way with the direction of the potteries, so that there is in this respect no parallel between him and the directors Ts'ang, Nien, and T'ang. Thirdly, the history of Ch'ing-tê Chên as given in the *T'ao lu*, and the history of Chinese porcelain as given in the *T'ao shuo*, make no mention whatever of *lang yao* or of Lang T'ing-tso, while the former takes special notice of the wares of Ts'ang, Nien, and T'ang, and the latter discusses T'ang's work at some length. Had so important a person as the viceroy of two provinces been connected with the invention or perfection of such celebrated wares as the *lang yao*, the occur-rence would hardly have escaped the notice of the Chinese chronicler.

There are other attempts to explain the name *lang yao*. In the catalogue of Mr. A. B. Mitford's collection[2] it is stated that " the Lang family were a family of famous potters who possessed the secret of this peculiar glaze and paste. They became extinct about the year 1610." Bushell[3] dismisses this with the comment that " the family is apocryphal and the porcelain antedated," and in

[1] *O. C. A.*, p. 302. [2] Quoted in the *Franks Catalogue*, p. 8.
[3] *O. C. A.*, p. 302 footnote.

the same passage gives an alternative theory, viz. " this name has been derived by some Chinese of less weight from that of Lang Shih-ning, an artist protégé of the Jesuits,[1] who also lived in the reign of K'ang Hsi, and whose pictures are still appreciated."

The evidence for all these versions seems to be equally defective. They are, in fact, mere assertions, and the reader can take his choice of any of them, provided he does not insist on Mr. Mitford's date (anterior to 1610), for all authorities are now agreed that the *lang yao* is a K'ang Hsi production. The fact is that the name has been handed down without any explanation, and the current theories are of comparatively modern construction. The secret of the *lang yao* consisted in the first instance in the knowledge of means to produce a brilliant red glaze from copper oxide. It was not a new discovery, but merely a revival of the wonderful " precious stone " red of the early Ming period.[2] The supplies of some essential ingredient for this colour had failed in the Chia Ching period,[3] and the secret of the true colour had been temporarily lost. This secret was now recovered probably by a potter of the name of Lang, and that name has been associated with it ever since. So far from the *lang yao* being limited to the early part of the reign of K'ang Hsi or to the few years when Lang T'ing-tso might have been concerned with it, there can be little doubt that the *sang de bœuf* red or red *lang yao* is the special colour described in detail by Père d'Entrecolles in 1712, and again in 1722 under the significant name of *yu li hung*, or " red in the glaze." The reader can judge for himself from the description given in the second letter [4]: " This red *inside the glaze* is made with granulated red copper and the powder of a certain stone or pebble of a reddish colour. A Christian doctor told me that this stone was a kind of alum, used in medicine. The whole is pounded in a mortar and mixed with a boy's

[1] See also Hippisley, *Catalogue*, p. 346, where another version is given which makes this Lang actually a Jesuit missionary, a version which Mr. Hippisley afterwards abandoned when research in the Jesuit records failed to discover any evidence for the statement.

[2] See p. 11.

[3] See p. 34.

[4] Op. cit., Section ix. The paragraph in the first letter runs : " Il y en a d'entièrement rouges, et parmi celles-là, les unes sont d'un rouge à l'huile, *yeou li hum ;* les autres sont d'un rouge soufflé, *tschoui hum* (*ch'ui hung*), et sont semées de petits points à peu près comme nos mignatures. Quand ces deux sortes d'ouvrages réüssissent dans leur perfection, ce qui est assez difficile, ils sont infiniment estimez et extrêmement chers."

urine and the ordinary porcelain glaze ; but I have not been able to ascertain the quantities of the ingredients, for those in possession of the secret take good care not to divulge it. This mixture is applied to the porcelain before it is fired and no other glaze is used ; but care has to be taken that the red colour does not run to the bottom of the vase during the firing. They tell me that when they intend to apply this red to porcelain they do not use porcelain stone (*petuntse*) in the body, but they use in its place, mixed with the porcelain earth (*kaolin*), a yellow clay prepared in the same manner as the *petuntse*. Probably it is a kind of clay specially suited to receive this colour." Would that the worthy father had named the possessors of the secret ! Had it been a Jesuit family, is it likely that he would not have said so ? But here, at any rate, is not only such an accurate description of the manufacture of the *sang de bœuf* red that little need be added to it, but also a valuable commentary on the obscure passages in which the allusion is made to the brilliant red of the Hsüan Tê and other early Ming periods. For what is the reddish stone or pebble but the " red precious stone from the West," which played a mysterious part in the *pao shih hung* of the Hsüan Tê period ? Chinese tradition has imagined this stone to have been the ruby, on the impossible assumption that the red colour of the glaze was derived from the red of the ruby. But it was, in all probability, cornaline (the *ma nao* used in the Sung porcelain of Ju Chou) or amethystine quartz, and its only function would have been to increase the brilliancy and transparence of the glaze, the red colour being entirely due to copper oxide. It is interesting, too, to note that the composition of the porcelain body was varied to suit this red colour, and that a yellow clay was substituted for the porcelain stone, in view of the alleged difficulties in obtaining the proper " earth for the fresh red (*hsien hung*) " in the Chia Ching period. In a similar manner a more earthy composition was found to be more sympathetic than the pure white porcelain to some of the other monochromes, as may be observed in existing specimens of turquoise blue.

The *lang yao*, then, is the *chi hung* of the K'ang Hsi period, the brilliant blood red commonly known by the French name *sang de bœuf*, and to-day it is one of the most precious monochromes. A choice example illustrated on Plate 88 shows the changing tints from a brilliant cherry red below the shoulder to the massed blood red where the fluescent glaze has formed thickly above the base.

The colour flowing down has left an even white band round the mouth, and has settled in thick coagulations on the flat parts of the shoulders and again above the base ; but in spite of its apparent fluidity the glaze has stopped in an even line without overrunning the base. The glaze under the base is of pale buff tone and crackled, and a careful examination of the surface generally shows that a faint crackle extends over the whole piece. The glaze, moreover, is full of minute bubbles and consequently much pinholed, and the red colour has the appearance of lying on the body in a dust of minute particles which the glaze has dragged downward in its flow and spread out in a continuous mass, but where the colour and the glaze have run thick the particles reappear in the form of a distinct mottling or dappling.

To obtain the best colour from the copper oxide in this glaze it was necessary to regulate the firing to a nicety, the margin between success and failure being exceedingly small. Naturally, too, the results varied widely in quality and tone ; but the permanent characteristics of the K'ang Hsi *sang de bœuf* are (1) a brilliant red varying in depth and sometimes entirely lost in places,[1] but always red and without any of the grey or grey blue streaks which emerge on the *flambé* red and the modern imitations of the *sang de bœuf ;* (2) the faint crackle of the glaze ; (3) the stopping of the glaze at the foot rim. The colour of the glaze under the base and in the interior of vases varied from green or buff crackle to plain white. The secret of this glaze, which Père d'Entrecolles tells us was carefully guarded, seems to have been lost altogether about the end of the K'ang Hsi period. Later attempts to obtain the same effects, though often successful in producing large areas of brilliant red, are usually more or less streaked with alien tints such as grey or bluish grey, and are almost invariably marred by the inability of the later potters to control the flow of the glaze which overruns the foot rim and consequently has to be ground off. But it is highly probable that the modern potter will yet surmount these difficulties, and I have actually seen a large bowl of modern make in which the ox-blood red was successfully achieved on the exterior (the interior was relatively poor), and the flow of the glaze had been stopped along the foot rim except in one or two small places

[1] There is a very beautiful glaze effect known as " ashes of roses," which seems to be a partially fired-out *sang de bœuf*. It is a crackled glaze, translucent, and lightly tinged with a copper red which verges on maroon.

where the grinding was cleverly masked. So that it behoves the collector to be on his guard.

Fig. 2 of Plate 88 shows another type of red, also classed as *lang yao*, which has the same peculiarities of texture as the *sang de bœuf*, but the colour is more of a crushed-strawberry tint, and has in a more marked degree that thickly stippled appearance which suggests that the colour mixture has been blown on to the ware through gauze. This is probably the *ch'ui hung* or *soufflé* red mentioned by Père d'Entrecolles in connection with the *yu li hung*. The same glaze is often found on bowls, the colour varying much in depth and the base being usually covered with a crackled green glaze beneath. This crackled green is a very distinctive glaze, highly translucent and full of bubbles, like the red *lang yao*, and it is sometimes found covering the entire surface of a vase or bowl and serving as a background for paintings in *famille verte* enamels. It seems, in fact, to be the true green *lang yao*, and one is tempted to ask if it was not in reality intended to be a *sang de bœuf* red glaze from which a lack of oxygen or some other accident of the kiln has dispelled all the red, leaving a green which is one of the many hues produced by copper oxide under suitable conditions. These conditions might well be present in such an enclosed space as the foot of a bowl; and if they happened to affect the whole of the piece, what more natural than to trick out the failure with a gay adornment of enamel colours ?

On the other hand, what is commonly known as green *lang yao* is the brilliant emerald or apple green crackle which has already been discussed on p. 102. But why this colour should be connected in any way with the Lang or any particular family is a mystery. The method of producing it is transparently obvious— a green enamel laid over a stone-coloured crackle; and there are examples of all periods from the Ming down to modern times. Indeed, the modern specimens are only distinguished with the greatest difficulty from the old.

To return to the history of the period from which we digressed to discuss the *lang yao*, the progress of the reviving industry suffered a rude set-back between 1674–1678 when the Imperial factory was destroyed during the rebellion of Wu San-kuei, viceroy of Yunnan. It is improbable that up to this time any notable development had taken place in the manufacture of porcelain, and those

who think to flatter a specimen by suggesting that it is " *very* early K'ang Hsi " are likely to be paying a doubtful compliment. When, however, peace was restored and the factory rebuilt, a veritable renaissance of the porcelain industry began. In 1680 [1] an official of the Imperial household was sent to reside at the factory and to superintend the work ; and we are told in the *T'ao shuo* [2] that " previously to this the first-class workmen had been levied from the different districts of Jao Chou; but now all this forced labour was stopped, and as each manufactory was started the artisans were collected and materials provided, the expenses being defrayed from the Imperial exchequer and the money paid when due, in accordance with the market prices. Even the expenses for carriage were not required from the different districts. None of the proper duties of the local officers were interfered with ; both the officials and the common people enjoyed the benefit, and the processes of manufacture were all much improved."

The success of this new movement was assured by the appointment in 1682 of Ts'ang Ying-hsüan 臧應選 to the control of the Imperial works. We are not told how long this distinguished person retained the directorship, but his merits are clearly indicated in the encomiums of a subsequent director, the celebrated T'ang Ying. In his " History of the God of the Furnace Blast," the latter states that when Ts'ang was in charge of the factory the god laid his finger on the designs and protected the porcelain in the kiln, so that it naturally came out perfect. Unfortunately, the notice of Ts'ang's work in the *T'ao lu* [3] is in the conventional style, and extremely meagre. The earth used, we are told, was unctuous, the material lustrous and thin. Every kind of colour was made, but the snake-skin green (*shê p'i lü*), the eel yellow (*shan yü huang*), the (?) turquoise (吉翠 *chi ts'ui*), and the " spotted yellow " (黃斑點 *huang pan tien*) were the most beautiful. The monochrome (*chiao*) [4]

[1] The Emperor K'ang Hsi was specially concerned to encourage industry and art, and in 1680 he established a number of factories at Peking for the manufacture of enamels, glass, lacquer, etc. Père d'Entrecolles mentions that he also attempted to set up the manufacture of porcelain in the capital, but though he ordered workmen and materials to be brought from Ching-tê Chên for the purpose, the enterprise failed, possibly, as d'Entrecolles hints, owing to intrigues of the vested interests elsewhere.

[2] Bushell, op. cit., p. 3.

[3] Bk. v., fol. 11.

[4] 澆 lit. watered. This word has been rendered by some translators as " pale " ; but probably it has merely the sense of " mixed with the (glaze) water," i.e. a monochrome glaze. The recipe given in the *T'ao lu* (see Julien) is incomplete, only mention-

yellow, the monochrome brown or purple (*tzŭ*), the monochrome green, the *soufflé* (*ch'ui*) red and the *soufflé* blue, were also beautiful. The Imperial factory under the administration of T'ang-ying imitated these glaze colours. ۱

Most of these colours explain themselves. The *soufflé* red is no doubt the same as the *ch'ui hung* described by Père d'Entrecolles and discussed above with the so-called *lang yao*. The *soufflé* blue will be no other than the familiar " powder blue." But the " spotted yellow " is an ambiguous term, for the Chinese *huang pan tien*[1] might mean a yellow glaze spotted with some other colour, a mottled yellow, or even a glaze with yellow spots like that of a rare vase in the Eumorfopoulos Collection, which has a brown black glaze flecked with greenish yellow spots.

Bushell identified the spotted yellow glaze with the " tiger skin," with its patches of green, yellow and aubergine glazes applied to the biscuit, which in the finer specimens is etched with dragon designs.[2]

This is practically all the direct information which the Chinese annals supply on the K'ang Hsi period, but in contrast with this strange reticence we have a delightful account of the industry at Ching-tê Chên during this important time in the two oft-quoted letters[3] written by the Jesuit father, d'Entrecolles, in 1712 and 1722. The worthy father's work lay among the potters themselves, and his information was derived from first-hand observation and from the notes supplied by his potter converts, with whatever help he was able to extract from the Annals of Fou-liang and similar native books. No subsequent writer has enjoyed such a favoured position, and as his observations have been laid under heavy contribution ever since, no apology is necessary for frequent reference to them in these pages.

ing " crystals of saltpetre and ferruginous earth (*fer ologiste terreux*)." Another *chiao* which signifies " beautiful, delicate," is applied to the Hung Chih yellow in Hsiang's Album. See vol. ii., p. 28.

[1] Lit. " yellow distribute spots." See, however, p. 190.

[2] See *O. C. A.*, p. 317.

[3] The two letters were published in *Lettres édifiantes et curieuses*. They are reprinted as an appendix to Dr. Bushell's translation of the *T'ao shuo*. They have been well translated by William Burton, in his *Porcelain*, Chap. ix. ; Bushell gave a *précis* of them in his *O.C. A.*, Chap. xi., and Stanislas Julien quoted them extensively in his *Porcelaine Chinoise*.

CHAPTER IX

WESTERN collectors have agreed to give the place of honour to the K'ang Hsi blue and white. The Ming wares of the same kind, mainly from lack of adequate representation, have not yet been fully appreciated; and in the post-K'ang Hsi periods the blue and white took an inferior status, owing to the growing popularity of enamelled wares. The peculiar virtues of the K'ang Hsi blue and white are due to simple causes. Blue was still regarded as the best medium for painted designs, and the demand for it, both in China and abroad, was enormous. The body material was formed of carefully selected clay and stone, thoroughly levigated and freed from all impurities. No pains were spared in the preparation of the blue, which was refined over and over again until the very quintessence had been extracted from the cobaltiferous ore. Naturally this process was costly, and the finest cobalt was never used quite pure; even on the most expensive wares it was blended with a proportion of the lower grades of the mineral, and this proportion was increased according to the intended quality of the porcelain. But the choicest blue and white of this period was unsurpassed in the purity and perfection of the porcelain, in the depth and lustre of the blue, and in the subtle harmony between the colour and the white porcelain background; and the high standard thus established served to raise the quality of the manufacture in general.

Vast quantities of this blue and white were shipped to Europe by the Dutch and the other East India companies, who sent extensive orders to Ching-tê Chên. It need hardly be said that this export porcelain varied widely in quality, but it included at this time wares of the highest class. Indeed, in looking through our large collections there are surprisingly few examples of the choice K'ang Hsi blue and white which cannot be included in the export class, as indicated by the half-Europeanised forms of plates, jugs, tankards,

and other vessels, and by the fact that the vases are made in sets
of five. But considering that it was made to suit purchasers of
such varied tastes and means, it is surprising how little of this
K'ang Hsi porcelain is bad. Even the roughest specimens have
a style and a quality not found on later wares, and all have an
unquestionable value as decoration.

It would be futile to attempt to describe exhaustively the different
kinds of K'ang Hsi blue and white and the innumerable patterns
with which they are decorated. We must confine our descriptions
to a few type specimens, but first it will be useful to give the points
of a choice example. Such a vessel, whatever its nature, will be
potted with perfect skill, its form well proportioned and true. The
surface will be smooth, because the material is thoroughly refined
and the piece has been carefully trimmed or finished on the lathe,
and finally all remaining inequalities have been smoothed away
with a moist feather brush before the glazing. The ware will be
clean and white, and the glaze[1] pure, limpid, and lustrous, but
with that faint suspicion of green which is rarely absent from
Chinese porcelain. The general effect of the body and glaze com-
bined is a solid white like well set curds. The base, to which the
connoisseur looks for guidance, is deeply cut and washed in the
centre with glaze which reaches about half-way down the sides
of the foot rim. This patch of glaze is usually pinholed, as though
the nemesis of absolute perfection had to be placated by a few
flaws in this inconspicuous part. The rim itself is carefully trimmed,
and in many cases grooved or beaded, as though to fit a wooden
stand,[2] and the unglazed edge reveals a smooth, close-grained bis-
cuit whose fine white material is often superficially tinged with
brown in the heat of the furnace. The decoration is carefully painted
in a pure sapphire blue of great depth and fire, and singularly free
from any strain of red or purple—a quality of blue only obtained
by the most elaborate process of refining. The designs, as on the
Ming porcelains, are first drawn in outline; but, unlike the strong

[1] Père d'Entrecolles (second letter, section xii.) points out that the glaze used for
the blue and white was considerably softer than that of the ordinary ware, and was
fired in the more temperate parts of the kiln. The softening ingredient (which consisted
chiefly of the ashes of a certain wood and lime burnt together) was added to the glaze
material (*pai yu*) in a proportion of 1 to 7 for the blue and white as against 1 to 13
for the ordinary ware.

[2] On some of the large saucer-shaped dishes of this period the foot rim is unusually
broad and channelled with a deep groove.

Ming outlines, these are so faint as to be practically unobserved ; and the colour is filled in, not in flat washes, as on the Ming blue and white, but in graded depths of pulsating blue. This procedure is clearly shown by two interesting bowls in the British Museum. They are identical in form and were intended to match in pattern ; but in one the design (the Eight Immortals of the Wine Cup) is completed, while on the other it remains in outline only, giving us a wonderful illustration of the beautiful firm touch with which the artists traced these faint outlines. The work of decoration was systematically subdivided in the Chinese factory, and Père d'Entre-colles tells us that " one workman is solely occupied with the ring which one sees on the border of the ware ; another outlines the flowers, which a third paints ; one does the water and the mountains, another the birds and animals."[1] Whatever the advantages and disadvantages of this divided labour, the designs on the blue and white were admirably chosen to show off the fine qualities of the colour ; and it is to the blue that the collector looks first. The distinction between the various qualities of blue hardly admit of verbal definition. It can only be learnt by comparing the actual specimens, and by training the eye to distinguish the best from the second best.

The patterns are not always blue on a white ground. Many of the most beautiful results were obtained by reserving the design in white in a blue ground, and both styles are often combined on the same piece. The second is fairly common on the K'ang Hsi porcelains, being specially suited to the lambrequins, arabesques, and formal patterns which were a favourite decoration at this time. See Plates 89 and 91.

The choicest materials were lavished on the porcelains with these formal designs, which consisted now of bands of *ju-i* shaped lappets [2] filled with arabesque foliage, forming an upper and lower border, between which are floral sprays, now of a belt of three or four palmette-like designs, similarly ornamented, and linked together round the centre of a vase or bottle ; of large, stiff, leaf-shaped medallions borrowed, like the patterns which fill them, from ancient

[1] See Bushell, *T'ao shuo*, op. cit., p. 192. It is tolerably clear that d'Entrecolles in this passage is giving a verbatim rendering of a Chinese description. The " flowers " is, no doubt, *hua*, and might be rendered " decoration " in the general sense, and the " water and the mountains " is, no doubt, *shan shui*, the current phrase for " landscape."

[2] For the shape of the *ju-i* head, see vol. i., p. 227.

bronzes, and of ogre-head designs from a similar source ; of successive belts of arabesque scrolls and dragon designs covering cylindrical jars ; of a mosaic of small blossoms, or of network diapers recalling the pattern of a crackled porcelain. The white on blue process is constant in a well known decoration in which archaic dragons, floral arabesques, roses or peonies are arranged in " admired disorder " over the whole surface of a cylinder vase or a triple gourd, as on Plate 91. Sometimes the roses occupy the greater part of the design, and among them are small oval or round blank medallions, which have earned for the pattern the name of " rose and ticket."

This type of ware is represented in almost every variety in the Dresden collection, and there are examples of the " rose and ticket " jars in the *Porzellan-zimmer* of the Charlottenburg Palace. Both these collections are mainly composed of the export porcelain sent from China in the last decades of the seventeenth century, and the latter is practically limited to the presents made by the English East India Company to Queen Sophia Charlotte of Prussia (1688–1705). The white on blue patterns are also freely used in combination with blue and white to form borders and to fill in the ground between panels.

As for the blue on white designs, they are legion. There are the old Ming favourites such as the Court scenes, historical and mythological subjects, pictorial designs, such as ladies looking at the garden flowers by candlelight.[1] There are landscapes after Sung and Ming paintings, the usual dragon and phœnix patterns, animal, bird, and fish designs, lions and mythical creatures, the familiar group of a bird (either a phœnix or a golden pheasant) on a rock beside which are peony, magnolia, and other flowering plants. Panel decoration, too, is frequent, the panels sometimes petal-shaped and emphasised by lightly moulded outlines, or again mirror-shaped, circular, fan-shaped, leaf-shaped, oval, square, etc., and surrounded by diapers and " white in blue " designs. The reserves are suitably filled with figure subjects from romance, history, or family life, mythical subjects such as the adventures of Taoist sages, the story of Wang Chi watching the game of chess, Tung-fang So and his peaches, or, if numerical sequences are needed, with the Four Accomplishments (painting, calligraphy, music and chess), the

[1] " Flaming silver candle lighting up rosy beauty," a Ch'êng Hua design (see p. 25) but often found in K'ang Hsi porcelain, which usually has, by the way, the Ch'êng Hua mark to keep up the associations.

flowers of the Four Seasons, the Eight Taoist Immortals, the Eight Immortals of the Wine Cup, etc. Another favourite panel design is a group of vases, furniture, and symbolical objects from the comprehensive series known as the Hundred Antiques.[1] Sometimes the whole surface of a vase is divided into rows of petal-shaped compartments filled with floral designs, figure subjects, birds and flowers or landscapes. Plate 91, Fig. 3, from a set of five, is one of the large vases in the Dresden collection which, tradition says, were obtained by Augustus the Strong from the King of Prussia in exchange for a regiment of dragoons. It is decorated with panels illustrating the stories of the Twenty-four Paragons of Filial Piety.

Some of the purely floral patterns strike perhaps a more distinctive note. The " aster pattern," for instance, is a design of stiff, radiating, aster-like flowers usually in a dark tone of blue and displayed on saucer dishes or deep covered bowls. Some of the specimens of this class appear to be a little earlier than K'ang Hsi. The so-called " tiger-lily " pattern illustrated by Fig. 2 of Plate 89 is usually associated with deep cylindrical covered bowls of fine material and painted in the choicest blue. A beaker (Plate 91, Fig. 2) shows a characteristic treatment of the magnolia, parts of the blossoms being lightly sculptured in relief and the white petals set off by a foil of blue clouding. It evidently belongs to a set of five (three covered jars and two beakers) made as a *garniture de cheminée* for the European market.

The squat-bodied bottle (Plate 92, Fig. 1) illustrates a familiar treatment of the lotus design, with a large blossom filling the front of the body.

But perhaps the noblest of all Chinese blue and white patterns is the prunus design (often miscalled hawthorn) illustrated by Plate 90, a covered vase once in the Orrock Collection and now in the Victoria and Albert Museum. The form is that of the well-known ginger jar, but these lovely specimens were intended for no banal uses. They were filled with fragrant tea or some other suitable gift, and sent, like the round cake boxes, by the Chinese to their friends at the New Year, but it was not intended that the jars or boxes should be kept by the recipients of the compliment.

The New Year falls in China from three to seven weeks later than in our calendar, and it was seasonable to decorate these jars

[1] For further notes on design, see chap. xvii.

with sprays and petals of the flowering prunus fallen on the ice, which was already cracked and about to dissolve. The design is symbolic of the passing of winter and the coming of spring ; and the vibrating depths of the pure sapphire blue broken by a network of lines simulating ice cracks form a lovely setting for the graceful prunus sprays reserved in the pure curd-like white of the ware.

The prunus pattern has been applied to every conceivable form, whether to cover the whole surface or to serve as secondary ornament in the border of a design or on the rim of a plate, and the prunus jar appears in all qualities of blue and on porcelain good and bad, old and new. The graceful sprays have become stereotyped and the whole design vulgarised in many instances ; and in some cases the blossoms are distributed symmetrically on a marbled blue ground as a mere pattern. But nothing can stale the beauty of the choice K'ang Hsi originals, on which the finest materials and the purest, deepest blue were lavished. The amateur should find no difficulty in distinguishing these from their decadent descendants. The freshness of the drawing, the pure quality of the blue, and the excellence of body, glaze, and potting are unmistakable. The old examples have the low rim round the mouth unglazed where the rounded cap-shaped cover fitted, and the design on the shoulders is finished off with a narrow border of dentate pattern. The original covers are extremely rare, and in most cases have been replaced with later substitutes in porcelain or carved wood.

There are, besides, a number of types specially prevalent among the export porcelains, some purely Chinese in origin, others showing European influence. Take, for example, the well-known saucer dish with mounted figures of a man and a woman hunting a hare —a subject usually known as the " love chase "—a free and spirited design, rather sketchily painted in pale silvery blue. The porcelain itself is scarcely less characteristic, a thin, crisp ware, often moulded on the sides with petal-shaped compartments, and in many ways recalling the earlier type described on p. 70. It is, however, distinguished from the latter class by slight differences in tone and finish which can only be learnt by comparison of actual specimens. It is, moreover, almost always marked with a *nien hao* in six characters, whereas marks on the other type are virtually unknown. The *nien hao* is usually that of Ch'êng Hua, but an occasional example with the K'ang Hsi mark gives the true date of the ware.

A quantity of this porcelain was brought up by divers from wrecks of old East Indiamen in Table Bay, among which was the *Haarlem*, lost in 1648,[1] though most of the ships were wrecked at later dates. It is a thin and sharply moulded ware, often pure eggshell, and the blue varies from the pale silvery tint to vivid sapphire. The usual forms are of a utilitarian kind—plates, saucer dishes, cups and saucers, small vases and bottles, jugs, tankards, and the like—and the designs are not confined to the " love chase," but include other figure subjects (e.g. a warrior on horseback carrying off a lady,[2] and various scenes from romance and family life), floral designs, deer, phœnixes, fish, birds, etc., and perhaps most often the tall female figures, standing beside flowering shrubs or pots of flowers, which are vulgarly known as " long Elizas," after the Dutch *lange lijsen* (see Plate 92, Fig. 2).

Graceful ladies (*mei jên*) are familiar motives in Chinese decoration, but this particular type, usually consisting of isolated figures in small panels or separated from each other by a shrub or flower-pot, and standing in a stereotyped pose, are, I think,[3] peculiar to the export wares of the last half of the seventeenth century.

This same type of thin, crisply moulded porcelain was also painted with similar designs in *famille verte* enamels over the glaze. It has a great variety of marks, the commonest being the apocryphal Ch'êng Hua date-mark, while others are marks of commendation,[4] such as *ch'i chên ju yü* (a rare gem like jade), *yü* (jade), *ya* (elegant), and various hall-marks.

Yet another group of superior quality is obviously connected with the European trade by a peculiar mark (see vol. i., p. 223) resembling the letter C or G. It is most commonly represented by pairs of bottles with globular body and tall, tapering neck, decorated with flowing scrolls of curious rosette-like flowers, a design stated with much probability to have been copied from Dutch delft. As the Dutch design in question had evidently been based on a Chinese original, the peculiar nature of the flowers explains itself. There are other instances of patterns bandied in this way between the

[1] There is a small collection of these porcelains salved from the sea and presented to the British Museum by H. Adams in 1853 ; but there is no evidence to show which, if any, were on board the *Haarlem*.

[2] This design was copied on early Worcester blue and white porcelain.

[3] In spite of Bushell's translation of a Ming passage which would lead one to think otherwise ; see p. 40.

[4] See vol. i., p. 226.

Far East and the West. The same peculiar floral scroll appears in *famille verte* associated with the same mark ; and the same G mark occurs on two rare bottles in the collection of Mr. J. C. J. Drucker, which have blue and white painting on the neck and *famille verte* designs in the finest enamels on the body. A deep bowl in the Eumorfopoulos collection with *famille verte* panels of symbols from the Hundred Antiques, and a ground of green " prunus " pattern, bears the same mark. Neither of these last examples can be even remotely connected with Dutch influence, so that we may dismiss the suggestion that the letter in the mark is intended to be a D, standing for D(elft), for this reason quite apart from the fact that such a mark on Delft ware is non-existent. I imagine that the true explanation is that this peculiar mark is a merchant's sign placed by order on the goods made for some particular trader.

A close copy of the " wing handles " of Venetian glass on certain blue and white bottles (Plate 92, Fig. 3), the appearance of Prince of Wales's feathers in the border of a plate and of an heraldic eagle in the well of a salt cellar, no less than many forms obviously Western in origin, further emphasise the close relations between the Ching-tê Chên potters and European traders.[1] An immense quantity of

[1] There are frequent allusions to the European trade in the letters of Père d'Entre-colles. In the first letter (Bushell, *T'ao shuo*, p. 191) a reference is made among moulded porcelains to " celles qui sont d'une figure bisarre, comme les animaux, les grotesques, les Idoles, les bustes que les Europeans ordonnent." On p. 193 : " Pour ce qui est des couleurs de la porcelaine, il y en a de toutes les sortes. On n'en voit gueres en Europe que de celle qui est d'un bleu vif sur un fond blanc. Je crois pourtant que nos Marchands y en ont apporté d'autres." On p. 202, to explain the high price of the Chinese porcelain in Europe, we are told that for the porcelain for Europe new models, often very strange and difficult to manufacture, are constantly demanded, and as the porcelain was rejected for the smallest defect, these pieces were left on the potter's hands, and, being un-Chinese in taste, were quite unsaleable. Naturally the potter demanded a high price for the successful pieces to cover his loss on the rejected.

On the other hand, we are told (p. 204) that the mandarins, recognising the inventive genius of the Europeans, sometimes asked him (d'Entrecolles) to procure new and curious designs, in order that they might have novelties to offer to the Emperor. But his converts entreated him not to get these designs, which were often very difficult to execute and led to all manner of ill-treatment of the unfortunate workmen.

On the same page we are told that the European merchants ordered large plaques for inlaying in furniture, but that the potters found it impossible to make any plaque larger than about a foot square. In the second letter (section x.), however, we learn that " this year (1722) they had accepted orders for designs which had hitherto been considered impossible, viz. for urns (*urnes*) 3 feet and more high, with a cover which rose in pyramidal form to an additional foot. They were made in three pieces, so skil-fully joined that the seams were not visible, and out of twenty-five made only eight

indifferent blue and white was made for the European table services, and summarily decorated with baskets of flowers, the usual flowering plant designs, close patterns of small blossoms, floral scrolls with large, meaningless flowers, ivy scrolls, passion flowers, and numerous stereotyped designs, such as dragons in sea waves, prunus pattern borders, pine tree and stork, a garden fence with rockery and flowering shrubs, groups from the Hundred Antiques, a parrot on a tree stump, etc. The blue of these pieces is usually rather dull and heavy, but the ware has the characteristic appearance of K'ang Hsi porcelain, and was evidently made for the most part about the year 1700. If marked at all, the marks are usually symbols, such as the double fish, the lozenge, the leaf, a tripod vase, and a strange form of the character *shou* known as the " spider mark " (see vol. i., p. 225). The plates are often edged with lustrous brown glaze to prevent that chipping and scaling to which the Chinese glaze was specially liable on projecting parts of the ware.[1]

Something has already been said [2] of another very distinctive class of blue and white for which the misleading name of " soft paste " has been widely adopted. The term is of American origin and has been too readily accepted, for it is not only inaccurate as a description, but is already current in Europe for a totally different ware, which it describes with greater exactitude, viz. the artificial, glassy porcelains made at Sèvres and Chelsea and other factories, chiefly in France and England, in the middle of the eighteenth century. In actual fact the Chinese ware to which the term " soft paste " is applied has an intensely hard body. The glaze, however, which is softer than that of the ordinary porcelain, contains a proportion of lead, and if not actually crackled from the first becomes so in use, the crackle lines being usually irregular and undecided.

A detailed description of the manufacture of this ware is given by Père d'Entrecolles,[3] though he is probably at fault in supposing that its chief ingredient was a recent discovery in 1722. It was

had been successful. These objects were ordered by the Canton merchants, who deal with the Europeans ; for in China people are not interested in porcelain which entails such great cost."

[1] This defect is noticed by Père d'Entrecolles, who mentions another remedy used by the Chinese potters. They applied, he tells us in section ii. of the second letter, a preparation of bamboo ashes mixed with glazing material to the edges of the plate before the glazing proper. This was supposed to have the desired effect without impairing the whiteness of the porcelain.

[2] See p. 74.

[3] Second letter, section iv.

made, he says, with a mineral called *hua shih* (in place of kaolin), a stone of glutinous and soapy nature, and almost certainly corresponding to the steatite or " soapy rock " which was used by the old English porcelain makers at Bristol, Worcester and Liverpool. " The porcelain made with *hua shih*," to quote Père d'Entrecolles, " is rare and far more expensive than the other porcelain. It has an extremely fine grain ; and for purposes of painting, when compared with ordinary porcelain, it is almost as vellum to paper. Moreover, this ware is surprisingly light to anyone accustomed to handle the other kinds ; it is also far more fragile than the ordinary, and there is difficulty in finding the exact temperature for its firing. Some of the potters do not use *hua shih* for the body of the ware, but content themselves with making a diluted slip into which they dip their porcelain when dry, so as to give it a coating of soapstone before it is painted and glazed. By this means it acquires a certain degree of beauty." The preparation of the *hua shih* is also described, but it is much the same as that of the kaolin, and the composition of the steatitic body is given as eight parts of *hua shih* to two of porcelain stone (*petuntse*).

There are, then, two kinds of steatitic porcelain, one with the body actually composed of *hua shih* and the other with a mere surface dressing of this material. The former is light to handle, and opaque ; and the body has a dry, earthy appearance, though it is of fine grain and unctuous to touch. It is variously named by the Chinese [1] *sha-t'ai* (sand bodied) and *chiang-t'ai* (paste bodied), and when the glaze is crackled it is further described as *k'ai pien* (crackled).

The painting on the steatitic porcelain differs in style from that of the ordinary blue and white of this period. It is executed with delicate touches like miniature painting, and every stroke of the brush tells, the effects being produced by fine lines rather than by graded washes. The ware, being costly to make, is usually painted by skilful artists and in the finest blue. Fig. 3, of Plate 93, is an excellent example of the pure steatitic ware, an incense bowl in the Franks collection, of which the base and a large part of the interior is unglazed and affords a good opportunity for the study of the body material. The glaze is thin and faintly crackled, and the design—Hsi Wang Mu and the Taoist Immortals—is delicately drawn in light, clear blue.

[1] See Bushell, *O. C. A.*, p. 320.

The second type, which has only a dressing of steatite over the ordinary body, has neither the same lightness nor the opacity of the true steatitic ware, but it has the same soft white surface, and is painted in the same style of line drawing.

There are, besides, other opaque and crackled wares painted in underglaze blue, which are also described as " soft paste," and, indeed, deserve the name far more than the steatitic porcelain. The creamy, crackled copies of old Ting wares, for instance, made with *ch'ing tien* stone,[1] are occasionally enriched with blue designs ; and the ordinary stone-coloured crackle with buff staining is also painted at times with underglaze blue,[2] or with blue designs on pads of white clay in a crackled ground.

On the other hand, there are numerous wares of the Yung Chêng and Ch'ien Lung periods which are probably composed in part, at least, of steatite. They are usually opaque, and the surface is sometimes dead white, sometimes creamy and often undulating like orange peel, and in addition to blue decoration, enamel painting is not infrequent on these later types. The purely steatitic porcelains are generally of small size, which was appropriate to the style of painting as well as to the expensive nature of the material. The furniture of the scholar's table, with its tiny flower vases for a single blossom, its brush washers and water vessels of fanciful forms, its pigment boxes, etc., were suitable objects for the material, and many of these little crackled porcelains are veritable gems. Snuff bottles are another appropriate article, and a representative collection of snuff bottles will show better than anything the great variety of these mixed wares and so-called " soft pastes."

It has been already observed that crackled blue and white porcelain of the steatitic kind is found with the date marks of Ming Emperors, and there can be little doubt that it was made from early Ming times, but as the style of painting seems to have known no change it will be always difficult to distinguish the early specimens. It is safe to assume that almost all the specimens in Western collections belong to the Ch'ing dynasty, a few to the K'ang Hsi period, but the bulk of the better examples to the reigns of Yung Chêng and Ch'ien Lung. Modern copies of the older wares also abound.

[1] See p. 201.
[2] The use of crackle glaze over blue (*porcelaine toute azurée*) is noted by Père d'Entre-colles in his first letter. See Bushell, op. cit., p. 195.

Fig. 3

Fig. 1

Fig. 2

Plate 91.—Blue and White K'ang Hsi Porcelain.

Fig. 1.—Triple Gourd Vase, white in blue designs of archaic dragons and scrolls of season flowers. Height 36¾ inches. *Dresden Collection.* Fig. 2.—Beaker, white magnolia design slightly raised, with blue background. Height 18 inches. *British Museum.* Fig. 3.—"Grenadier Vase," panels with the Paragons of Filial Piety. Height 44 inches. *Dresden Collection.*

Fig. 1

Fig. 2

Fig. 3

Plate 92.—Blue and White K'ang Hsi Porcelain.

Fig. 1.—Sprinkler with lotus design. Height 11 inches. Fig. 2.—Bottle with biscuit handles, design of graceful ladies (*mei jên*). Height 6¾ inches. *British Museum*. *Fitzwilliam Museum (formerly D. G. Rosetti Collection)*. Fig. 3.—Bottle with handles copied from Venetian glass. Height 6¾ inches. *British Museum.*

Fig. 1

Fig. 2

Fig. 3

Plate 93.—Blue and White Porcelain.

Fig. 1.—Tazza with Sanskrit characters. Ch'ien Lung mark. Height 4¼ inches. *British Museum.* Fig. 2.—Water Pot, butterfly and flowers, steatitic porcelain. Wan Li mark. Height 1⅞ inches. *Eumorfopoulos Collection.* Fig. 3.—Bowl, steatitic porcelain. Immortals on a log raft. K'ang Hsi period. Diameter 5¾ inches. *British Museum.*

Fig. 1

Fig. 2

Plate 94.—Porcelain decorated in enamels on the biscuit.

Fig. 1.—Ewer in form of the character *Shou* (Longevity); blue and white panel with figure designs. Early K'ang Hsi period. Height 8¾ inches. *Salting Collection.* Fig. 2.—Ink Palette, dated 31st year of K'ang Hsi (1692 A.D.). Length 5¼ inches. *British Museum.*

An interesting passage in the first letter[1] of Père d'Entrecolles describes a curious kind of porcelain, of which the secret had already been lost. It was known as *chia ch'ing* or "blue put in press," and it was said that the blue designs on the cups so treated were only visible when the vessel was filled with water. The method of the manufacture is described as follows : " The porcelain to be so decorated had to be very thin ; when it was dry, a rather strong blue was applied, not to the exterior in the usual manner, but on the interior to the sides. The design usually consisted of fish, as being specially appropriate to appear when the cup was filled with water. When the colour was dry a light coating of slip, made with the body material, was applied, and this coating enclosed the blue between two layers of clay. When this coating was dry, glaze was sprinkled inside the cup, and shortly afterwards the porcelain was placed on the wheel. As the body had been strengthened on the interior, the potter proceeded to pare it down outside as fine as possible without actually penetrating to the colour. The exterior was then glazed by immersion. When completely dry it was fired in the ordinary furnace. The work is extremely delicate, and requires a dexterity which the Chinese seem no longer to possess. Still, they try from time to time to recover the secret of this magical painting, but without success. One of them told me recently that he had made a fresh attempt, and had almost succeeded."

No example of this mysterious porcelain is known to exist, and it is probable that the whole story is based on some ill-grounded tradition. It is true that water will bring out the faded design on certain old potteries, but this is due to the action of the water in restoring transparency to a soft decayed glaze. But how the water or any other liquid could affect the transparency of a hard, impenetrable porcelain glaze, still less influence the colour concealed beneath a layer of clay and glaze, is far from clear. Indeed, the whole story savours of the " tall tales " quoted in chap. x. of vol. i.

But perhaps it will not be inappropriate to mention here another peculiar type of blue and white, which, if we may judge by the early date mark usually placed upon it, throws back to some older model. The design, usually a dragon, is delicately traced with a needle point on the body of the ware, and a little cobalt blue is

[1] See Bushell, *T'ao shuo*, p. 197.

dusted into the incisions.[1] The glaze is then applied, and when
the piece is fired and finished the dragon design appears faintly
" tattooed " in pale blue. The effect is light and delicate, but of
small decorative value, and the few examples which I have seen
are redeemed from insignificance by a peculiarly beautiful body
of pure glassy porcelain. They bear an apocryphal Ch'êng Hua
mark, but evidently belong to the first half of the eighteenth century,
to the Yung Chêng, or perhaps the late K'ang Hsi period.

[1] A somewhat similar but clumsier decoration was the " scratched blue " of the
Staffordshire salt glaze made about 1750.

CHAPTER X

BROADLY speaking, the polychrome porcelains of the Ming and K'ang Hsi periods are the same in principle, though they differ widely in style and execution. The general types continued, and the first to be considered is that in which all the colours are fired in the high temperature of the large kiln, comprising underglaze blue and underglaze red, and certain slips and coloured glazes. Conspicuous among the last is a pale golden brown commonly known as Nanking yellow, which is found in narrow bands or in broad washes, dividing or surrounding blue designs, and is specially common on the bottles, sprinklers, gourd-shaped vases, and small jars exported to Europe in the last half of the seventeenth century. The golden brown also darkens into coffee brown, and in some cases it alternates in bands with buff crackle and pale celadon green.

A deep olive brown glaze is sometimes found as a background for ornament in moulded reliefs which are touched with underglaze blue and red. A fine vase of this type is in the Salting Collection, and a good example was given by Mr. Andrew Burman to the British Museum. Both seem to be designed after bronze models.

But the central colour of this group is undoubtedly the underglaze red. Derived from copper it is closely akin to the red of the *chi hung* glaze, and both were conspicuous on the Hsüan Tê porcelain, both fell into disuse in the later Ming periods, and both were revived in the reign of K'ang Hsi.

I have seen two examples of this colour in combination with underglaze blue bearing the hall mark *chung-ho-t'ang*, and cyclical dates corresponding to 1671 and 1672 respectively. In neither of these pieces, however, was the red very successful, and probably the better K'ang Hsi specimens belong to a later period of the reign. It was, however, always a difficult colour to fire, and examples

in which the red is perfectly developed are rare. As a rule, it tends to assume a maroon or dark reddish brown tint.

Nor is the method of its application always the same. Sometimes it is painted on in clean, crisp brush strokes ; at others it is piled up in thick washes which flow in the firing and assume some of the qualities and the colour of *sang de bœuf* red, even displaying occasional crackle ; on other pieces again a " peach bloom " tint is developed.[1] On two of the best examples in the Franks Collection, where a deep blood red is combined with a fine quality of blue, it is noteworthy that the surface of the white glaze has a peculiar dull lustre. This, I understand, is due to " sulphuring " in the kiln, a condition which, whether accidental or intentional, is certainly favourable to the red colour. It is also noticeable that the red is particularly successful under a glaze which is faintly tinged with celadon green such as is often used on imitations of Ming porcelains, and it was no doubt this consideration which led to the frequent use of celadon green in this group. The celadon is used either as a ground colour for the whole piece or in parts only of the design, and the addition of white slip further strengthened the palette. With these colours some exquisite effects have been compassed in such designs as birds on prunus boughs and storks among lotus plants, the main design being in blue, the blossoms in white slip slightly raised and touched with red, and the background plain white, celadon green (Plate 115), and sometimes pale lavender blue. The celadon and pale lavender vases with this decoration were favourites with the French in the eighteenth century, and many sets of vases and beakers in this style have been furnished with sumptuous ormolu mounts by the French goldsmiths.

The painting in underglaze red, which was revived in the K'ang Hsi period, continued with success in the succeeding reigns of Yung Chêng and Ch'ien Lung (indeed it has not ceased to this day), but the bulk of the finer examples in our collections seem to belong to the late K'ang Hsi and the Yung Chêng periods. The underglaze red is used alone as well as in combination, and some of its most successful effects are found on small objects like colour boxes and snuff bottles.

The black or brown pigment used for outlining designs under

[1] On exceptional examples the red seems to have turned almost black, and in some cases it seems to have penetrated the glaze and turned brown.

the softer enamel colours such as green and yellow, though in one sense an underglaze colour, does not belong to this group.

From this group of polychrome porcelain we pass to another in which the colour is given by washes of various glazes. A few of the high-fired glazes are employed for this purpose, especially blue in combination with celadon green and white, and a few clay slips, of which the commonest is a dressing of brown clay applied without any glaze and producing an iron-coloured surface. The most familiar members of this group are small Taoist figures of rough but vivacious modelling with draperies glazed blue, celadon and white,[1] and the base unglazed and slightly browned in the firing. Collectors are tempted to regard these figures as late or modern productions, but examples in the Dresden collection prove that this technique was employed in the K'ang Hsi period. In the same collection there are numbers of small toy figures, such as monkeys, oxen, grotesque human forms, etc., sometimes serving as whistles or as water-droppers. They are made of coarse porcelain or stoneware with a thin dressing of brown ferruginous clay, and touches of high-fired glazes. The appearance of these, too, is so modern that we realise with feelings of surprise that they formed part of the collection of Augustus the Strong.

The polychrome porcelain coloured with glazes of the *demi-grand feu* (i.e. glazes fired in the more temperate parts of the large kiln) has been discussed in the chapters on the Ming period.[2] The group characterised by green, turquoise and aubergine violet, semi-opaque, and minutely crackled is not conspicuous among K'ang Hsi porcelains; indeed it seems to have virtually ceased with the Ming dynasty. The individual colours, however, were still used as monochromes; in combination they are chiefly represented by aubergine violet and turquoise in broad washes on such objects as peach-shaped wine pots, Buddhist lions with joss-stick holders attached, parrots, and similar ornaments.

The other three-colour group, composed of transparent green, yellow and aubergine purple glazes, usually associated with designs finely etched with a metal point on the body, were freely used in the K'ang Hsi and Yung Chêng periods in imitation of Ming prototypes. Such specimens are often characterised by extreme neatness

[1] A similar combination of coloured glazes was effectively used on the moulded porcelains of the Japanese Hirado factory.

[2] See pp. 48 and 100.

of workmanship and technical perfection of the ware. The best-known examples are thin, beautifully potted rice bowls, with slightly everted rim, and a design of five-clawed Imperial dragons traced with a point and filled in with a colour contrasting with that of the ground, e.g. green on yellow, or green on aubergine, all the possible changes being rung on the three colours. Being Imperial wares these bowls are usually marked with the *nien hao* of their period, but such is the trimness of their make that collectors are tempted to regard them as specimens of a later reign. But here again the Dresden collection gives important evidence, for it contains a bowl of this class with dragons in a remarkable purplish black colour (probably an accidental variety of the aubergine) in a yellow ground. It bears the mark of the K'ang Hsi period.

The application of similar plumbo-alcaline glazes to a commoner type of porcelain is described by Père d'Entrecolles [1] :—" There is a kind of coloured porcelain which is sold at a lower rate than the enamelled ware just described. . . . The material required for this work need not be so fine. Vessels which have already been baked in the great furnace without glaze, and consequently white and lustreless, are coloured by immersion in a bowl filled with the colouring preparation if they are intended to be monochrome. But if they are required to be polychrome like the objects called *hoam lou houan*,[2] which are divided into kinds of panels, one green, one yellow, etc., the colours are laid on with a large brush. This is all that need be done to this type of porcelain, except that after the firing a little vermilion is applied to certain parts such as the beaks of birds, etc. This vermilion, however, is not fired, as it would evaporate in the kiln, and consequently it does not last. When the various colours have been applied, the porcelain is refired in the great furnace with the other wares which have not yet been baked ; but care is taken to place it at the bottom of the furnace and below the vent-hole where the fire is less fierce ; otherwise the great heat would destroy the colours."

In this interesting passage, written in 1722, we have a precise

[1] Loc. cit., second letter, section xiv.

[2] Apparently *huang lü huan*, yellow and green (?) circles. But without the Chinese characters it is impossible to say which *huan* is intended. The description seems to apply to the " tiger skin " ware, where yellow, green and aubergine glazes have been applied in large patches. Bushell (*O. C. A.*, p. 331) makes this expression refer to the specimens with engraved designs in colour contrasting with the surrounding ground, such as Fig. 1 of Plate 79 ; but this does not seem to suit the word *huan*.

account of the manufacture of one of the types of porcelain which have been indiscriminately assigned to the Ming period. This on-biscuit polychrome was undoubtedly made in the Ming dynasty, but in view of d'Entrecolles' description it will be safe to assume that, unless there is some very good evidence to the contrary, the examples in our collections are not older than K'ang Hsi. The type is easily identified from the above quotation, and there is a little group of the wares in the British Museum, mostly small figures and ornaments with washes of green, brownish yellow and aubergine purple applied direct to the biscuit, and on some of the unglazed details the unfired vermilion still adheres. These coloured glazes are compounded with powdered flint, lead, saltpetre, and colouring oxides, and the porcelain belongs to the comprehensive group of *san ts'ai* or three-colour ware, although the three colours—green, yellow and aubergine—are supplemented by a black formed of brown black pigment under one of the translucent glazes and a white which d'Entrecolles describes [1] as composed of $\frac{2}{5}$ ounce of powdered flint to every ounce of white lead. This last forms the thin, iridescent film often of a faintly greenish tinge, which serves as white on these three-colour porcelains. In rare cases also a violet blue enamel is added to the colour scheme.

A characteristic of this particular type is the absence of any painted outlines. The colours are merely broad washes bounded by the flow of the glaze, and this style of polychrome is best suited to figures and moulded ornamental pieces, in which the details of the design form natural lines of demarcation for the glazes. On a flat surface this method of coloration is only suited to such patchy patterns as the so-called tiger skin and the tortoiseshell wares.

The Dresden collection is peculiarly rich in this kind of *san ts'ai*, but though two or three of the specimens (Plate 71, Figs. 1 and 2) differing considerably from the rest, are clearly of the Ming period, the great majority are undoubtedly contemporaneous with the form-ing of the collection, viz. of the K'ang Hsi period. The latter include numerous figures, human and animal, and ornaments such as the junk on Plate 98, besides some complicated structures of rocks and shrines and grottos, peopled with tiny images and human figures. To this group belong such specimens as the " brinjal bowls," with everted rim and slight floral designs engraved in outline

[1] Loc. cit., section xiv.

and filled in with coloured glaze in a ground of aubergine (brinjal) purple. There are similar specimens with green ground, and both types are frequently classed with Ming wares. Some of them may indeed belong to the late Ming period,[1] but those with finer finish are certainly K'ang Hsi. They are usually marked with rough, undecipherable seal marks in blue, which are commonly known as shop marks.

Some of the figures of deities, birds and animals, besides the small ornamental objects such as brush-washers in the form of lotus 'eaves and little water vessels for the writing table are of very high quality, skilfully modelled and of material far finer than that described by d'Entrecolles. Fig. 2, Plate 99, a statuette of Ho Hsien-ku, one of the Eight Immortals, is an example. The flesh is in white biscuit, showing the fine grain of the porcelain, white to-day, though possibly it was originally coloured with unfired pigment and gilt as was often the case. The glazes on this finer quality of ware, especially the green and the aubergine, are peculiarly smooth and sleek, and the yellow is fuller and browner than on the kindred ware, enamelled on the biscuit, which we now proceed to investigate.

The French term, *émaillé sur biscuit,* is used somewhat broadly to cover the coloured glazes just described, as well as the enamels proper of the muffle kiln. We shall try to confine the expression, " on-biscuit enamels," to the softer, vitrifiable enamels which are fired at a lower temperature and in a smaller kiln or muffle. These are, in fact, the same enamels as are used in the ordinary *famille verte* porcelain painted over the finished glaze, but when applied direct to the biscuit they have a slightly darker and mellower tone, the background of biscuit reflecting less light than the glittering white glaze.

Though the colour scheme of this group is substantially the same as that of the *san ts'ai* glazes, and though the enamels when used in wide areas are not always easily distinguished from the glazes, the former do, in fact, differ in containing more lead, being actually softer and more liable to acquire crackle and iridescence, and in some cases there are appreciable differences in tint. The yellow enamel, for instance, is as a rule paler, and even when of a dark tint it has a muddy tone wanting in the fullness and strength of the yellow glaze; the green enamel varies widely in tone from the glaze, and includes, besides, several fresh shades, among which is a

[1] See footnote on p. 89.

soft apple green of great beauty; and the aubergine is less claret coloured and often of a decidedly pinkish tone.

But perhaps the most distinctive feature of this *san ts'ai* of the muffle kiln is the careful tracing of the design in a brown black pigment on the biscuit. The transparent enamels are washed on over these black outlines, and give appropriate colours without obscuring the design which is already complete in itself.[1] The same brown black pigment [2] is also used over wide areas, laid on thickly and washed with transparent green to form the fine green black which is so highly prized. Like so much of the porcelain with coloured ornament applied to the biscuit this large group has been indiscriminately assigned to the Ming dynasty. The lack of documentary evidence has made it difficult to combat this obvious fallacy, obvious because the form and style of decoration of the finest specimens are purely K'ang Hsi in taste and feeling; but, while fully recognising that the scheme of decoration was not a new one, but had been in use in the Ming porcelains, I would point a warning finger again [3] to the ink slab in the British Museum with its design of aubergine plum blossoms on conventional green waves, its borders of lozenge and hexagon diaper, all enamelled on the biscuit, and in the characteristic style habitually described as Ming in sale catalogues, but actually dated 1692. Another consideration is the quantity of these pieces in the Dresden collection which consists mainly of K'ang Hsi wares, and the presence of several examples (e.g. bamboo vases such as Fig. 2 of Plate 95) in the rooms of the Charlottenburg Palace, which were furnished mainly with presents made by the British East India Company to Queen Sophia Charlotte (1668–1705).

Marks are rare on this group, as a whole, though they occur fairly frequently on the large vases, the commonest being the date mark of the Ch'êng Hua period. No one would, however, seriously argue a fifteenth century date from this mark which is far more common than any other on K'ang Hsi porcelain; and I have actually seen the K'ang Hsi mark on one or two specimens which appeared to be perfectly genuine. Curiously enough the K'ang Hsi mark is more often a sign of a modern imitation, but this in view of the perverse methods of marking Chinese porcelain is in itself evidence

[1] The same technique is employed on some of the Japanese Kaga wares.
[2] Apparently derived from manganese.
[3] See p. 80.

that the modern copyist regards the reign of K'ang Hsi as the best period of manufacture for this style of ware.

The noblest examples of this group, and perhaps the finest of all Chinese polychromes, are the splendid vases with designs reserved in grounds of green black, yellow or leaf green. Plates 96, 97 and Frontispiece will serve to illustrate the colours and at the same time some of the favourite forms [1] of these sumptuous pieces, the baluster vase, and the square vase with pendulous body, pyramidal base, and two handles usually of archaic dragon form. The favourite design for the decoration of these forms is the flowering prunus tree, beside a rockery with a few bright plumaged birds in the branches, one of the most familiar and at the same time most beautiful of Chinese patterns (see Plate 96). The flowers of the four seasons—peony, lotus, chrysanthemum and prunus—form a beautiful decoration for the four sides of another favourite form, a tall vase of square elevation with sides lightly tapering downwards, rounded shoulders, and circular neck, slightly flaring at the mouth. The specimens illustrated are in the British Museum, but there is a wonderful series of these lordly vases in the Salting Collection, and in the Pierpont Morgan and Altmann Collections in New York. To-day they are rare, and change hands at enormous prices. Consequently all manner of imitations abound, European and Oriental, the modern Chinese work in this style being often highly successful. But the most insidious copies are the deliberate frauds in which old K'ang Hsi vases are stripped of a relatively cheap form of decoration, the glaze and colour being removed by grinding, and furnished with a cleverly enamelled design in colours on the biscuit. The actual colours are often excellent, and as the ware seen at the base is the genuine K'ang Hsi porcelain even the experienced connoisseur may be deceived at first, though probably his misgivings will be aroused by something in the drawing which betrays the copyist, and a searching examination of the surface will reveal some traces of the sinister treatment to which it has been subjected or the tell-tale marks, such as black specks or burns, left on the foot rim by the process of refiring. There is much truth besides in the saying that things " look their age," and artificial signs of wear imparted by friction and

[1] Another favourite form is the ovoid beaker (see Plate 101), which is sometimes called the *yen yen* vase, apparently from *yen*, beautiful. But I only have this name on hearsay, and it is perhaps merely a trader's term.

rubbing with sand or grit are not difficult for the experienced eye to detect.

As already noted, the black of the precious black-ground vases, the *famille noire* as they are sometimes called, is formed by overlaying a dull black pigment with washes of transparent green enamel. The result is a rich greenish black, the enamel imparting life and fire to the dull pigment ; and as the green is fluxed with lead it tends to become iridescent, giving an additional green *reflet* to the black surface. The modern potters have learnt to impart an iridescence to their enamels, and one often sees a strong lustre on specimens which are clearly " hot from the kiln " ; but these enamels have a sticky appearance differing widely from the mellow lustre which partial decay has spread over the K'ang Hsi colours. It will be found, besides, that the shapes of the modern copies are wanting in the grace and feeling of the originals.

This type of porcelain enamelled on the biscuit is particularly well suited to statuettes and ornamental objects of complex form. The details of the biscuit remain sharp and clear, and there is no thick white glaze to soften the projections and fill up the cavities, for the washes of transparent enamel are too slight to obscure the modelling. Consequently we find in this style of ware all the familiar Chinese figures, the Buddhist and Taoist deities, demigods, and sages, which, like our own madonnas and saints, mostly conform to well established conventions, differing mainly in their size, the quality of their finish, the form of their bases or pedestals, and the details of the surface colouring. Of these the figures of Kuan-yin [1] are the most frequent and the most attractive, the compassionate goddess with sweet pensive face, mounted on a lotus pedestal or a rocky throne and sometimes canopied with a cloak which serves as a hood and a covering for her back and shoulders. She has moreover a long flowing robe open at the neck, and displaying a jewelled necklace on her bare bosom. There are, besides, the god of Longevity : the Eight Immortals : Tung-fang So with his stolen peaches : the star-gods of Longevity, Rank, and Happiness : the twin genii of Mirth and Harmony : Kuan-ti, the god of War, on a throne or on horse-back : Lao-tzŭ on his ox : the demon-like Kuei Hsing, and the dignified Wên Ch'ang, gods of Literature; and all the throng. There are a few animal forms such as the horse, the ox, the elephant, the mythical *ch'i-lin*, and most common of all the Buddhist lions

[1] See p. 110.

(sometimes called the dogs of Fo), usually in pairs, one with a cub, and the other playing with a ball of brocade, mounted on an oblong base, to which is attached, in the smaller sizes at any rate, a tube for holding incense sticks. Other familiar objects are four-footed or tripod stands for manuscript rolls, boxes for brushes, colours, etc., ink screens, water pots of fanciful shape for the writing table, picture plaques (Plate 100), supper sets made up of a number of small trays which fit together in the form of a lotus flower[1] or a rosette, perforated boxes and hanging vases for fragrant flowers (Fig. 2 of Plate 98), " butterfly cages," and " cricket boxes." Another well-known specimen represents the famous T'ang poet, Li T'ai-po, the Horace of China, reclining in drunken stupor against a half overturned wine jar, the whole serving as a water vessel for the writing table.

Instances of the combination of on-glaze and on-biscuit enamels in the same piece also occur. Thus on the splendid black-ground potiche in the Franks Collection (Frontispiece) passages of white glaze have been inserted to receive the coral red colour which apparently could not be applied to the biscuit. And conversely in the ordinary *famille verte* decoration on the glaze there are sometimes inserted small areas of on-biscuit enamels on borders, handles, base ornaments, etc. Such combinations give an excellent opportunity for observing the contrast between the softer, fuller tints on the biscuit and the brighter, more jewel-like enamels on the white glaze. In rare instances we find passages of blue and white decoration associated with the on-biscuit enamels as on the curious ewer illustrated by Fig. 1 of Plate 94. Blue and white is similarly combined with decoration in coloured glazes on the biscuit in a late Ming jar in the Victoria and Albert Museum (Case 9, No. 4396–57).

The familiar phrase, *famille verte,* was first used by Jacquemart as a class name for the enamelled porcelains on which green plays a leading part. According to this definition it should include the *Wan li wu ts'ai,* the Ming enamelled porcelain, as well as much of the on-biscuit enamelled wares, in addition to the typical K'ang Hsi enamelled porcelain to which usage has specially consecrated the term. A direct descendant of the *Wan li wu ts'ai,* the *famille verte* includes the combinations of underglaze blue with the translucent on-glaze enamels green, yellow, and aubergine, and the coral red (derived from iron), the French *rouge de fer,* which is so thin that it

[1] A lotus-shaped set in the Salting collection numbers thirteen sections.

Fig. 1 Fig. 2

Fig. 3

Plate 98.—K'ang Hsi Porcelain with on-biscuit decoration.
Dresden Collection.

Fig. 1.—Teapot in form of a lotus seed-pod, enamels on the biscuit. Height
2¾ inches. Fig. 2.—Hanging Perfume Vase, reticulated, enamels on the biscuit.
Height 3½ inches. Fig. 3.—Ornament in form of a junk, transparent *san ts'ai*
glazes. Height 11½ inches.

Fig. 3

Fig. 1 Fig. 2

Plate 99.—K'ang Hsi Porcelain with on-biscuit decoration.

Fig. 1.—Ewer with black enamel ground, lion handle. Height 8¾ inches. Cope Bequest (V. & A. Museum). Fig. 2.—Figure of the Taoist Immortal, Ho Hsien Ku, transparent san ts'ai glazes. Height 10⅛ inches. S. E. Kennedy Collection. Fig. 3.— Vase and Stand, enamelled on the biscuit. Height 8¾ inches. Cope Bequest.

Plate 100.—Screen with Porcelain Plaque, painted in enamels on the biscuit.

Light green background. K'ang Hsi period (1662–1722). Total height 22½ inches.
In the Collection of the Hon. E. Evan Charteris.

Plate 101.—Vase with panels of landscapes and *po ku* symbols in
famille verte enamels

In a ground of underglaze blue trellis pattern. K'ang Hsi period (1662–1722).
Height 32 inches. *Dresden Collection.*

Fig. 1

Fig. 2

Plate 102.—Two Dishes of *famille verte* Porcelain in the
Dresden Collection. K'ang Hsi period (1662-1722).

Fig. 1.—With birds on a flowering branch, brocade borders.
Artist's signature in the field. Diameter 16 inches. Fig. 2.—
With ladies on a garden terrace. Diameter 21 inches.

resembles a pigment rather than a vitreous enamel. Add to these the brown black pigment, which is used to trace the outlines of the design and with a covering of green to form the green black, and we have one type of *famille verte* which differs in no essential from the Wan Li prototype. It is, in fact, no easy matter to find the line which divides the two groups. The nature of the ware and the style of the painting are the best guides; and the study of the K'ang Hsi blue and white will be a great help in this delicate task.

But the real K'ang Hsi *famille verte*, which we might call the *K'ang hsi wu ts'ai*, is distinguished by the addition of an overglaze blue enamel which enhanced the brilliancy of the colour scheme, and at the same time removed the necessity of using underglaze and overglaze colours together.[1] It is not to be supposed, however, that the underglaze blue disappeared entirely from the group. The old types were always dear to the Chinese mind, and there were frequent revivals of these in addition to the special wares,[2] such as the " Chinese Imari," in which this kind of blue was essential. There are indeed examples of both blues on the same pieces.

The history of this overglaze blue enamel has already [3] been partially discussed, and evidence has been given of its tentative use in the Wan Li porcelain. A passage in the second letter of Père d'Entrecolles [4] actually places its invention about the year 1700, but the worthy father's chronology (based no doubt chiefly on hearsay) is often at fault. It is fairly certain, however, that the blue enamel was not used to any extent before the Ch'ing dynasty, owing no doubt to the fact that it had not been satisfactorily made until that date.

A beautiful enamel of violet blue tone, it is an important factor of the *famille verte* decoration, and the merits of a vase or dish are

[1] The underglaze blue almost invariably suffered in the subsequent firings which were necessary for the enamels, and, as we shall see, a different kind of glaze was used on the pure enamelled ware and on the blue and white.

[2] Apart from the cases in which the enamel colours were added to faulty specimens of blue and white to conceal defects.

[3] See p. 85.

[4] Op. cit., section vi. " Il n'y a, dit on, que vingt ans ou environ qu'on a trouvé le secret de peindre avec le *tsoui* ou en violet et de dorer la porcelaine." As far as the gilding is concerned, this statement is many centuries wrong. The *tsoui* is no doubt the *ts'ui*, which is very vaguely described in section xii. (under the name *tsiu*) of the same letter. Here it is stated to have been compounded of a kind of stone, but the description of its treatment clearly shows that the material was really a coloured glass, which is, in fact, the basis of the violet blue enamel.

often decided on the purity and brilliance of this colour alone. There is, however, something in the nature of the enamel which seems to affect the surrounding glaze; at any rate, it is often ringed about by a kind of halo of dull lustre, reflecting faint rainbow tints to a distance of perhaps an inch from the edge of the blue. It is as though an exhalation from the blue enamel deposited a thin film of lustre on the glaze, and it is a very frequent occurrence, though not always in the same conspicuous degree. Collectors who are ever looking for a sign have been tempted to hail its presence as a sure proof of antiquity. But it is by no means constant on the old *famille verte*, and it has yet to be proved that the same enamel will not produce a similar effect on the modern glaze.

In view of the appreciation of *famille verte* porcelain at the present day a contemporary criticism will be of interest. D'Entrecolles in his first letter,[1] referring to " porcelain painted with landscapes in a medley of almost all the colours heightened with gilding," says : " They are very beautiful, if one pays a high price, but the ordinary wares of this kind are not to be compared with blue and white." And again,[2] following an exact description of painting with enamel colours on the finished glaze and of the subsequent refiring of the ware, we read : " Sometimes the painting is intentionally reserved for the second firing; at other times they only use the second firing to conceal defects in the porcelain, applying the colours to the faulty places. This porcelain, which is loaded with colour, is not to the taste of a good many people. As a rule one can feel inequalities on the surface of this kind of porcelain, whether due to the clumsiness of the workmen, to the exigencies of light and shade in the painting, or to the desire to conceal defects in the body of the ware."

The tenor of these criticisms will not be endorsed by the modern collector of K'ang Hsi porcelain. *Famille verte* porcelain is enthusiastically sought, and even indifferent specimens command a high price, while the really choice examples can only be purchased by the wealthy. As to the inequalities on the surface, the second of the three reasons hazarded by d'Entrecolles is nearest the truth. The enamels used by the Chinese porcelain painter contain a remarkably small percentage of colouring oxide, and one of the characteristics of *famille verte* colours is their transparency. To obtain full tones and the contrast between light and shade (even to the limited extent

[1] Bushell, op. cit., p. 193. [2] Loc. cit., p. 195.

to which the Chinese use this convention) it was necessary to pile up the layers of colour at the risk of unduly thickening the enamel. But the connoisseur of to-day finds nothing amiss in these jewel-like incrustations of colour, so long as the enamels are pure and bright, and have not scaled off or suffered too severely from the wear to which their prominent surface is exposed.

It seems [1] that when the porcelain was destined to receive on-glaze enamels (without any underglaze blue) a special glazing mixture was used in which only one part of the softening element [2] was combined with thirteen of the ordinary glazing fluid. This glaze was very white and strong, and too opaque to do justice to an underglaze blue.

There is a reference in the first letter of Père d'Entrecolles to a white colour which was used on the " porcelain painted in various colours." It was fluxed with lead like the other enamel colours, and it was also used mixed with the latter to modify their tint. In fact there can be little doubt that it was arsenical white, an opaque white familiar on the Yung Chêng and Ch'ien Lung porcelains, and prominent in the *famille rose* palette, but not usually suspected of such an early appearance as 1712, the date of the letter in question.

The designs of the *famille verte* porcelain, like those on the blue and white, are first traced in outline and then filled in with washes of colour. The outlines are in a dry dull pigment of red or brown black tint, inconspicuous in itself, but acquiring prominence when covered with transparent enamel. M. Grandidier tried to formulate certain rules for these outlines which, if reliable, would simplify greatly the task of dating the porcelains. On Ming ware, he said, the outlines were blue ; on K'ang Hsi wares the face and body outlines were red, those of the vestments and other objects black. Unfortunately the first of these generalisations is wholly wrong, and the second pointless, because only partly right.

Omitting the underglaze blue as foreign to this particular group of *famille verte* under discussion, the colours consist of dark leaf green often of a mottled appearance, a beautiful light apple green, which is characteristic of the K'ang Hsi wares just as the blue green is of the sixteenth century polychrome, an aubergine colour (derived from manganese) which varies from purple brown to rosy purple, a yellow of varying purity and usually of brownish tone, a green

[1] See d'Entrecolles, second letter, section xii.
[2] Burnt lime and wood ashes. See p. 92.

black formed of the brown black pigment under washes of transparent green, a blue enamel of violet tone, and the thin iron red. The blue enamel and the red are sometimes omitted, leaving a soft harmony of green, aubergine and yellow in which green plays the chief part. A little gilding is often used to heighten parts of the design.

As for the shapes of the *famille verte* porcelain, they are substantially the same as those of the blue and white and call for no further comment. The designs, too, of the painted decoration are clearly derived from the same sources as those in the blue and white, viz. books of stock patterns, pictures, illustrations of history and romance, and of such other subjects as happened to be specially appropriate or of general interest.

To take a single instance of a pictorial design, the familiar rockery and flowering plants (peony, magnolia, etc.) and a gay-plumaged pheasant lends itself to effective treatment in enamel colours. It is taken from a picture, probably Sung in origin, but there are many repetitions of it in pictorial art, one of which by the Ming painter Wang-yu is in the British Museum collection.[1] The original is said to have been painted by the Emperor Hui Tsung in the beginning of the twelfth century. Another familiar design—quails and millet —is reputed to have been painted by the same Imperial artist.

A good instance of the kind of illustrated book which supplied the porcelain decorator with designs is the *Yü chih kêng chih t'u* (Album of Ploughing and Weaving, compiled by Imperial order), which deals with the cultivation of rice and silk in some forty illustrations. It was first issued in the reign of K'ang Hsi, and there are copies of the original and of several later editions in the British Museum. A specimen of *famille rose* porcelain in the Franks Collection is decorated with a scene from this work, and in the Andrew Burman Collection there are two *famille verte* dishes with designs from the same source. In the Burdett Coutts Collection, again, there is a polygonal bowl with subjects on each side representing the various stages of cotton cultivation, evidently borrowed from an analogous work.

Signatures and seals of the artist usually attached to a stanza of verse, or a few phrases which allude to the subject, are often found in the field of the pictorial designs. Fig. 1 of Plate 102, for instance, belongs to a series of beautiful dishes in the Dresden collection, which

[1] Catalogue of the 1910 exhibition, No. 84.

display the same seal—apparently [1] *wan shih chü* (myriad rocks retreat), the studio name not, I think, of the porcelain painter but of the artist whose picture was copied on the porcelain. There are numerous examples of similar seals in the field of the design, and we shall return to the subject later in a place where important issues turn on the solution of the problem which it raises.[2]

The types of *famille verte* porcelain are extremely numerous, almost as varied as those of the blue and white (p. 136). Like the latter they include much that was obviously made for European consumption, and most of the groups which were singled out from the mass of blue and white for special description can be paralleled in the *famille verte*. The thin, crisp, moulded ware with petal-shaped panels and lobed borders, the group with the " G " mark, and many other types are found with the same peculiarities of paste and glaze, and even the same design painted in on-glaze enamels. As in the case of the blue and white, the quality of this export ware varies widely, and the individual specimens will be judged by the drawing of the designs and the purity and fire of the enamels.

A few of the more striking types are illustrated on Plates 103 and 104. Perhaps the most sumptuous effects of this colour scheme are displayed in the vases decorated with panel designs surrounded by rich diapers borrowed from silk brocades. A favourite brocade pattern consists of single blossoms or floral sprays woven into a ground of transparent green covering a powder of small brown dots. This dotted green ground is commonly known as " frog's spawn," and another diaper of small circles under a similar green enamel is easily recognised under the name of " fish roe." But the variety of these ground patterns is great, and in spite of their prosaic nomenclature they render in a singularly effective manner the soft splendour of the Chinese brocades.

In dating the *famille verte* porcelains the collector will find his study of the blue and white of great assistance. There is, for instance, the well-known type of export ware—sets of vases with complex

[1] These seals are usually difficult to decipher, and the one in question might be read *shui shih chü* (water and rock dwelling). This would be a matter of small importance did not the signature read by Bushell as *wan shih chü* occur in the Pierpont Morgan Collection. Other instances in the same collection are *chu chü* (bamboo retreat), *shih chü* (rock retreat), and *chu shih chü* (red rock retreat). The signature *chu chü* also occurs on a dish in the Dresden collection.

[2] See p. 212.

moulding, and dishes and plates, etc., with petal-shaped lobes on the sides or borders. The central design of the decoration commonly consists of *ch'i lin* and phœnix, sea monsters (*hai shou*), storks or ducks beside a flowering tree or some such familiar pattern ; and the surrounding petal-shaped panels are filled each with a growing flower, or a vignette of bird and plant, plant and insect, or even a small landscape. These bright but often perfunctorily painted wares are paralleled in the early K'ang Hsi blue and white. They are among the first Chinese polychrome porcelains to be copied by the European potters. See Plate 107.

In the purely native wares the early Ch'ing *famille verte* is distinguished by strong and rather emphatic colouring, the energy of the drawing and the breadth of design which recall the late Ming polychromes. The zenith of this style of decoration was reached about 1700, say between 1682 and 1710. This is the period of the magnificent vases with panel designs in brocaded grounds, or with crowded figure subjects, Court scenes, and the like, filling large areas of the surface, such vases as may be seen in the splendid series of the Salting Collection or in the Grandidier Collection in the Louvre. They are probably children of the great renaissance which began under the auspices of Ts'ang Ying-hsüan. Dated examples are extremely rare, and consequently the square vase on Plate 104 assumes unusual importance on account of the cyclical date which occurs in the long inscription, " the 29th day of the 9th moon of the *kuei mo* year," which we can hardly doubt is 1703. Incidentally another side of this vase illustrates the celebrated scene of the wine cups started from the " orchid arbour to float down the nine-bend river." [1]

Another example with a cyclical date (the year *hsin mao*, and no doubt 1711) is a globular water bottle " of the highest quality and technique, decorated with transparent luminous enamels of great beauty and delicacy," in the Pierpont Morgan Collection.[2] But in this case the date is attached to a verse in the field of the decoration, and it may belong to the design rather than to the porcelain.

The lateness of this latter date and the use of the word " delicacy " in the description of the piece lead us naturally to that peculiarly refined type of late *famille verte* in which the ware is of eggshell thinness, the painting extremely dainty and delicate, and the

[1] See p. 64. [2] *Cat.*, vol. i., p. 156.

Fig. 2

Fig. 1

Fig. 3

Plate 104.—Three Examples of K'ang Hsi *famille verte* Porcelain.

Fig. 1.—Square Vase with scene of floating cups on the river; inscription with cyclical date 1703 A.D.; *shou* characters on the neck. Height 18¾ inches. *Hippisley Collection.* Fig. 2.—Lantern with river scenes. Height 13¾ inches. *Dresden Collection.* Fig. 3.—Covered Jar of *rouleau* shape, peony scrolls in iron red ground, brocade borders. Height 22 inches. *Dresden Collection.*

Plate 105.—Covered Jar painted in *famille verte* enamels

With brocade ground and panel with an elephant (the symbol of Great Peace). Lion on cover. K'ang Hsi period (1662–1722). Height 21¼ inches. *Dresden Collection.*

Fig. 2

Fig. 1

Plate 106.—K'ang Hsi *famille verte* Porcelain. *Alexander Collection.*

Fig. 1.—Dish with rockery, peonies, etc., birds and insects. Diameter 16¼ inches. Fig. 2.—"Stem Cup" with vine pattern. Height 5¾ inches.

Plate 107.—*Famille verte* Porcelain made for export to Europe. K'ang Hsi period (1662–1722).
British Museum.

Fig. 1.—Vase with " sea monster " (*hai shou*). Fig. 2.—Dish with basket of flowers. Mark, a leaf. Diameter 11 inches.
Fig. 3.—Covered Jar with *ch'i-lin* and *fêng-huang* (phœnix).

colours rather pale but of perfect purity. Such are the well-known
" birthday plates " with the reign mark of K'ang Hsi on the
back and the birthday salutation in seal characters on the border :
wan shou wu chiang—" a myriad longevities without ending ! " They
are reputed to have been made for the Emperor's sixtieth birthday
which fell in the year 1713, but the story is supported by no evidence
of any kind, and they would have been equally appropriate for any
Imperial birthday. The character of these wares is more suggestive
of the Yung Chêng period, and it is probable that they belong to
the extreme limit of the long reign of K'ang Hsi. To this period
then we shall assign these and the whole group of kindred porcelains,
the plates with designs similar to those of the " birthday plates,"
but without the inscribed border, the small eggshell plates with one
or two figures painted in the same delicate style, others with a single
spray of some flowering shrub almost Japanese in its daintiness,
and occasional bowls and vases with decoration of the same character.
See Plate 113.

For extreme delicacy of treatment is by no means a feature
of the K'ang Hsi *famille verte* in general, in which the Ming
spirit with its boldness and vigour still breathed. It is rather a
late development in the decadence of the ware, heralding the more
effeminate beauty of the *famille rose*, and were it not for the evidence
of the birthday plates I believe many connoisseurs would be tempted
to ascribe these delicate porcelains to a much later reign.

Such, however, is the evolution of the *famille verte* during the
sixty years of the K'ang Hsi period, from the strong colours and
forceful Ming-like designs of the earlier specimens to the mature
perfection of the splendid wares made about 1700, and thence by
a process of ultra-refinement to the later types in which breadth
of treatment gives place to prettiness and the strong thick enamels
to thinner washes of clear, delicate tints. These thin transparent
colours continued in use ; indeed, they are a feature of a special
type of enamelling which will be discussed with the Yung Chêng
wares ; but the pure *famille verte* may be said to have come to an
end with the last years of the reign of K'ang Hsi. Later reproductions
of course exist, for no style of decoration is ever wholly extinct
in Chinese art, but they are merely revivals of an old style, which
even before the end of the K'ang Hsi period had reached the stage
of transition to another family. The opaque enamels of the *famille
rose* palette had already begun to assert themselves. Timid intruders

at first—a touch of opaque pink, a little opaque yellow and arsenical white breaking in upon the old harmony of transparent tints—they gradually thrust the *famille verte* enamels into a subsidiary position, and in the succeeding reigns rose pinks entirely dominate the field.

A word must be said of the use of the *famille verte* painting in combination with other types of decoration, in the subordinate position of border patterns or more prominently in panel designs. Exquisite effects are obtained by the latter in a ground of coral red, or where a brilliant powder blue field is broken by shapely panels with flowering plants and birds and other familiar vehicles for *famille verte* colouring. Occasionally we find the enamels actually painted over a powder blue or an ordinary blue glaze, but the combination is more peculiar than attractive ; for the underlying colour kills the transparent enamels, and the enamels destroy the lustre of the blue ground. Indeed, it is probable that in many cases these freak decorations were intended to hide a faulty background.

A similar painting over the crackled green *lang yao* glaze has already been described, and it occurs over the grey white crackles, and rarely but with much distinction, over a pale celadon glaze. But perhaps the most effective combination of this kind is that in which a pale lustrous brown or Nanking yellow is the ground colour. The quiet and refined effects of this union are well exhibited by a small group of vases, bowls, and dishes in the Salting Collection.

Something has already been said of the use of underglaze blue in combination with *famille verte* enamels. The blue is either an integral part of the general design as in the Wan Li " five colour " scheme, or it forms a distinct decoration by itself, apart from the enamels, though sharing the same surface. The latter use is exemplified by a pair of bottles in the Salting Collection which have blue patterns on the neck and *famille verte* decoration on the body, consisting of landscape panels surrounded by brocade patterns.[1] But the great drawback to this union of underglaze and overglaze colours is usually apparent. The blue was liable to suffer in the subsequent firings necessitated by the enamels, even though those firings took place at a relatively low temperature. Probably the potter would not expose his finest blue to such risks, but at any rate the blue of this mixed decoration is rarely of first-rate quality.

There is one group of porcelain which combines the underglaze blue with on-glaze enamels, and which deserves special notice if

[1] Similar bottles in the Drucker Collection have the " G " mark.

only because it has been recently favoured with particular attention by collectors. This is what we are pleased to call "Chinese Imari." Our ceramic nomenclature has never been noted for its accuracy, and like good conservatives we hold firmly to the old names which have been handed down from days when geography was not studied, and from ancestors who were satisfied with old Indian china, or Gombroon ware, as names for Chinese porcelain. So Meissen porcelain is still Dresden, the blue and white of Ching-tê Chên is Old Nanking, Chinese export porcelain painted at Canton with pink roses is Lowestoft, and the ware made at Arita, province of Hizen, in Japan, is Imari, because that is the name of the seaport from which it was shipped. In fact, there are many shops where you cannot make yourself understood in these matters unless you call the wares by the wrong name.

The Arita porcelain in question, this so-called Imari, was made from the middle of the seventeenth century onwards, and it must have competed seriously with the export wares of Ching-tê Chên. At any rate, it was brought to Europe in large consignments by the Dutch traders, who enjoyed the privilege of a trading station on the island of Deshima, after the less politic Portuguese had been driven out of Nagasaki in 1632. For the moment we are specially concerned with two types of Arita ware. The first is distinguished by slight but artistic decoration in vivid enamels of the *famille verte,* supplemented by gilding and occasionally by underglaze blue. Favourite designs are a banded hedge, prunus tree, a Chinese boy and a tiger or phœnix ; two quails in millet beside a flowering prunus ; simple flowering sprays or branches coiled in circular medallions ; or only a few scattered blossoms. Whatever the nature of the design, it was artistically displayed, and in such a manner as to enhance without concealing the fine white porcelain. This is what the old catalogues call the *première qualité coloriée de Japon,* and a very popular ware it was in eighteenth century Europe, when it was closely copied on the early productions of the St. Cloud, Chantilly, Meissen, Chelsea, and other porcelain factories. To-day it is commonly known as Kakiemon ware, because its very distinctive style of decoration is traditionally supposed to have been started by a potter named Kakiemon, who, with another man of Arita, learned the secret of enamelling on porcelain from a Chinese merchant about the year 1646.

The second type was made entirely for the European trade,

and it is distinguished by large masses of dark, cloudy blue set off by a soft Indian red (derived from oxide of iron) and gilding. These colours are supplemented by touches of green, yellow, and aubergine enamels, and occasionally by a brownish black. The ware itself is heavy, coarse and greyish, but its rough aspect is well concealed by irregular and confused designs of asymmetrical panels surrounded by mixed brocade patterns. The panels often contain Chinese figures, phœnixes, lions, floral designs of chrysanthemums, peony and prunus, a basket of flowers, rough landscapes or garden views. They are medleys of half-Chinese, half-Japanese motives, a riot of incoherent patterns, but not without broad decorative effect thanks to the bold masses of red, blue and gold. Such is the typical " Old Imari." There is, however, a finer and more Japanese variety of the same group which is distinguished by free use of the chrysanthemum rosette, and the Imperial kiri (paulonia imperialis), and by panels of diaper pattern and floral designs alternating and counterchanged in colour, the grounds now red, now blue, and now gold. The same colour scheme prevailed in this sub-group, and the dark blue was usually netted over with gold designs.

It was no doubt the success which these wares met in European commerce that induced the Chinese to take a lesson from their pupils, and to adopt the " Imari " style. At any rate, they did copy all these types, sometimes very closely, sometimes only in part. Thus in some cases the actual Japanese patterns as well as the colour scheme are carefully reproduced, in others the Japanese colour scheme is employed on Chinese patterns or vice versa, and, again, there are cases in which passages of Japanese ornament are inserted in purely Chinese surroundings. But whether pure or diluted the Japanese style is unmistakable to those who have once learnt to know its peculiarities, of which masses of blue covered with gilt patterns and the prominence of red and gold are the most conspicuous.

There will, of course, always be a few specimens the nationality of which will be difficult to decide, but to anyone familiar with Chinese and Japanese porcelain the distinction between the Chinese " Imari " and its island prototype is, as a rule, a simple matter. The Chinese porcelain is thinner and crisper, its glaze has the smooth oily sheen and faintly greenish tint which are peculiar to Chinese wares, and the raw edge of the base rim is slightly browned. The Japanese porcelain, on the other hand, is whiter in the Kakiemon

ware, greyer and coarser in the " Old Imari," and the glaze in both cases has the peculiar bubbled and " muslin-like " texture which is a Japanese characteristic. The Japanese underglaze blue is dark and muddy in tone, the Chinese bright, and purer, and the other colours differ, though not perhaps so emphatically. The iron red of the Chinese, for instance, is thinner and usually lighter in tone than the soft Indian red or thick sealing-wax colour of the Japanese ; and to those who are deeply versed in Oriental art there is always the more subtle and less definable distinction, the difference between the Chinese and Japanese touch and feeling.

Plate 108 is a fine specimen which shows the blend of Chinese motives and the Japanese colouring.

The general character of the Chinese " Imari " is that of the K'ang Hsi period, to which most of the existing specimens will be assigned ; but it is clear that the Chinese continued to use Japanese models in the succeeding reign, for the last three items in the Imperial list of porcelain made in the Yung Chêng period comprise wares " decorated in gold and in silver in the style of the Japanese." [1]

[1] *Fang tung yang,* " imitating the Eastern Sea" (i.e. Japan).

CHAPTER XI

IN passing to the K'ang Hsi monochromes we enter a large field with boundaries ill defined. Many of the colours are legacies from the Ming potters, and most of them were handed on to after generations ; some indeed have enjoyed an unbroken descent to the present day. Consequently there are few things more difficult in the study of Chinese porcelain than the dating of single-colour wares.

In some cases the origin of a particular glaze has been recorded, and within certain limits the style of the piece will guide us in assessing its age ; but how often must we be content with some such non-committal phrase as " early eighteenth century," which embraces the late K'ang Hsi, the Yung Chêng and the early Ch'ien Lung periods ? On the other hand, the careful student observes certain points of style and finish, certain slight peculiarities of form which are distinctive of the different periods, and on these indefinite signs he is able to classify the doubtful specimens. To the inexpert his methods may seem arbitrary and mysterious, but his principles, though not easy to enunciate, are sound nevertheless.

We have already had occasion to discuss a few of the K'ang Hsi monochromes in dealing with the question of *lang yao*. But besides the *sang de bœuf* there is another rare and costly red to which the Americans have given the expressive name of " peach bloom." Since their first acquaintance with this colour in the last half of the nineteenth century,[1] American collectors have been enamoured of it, and as they have never hesitated to pay vast sums for good specimens, most of the fine " peach blooms " have found their way to the United States, and choice examples are rare in England. " The prevailing shade," to quote from Bushell's description, " is

[1] The first specimens (according to Bushell, *O. C. A.*, p. 309) to reach America came from the collection of the Prince of Yi, whose line was founded by the thirteenth son of the Emperor K'ang Hsi.

Plate 109.—Figure of Shou Lao, Taoist God of Longevity.

Porcelain painted with *famille verte* enamels. K'ang Hsi period (1662-1722). Height 17¼ inches. *Salting Collection (V. & A. Museum).*

a pale red, becoming pink in some parts, in others mottled with russet spots, displayed upon a background of light green celadon tint. The last colour occasionally comes out more prominently, and deepens into clouds of bright apple green tint." The Chinese, in comparing the colour, have thought of the apple rather than the peach ; it is *p'in-kuo hung* (apple red), and the markings on it are *p'in-kuo ch'ing* (apple green), and *mei kuei tzŭ* (rose crimson). Another Chinese name for the colour is *chiang-tou hung* (bean red), in allusion to the small Chinese kidney-bean with its variegated pink colour and brown spots.

It is generally supposed that, like the *sang de bœuf*, the " peach bloom " owes its hue to copper oxide, and that all the accessory tints, the russet brown and apple green, are due to happy accidents befalling the same colouring medium in the changeful atmosphere of the kiln.[1] This precious glaze is usually found on small objects such as water pots and brush washers for the writing table (see Plate 111 [2]), and snuff bottles, and a few small elegantly formed flower vases of bottle shape, with high shoulders and slender neck, the body sometimes moulded in chrysanthemum petal design, or, again, on vases of slender, graceful, ovoid form, with bodies tapering downwards, and the mouth rim slightly flaring. In every case the bottom of the vessel shows a fine white-glazed porcelain with unctuous paste, and the K'ang Hsi mark in six blue characters written in a delicate but very mannered calligraphy, which seems to be peculiar to this type of ware, and to a few choice *clair de lune* and celadon vases of similar form and make.

[1] The general reader will probably not be much concerned as to whether the peach bloom was produced by oxide of copper or by some other process. Having learnt the outward signs of the glaze, he will take the inner meaning of it for granted. Others, however, will be interested to know that practically all the features of the peach bloom glaze, the pink colour, the green ground and the russet brown spots can be produced by chrome tin fired at a high temperature. I have seen examples of these chrome tin pinks made by Mr. Mott at Doulton's, which exhibit practically all the peculiarities of the Chinese peach bloom. It does not, of course, follow that the Chinese used the same methods or even had any knowledge of chrome tin. They may have arrived at the same results by entirely different methods, and the peach bloom tints developed on some of the painted underglaze copper reds point to the one which is generally believed to have been used ; but the difference between these and the fully developed peach bloom is considerable, and though we have no definite evidence one way or the other, the possibilities of chrome tin cannot be overlooked.

[2] The form of this water pot is known (according to Bushell, *O. C. A.*, p. 318) as the *T'ai-po tsun*, because it was designed after the traditional shape of the wine jar of Li T'ai-po, the celebrated T'ang poet. In its complete state it has a short neck with slightly spreading mouth.

The colour in the peach bloom glaze, as in the *sang de bœuf*, is sometimes fired out and fades into white or leaves a pale olive green surface with only a few spots of brown or pink to bear witness to the original intention of the potter. The glaze is sometimes crackled and occasionally it runs down in a thick crystalline mass at the base of the vessel.

Needless to say this costly porcelain has claimed the earnest attention of the modern imitator. The first real success was achieved by a Japanese potter at the end of the last century. He was able to make admirable copies of the colour, but failed to reproduce adequately the paste and glaze of the originals. I am told that he was persuaded to transfer his secret to China, and with the Chinese body his imitations were completely successful. The latter part of the story is based on hearsay, and is given as such ; but it is certain that there are exceedingly clever modern copies of the old peach blooms in the market ; otherwise how could an inexpert collector in China bring home half a dozen peach blooms bought at bargain prices ?

The copper red used in painting underglaze designs [1] will sometimes develop a peach bloom colour, and there is a vase in the British Museum with parti-coloured glaze in large patches of blue, celadon, and a copper red which has broken into the characteristic tints of the peach bloom vases.

Another red of copper origin allied to the *sang de bœuf* and the peach bloom, and at times verging on both, is the maroon red, which ranges from crimson to a deep liver colour. There are wine cups of this colour whose glaze clouded with deep crimson recalls the " dawn red " of the wine cups made by Hao Shih-chiu.[2] Sometimes the red covers part only of the surface, shading off into the white glaze. The finer specimens have either a crimson or a pinkish tinge, but far more often the glaze has issued from the kiln with a dull liver tint.

Naturally the value of the specimens varies widely with the beauty of the colour. The pinker shades approach within measurable distance of the pink of the peach bloom, and they are often classed with the latter by their proud owners ; but the colour is usually uniform, and lacks the bursts of russet brown and green which variegate the true peach bloom, and the basis of the maroon is a pure white glaze without the celadon tints which seem to underlie

[1] See p. 146. [2] See p. 64.

the peach bloom. It may be added that the maroon red glaze is usually uncrackled.

As to the overglaze red, which is known by the names of *mo hung* (painted red) and *ts'ai hung* (enamel red), it is the colour derived from iron, and it was used both as one of the enamels of the *famille verte* palette and as a monochrome. In both capacities it figured on Ming porcelain, and was fully discussed in that connection. On K'ang Hsi wares it varied in tone from dark brick red to a light orange, according to the density of the pigment, and in texture from a thin dry film to a lustrous enamel, according to the quantity of fluxing material [1] combined with it. Among the richly fluxed varieties is a fine tomato colour of light, translucent tone. Sometimes the iron red is found as sole medium for painted designs, as on a rouleau vase in the Salting collection, but more commonly it serves as a ground colour between panels of enamelled ornament (Plate 103), or in border passages. In these last two positions it is usually of a light orange shade, and broken by floral scrolls reserved in white. A dark shade of the same pigment is also used in diapers of curled scrolls, forming a groundwork for enamelled decoration. There are besides beautiful examples of a pure red monochrome formed of this colour, but I have only met with these among the later wares.

The blue monochromes include a large number of glazes varying in depth and shade with the quality and quantity of the cobalt which is mingled with the glazing material. These are *chiao ch'ing* (blue monochrome glazes), and they are all high-fired colours. They include the *chi ch'ing* [2] or deep sky blue, whose darker shades are also named *ta ch'ing* (*gros bleu*), the slaty blue, the pale clear blue,[3] the dark and light lavender shades, and the faintly tinted *clair de lune* or " moon white " (*yüeh pai*), in which the amount of cobalt used must have been infinitesimal. But it would be useless to attempt to catalogue the innumerable shades of blue, which must have varied with every fresh mixture of colour and glaze and every fresh firing.

There is, however, another group materially different from the

[1] i.e. lead glass.

[2] *Chi*, lit. sky-clearing, and *chi ch'ing* might be rendered " blue of the sky after rain."

[3] There are some bowls and bottles in the Dresden collection with glazes of a pale .uminous blue which are hard to parallel elsewhere.

ordinary blue glazes. In this the colour was applied direct to the body, as in blue and white painting, and a colourless glaze subsequently added, with the natural result that the blue seems to be incorporated with the body of the ware rather than with the glaze. There were several ways of applying the colour, each producing a slightly different effect. The cobalt powder could be mixed with water, and washed on smoothly with a brush, or dabbed on with a sponge to give a marbled appearance, or it could be projected on to the moistened surface in a dry powder, through gauze stretched across the end of a bamboo tube.

The result of the last process was an infinity of minute specks of blue, a massing of innumerable points of colour. This is the well-known " powder blue," the *bleu soufflé*, or blown blue described by Père d'Entrecolles in his second letter [1] : " As for the *soufflé* blue called *tsoui tsim* (*ch'ui ch'ing*), the finest blue, prepared in the manner which I have described, is used. This is blown on to the vase, and when it is dry the ordinary glaze is applied either alone or mixed with *tsoui yeou* (*sui yu*), if crackle [2] is required." We are further told that as on the blue and white a glaze softened with a considerable proportion of lime was necessary for the perfection of the colour.

The " powder blue " seems to have been a new invention in the K'ang Hsi period. Under the name of *ch'ui ch'ing* (blown blue) it figures in the *T'ao lu* [3] among the triumphs of Ts'ang Ying-hsüan's directorate. It is certainly a singularly beautiful colour effect, and worthy of the homage it has received from collectors and ceramic historians. Though the blue used was as a rule of the finest quality, it varied much in intensity and tone with the nature of the cobalt and amount applied. Probably the majority of collectors would give the palm to the darker shades, but tastes differ, and the lighter tones when the blue is pure sapphire have found whole-hearted admirers. A notable feature of the powder blue is its surprising brilliancy in artificial light, when most other porcelain colours suffer eclipse.

It was used indifferently as a simple monochrome or as a ground in which panel decoration was reserved, the panels painted in *famille*

[1] Loc. cit., section xvii. In another place (section iii.) we are told how the Chinese surrounded the ware with paper during the blowing operation, so as to catch and save all the precious material which fell wide of the porcelain.

[2] I cannot recall any example of the powder blue crackle which is here described.

[3] See Julien, p. 107.

verte enamels or in blue and white ; and in both cases the blue surface was usually embellished with light traceries in gold. Plate 110 illustrates both types. Both are highly prized by collectors, and change hands at high prices when of the good quality which is usual on the K'ang Hsi specimens. We have already noted [1] the occasional decoration of the powder blue ground with designs in *famille verte* enamels, and Père d'Entrecolles [2] records another process of ornamentation which was applied to all the blue grounds of this group, viz. the washed, the sponged, and the powder blues : " There are workmen who trace designs with the point of a long needle on this blue whether *soufflé* or otherwise; the needle removes as many little specks of dry blue as are necessary to form the design; then the glaze is put on." From this precise description it is easy to recognise this simple but effective decoration. There are two examples in the British Museum with dragon designs etched in this fashion, the one in a washed blue, and the other in a sponged blue ground. The pattern appears in white outline where the blue has been removed by the needle and the porcelain body exposed.

Long usage has given sanction to the term " mazarine blue." It was applied to the dark blue ground colour of eighteenth century English porcelain, and in the contemporary catalogues the name " mazareen " was given to any kind of deep blue from the mottled violet of Chelsea to the powdery *gros bleu* of Worcester. In reference to Chinese porcelain it is used to-day with similar freedom for the *ta ch'ing* or dark sky blue and for the powder blue. Assuming that the phrase derives from the famous Cardinal Mazarin, it cannot in its original sense have had any reference to powder blue, for the Cardinal died in 1661, and, if he had a weakness for blue monochrome, it must have been for some variety of the *chiao ch'ing* or blue glazes proper which were current at the end of the Ming and the beginning of the Ch'ing dynasties. At the present day it is impossible to guess the true shade of mazarine blue, and we must be content to regard it as a phrase connoting a deep blue monochrome the exact definition of which has gone beyond recall. [3]

The K'ang Hsi mark is sometimes found on porcelain coated with a very dark purplish blue glaze with soft looking surface and

[1] P. 170.

[2] Second letter, section xvii.

[3] The word " mazarine " has become naturalised in the English language. Goldsmith spoke of " gowns of mazarine blue edged with fur " ; and " Ingoldsby " says the sky was " bright mazarine." See R. L. Hobson, *Worcester Porcelain*, p. 101.

minute crackle. It is apparently one of those glazes which are fired in the temperate parts of the kiln, and its use is more frequent on porcelains of a slightly later period.

Finally, the turquoise blue, variously named *fei ts'ui* (kingfisher blue) and *k'ung ch'iao lü* (peacock green), was freely used as a monochrome on figures and ornamental wares. It is a colour which descends from Ming times, and whose use has continued unchecked to the present day, so that it is often extremely difficult to give a precise date to any particular specimen, especially if the object happens to be of archaic form, a copy of an old bronze or the like. Its nature has already been discussed [1] among the Ming glazes, and one can only say that the K'ang Hsi pieces have all the virtues of the K'ang Hsi manufacture—fine material, good potting, shapely form, and beautiful quality of colour. The tint varies widely from the soft turquoise blue of kingfisher feathers to a deep turquoise green, and some of the most attractive specimens are mottled or spotted with patches of greenish black. The glaze is always minutely crackled, and has sufficient transparency to allow engraved or carved designs on the body to be visible. It is a colour which develops well on an earthen body, and the potters often mixed coarse clay with the ware which was intended to receive the turquoise glaze; but this, I think, was mainly practised after the K'ang Hsi period, and the K'ang Hsi specimens will, as a rule, be found to have a pure white porcelain basis.

As in the Ming wares, the turquoise sometimes shares the field with an aubergine purple of violet tone, both colours being of the *demi-grand feu*. The purple is also used as a monochrome. There are, in fact, two aubergine purple monochromes, the one a thick and relatively opaque colour sometimes full of minute points as though it had been blown on like the powder blue, the other a thin transparent (and often iridescent) glaze of browner tone. Both are derived from cobaltiferous ore of manganese, both have descended from the Ming period, and have already been discussed as monochromes and as colours applied to the biscuit.

The cobaltiferous ore of manganese is the same material which is used to give a blue colour, but in this case the manganese is removed, and the cobalt rendered as pure as possible. For the manganese if in excess produces a purplish brown, and its presence

[1] See p. 99.

in however small a quantity gives the blue a purple or violet strain. By the simple method of graduating the amount of manganese which was allowed to remain with the cobalt the potters were able to obtain many intermediate shades between dark blue and purple for their monochrome glazes.

The green monochromes are scarcely less numerous than the blue. There are the transparent greens of apple or leaf green shades whether even or mottled, which have been described among the glazes applied to the biscuit and among the enamels of the *famille verte*. These were used as monochromes and ground colours ; and closely akin to them are (1) the cucumber green (*kua p'i lü*), in which a yellowish leaf green is heavily mottled with darker tints, and (2) the snake skin green (*shê p'i lü*), a deep transparent green with iridescent surface, one of the colours for which the directorate of Ts'ang Ying-hsüan was celebrated. There are good examples of both in the Salting Collection, but it would be useless to reproduce them except in colour.

There are the apple and emerald green crackles (in both cases a green glaze overlying a grey or stone-coloured crackle), but these have already been discussed.[1] A somewhat similar technique characterises the series of semi-opaque and crackled green glazes of camelia leaf, myrtle, spinach, light and dark sage, dull emerald and several intermediate tints. These are soft-looking glazes with small but very regular crackle,[2] and their surface often has a " satiny " sheen which recalls the Yi-hsing glazes. They are evidently glazes of the *demi-grand feu*, and the colouring agent is doubtless copper, though apparently modified with other ingredients. How far this particular group was used in the K'ang Hsi period is hard to say. Most of the specimens which I have seen give me the impression of a later make, but as there are a few which might come within the K'ang Hsi limits I have taken this opportunity to discuss them.

There is one specimen of a rare green in the British Museum to which I cannot recall a parallel. It is a bowl with the ordinary white glaze, but covered on the exterior with a very bright yellowish green, like the young grass with the sun shining on it. It is, perhaps, rather in the nature of an enamel than a glaze, but the ware has

[1] See p. 102.

[2] These glazes generally have the appearance of being in two coats, and in some cases there actually seem to be two layers of crackle.

the appearance of age and should belong to the early part of the K'ang Hsi period.

Most of the green glazes are low fired, melting in the temperature of the *demi-grand feu* and the muffle kiln. The high-fired greens are those of celadon class. There is the *lang yao* [1] green, which has been discussed under that heading, a crackled glaze, in colour intermediate between apple green and the sea green celadon, and with a surface texture hazy with bubbles like the *sang de bœuf*, to which it is a near relation. This soft and beautiful colour has been described as a " copper celadon," and though Dr. Bushell refuses his blessing on the name it seems to me a particularly happy expression. For the colour apparently results from the same copper medium which under slightly different firing conditions produces the *sang de bœuf* red and at the same time its tint approaches very nearly to the typical celadon green.

The true celadon glaze was freely employed on the early Ch'ing porcelains, especially on those of K'ang Hsi and Yung Chêng periods. It is a beautiful pale olive or sea green colour, made light by the pure white porcelain beneath which its transparent nature permits to shine through. Compared with the Sung celadons as we know them,[2] the Ch'ing dynasty ware is thinner in material and glaze, wanting in the peculiar solidity of appearance of the ancient wares ; the body is whiter and finer, and the base is usually white with the ordinary porcelain glaze. There is, moreover, no " brown mouth and iron foot," unless indeed this feature has been deliberately added by means of a dressing of ferruginous clay, a make-up which is too obvious to deceive the initiated. There were, however, some careful imitations of the ancient celadons made at this time and got up with the appearance of antiquity, but these were exceptional productions.[3]

Père d'Entrecolles, writing in 1722, alludes to the K'ang Hsi celadon in the following terms [4] :—" I was shown this year for the first time a kind of porcelain which is now in fashion ; its colour verges on olive and they call it *long tsiven*. I saw some which was called *tsim ko* (*ch'ing kuo*), the name of a fruit which closely resembles

[1] See p. 125.

[2] i.e. the strong heavy types. Chinese literature speaks of thinner and more refined celadons of the Sung period, but few of these have come down to our day.

[3] Père d'Entrecolles fully describes these spurious celadons. See vol. i., p. 83.

[4] Second letter, section vii.

the olive." The *long tsiven* is clearly a transliteration of the characters which we write *Lung-ch'üan*, the generic name of the old celadons ; but it is odd that Père d'Entrecolles should not have seen copies of this glaze before 1722, for its use must have been continuous at Ching-tê Chên from very early times, and we have found reference to it in various periods of the Ming dynasty. It is evident, however, that the colour was enjoying a fresh burst of popularity just at this time. D'Entrecolles gives a few further notes which concern its composition. His recipe is substantially the same as that given in Chinese works, viz. a mixture of ferruginous earth, which would contribute a percentage of iron oxide, with the ordinary glaze.[1] He also states that *sui yu* (crackle glaze) was added if a crackled surface was required, and there are numerous examples of this kind of ware to be seen. The most familiar are the vases with crackled celadon or grey green glaze interrupted by bands of biscuit carved with formal patterns and stained to an iron colour with a dressing of ferruginous earth. Monster heads with rings (loose or otherwise) serve as twin handles on these vases, which are designed after bronze models. These crackled celadons are evidently fashioned after an old model, but they have been largely imitated in modern times, and almost every pawnbroker's window displays a set of execrable copies (often further decorated in underglaze blue) which are invariably furnished with the Ch'êng Hua mark incised on a square brown panel under the base.

The yellow monochromes of the K'ang Hsi period are mostly descendants of the Ming yellows. There is the pale yellow applied over a white glaze reproducing the yellow of " husked chestnuts," for which the Hung Chih (q.v.) porcelains were celebrated ; and there is a fuller yellow, usually of browner shade, applied direct to the biscuit. Yellow is one of the Imperial colours, the usual tint being a full deep colour like the yolk of a hen's egg, and the Imperial wares are commonly distinguished by five-clawed dragons engraved under the glaze. Other glazes[2] used on the services made for the Emperor are the purplish brown (aubergine) and the bright green of camelia leaf tint, which with the yellow make up the *san ts'ai* or three colours. In fact the precise shades of these colours

[1] The *T'ao lu* (see Julien, p. 213) gives this recipe for the kind of celadon known as *Tung ch'ing*, and a similar prescription with a small percentage of blue added for the variety known as *Lung-ch'üan*.

[2] See Bushell, *O. C. A.*, p. 316.

are those used on finer types of three-colour porcelain[1] with transparent glazes fired in the temperate part of the great kiln. All these glazes tend to become iridescent with age.

The colouring medium of the pale yellow is antimony combined with a proportion of lead, and iron oxide is added to give the glaze an orange or brown tinge.[2] It is noticeable that the yellow applied to the biscuit is usually browner in tone. This is the nature, if we may judge from the excellent coloured illustrations in the Walters catalogue,[3] of the eel yellow (*shan yü huang*), a brownish colour of clouded smoky appearance, and one of the few glazes named in the *T'ao lu* as a speciality of the directorate of Ts'ang Ying-hsüan. The other yellow associated with the name of Ts'ang is the " spotted yellow " (*huang pan t'ien*), discussed on p. 127. Its identification is uncertain, and Brinkley describes it as " stoneware with a dark olive green glaze with yellow speckles," while Bushell (*O. C. A.*, p. 317) regards it as a " tiger skin " glaze with large patches of yellow and green enamel, the same as the *huang lü tien* (yellow and green spotted), which he quotes from another context.

All these varieties belong to the *couleurs de demi-grand feu* ; but there are besides several varieties of yellow enamels fired in the muffle kiln. Of these the transparent yellow was used as a ground colour in the K'ang Hsi period, but the opaque varieties, such as the lemon yellow, etc., belong rather to a later period. Among the latter I should include the crackled mustard yellow, though examples of it have often been assigned to the K'ang Hsi and even earlier reigns. There is, for instance, a bottle-shaped vase with two elephant handles in the Victoria and Albert Museum, which Bushell [4] regarded as a specimen of the old *mi-sê* (" millet colour ") glaze of the Sung dynasty. A careful examination shows that this crackled brownish yellow is made in much the same fashion as the apple green and the sage green crackles, viz. a yellow glaze or enamel overlying a stone-coloured crackle. This is not a Sung technique, but rather

[1] See p. 147.

[2] There are some fine examples of orange yellow monochrome in the Peters Collection in New York. The colour was also used with success in the Ch'ien Lung period, the mark of which reign occurs on a good example in the Peters Collection.

[3] Bushell, *O. C. A.*, Plates xxv. and lxxxiii.

[4] See Monkhouse, op. cit., fig. 22. The crackle on the mustard yellow glaze is usually small, but there is a fine specimen in the Peters Collection with large even crackle. Sometimes this yellow has a greenish tinge, and in a few instances it is combined with crackled green glaze.

an imitative method belonging perhaps to the Yung Chêng period, when old glazes and archaic shapes were reproduced with wonderful skill and truth.

There is a solitary specimen of a high-fired glaze of pale buff yellow colour in the British Museum, which perhaps should be ranked with the yellow monochromes, though its appearance suggests an exceptional effect of the pale *tzŭ chin* or " Nanking yellow " glaze. And a rare vase in the Peters Collection has a minutely crackled brownish yellow glaze clouded with dark olive in bold markings like those of tortoiseshell.

Another Ming monochrome freely used in the K'ang Hsi period is the lustrous brown (*tzŭ chin*), formed like the celadon by mixing ferruginous earth called *tzŭ chin shih* with the ordinary glaze. Presumably the quantity of this material was greater in the brown glaze than in the celadon. Père d'Entrecolles describes this glaze in its diverse shades of bronze, coffee and dead-leaf brown, but he makes the curious error of proclaiming it a new invention in 1722.[1] He also refers to its use on the exterior of white cups and as a ground colour in which white panels were reserved. " On a cup or vase," he tells us, " which one wished to glaze with brown, a round or square of damped paper was applied in one or two places ; after the glaze had been laid on, the paper was peeled off, and the unglazed space was painted in red or blue. This dry, the usual glaze was applied to the reserve by blowing or by some other method. Some of the potters fill the blank spaces with a ground of blue or black, with a view to adding gilt designs after the first firing."

There were other methods of decorating these panels, and perhaps the most familiar is that in which the early *famille rose* enamels were employed. This combination of brown ground with panels of floral designs in thick opaque rose red, yellow, white and green was a favourite with the Dutch exporters. In fact this ware is still called Batavian, the old catalogue name derived from the Dutch East Indian settlement of Batavia, which was an entrepot for far-Eastern merchandise. The date of the Batavian porcelain is clearly indicated by the transition enamels as late K'ang Hsi.

The *tzŭ chin* brown was used as a monochrome in all its various shades from dark coffee colour to pale golden brown, and the lighter and more transparent shades were sometimes laid over engraved decoration. In the British Museum there are two candlesticks,

[1] Second letter, section vi.

the stems of which with dragon designs in full relief are in an intensely dark *tzŭ chin* glaze, so dark, indeed, that the tops have been exactly matched in the deep brown ware made by Böttger of Dresden about 1710, the latter polished on the lathe to simulate the lustrous surface of the Chinese glaze. In the same collection are two saucer dishes of dark *tzŭ chin* glaze of fine quality painted with slight floral designs in silver.[1] This kind of decoration must have been singularly effective in its original state, but the silver does not stand the test of time, and though 'it still firmly adheres its surface has turned black. An unusual effect is seen on a vase in the Peters collection which has a lustrous coffee brown glaze passing into olive and clouded with black; and a very rare specimen in the same collection has a " leopard skin " glaze of translucent olive brown with large mottling of opaque coffee brown. The latter piece bears the Wan Li mark.

The lightest shade of this colour is what has been described as Nanking yellow.[2] It is used as a monochrome or as a ground colour with panels usually of *famille verte* enamels, and sometimes with enamelled decoration applied over the brown glaze itself. It is clear that the *sui yu* or crackle glaze was sometimes mixed with the *tzŭ chin*, for we find many examples of beautiful lustrous brown crackle. They have, however, in many cases an adventitious tinge of grey or green, for which the crackle glaze is perhaps responsible.

A near relation to the *tzŭ chin* (brown gold) glaze is the *wu chin* (black gold), a lustrous black glaze obtained by mixing a little impure cobaltiferous ore of manganese (or coarse blue material [3]) with the *tzŭ chin* glaze. Like the latter the black is an intensely hard glaze fired in the full heat of the great kiln, and it has a lustrous metallic surface which earned for it the name of " mirror black." [4] This glaze seems to have really been a K'ang Hsi innovation,[5] and possibly it was a confusion with this fact which led d'Entrecolles into his erroneous statement about the date of the lustrous brown.

[1] See Père d'Entrecolles, second letter, section xiii. : " L'argent sur le vernis *tse kin* (*tzŭ chin*) a beaucoup d'éclat."

[2] See p. 145.

[3] The blue of the cobalt is sometimes clearly visible in the fracture of the glaze; and in other cases the black has a decided tinge of brown.

[4] d'Entrecolles, loc. cit., section viii. : " Le noir éclatant ou le noir de miroir appellé ou *kim* " (*wu chin*).

[5] d'Entrecolles declares that it was the result of many experiments, apparently in his own time. See p. 194.

Fig. 3

Fig. 2

Fig. 1

Plate 112.—Three figures of Birds, late K'ang Hsi Porcelain, with coloured enamels on the biscuit.

Fig. 1.—Stork. Height 17¼ inches. *British Museum.* Fig. 2.—Hawk. Height 10 inches. *S. E. Kennedy Collection.*
Fig. 3.—Cock. Height 13½ inches. *British Museum.*

Fig. 1

Fig. 2

Plate 113.—Porcelain delicately painted in thin *famille verte* enamels. About 1720.

Fig. 1.—Dish with figures of Hsi Wang Mu and attendant. Ch'êng Hua mark. Diameter 6¾ inches. *Hippisley Collection.* Fig. 2.—Bowl with the Eight Immortals. Diameter 8⅞ inches. *S. E. Kennedy Collection.*

Plate 114.—Hanging Vase with openwork sides, for perfumed
flowers. *Cumberbatch Collection.*

Porcelain painted in late *famille verte* enamels. About 1720. Blackwood
frame. Total height 17 inches.

The mirror black is usually a monochrome tricked out with gilt traceries, but as in the case of the powder blue the light Chinese gilding is usually worn away, and often its quondam presence can now only be detected by a faint oily film which appears when the porcelain is held obliquely to the light. It is a common practice to have this lost gilding replaced by modern work.

There are several large vases of triple-gourd form in the Charlottenburg Palace with the upper and lower lobes coated with gilt mirror black, and the central bulb enamelled with *famille verte* colours ; and another use of the glaze as panel decoration in a lustrous brown ground has already been noted in an extract from Père d'Entrecolles ; it is also found on rare specimens as a background for panels of *famille verte* enamelling. But its most effective use is as a pure monochrome only relieved by faint gilding, and some of the choicest K'ang Hsi specimens have soft brown reflexions in the lustre of the surface. Another and probably a later type of mirror black is a thick lacquer-like glaze with signs of minute crackle.

There is a type of glaze which, though variegated with many tints, still belongs to the category of monochromes. This is the *flambé*, to use the suggestive French term which implies a surface shot with flame-like streaks of varying colour. This capricious colouring, the result of some chance action of the fire upon copper oxide in the glaze, had long been known to the Chinese potters. It appeared on the Chün Chou wares of the Sung and Yüan dynasties, and it must have occurred many times on the Ming copper monochromes ; but up to the end of the K'ang Hsi period it seems to have been still more or less accidental on the Ching-tê Chên porcelain, if we can believe the circumstantial account written by Père d'Entrecolles in the year 1722 [1] :—" I have been shown one of the porcelains which are called *yao pien,* or transmutation. This transmutation takes place in the kiln, and results from defective or excessive firing, or perhaps from other circumstances which are not easy to guess. This specimen which, according to the workman's idea, is a failure and the child of pure chance, is none the less beautiful, and none the less valued. The potter had set out to make vases of *soufflé* red. A hundred pieces were entirely spoilt, and the specimen in question came from the kiln with the appearance of a sort of agate. Were they but willing to take the risk and the expense of successive experiments, the potters would eventually discover the secret of

[1] Second letter, section xi.

making with certainty that which chance has produced in this solitary case.　This is the way they learnt to make porcelain with the brilliant black glaze called *ou kim* (*wu chin*) ; the caprice of the kiln determined this research, and the result was successful."

It is interesting to read how this specimen of *flambé* resulted from the misfiring of a copper red glaze, no doubt a *sang de bœuf* ; for in the most common type of *flambé* red (see Plate 123, Fig. 1) passages of rich *sang de bœuf* emerge from the welter of mingled grey, blue and purple tints.　The last part of d'Entrecolles' note was prophetic, for in the succeeding reigns the potters were able to produce the *flambé* glaze at will.

There are, besides, many other strangely coloured glazes which can only be explained as misfired monochromes of the *grand feu*, those of mulberry colour, slaty purple, and the like, most of which were probably intended for maroon or liver red, but were altered by some caprice of the fire.　But it would be useless to enumerate these erratic tints, which are easily recognised by their divergence from the normal ceramic colours.

The French have always been partial to monochrome porcelains. In the eighteenth century they bought them eagerly to decorate their hotels and châteaux, and enshrined them in costly metal mounts.　But as the style of the mounting, rococo in the early part of the century, neo-classical in the latter part, was designed to match the furniture of the period, the oriental shapes were often sacrificed to the European fashion.　Dark blue and celadon green were favourite colours, if we may judge by surviving examples, and to-day enormous prices are paid for Chinese monochromes fitted with French ormolu mounts by the Court goldsmiths, such as Gouthière, Caffieri, and the rest.[1]　But these richly mounted pieces have more interest as furniture and metal work, and the ceramophile regards them askance for their foreign and incongruous trappings, which disturb the pure enjoyment of the porcelain.[2]

[1] See M. Seymour de Ricci in the introduction to the *Catalogue of a Collection of Mounted Porcelain belonging to E. M. Hodgkins*, Paris, 1911, where much interesting information has been collected on the subject of French mounts and their designers. He quotes also from the *Livre-journal de Lazare Duvaux marchand-bijoutier ordinaire du Roy* (1748-1758), which includes a list of objects mounted for Madame de Pompadour and others, giving the nature of the wares and the cost of the work.

[2] Persian, Indian, and occasionally even Chinese metal mounts are found on porcelain ; and Mr. S. E. Kennedy has a fine enamelled vase of the K'ang Hsi period with spirited dragon handles of old Chinese bronze.

It remains to consider the white porcelain, that is to say the porcelain which was intended to remain white and undecorated with any form of colouring. White was the colour used by the Court in times of mourning, and large services of white porcelain were made for the Emperor on these occasions. But it is not to be supposed that all the beautiful white wares were made solely for this purpose.[1] They have always been highly esteemed by the Chinese from the early Ming times, when the Yung Lo bowls and the white altar cups of Hsüan Tê were celebrated among porcelains, down to the present day. Many exquisite whites were made in the early reigns of the Ch'ing dynasty, and as with so many of the perennial monochromes their exact dating is full of difficulty. We are not concerned here with the *blanc de chine* or white porcelain of Tê-hua in Fukien, which has already been discussed, but with the white of Ching-tê Chên, the glaze of which is distinguished from the former by its harder appearance, and its bluish or greenish tinge.

The latter was made to perfection in the K'ang Hsi period. Having no colours to distract the eye from surface blemishes, nothing short of absolute purity could satisfy the critic. In choice specimens the paste was fine, white and unctuous, the glaze clear, flawless, and of oily lustre,[2] the form was elegant and the potting true. Such pieces without blemish or flaw are the very flower of porcelain, whether they be of eggshell thinness (*t'o t'ai*), half eggshell (*pan t'o t'ai*), or of the substance of ordinary wares.

But though innocent of colour the white porcelain was rarely without decoration. The finest Imperial services were usually delicately etched under the glaze with scarcely visible dragon designs. Other kinds have the ornament strongly cut, such as the eggshell cups and saucers with patterns of hibiscus, lotus, or chrysanthemum petals firmly outlined, or the vases with full-bodied designs in low relief obtained by carving away the ground surrounding the pattern.[3] Others have faint traceries or thickly painted patterns in white

[1] White was also used in the worship of the Year Star (Jupiter). Other colours which have a ritual significance are *yellow*, used in the Ancestral Temple by the Emperor, and on the altars of the god of Agriculture and of the goddess of Silk ; *blue*, in the Temple of Heaven and in the Temple of Land and Grain ; and *red*, in the worship of the Sun.

[2] Brinkley has aptly described it as " snow-white oil."

[3] Cf. Père d'Entrecolles, second letter, section xviii. : " (The designs) are first outlined with a graving-tool on the body of the vase, and afterwards lightly channelled around to give them relief. After this they are glazed."

slip, in steatite,[1] or in fibrous gypsum under the glaze. A fuller relief was obtained by pressing in deeply cut moulds or by applying strips and shavings of the body clay, and working them into designs with a wet brush after the manner of the modern *pâte sur pâte*. There are still higher reliefs in K'ang Hsi porcelain, figures, and symbolical ornaments, formed separately in moulds and " luted " on to the ware with liquid clay, but these generally appeared on the enamelled wares, and are themselves coloured. The applied reliefs on the white wares are usually in unglazed biscuit, and there are, besides, pierced and channelled patterns, but these processes have been fully described among the late Ming wares,[2] and nothing further need be said of them, except that they were employed with supreme skill and refinement by the K'ang Hsi potters. Père d'Entrecolles [3] alludes to these perforated wares in the following passage :—" They make here (i.e. at Ching-tê Chên) another kind of porcelain which I have never yet seen. It is all pierced *à jour* like fretwork, and inside is a cup to hold the liquid. The cup and the fretwork are all in one piece." Wares of various kinds with solid inner lining and pierced outer casing are not uncommon in Chinese porcelain and pottery. Sometimes, however, the cups are completed without the inner shell, like Fig. 2, of Plate 78, which could be fitted with a silver lining if required to hold liquid.

Objects entirely biscuit are exceptional. There are, however, two small Buddhistic figures, and two lions of this class in the British Museum, and curiously enough both are stamped with potter's marks, which is itself a rare occurrence on porcelain. The former bear the name of Chang Ming-kao and the latter of Ch'ên Mu-chih (see vol. i., page 223). Bushell [4] tells us that the Chinese call biscuit porcelain *fan tz'ŭ* (turned porcelain), a quaint conception which implies that the ware is turned inside out, as though the glaze were inside, and the body out ; and this illusion is occasionally

[1] See d'Entrecolles, loc. cit., sections iv. and v. After describing the preparation of the steatite (*hua shih*) by mixing it with water, he continues : " Then they dip a brush in the mixture and trace various designs on the porcelain, and when they are dry the glaze is applied. When the ware is fired, these designs emerge in a white which differs from that of the body. It is as though a faint mist had spread over the surface. The white from *hoa che* (*hua shih* or steatite) is called ivory white, *siam ya pe* (*hsiang ya pai*)." In the next section he describes another material used for white painting under the glaze. This is *shih kao*, which has been identified with fibrous gypsum.

[2] See p. 74.

[3] First letter, Bushell, op. cit., p. 195.

[4] *O. C. A.*, p. 533.

kept up by applying a touch of glaze inside the mouth of the unglazed vessel.

Biscuit porcelain is specially suitable for figure modelling, because the sharpness of the details remains unobscured by glaze. It has been largely employed in European porcelain factories for this purpose, but the Chinese seem to have been prejudiced against this exclusive use of the material. As a rule they reserve it for the fleshy parts of their figures, giving the draperies a coating of glaze or of enamel or both. A rare example of the use of biscuit is illustrated in the catalogue of the Walters Collection (*O. C. A.*, Plate **XXIX.**), a white bottle with a dragon carved out of the glaze and left in biscuit.

The white wares so far described were made of the ordinary porcelain body and glaze, but there is another group of whites which is ranked with the so-called " soft pastes." This is a creamy, opaque and often earthy-looking ware, the glaze of which is almost always crackled. It is in fact an imitation of the old Ting yao (q.v.), and its soft-looking surface and warm creamy tone are seen to perfection in small vases, snuff bottles, and ornamental wares. Indeed, the elegantly shaped and finely potted vessels of this soft, ivory crackle are among the gems of the period.

Crackle is a feature which is common to many of the monochromes, and incidental mention has frequently been made of it in the preceding pages. It is essentially a Chinese phenomenon, dating back to the Sung dynasty, and there are various accounts of the methods employed to produce it. We are speaking of the intentional crackle which is clearly defined and usually accentuated by some colouring matter rubbed into the cracks, as opposed to the accidental crazing which appears sooner or later on most of the glazes of the *demi grand feu*, and on many low-fired enamels. One crackling process used by the Sung potters has been described on p. 99, vol. i. Another method is mentioned in the K'ang Hsi Encyclopædia,[1] viz. to heat the unglazed ware as much as possible in the sun, then plunge it into pure water. By this means a crackle was produced on the ware after the firing.

But the normal process in the Ch'ing dynasty seems to have been

[1] *Ku chin t'u shu*, section xxxii., vol. 248, fol. 15. In this way, we are told, were produced (1) the thousandfold millet crackle and (2) the drab-brown (*ho*) cups. The colour of the latter was obtained by rubbing on a decoction of old tea leaves. The former is a name given to a glaze broken into " numerous small points."

to mix a certain ingredient with the glaze which produced a crackle when fired. There are constant references to this ingredient under the name of *sui yu* (crackle glaze) in the letters of Père d'Entrecolles in connection with various monochromes, and in the first letter,[1] the following definite account appears :—" It is to be observed that when no other glaze but that composed of white pebbles [2] is added to the porcelain, the ware turns out to be of a special kind known as *tsoui ki* (*sui ch'i* = crackled ware). It is marbled all over and split up in every direction into a infinite number of veins. At a distance it might be taken for broken porcelain, all the fragments of which have remained in place. It is like mosaic work. The colour produced by this glaze is a slightly ashen white."

The effect of this ingredient of the glaze whatever its composition may have been is easily understood. All porcelain and pottery undergoes a considerable amount of contraction—from loss of moisture, etc.—in the kiln, and to obtain a perfectly even glaze it is necessary that the contraction of the glaze should be the same as that of the body. Clearly this ingredient caused the glaze to contract to a greater extent than the body, and so to split up into minute fissures. The Chinese were able to control to a great extent the size and nature of the crackle, as is shown by the appearance of alternate bands of large and small crackle on the same piece. The methods of colouring the crackle include rubbing red ochre, ink, and decoction of tea leaves into the cracks before the ware was quite cool. Another method is described by Bushell (*O. C. A.,* p. 511) by which a white crackled ware was stained pink or crimson. The vessel was held in the fire in an iron cage until thoroughly heated, and then water mixed with gold-pink colouring matter was blown on to it. This, however, is a later process. Most of the monochrome glazes are occasionally crackled, but the most characteristic colours of the crackle glazes are the greyish white (the *blanc un peu cendré* of Père d'Entrecolles), and light buff, which were probably

[1] See Bushell, *T'ao shuo,* loc. cit., p. 195.

[2] The *T'ao lu* (see Julien, p. 214) informs us that the *sui ch'i yu* (crackle ware glaze) was made from briquettes formed of the natural rock of San-pao-p'êng. If highly refined this material produced small crackle ; if less carefully refined, coarse crackle. In reference to *sui ch'i* in an earlier part of the same work, we are told that the Sung potters mixed *hua shih* with the glaze to produce crackle. *Hua shih* is a material of the nature of steatite, and Bushell (*O. C. A.,* p. 447) states that the Chinese potters mix powdered steatite with the glaze to make it crackle. It is, then, highly probable that the "white pebbles" of Père d'Entrecolles and the rock of San-pao-p'êng are the same material and of a steatitic nature.

intended to recall the ash colour (*hui sê*) and the millet colour (*mi sê*) of the Sung *Ko yao*. Some of the light buff or "oatmeal" crackles of the early Ch'ing period are peculiarly refined and beautiful.

Though this has seemed a favourable opportunity for discussing crackle glazes it is not to be supposed that they were a speciality of the K'ang Hsi period. They are common to every age since the Sung dynasty, and probably they were never made in such abundance and with such care as in the Yung Chêng and early Ch'ien Lung periods.

CHAPTER XII

YUNG CHÊNG 雍正 PERIOD (1723–1735)

THE Emperor, K'ang Hsi, was succeeded by his son, who reigned from 1723–1735 under the title Yung Chêng. The interest which the new ruler had taken as a prince in ceramic manufactures is proved by a passage in the first letter (written in 1712) of Père d'Entrecolles in which he instances among remarkable examples of the potter's skill a " great porcelain lamp made in one piece, through which a torch gave light to a whole room. This work was ordered seven or eight years ago by the Crown Prince." We are further told that the same prince had ordered the manufacture of various musical instruments in porcelain. These could not all be made, but the most successful were flutes and flageolets, and a set of chimes made of nine small, round and slightly concave plaques, which hung in a frame, and were played with drum-sticks. Apparently the Emperor continued to take an intimate interest in the industry after he had ascended the throne, for he commanded his brother the prince of Yi to announce personally to T'ang Ying his appointment at Ching-tê Chên in 1728.

At the beginning of the reign the direction of the Imperial factory was in the hands of Nien Hsi-yao,[1] who, in his capacity of inspector of customs at Huai-an Fu,[2] dispensed the funds for the Imperial porcelain. A brief note in the *T'ao lu*,[3] under the heading " Nien ware of the Yung Chêng period," sums up in the usual compressed style of Chinese ceramic writers the character of the porcelain made at this time. The duty of Nien, inspector of customs at Huai-an Fu, we read, was to select the materials, and to see that the porcelain was furnished to the Imperial orders. The ware was extremely refined and elegant. The coloured porcelains

[1] 年希堯. Another name of this official, *Yen kung*, is mentioned in the *T'ao lu*, bk. v., fol. 11 verso.

[2] Situated at the junction of the Grand Canal and the Yangtze.

[3] Loc. cit.

were sent twice monthly to Nien at the Customs, and forwarded by him to the Emperor. Among the vases (*cho ch'i*) many were of egg colour, and of rounded form, lustrous and pure white like silver. They combined blue and coloured decoration, and some had painted, engraved, etched, or pierced ornament all ingeniously fashioned. Imitation of the antique and invention of novelties, these were truly the established principles of Nien.

The interesting list of wares made at the Imperial factory which is given in detail on pp. 223–226 supplies a full commentary on this meagre notice, illustrating the types which are merely hinted in the *T'ao lu* and specifying the particular kinds of antiques which were reproduced and many of the new processes invented in this reign. With regard to the last, however, it appears that the chief credit was due to Nien's gifted assistant, T'ang Ying. Most of the actual processes, such as carving, engraving, piercing *à jour*, embossing in high and low relief, blowing on of the glazes, painting in enamels, in gold and in silver,[1] have already been described in previous chapters. Indeed we may assume that all the science of the K'ang Hsi potters was inherited by their successors in the Yung Chêng period, and we need only concern ourselves with the novelties and the specialities of the period.

A few words should be said first about the ware itself. Necessary variations in the appearance of the Ching-tê Chên porcelain, which were due to purely natural causes such as the use of clays of varying qualities or those from different localities, have been noted from time to time. These differences are generally quite obvious and they explain themselves. But apart from these there are numerous instances in which the potters have deliberately departed from the normal recipes in order to obtain some special effect. Thus we saw that the *ch'ing-tien* stone was introduced into the body in imitations of the opaque and rather earthy-looking white Ting Chou ware ; *hua shih* (steatite) was used for another type of opaque porcelain which offered a vellum-like surface to the blue painter ; and coarse, impure clays were found of great service in the imitation of the dark-coloured body of the antique wares.

Many other modifications appear in the porcelain of the first half of the eighteenth century. There is, for instance, a very dead white ware, soft looking, but translucent, which occurs on some

[1] Silvering the entire surface (*mo yin*), as opposed to merely decorating with painted designs in silver (*miao yin*), appears to have been a novelty introduced by T'ang Ying.

of the choicer examples of armorial porcelain.[1] There are several specimens of this in the British Museum, one of which bears the early date, 1702, while others belong to the Yung Chêng period. Again there is the highly vitreous ware evolved by T'ang Ying to imitate the opaque glass of *Ku-yüeh-hsüan* ; but that will be discussed later.[2] These special bodies were mainly employed for articles of small size and ornamental design, and they can be studied in all their varieties in a representative collection of snuff bottles. The Chinese potters lavished all their skill on these dainty little objects. Not only do they include every kind of ware, crackled or plain, translucent or opaque, but they illustrate in miniature every variety of decoration—monochrome, painted, carved, moulded, incised, pierced and embossed. Probably the choicest snuff bottles were made in the Yung Chêng and Ch'ien Lung periods ; but the Chinese have never ceased to delight in them, and many beautiful examples were manufactured in the nineteenth century, particularly in the Tao Kuang period.

The ordinary Yung Chêng porcelain differs but little from that of the previous reign, though it tends to assume a whiter appearance, and the green tinge of the glaze is less marked. Moreover, a change is noticeable in the finish of the base rim of vases and bowls. Bevelling of the edge is less common, and gives place to a rounded or angular finish, the foot rim being often almost V-shaped ; while the slight tinge of brown around the raw edge, which is usual on K'ang Hsi wares, is often entirely absent. The actual potting of the porcelain displays a wonderful degree of manipulative skill, and the forms, though highly finished, are not lacking in vigour. They are, in fact, a happy mean between the strong, free lines of the K'ang Hsi and the meticulous finish of the later Ch'ien Lung porcelains. The verdict of the *T'ao lu*, " extremely refined and elegant," is fully justified by the porcelain itself no less than by its decoration.

Not the least deserving of this praise, though mainly made for export, is the important group discussed on page 209, viz. the saucer dishes, plates, tea and coffee wares, etc., of delicate white porcelain, painted, apparently at Canton, in the *famille rose* enamels. It is an " eggshell " porcelain, white, thin, and beautifully finished, and the dainty little conical or bell-shaped tea cups, though without handles, are the perfection of table ware. This kind of " eggshell "

[1] i.e. porcelain services painted with European coats of arms.
[2] See p. 215.

is easily distinguished from the Ming type, which is greener in tone and has the appearance of melting snow by transmitted light.

The Yung Chêng period is not conspicuous for blue and white porcelain. The perfection of the *famille rose* colours and the growing demand for enamelled wares seem to have withdrawn the attention of the potters from their old speciality. Marked examples of Yung Chêng blue and white are so uncommon that it is difficult to estimate the merits of the ware from them. A saucer dish in the British Museum shows the familiar pattern of a prunus spray reserved in white in a marbled blue ground ; but though the ware itself preserves much of the K'ang Hsi character, the blue is dull and grey, and wanting in the vivacity and depth of the old models. One would say that little care had been spent on the refining of the blue, and without the old perfection of material the K'ang Hsi style, with its broad washes of colour, was doomed to failure. Considerations of this sort may have led the painters to abandon the washes in favour of pencilling in fine lines, a method apparent on the armorial porcelain which can be dated to this period. Such a treatment of the blue was admirably suited to small objects. Indeed it was the usual style of decoration on the steatitic porcelain, of which many excellent examples belonging to this time are to be found among the snuff bottles, vermilion boxes, and the small, artistic furniture of the writing table. On large specimens the effect is thin and weak.

On the other hand the Yung Chêng potters, who excelled in re-producing the antique, were most successful in their imitation of the old Ming blue and whites. The Imperial list [1] includes such items as " reproductions of the pale blue painted designs of Ch'êng Hua," and of the dark blue of Chia Ching. An interesting example of a Ming reproduction is a bowl in the British Museum, which is painted on the exterior with the old design of ladies walking in a garden by candle light.[2] In spite of its Yung Chêng mark this piece is obviously a copy of a Ming model. The porcelain is white and thick, and the glaze, which is of greenish tint, has a peculiar soft-looking surface, while the blue design inside is of characteristic Ming colour, though that of the exterior is scarcely so successful.

[1] See p. 225, Nos. 41 and 42.
[2] Cf. p. 25, where "high-flaming silver candle lighting up rosy beauty" is explained in this sense among the Ch'eng Hua designs.

Another type much copied at this period as well as in the succeeding reign is that in which the blue is mottled and blotched with darker spots, a type discussed among the early Ming wares.[1] And similarly such specimens as Fig. 2 of Plate 116, which bears a Hsüan Tê mark, doubtless belong to this period of imitative manufacture. It is of thick, solid build with smooth, soft-looking glaze, whose bubbled texture gives the blue a hazy appearance.

Painting in underglaze red alone, or in combination with underglaze blue, was freely practised in the reign of Yung Chêng, and probably most of the fine examples of this type in our collections belong to this and the succeeding reign (Fig. 1, Plate 117). There is a good example with the Yung Chêng mark in the British Museum, a vase of " pilgrim-bottle " form with central design of the three emblematic fruits—peach, pomegranate, and finger citron, symbols of the Three Abundances of Years, Sons and Happiness. The fruits are in a soft underglaze red, verging on the peach-bloom tint, and the foliage, together with the borders and accessory designs, are pencilled in dark blue.

The Imperial list alludes to this decoration under the heading of " red in the glaze " (yu li hung), including (1) red used alone for painted designs, and (2) red foliage combined with blue flowers.[2] Examples of both these styles are frequent in large and small objects, and especially in the decoration of snuff bottles, which often bear the Yung Chêng mark. They are, however, by no means confined to the Yung Chêng period, but have continued in uninterrupted use to the present day.

Other references in the list [3] to underglaze red painting include designs of three fishes,[4] three fruits, three funguses, and five bats (for the five blessings) in the Hsüan Tê style, red in a white ground ; and the same red designs in a celadon green ground, the latter combination being a novelty of the previous reign. Plate 115 is a choice example of the underglaze colours in a celadon ground ; and similar designs in a pale lavender blue ground, besides other combinations of the same colours, coloured slips, and high-fired glazes which

[1] See p. 13.
[2] See p. 225, No. 45.
[3] See p. 224, Nos. 19 and 20.
[4] A beautiful example of a " stem-cup " in the Eumorfopoulos Collection, with three fishes on the exterior in underglaze red of brilliant quality and the Hsüan Tê mark inside the bowl, probably belongs to this class.

form the polychrome decoration of the *grand feu* have been already discussed on p. 146. They belong to the Yung Chêng and Ch'ien Lung periods no less than to the K'ang Hsi.

Of the other kinds of polychrome, the porcelain with glazes of the *demi-grand feu*, and enamels of the muffle kiln in the three colours, green, yellow, and aubergine, was still made. It is hardly likely that the manufacture [1] which Père d'Entrecolles describes in 1722 ceased immediately, and we know that the finer types with engraved designs and transparent glazes in the three colours were made to perfection at the Imperial factory. Fig. 1 of Plate 116 illustrates a bowl of this kind with the Yung Chêng mark and, to judge from its exquisite quality, an Imperial piece. The ornament is in green, in a full yellow ground. This type of decoration is a legacy from the Ming dynasty, and doubtless many of the saucer dishes, bowls, etc., with Chêng Tê marks, but with all the trimness and neatness of the Yung Chêng wares, belong to the latter period. One variety is actually specified in the Imperial list,[2] viz. "reproductions of porcelain with incised green decoration in a monochrome yellow ground."

As for the on-glaze enamels of the muffle kiln the old *famille verte* colour scheme was to a great and increasing extent supplanted by the *famille rose*. It survived, however, in certain modified forms—in the delicately painted wares, for example, usually of eggshell thinness and decorated in thin, clear, transparent enamels, such as were described in connection with the late K'ang Hsi "birthday plates" (see Plate 113). And again the same colours were employed in a special type of decoration which seems to have originated in the Yung Chêng period, though it was freely used in later reigns. In this the design was carefully traced in pale blue outlines under the glaze, and filled in with light uniform washes of transparent enamels on the glaze. The effect is delicate and refined, though somewhat weak in comparison with the full, iridescent colours and broad washes of the older *famille verte*.

Possibly this style of decoration was intended to reproduce the traditional refinement of the Ch'êng Hua cups. The Imperial list [3] includes "reproductions of Ch'êng Hua polychrome (*wu ts'ai*)," and four exquisite eggshell wine cups in the Hippisley Collection

[1] See p. 148. [2] See p. 225, No. 30. [3] See p. 224, No. 26.

which bear the Ch'êng Hua mark, are painted in this fashion.[1] Similarly in the Bushell collection there are some beautiful reproductions of the Ch'êng Hua " stem-cups," with grape vine patterns, etc., which are no doubt of the same origin. Larger work in the same style is illustrated by a fine vase in the Victoria and Albert Museum with a phœnix design which suggests an Imperial destination (Plate 117).

Thirdly, there are the reproductions of the enamelled porcelain of the Chêng Tê and Wan Li periods [2] (q.v.), characterised, no doubt, by the combination of underglaze blue and overglaze enamels. We have already seen [3] from the note on Nien yao in the *T'ao lu* that this combination was conspicuous at this period, and it is probable that much of the " five colour " porcelain in late Ming style should be dated no further back than the Yung Chêng revival. Other types of Ming coloured wares reproduced at this time were " porcelain with ornament in Hsüan Tê style in a yellow ground," [4] which seems to mean underglaze blue designs with the ground filled in with yellow enamel—a not unfamiliar type—and porcelain with designs painted in iron red (*ts'ai hung*) " reproduced from old pieces." [5] But the most prominent feature of the enamelled porcelains of this time is the rapid development of the *famille rose* colours. We have already noted the first signs of their coming in the thick rose pink and opaque white, which made their appearance in the latter years of K'ang Hsi. The group derives its name from its most conspicuous members, a series of rose pinks graduating from pale rose to deep crimson, all derived from gold, the use of which as a colouring agent for vitreous enamel was only at this period mastered by the Chinese potters. It includes besides a number of other colours distinguished from those of the *famille verte* palette by their relative opacity. They display, moreover, a far wider range of tints, owing to scientific blending of the various enamels and to the judicious use of the opaque white to modify

[1] See *Catalogue* 300–303. " On each is a miniature group of the Seven Worthies of the Bamboo Grove with an attendant bringing a jar of wine and flowers. The porcelain is so thin that the design, with all the details of colour, can be distinctly perceived from the inside." It is only right to say that their learned possessor has catalogued them as genuine examples of the Ch'êng Hua period.

[2] See p. 224, No. 25.

[3] See p. 201.

[4] See p. 224, No. 27.

[5] See p. 225, No. 36.

Fig. 1

Fig. 2

Plate 116.—Yung Chêng Porcelain.

Fig. 1.—Imperial Rice Bowl with design of playing children *(wa wa)*, engraved outlines filled in with green in a yellow ground, transparent glazes on the biscuit. Yung Chêng mark. Diameter 6 inches. *British Museum.* Fig. 2.—Blue and white Vase with fungus *(ling chih)* designs in Hsüan Tê style. Height 7½ inches. *Cologne Museum.*

Fig. 1

Fig. 2

Plate 117.—Yung Chêng Porcelain.

Fig. 1.—Vase with prunus design in underglaze red and blue. Height 15 inches. C. H. Read Collection. Fig. 2.— Imperial Vase with phœnix and peony design in pale *famille verte* enamels over underglaze blue outlines. Height 25⅝ inches. V. & A. Museum.

Fig. 1

Fig. 2

Plate 118.—Early Eighteenth Century Enamels.

Fig. 1.—Plate painted at Canton in *famille rose* enamels (*yang ts'ai*, "foreign colouring"). Yung Chêng period. Diameter 21½ inches. *S. E. Kennedy Collection.* Fig. 2.—Arrow Stand, painted in late *famille verte* enamels. About 1720. Height 19¼ inches. *V. & A. Museum.*

Fig. 1 Fig. 2

Fig. 3 Fig. 4

Plate 119.—Yung Chêng Porcelain, painted at Canton with *famille rose* enamels.
British Museum.

Fig. 1.—." Seven border " Plate. Diameter 8¼ inches. Fig. 2.—Eggshell Cup and Saucer
with painter's marks (see p. 212). Diameter of saucer, 4½ inches. Fig. 3.—Eggshell
Plate with vine border. Diameter 8¼ inches. Fig. 4.—Armorial Plate with arms of
Leake Okeover. Transition enamels, about 1723. Diameter 8⅞ inches.

the positive colours. Most of the opaque colours have considerable body, and stand out on the porcelain like a rich incrustation, and they are laid on not in broad washes, but with careful brush strokes and miniature-like touches.

The *famille rose* colours are known to the Chinese as *juan ts'ai* (" soft colours," as opposed to the *ying ts'ai*, or hard colours of the *famille verte*), *fên ts'ai* (pale colours), or *yang ts'ai* (foreign colours). Their foreign origin is generally admitted, and T'ang Ying in the seventeenth of his descriptions of the processes of manufacture alludes to them under the heading, " Decorating the round ware and vases with foreign colouring." [1] Painting the white porcelain in polychrome (*wu ts'ai*) after the manner of the Europeans (*hsi yang*), he tells us, is called foreign colouring, and he adds that the colours employed are the same as those used for enamels on metal (*fo lang*). Taking this statement with the note on " foreign coloured wares " in the Imperial list,[2] where reference is made to painting on enamels (*fa lang*) " landscapes and figure scenes, flowering plants and birds," it is evident that *fa lang* is used here not in the usual sense of cloisonné enamel, but for the painted enamels on copper which we distinguish as Canton enamels. These, we are told elsewhere,[3] were first made in the kingdom of Ku-li, which is washed by the Western sea. Ku-li is identified as Calicut, but it does not necessarily follow that the Chinese associated the origin of the painted enamels with India. The expression was probably used quite vaguely in reference to European goods which came by way of India, and does not really conflict with the other phrase, *hsi yang* (Western foreigners), which is always rendered " Europeans."

There is quite a number of references to the foreign or European colours in the Imperial list,[4] e.g. " porcelain in yellow after the European style," which Bushell considers to be the lemon yellow which originated in this reign ; " porcelain in purple brown (*tzŭ*) after the European style " ; " European red-coloured wares," i.e. rose pink ; " European green-coloured wares," which Bushell

[1] *T'ao shuo*, bk. i., fol. 15 verso.

[2] See p. 225, No. 49. *Fo-lang, fa-lang, fu-lang,* and *fa-lan* are used indiscriminately by the Chinese in the sense of enamels on metal.

[3] In the *T'ao lu*, under the heading *Yang tz'ŭ*. It is a curious paradox that the Chinese called *famille rose* porcelain *yang ts'ai* (foreign colours) and the Canton enamels *yang tz'ŭ* (foreign porcelain). See *Burlington Magazine*, December, 1912, " Note on Canton Enamels."

[4] See pp. 224–226, Nos. 29, 37, 38, 49, 51, 53, and 54.

explains as pale bluish green or *eau de nil* enamel ; and " European black (*wu chin*) wares." In fact the words, "foreign or European," seem to be practically synonymous with " opaque enamel." [1]

The most complete display of the foreign colouring is given by a special group of porcelain which is painted in a characteristic and mannered style. It is best known as "eggshell" or "ruby-back" porcelain, from the fact that it is usually very thin and translucent and beautifully potted, and that the exterior of the dishes and plates is often coated with a gold pink enamel varying from pale ruby pink to deep crimson. It usually consists of saucer-shaped dishes, plates, and tea and coffee wares, obviously intended for European use. Occasionally there are vases and lanterns of exquisite lightness and translucency, but the vase forms usually

[1] Apart from the rose pinks which are derived from purple of cassius, i.e. precipitate of gold, and the opaque white derived from arsenic, the colouring agents of the *famille rose* enamels are essentially the same as those of the *famille verte*. The colours themselves were brought to Ching-tê Chên in the form of lumps of coloured glass prepared at the Shantung glass works. These lumps were ground to a fine powder and mixed with a little white lead, and in some cases with sand (apparently potash was also used in some cases to modify the tones), and the powder was worked up for the painter's use with turpentine, weak glue, or even with water. Cobaltiferous ore of manganese, oxide of copper, iron peroxide, and antimony were still the main colouring agents. The first produced the various shades of blue, violet, purple, and black ; the second, the various greens ; the third, coral or brick red ; and the fourth, yellow of various shades. A little iron in the yellow gave the colour an orange tone.

The modifications of the green are more numerous. The pure binoxide of copper produced the shade used for distant mountains (*shan lü*), which could be converted into turquoise by the admixture of white. The ordinary leaf green was darkened by strengthening the lead element in the flux and made bluer by the introduction of potash in the mixture. Combined with yellow it gave an opaque yellowish green colour known as *ku lü* (ancient green); and a very pale greenish white, the " moon white " of the enameller, was made by a tinge of green added to the arsenious white.

The carmine and crimson rose tints derived from the glass tinted with precipitate of gold, which was known as *yen chih hung* (rouge red), were modified with white to produce the *fên hung* or pale pink ; and the same carmine was combined with white and deep blue to make the amaranth or blue lotus (*ch'ing lien*) colour.

The ordinary brick red (the *ta hung* or *mo hung*) was derived from peroxide of iron mixed with a little glue to make it adhere, but depending on the glaze for any vitrification it could obtain. The addition of a plumbo-alcaline flux produced the more brilliant and glossy red of coral tint known as *tsao'rh hung* (jujube red).

The dry, dull black derived from cobaltiferous manganese was converted into a glossy enamel by mixing with green. This is the *famille rose* black as distinct from the black of the *famille verte*, which was formed by a layer of green washed over a layer of dull black on the porcelain itself.

There are, besides, numerous other shades, such as lavender, French grey, etc., obtained by cunning mixtures, and all these enamels were capable of use as monochromes in place of coloured glazes as well as for brushwork.

required a more substantial construction, and such specimens as Plate 120, are strongly built, though decorated in the same style as the eggshell wares.

The decoration of these porcelains is scarcely less distinctive than their colouring. The central design usually consists of one of the following : a Chinese interior with figures of ladies and children, groups of vases and furniture, baskets of flowers and dishes of fruit, a pheasant on a rock, two quails and growing flowers, a cock and peonies, etc. ; and these designs are enclosed by rich borders, sometimes totalling as many as seven in number, composed of hexagon and square, lozenge, trellis or matting diapers, in varying colours, and broken by small irregular panels of flowers or archaic dragons. There are, of course, many other kinds of decoration on these wares. Sometimes the whole designs is executed in opaque blue enamel, sometimes it is black and gold. On some the borders are simpler, merely delicately gilt patterns ; on others they are ruby pink, plain or broken by enamelled sprays. On the vase forms the ruby either covers the entire ground or is broken, as in Plate 121, Fig. 3, by fan-shaped or picture-shaped panels with polychrome designs. The painting is, as a rule, very finely and carefully executed, but almost always in a distinctive style which is closely paralleled by the Canton enamels.

Indeed, it is impossible to resist the conclusion that much of this ware was actually decorated in the enamelling establishments at Canton, the porcelain itself being sent in the white from Ching-tê Chên. The same designs are found on both the porcelain and the enamels, and there is one instance at least of an artist whose paintings were used on both materials, as is testified by his signature. This is the painter whose art-name is *Pai shih shan jên* (hermit of the white rock), or in a shortened form, Pai-shih (see vol. i., p. 223). He was evidently a Cantonese, for one of his designs on a saucer in the British Museum is inscribed *Ling nan hui chê* (a Canton picture), the subject being a vase of flowers and a basket of fruit. His signature is also attached to a dish with cock and peonies in the Victoria and Albert Museum,[1] and to a similar design figured by Jacquemart,[2] which also bears the date corresponding to 1724. It occurs, besides, fairly frequently on Canton enamels, though in this case usually attached to landscape designs. In all these instances, however, it is placed in the

[1] Bushell, *Chinese Art*, vol. ii., fig. 61.
[2] *Histoire de la porcelaine*, pt. viii., fig. 3.

field of the design appended, as a rule, to a stanza of verse or a descriptive sentence. This is a usual position for the signature of a painter on silk or paper, and we can hardly be wrong in inferring that Pai-shih was the artist whose designs were copied on the wares, perhaps one who was specially employed to design for the enamellers, rather than an actual pot-painter or enameller. The proper place for the signature of the latter is underneath the ware, on the base; and here we find on a cup and saucer in the British Museum the name apparently of the real decorator whose painting is not to be distinguished from that on the piece with the Pai-shih signature, just mentioned as in the same collection. Under the saucer (Plate 119, Fig. 2) is the seal *Yü fêng yang lin,* i.e. Yang Lin of Yü-fêng, an old name for the town of K'un-shan; and under the cup is the seal *Yu chai* (quiet pavilion), which is no doubt the studio name of Yang-lin.[1] K'un-shan Hsien is situated between Su-chou and Shanghai, in the province of Kiangsu, and we are to understand that Yang-lin was either a native of K'un-shan or that he resided there—more probably the former, for his work is typical of the Canton enamellers. It is, however, probable enough that there were decorating establishments working for the European markets in the neighbourhood of Shanghai as well as at Canton, just as there are still decorating kilns not only at Ching-tê Chên but " at the other towns on the river." [2]

It is highly probable that the brushwork of the Canton enamellers, like the enamels themselves, was copied at Ching-tê Chên, and even that some of the enamellers migrated thither. A tankard among the armorial porcelain in the British Museum, bearing the arms of Yorke and Cocks, combines a few touches of underglaze blue with passages of *famille rose* decoration in the Canton style. The blue can only have been applied at the place of manufacture, and as no porcelain of this kind was actually made at Canton, it is evident that the piece was made and decorated elsewhere (which can only mean at Ching-tê Chên), unless we assume the improbable alternative that the tankard travelled from the factory, bare save for a faintly outlined shield with a saltire in blue, to be finished off at Canton.

Needless to say there is much *famille rose* porcelain in which

[1] These marks were discussed by Bushell in the *Burlington Magazine,* August and September, 1906. They are figured on vol. i., pp. 219 and 223.

[2] Quoted from a letter written to Sir Wollaston Franks by Mr. Arthur B. French, who visited Ching-tê Chên in 1882.

the Cantonese style is not apparent, and this we assume without hesitation to have been decorated at Ching-tê Chên.

It only remains to say a few words on the dating of the *famille rose* wares and for this we must return to the ruby-back porcelains. Dated pieces are rare, but the British Museum is fortunate in possessing a few documentary specimens. The most interesting of these is a bowl with pale ruby enamel covering the exterior, and a dainty spray of flowers in *famille rose* enamels inside. It is marked in blue under the glaze with the cyclical date " made in the *hsin chou* year recurring " (see p. 213). The only year to which this can be referred is 1721, when the *hsin chou* year came round for the second time in the long reign of K'ang Hsi.[1] It is of course possible that this bowl was not enamelled in the year of its manufacture, but there are two other pieces in the same case, an octagonal plate with ruby border and a dish, both with the mark of the Dresden collection, and therefore not later than the early years of Yung Chêng. A fourth document is a ruby-back saucer dish delicately painted with a lady and boys, vases and furniture in typical style, which has the mark of the Yung Chêng period.

Unfortunately it is no longer possible to regard the year 1724, to which the signature Pai-shih is attached on the plate mentioned above, as conclusive evidence of the date of decoration.[2] It is certainly the date of the design, and it is probable enough that the porcelain was painted within a few years of the original picture, but beyond that no further inferences can be drawn.[3] The Yorke-Cocks tankard, however, to which we have also alluded, must for heraldic reasons have been painted between the years 1720 and 1733 ; and there is an eggshell cup and saucer in the British Museum painted in rose pink and other enamels of this type, with the arms of the Dutch East India Company and the date 1728.

From this cumulative evidence it is clear that the manufacture of eggshell dishes and services with *famille rose* enamels in the Canton style and with " ruby backs " was in full swing in the Yung Chêng period, and the general tendency to label them all Ch'ien Lung errs on the side of excessive caution.

[1] Officially the reign of K'ang Hsi dates from 1662-1722, but he actually succeeded to the throne on the death of Shun Chih in 1661, so that his reign completed the cycle of sixty years in 1721.

[2] As Bushell has done in *Chinese Art*, vol. ii., p. 42.

[3] See " Note on Canton Enamels," *Burlington Magazine*, December, 1912.

Passing from this particular group, which was affected by special influences, the general character of the Yung Chêng enamelled decoration is one of great refinement in design and execution. The over-elaboration and the overcrowding which are observable on the later Ch'ien Lung *famille rose* are absent at this period. The tendency was on the contrary towards elegant and restrained effects, such as a flowering spray thrown artistically across the field, birds on a bough and other graceful designs which left plenty of scope for the fine quality of the white background. It is this nicely balanced decoration coupled with the delicacy of the painting and the beautiful finish of the porcelain itself, which gives the Yung Chêng enamelled wares their singular distinction and charm.

There are still a few special types of painted wares to be noticed before passing to the monochromes. One of these is named in the Imperial list,[1] under the heading " Porcelain painted in ink (*ts'ai shui mo*)," a figurative expression, for Indian ink could not stand the heat even of the enamelling kiln, and could never have served as a true ceramic pigment. The material used was a dry black or brown black pigment derived from manganese, and closely allied to the pigment which had long served in a subordinate position for tracing outlines. Evidently this material was now greatly improved, and could be used for complete designs which resembled drawings in Indian ink or in sepia. It is certain, however, that the Chinese, whose methods were necessarily empirical, had first experimented with actual ink, for Père d'Entrecolles wrote in 1722 [2] —" an attempt made to paint in black some vases with the finest Chinese ink met with no success. When the porcelain had been fired, it turned out white. The particles of this black had not sufficient body, and were dissipated by the action of the fire ; or rather they had not the strength to penetrate the layer of glaze or to produce a colour differing from the plain glaze." Between that date and about 1730 when the Imperial list was drawn up, the secret of the proper pigment seems to have been mastered, and we find the black designs effectively used on Yung Chêng eggshell and other wares, alone or brightened by a little gilding. Among other uses it was found to be admirably suited for copying the effect of European prints and line engravings, a *tour de force* in which the proverbial patience and imitative skill of the Chinese are well

[1] See p. 225, No. 40. [2] Op. cit., second letter, section xx.

exemplified. Another effect sometimes mistaken for black paint-
ing is produced by silvered designs which become rapidly dis-
coloured ; but it is generally possible to see a slight metallic sheen
even on the blackened silver if the porcelain is held obliquely to
the light.

Another refined and unobtrusive decoration was effected by
pencilling in pale iron red supplemented with gilding. There is
a large series of this red and gold porcelain in the Dresden collection,
and it seems to belong to the late K'ang Hsi or the Yung Chêng
period. Another telling combination, including black, red and
gold, dates from this time. The black and gold variety is well
illustrated by an interesting plate in the British Museum which
represents European figures in early eighteenth-century costume
in a Chinese interior (Plate 131, Fig. 1). The Imperial list [1]
alludes to the use of silver and gold both to cover the entire
surface like a monochrome (*mo yin* and *mo chin*), and in painted
designs (*miao yin* and *miao chin*).[2] Three of these decorations are
said to have been in Japanese style, but the precise significance
of this is not clear. Gilding was freely used in combination with
red and blue, and especially over the blue, on Arita porcelain, but
the application of it does not seem to differ from the ordinary
Chinese gilding. The one feature common to the Chinese and
Japanese gilding is its lightness and restraint as compared with
the heavy gilding of European porcelains.

Plate 125 illustrates a peculiar ware which belongs in part to the
reign of Yung Chêng and in part to that of Ch'ien Lung. It attempts
to reproduce the soft colouring on the enamelled glass made by Hu,[3]
whose studio-name was Ku-yüeh-hsüan ("ancient moon pavilion ").
A small brush holder [4] of this glass is shown on Fig. 125, an opaque
white material, not unlike our old Bristol glass, delicately painted
in *famille rose* colours with groups of the Seven Worthies of
the Bamboo Grove. It is said that [5] the Emperor admired the
soft colouring on this ware, and expressed a wish to see the
same effect produced in porcelain. T'ang Ying thereupon set out
to solve the problem by making a highly vitreous body with

[1] Nos. 39 and 55-57.

[2] *Miao* is used in the sense of to " draw " a picture or design.

[3] Bushell, *O. C. A.*, p. 400, explains how the studio name was formed by the common
device of splitting up Hu 胡 into its component parts *ku* 古 and *yüeh* 月.

[4] From the Hippisley collection, *Catalogue*, p. 408.

[5] *Catalogue of Hippisley Collection*, p. 347.

glassy glaze on which the enamels assumed the soft tints of the original model. This type of porcelain, known as *fang ku yüeh hsüan* ("imitation of Ku-yüeh-hsüan"), is greatly prized. Mr. A. E. Hippisley has described a small group in the catalogue of his collection from which I have been permitted to illustrate an example (Plate 125). Mr. Hippisley states that the earlier specimens of the glass are marked with the four characters *ta ch'ing nien chih* (made in the great Ch'ing period), the reign name Yung Chêng being omitted ; the later pieces, of which the brush pot in our illustration is one, have the Ch'ien Lung mark in four characters. Bushell [1] has figured a yellow glazed snuff bottle with the actual mark *Ku yüeh hsüan chih* (see vol. i. p. 219).

The reigns of Yung Chêng and Ch'ien Lung were prolific in monochromes. Never since the Sung dynasty had these wares been produced in such quantity, and the tale of the glazes was swollen to an unprecedented extent by the accumulated traditions of the past centuries, and by the inventive genius of T'ang Ying. It is scarcely practicable to attempt to distinguish very closely between the Yung Chêng monochromes and those of the early years of Ch'ien Lung. The activities of T'ang-ying extended from 1728–1749, and we are expressly told that many of the types enumerated in the Imperial list were his inventions, besides which there was nothing made by the potters of the past which he could not reproduce. To enumerate all the colours now used would be merely to repeat what has been said under the heading of monochrome porcelain in the previous chapters. Moreover, the Imperial list given on page 223 serves to draw attention to the principal types, and it is only necessary here to supplement it with a few comments.

A special feature of the time was the reproduction of the glazes made in the classical periods of the Sung and Ming dynasties, and in many cases these copies were based on originals lent to the factory from the Imperial collections. Thus the Ju, Kuan, Ko, Lung-chüan, Tung-ch'ing, Chün and Ting wares, all the specialities of the Sung dynasty, are included in the list, and though one type of Kuan glaze is specifically stated to have been laid on a white porcelain body, many of the others, we read, were provided with special bodies imitating the copper- and iron-coloured wares of antiquity. But experience shows that in the majority of

[1] *Chinese Art*, vol. ii., fig. 74.

cases the potters were content to simulate the "brown mouth and iron foot" of the dark-bodied Sung wares by dressing the mouth and the exposed part of the base with ferruginous clay. This is observable on the lavender crackles which imitate the Kuan, and the stone grey crackles of the Ko type, by which the Sung originals were until recent years represented in most Western collections.

In other cases coarse clays of impure colour, and even earthenware bodies were used in the reproductions. The admirable imitations of the mottled and *flambé* Chün glazes which were apparently a special triumph of T'ang-ying appear both on a white porcelain which had to be carefully concealed by the coloured glazes, and on a soft earthenware body. Both these kinds are found with the Yung Chêng mark stamped in the paste, and so correct are the glaze effects that even collectors of considerable experience have been deceived by specimens from which the mark in question has been ground away.

In addition to the copies of the high-fired Chün glazes, there was the "Chün glaze of the muffle kiln" (*lu chün yu*) which is described as something between the glaze applied to the Yi-hsing stoneware and the Kuangtung glazes. The items immediately following this information in the Imperial list [1] make it clear that the writer refers to the glazes of Ou on the Yi-hsing pottery, and to the blue mottled glazes of the Canton stoneware. The enamel which most closely answers to the description of this Chün glaze of the muffle kiln [2] is that illustrated in Fig. 4 of Plate 128, a vase with dark-coloured foot rim, and an opaque greenish blue enamel flecked with dark ruby pink. This enamel varies considerably in appearance according to the preponderance of the red or the blue in the combination; but it is an enamel of the muffle kiln and its markings recall the dappled Chün glazes. I have, moreover, seen this glaze actually applied to a teapot of Yi-hsing red stoneware. This glaze seems to belong to a type, which was largely developed in the Ch'ien Lung period, of glazes resembling if not actually imitating the mottled surface of certain birds' eggs, e.g. the robin, the lark, the sparrow, etc.

[1] See p. 224, Nos. 15-17.

[2] A recipe given in the *T'ao lu* (bk. iii., fol. 12 verso) for the *lu chün* glaze speaks of "crystals of nitre, rock crystal, and (?) cobaltiferous manganese (*liao*) mixed with ordinary glaze." But apart from the uncertain rendering of *liao* (which Bushell takes as *ch'ing liao*, i.e. the material used for blue painting), it is difficult to see how this composition, including the ordinary porcelain glaze, can have been fired in the muffle kiln.

In these instances one colour seems to have been powdered or blown on to another, the commonest kind having a powdering of ruby pink on pale blue or green. This glaze differs from the Chün glaze, described above, only in the size of the pink specks. It was probably in experimenting for the effect of the *flambé* Chün glazes that T'ang Ying acquired the mastery of the furnace transmutations (*yao pien*) which made it possible for him and his successors to produce at will the variegated glazes. These had been described by Père d'Entrecolles a few years earlier as accidental effects in his time, but the French father already foresaw the day when they would be brought under control.

Of the celebrated Ting Chou wares only the fine ivory white Ting (*fên ting*) was copied at the Imperial factory; but this does not preclude the reproduction of the other kind, the creamy crackled *t'u-ting*, in the other potteries. There are, at any rate, many lovely porcelains in both styles which appear to belong to the Yung Chêng and early Ch'ien Lung periods. Coloured glazes with crackle and crackled grey-white of the Ko type were made in great quantity, and most of the choicer crackles in our collections, especially those of antique appearance but on a white and neatly finished porcelain body, date from this time.

The reproductions of Ming monochromes include the underglaze red and the purplish blue as in the previous reign, and the eggshell and pure white of the Yung Lo and Hsüan Tê periods. The purplish blue or *chi ch'ing* of this time is illustrated by a large dish in the British Museum which is further enriched with gilding. It is covered with a splendid deep blue of slightly reddish tinge, varying depth and rather stippled appearance, and it was found in Turkey, where this colour has been much prized. Turquoise green, aubergine purple and yellow of the *demi-grand feu*, and the lustrous brown (*tzŭ chin*) in two shades, brown and yellow, are all mentioned in the Imperial list as used with or without engraved and carved designs under the glaze.

As for the K'ang Hsi porcelains it may be assumed that practically all their glaze colours were now reproduced. A few only are specified in the list, eel yellow, snake-skin green, spotted yellow, *soufflé* red, *soufflé* blue (powder blue) and mirror black (*wu chin*). The term *soufflé* red may refer to the underglaze red from copper or the overglaze iron red. The latter is further subdivided into *mo hung* or *ta hung*, the deep red of Ming origin, and the *tsao'rh hung*

or jujube red, a softer and more vitreous [1] variety of the same colour which Dr. Bushell considered to have originated in the Yung Chêng period. On the *soufflé* red under the glaze we may quote Bushell's remarks [2] : " Two of the colours especially characteristic of the Nien yao or ' Nien porcelain ' of this epoch are the *clair de lune* or *yüeh pai*, and the bright *soufflé* copper red." The latter is further described on a vase in the Walters collection " exhibiting the characteristic monochrome glaze of bright ruby red tint, and stippled surface. The *soufflé* glaze is applied over the whole surface with the exception of a panel of irregular outline reserved on one side, where it is shaded off so that the red fades gradually into a nearly white ground." This panel was afterwards filled in with a design in overglaze enamels. A tazza in the British Museum has this same red covering three-quarters of the exterior, and fading into the white ground. This red also occurs in its beautiful translucent ruby tints on a pair of small wine cups in the same collection, and on a set of larger cups belonging to Mr. Eumorfopoulos. One would say it was the " liquid dawn " tint of the celebrated wine cups of the late Ming potter, Hao Shih-chiu.

The *clair de lune* or moon white (*yüeh pai*), an exquisite glaze of palest blue, is illustrated on Plate 130. It is often faintly tinged with lavender which bears out its description in the Imperial list [3] : " This colour somewhat resembles the Ta Kuan glaze, but the body of the ware is white. The glaze is without crackle, and there are two shades—pale and dark." The Kuan glaze, it should be explained, was characterised by a reddish tinge.

In addition to the foreign colours which were capable of being used as monochromes as well as in painted designs, there are a few other new glazes named in the Imperial list. The *fa ch'ing* (cloisonné blue) which " resulted from recent experiments to match " the deep blue of the enamellers on copper, is identified by Bushell with the dark sapphire blue known as *pao shih lan* (precious stone blue). It was, we are told, darker and bluer than the purplish *chi ch'ing*, and it had not the orange peel and palm eye markings of the latter. It has, however, a faint crackle, and is apparently a glaze of the

[1] In the jujube red the iron oxide is mixed with the plumbo-alcaline flux of the enameller, whereas in the *mo hung* it is simply made to adhere to the porcelain by means of glue, and depends for the silicates, which give it a vitreous appearance, on the glaze beneath it.

[2] *O. C. A.*, p. 360.

[3] See p. 224, No. 18.

demi-grand feu. We learn elsewhere that this cloisonné blue was one of T'ang-ying's inventions.

Among the yellows are " porcelain with yellow after the European style " which is identified by Bushell with the opaque lemon yellow enamel introduced at this time, and there are two kinds of *mi sê* (millet colour) glazes,[1] pale and dark, which we are told " differed from the Sung *mi sê*." Bushell's explanation of the term *mi sê* given in Monkhouse's *Chinese Porcelain*,[2] traverses his rendering of the terms as rice colour in other books : " The Chinese term used here is *mi sê*, which Julien first translated *couleur du riz*, and thereby misled us all. It really refers to the colour (*sê*) of the yellow millet (*huang mi*), not of rice (*pai mi*). *Mi sê* in Chinese silks is a full primrose yellow ; in Chinese ceramic glazes it often deepens from that tint to a dull mustard colour when the materials are less pure. It has often been wondered why the old " mustard crackle " of collectors is apparently never alluded to in " L'Histoire des Porcelaines de King-tê-chin." It is necessary to substitute yellow for " rice coloured " in the text generally, remembering always that a paler tone is indicated than that of the Imperial yellow, which Mr. Monkhouse justly likens to the yolk of an egg."

In Giles's Dictionary *mi sê* is rendered " straw colour, the colour of yellow millet," and all my inquiries among Chinese collectors as to the tint of the *mi sê* glaze have led to the same conclusion. One of the Chinese experts indicated a bowl with pale straw yellow glaze of the K'ang Hsi period as an example of *mi sê*, and this I take to be the *mi sê* which " differed from the Sung colour," being, in fact, an ordinary yellow glaze, following the type made in the Ming dynasty, and entirely different in technique from the Sung glazes.

The precise nature of the Sung *mi sê* which is included among the Ko yao, Chün yao and Hsiang-hu wares reproduced by the Yung Chêng potters according to the Imperial list is a little doubtful. Possibly one type was illustrated by the " shallow bowl with spout : grey stoneware with opaque glaze of pale sulphur yellow," which Mr. Alexander exhibited at the Burlington Fine Arts Club in 1910.[3] Another is indicated in the Pierpont Morgan collection [4] in a " shallow

[1] See p. 225, No. 44.
[2] Op. cit., p. 67.
[3] *Catalogue*, K. 18.
[4] *Catalogue*, vol. i., p. 38. The colour has already been discussed in a note on p. 68 of vol. i. of this book.

bowl with greenish yellow crackled glaze," apparently of the type found occasionally in Borneo, where such wares are still treasured by the Dyaks. The vase in the Victoria and Albert Museum which is figured by Monkhouse (op. cit., Fig. 22) as a specimen of old *mi sê*, appears for reasons already given [1] to be a Yung Chêng reproduction of this type. The " mustard yellow " which Bushell included under the description *mi sê* is an opaque crackled enamel which can hardly have originated before the Yung Chêng period, and it is possible that it resulted from an attempt to reproduce the old Sung *mi sê* crackle.

The following list of the decorations used at the Imperial factory was compiled by Hsieh Min, the governor of the province of Kiangsi from 1729 to 1734. [2] It was translated by Bushell in his *Oriental Ceramic Art* ; but reference has been made to it so often in these pages, and its importance is so obvious, that no apology is necessary for giving it in full. The following version is taken from the *Chiang hsi t'ung chih*, bk. 93, fols. 11 to 13, and in most cases Bushell's rendering has been followed :—

1. Glazes of the Ta Kuan period (i.e. Sung Kuan yao) on an " iron " body, including moon white (*yüeh pai*), pale blue or green (*fên ch'ing*) and deep green (*ta lü*).*
2. Ko glaze on an " iron " body, including millet colour (*mi sê*) and *fên ch'ing*.*
3. Ju glaze without crackle on a " copper " body : the glaze colours copied from a cat's food basin of the Sung dynasty, and a dish for washing brushes moulded with a human face.
4. Ju glaze with fish-roe crackle on a " copper " body.*
5. White Ting glaze. Only the *fên Ting* was copied, and not the *t'u Ting*.
6. Chün glazes. Nine varieties are given, of which five were copied from old palace pieces and four from newly acquired specimens ; see p. 000.
7. Reproductions of the *chi hung* red of the Hsüan Tê period : including fresh red (*hsien hung*) and ruby red (*pao shih hung*).
8. Reproductions of the deep violet blue (*chi ch'ing*) of the Hsüan Tê period. This glaze is deep and reddish (*nêng hung*), and has orange peel markings and palm eyes.
9. Reproductions of the glazes of the Imperial factory : including eel yellow (*shan yü huang*), snake-skin green (*shê p'i lü*), and spotted yellow (*huang pan tien*).
10. Lung-ch'üan glazes : including pale and dark shades.

[1] See vol. i., p. 68.
[2] See Bushell, *O. C. A.*, p. 368
* The items marked with an asterisk are stated to have been copied from old specimens in the palace collections.

11. Tung-ch'ing glazes : including pale and dark shades.
12. Reproductions of the Sung millet-coloured (*mi sê*) glaze : copied in form and colour from the fragmentary wares dug up at Hsiang Hu (q.v.).
13. Sung pale green (*fên ch'ing*) glaze : copied from wares found at the same time as the last.
14. Reproduction of " oil green " (*yu lü*) glaze : " copied from an old transmutation (*yao pien*) ware like green jade (*pi yü*), with brilliant colour broken by variegated passages and of antique elegance."
15. The Chün glaze of the muffle stove (*lu chün*). " The colour is between that of the Kuangtung wares and the Yi-hsing applied glaze [1] ; and in the ornamental markings (*hua wên*) and the transmutation tints of the flowing glaze it surpasses them."
16. Ou's glazes, with red and blue markings.
17. Blue mottled (*ch'ing tien*) glazes : copied from old Kuang yao.
18. Moon white (*yüeh pai*) glazes. " The colour somewhat resembles the Ta Kuan glaze, but the body of the ware is white. The glaze is without crackle, and there are two shades—pale and dark."
19. Reproductions of the ruby red (*pao shao*) of Hsüan Tê : in decoration consisting of (1) three fishes, (2) three fruits, (3) three funguses, or (4) the five Happinesses (symbolised by five bats).
20. Reproductions of the Lung-ch'üan glaze with ruby red decoration of the types just enumerated. " This is a new style of the reigning dynasty."
21. Turquoise (*fei ts'ui*) glazes. Copying three sorts, (1) pure turquoise, (2) blue flecked, and (3) gold flecked (*chin tien*).[2]
22. *Soufflé* red (*ch'ui hung*) glaze.
23. *Soufflé* blue (*ch'ui ch'ing*) glaze.
24. Reproductions of Yung Lo porcelain : eggshell (*t'o t'ai*), pure white with engraved (*chui*) or embossed (*kung*) designs.
25. Copies of Wan Li and Chêng Tê enamelled (*wu ts'ai*) porcelain.
26. Copies of Ch'êng Hua enamelled (*wu ts'ai*) porcelain.
27. Porcelain with ornament in Hsüan Tê style in a yellow ground.
28. Cloisonné blue (*fa ch'ing*) glaze.[3] " This glaze is the result of recent attempts to match this colour (i.e. the deep blue of the cloisonné enamels). As compared with the deep and reddish *chi ch'ing*, it is darker and more vividly blue (*ts'ui*), and it has no orange peel or palm eye markings."
29. Reproductions of European wares with lifelike designs carved and engraved. " Sets of the five sacrificial utensils, dishes, plates, vases, and boxes and the like are also decorated with coloured pictures in European style."

[1] The Chinese is *kua yu* 掛釉, lit. hanging, suspended or applied glaze. The Yi-hsing stoneware was not usually glazed ; hence the force of the epithet *kua* applied).

[2] The gold-flecked turquoise has yet to be identified.

[3] Bushell says this is the sapphire blue (*pao shih lan*) of the period.

Fig. 1

Fig. 2

Fig. 3

Plate 121.—Two Beakers and a Jar from sets of five, *famille rose* enamels. Late Yung Chêng Porcelain.

Fig. 1.—Beaker with "harlequin" ground. Height 15¾ inches. *S. E. Kennedy Collection.* Fig. 2.—Jar with dark blue glaze gilt and leaf-shaped reserves. Height 21½ inches. *Burdett-Coutts Collection.* Fig. 3.—Beaker with fan and picture-scroll panels, etc., in a deep ruby pink ground. Height 14½ inches. *Wantage Collection.*

Fig. 3

Fig. 2

Fig. 1

Plate 122.—White Porcelain with designs in low relief.

Fig. 1.—Vase, peony scroll, *ju-i* border, etc. Ch'ien Lung period. Height 7 inches. Fig. 2.—Bottle with "garlic mouth," Imperial dragons in clouds. Creamy crackled glaze imitating Ting ware. Early eighteenth century. Height 9½ inches. *Salting Collection.* Fig. 3.—Vase with design of three rams, symbolising Spring, Ch'ien Lung period. Height 3½ inches. *W. Burton Collection.*

30. Reproductions of wares with incised green decoration in a yellow glaze (*chiao huang*).
31. Reproductions of yellow-glazed wares: including plain and with incised ornament.
32. Reproductions of purple brown (*tzŭ*) glazed wares: including plain and with incised ornament.
33. Porcelain with engraved ornament: including all kinds of glazes.
34. Porcelain with embossed (*tui*) ornament: including all kinds of glazes.
35. Painted red (*mo*[1] *hung*): copying old specimens.
36. Red decoration (*ts'ai hung*): copying old specimens.
37. Porcelain in yellow after the European style.[2]
38. Porcelain in purple brown (*tzŭ*) after the European style.
39. Silvered (*mo yin*) porcelain.
40. Porcelain painted in ink (*shui mo*): see p. 214.
41. Reproductions of the pure white (*t'ien pai*)[3] porcelain of the Hsüan Tê period: including a variety of wares thick and thin, large and small.
42. Reproductions of Chia Ching wares with blue designs.
43. Reproductions of Ch'êng Hua pale painted (*tan miao*) blue designs.
44. Millet colour (*mi sê*) glazes. "Differing from the Sung millet colour." In two shades, dark and light.
45. Porcelain with red in the glaze (*yu li hung*): including (1) painted designs exclusively in red, (2) the combination of blue foliage and red flowers.[4]
46. Reproductions of lustrous brown (*tzŭ chin*) glaze: including two varieties, brown and yellow.
47. Porcelains with yellow glaze (*chiao huang*) decorated in enamels (*wu ts'ai*). "This is the result of recent experiments."
48. Reproductions of green-glazed porcelain: including that with plain ground and with engraved ornament.
49. Wares with foreign colours (*yang ts'ai*). "In the new copies of the Western style of painting in enamels (*fa-lang*) the landscapes and figure scenes, the flowering plants and birds are without exception of supernatural beauty and finish."[5]
50. Porcelain with embossed ornament (*kung hua*): including all kinds of glazes.
51. Porcelain with European (*hsi yang*) red colour.

[1] 抹 *mo*, lit. "rubbed." Bushell (*O. C. A.*, p. 383) explains the term *mo hung* as "applied to the process of painting the coral red monochrome derived from iron over the glaze with an ordinary brush."

[2] Bushell takes this to be the lemon yellow enamel which was first used at this time.

[3] See p. 37.

[4] 有通用紅釉繪畫者有青葉紅花者 *yu t'ung yung hung yu hui hua chê, yu ch'ing yeh hung hua chê.* Bushell (*O. C. A.*, p. 386) gives a slightly different application of this passage, but the meaning seems to be obviously that given above.

[5] This note is given by Bushell, apparently from the Chinese edition which he used; but it does not appear in the British Museum copy. It is, however, attached to the list as quoted in the *T'ao lu.*

52. Reproductions of *wu chin* (mirror black) glazes : including those with black ground and white designs and those with black ground and gilding.
53. Porcelain with European green colour.
54. European *wu chin* (mirror black) wares.
55. Gilt (*mo chin*) porcelain : copying the Japanese.
56. Gilt (*miao chin*)[1] porcelain : copying the Japanese.
57. Silvered (*miao yin*) porcelain : copying the Japanese.
58. Large jars (*ta kang*) with Imperial factory (*ch'ang kuan*) glazes. " Dimensions : diameter, at the mouth, 3 ft. 4 or 5 in. to 4 ft. ; height, 1 ft. 7 or 8 in. to 2 ft. Glaze colours, (1) eel yellow, (2) cucumber (*kua p'i*) green, and (3) yellow and green mottled (*huang lü tien*).

This last item, which is not included in Bushell's list, appears to be almost a repetition of No. 9, with slightly different phrasing. *Huang lü tien*, which is used instead of the difficult phrase *huang pan tien*, may perhaps be taken as a gloss on the latter, indicating that the spots in the mottled yellow were green. In this case it would appear that the " spotted yellow " was a sort of tiger skin glaze, consisting of dabs of green and yellow (and perhaps aubergine as well). Bushell interpreted it in this sense.

[1] As already explained, *miao chin* refers to gilt designs painted with a brush, and *mo chin* to gilding covering the entire surface.

CHAPTER XIII

CH'IEN LUNG 乾隆 (1736–1795)

THE brief reign of Yung Chêng was followed by that of his son, who ruled under the title of Ch'ien Lung for a full cycle of sixty years, at the end of which he abdicated in accordance with his vow that he would not outreign his grandfather, K'ang Hsi. Ch'ien Lung was a devotee of the arts, and they flourished greatly under his long and peaceful sway. He was himself a collector, and the catalogue of the Imperial bronzes compiled under his orders is a classic work; but more than that, he was personally skilful in the art of calligraphy, which ranks in China as high as painting; and he was a voluminous poet. It is no uncommon thing to find his compositions engraved or painted on porcelain and other artistic materials. Bushell[1] quotes an example from a snuff bottle in the Walters Collection; there is a bowl for washing wine cups in the Eumorfopoulos Collection with a descriptive verse engraved underneath, and entitled, "Imperial Poem of Ch'ien Lung"; and a beautiful coral red bowl in the British Museum has a similar effusion pencilled in gold in the interior.

His interest in the ceramic art is further proved by the command given in 1743 to T'ang Ying to compose a description of the various processes of manufacture as a commentary on twenty pictures of the industry which belonged to the palace collections; and one of the earliest acts of his reign was to appoint the same celebrated ceramist in 1736 to succeed Nien Hsi-yao in the control of the customs at Huai-an Fu, a post which involved the supreme control of the Imperial porcelain manufacture.

There is little doubt that T'ang Ying[2] was the most distinguished of all the men who held this post. He is, at any rate, the one whose achievements have been most fully recorded. He was himself a prolific writer, and a volume of his collected works has been

[1] *O. C. A.*, p. 50. [2] 唐英

published with a preface by Li Chü-lai. His autobiography is incor-
porated in the *Chiang hsi t'ung chih ;* his twenty descriptions of
the processes of porcelain manufacture are quoted in the *T'ao shuo*
and the *T'ao lu,* and in themselves form a valuable treatise on
Chinese porcelain ; and before taking up his post at Huai-an Fu
in 1736 he collected together, for the benefit of his successors at
Ching-tê Chên, the accumulated notes and memoranda of eight
years. This last work is known as the *T'ao ch'êng shih yu kao*
(" Draughts of Instructions on the Manufacture of Porcelain "),
and the preface [1] quoted in the Annals of Fou-liang furnishes some
interesting details concerning T'ang's labours. We learn, for in-
stance, that when he was appointed to the factory at Ching-tê
Chên in 1728, he was " unacquainted with the finer details of the
porcelain manufacture in the province of Kiangsi," having never
been there before. He worked with heart and strength, however,
sleeping and eating with the workmen during a voluntary appren-
ticeship of three years, until in 1731 " he had conquered his ignor-
ance of the materials and processes of firing, and although he could
not claim familiarity with all the laws of transformation, his know-
ledge was much increased."

The commissionership of the customs was transferred in 1739
from Huai-an Fu to Kiu-kiang, which is close to the point of junc-
tion between the Po-yang Lake and the Yangtze, and considerably
nearer to the Imperial factory at Ching-tê Chên, the control of
which remained in T'ang's hands until 1749.

The *Ching-tê Chên T'ao lu* [2] is almost verbose on the subject
of T'ang's achievements. He had a profound knowledge, it tells
us, of the properties of the different kinds of clay and of the action
of the fire upon them, and he took every care in the selection of
proper materials, so that his wares were all exquisite, lustrous, and
of perfect purity. In imitating the celebrated wares of antiquity
he never failed to make an exact copy, and in the imitation of
all sorts of famous glazes there were none which he could not
cleverly reproduce. There was, in fact, nothing that he could
not successfully accomplish. Furthermore, his novelties [3] included

[1] Translated by Bushell, *O. C. A.,* p. 398.

[2] Bk. v., fol. 12.

[3] 又新製, *yu hsin shih,* lit. " also he newly made." This is undoubtedly the sense
given by the Chinese original, and Julien renders it " il avait nouvellement mis en
œuvre." Bushell, on the other hand, translates: " He also made porcelain decorated
with the various coloured glazes *newly invented,*" a reading which makes the word *chih*

porcelains with the following glazes and colours : foreign purple (*yang tzŭ*), cloisonné blue (*fa ch'ing*), silvering (*mo yin*), painting in ink black (*ts'ai shui mo*), foreign black (*yang wu chin*), painting in the style of the enamels on copper (*fa lang*), foreign colouring in a black ground (*yang ts'ai wu chin*), white designs in a black ground (*hei ti pai hua*), gilding on a black ground (*hei ti miao chin*), sky blue (*t'ien lan*), and transmutation glazes (*yao pien*). The clay used was white, rich (*jang*) and refined, and the body of the porcelain, whether thick or thin, was always unctuous (*ni*). The Imperial wares attained their greatest perfection at this time.

The preface to T'ang's collected works, which is quoted in the same passage, singles out as special triumphs of his genius the revival of the manufacture of the old dragon fish bowls (*lung kang*) and of the Chün yao, and the production of the turquoise and rose (*mei kuei*) colours in " new tints and rare beauty." It is obvious from these passages that T'ang was responsible for many of the types enumerated in Hsieh Min's list in the preceding chapter, not only among the reproductions of antiques but among the new inventions of the period, such as the cloisonné blue, foreign purple, silvering, painting in ink black, and foreign black. It follows, then, that these novelties could not have been made much before 1730, for T'ang was still at that time occupied chiefly with learning the potter's art. It is equally certain that he continued to make a specialty of imitating the older wares during the reign of Ch'ien Lung, so that we may regard the best period of these reproductions as extending from 1730–1750.

In reading the list of T'ang's innovations the reader will perhaps be puzzled by the varieties of black decoration which are included. Before attempting to explain them it will be best to review the different kinds of black found on Chinese porcelain of the Ch'ing dynasty. There is the high-fired black glaze, with hard shining surface likened to that of a mirror and usually enriched with gilt traceries. This is the original *wu chin* described by Père d'Entrecolles.[1] The other blacks are all low-fired colours of the muffle kiln applied over the glaze and ranking with the enamel colours. They include at least five varieties : (1) The dry black pigment,

do duty twice over, and leaves it doubtful whether T'ang was the inventor of these types of decoration or merely the user of them. Both the grammar and the balance of the sentences in the original are against this colourless rendering.

[1] See p. 192.

derived from cobaltiferous ore of manganese, applied like the iron red without any glassy flux. (2) The same pigment washed over with a transparent green enamel. This is the iridescent greenish black of the *famille verte*, and it continued in use along with the *famille rose* colours in the Yung Chêng and Ch'ien Lung periods and onwards to modern times. (3) A black enamel in which the same elements—manganese black and copper green—are compounded together. This is the modern *wu chin*, of which a sample in the Sèvres Museum (from the collection of M. Itier) was described by Julien [1] as "noir mat; minerai de manganese cobaltifère et oxyde de cuivre avec céruse." It appears on modern Chinese porcelain as a sticky greenish black enamel, inferior in depth and softness to the old composite black of the *famille verte ;* but for all that, this is the *yang wu chin* (foreign black) of the Yung Chêng and Ch'ien Lung periods. In the days of T'ang Ying it was a far superior colour. (4) A mottled greenish black occurs as a monochrome and as a ground colour with reserved discs enamelled with *famille rose* colours on the exterior of two bowls in the British Museum, both of which have the cyclical date, *wu ch'ên,* under the base, indicating the year 1748 or 1808, probably the latter. (5) An enamel of similar texture but of a purplish black colour is used on a snuff bottle in the same collection to surround a figure design in underglaze blue. This piece has the Yung Chêng mark in red, but from its general character appears to be of later date.

In the list of T'ang's innovations there is *yang wu chin* (foreign black), which is doubtless the same as the *hsi yang wu chin* (European black) of Hsieh Min's list. It is clear that this is something different from the old green black of the *famille verte* porcelain, and we can hardly be wrong in identifying it with the *wu chin* enamel described above in No. 3. Compared with the original mirror black *wu chin* glaze this enamel has a dull surface, and we can only infer that the term *wu chin* had already lost its special sense of metallic black, and was now used merely as a general term for black.

Assuming this inference to be correct, the term *yang ts'ai wu chin* (foreign painting in a black ground) should mean simply *famille rose* colours surrounded by a black enamel ground of the type of either No. 2 or No. 3. It is, of course, possible that the *wu chin* here is the old mirror black glaze on which enamelling in *famille*

[1] *La Porcelaine Chinoise,* p. 216.

rose colours would be perfectly feasible ; but I do not know of any example, whereas there is no lack of choice porcelains answering to the alternative description.

The two remaining types, *hei ti pai hua* (white decoration in a black ground) and *hei ti miao chin* (black ground gilt), apparently leave the nature of the black undefined, but as the expressions appear verbatim in the note attached to No. 52 of Hsieh Min's list, which is " reproductions of *wu chin* glaze," we must regard the black in this case, too, as of the *wu chin* type. The black ground with gilding can hardly refer to anything but the well-known mirror black glaze with gilt designs ; and the white designs in black ground is equally clearly identified with a somewhat rarer type of porcelain in which the pattern is reserved in white in a ground of black enamel of the type of No. 3. There are two snuff bottles in the British Museum respectively decorated with " rat and vine," and figure subjects white with slight black shading and reserved in a sticky black enamel ground. Both these are of the Tao Kuang period, but there are earlier and larger examples elsewhere with a black ground of finer quality. Such a decoration is scarcely possible with anything but an enamel black, and though there is some inconsistency in the grouping of an enamel and a glaze together in Hsieh Min's list, they were apparently both regarded as " reproductions " of the old mirror black *wu chin*.

Out of the remaining innovations ascribed to T'ang's directorate, the *fa ch'ing* (cloisonné or enamel blue) and the *fa lang hua fa* (painting in the style of the enamels on copper) have already been described in connection with Hsieh Min's list. The latter expression occurs verbatim in the note attached in the Annals of Fou-liang [1] to No. 49 of the list, which is " porcelain with foreign colouring," and it clearly refers to the free painting on the Canton enamels for reasons already given.[2] It is true that *fa lang* (like *fo lang*, *fu lang*, and *fa lan*, all phrases suggestive of foreign and Western origin) is commonly used in reference to cloisonné enamel, but the idea of copying on porcelain " landscapes, figure subjects, flowering plants, and birds " from cloisonné enamels is preposterous to anyone who is familiar with the cramped and restricted nature of work bounded

[1] See p. 225. " In the new copies of the Western style of painting in enamels (*hsi yang fa lang hua fa*), the landscapes and figure scenes, the flowering plants and birds are without exception of supernatural beauty."

[2] See p. 209.

by cloisons. It is a pity that Bushell has confused the issue by rendering this particular passage " painting in the style of cloisonné enamel " in his *Oriental Ceramic Art*.[1]

But, it will be objected, the painting in foreign colours has been already shown to have been in full swing some years before T'ang's appointment at Ching-tê Chên. The inconsistency is only apparent, however, for it is only claimed that T'ang introduced this style of painting on the Imperial porcelain, and it may—and indeed must—have been practised in the enamelling establishments at Canton and elsewhere for some time before. Indeed, when one comes to consider the list of T'ang innovations which we have discussed so far, they are mainly concerned with the adaptation of various foreign colours and of processes already in use in the previous reign.

Of those which remain, the *t'ien lan* or sky blue may perhaps be identified with a light blue verging on the tint of turquoise, a high-fired glaze found occasionally in the Ch'ien Lung monochromes. But probably the greatest of T'ang's achievements was the mastery of the *yao pien* or furnace transmutation glazes, which were a matter of chance as late as the end of the K'ang Hsi period. These are the variegated or *flambé* glazes in which a deep red of *sang de bœuf* tint is transformed into a mass of streaks and mottlings in which blue, grey, crimson, brown and green seem to be struggling together for pre-eminence. All these tints spring from one colouring agent —copper oxide—and they are called into being by a sudden change of the atmosphere of the kiln, caused by the admission of wood smoke at the critical moment and the consequent consumption of the oxygen. Without the transformation the glaze would be a *sang de bœuf* red, and in many cases the change is only partial, and large areas of the deep red remain. Fig. 1 of Plate 123 illustrates a small but characteristic specimen of the Ch'ien Lung *flambé*. It will be found that in contrast with the K'ang Hsi *sang de bœuf* these later glazes are more fluescent, and the excess of glaze overrunning the base has been removed by grinding.

Another development of the *yao pien* at this time is the use of a separate " transmutation " glaze which could be added in large or small patches over another glaze, and which assumed, when fired, the usual *flambé* appearance. When judiciously applied the effect of this superadded *flambé* was very effective, but it is

[1] P. 397.

often used in a capricious fashion, with results rather curious than beautiful. There are, for instance, examples of blue and white vases being wholly or partially coated with *flambé*, which have little interest except as evidence that the potters could now produce the variegated effect at will and in more ways than one.

The use of double glazes to produce new and curious effects is characteristic of the period. The second glaze was applied in various ways by blowing, flecking, or painting it over the first. The Chün glaze of the muffle kiln belongs to this type if it has, as I think, been correctly identified with the blue green dappled with crimson on Fig. 4 of Plate 128; and the bird's egg glazes mentioned on p. 217 belong to the same class.[1] Others of a similar appearance, though not necessarily of the same technique, are the tea dust (*ch'a yeh mo*) and iron rust (*t'ieh hsiu*).

The tea dust glaze has a scum of dull tea green specks over an ochreous brown or bronze green glaze, applied either to the biscuit or over an ordinary white glazed porcelain ; and it seems to have been a speciality of the Ch'ien Lung period, though there are known specimens with the Yung Chêng mark and many fine examples were made in later reigns. But neither this glaze nor double glazes in general are inventions of this time. It would be more correct to speak of them as revivals, for the early Japanese tea jars, which are based on Chinese originals, illustrate the principle of the double glaze, and there are specimens of stoneware as old as the Sung if not the T'ang dynasty, with dark olive glaze flecked with tea green, and scarcely distinguishable from the Ch'ien Lung tea dust. It is stated on the authority of M. Billequin (see Bushell, *O. C. A.*, p. 518) that a " sumptuary law was made restricting the use of the tea dust glaze to the Emperor, to evade which collectors used to paint their specimens with imaginary cracks,[2] and even to put in actual rivets to make them appear broken."

The iron rust is a dark lustrous brown glaze strewn with metallic

[1] An interesting series of these bird's egg glazes appearing, as they often do, on tiny vases was exhibited by his Excellency the Chinese Minister at the Whitechapel Art Gallery in November, 1913.

[2] There is a very old superstition in China that cracked or broken pottery is the abode of evil spirits. The modern collector abhors the cracked or damaged specimen for other reasons, and it is certain that such things would not be admitted to the Imperial collections. Many rare and interesting pieces which have come to Europe in the past will be found on examination to be more or less defective, and it is probable that we owe their presence chiefly to this circumstance.

specks (due to excess of iron), and in the best examples clouded with passages of deep red. But these are only two examples of skill displayed by the Ch'ien Lung potters in imitating artistic effects in other materials. Special success was attained in reproducing the many tints of old bronze and its metallic surface. Bright-coloured patina was suggested by touches of *flambé*, and the effects of gilding or gold and silver inlay were rendered by the gilder's brush. The appearance of inlaid enamels was skilfully copied. " In fact," to quote from the *T'ao shuo*,[1] " among all the works of art in carved gold, embossed silver, chiselled stone, lacquer, mother-of-pearl, bamboo and wood, gourd and shell, there is not one that is not now [2] produced in porcelain, a perfect copy of the original piece." Nor is this statement much exaggerated, for I have seen numerous examples in which grained wood, red lacquer, green jade, bronze, and even *mille fiori* glass have been so closely copied that their real nature was not detected without close inspection.

Reverting to T'ang's achievements, we find special mention made of the reproductions of Chün yao which have been already discussed in detail,[3] and of the revived manufacture of the large dragon fish bowls. The latter are the great bowls which caused such distress among the potters in the Wan Li period. They are described in the *T'ao lu* [4] as being fired in specially constructed kilns, and requiring no less than nineteen days to complete their baking. The largest size is said to have measured 6 ft.[5] in height, with a thickness of 5 in. in the wall, one of them occupying an entire kiln. The old Ming dragon bowl found by T'ang Ying [6] at the factory was one of the smaller sizes, and measured 3 ft. in diameter and 2 ft. in height. They were intended for the palace gardens for keeping goldfish or growing water-lilies, and the usual decoration consisted of Imperial dragons. They are variously described as *lung kang* (dragon bowls), *yü kang* (fish bowls), and *ta kang* (great bowls).

[1] See Bushell's translation, op. cit., p. 6.

[2] The *T'ao shuo* was published in 1774.

[3] See vol. i., p. 119.

[4] See Julien, op. cit., p. 101, under the heading *lung kang yao* (kilns for the dragon jars).

[5] The Chinese foot as at present standardised is about two inches longer than the English foot, and the Chinese inch is one-tenth of it.

[6] See p. 58.

Owing to the tremendous difficulty of firing these huge vessels the order for their supply in the reign of Shun Chih was eventually cancelled, and no attempt was made to resume their manufacture until T'ang's directorate. The usual fish bowl of the K'ang Hsi period is a much smaller object, measuring about 20 in. (English) in diameter by 1 ft. in height; but from the note appended to Hsieh Min's list in the *Chiang hsi t'ung chih* on the Imperial *ta kang*, it appears that already (about 1730) the manufacture had been resumed on the old scale,[1] for the dimensions of those described are given as from 3 ft. 4 or 5 in. to 4 ft. in diameter at the mouth, and from 1 ft. 7 or 8 in. to 2 ft. in height. An example of intermediate size is given on Plate 133, one of a pair in the Burdett-Coutts Collection measuring 26½ in. in diameter by 20 in. in height.

It remains to notice two glaze colours to which T'ang Ying appears to have paid special attention: the *fei ts'ui* (turquoise) and the *mei kuei* (rose colour). The former has already been dealt with in connection with Ming, K'ang Hsi, and Yung Chêng porcelain, and it is only necessary to add that it occurs in singularly beautiful quality on the Ch'ien Lung porcelains, often on vases of antique bronze form, but fashioned with the unmistakable " slickness " of the Ch'ien Lung imitations. Occasionally this glaze covers a body of reddish colour due to admixture of some coarser clay, which seems to have assisted the development of the colour, and it is worthy of note that there are modern imitations on an earthen body made at the tile works near Peking which, thanks to the fine quality of their colour, are liable to be passed off as old. I have noticed that Ch'ien Lung monochrome vases—especially those which have colours of the *demi-grand feu* like the turquoise—are often unglazed under the base. The foot is very deeply cut, and the biscuit is bare or skinned over with a mere film of vitreous matter, which seems to be an accidental deposit.

The *mei kuei* is the colour of the red rose (*mei kuei hua*), and it is obviously to be identified with the rose carmines derived from gold which were discussed in the last chapter. These tints are found in considerable variety in the early Ch'ien Lung porcelains, from deep crimson and scarlet or rouge red to pale pink, and they are used as monochromes, ground colours, and in painted decoration. A superb example of their use as ground colour was

[1] There are four examples of the large size of fish bowl in the Pierpont Morgan Collection, but they are of late Ming date.

illustrated on the border of Plate 120, which is probably a Yung Chêng piece. Among the gold red monochromes of the the Ch'ien Lung period one of the most striking is a dark ruby pink with uneven surface of the " orange peel " type. Mr. S. E. Kennedy has a remarkable series of these monochromes in his collection.

Speaking generally, the Ch'ien Lung monochromes repeat the types in vogue in the previous reigns of the dynasty with greater or less success. Among the greens, the opaque, crackled glazes of pea, apple, sage, emerald, and camellia leaf tints described on p. 187 were a speciality of the time, and the snake-skin and cucumber tints were also made with success. There were, besides, beautiful celadon glazes of the *grand feu,* and an opaque enamel of pale bluish green *eau de nil* tint. Underglaze copper red was used both for monochromes and painted wares, but with the exception of the liver or maroon colour the former had not the distinction of the K'ang Hsi *sang de bœuf* or the Yung Chêng *soufflé* red. There is a jug-shaped ewer with pointed spout in the British Museum which has a fluescent glaze of light liver red deepening into crimson, and known in Japan as *toko.* It has the Hsüan Tê mark, but I have seen exactly similar specimens with the mark of Ch'ien Lung, to which period this colour evidently belongs. On the other hand, great improvement is observable in the overglaze coral red monochrome derived from iron, whether it be the thin lustrous film of the *mo hung* or the richly fluxed " jujube " red which attains the depth and fullness of glaze. Fig. 3, Plate 123, is a worthy example of the iron red monochrome of the period. As a thick, even and opaque colour this enamel was used in small pieces which wonderfully simulate the appearance of red cinnabar lacquer.

An endless variety of blue glazes were used, the pure blue in dark and light shades, *soufflé* or plain, the purplish blues and violets, the lavenders and *clair de lunes.* These are mainly high-fired glazes, but a favourite blue of this period is a deep purplish blue of soft, fluescent appearance and minutely crackled texture which is evidently a glaze of the *demi-grand feu.* The " temple of heaven " blue is of this nature, though of a purer and more sapphire tint. It is the colour of the ritual vessels used in the worship of heaven and of the tiles with which the temple was roofed. Another variety of this glaze has the same tint, but is harder and of a bubbly, pinholed texture, apparently a high-fired colour. The *t'ien ch'ing* (sky blue) has already been mentioned—a lighter colour between

lavender and turquoise. And among the blue enamels which were sometimes used as monochromes at this time is an opaque deep blue of intense lapis lazuli tone.

Among the yellows, in addition to the transparent glazes of the older type, there are opaque enamels, including the lemon yellow with rough granular texture, the waxen[1] sulphur yellow which often displays lustrous patches, and the crackled mustard yellow.

Among the purples and browns there are few changes to note, though much of the greenish brown crackle probably belongs to this time ; and there is little to be said about the white wares except that both the true porcelain, whether eggshell or otherwise, and the opaque crackled wares of the Ting yao type were still made with exquisite refinement and finish. The uneven glaze surface, happily compared to " orange peel," was much affected on the Ch'ien Lung whites in common with many other wares of the time. But there were many new enamel monochromes formed by blending the *famille rose* colours, shades of opaque pink, lavender, French grey, and green, which are sometimes delicately engraved with close scroll patterns all over the surface, a type which is known by the clumsy name of *graviata*. These enamel grounds are often interrupted by medallions with underglaze blue or enamelled designs, as on the vase illustrated in Plate 125, Fig. 4, and on the so-called Peking bowls ; or, again, they are broken by reserved floral designs which are daintily coloured in *famille rose* enamels. But we are already drifting from the monochromes into the painted porcelains of the period, and we shall return to the Peking bowls presently.

With regard to the Ch'ien Lung blue and white, little need be added to what was said of this kind of ware in the last chapter. It was still made in considerable quantity, and T'ang Ying, in his twenty descriptions of the manufacture of porcelain, supplies a commentary to three pictures[2] dealing with the " collection of the blue material," " the selection of the mineral," and " the painting of the round ware in blue." From these we learn that large services were made in blue and white, and the decoration was still rigidly subdivided, one set of painters being reserved for the out-

[1] Possibly the tint named in the *T'ao shuo* (Bushell, op. cit., p. 5). " They are coloured wax yellow, tea green, gold brown, or the tint of old Lama books," in reference to incense burners of this period.

[2] Nos. 8, 9 and 11. See Bushell, *T'ao shuo*, op. cit., pp. 16-19.

lining of the designs and another for filling them in, while the plain blue rings were put on by the workman who finished the ware on the polishing wheel, and the inscriptions, marks and seals were added by skilful calligraphers. The blue material was now obtained in the province of Chêkiang, and close attention was paid to the selection of the best mineral. There was one kind of blue " called onion sprouts, which makes very clearly defined strokes, and does not run in the fire, and this must be used for the most delicate pieces." This latter colour is to be looked for on the small steatitic porcelains and the fine eggshell cups.

In common with the other Ch'ien Lung types, the blue and white vases are often of archaic bronze form, and decorated with bronze patterns such as borders of stiff leaves, dragon feet and ogre heads. Another favourite ornament is a close pattern of floral scrolls studded with lotus or peony flowers, often finely drawn but inclined to be small and fussy. These scrolls are commonly executed in the blotchy blue described on p. 13, and the darker shades are often thickly heaped up in palpable relief with a marked tendency to run into drops. On the other hand, one sometimes finds the individual brush strokes, as it were, bitten into the porcelain body, and almost suggesting scratched lines. Both peculiarities, the thick fluescent blue and the deep brush strokes, are observable on a small vase of unusually glassy porcelain in the Franks Collection. Two other pieces in the same collection may be quoted. One is a tazza or high-footed bowl with a band of Sanskrit characters and deep borders of close lotus scrolls, very delicately drawn in a soft pure blue, to which a heavily bubbled glaze has given a hazy appearance. This piece (Plate 93, Fig. 1) has the six characters of the Ch'ien Lung seal-mark in a single line inside the foot. The other is a jar which bears the cyclical date corresponding to 1784. Like the last, it has a decoration of Buddhistic import, viz. the four characters 天竺恩波 t'ien chu ên po (propitious waves from India), each enclosed by formal cloud devices. It is painted in a soft but rather opaque blue, and the glaze is again of bubbly texture.

In the commoner types of Ch'ien Lung blue and white, the blue is usually of a dullish indigo tint, wanting in life and fire. There is, in fact, none of the character of the K'ang Hsi ware ; the broad washes, the clear trembling sapphire, and the subtle harmony existing between the glaze and blue, are all missing. Moreover, the decoration, with its careful brushwork and neat finish,

Fig. 1

Fig. 2

Fig. 3

Plate 124.—Miscellaneous Porcelain.

Fig. 1.—Magnolia Vase with *flambé* glaze of crackled lavender with red and blue streaks. Ch'ien Lung period. Height 7 inches. *Alexander Collection.* Fig. 2.—Bottle with elephant handles, yellow, purple, green and white glazes on the biscuit. Ch'ien Lung period. Height $8\frac{1}{4}$ inches. *British Museum.* Fig. 3.—Dish with fruit design in lustrous transparent glazes on the biscuit, covering a faintly etched dragon pattern. K'ang Hsi mark. Diameter $9\frac{7}{8}$ inches. *British Museum.*

Fig. 1

Fig. 3

Fig. 2

Fig. 4

Plate 125.—Ch'ien Lung Wares. *Hippisley Collection.*

Fig. 1.—Brush Pot of enamelled Ku-yüeh-hsüan glass. Ch'ien Lung mark. Height 2⅔ inches. Fig. 2.—Bottle, porcelain painted in Ku-yüeh style, after a picture by the Ch'ing artist Wang Shih-mei. Height 7 inches. Fig. 3.—Imperial Presentation Cup marked *hsü hua t'ang chih tsèng.* Height 2 inches. Fig. 4.—Medallion Vase, brocade ground with bats in clouds, etc. Ch'ien Lung mark. Height 7¼ inches.

Plate 126.—Vase with "Hundred Flower" design in *famille rose*
enamels.

Ch'ien Lung period (1736–1795). **Height 19¼ inches.** *Grandidier Collection*
(The Louvre).

Plate 127.—Vase painted in mixed enamels. The Hundred Deer.
Grandidier Collection (Louvre).
Late Ch'ien Lung period. Height 18 inches.

has none of the freedom and breadth of the older types. On the whole, it is small wonder that the collector finds little to arouse enthusiasm in the blue and white of this period, if we except the steatitic[1] or " soft pastes," which are eagerly acquired.

Underglaze red painting, and the same in combination with blue or with high-fired glazes and coloured slips, celadon, white, golden brown, olive brown and coffee brown, were perpetuated from the previous reigns ; and underglaze blue designs are found accompanied by yellow or coral red enamel grounds in old Ming style, and even by *famille rose* painting.

Decoration in transparent glazes of three colours—green, yellow and aubergine—applied direct to the biscuit is not common on Ch'ien Lung porcelain, but when used it displays the characteristic neatness and finish of the period. I suspect that many of the trim rice bowls with neatly everted mouth rim and dragon designs etched in outline and filled in with aubergine in a green ground, yellow in an aubergine, or the other combinations of the three colours, belong to this reign, in spite of the K'ang Hsi mark under the base. At any rate, the body, glaze and form can be exactly paralleled in other bowls which have a Ch'ien Lung mark.

This criticism applies equally to a striking group of porcelain of which Fig. 3 of Plate 124 is an example. It consists of bowls and dishes, so much alike in decoration that one might suppose all existing examples to be parts of some large service. The body is delicately engraved with five-clawed dragons pursuing pearls, and somewhat inconsequently over these are painted large and boldly designed flowering sprays (rose, peony, etc.) or fruiting pomegranate branches with black outlines filled in with fine, transparent aubergine, full yellow and green in light and dark shades. The remaining ground space is coated with the thin greenish wash which does duty for white in this colour scheme, but in these particular pieces it is unusually lustrous and iridescent. In fact, on the back of a dish in the British Museum it has developed patches of golden lustre of quite a metallic appearance and similar to those noted on the sulphur yellow monochrome described on p. 239. This lustrous appearance, however, is probably no more than an exaggerated iridescence, for there is no reason to suppose that the Chinese ever used metallic lustre

[1] See p. 140.

of the Persian or European kind.[1] This group of porcelain always bears the K'ang Hsi mark, but a comparison with the bowls of later date, both in material and in the general finish of the ware and the style of the colouring, irresistibly argues a later period of manufacture, unless, indeed, we admit that the Imperial bowls of the late K'ang Hsi and the Ch'ien Lung periods are not to be differentiated. The finish of these wares, in fact, compares more closely with that of the finer Tao Kuang bowls than with the recognised types of K'ang Hsi porcelain.

Another kind of on-biscuit decoration of the Ch'ien Lung—and perhaps the Yung Chêng—period is best described from a concrete example, viz., Fig. 2 of Plate 124, a pear-shaped bottle in the British Museum with sides moulded in shallow lobes, an overlapping frill or collar with scalloped outline on the neck, and above this two handles in shape of elephants' heads. The ground colour is a deep brownish yellow relieved by borders of stiff leaves with incised outline filled in with smooth emerald green; and the collar and handles are white with cloud scroll borders of pale aubergine edged with blue. The general colouring, as well as the form of this vase, is closely paralleled in fine pottery of the same period.

It may be added that *famille rose* enamels are sometimes used in on-biscuit polychrome decoration, but the effect is not specially pleasing. Some of the opaque colours serving as monochromes are also applied in this way, but here the absence of a white glaze beneath is scarcely noticeable, owing to the thickness and opacity of the enamels.

But all the other forms of polychrome decoration at this period must yield (numerically, at any rate) to the on-glaze painting in *famille rose* enamels, or, as the Chinese have named them, "foreign colours." The nature of these has been fully discussed, but there is no doubt that their application was widely extended in the Ch'ien Lung period, and one point of difference, at least, is observable in their technique, viz. the mixing of the tints in the actual design so as to produce the European effect of shading. By this means the graded tints in the petals of a flower, and the stratified surface of rocks and mountains, are suggestively rendered.

It would be impossible to enumerate the endless varieties of

[1] A plaque in the Bushell Collection with *famille verte* painting has also a remarkably lustrous appearance, which I can only ascribe to excessive iridescence.

design employed in this large group. Contrasting the decoration of his own time with that of the Ming porcelain, the author of the *T'ao shuo*,[1] which was published in 1774, says : " Porcelain painted in colours excelled in the Ming dynasty, the majority of the patterns being derived from embroidery and brocaded satins, three or four only out of each ten being from nature and copies of antiques. In modern porcelain, out of ten designs you will get four of foreign colouring, three taken from nature, two copies of antiques, one from embroidery or satin brocade."

In their ordinary acceptation the terms are not mutually exclusive, and the last three types might be, and indeed are, all expressed in foreign colouring ; but presumably the writer refers especially to that kind of " foreign colouring " which was directly based on the Canton enamels and is illustrated in the ruby-back eggshell dishes.

The designs taken from nature would include figure subjects representing personages and interiors, landscapes, growing flowers and fruit, and the like, good examples of which are shown on Plates 126 and 127. The one represents the "Hundred Flowers," the vase being, as it were, one great bouquet and the flowers being drawn naturalistically enough to be individually recognised. The other recalls the celebrated picture of the "Hundred Deer" by the late Ming artist, Wên Chêng-ming.[2]

The copies of antiques would comprise bronze patterns and designs borrowed from old porcelain, examples of which are not uncommon. And the brocade patterns, in spite of the low proportion assigned to them in the *T'ao shuo*, occur in relatively large numbers in Western collections. They mostly consist of flowers or close floral scrolls in colour, and reserved in a monochrome ground of yellow, blue, pink, etc. This is the characteristic Ch'ien Lung scroll work which is used both in borders and over large areas such as the exterior of a bowl or the body of a vase. The reserved pattern, highly coloured and winding through a ground of solid opaque enamel, suggests analogy with the scroll grounds of the contemporary cloisonné enamel ; but this incidental likeness has nothing to do with the question of " painting in *fa lang* style," which was dis-

[1] See Bushell's translation, op. cit. p. 20.

[2] Figured by L. Binyon, *Painting in the Far East*, first edition, Plate XIX. There is a fine vase of late Ming blue and white porcelain with this design in the Dresden collection.

cussed among T'ang's innovations. The finer Ch'ien Lung porce-lains, and especially those enamelled with brocade designs, are frequently finished off with a coating of opaque bluish green enamel inside the mouth and under the base, a square panel being reserved for the mark. Needless to say, with all this weight of enamelling little or nothing is seen of the porcelain itself, the fine quality of which is only indicated by the neatness of the form and the elegance of the finish.

The green black which was discussed earlier in the chapter is used with striking effect, both in company with *famille rose* colours (as on Fig. 2 of Plate 131) and without them. An effective decoration of the latter kind is shown on a beautiful bottle-shaped vase with wide, spreading mouth in the Salting Collection, which is covered with close floral scrolls reserved in a ground of black pigment, the whole surface being washed over with trans-parent green. The result is a peculiarly soft and rich decoration of green scrolls in a green black ground.

Nor was the iron red—a colour much employed in monochromes at this time—neglected in the painted wares. Indeed, it occurs as the sole pigment on many pieces, and on others it forms a solid brick red or stippled *soufflé* ground for floral reserves, medallions and panels of *famille rose* enamelling.

Among the opaque enamels a few shades of blue are similarly used, while the others, as already mentioned, form plain or engraved backgrounds for floral reserves and panel decoration as on Fig. 2 of Plate 125, and on the Peking bowls. The latter are so named not because they were made at Peking, but because the specimens acquired by Western collectors have been chiefly obtained from that source. Many of them have the Ch'ien Lung mark, and their ground colours comprise a variety of pinks, yellow, green, French grey, dark blue, slaty blue, amaranth, lavender, bluish green,[1] delicate greenish white and coral red. The medallions on the bowls —usually four in number—are commonly decorated with growing flowers, such as the flowers of the four seasons in polychrome enamels, while others have figure subjects, frequently European figures in landscape setting and with Chinese attributes, such as a *ju-i* or *ling-chih* fungus. The finish of these bowls is extremely

[1] This green enamel is sometimes netted over with lines suggesting crackle studded with prunus blossoms. Possibly this is intended to recall both in colour and pattern the " plum blossom " crackle of the Sung Kuan yao ; see vol. i., p. 61.

fine, and they are well worthy of the Imperial use to which they were mostly destined.

The mention of a delicate greenish white enamel on these medallion bowls reminds us that this colour is used with exquisite effect for borders of floral design, or even for the main decoration of tea and coffee wares ; and there is a little plate in the British Museum with Ch'ien Lung mark on which it appears with a peculiar chilled or shrivelled surface as a background for painted designs in iron red.

There is a large class of enamelled porcelain, doubtless made chiefly for export, which found its way into our country houses in the last half of the eighteenth century. It is painted with panels of figure subjects in which rose pink and iron red are uncompromisingly blended, and the space surrounding the panels is filled with composite designs of blue and white with passages of pink scale diaper or feathery gilt scrolls broken by small vignettes in which a bird on a bough, insects, growing plants or fragments of landscape are painted in *camaieu* pink, red or sepia. In some cases the panels are framed with low, moulded reliefs, which extend into the border spaces, and the groundwork in these parts is powdered with tiny raised dots. The wares include large punch bowls, bottle-shaped ewers with their basins, and sets of five vases, two of which are beakers and three covered jars with lion knobs, ovoid or square, and sometimes of eggshell thinness. Others again have their panels enclosed by wreaths of flowers and foliage or " rat and vine pattern " in full relief, and many of them have a glaze of lumpy, " orange peel " texture. The name " Mandarin " has been given to these wares because the central figure subjects usually contain personages in official dress ; and the large punch bowls brought back by the tea-merchants are included in this group, though the mandarin figures in the panels are in this case often replaced by European subjects.

Elaborately moulded and pierced ornament coloured in *famille rose* enamels often appears on the table ware of this period, a familiar example being the lotus services in which the motive of the pink lotus flower is expressed partly by moulding and partly by painting, the tendrils and buds being utilised for feet and handles; and there are elegant *famille rose* teapots which have outer casings with panels of prunus, bamboo and pine carved in openwork in the style of the Yi-hsing pottery.

Gilding was, of course, freely employed, and, to a lesser extent, silvering. Elaborate gilt patterns are found covering dark blue, powder blue, lustrous black, bronze green, pale celadon, and iron red monochrome grounds ; and the finer enamelled vases and bowls are often finished off with gilt edging, which does not seem to have been much used before this period, though traces of gilding are sometimes seen on the lustrous brown edges of the older plates and bowls.

The manual dexterity of the Ch'ien Lung potters is shown in openwork carving and pierced designs on lanterns, perfume boxes, insect cages, spill vases, etc., but more especially on the amazing vases with free-working belts, revolving necks, or decorated inner linings which can be turned round behind a pierced outer casing, chains with movable links, and similar *tours de force*.

There are, beside, two types of ornament dating from this period which demand no little manual skill. These are the lacework and rice grain. In the former the design is deeply incised in the body and the whole covered with a pale celadon green glaze, and it is usually applied to small vases and tazza-shaped cups, the pattern consisting of close and intricate Ch'ien Lung scrollwork. The resultant effect is of a very delicate green lace pattern, which appears as a partial transparency when held to the light (Plate 128, Fig. 2). The rice-grain ornament carries the same idea a step farther, for the incised pattern is cut right through the body, leaving small perforations to be filled up by the transparent glaze. Only small incisions could be made, and these generally took the lenticular form which the French have likened to grains of rice (Plate 128, Fig. 1). The patterns made in this fashion are naturally limited. Star-shaped designs or flowers with radiating petals are the commonest, though occasionally the transparencies are made to conform to the lines of painted decoration and even of dragon patterns.

Both ordinary and steatitic porcelain are used for this treatment ; and the ware is either plain white or embellished with underglaze blue borders and designs, and occasionally with enamels. The effect is light and graceful, especially when transmitted light gives proper play to the transparencies.

As to the antiquity of this decoration in China, I can find no evidence of its existence before the eighteenth century, and I am inclined to think it was even then a late development. There are two cups in the Hippisley Collection with apocryphal Hsüan Tê

dates, but the majority of marked examples are Ch'ien Lung or later. Out of fourteen pieces in the Franks Collection five have the Ch'ien Lung mark, two have palace marks of the Tao Kuang period,[1] and one has a long inscription stating that it was made by Wang Shêng-Kao in the fourth month of 1798.[2] The rest are unmarked. The manufacture continues to the present day, and the same process has been freely used in Japan, where it is called *hotaru-de*, or firefly decoration. In this type of ornament the Chinese were long forestalled by the potters of Western Asia, for the rice-grain transparencies were used with exquisite effect in Persia and Syria in the twelfth century if not considerably earlier.

It remains to mention a species of decoration which is not strictly ceramic. It consists of coating the porcelain biscuit with black lacquer in which are inlaid designs in mother-of-pearl, the *lac burgauté* of the French (Plate 128, Fig. 3). This porcelain is known by the French name of *porcelaine laquée burgautée*, and it seems to have been originally a product of the Ch'ien Lung period ; at any rate, I can find no evidence of its existence before the eighteenth century.

In the Ch'ien Lung period Chinese porcelain reaches the high-water mark of technical perfection. The mastery of the material is complete. But for all that the art is already in its decline. By the middle of the reign it is already overripe, and towards the end it shows sure signs of decay. At its best the decoration is more ingenious than original, and more pretty than artistic. At its worst it is cloying and tiresome. The ware itself is perfectly refined and pure, but colder than the K'ang Hsi porcelain. The *famille rose* painting is unequalled at its best for daintiness and finish, but the broken tints and miniature touches cannot compare in decorative value with the stronger and broader effects of the Ming and K'ang Hsi brushwork. The potting is almost perfect, but the forms are wanting in spontaneity ; and the endless imitation of bronze shapes becomes wearisome, partly because the intricate forms of cast metal are not naturally suited to the ceramic material, and partly because the elaborate finish of the Ch'ien Lung wares makes the imitation of the antique unconvincing. In detail the wares are marvels of neatness and finish, but the general impression is of an artificial elegance from which the eye gladly

[1] *Shên tê t'ang* and *ch'ing wei t'ang*. See vol. i., p. 220.
[2] See Burton and Hobson, *Marks on Pottery and Porcelain*, p. 151.

turns to the vigorous beauty of the earlier and less sophisticated types.

As already mentioned, T'ang Ying was commanded by the Emperor in 1743 to arrange and explain twenty pictures of the manufacture of porcelain which were sent to him from the palace. In twelve days he completed the descriptions which have since been incorporated in various books on porcelain, including the *T'ao shuo* and the *T'ao lu*. They have been translated by Julien [1] and by Bushell,[2] and as most of their facts have been embodied in the previous pages, it would be superfluous to give a verbatim translation of them. The following summary, however, will give the drift of them, and Bushell's translation of the *T'ao shuo* can be consulted for a full rendering.

Illustration

I.—COLLECTION OF THE STONES AND FABRICATION OF THE PASTE.

The porcelain stone (*petuntse*) was obtained at this time from *Ch'i-mên*, in the province of Kiangnan. " That of pure colour and fine texture is used in the manufacture of bowls and vases of eggshell (*t'o-t'ai*), pure white (*t'ien pai*), and blue and white porcelain." Other earths, including *kaolin*, were mined within the limits of Jao-chou Fu.

II.—WASHING AND PURIFICATION OF THE PASTE.

III.—BURNING THE ASHES AND PREPARING THE GLAZE.

The ashes of burnt lime and ferns were mixed with *petuntse* in varying proportions to form the glazing material.

IV.—MANUFACTURE OF SEGGARS.

The seggars, or fireclay cases, by which the porcelain was protected in the kiln were made of a coarse clay from Li-ch'un, near Ching-tê Chên, and we are told that the seggar-makers also manufactured rough bowls for the use of the workmen from the same material.

V.—PREPARING THE MOULDS FOR THE ROUND WARE.

VI.—FASHIONING THE ROUND WARE ON THE WHEEL.

VII.—FABRICATION OF THE VASES (*cho ch'i*).

VIII.—COLLECTION OF THE BLUE COLOUR.

The mineral was obtained at this time from Shao-hsing and Chin-hua in Chêkiang.

IX.—SELECTION OF THE BLUE MATERIAL.

X.—MOULDING THE PASTE AND GRINDING THE COLOURS.

XI.—PAINTING THE ROUND WARE IN BLUE.

[1] Op. cit., pp. 116-175.
[2] *T'ao shuo*, op. cit., pp. 7-30 and *O. C. A.*, ch. xv.

Fig. 1

Fig. 2

Fig. 3

Fig. 4

Plate 128.—Ch'ien Lung Porcelain. *British Museum.*

Fig. 1.—Vase with "rice grain" ground and blue and white design. Height 7¾ inches.
Fig. 2.—Vase with "lacework" designs. Ch'ien Lung mark. Height 7¼ inches.
Fig. 3.—Vase with the Seven Worthies of the Bamboo Grove in *lac burgauté.*
Height 14½ inches. Fig. 4.—Vase with "robin's egg" glaze. Height 4⅛ inches.

Plate 129.—Octagonal Vase and Cover, painted in *famille rose*
enamels. Ch'ien Lung period (1736–1795).

Height 35 inches. *One of a pair in the Collection of Dr. A. E. Cumberbatch.*

XII.—FABRICATION AND DECORATION OF VASES.

XIII.—DIPPING THE WARE INTO THE GLAZE OR BLOWING THE GLAZE ON TO IT.

Three methods of glazing are described : the old method of painting the glaze on with goat's-hair brush; dipping the ware into a large jar of glaze ; and blowing on the glaze with a bamboo tube covered at the end with gauze.

XIV.—TURNING THE UNBAKED WARE AND HOLLOWING OUT THE FOOT.

This turning or polishing was done on a wheel. For convenience of handling the foot of the vessel was left with a lump of clay adhering until all the processes, except firing, were complete ; the foot was then trimmed and hollowed out, and the mark painted underneath.

XV.—PUTTING THE FINISHED WARE INTO THE KILN.

XVI.—OPENING THE KILN WHEN THE WARE IS BAKED.

XVII.—DECORATING THE ROUND WARE AND VASES IN FOREIGN COLOURING. See p. 242.

XVIII.—THE OPEN STOVE AND THE CLOSED STOVE.

Two types of small kiln used to fire the on-glaze enamels.

XIX.—WRAPPING IN STRAW AND PACKING IN CASKS.

XX.—WORSHIPPING THE GOD AND OFFERING SACRIFICE.

There are a few illustrations appended to the *T'ao lu* which cover much the same field, but they are roughly drawn. A much better set of coloured pictures is exhibited in frames in the Franks Collection in the British Museum, showing most of the processes described by T'ang.

CHAPTER XIV

HITHERTO the references to European influence on Chinese porcelain have been of an incidental nature. But the use of Western designs on the porcelains of the Ch'ing dynasty, and especially in the eighteenth century, attained such large proportions that it is necessary to treat the wares so decorated as a class apart. A highly instructive collection of this type of porcelain is exhibited in the British Museum, where it has been subdivided in groups illustrating porcelain painted in China with European armorial designs, porcelain painted in China after pictures, engravings and other patterns of European origin, European forms in Chinese porcelain, and, lastly, Chinese porcelain decorated in Europe.

The un-Chinese nature of these decorations, which is apparent at the first glance, justifies their segregation. Indeed, the foreign features are in many cases so conspicuous that it is small wonder if in days when little was known of Chinese ceramic history these wares were often attributed to European manufacture. We now know so much of the intercourse between China and Europe in the past, and of the enormous trade carried on by the various East India companies, that no surprise is felt at the idea of orders for table services sent out to China with armorial and other designs for their decoration. Not that anyone whose eye was really trained to appreciate the peculiarities of Chinese porcelain could ever mistake the nature of these wares. The paste and glaze are, with few exceptions, uncompromisingly Chinese, no matter how closely the decorator with his proverbial genius for imitation may have rendered the European design. And even here, if the Oriental touch is not betrayed in some detail, the Chinese colours and gilding will disclose themselves to the initiate.

It is hardly necessary here to allude to the absurd notion that any of this group was made at the little English factory of Lowestoft. If an error which has once had currency is ever completely

dissipated, Chaffers's great blunder on the subject of Chinese armorial porcelain should be forgotten by now. But it is high time that those who are fully aware of the facts of the case should abandon the equally stupid and wholly illogical expression, " Oriental Lowestoft," not for Lowestoft porcelain decorated in Chinese style, which would be reasonable enough, but (save the mark !) for Chinese porcelain decorated with European designs. As if, indeed, an insignificant Suffolk pottery, which made no enamelled porcelain[1] until about 1770, had any influence on the decoration of a Chinese ware which was distributed all over Europe during the whole of the century.

The European style of flower painting and the European border patterns were used by the Chinese decorators on this class of ware in the last half of the century, but they were the patterns which originated at Meissen and Sèvres, and which were adopted and developed at Chelsea, Derby and Worcester. Any of these wares might have found their way to China and served as models to the Canton decorators, but the likelihood of Lowestoft porcelain exerting any appreciable influence in the Far East is simply laughable.

But to return to the subject of this chapter, the actual European shapes found in Chinese porcelain can be dismissed in a few words. There are a few figures, such as the well known pair reputed to represent Louis XIV. and his queen. These are of K'ang Hsi type, and decorated with enamels on the biscuit. And there are numerous groups or single figures of the same period in the white Fukien porcelain, discussed on p. 111. A few vase forms, copied apparently from Italian wares and belonging to a slightly later date, and a curious pedestal in the British Museum, modelled in the form of a tree trunk with two Cupids in full relief near the top, are purely Western.[2] Needless to say, the bulk of the useful ware, being intended for European consumption, was made after European models, which speak for themselves.

Much might be written on the painted designs of this class if

[1] The Lowestoft factory started about 1752, but its earlier productions were almost entirely blue and white, often copied, like most of the contemporary blue and white from Chinese export wares.

[2] A curious instance of imitation of European ornament is a small bowl which I recently saw with openwork sides and medallions, apparently moulded from a glass cameo made by Tassie at the end of the eighteenth century; and there is a puzzle jug with openwork neck, copied from the well known Delft-ware model, in the Metropolitan Museum, New York.

space permitted, but we must be content with citing a few typical instances, most of which may be seen in the Franks Collection. To the K'ang Hsi period belong some curious imitations of Dutch Delft, in which even the potter's marks are copied, the designs having been, oddly enough, borrowed in the first instance from Oriental wares by the Dutch potters. There are the so-called " Keyser cups," tall, covered cups with saucers, painted in blue with kneeling figures surrounding a king and queen, who probably represent St. Louis of France and his consort ; and in the border is the inscription, L'EMPIRE DE LA VERTU EST ESTABI JUSQ'AU BOUT DE L'UNERS. Another cup has a design of a ship and a syren, with legend, GARDES VOUS DE LA SYRENE ; and there are small plates with the siege of Rotterdam[1] copied in blue from a Dutch engraving.

But the group which probably commands the greatest interest is that known as "Jesuit china," decorated with subjects bearing on the Christian religion. The earliest examples are painted in underglaze blue, the Christian designs being accompanied by ordinary Chinese ornaments. An early (to judge from the general style of the piece, late Ming) example is a pear-shaped ewer, with elongated spout and handle, in the Kunstgewerbe Museum, Berlin. On the side is the sacred monogram IHS, surrounded by formal ornament, and it has been plausibly suggested that the little vessel had been used for Communion purposes. A bowl with fungus mark in the Franks Collection has a Crucifixion on the exterior, framed in a pattern of cloud-scrolls, and inside with truly Chinese tolerance is painted a Buddhist pearl symbol in flames and clouds. A cup in the same series with the " jade " mark [2] has a Crucifixion half lost among the surrounding arabesque scrolls. These two are of the K'ang Hsi period, and were probably made with the pieces to which Père d'Entrecolles [3] alludes, in his letter dated 1712, as follows : " From the debris at a large emporium they brought me a little plate which I treasure more than the finest porcelain made during the last thousand years. In the centre of the plate is painted a crucifix between the Virgin and St. John, and I am told that

[1] Rotterdam was captured by the Spaniards in 1572 ; but those who are interested in the anachronism of Chinese marks will observe that these plates have the date mark of the Ch'êng Hua period (1465–1487).

[2] See vol. i., p. 226.

[3] Op. cit., p. 207.

this kind of porcelain was shipped sometimes to Japan, but that this commerce came to an end sixteen or seventeen years ago. Apparently the Japanese Christians took advantage of this manufacture at the time of the persecution to obtain pictures of our mysteries, and these wares, mingled with others in the crates, eluded the vigilance of the enemies of our religion. This pious artifice was no doubt eventually discovered and rendered useless by more stringent investigation, and that is why the manufacture of this kind of ware has ceased at Ching-tê Chên."

These early types, which are rare to-day, have a special interest because they were decorated at Ching-tê Chên, and their general style indicates that they were made for Oriental use.

After an interval of some years the Jesuit china reappeared in a more sophisticated form, probably the work of Canton decorators. The designs, various Biblical scenes, are copied in black and gold from European engravings, and they occur on plates with rims, tea and coffee services, and other articles of European use. The earliest may date from the Yung Chêng period, but they are mostly Ch'ien Lung, and the same designs are occasionally executed in enamel colours. In addition to the Christian china there are plates and dishes decorated with rings of Koranic inscriptions in Arabic, surrounding magic squares, and destined for the Mussulman markets.

The Franks Collection includes, besides, numerous examples of profane subjects [1] copied in black or in colours from European engravings and designs. A striking instance of the patient skill of the Chinese copyist is given by two large plates completely covered with the designs—the Triumph of Mordecai and Achilles dipped in the Styx—copied line for line, apparently, from Le Sueur's engravings. The effect of the fine lines and cross-hatching is perfectly rendered, and one would say at first that they had been transfer-printed if this process had ever been used by the Chinese. It is amusing, too, to find English topical and political subjects rendered on Chinese porcelain, mugs and punch bowls, with busts of the Duke of Cumberland, Prince Charles Edward, and John Wilkes with appropriate inscriptions. There are, too, satirical pictures in the style of Hogarth, and a few popular but not over-

[1] An interesting example of an early eighteenth century service with European designs is the " trumpeter service," of which several specimens may be seen in the Salting Collection. It has a design of trumpeters, or perhaps heralds, reserved in a black enamelled ground.

refined subjects which gain an additional drollery from the obviously Chinese rendering of the figures. Many large punch bowls still survive decorated to suit their owner's tastes, with a full-rigged ship for the sea captain, a hunting scene for the master of hounds, and agricultural designs for the farmer, often proudly inscribed with the name of the destined possessor and the date of the order. The Chinese touch is usually betrayed in these inscriptions, which are obviously reproduced mechanically, and with no compunction felt for a letter here and there inverted or misplaced.

These porcelains with European pictorial designs are, as a rule, more curious than beautiful, but it cannot be denied that the next group with European coats of arms emblazoned in the centre is often highly decorative. This is particularly true of the earlier examples in which the shields of arms are not disproportionately large, and are surrounded with tasteful Chinese designs. The heraldry is carefully copied and, as a rule, the tinctures are correct. In the older specimens the blue is usually under the glaze, and from this, and from the nature of the surrounding decoration in *famille verte* or transition colours, one may assume that the pieces in question were decorated at Ching-tê Chên. From the middle of the Yung Chêng period onwards a large and constantly increasing proportion of the ware was decorated at Canton, in the enamelling establishments which were in close touch with the European merchants, and from this time European designs begin to encroach on the field of the decoration. Finally, in the last decades of the century the Chinese armorial porcelain is decorated in purely European style. An important though belated witness to the Canton origin of this decoration is a plate in the Franks Collection with the arms of Chadwick in the centre, a band of Derby blue, and a trefoil border on the rim, and on the reverse in black the legend, *Canton in China, 24th Jan^y, 1791.*

Side by side with this armorial porcelain, and apparently also decorated at Canton, there was painted a large quantity of table ware for Western use with half-European designs in which small pink rose-sprays are conspicuous. These are the cheaper kinds of useful ware which are found everywhere in Europe, and must have formed a large percentage of the export trade in the last half of the eighteenth century. The decoration, though usually slight and perfunctory, is quite inoffensive and suitable to the purpose of the ware.

But to return to the armorial porcelain : apart from its heraldic and decorative value, it is often important to the student of Chinese ceramics, because there are specimens which can be dated very precisely from the armorial bearings and other internal evidence. In the British Museum series there are some twenty pieces belonging to the K'ang Hsi period, including an early underglaze blue painted dish with arms of Talbot, and one or two specimens of pure *famille verte*, including the plate dated 1702, which has already been mentioned as being cf a peculiar white and glassy-looking ware. There are examples with underglaze blue and enamel decoration in the Chinese Imari style, and there is a very distinctive group which can be dated armorially[1] to the late K'ang Hsi and early Yung Chêng period. These latter pieces are usually decorated with a shield of arms in the centre in enamel colours, with or without underglaze blue ; the sides are filled with a band of close floral scrolls or brocade diaper in red and gold, broken by small reserves containing flowers and symbols ; on the rim are similar groups of flowers and symbols and a narrow border of red and gold scrolls ; and on the reverse are a few floral sprays in red. The enamels are of the transition kind, *famille verte* with occasional touches of rose pink and opaque yellow. The porcelain is the crisp, sonorous, well potted ware with shining oily glaze of K'ang Hsi type, and the accessory ornament is of purely Chinese character. A border of trefoil cusps, not unlike the strawberry leaves of the heraldic crown, but traceable to a Chinese origin, makes its first appearance on this group. It is a common feature of subsequent armorial wares, like the narrow border of chain pattern which seems to have come into use about 1730.

Dated specimens of Yung Chêng armorial, with painting in the " foreign colours," have been already described.[2] Other examples of this period have the decoration in underglaze blue outlines washed with thin transparent colours, in black pencilling and in black and gold. The border patterns of lacework, vine scrolls, bamboos wreathed with foliage and flowers, and fine floral scrolls, are often beautifully executed in delicate gilding or in brown and gold.

In the Ch'ien Lung period there was an ever-increasing tendency to displace the Chinese patterns in favour of European ornament.

[1] One of these pieces, for instance, is a plate with arms of Sir John Lambert, who was created a baronet in 1711 and died in 1722. It has enamels of the transition kind.
[2] P. 209.

About the middle of the century small bouquets and scattered floral sprays in the well-known Meissen style of painting made their appearance, and the gradual invasion of the border patterns by European motives is apparent. It may be of interest to note a few of the latter as they occur on dated specimens :

1. Light feathery scrolls, gilt or in colours : first half of Ch'ien Lung period.

2. Rococo ornaments combined with floral patterns : first half of Ch'ien Lung period.

3. Large shell-like ornaments and scroll edged frames of lattice work, loosely strung together : early Ch'ien Lung period.

4. Similar motives with more elaborate framework, enclosing diapers, and interrupted by four peacocks at regular intervals and generally black and gold : about 1740 to 1760.

5. Black and brown hexagon diaper, edged with dragon arabesques in gold : an early type of border, but lasting as late as 1780.

6. Composite borders with diapers, symbols, flowers, etc., and sometimes including butterflies, half Chinese and half European : on specimens ranging from 1765 to 1820.

This last border pattern was adopted at Coalport and in other English factories to surround the willow pattern.[1]

In the last decades of the century, such purely European borders as the swags of flowers used at Bow and Bristol, floral and laurel wreaths and husk festoons ; the pink scale patterns of Meissen ; ribbons and dotted lines winding through a floral band, feather scrolls, etc., of Sèvres origin, and afterwards adopted at Worcester, Bristol, Lowestoft and elsewhere in England ; blue with gilt edges and gilt stars, as on the Derby borders, which also derive from Sèvres ; and the corn-flower sprigs of the French hard-paste porcelains.

A conspicuous feature of the Ch'ien Lung export porcelain in general is the use of a thin, washy pink in place of the thick carmine of the early *famille rose*. This is a colour common to European porcelain of the period, and it may have been suggested to the Chinese by specimens of Western wares. We may, perhaps, note

[1] The willow pattern is merely an English adaptation of the conventional Chinese landscape and river scene which occurs frequently on the export blue and white porcelain of the eighteenth century. That it represents any particular story is extremely improbable.

here a design of Oriental figures (as on the Mandarin porcelain) in pink and red surrounded by borders of pink scale diaper, broken by small panels of ornament. It has no connection with the armorial group, but it has apparently been bandied back and forward from East to West. Based on a Chinese original, it was largely copied on English porcelain, such as Worcester, Lowestoft, etc., and apparently services of the English make found their way east and were copied again at some coast factory, or even in Japan, for the export trade. Much of this hybrid ware is found in Australia and on the east coast of Africa, and though the material and the colours are obviously Oriental, the drawing of the faces reflects a European touch. The porcelain is coarse and greyish, and the decoration roughly executed, probably in the first decades of the nineteenth century.

The trade in Chinese armorial porcelain seems to have gradually died out in the nineteenth century, for reasons which are not far to seek. As far as England was concerned, the improvements in the manufacture both of porcelain and fine earthenware changed her position from that of a consumer to that of a producer. In addition to which, a high protective duty must have adversely affected the import trade, for we read [1] in the notes of Enoch Wood, the Staffordshire potter, that alarm was felt in 1803 in the potteries at the " proposed reduction of £59 8s. 6d. per cent. from the duty on the importation of Oriental porcelain, leaving it at 50 per cent."

Not the least interesting part of the Franks Collection is the section devoted to Chinese porcelain decorated in Europe. In the early years of the eighteenth century a number of enamelling establishments appeared in Holland and in other countries where glass and pottery were decorated in the enamel colours which were then coming into play. As the supply of home-made porcelain was as yet practically non-existent, the enamellers had to look for this material in the Oriental market. Chinese porcelains with slight decoration, plain white wares, or those mainly decorated with incised and carved design under the glaze, and white Fukien porcelain offered the most suitable surface ; and these we find treated by Dutch enamellers with the decoration then in vogue among the Delft potters. In the British Museum there are plates with portraits of Dutch celebrities, with designs satirising John

[1] Frank Falkner, *The Wood Family of Burslem*, p. 67.

Law's bubble, and even with Japanese and Chinese patterns, especially those which the Delft potters were in the habit of copying from the " old Imari." Thus we find the curious phenomenon of Chinese porcelain decorated in Europe with Oriental patterns, and, as may be imagined, these pieces have caused much perplexity to collectors. They are, however, to be recognised by the inferior quality of the enamels and the stiff drawing of the copyists. In the case of the Fukien porcelain with relief ornament, the decorators often confined themselves to touching the raised pattern with colour.

As a rule, these added decorations are crude and unsightly, but there were artists of great skill among the German *chambrelans* (as these unattached enamellers were called), such men as Ignatius Bottengruber and Preussler of Breslau,[1] who flourished about 1720 to 1730. Their designs of figures, mythical subjects, etc., enclosed by baroque scrollwork, were skilfully executed in *camaieu* red or black, heightened with gilding, and their work, which is very mannered and distinctive, is highly prized at the present day. Occasionally we find the handiwork of the Dutch lapidary on Chinese porcelains, a design of birds and floral scrolls being cut through a dark blue or brown glaze into the white biscuit.

About the middle of the eighteenth century a more legitimate material was found for the European decorator in small quantities of Chinese porcelain sent over " in the white." Regular supplies in this state must have been forwarded from Ching-tê Chên to Canton for the enamellers there, and, no doubt, the European merchants were able to secure a small amount of this. Thus it was that Chinese porcelain is occasionally found with decoration by artists whose touch is recognised on Chelsea and other wares. It is not necessary to assume that such pieces were painted in the Chelsea factory. That may have been the case, but we know of important enamelling establishments, such as Duesbury's in London, where Chelsea, Bow and Worcester porcelains obtained in the white were decorated to order. It is probable that the painters trained in this work afterwards passed into the porcelain factories. There are rare examples of Chinese porcelain with transfer prints executed at Battersea or even at Worcester, and apparently one or two pieces have had inscriptions added at Lowestoft; but, after

[1] Another *chambrelan* who flourished about the same time and who worked in the same style was C. F. de Wolfsbourg.

all, this group of decorated Oriental is a very small one, and the specimens painted in the style of any particular English factory except Chelsea could be counted on one's fingers. No doubt the same proceedings were repeated in various parts of the Continent, and there are certainly specimens decorated in the Meissen style, and in one piece in the Franks Collection the Meissen mark has been added.

But besides this more or less legitimate treatment of Chinese porcelain, there is a large group of hideously disfigured wares known by the expressive name of " clobbered china." On these pieces Chinese underglaze decoration has been " improved " by the addition of green, yellow, red, and other enamels and gilding, which fill up the white spaces between the Chinese painting and even encroach on the blue designs themselves. This malpractice dates from the early years of the eighteenth century, and we find even choice specimens of K'ang Hsi blue and white among the victims. Possibly there was a reaction at this time against the Chinese blue and white with which the Dutch traders had flooded the country, but it is pitiful to find nowadays a fine vase or bottle of this ware plastered with meaningless daubs of inferior colour.

Strange to say, the clobberer became an established institution, and he was at work in London in the last century, and maybe he is not yet extinct ; and, stranger still, his wretched handiwork has been actually taken as a model for decoration in English potteries, even to the ridiculous travesties of Oriental marks which he often added as the last insult to the porcelain he had defaced. As a rule, the clobbered decoration occurs on blue and white and follows more or less the lines of the original, though it is at once betrayed by its clumsiness and the wretched quality of the enamels used. Occasionally the clobberer was more ambitious, as on a bottle in the British Museum decorated with three spirited monsters in underglaze red. Into this admirably spaced design the clobberer has inserted graceless trees and three ridiculous figures in classical dress standing in Jack-the-giant-killer attitudes with brandished swords over the Chinese creatures. The effect is laughable, but it was vandal's work to deal in this way with choice K'ang Hsi porcelain.

CHAPTER XV

Chia Ch'ing 嘉慶 (1796–1820)

THERE is little to distinguish the porcelain of this reign from that of Ch'ien Lung. The old traditions were followed and the high standard of technical skill was maintained to a great extent, though in the absence of original ideas the natural tendency was towards a gradual decline. The blue and white is a mere echo of the Ch'ien Lung blue and white, as is shown by a square jar in the Franks Collection, which bears the date corresponding to 1819. Another dated specimen in the same collection is a little bowl with design of the "Eight Ambassadors of the Tribes of Man" mounted on strange beasts, painted in thin garish blue under a bubbly glaze. There are well-finished monochromes of the Ch'ien Lung type, conspicuous among which is an intense brick red (derived from iron), which has all the depth and solidity of a glaze. The enamelled wares are in no way inferior to their late Ch'ien Lung models, and the medallion bowls with engraved enamel grounds are particularly choice. Plate 132, a richly decorated vase belonging to the Lady Wantage, illustrates a type common to both periods. The design of ladies of the harem in an Imperial pleasure ground is carefully painted in mixed colours and enclosed by rich borders of dark ruby pink enamel, brocaded with polychrome floral scrolls. Another vase in the same collection (marked Chia Ch'ing) has a movable inner lining and pierced outer shell richly enamelled in the same style. The blue green enamel of the Ch'ien Lung porcelain was freely used to finish off the base and mouth of the vases of this time.

Bushell [1] describes as a speciality of the Chia Ch'ing period, vases with elaborate scrollwork of various kinds in underglaze blue enhanced by a richly gilded background ; and the mark of this reign will be found on many of the choicer snuff bottles, including those sump-

[1] *O. C. A.*, p. 464.

tuous little vessels with richly carved and pierced outer casing as finely tooled as Su Chou or Peking lacquer.

We have already seen that rice-grain decoration was effectively used at this time, and no doubt many specimens of the kindred " lacework " were also made. In fact in a general classification of Chinese porcelain it would be almost superfluous to separate the Chia Ch'ing from the Ch'ien Lung groups.

Tao Kuang 道光 (1821–1850)

The reign of Tao Kuang is the last period of which collectors of Chinese ceramics take any account. It is true that the general deterioration which was already remarked in the previous reign became more and more conspicuous towards the middle of the nineteenth century. It seemed as though the wells of inspiration in China had dried up and the bankrupt arts continued to exist only by virtue of their past. Curiously enough the same wave of decadence was felt all the world over at this period, and if we compare the porcelain of Tao Kuang with the contemporary English and Continental productions we must confess that the decadence of China was Augustan beside the early Victorian art. The Tao Kuang porcelain in the main is saved from utter banality by the high traditions on which it was grounded and by the innate skill of the Chinese potters. Indeed there are not a few out of the numerous specimens of this period in our collections which have a certain individuality and distinction entitling them to a place beside the eighteenth-century wares.

But, speaking generally, the porcelain is a weak edition of the Yung Chêng types. The forms are correct but mechanical, the monochromes are mere understudies of the fine old colours, and the enamels are of exaggerated softness and weak in general effect.

There are numerous marked specimens of all varieties in the Franks Collection. These include a blue and white vase with bronze designs of ogre heads, etc., in the K'ang Hsi style, but painted in pale, lifeless grey blue, and a bowl with lotus designs and symbols surrounding four medallions with the characters *shan kao shui ch'ang*[1] neatly painted in the same weak blue and signed by Wen Lang-shan in the year 1847. Among the monochromes is a dignified vase of bronze form with deep turquoise glaze dated 1844,

[1] " The mountains are high, the rivers long."

besides coffee brown bowls, full yellow bowls, vases with curiously bubbled glaze of dark liver red, and a coral red jar and cover. There is also a large bowl with "tiger skin" glaze patched with yellow, green, aubergine and white. All of these pieces are lacking in quality and distinction, though I have seen far superior specimens of lemon yellow monochrome and tea dust glaze.

The enamelled wares are much more attractive, and many of the rice bowls are prettily decorated in soft colours. The Peking or medallion bowls, for instance, are little if anything below the standard of previous reigns, and in addition to the medallions in engraved enamel grounds of pink, green, grey, etc., outside, the interior is often painted in underglaze blue. There are tasteful bowls with white bamboo designs reserved in a ground of coral red, and there are dishes with blackthorn boughs with pink blossom in a white ground. The Yung Chêng style of underglaze blue outlines with washes of thin transparent enamels was also affected, but the most characteristic enamelling of the period is executed in a mixture of transparent and opaque enamels, a blend of *famille verte* and *famille rose*. This colouring, soft and subdued, but often rather sickly in tone, is frequently seen on bowls and tea wares with Taoist subjects, such as the Eight Immortals, the fairy attendants of Hsi Wang Mu in boats, or the goddess herself on a phœnix passing over the sea to the *t'ien t'ang* or cloud-wrapt pavilions of Paradise, preceded by a stork with a peach of longevity in its beak. The sea is usually rendered by a conventional wave pattern delicately engraved in greenish white, and sometimes the ground of the design is washed with the same thin, lustrous, greenish white, which was remarked on a group of porcelains described on page 151. The porcelain of these bowls has a white, if rather chalky, body and a greenish white glaze of exaggerated oily sheen, and of the minutely bubbled, "muslin-like" texture which is common to Japanese porcelains. But the ordinary Tao Kuang wares are of poor material, greyish in tone and coarser in grain, with the same peculiarities in the texture of the glaze in an exaggerated degree.

A typical example of the fine Tao Kuang rice bowl with Taoist design in the Franks Collection, delicately painted in mixed colours, which recall the Ku-yüeh-hsüan ware of the early Ch'ien Lung period, has the palace mark, *Shên tê t'ang*,[1] in red under the base.

[1] See vol. i., p. 220.

Fig. 1

Fig. 2

Plate 131.—Eighteenth Century Painted Porcelain.

Fig. 1.—Plate painted in black and gold, European figures in a Chinese interior. Yung Chêng period. Diameter 9 inches. *British Museum.*
Fig. 2.—Dish with floral scrolls in *famille rose* enamels in a ground of black enamel diapered with green foliage scrolls. Ch'ien Lung period. Diameter 23¼ inches. *Wantage Collection.*

Plate 132.—Vase painted in mixed enamels, an Imperial park
and a bevy of ladies. *Wantage Collection.*

Deep ruby pink borders with coloured floral scrolls and symbols. Ch'ien
Lung mark. About 1790. Height 30 inches.

A specimen with this mark in the Hippisley Collection [1] is inscribed with a poem by the Emperor Tao Kuang, definitely fixing the date of this hall mark, which is found on choice porcelains made for Imperial use. It occurs on a vase of fine workmanship in the British Museum, decorated with polychrome five-clawed dragons in a lavender enamel ground, of which the base and interior are coated with blue green enamel; and we have already [2] commented on an interesting dish with archaic designs in Ming red and green, which is explained in the mark as an " imitation of the antique made for the *Shên-tê* Hall."

It is worthy of note that most of the porcelain with hall and studio marks in red belong to the nineteenth century, chiefly to the Tao Kuang period. Several of these marks are figured and explained on p. 220 (vol. i.), but it may be useful if we describe here a few of the specimens on which they occur. The hall mark, *Ch'êng tê t'ang*, appears on a shallow bowl in the Franks Collection painted inside with a coiled dragon in green and a border of bats in red, while outside is a landscape carefully painted in mixed colours in a style similar to Plate 125, Fig. 3. The latter has the Imperial hall mark, *Hsü hua t'ang*, with addition of the word *tsêng* (for presentation), and it has besides an inscription proclaiming that it is the "cup of him who departed as General and returned as Grand Secretary" (*ch'u chiang ju hsiang chih pei*). It is painted with a scene in the palace grounds with the Emperor receiving a military officer.[3] A pretty bowl in the Franks Collection with rockery, flowering plants, fungus, etc., in colours has the palace mark, *ssŭ pu t'ang;* and there are two saucer dishes with Buddhist decoration of palmettes in cruciform arrangement, and a border of Sanskrit characters painted in underglaze blue with washes of transparent enamels marked respectively *Ts'ai jun t'ang*, and *Ts'ai hua t'ang* (hall of brilliant colours and hall of brilliant decoration), which are probably synonymous.

A distinctive group of porcelain, which seems to belong to the Tao Kuang period, consists of small boxes and of vases with landscapes and similar elaborate ornament deeply carved in the manner of red lacquer. The surface is usually covered with an opaque green or yellow monochrome enamel, but occasionally it is left in white biscuit. These pieces have almost always a maker's mark, such as Wang Ping-jung, Wang Tso-t'ing (see vol. i., p. 223),

[1] *Catalogue*, No. 367. [2] Vol. i., p. 220. [3] Hippisley Collection, *Catalogue*, No. 169.

and probably come from one factory. Bushell [1] also alludes to white unglazed porcelain made at this time, and recalling the English Parian ware. It is chiefly seen on small objects for the writing table.

The collector will always be glad to secure specimens of the palace porcelains of the Tao Kuang period, and of the smaller objects on which the weakness of the colouring is not noticeable. There are, for instance, many exquisite snuff bottles with the mark of this reign, with carved, monochrome and enamelled ornament. On the other hand quantities of these little objects coarsely manufactured and sketchily decorated were made at this time, and among them the crude specimens with a floral spray on one side, a line of verse in grass characters on the other, and a granulated border coated with opaque yellowish or bluish green enamel, whose supposed discovery in ancient Egyptian tombs made a sensation some sixty years ago. It is not difficult to guess how these objects traded among the Arabs found their way into the tombs which were in course of excavation, but for a time they were believed to prove the existence of Chinese porcelain in the second millennium before Christ. [2]

Three other types of indifferent ware may be mentioned here in passing. They belong to the middle of the nineteenth century, and in part at least to the Tao Kuang period. One is painted with a large pink peony and foliage in a bright green enamel ground ; the second has cut flowers, butterflies and insects in strong rose colours on a celadon green glaze ; and the third has rectangular panels with crowded figure subjects in red and pink enclosed by a brocade pattern of flowers, fruit and insects as in the second type. This third class is often represented by large and rather clumsily shaped vases with two handles of conventionalised dragon form, and the border patterns are sometimes backed with gilding ; but it also occurs in quite recent manufacture in tea and toilet services made for the export trade. The porcelain in all these cases is of a rough, coarse-grained make, and the reader might have been spared a description of them were it not that in spite of their inferior quality they are the subject of frequent inquiries.

[1] *O. C. A.,* p. 469.

[2] This extravagant idea has been long ago exploded, and need not be rediscussed. See, however, Julien *Porcelaine Chinoise,* p. xix., and Medhurst, *Transactions of the China Branch of the Royal Asiatic Society,* Hong Kong, 1853.

Hsien Fêng 咸豐 (1851–1861)

In the third year of Hsien Fêng the T'ai p'ing rebels captured Ching-tê Chên and burnt down the Imperial factory, which was not rebuilt till 1864. The potters themselves were killed or scattered; and, naturally, marked examples of this reign are scarce. Such, however, as do exist are of little account, and may be regarded as continuations of the Tao Kuang manufacture. Bushell [1] mentions vases of good form painted in soft colours with nine five-clawed dragons on a white background, which is etched in the paste with scrolled waves, and a dinner service of bowls, cups and saucer dishes painted in colours with processional figures of the eighteen Lohan. And in the British Museum there is a large globular bowl on a high foot painted with green dragon designs and a bowl with medallions of lanterns and vases separated by lotus ornament, neither of which are in any way different from the Tao Kuang wares. No doubt a good deal of porcelain was made at the private factories even during this troubled period, but the specimens which I have seen are not worthy of description.

T'ung Chih 同治 (1862–1873)

When the T'ai p'ing rebels had been expelled from the province of Kiangsi by the celebrated viceroy, Li Hung-chang, in 1864, the Imperial factory was rebuilt on the old lines by the new director, Ts'ai Chin-ch'ing. In the same year a list of the porcelain forwarded to the Emperor was drawn up, and it is published in the *Chiang hsi t'ung chih* [2] immediately after Hsieh Min's list. It consists mainly of bowls, wine and tea cups, saucer dishes and plates classified as *yüan ch'i* (round ware), and a few vases under the general heading, *cho ch'i*; and though there is little originality in the designs, lists of this kind are so rare and so instructive that I have no hesitation in giving it in full below, following Bushell's [3] renderings in most cases.

Actual examples of T'ung Chih porcelain are not inspiring. Those in the British Museum include a covered bowl with coloured sprays in a ground of red diaper; a bowl with enamelled sprays on a pale brown (*tzŭ chin*) glaze; a saucer with dragons etched under a transparent green glaze, the exterior in unglazed biscuit painted in black; a cup with red dragons in a ground of black enamel and the cyclical

[1] *O. C. A.*, p. 470. [2] Bk. 93, fols. 13-15. [3] *O. C. A.*, pp. 474-83.

date 1868; a low, octagonal bowl with the Eight Trigrams in relief outside, the interior of this and of the preceding specimen as well being coated with blue green enamel; and a basin enamelled with the Eight Ambassadors of the Tribes of Man. The most favourable specimen of the ware in the same collection is a carefully painted wedding bowl with canary yellow ground and medallions of appropriate symbols, the peach- and dragon-headed staff of longevity, the double fish symbol of conjugal felicity, and the group of pencil brush, cake of ink and *ju-i* sceptre forming the rebus *pi ting ju i*, " may things be as you wish."

List of Imperial Porcelains Supplied in the Third Year of T'ung Chih (1864)

VASES (*cho ch'i*)

1. Quadrangular vases with apricot medallions and two tubular handles with Chün glaze. [For the shape see Plate 123, and for the glaze see p. 1.]
2. Vases of the same form with Ko glaze.
3. Quadrangular vases with the Eight Trigrams (*pa kua*), and Ko glaze. [The form is quadrangular body with round neck and foot, moulded in relief with the trigrams; for the Ko glaze see vol. i., p. 71.]
4. Vases in form of jade ewers (*yü hu ch'un*) with *chi hung* (or copper red) glaze.
5. Vases of the same form, with blue and white decoration and raised threads. [Bushell explains that the surface is divided into patterns or sections by raised rings.]
6. Vases of the same form, with blue and white decoration with balcony (*lan kan*). [Bushell explains, " garden scenes enclosed by railings."]
7. Paper-beater (*chih ch'ui*) vases with the *t'ai chi* symbol and the glaze of the Imperial factory decorated in colours. [The form is the club-shape or *rouleau;* and the symbol is apparently the *yin-yang*, the Confucian symbol for the Absolute.]
8. Quadrangular vase with elephant symbol of great peace (*t'ai ping yu hsiang*, a rebus meaning " augury of great peace "). [These are apparently square vases with two handles in form of elephant (*hsiang*) heads.]

ROUND WARES (*yüan ch'i*)

9. Medium-sized bowls with dragons in purple brown (*tzŭ*).
10. Medium-sized bowls with *chi hung* glaze.
11. Large bowls (*wan*) with Indian lotus (*hsi lien*) in blue.
12. Five-inch dishes (*p'an*), similarly decorated.
13. Medium-sized bowls with storks and Eight Trigrams (*pa kua*).
14. Wine cups with narcissus flowers (*shui hsien hua*) in enamels.

15. Wine cups with spreading rim painted with dragons in red.
16. Dishes (*p'an*) a foot in diameter decorated in blue with a pair of dragons filling the surface.
17. Soup bowls (*t'ang wan*) with incised dragons under a dark yellow monochrome glaze. [These, according to Bushell, are smaller and shallower than rice bowls.]
18. Medium-sized bowls, barrel shaped, with dragons engraved under a yellow monochrome glaze.
19. Yellow monochrome tea cups.
20. Medium-sized bowls with dragons engraved under a yellow monochrome glaze.
21. Medium-sized bowls with the three fruits in groups (*pan tzŭ*[1]) painted in blue. [The fruits are peach, pomegranate and finger citron.]
22. Soup bowls with expanding rim and dragons incised under yellow monochrome glaze.
23. Six-inch bowls with a pair of dragons in blue.
24. One-foot dishes painted in blue with silkworm scrolls (*ts'an wên*) and longevity characters.
25. Tea cups decorated in blue with *mu hsi* flowers (a small variety of the *olea fragrans*).
26. Medium-sized bowls with precious lotus in enamel colours.
27. Tea cups with white bamboo on a painted red ground.
28. Six-inch dishes painted in blue with the " three friends " (*san yu*) and figure subjects. [The three friends in floral language are the pine, bamboo and prunus. It is also a name given to the group of Confucius, Buddha, and Lao-tzŭ, who are often represented examining a picture scroll or standing in conversation.]
29. Tea dishes (*ch'a p'an*) with a pair of dragons in blue. [Bushell describes these as " little trays with upright borders, of oblong, four-lobed, and fluted outline." They must in fact have closely resembled the old teapot stands of European services.]
30. Six-inch dishes with green dragons on a ground of engraved water-pattern painted in colour.
31. One-foot dishes painted in blue with archaic phœnixes (*k'uei fêng*). [These designs are ornaments of bird form, terminating in scrolls such as appear on ancient bronzes.]
32. Nine-inch dishes with blue ground and dragons in clouds painted in yellow.
33. Medium-sized bowls with pure white glaze and ruby red (*pao shao*) phœnix medallions.
34. Tea cups with dragons and clouds painted in yellow in a blue ground.
35. Six-inch dishes with *chi hung* (copper red) glaze.
36. Medium-sized bowls with *chi ch'ing* (deep violet blue) glaze.
37. Nine-inch dishes with *chi hung* glaze.
38. Soup bowls, barrel shaped, with lustrous brown glaze.

[1] Bushell applies the phrase *pan tzŭ* to the bowls and renders it " of ring-like outline."

39. Medium-sized bowls with red phœnix medallions in a celadon (*tung ch'ing*) glaze.
40. Nine-inch dishes with silkworm scrolls and *ju-i*[1] ornament in enamel colours.
41. Tea cups enamelled in colours with mandarin ducks and lotus flowers.
42. Tea bowls (*ch'a wan*) with *chi ch'ing* glaze.
43. Tea bowls decorated in colours with the *pa pao* (eight attributes of the Taoist Immortals ; see p. 287).
44. Large bowls with the Eight Immortals in blue on red enamelled waves.
45. Medium-sized bowls, blue and white inside, and with coloured lotus flowers outside.
46. Bowls with the Eight Buddhist symbols of happy augury (*pa chi hsiang*).
47. Porcelain bowls with green designs and peach yellow ground.
48. Five-inch dishes with purple and green dragons in a yellow monochrome ground.
49. Three-inch platters with similar ornament.
50. Soup bowls of the fourth size (*ssŭ hao*) with green monochrome glaze.
51. Five-inch dishes with phœnixes in clouds.
52. Medium-sized bowls with dragons and phœnixes among flowers in coloured enamels.
53. Four-inch platters (*tieh*) with purple and green dragons in yellow monochrome ground.
54. Nine-inch dishes painted in colours with the eight Buddhist symbols among flowers.
55. Large bowls painted in colours with archaic phœnixes (*k'uei fêng*) among flowers.

Kuang Hsü 光緒 (1875–1909)

Marked examples of this modern ware in the Franks Collection include a saucer with coloured sprays in a cloudy pink enamel ground ; a covered cup with spout decorated in red with cartouches of seal characters accompanied by translations in the ordinary script, and a dish with blackthorn bough and pink blossoms in Tao Kuang style. In every case the ware is coarse-grained and rough to the touch, while the glaze is of the lustrous surface and " musliny " texture, which is characteristic of the nineteenth century porcelains ; and the painting is mechanical and devoid of any distinction. There are two little saucers of better quality both in material and painting, with stork and lotus designs in mixed enamels and marks[2] which show that they are palace pieces made for the Empress Dowager.

[1] Bushell renders *ju-i* in the general sense, " with words of happy augury " ; it is, however, applied to ornaments of *ju-i* staffs and to borders of *ju-i* heads.

[2] See vol. i., p. 225.

But the collector's interest in Kuang Hsü porcelain is of a negative kind. When it is frankly marked he sees and avoids it. But the Chinese potters towards the close of the century evidently recovered some part of the skill which the ravages of the T'ai p'ing rebels seemed to have effectually dissipated; for they succeeded in making many excellent *sang de bœuf* reds and crackled emerald green monochromes which have deceived collectors of experience. Even the best, however, of these wares should be recognised by inferiority of form and material, and in the case of red the fluescent glaze will be found in the modern pieces to have overrun the foot rim, necessitating grinding of the base rim. There are also fair imitations of the K'ang Hsi blue and white and the enamelled vases of *famille verte* or on-biscuit colours, and even of the fine black and green grounds. But here again the inferior biscuit, the lack of grace in the form and the stiffness of the designs will be at once observed by the trained eye. When marked most of these imitations have the *nien hao* of K'ang Hsi, and this is almost invariable on the modern blue and white.

There is, of course, a great quantity of modern porcelain, chiefly enamelled and blue and white, made for the export trade and sold at prices which compete successfully with those of the European wares. It is chiefly in the style of the K'ang Hsi and Ch'ien Lung wares, and is marked accordingly; but the ware is coarse-grained, and the decorations summary, and there is no excuse for mistaking these obvious reproductions for anything but what they are and, in fact, what they pretend to be.

The brief reign of Hsüan T'ung 宣統 (1909–1911) is a blank so far as ceramic history is concerned; and with the fall of the Ch'ing dynasty in 1912 the Imperial works ceased its activity, and it remains to be seen whether Ching-tê Chên will again have the advantage of a state factory to set a standard for the industry in general.

ACONSIDERABLE number of the forms which Chinese porcelain assumes have been described in the chapters dealing with the Ming wares; but these may be usefully supplemented by a rapid survey of those employed by the potters of the Ch'ing dynasty. The latter will, of course, include many of the former because the Chinese delight in reproducing the older types.

The brief summary of the eighteenth-century porcelain forms given in the opening pages of the *T'ao shuo* [1] begins in the correct style with the reproductions of the ancient ritual vessels *tsun, lei, yi, ting, yu* and *chüo*. These are all bronze forms, *tsun* being applied to wine vessels, *lei* to vases ornamented with the meander pattern known as " cloud and thunder " scrolls,[2] *yi* to bowl-shaped vessels without feet, *ting* to cauldrons with three or four legs and two handles, *yu* to wine jars with covers, and large loop handles for suspension, and *chüo* to libation cups of helmet and other shapes. The bronze forms are commonly decorated with bronze patterns such as the key-fret, archaic dragon and phœnix scrolls, cicada pattern, ogre heads and bands of stiff (banana) leaves, either painted, moulded, engraved, or carved in relief; and the complicated bronze shapes are usually fashioned in moulds, and in many cases furnished with ring handles attached to monster heads. Another ritual type manufactured in porcelain as well as bronze is the altar set of five pieces (*wu kung*), which consists of a *ting* or tripod incense vase, two flower vases, and two pricket candlesticks. A humbler altar set was composed of a single censer or a tazza-shaped cup (Plate 93, Fig. 1) for flowers, and a pair of lions on stands fitted with tubes for holding sticks of incense. The bronze forms have always been used by

[1] Bk. i., fols. 1 and 2 ; see Bushell, op. cit., pp. 3-6.

[2] This is a variety of the key pattern or Greek fret, which is of world-wide distribution.

the Chinese potters, but they were specially affected in the archaising period of Ch'ien Lung.

In the Western judgment, however, which is unbiased by the associations of these antique forms, the true pottery shapes, made on the wheel, will appear far more attractive ; for nothing can surpass the simple rounded forms which sprang to life beneath the deft fingers of the Chinese thrower. Their simplicity, grace, and perfect suitability for their intended uses have commended them as models to the Western potter far more congenial than the cold perfection of the Greek vases. Naturally they vary in quality with the skill and taste of the individual, but a high level of manual skill ruled among the Chinese potters, and their wheel-work rarely fails to please.

It would be useless to attempt to exhaust all the varieties of wheel-made forms. Many of them are due to slight alterations of line according to the caprice of the thrower. It will be enough to enumerate the principal types and to note a few of the more significant changes which came in at ascertained periods. By comparing the illustrations in different parts of this book, and better still, by comparing the specimens in some well classified collection, the reader will soon learn to notice the periodical changes of shape. To take the familiar bottle-shaped vases as an instance, there is probably no shape on which more numerous changes have been rung, nor one which is more susceptible to the individual touch ; and yet the trained eye will generally distinguish the K'ang Hsi bottle from the later forms, though the distinction is often more subtle than that which separates the typical K'ang Hsi form (Plate 123, Fig. 2) from that with depressed body and straight wide neck (Plate 128, Fig. 3), which is characteristic of the Ch'ien Lung period.

The K'ang Hsi bottles vary in themselves in length and slenderness of neck, and in the form of the body, which may be globular, ovoid, barrel shaped or pear shaped. Again they are often of double or even triple gourd shape, or plain with a bulbous swelling on the upper part of the neck or actually at the mouth. The last variety are called " garlic-shaped " bottles by the Chinese. The normal types are used to hold a single spray or a flowering branch, but there are others with slender necks tapering to a point which are designed for sprinkling perfumes and are generally known as sprinklers.

Of flower vases there are numerous varieties : egg-shaped vases ;

baluster-shaped vases with spreading mouth; high-shouldered vases with small mouth, the *mei p'ing* of the Ming period; beakers (*ku*) with slender body, swelling belt in the middle and flaring mouth; the so-called *yen yen* vase with ovoid body and high neck with trumpet mouth,[1] which is used for some of the choicest K'ang Hsi decorations (Plate 101); the *Kuan yin*[2] vase of ovoid form with short neck and spreading mouth; the cylindrical vase with short straight neck and spreading mouth (Plate 103), called by the French *rouleau* and by the Chinese "paper-beater" (*chih ch'ui p'ing*), whence our name "club-shaped." A smaller form of the same is known to the Chinese as *yu ch'ui p'ing* (oil-beater vase).

There is besides the wide oval jar or *potiche* with dome-shaped cover (*tsun*), and the more slender form known as *t'an*, which often has a lion or *ch'i-lin* on the cover serving as a knob; the tall cylinder to hold arrows and the low cylinder for brushes, and numerous pots and jars for various uses.

Most of these rounded forms have counterparts among the square and polygonal vases which are made in moulds or built up by the difficult process of joining together flat bats of clay. The square vases made by the latter method were a source of much trouble to the potters owing to the danger of imperfect jointing or of warping in the kiln. Fig. 1 of Plate 104 illustrates an effective type of the square vase with gracefully tapering body, the four sides of which are so often appropriately decorated with the flowers of the four seasons. Occasionally the angles are flattened, giving an irregular octagonal form. Another form selected for sumptuous decoration is the square vase with pendulous body and two dragon handles figured on Plate 97; and another is the arrow stand and square tube with deeply socketed stand and railed border (Plate 118).

The pilgrim bottle supplies an effective model with a flattened circular body, small neck and foot, and loops on the periphery to carry a cord. These loops tended to disappear when the form had lost its first significance and was only regarded as a vase.

The list of Imperial wares made in the reign of T'ung Chih includes vases for divining rods of square form with low round neck and base, ornamented with *pa kua* designs in relief; vases with apricot medallions and tubular handles like Fig. 1 of Plate 123. Other familiar types are the bag-shaped vases with the mouth tied with silk, melon

[1] A less usual variety has the ovoid body actually surmounted by a beaker.
[2] See Bushell, *O. C. A.*, p. 797.

and gourd forms, and the vase shaped like a double fish erect on its tail or a single fish rising from waves.

To quote a few of the types named in the *T'ao shuo* [1] :—" For holding flowers there are vases from two or three inches to five or six feet high, round like a *hu*, round and swelling below like a gall-bladder (*tan*), round and with spreading mouth and contracted below like a *tsun*, with flat sides and full angles like a *ku*, upright like bamboo joints, square like a corn measure (*tou*), with contracted mouth and flattened sides, with square and round flutings, and cut in halves with flat backs for hanging on walls."

For pot-pourri and for fragrant flowers to perfume the rooms various covered jars were provided, hanging vases with reticulated sides (Plate 114), and boxes with perforated covers. For growing plants there were deep flower pots and shallow bulb bowls, and the large and small fish bowls were used for growing water-lilies as well as for keeping gold-fish; and shallow bowls were apparently used as arenas for fighting crickets.[2] As for the vessels in which the crickets were kept, various suggestions have been made in reference to the " cricket pots " mentioned in Chinese books, and the name is sometimes given to reticulated vases and boxes; but we are told that the cricket prefers a damp dwelling, and that their pots were consequently made as a rule of absorbent earthenware. There is a snuff bottle decorated with crickets in the British Museum, and one is represented perched on an overturned pot from which he has apparently escaped, the lid having fallen off. This pot is of ordinary ovoid jar form apparently ornamented with incised fret pattern.

The apparatus of the library table is peculiarly Chinese; and as calligraphy and painting were regarded as among the highest accomplishments, so the potter lavished on the implements of the writer his most ingenious fancies and his most beautiful workmanship. There were porcelain handles for the pencil brush called *pi kuan*; a brush rest (*pi ko*) of many fanciful forms (see Fig. 3 of Plate 60) of which a miniature range of hills was the commonest; a bed (*pi ch'uang*) for it to lie down on, and a cylindrical jar (*pi t'ung*) for it to stand up in; vessels called *hsi* to wash it in, usually of shallow bowl form or shaped like crinkled lotus leaves or in some such dainty design. There were rests for the writer's wrist and paper weights of fantastic form. For the ink (*mo*), there is the pallet (*mo yen*) for rubbing (Plate 94, Fig. 2), and a bed

[1] See Bushell's translation, op. cit., p. 4. [2] See Bushell, *O. C. A.*, p. 489.

for the ink-cake (*mo ch'uang*), a screen (*yen p'ing*) behind which it was rubbed, small water pots (*shui ch'êng*) in innumerable shapes and served by a tiny ladle, and water droppers (*shui ti*) of quaint and ingenious designs.[1] There were rollers for picture scrolls (*hua chou*) with porcelain ends, and stands for books in the form of small elegantly shaped tables with three or four legs often beautifully painted in enamels on the biscuit.

With these is the incense-burning apparatus which consists of incense box (*hsiang ho*), the vase to hold the tiny tongs and shovel used for the charcoal and incense, and the urn or burner (*shao hsiang lu*). The last appears in very varied shapes, of which the most usual is the tripod cauldron (*ting*) with upright ear-handles. Others take the purely fantastic form of figures of animals, birds and even human beings with open mouth or nostrils to emit the smoke. Tiny vases for a single flower are usually placed upon the writing table, the furniture of which is completed by seals (*yin*), which are commonly modelled after Han dynasty jades with handles in form of camels, tortoises, dragons, tigers, etc., and small boxes to contain the seal vermilion (*yin sê ch'ih*).

Other porcelain objects which combined use and ornament were plaques (*pan*) for screens and slabs for inlaying in pillows, beds, couches and verandah partitions; actual pillows of oblong or semi-circular shape with concave surface, the inside hollow and capable of being filled with fragrant herbs; bowls, shaped like the Buddhist alms bowl, for holding black and white chess pieces, and the other requisites for chess (*wei-ch'i*) or *gô*.

With regard to the plaques, we learn that the Emperor Shun Chih gave an order in 1659 for oblong plaques 3 feet by 2½ feet and 3 inches in thickness, but these like the large fish bowls were beyond the powers of the potters at that time. Indeed Père d'Entrecolles tells us that in 1712, the date of his first letter,[2] the potters had much difficulty in executing the orders given by the European merchants for plaques for table tops, etc., and that the largest practicable size was only about a foot square. No advantage was obtained by giving them additional thickness to prevent the fatal warping in the kiln, and it was found better to make the two faces

[1] Among others is the "tantalus cup," with a small tube in the bottom concealed by a figure of a man or smiling boy. When the water in the cup reaches the top of the tube it runs away from the base.

[2] Loc. cit., p. 204.

in separate slabs united by cross pieces. Bushell points out that these double plaques were frequently sawn apart and mounted in screens, etc., as separate panels. The complete plaque is usually decorated on one side with a figure subject and on the other with flowers.

We should mention also among miscellaneous objects the beautiful hanging lanterns of egg-shell thinness or perforated in openwork patterns ; the barrel-shaped garden seats ; the curious hat stands, a sphere on top of a tall stem or a little box mounted on long curved legs, the top in either case being hollow and perforated to hold perfumes or ice or charcoal according to the season ; boxes of all kinds ; small personal ornaments such as hair-pins, ear-rings, girdle-clasps, rosary beads, thumb rings, finger-nail covers, tubes for mandarin feathers, buttons and pendants ; the little bottles or flasks originally intended for drugs but afterwards consecrated to snuff when the Spaniards or Portuguese had introduced the tobacco plant into China at the end of the sixteenth century ; and finally the ornamental heads of opium pipes made chiefly in pottery.

For household use the *T'ao shuo* enumerates rice spoons, tea spoons (*ch'a shih*), sets of chop sticks, vessels for holding candle snuffs, wax pots, vinegar droppers, washing basins (*tsao p'ên*), pricket candle sticks (*têng ting*), pillows (*chên*), square and round, tubs (*p'ên ang*), jars (*wêng*) with small mouth, alms bowls (*po*) with globular body and contracted mouth, plates (*tieh*), and bowls (*wan*) ; and for tea and wine parties and dinner services, tea pots, wine vessels, bowls, and dishes of every sort.

Bowls (*wan*) are found in many sizes and shapes, the commonest being the small rice bowl ; the shallower type was used for soup (*t'ang wan*). There are deep bowls with covers which might almost be described as jars, and there are tea bowls with covers used for infusing tea in the absence of a tea pot. In drinking from these it was usual to tilt the cover very slightly so as to leave only a narrow egress for the tea and to prevent the leaves accompanying it.

When a tea pot was used, the liquid was served in a tea cup (*ch'a chung*) of tall upright form without handle [1] or cover. The Chinese

[1] The cup with handle was made in the tea services for the European market, but the handle is not, as has been sometimes asserted, a European addition to the cup. Cups with handles were made in China as early as the T'ang dynasty (see Plate 11, Fig. 2) ; but for both wine and tea drinking the Chinese seem to have preferred the handleless variety.

cup is not furnished with a saucer in European style, but there are straight-edged trays which serve a similar purpose, holding one or more cups, and the old tea bowls and wine cups used to be provided with a circular stand with hollow ring in which the base of the cup could be inserted. The tea pot itself does not seem to be older than the Ming dynasty, and before that time tea bowls only had been used, the vessels with spouts and handles being reserved for wine and other liquids.

A tiny bowl is the usual form of wine cup, but beside these there are goblets with deep bowl, and the shallow-bowled *tazze* with high stems, like the early Ming "stem cups." For ceremonial purposes, the wedding cups and libation cups were shaped after bronze ritual vessels or rhinoceros horn cups; and wine cups for ordinary use sometimes take the ornamental form of a lotus leaf or a flower. The commonest form of wine ewer is the Persian type with pear-shaped body, long graceful handle and spout. Others take fanciful forms like that of a peach or aubergine fruit, a gourd or melon. The peach-shaped ewer with opening under the base is the original of our Cadogan tea pot, and we need be surprised at nothing in Chinese art when we find this same principle and practically the same form in a ewer of T'ang date in the Eumorfopoulos collection. The tall cylindrical ewers with body jointed like a bamboo, and the front shaped at the top like a tiara, are used for sweet syrups.

The Chinese dish is for the most part saucer-shaped. When over half a foot in diameter it is called *p'an*, the smaller dishes or platters being named *tieh*. There are large dishes for fragrant fruits to perfume the room, and lotus-leaf shaped dishes for sweetmeats and various small trays of fanciful form for the dinner table; and there are the "supper sets" consisting of a varying number of ornamental trays which can be used separately, or joined together to form a pattern suggesting a lotus or some other many-petalled flower.

In addition to the native Chinese forms there is a host of specialised objects made for export and designed in foreign taste; such as the deep bowls with pagoda covers for Siam; weights to hold down the corners of a mat for India, in form like a door knob mounted on a circular base; narghili bowls and ewers for Persia, besides the bottle-shaped pipes with mammiform mouthpieces, which sometimes take animal or bird forms such as those of the elephant or

phœnix; round covered dishes for Turkey; and all the familiar objects to meet European requirements. The sets of five vases (three covered jars and two beakers) are a purely European garniture intended for the mantelpiece or the sideboard.

There are, besides, all manner of figures—human, animal, or mythical—but they belong rather to the chapter on ornamental motives.

CHAPTER XVII

MOTIVES OF THE DECORATION

CHINESE decoration, its motives and its meaning, might form the subject for a substantial and very interesting volume. But it can only be treated here in a summary fashion by enumerating a few of the motives which occur most frequently in porcelain. The designs on the earlier wares have already been discussed in the chapters dealing with the Ming and the preceding periods, but in view of the conservatism of the Chinese artists a certain amount of repetition will be inevitable in discussing the ornament of the Ch'ing dynasty porcelain.

If we except some of the hybrid designs on the export wares which were made for people unfamiliar with Chinese thought, we may assume that there is a meaning in all Chinese decoration apart from its ornamental intention; and this applies not only to the central motives but also as a rule to the subsidiary ornament such as borders and formal patterns. Consequently it is clear that a study of this inner meaning is a necessary condition for the full appreciation of the decorated porcelain.

Figure subjects and symbolical ornaments probably require the most explanation for the Western student; but unfortunately the former are often so difficult to identify that we have to be content with general headings such as court scenes, military scenes, dramatic subjects, illustrations of romance, etc. Possibly to the unusually well-read native most of these scenes would recall some known story, but the European can only hope to identify one here and there by a lucky chance. He can, of course, take a book of Chinese legends and by the exercise of a little imagination find a story for every scene; but such methods are not to be recommended, and it is infinitely preferable to give the design no label at all unless the identification is fully established. That at least leaves the question open.

These scenes from history and romance were favourite subjects

Fig. 1

Fig. 2

Plate 133. – Late *famille rose* Enamels.

Fig. 1.—Bowl painted in soft enamels, attendants of Hsi Wang Mu in boats.
Mark, *Shên tê t'ang chih.* Tao Kuang period. Diameter 6⅞ inches. *British
Museum.* Fig. 2.—Imperial Fish Bowl with five dragons ascending and
descending, borders of wave pattern, *ju-i* pattern, etc., *famille rose* enamels.
Late eighteenth century. Height 20 inches. *Burdett-Coutts Collection.*

Fig. 1 Fig. 2 Fig. 3

Fig. 4 Fig. 5

Plate 134.—Porcelain Snuff Bottles. Eighteenth Century.

British Museum.

Fig. 1.—Subject from the drama, black ground. Yung Chêng mark. Height 2¾ inches. Fig. 2.—Battle of demons, underglaze blue and red. Mark, *Yung-lo t'ang.* Height 3¾ inches. Fig. 3.—Blue and white "steatitic" ware. Height 2½ inches. Fig. 4.—Crackled cream white *ting* glaze, pierced casing with pine, bamboo and prunus. Height 3¼ inches. Fig. 5.—"Steatitic" ware with Hundred Antiques design in coloured relief. Chia Ch'ing mark. Height 2½ inches.

with the K'ang Hsi decorators of blue and white and *famille verte* porcelains. To instance a few types : the scene of the half-legendary Yao with his cavalcade coming to greet the Emperor Shun who is engaged, like the Roman Cincinnatus, in ploughing ; the episodes of the three heroes of the Han dynasty, Chang Liang, Ch'ên P'ing and Han Hsin[1] ; the heroes of the romantic period of the Three Kingdoms (221—265 A.D.) whose stories may be compared with those of our knights of the Round Table ; the stories of brigands in the reign of Hui Tsung of the Sung dynasty.[2] The story of Su Wu, the faithful minister of Han Wu Ti, tending cattle in captivity among the Hiung-nu, is depicted on a bowl in the British Museum, and a dish in the same collection shows an emperor (perhaps Kao Tsu, the first of the T'ang dynasty) surrounded by his captains.

Processional scenes and subjects illustrating the life and customs of the times, peaceful domestic scenes with interiors of house or garden peopled by women and children, are more common in the *famille rose* period when the warlike tastes of the Manchus had already been softened by a long period of peace. A civil procession and a military procession sometimes balance each other on two vases, the one being the *wên p'ing* (civil vase), and the other the *wu p'ing* (military vase). A mock dragon-procession formed by children at play is a not uncommon motive. Indeed playing children (*wa wa*) have been from the earliest times a subject frequently and most sympathetically depicted on Chinese porcelain. A historical child-scene is that in which the boy Ssǔ-ma Kuang broke the huge fish bowl with a stone to let out the water and save his drowning companion.

There are many motives intended to appeal to the Chinese literatus, and specially suited to ornament the furniture of the writing table. Symposia of literary personages, for instance, make an appropriate design for a brush pot, or again, the meeting of the celebrated coteries, the Seven Worthies of the Bamboo Grove who lived in the third century, and the worthies of the Orchid Pavilion, including the famous calligrapher, Wang Hsi-chih, who met in the fourth century to drink wine, cap verses, and set their cups floating down the " nine-bend river " (see Plate 104, Fig. 1). The Horace

[1] When the names are known the incidents can usually be found in such works of reference as Mayers' *Chinese Reader's Manual*, Giles's *Chinese Biographical Dictionary*, and Anderson's Catalogue of Chinese and Japanese Pictures.

[2] Told in the *Shui Hu Chuan;* see *O. C. A.*, p. 570, a note in Bushell's excellent chapter on Chinese decorative motives, of which free use has been made here.

of China, Li T'ai-po, the great T'ang poet, is represented in drunken slumber leaning against an overturned wine jar or receiving the ministrations of the Emperor and his court. He also figures among the Eight Immortals of the Wine Cup, a suitable subject for an octagonal bowl. Poets, painters, and sages are often seen in mountain landscapes contemplating the beauties of Nature ; two sages meeting on a mountain side is a frequent subject and is known as the " happy meeting," or again, it is a single sage, with attendant carrying a bowl, book, and fan, or sometimes bringing an offering of a goose. In rare instances these figures can be identified with Chinese worthies such as Chiang Tzŭ-ya, who sits fishing on a river bank, or Chu Mai-ch'ên, the wood-cutter, reading as he walks with his faggots on his back.

The stories of the *Twenty-four Paragons of Filial Piety* provide a complete series of popular subjects, which may be seen in the panels of Plate 91, Fig. 3. Women are represented by the Virtuous Heroines ; by celebrated beauties such as Yang Kuei-fei, consort of the T'ang ruler Ming Huang,[1] and Hsi Shih, the Chinese Delilah who was the undoing of Fu Ch'ai, prince of Wu, in the fifth century B.C. ; by the poetess Tan Hui-pan, and by a hundred nameless figures which occur in genre designs, and by the idealised beauties, *mei jên* (graceful ladies), which the Dutch ungallantly dubbed with the name of *lange lijsen* or long Elizas. The domestic occupations of a lady form another series of subjects for polygonal vessels ; and women are sometimes seen engaged in the Four Subjects of Study—Poetry, Rites, History, and Music—or in the Four Liberal Accomplishments —Writing, Painting, Music, and Checkers—but the groups who make up these scenes are more often composed of men. The game of checkers or *gô*, which is so often loosely rendered chess,[2] is *wei ch'i* the " surrounding game," a favourite Chinese amusement, which figures in two well-known subjects of porcelain decoration. One of these is the legend of Wang Chih, the Taoist patriarch, watching the game played by two old men, the spirits of the Pole Stars, in a mountain retreat ; the other is the story of the general Hsieh An, who refused to allow the news of an important victory to disturb his game.

[1] A not uncommon subject is the meeting of a young horseman with a beautiful lady in a chariot, and it has been suggested that this may be the meeting of Ming Huang and Yang Kuei-fei ; but the identification is quite conjectural.

[2] Another game, *hsiang ch'i* (elephant checkers), is far nearer to our chess.

Ladies of the court picking lotus flowers from boats on an ornamental lake in the presence of the Emperor and Empress represent the annual Lotus Fête at Peking, and there are numerous scenes in the Imperial pleasure grounds in which bevies of ladies from the harem are depicted.

The Eight Ambassadors of the Tribes of Man, the barbarian nations from the eight points of the compass, form a processional subject suitable for the exterior of bowls and cups. The ambassadors are grotesquely drawn figures, sometimes mounted on strange beasts, and carrying gifts as tribute to the Emperor. Dreams and visions are depicted in the usual Oriental manner by a cloud issuing from the dreamer's head and expanding into a scene which represents the subject of the dream. Thus the youthful scholar is seen asleep with a vision of his future dignity floating above his head. Divine apparitions are differentiated by the presence of clouds around or below the main figures.

Deities and deified mortals are favourite subjects for porcelain decoration as well as for figures and groups modelled in the round. The three principal Chinese religions—Confucianism, Buddhism, and Taoism—exist side by side with perfect mutual toleration. Indeed the principles of the one are in many cases incorporated in the others. Buddhist and Taoist emblems are freely mingled in decorative art, and the three founders—Confucius, Buddha, and Lao-tzǔ—are grouped together in friendly conversation or examining a scroll on which is drawn the Yin-yang symbol of the duality of Nature.[1]

Confucianism is the religious or rather philosophical system officially recognised in China, but its adherents are chiefly among the literati. Though it inculcates ancestor-worship, it is not in itself concerned with an after life, and it contains few romantic superstitions calculated to fire the popular imagination or to suggest motives for decorative art. Confucius himself is frequently represented both in painting and sculpture, and his meeting with Lao-tzǔ is familiar in pictorial art. Confucianism recognises certain canonised mortals, the logical outcome of ancestor-worship, and among these the best known in art is Kuan Yü, a warrior famous at the end of the Han dynasty, who was not, however, canonised until the Sung period, and only in 1594 raised to the rank of a god (of War) under the title

[1] A group of five old men similarly employed represents the *wu lao* (the five old ones), the spirits of the five planets.

of Kuan Ti. It is reasonable to suppose that most of the numerous statuettes of this popular deity were made after the latter date. He is usually represented as a dignified personage with flowing beard seated in full armour with right hand raised in a speaking attitude ; but he figures also on horseback or beside his charger, and with his faithful squires—Chou Ts'ang, who carries a halberd, and Kuan P'ing, his own son. Occasionally he is seen seated with a book in his hand, in which case he is regarded as a literary rather than a military power.

The gods of Literature have a very large following in China, where scholarship has been the key to office for upwards of two thousand years, the chief deity of the cult being Wên Ch'ang, or in full, Wên Ch'ang ti chün. He is the star god who resides in one of the groups of the Great Bear, a dignified bearded figure in mandarin dress seated with folded hands or mounted on a mule. A lesser but more popular divinity is the demon-faced K'uei Hsing, who was canonised in the fourteenth century. Originally a scholar, who though successful in the examinations was refused office on the ground of his preternatural ugliness, he threw himself in despair into the Yangtze and was carried up to heaven on a fish-dragon. He is easily recognised as a demon-like person, poised with one foot on the head of a fish-dragon (*yü lung*) which is emerging from waves. He brandishes triumphantly in his hands a pencil brush and a cake of ink.[1] The fish-dragon is itself a symbol of literary aspiration, from the legend that when the salmon come every year up the river to the famous falls of Lung-mên (the dragon gate), those which succeed in leaping up the falls are transformed into fish-dragons. This metamorphosis of the fish as it emerges from the water into the dragon is a favourite motive for porcelain decoration.

Buddhism, which was officially recognised in China by the Emperor Ming Ti in 67 A.D., had a far-reaching influence over the arts of sculpture and painting, and the revolution which it worked in the greater arts was naturally reflected in the lesser handicrafts. Buddhistic motives appear early in the Chinese pottery, and in the period with which we are at present concerned, the Buddhist religion supplied a great number of motives for the porcelain painter and the figure modeller. Sakyamuni himself is depicted or sculptured in various poses : (1) As an infant standing on the lotus and proclaiming

[1] Chang Kuo Lao, the Taoist Immortal, is also regarded as one of the gods of Literature ; see p. 287.

his birth; (2) as an ascetic returning from his fast in the mountains; (3) seated cross-legged on a lotus throne with right hand raised in teaching attitude, the most frequent representation; (4) recumbent on a lotus pillow, in Nirvana; (5) in the Buddhist Trinity holding the alms bowl or patra between the Bodhisattvas Manjusri and Samantabhadra. These two last when represented singly are usually mounted, Manjusri on a lion, and Samantabhadra on an elephant.

But by far the most popular figure of the Buddhist theogony in China is Kuan-yin, the Compassionate, and Kuan-yin, the Maternal; in the latter capacity she holds a child in her arms and displays a wonderful likeness to our images of the Virgin. But a full account of her has been given on p. 110, and need not be repeated. Next in popularity perhaps is the jolly monk with the hempen bag, Pu-tai Ho-shang, a semi-nude, corpulent person, with smiling face, and a large bag full of the " precious things." He is also a great favourite in Japan, where he is known as Hotei, and worshipped as the god of Contentment. By the Chinese he is also regarded as Mi-lo Fo, the Maitreya or coming Buddha, and he has been added by them to the list of Arhats or apostles of Buddha. He is often represented surrounded by playful children to whom he is devoted.

The Arhats, or Lohan, are all known by their several attributes, but in porcelain decoration they usually appear in groups consisting of the whole or a large part of their number, which, originally sixteen, was increased in China to eighteen by the inclusion of Ho-shang and Dharmatrata. The latter is a long-haired individual who carries a vase and a fly whisk in his hands and a bundle of books on his back while he sits gazing at a small image of Buddha.

He is not to be confused with Tamo, the Indian Bodhidharma, the first Chinese patriarch, who came to Lo-yang and remained there in contemplation for nine years. The legend is that after his death (about 530 A.D.) he was seen returning to India wrapped in his shroud and carrying one shoe in his hand, the other having been left behind in his tomb. This is the guise in which he frequently appears in art (Plate 86), and he is often depicted crossing the Yangtze on a reed.

Many of the symbolical ornaments on porcelain have a Buddhistic significance, such as the eight emblems (see p. 298), the crossed

dorjes or thunderbolts of Vajrapani,[1] the Buddhist jewel in a leaf-shaped halo of flames ; and Sanskrit characters of sacred import are used as decoration for bowls and dishes, made no doubt for the use of the faithful. The principal animals associated with Buddhist designs are the elephant, who carries the jewel vase on his back, the white horse (*pai ma*), who brought the Buddhist scriptures across the desert from India, the hare, who offered himself as food to Buddha, and the Chinese lion who, under the name of the " dog of Fo " (Buddha), acts as guardian of Buddhist temples and images.

But the religion which has taken the greatest hold on Chinese imagination and which consequently has supplied the largest number of motives for their decorative art is undoubtedly Taoism. As originally taught by Lao-tzŭ, a contemporary of Confucius, in the sixth century B.C., the doctrine of Tao (the Way) pointed to abstraction from worldly cares and freedom from mental perturbation as the highest good. But just as the later but closely analogous doctrine of Epicurus degenerated into the cult of pleasure, so the true teaching of Lao-tzŭ was afterwards lost among the adventitious beliefs and superstitions which were grafted on to it by his followers. The secret of transmuting metals into gold and of compounding the elixir of life became the chief preoccupations of the Taoist sages, the latter quest appealing particularly to the Chinese with their proverbial worship of longevity ; and a host of legends grew up concerning mortals who won immortality by discovering the elixir, about fairies and the denizens of the Shou Shan or Hills of Longevity, about the Isles of the Blessed and the palace of Hsi Wang Mu in the K'un-lun mountains. It is this later and more popular phase of Taoism which figures so largely in porcelain decoration.

Lao-tzŭ is represented as a venerable old man with bald, protuberant forehead, who rides upon an ox, the same in features as the god of Longevity, Shou Lao, who is in fact regarded as his disembodied spirit. Shou Lao, however, is more commonly shown enthroned upon a rocky platform in the Hills of Longevity, holding in one hand a curious knotted staff, to which are attached rolls of writing, and in the other a peach, and surrounded by his special attributes, the spotted deer, the stork, and the *ling chih* fungus.

[1] Vajrapani is one of the gods of the Four Quarters of the Heaven, who are guardians of Buddha. They are represented as ferocious looking warriors, sometimes stamping on prostrate demon-figures. As such they occur among the T'ang tomb statuettes, but they are not often represented on the later porcelains.

Thus seated he receives homage from the Eight Immortals and the other Taoist genii or *hsien*, who are as numerous as the fairies of our countryside. Other designs represent Shou Lao riding on a deer or flying on the back of a stork, or simply standing with his staff and peach, his robes embroidered with seal forms of the character *shou* (longevity). In this last posture he is often grouped with two other popular deities, one in mandarin robes and official hat holding a *ju-i* sceptre, which fulfils every wish, and the other also in official robes but holding a babe who reaches out for a peach in his other hand. Together they form the Taoist triad, Shou-hsing, Lu-hsing, and Fu-hsing, stargods (*hsing*) of Longevity, Preferment, and Happiness. Fu-hsing in addition has sometimes two boy attendants carrying respectively a lotus and a hand-organ.

The Eight Taoist Immortals (*pa hsien*) are :—

1. Chung-li Ch'üan, also known as Han Chung-li, represented as a fat man, half-draped, who holds a *ling chih* fungus in one hand and a fly-whisk or fan in the other.

2. Lü Tung-pin, a figure of martial aspect armed with a sword to slay dragons and evil spirits. He is the patron of barbers.

3. Li T'ieh-kuai, Li with the iron crutch, a lame beggar with a crutch and pilgrim's gourd from which issue clouds and apparitions. He is patron of astrologers and magicians.

4. Ts'ao Kuo-ch'iu, in official robes, wearing a winged hat, and carrying a pair of castanets. He is patron of mummers and actors.

5. Lan Ts'ai-ho, of uncertain sex, carrying a hoe and a basket of flowers. Patron of gardeners and florists.

6. Chang Kuo Lao, the necromancer with the magic mule, of which he kept a picture folded up in his wallet. He would make the beast materialise from the picture by spurting water on to it ; and at other times he would conjure it out of a gourd. His attribute is a musical instrument consisting of a drum and a pair of rods. He is patron of artists and calligraphers, and ranks as one of the gods of Literature

7. Han Hsiang Tzŭ, who gained admission to the Taoist paradise and climbed the peach-tree of Immortality. He is shown as a young man playing on a flute, and is specially worshipped by musicians.

8. Ho Hsien Ku, a maiden who wears a cloak of mug-wort leaves and carries a lotus. She is patroness of housewives.

The Immortals are commonly represented in a group paying court to Shou Lao, or crossing the sea on the backs of various strange creatures or other supernatural conveyances on their way to the Islands of Paradise. Grouped in pairs they lend themselves to the decoration of quadrangular objects.

Other frequenters of the Shou Shan are the twin genii [1] of Union and Harmony (*ho ho êrh hsien*), an inseparable pair, depicted as ragged mendicants with staff and broom, or as smiling boyish figures, the one with a lotus and the other holding a Pandora box of blessings, from which a cloud is seen to rise ; Tung-fang So, who stole the peaches of Hsi Wang Mu and acquired thereby a longevity of nine thousand years, is represented as a smiling bearded old man, not unlike Shou Lao himself, carrying an enormous peach, or as a boy with a peach to recall his youthful exploit. Liu Han, with his familiar three-legged toad, a wild-looking person, who waves a string of cash in the air, and very closely resembles the Japanese Gama Sennin (the Hou Hsien Shêng of China); Wang Tzǔ-ch'iao, who rides on a crane playing a flute, and Huang An, the hermit, whose steed is a tortoise. The god of Alchemy is figured, according to the identification of a statuette in the Musée Guimet, as a tall, draped person with beard and moustaches flowing down in five long wisps, a leaf-shaped fan in his left hand, and beside him a small figure of a devotee who holds up a book with questioning gesture.

The Queen of the Genii is Hsi Wang Mu (Queen Mother of the West). Her home is in the K'un-lun mountains, and the peach tree of Longevity grows in her gardens. In the tenth century B.C., the Emperor Mu Wang is reputed to have visited her palace, and the reception forms a pleasing subject for the artist, as does also her return visit paid to the Emperor Wu Ti of the Han dynasty. She also figures frequently on porcelain with her fair attendants crossing the sea on a raft, flying on the back of a phœnix or standing with a female attendant who carries a dish of peaches. Her messengers are blue-winged birds like the doves of Venus, who carry the fruit of longevity to favoured beings. With her attendant phœnix she presents a strong analogy with Juno and her peacock ; and her Western habitat has favoured the theories which would connect her with Græco-Roman mythology, though her consort Hsi Wang Fu (King Father of the West and a personage obviously invented

[1] The Kanzan and Jitoku of Japanese lore.

ad hoc) is quite insignificant and has nothing in common with the cloud-compelling Jove.

There is a female figure which is scarcely distinguishable from one of the attendants of Hsi Wang Mu on the one hand and from Lan Ts'ai-ho on the other. This is the Flower Fairy (*Hua hsien*) who carries a basket of flowers suspended from a hoe. And there are besides numerous magicians of more or less repute, such as Chang Chiu-ko, who is seen transforming pieces cut from his scanty garments into butterflies; and a host of nameless *hsien* of local fame who figure in mountain retreats, such as the *Ssŭ hao* or four hoary hermits.[1]

The animals connected with Taoist lore include the eight fabulous horses of Mu Wang which brought him to the palace of Hsi Wang Mu. They are usually seen at pasture frisking about in wild gambols. The deer, the familiar of Shou Lao, is depicted usually with a *ling chih* fungus in his mouth; the toad and hare live in the moon where they pound the elixir of immortality; and the tortoise develops a long bushy tail after a thousand years of existence. All these are suggestive of longevity, as is also the crane and a number of flowers, fruits and trees such as the pine, bamboo and prunus (the three friends), the chrysanthemum, the willow, the peach, the gourd, and more especially the *ling chih* fungus, the *polyporus lucidus*, which was originally an emblem of good luck, but afterwards of longevity.

The head of the *ling chih* closely resembles [2] that of the familiar *ju-i* sceptre which grants every wish, an auspicious object commonly seen in the hands of Taoist genii; and the same form occurs in a decorative border (see Plate 77, Fig. 2) which is variously known as the *ju-i* head border, the *ju-i* cloud border, or the cloud-scroll border, the conventional cloud being commonly rolled up in this form. It will also be found that formal ornaments, pendants and lambrequins often take the form of the *ju-i* head in Chinese decoration.

The attributes of the Eight Immortals occur among the many

[1] See *Catalogue of the Pierpont Morgan Collection*, vol. i., p. 156.

[2] Indeed it is likely that the modern *ju-i* head derives from the fungus. The *ju-i* 如意 means " as you wish " or " according (*ju*) to your idea (*i*)," and the sceptre, which is made in all manner of materials such as wood, porcelain, lacquer, cloisonné enamel, etc., is a suitable gift for wedding or birthday. Its form is a slightly curved staff about 12 to 15 inches long, with a fungus-shaped head bent over like a hook. On the origin of the *ju-i*, see Laufer, *Jade*, p. 335.

symbols used in porcelain ornament ; and among the landscapes will be found the gardens of Hsi Wang Mu and Mount P'êng-lai,[1] one of the three islands of the blessed, situated in the ocean east of China. Here the fountain of life flows in a perpetual stream : " the pine, the bamboo, the plum, the peach, and the fungus of longevity grow for ever on its shores ; and the long-haired tortoise disports in its rocky inlets, and the white crane builds her nest on the limbs of its everlasting pines." [2] Presumably, too, the Shou Shan is situated on this delectable island ; and perhaps also the heavenly pavilion (t'ien t'ang), which appears among clouds as the goal to which a crane is often seen guiding some of the Taoist genii. Possibly, too, the conventional border of swirling waves punctuated by conical rocks carries a suggestion of the rocky islands of paradise rising from the sea.

Fig. 1.—The Yin-yang and Pa-kua

There are besides many primitive beliefs traceable for the most part to Nature-worship, which prevailed in China long before the days of Confucius, Lao-tzŭ or Buddha. Some of these have been incorporated in the later religious systems, especially in that of Taoism, which was ready to adopt any form of demonology. The oldest system is that expounded by the legendary Fu Hsi, in which the phenomena of Nature were explained by reference to the mystic diagrams revealed to him on the back of a dragon horse (lung ma) which rose from the Yellow River. These are the pa-kua or eight trigrams formed by the permutations of three lines, broken and unbroken, as in Fig. 1. A more common arrangement of them is according to the points of the compass, and enclosing another ancient device, the Yin-yang, a circle bisected by a wavy line, which symbolises the duality of Nature, yin being the female and yang the male element.

Demons abound in Chinese superstitions, and the demon face appears early in art on the ancient bronzes, from which it was some-times borrowed by the porcelain decorator. This is the face of the t'ao t'ieh (the gluttonous ogre) supposed originally to have repre-sented the demon of the storm, and as such appropriately appear-ing against a background of " cloud and thunder " pattern, as the

[1] The Japanese Mt. Horai. [2] See Hippisley, *Catalogue*, op. cit., p. 392.

key-fret is called by the Chinese. Afterwards the *t'ao t'ieh* seems to have been regarded, on homœopathic principles, as a warning against greed. Demons also appear in complete form in certain battle scenes and conflicts, such as the combat of the demons of the water and of air which proceeds in front of a group of Chinese dignitaries seated in the Kin-shan temple on the Yangtze river (see Plate 134, Fig. 2).

The sky and the stars of course contribute their quota of divinities. Beside the Taoist star-gods of Longevity, Honours and Happiness, there is the Jade Emperor or supreme lord of the universe, Yü wang shang ti, who is represented in mandarin dress holding a *ju-i* sceptre and closely resembling Lu Hsing, the star-god of Honours. There is, too, the goddess of the Moon with a butterfly ornamenting the front of her robes, and a mirror in her right hand, besides the other denizens of the moon—Liu Han, the moon-hare and the moon-toad. A cassia tree also grows in the moon, and the " cassia of the moon " is a symbol of literary success.

The Sun is represented as a disc on which is a three-legged bird ; and it is probable that the sun-disc is represented also in the so-called " pearl " [1] which is pursued or grasped by dragons ; but this idea of the power of the storm threatening the sun was lost sight of in later art, and " a dragon pursuing a pearl " was considered a sufficient description of the motive. A curious scene depicting a mandarin shooting arrows at a dog in the sky alludes to the dog who devours the sun and so causes the eclipse.

The zodiacal animals are named on p. 211 (vol. i), and the four points of the compass are symbolised by the azure dragon for the East, the white tiger for the West, the black tortoise for the North, and the red bird for the South. The romance of two stars is embodied in the story of the Spinning Maiden (*Chih Nü*) and her lover, the Cowherd (*Ch'ien Niu*), who are separated for all the year save on one night when the " magpies fill up the Milky Way and enable the Spinning Damsel to cross over."

Chang Ch'ien, the celebrated minister of Han Wu-ti, was one of the first great travellers of China, and among the legends which grew around his exploits is one which makes him ascend the Milky Way and meet the Spinning Damsel herself. This story arose because he was reputed to have discovered the source of the Yellow River, which had hitherto been supposed to rise in heaven, being in fact a

[1] The Buddhist pearl or jewel, which grants every wish.

continuation of the Milky Way. Chang Ch'ien is sometimes represented in Chinese art as floating on a log-raft on the Yellow River, and carrying in his hand a shuttle given to him by the Spinning Maiden.[1] The poet Li T'ai-po is also figured in the same kind of craft, but he is distinguished by a book in place of the shuttle.

Motives borrowed from the animal world are frequent on porcelain, though they represent to a large extent mythical creatures, first and foremost of which is the dragon. We need not enter into the conflicting theories as to the origin of the Chinese dragon. Whether he sprang from some prehistoric monster whose remains had come to light, or was evolved from the crocodile, he appears in any case to have belonged to Nature-worship as the power of the storm and the bringer of fertilising rain. There, are, however, various kinds of dragons—those of the air, the sea, the earth—and the monster takes many different forms in Chinese art. The archaic types borrowed by the porcelain decorators from ancient bronzes and jades are the *k'uei lung* 夔龍 or one-legged dragon, and the *ch'ih lung* 螭龍, the former a tapir-like creature which is said to have been, like the *t'ao t'ieh*, a warning against greed,[2] the latter a smooth, hornless reptile of lizard-like form with divided tail, who is also described as a *mang*.

But the dragon (*lung*) *par excellence* is a formidable monster with " bearded, scowling head, straight horns, a scaly, serpentine body, with four feet armed with claws, a line of bristling dorsal spines, and flames proceeding from the hips and shoulders." Such is the creature painted by the great master of dragon painting, Chang Sêng-yu, of the sixth century, and as such he is the emblem of Imperial power and the device of the Emperor. The Imperial dragon in the art of the last two dynasties has been distinguished by five claws on each of his four feet [3]; the four-clawed dragon was painted on wares destined for personages of lesser rank. The dragons are usually depicted flying in clouds, and pursuing the disc or pearl, which was discussed above, or rising from waves. Nine dragons form a decoration specially reserved for the Emperor ;

[1] See a rare silver cup depicting this legend, figured in the *Burlington Magazine*, December, 1912.

[2] See W. Perceval Yetts, *Symbolism in Chinese Art*, read before the China Society, January 8th, 1912, p. 3.

[3] Hippisley (op. cit., p. 368), speaking of the various dragons, says that " the distinction is not at present rigidly maintained, and the five-clawed dragon is met with embroidered on officers' uniforms."

and on the palace porcelain the dragon and the phœnix (*fêng*) frequently appear together as emblems of the Emperor and Empress.

The *fêng-huang*,[1] a phœnix-like bird, is usually shown with the " head of a pheasant and the beak of a swallow, a long flexible neck, plumage of many gorgeous colours, a flowing tail between that of an argus pheasant and a peacock, and long claws pointed backward as it flies." It is the special emblem of the Empress. In archaic designs there is a *k'uei fêng* or one-legged phœnix, a bird-like creature terminating in scrolls, which, like the corresponding *k'uei lung*, occasionally appears in porcelain designs. Another bird-like creature scarcely distinguishable from the *fêng* is the *luan*; the former being based, as it is said, on the peacock of India, and the latter on the argus pheasant. Another creature of dual nature is the *ch'i lin*, commonly called the kylin, which consists of the male (*ch'i*) and the female (*lin*). It is in itself a composite animal with the " body of a deer, with the slender legs and divided hoofs; the head resembles that of a dragon, the tail is curled and bushy, like that of the conventional lion, and the shoulders are adorned with the flame-like attributes of its divine nature. It is said to attain the age of a thousand years, to be the noblest form of animal creation, and the emblem of perfect good; and to tread so lightly as to leave no footprints, and so carefully as to crush no living creature." Its appearance was the sign of the coming of a virtuous ruler. It is important to note that the *ch'i lin* is quite distinct from the Chinese lion, and is also to be carefully separated from the other chimera-like creatures known in Chinese art under the general title *hai shou* or sea monsters.

The lion in Chinese art (*shih* or *shih tzŭ*, the Japanese *shishi*), though of qualified ferocity in appearance, is in reality a peaceful, docile creature who expends his energy on a ball of silk brocade, the streamers from which he holds in his massive jaws. In general aspect (Plate 95), in his tufts of hair and his bushy tail, he closely resembles the Peking spaniel, who is in fact called after him the lion dog (*shih tzŭ kou*). He is usually represented in pairs, the one with one foot on a ball of brocade, and the other, presumably the lioness, with a cub. The larger lion figures are placed as guardians by the gates of Buddhist temples, from which function the lion has earned the name of " dog of Fo " (i.e. Buddha); the smaller sizes, usually mounted on an oblong base with a tube attached to hold an

[1] A dual creature, the *fêng* being the male and the *huang* the female.

incense-stick, have a place on the domestic altar. Another mythical creature not unlike the lion is the *pi hsieh* of archaic art which is supposed to ward off evil spirits.[1]

The king of beasts in China is the tiger (*hu*), whose forehead is marked by Nature with the character *wang* 王 (prince). He is the solar animal, the lord of the mountains, and the chief of all quadrupeds. The white tiger represents the western quadrant and the autumn ; and images of tigers in ancient times served many purposes, such as guarding the graves of the dead and summoning the living to battle.

In addition to the sea monsters there are sea horses, who speed at a flying gallop over waves ; and there are the *pai ma* and *lung ma* and the eight horses of Mu Wang, already described, to represent the horse in art. The deer is a Taoist emblem of longevity, and also in its name *lu* suggests the auspicious word *lu* (preferment) ; and there is a fabulous one-horned creature distinct from the *ch'i lin*, and known as the *t'ien lu* or deer of heaven. Rams are sometimes represented as personifying the revivifying powers of spring ; and the monkey occasionally figures in decoration, his name *hou* suggesting another word *hou*, which means to expect (office), and providing an appropriate design for presentation to a candidate in the State examinations. Another motive suitable for the same purpose is the fish leaping from waves, which has been already explained ; and fish in general are cleverly depicted by the porcelain decorators swimming among water plants. The fish has always been a favourite motive in China, and in ancient art it appears to have symbolised power and rank. The double fish is one of the Buddhist emblems, and also symbolises conjugal felicity. The tortoise has already been mentioned among the emblems of longevity.

Birds are drawn with wonderful skill and spirit by Chinese artists, and they provide a frequent motive both for the painter and figure modeller. The crane is the companion of Shou Lao and a symbol of long life ; a pair of mandarin ducks suggest conjugal affection ; egrets among lotus plants, geese, and wild duck in marshy landscapes also pleased the Chinese fancy. The magpie is an emblem of happiness, and two magpies foretell a happy meeting ; the cock is the bird of fame, and he is often associated with the peony, which is the *fu kuei* flower, to suggest the phrase *kung ming* (fame), *fu kuei* (riches and honours !). There are other birds which are associated

[1] See Laufer, *Jade*, pl. 43.

with special trees and flowers; the pheasant is often seen perched on a rock beside the peony and magnolia; partridges and quails go with millet; swallows with the willow; sparrows on the prunus, and so on. A comprehensive group represents the " hundred birds " paying court to the phœnix.

The bat is a symbol of happiness from its name *fu* having the same sound as *fu* (happiness). Among insects, the cicada (at one time regarded as a symbol of life renewed after death) is a very ancient motive; and the praying mantis who catches the cicada is an emblem of courage and perseverance.[1] Fighting crickets are the fighting cocks of China, and supply a sporting motive for the decorator; and butterflies frequently occur with floral designs or in the decoration known as the Hundred Butterflies, which covers the entire surface of the vessel with butterflies and insects.

Flower painting is another forte of the Chinese decorator, and some of the most beautiful porcelain designs are floral. Conventional flowers appear in scrolls, and running designs, especially the lotus and peony scrolls and the scrolls of " fairy flowers," the *pao hsiang hua* of the Ming blue and white. But the most attractive designs are the more naturalistic pictures of flowering plants and shrubs, or of floral bouquets in baskets or vases. The flowers on Chinese porcelain are supple, free, and graceful; and, though true enough to nature to be easily identified, are never of the stiff copy-book order which the European porcelain painter affected at one unhappy period. A long list of the Chinese porcelain flowers given by Bushell includes the orchid (*lan*), rose, jasmine, olea fragrans, pyrus japonica, gardenia, syringa, several kinds of peony, magnolia (*yü lan*), iris, hydrangea, hibiscus, begonia, pink and water fairy flower (*narcissus tazetta*). Many more no doubt can be identified, for the Chinese are great cultivators as they are great lovers of flowers. In fact, the word *hua* 華 flowery is synonymous with Chinese, and *chung hua* 中華 is China. Plate 126 is an example of the Hundred Flower design, known by the French name *mille fleurs*, in which the ground of the vase is a mass of naturalistic flowers so that the porcelain looks like a bouquet.

There are special flowers for the months [2] :—(1) Peach (*t'ao*) for February, (2) Tree Peony (*mu tan*) for March, (3) Double Cherry (*ying t'ao*) for April, (4) Magnolia (*yü lan*) for May, (5) Pomegranate

[1] See Laufer, *Jade*, p. 266.
[2] See Bushell, *Chinese Art*, vol. i., p. 111.

(*shih liu*) for June, (6) Lotus (*lien hua*) for July, (7) Pear (*hai t'ang*) for August, (8) Mallow (*ch'iu k'uei*) for September, (9) Chrysanthemum (*chü*) for October, (10) Gardenia (*chih hua*) for November, (11) Poppy (*ying su*) for December, (12) Prunus (*mei hua*) for January. From these are selected four to represent the seasons—*mu-tan* peony for spring, lotus for summer, chrysanthemum for autumn, and prunus for winter—which supply charming motives for panel decoration or for the sides of quadrangular vases.

The chrysanthemum besides is associated with its admirer T'ao Yüan-ming, and the lotus with Chou Mao-shu and the poet Li T'ai-po. But as a rule the floral designs carry some hidden meaning, the flowers being grouped so as to suggest some felicitous phrase by a play on their names.[1] The peony we have seen to be the *fu kuei* (riches and honours) flower; the chrysanthemum, as Dr. Laufer has suggested, being the flower of the ninth (*chiu*) month, may connote longevity through the word *chiu* (long-enduring); the prunus (*mei hua*) carries the obvious suggestion of *mei* (beautiful), and instances might easily be multiplied.

Among the trees, the cassia suggests literary honours, the willow longevity, as also the pine, bamboo and plum, who are called the " three friends," [2] faithful even in the "winter of our discontent." Among the fruits the gourd is an emblem both of long life and of fertility, and the three fruits (*san kuo*)—peach, pomegranate and finger citron—symbolise the Three Abundances of Years, Sons and Happiness. The orange is a symbol of good luck, and no doubt the others which occur less frequently contain similar suggestions.

Landscape (*shan shui*) is one of the four main divisions of Chinese pictorial art, and it is well represented in porcelain decoration. The Sung and Ming masters provided designs which were freely copied, and views of the beauty spots of China and of the celebrated parks and pleasure grounds were frequently used. It is one of these landscapes which the English potters borrowed for the familiar " willow pattern " design, and the sentimental tale which some fanciful writer has attached to the pattern is a mere afterthought. Figure subjects and landscapes are combined in many designs, such as the meeting of sages, romantic incidents, besides the more homely motives of field work, fishing, rustics returning from the plough mounted on their oxen, and the like. The four seasons, too, are represented in

[1] See p. 300.

[2] They also symbolise the three friends, Confucius, Buddha, and Lao-tzŭ.

landscape with appropriate accessories, such as blossoming peach trees in a mountain scene for spring, a lake scene with lotus gatherers for summer, a swollen river and autumn tints for autumn, and a snow-storm for winter.

A great variety of symbols and emblematical devices appear in the porcelain decoration of all periods, whether interwoven with the designs, grouped in panels, or placed under the base in lieu of a mark. Bushell [1] classifies the most familiar of them under the following headings :—

1. Symbols of Ancient Chinese Lore: *Pa-kua* and *Yin-yang* (see p. 290); *Pa yin* (eight musical instruments); *Shih êrh chang* (twelve ornaments embroidered upon sacrificial robes).

2. Buddhist symbols: *Pa chi hsiang* (eight emblems of happy augury). *Ch'i pao* (seven paraphernalia of the *chakravartin* or universal sovereign).

3. Taoist symbols: *Pa an hsien* (attributes of the Eight Immortals).

4. The Hundred Antiques (*Po ku*). *Pa pao* (the Eight Precious Objects).

The *pa-kua* (eight trigrams) and the *Yin-yang* symbol of the duality of Nature have been described. The eight musical instruments are : (1) *Ch'ing*, the sounding stone, a sort of gong usually in form of a mason's square. It forms a rebus for *ch'ing* (good luck). (2) *Chung*, the bell. (3) *Ch'in*, the lute. (4) *Ti*, the flute. (5) *Chu*, the box, with a metal hammer inside. (6) *Ku*, the drum. (7) *Shêng*, the reed organ. (8) *Hsüan*, the ocarina, a cone with six holes.

The twelve *chang* or ancient embroidery ornaments are : (1) *Jih*, the Sun, a disc in which is a three-legged bird, and sometimes the character *jih* 日. (2) *Yüeh*, the moon ; a disc with hare, toad and cassia tree, and sometimes the character *yüeh* 月. (3) *Hsing ch'ên*, the stars: represented by three stars connected by straight lines. (4) *Shan*, mountains. (5) *Lung*, dragons. (6) *Hua ch'ung*, the " flowery creature," the pheasant. (7) *Tsung yi*, the temple vessels: one with a tiger design and the other with a monkey. (8) *Tsao*, aquatic grass. (9) *Huo*, fire. (10) *Fên mi*, grains of rice. (11) *Fu*, an axe. (12) *Fu*, a symbol of distinction [2] (see vol. i., p. 227).

[1] *O. C. A.*, p. 106.
[2] It is also used as a synonym for " embroidered," and when it occurs as a mark. on porcelain, it suggests the idea " richly decorated."

The Eight Happy Omens (*pa chi hsiang*) were among the signs on the sole of Buddha's foot. They are usually drawn with flowing fillets attached (Fig. 2), and they are as follows: (1) *Lun*, the

wheel or chakra, sometimes replaced by the bell (*chung*). (2) *Lo*, the shell. (3) *San*, the State umbrella. (4) *Kai*, the canopy. (5) *Hua*, the (lotus) flower. (6) *P'ing*, the vase. (7) *Yü*, the fish; a pair of them.[1] (8) *Ch'ang*, the angular knot representing the entrails; an emblem of longevity.[2]

The Seven Gems (*ch'i pao*) are: (1) *Chin lun*, the golden wheel. (2) *Yü nü*, the jade-like girl. (3) *Ma*, the horse. (4) *Hsiang*, the elephant. (5) *Chu ts'ang shên*, divine guardian of the treasury. (6) *Chu ping ch'ên*, general in command of the army. (7) *Ju i chu*, the jewels which fulfil every wish; a bundle of jewelled wands bound round with a cord.

The *Pa an hsien*, Attributes of the Eight Immortals, as detailed above (p. 287), are: (1) *Shan*, the fan of Chung-li Ch'üan. (2) *Chien*, the sword of Lü Tung-pin. (3) *Hu lu*, the gourd of Li T'ieh-kuai. (4) *Pan*, the castanets of Ts'ao Kuo-chiu. (5) *Hua lan*, the basket of flowers of Lan Ts'ai-ho. (6) *Yu ku*, the bamboo tube and rods of Chang Kuo Lao. (7) *Ti*, the flute of Han Hsiang Tzŭ. (8) *Lien hua*, the lotus flower of Ho Hsien Ku.

The *Po ku*, or Hundred Antiques, is, as its name implies, a comprehensive group including all manner of symbols and symbolical ornaments, which were frequently grouped together in panel decoration. Bushell[3] describes two typical panels on specimens in the Walters collection. One contained the apparatus of the scholar and painter, viz. books on tables, brushes in vases, water pots and scroll pictures,

Fig. 2.—The Pa chi hsiang

[1] Also a symbol of conjugal felicity; and a rebus for *yü*, fertility or abundance.
[2] Having the same sound as *ch'ang* (long).
[3] *O. C. A.*, p. 119.

all enveloped with waving fillets mingled with tasselled wands and double diamonds, which are symbols of literary success. The other contained a tall vase with peonies; a low vase with peacock feather, an emblem of high rank; a lion-shaped censer on a four-legged stand, the incense smoke from which rises in form of a pair of storks; a set of incense-burning implements, a bundle of scroll pictures, a *ju-i* sceptre, a musical stone, a sword, and a paper weight.

A favourite set of *Po-ku* emblems is the *Pa pao* (Fig. 3) or Eight Precious Objects : (1) *Chu*, the pearl, which grants every wish. (2) *Ch'ien*, the " cash," a copper coin used to symbolise wealth. (3) Lozenge, or picture (*hua*). (4) *Fang shêng*, the open lozenge, symbol of victory.[1] (5) *Ch'ing*, the musical stone. (6) *Shu*, a pair of books. (7) *Chüeh*, a pair of horn-like objects. (8) *Ai yeh*, the leaf of the artemisia, a fragrant plant of good omen and a preventive of disease.

A branch of coral, a silver ingot, a pencil brush and cake of ink are other common emblems ; and the swastika occurs both by itself (vol. i., p. 227) or interwoven with the character *shou* (vol. i., p. 227), or even as a fret or diaper pattern. The swastika is a world-wide symbol ; in China it is called *wan*, and used as a synonym for *wan* (ten thousand), and as such it is regarded as a symbol of *wan shou* (endless longevity). A lyre wrapped in an embroidered case, a chess- or gô-board with round boxes for the white and black pieces, a pair of books, and a pair of scroll pictures symbolise the " four elegant accomplishments," *ch'in, ch'i, shu, hua* (music, chess, writing and painting).

The figurative aspect of Chinese decoration has been repeatedly noticed, and occasional examples of direct play upon words or rebus devices have been given incidentally. The Chinese language is

Fig. 3.—The Pa pao

[1] A pair of open lozenges interlaced are read as a rebus *t'ung hsin fang shêng* (union gives success) ; see Bushell, *O. C. A.*, p. 120.

peculiarly suited for punning allusions, one sound having to do duty for many characters ; but it is obvious that a fair knowledge of the characters is required for reading these rebus designs. There is, however, a certain number of stock allusions with which the collector can easily make himself familiar. The commonest of these is perhaps the bat (*fu*) which symbolises happiness (also pronounced *fu* in Chinese). The Five Blessings (*wu fu*), which consist of longevity, riches, peacefulness and serenity, love of virtue and an end crowning the life, are suggested by five bats ; and a further rebus is formed of red bats among cloud scrolls, reading *hung fu ch'i t'ien*, " great happiness equally heaven " (*t'ien*) ; *hung* being the sound of the character for " great, vast," as well as for red, and red being, so to speak, the colour of happiness in Chinese eyes.

Other common rebus designs are suggested by such words as *lu* (deer), *lu* (preferment) ; *yü* (fish), *yü* (abundance) ; *ch'ing* (sounding stone), *ch'ing* (good luck) ; *ch'ang* (the intestinal knot), *ch'ang* (long) ; and the composition of the rebus phrase often includes such ideas as *lien* (lotus), *lien* (connect, combine) ; *tieh* (butterfly), *tieh* (to double). But almost every sound in the Chinese spoken language represents a considerable number of characters, and it would be possible with a little ingenuity to extract several rebus sentences out of any complicated decoration. It is well to remember, however, that most of the ordinary allusions have reference to some good wish or felicitous phrase bearing on the five blessings, on the three abundances or on literary success.

To quote a few further instances : the design of nine (*chiu*) lions (*shih*) sporting with balls (*chü*) of brocade has been read [1] *chiu shih t'ung chü*, " a family of nine sons living together." An elephant (*hsiang*) carrying a vase (*p'ing*) on its back (*pei*) is read [2] *hsiang pei tai p'ing*, " Peace (*p'ing*) rules in the north (*pei*)." A tub full of green wheat is read [3] *i t'ung ta ch'ing*, " the whole empire (owns) the great Ch'ing dynasty." Three crabs holding reeds is read [4] *san p'ang hsieh ch'uan lu*, " three generations gaining the first class at the metropolitan examinations." Two pigeons perched on a willow tree is read [5] *êrh pa (k'o) t'eng t'ê*, " at eighteen to be successful in examinations."

[1] Bushell, *O. C. A.*, p. 521.
[2] See Hippisley, *Catalogue* No. 381.
[3] *Ibid.* [4] *Ibid.*, No. 388. [5] *Ibid.*

A group of three objects consisting of a pencil brush (*pi*), a cake of ink (*ting*) and a *ju-i* sceptre crossed one over the other (Fig. 4), occurs both in the field of the decoration and as a mark under the base. It is a pure rebus, reading *pi ting ju i*, may things be fixed (*ting*) as you wish (*ju i*, lit. according to your idea). Another obvious rebus which occurs as a mark (Fig. 5) consists of two peaches and a bat (double longevity and happiness), and floral designs are very commonly arranged so as to suggest rebus phrases.

But the Chinese decorator did not always express himself in riddles. Inscriptions are frequent on all forms of decorative work, as is only natural in a country where calligraphy ranks among the highest branches of art. To the foreign eye Chinese writing will not perhaps appear so ornamental as the beautiful Neshky characters which were freely used for decorative purposes on Persian wares; but for all that, its decorative qualities are undeniable, and to the Chinese who worship the written character it is a most attractive kind of ornament. Sometimes the surface of a vessel is almost entirely occupied by a long inscription treating of the ware or of the decoration which occupies the remaining part; but more often the writing is limited to an epigram or a few lines of verse. The characters as a rule are ranged in columns and read from top to bottom, the columns being taken from left to right; and rhyming verse is written in lines of three, five or seven characters each. The inscriptions are often attested by the name or the seal of the author. The Emperor Ch'ien Lung, a prolific writer of verses, indited many short poems on the motives of porcelain decoration, and these have been copied on subsequent pieces.

Fig. 4

Fig. 5

As for the style of writing, the ordinary script is the *k'ai shu*, which dates from the Chin dynasty (265—419 A.D.), but there are besides many inscriptions in which the archaic seal characters *chuan tzŭ* are employed, or at least hybrid modern forms of them; and there is the cursive script, known as *ts'ao shu* or grass characters, which is said to have been invented in the first century B.C. The seal and the grass characters are often extremely difficult to translate, and require a special study, which even highly educated Chinese do not profess to have mastered.

Single characters and phrases of auspicious meaning in both seal form and in the ordinary script occur in the decoration and also

in the place of the mark. Many instances have already been noted in the chapters dealing with Ming porcelains, such as *fu kuei k'ang ning* (riches, honours, peace and serenity), *ch'ang ming fu kuei* (long life, riches and honours), etc., see vol. i., p. 225. The most frequent of these characters is *shou* (longevity), which is written in a great variety of fanciful forms, mostly of the seal type. The " hundred forms of shou " sometimes constitute the sole decoration of a vase; and as already observed [1] the swastika (*wan*) is sometimes combined with the circular form of the seal character *shou* to make the *wan shou* symbol of ten thousand longevities. *Fu* (happiness) and *lu* (preferment) also occur, though less frequently.

Buddhistic inscriptions are usually in Sanskrit characters, but we find occasional phrases such as *T'ien chu en po* 天竺恩波 (propitious waves from India) and *Fo ming ch'ang jih* 佛明常日 (the ever bright Buddha) in ordinary script or seal, one character in each of four medallions; and the sacred name of *O mi t'o fo* 阿彌陀佛, Amida Buddha, similarly applied, would serve as a charm against evil.

In addition to the central designs, there is a number of secondary ornaments which round off the decoration of a piece of porcelain. Chief of these are the border patterns, of which a few favourites may be exemplified. At the head of the list comes the Greek key-fret or meander (see Plate 12, Fig. 1), which, like the swastika, is of world-wide use. On the ancient bronze this pattern was freely used both in borders and as a diaper background, and it is described by Chinese archæologists as the " cloud and thunder pattern." It is sometimes varied by the inclusion of the swastika, in which case it is known as the swastika fret. Another bronze pattern freely borrowed by the porcelain decoration is the border of stiff plantain leaves which appears appropriately on the neck or stem of an upright vase (see Plate 89, Fig. 1).

The border of small " S " shaped scrolls is apparently derived from silkworm cocoons; but the curled scrolls and another scroll pattern with more elaborate curves are intended to suggest clouds. A further development of the cloud pattern is scarcely distinguishable from the *ju-i* head border (see Plate 77, Fig. 2). Indeed the terms, " connected cloud " pattern, *ju-i* cloud pattern, and *ju-i* head pattern, are used almost interchangeably by Chinese archæologists.

Conventional waves are represented by a kind of shaded scale

[1] See p. 299.

pattern or a diaper of spiral coils, and the more naturalistic "crested wave" border, punctuated by conical rocks, has already been mentioned. There are besides narrow borders of zig-zag pattern with diagonal hatching, and the ordinary diaper designs, in addition to the familiar gadroons and arcaded borders.

The wider borders are usually borrowed from brocade patterns with geometrical or floral ornament, broken by three or four oblong panels containing symbols or sprays of flowers; and when a similar scheme is followed in some of the narrow edgings, the flowers are unhesitatingly cut in half, as though the pattern were just a thin strip taken from a piece of brocade.

A few special borders have been described on the pages dealing with armorial porcelain,[1] among which were the well-known "rat and vine" or "vine and squirrel" pattern (see Plate 119, Fig. 3), reputed to have first appeared on a picture by the Sung artist, Ming Yüan-chang.[2] A rare border formed of red bats side by side occurs on a few plates of fine porcelain which are usually assigned to the K'ang Hsi period, but are probably much later.

On the whole, the Chinese border patterns are comparatively few in number, being in fact a small selection of well-tried designs admirably suited to fill the spaces required and to occupy the positions assigned to them on the different porcelain forms.

As to the sources from which these and the other designs described in this chapter were borrowed by the porcelain decorator, we can only speak in general terms. Ancient bronze vessels, metal mirrors, carved jades, stamped cakes of ink, embroideries, brocades, handkerchiefs, and illustrated books no doubt provided the greater part of them. The purely pictorial subjects would be based on the paintings in silk and paper which the Chinese arrange in four chief categories: (1) figures (*jên wu*), (2) landscape (*shan shui*), (3) nature subjects (*hua niao*, lit. flowers and birds), and (4) miscellaneous designs (*tsa hua*). Selections of desirable designs from various sources were no doubt arranged in pattern books, and issued to the porcelain painters.

[1] See p. 258. [2] See Anderson, op. cit., No. 747

CHAPTER XVIII

FORGERIES AND IMITATIONS

WITH their intense veneration for the antique, it is only natural that the Chinese should excel in imitative work, and a great deal of ingenuity has been quite legitimately exercised by them in this direction. The amateur will sometimes have difficulty in distinguishing the clever copies from the originals, but in most cases the material and the finish of the work frankly belong to a later period, and sometimes all doubt is removed at once by a mark indicating the true period of manufacture. But the collector has to be on his guard against a very different kind of article, the spurious antique and the old piece which has been "improved" by the addition of more elaborate decoration or by an inscription which, if genuine, would give it historic importance. The latter kind of embellishment is specially common on the early potteries of the Han and T'ang periods. Genuine specimens taken from excavated tombs have often been furnished with dates and dedicatory legends cut into the body of the ware and then doctored, to give the appearance of contemporary incisions. But a careful examination of the edges of the channelled lines will show that they have been cut subsequently to the firing of the ware, when the clay was already hard. Had the inscription been cut when the pot was made, it would have been incised in a soft unfired substance, like the writing of a stylus in wax, and the edges of the lines would be forced up and slightly bulging ; and if the ware is glazed, some of the glaze will be found in the hollows of the inscription. There are, besides, minor frauds in the nature of repairs. Pieces of old pottery, for instance, are fitted into a broken Han jar ; the lost heads and limbs of T'ang figures are replaced from other broken specimens, and defective parts are made up in plaster. Such additions are often carefully concealed by daubs of clay similar to that with which the buried specimen had become encrusted. Further than this, Han and T'ang figures have been recently manufactured

in their entirety, and mention has already been made (Vol. I., p. 27) of a factory at Honan Fu, where figures and vases with streaked and mottled glazes, fantastic ewers with phœnix-spouts and wing-like excrescences, and the like, are made with indifferent skill.

The collector of Sung and Yüan wares, too, has many difficulties to surmount. The fine imitations made from the Yung Chêng period onwards, both in pottery and porcelain, fortunately are often marked ; but sometimes the mark has been carefully removed by grinding, and the scar made up to look like the natural surface. The imitative wares made in Kuangtung, at Yi-hsing, and in various Japanese factories have been already discussed in the sections concerned ; and there is pottery with lavender blue, "old turquoise" and splashed glazes resembling the Chün types, but made at the present day in Honan and elsewhere, which is likely to deceive the beginner. The commonest kind has a buff earthen body which is usually washed with a dull brown clay on the exposed parts. But such obstacles as these add zest to the collector's sport, and they are not really hard to surmount if a careful study be made of the character of authentic specimens. The eye can be easily trained to the peculiarities both of the originals and of the various imitative types, and no one who is prepared to take a little trouble need be afraid of attacking this fascinating part of Chinese ceramics.

The T'ao lu [1] quotes an interesting note on the repairing of antique wares : " In the Chu ming yao it is stated with regard to old porcelain (tz'ŭ), such as (incense-) vessels which are wanting in handles or feet, and vases damaged at the mouth and edge, that men take old porcelain to patch the old, adding a glazing preparation, and giving the piece one firing. When finished it is like an old piece, and all uniform, except that the patched part is dull in colour. But still people prefer these specimens to modern wares. If the process of blowing the glaze on to (the joint of the repair) is used in patching old wares, the patch is still more difficult to trace. As for specimens with flaws (mao), I am told that on the Tiger Hill in Su-chou there are menders who have earned the name of chin (close-fitters)." The collector knows only too well that there are " close-fitters " in Europe as well as in China.

Apart from the numerous instances in which early Ming marks [2]

[1] Bk. viii., fol. 4, quoting the Shih ch'ing jihcha.
[2] See chap. xvii. of vol. i., which deals with marks.

have been indiscriminately added to later wares, the careful copies and imitations of true Ming types are comparatively few. Among the imitative triumphs of the Yung Chêng potters a few specialties are named, such as blue and white of the Hsüan Tê and the Chia Ching periods, and the enamelled decoration of the Ch'êng Hua and Wan Li, but reference has already been made to these in their respective chapters. The modern Chinese potters make indifferent reproductions of Ming types; and the most dangerous are those of the Japanese, who from the eighteenth century onward seem to have taken the sixteenth century Chinese porcelains as their model. The Chia Ching and Wan Li marks are common on these reproductions, which often catch the tone and spirit of the Ming ware with disquieting exactitude. A well-trained eye and a knowledge of the peculiarities of Japanese workmanship are the only protection against this type of imitation.

The high esteem in which the K'ang Hsi porcelains are now held has naturally invited imitation and fraud. The ordinary modern specimen with a spurious K'ang Hsi mark is, as a rule, feeble and harmless, and even the better class of Chinese and Japanese imitations of the blue and white and enamelled porcelains of this period are, as a rule, so wide of the mark as to deceive only the inexperienced. Many frauds, however, have been perpetrated with French copies of *famille verte*, of *famille rose* " ruby-back " dishes, and of vases with armorial decoration. These are cleverly made, but the expert will see at once that the colours and the drawing lack the true Oriental quality, and that the ware itself is too white and cold. Clever copies of Oriental porcelain, especially of the *famille rose*, have also been made at Herend, in Hungary. But perhaps the most dangerous Continental copies are some of the French-made monochromes of dark blue and lavender colours, with or without crackle, fitted with ormolu mounts in eighteenth century style, which conceal the tell-tale base. Monochromes are, as a rule, the most difficult porcelains to date, and the well-made modern Chinese and Japanese *sang de bœuf*, apple green, and peach bloom are liable to cause trouble, especially when the surface has been carefully rubbed and given the appearance of wear and usage. The expert looks to the truth of the form, the finish of the base, and the character of the clay exposed at the foot rim, and judges if in these points the piece comes up to the proper standard.

But without doubt the most insidious of all the fraudulent wares

are those which have been redecorated. I do not refer to the clobbered [1] and retouched polychromes or to the powder blue and mirror black on which the gilding has been renewed, but to the devilish ingenuity which takes a piece of lightly decorated K'ang Hsi porcelain, removes the enamelling, and even the whole glaze if the original ornament has been in underglaze blue, and then proceeds to clothe the denuded surface in a new and resplendent garb of rich enamel. Naturally, it is the most sumptuous style of decoration which is affected in these frauds, such as the prunus tree and birds in a ground of black, green, or yellow enamel on the biscuit; and the drawing, execution and colours are often surprisingly good. The enormous value of this type of vase, if successful, repays the expense and trouble involved in the *truquage ;* and the connoisseur who looks at the base for guidance is disarmed because that critical part has been undisturbed, and has all the points of a thoroughbred K'ang Hsi piece. If, however, his suspicion has been aroused by something unconvincing in the design or draughtsmanship, he will probably find upon minute examination some indication of the fraud, some trace of the grinding off of the glaze which the enamels have failed to cover, suspicious passages at the edge of the lip where the old and new surfaces join, or traces of blackening here and there which are rarely absent from a refired piece. But if the work is really successful, and no ingenuity or skill is spared to make it so, his suspicions may not be aroused until too late. Frauds of this kind belong to the most costly types, and concern the wealthy buyers. The poorer collectors have to deal with small deceits, the adding of a *famille verte* border to a bowl or dish, the retouching of defective ornament, the rubbing of modern surfaces to give them fictitious signs of wear, the staining of new wares with tobacco juice, and other devices easily detected by those who are forewarned. Against all these dangers, whether they be from wilful frauds or from innocent imitations, I can only repeat that the collector's sole defence is experience and a well-trained eye.

[1] See p. 261.

INDEX

316 Index